# SOUTHWEST INDIAN PAINTING

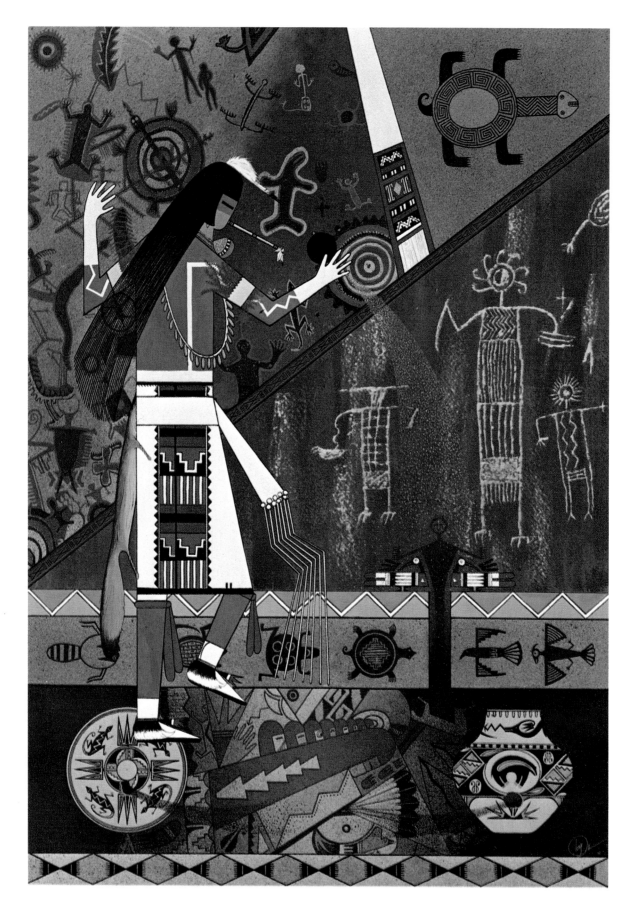

*An abstract by Tony Da, courtesy of*
*Mr. and Mrs. Clay Lockett.*

# SOUTHWEST INDIAN PAINTING

a changing art

# Clara Lee Tanner

Second Edition

**THE UNIVERSITY OF ARIZONA PRESS**
Tucson, Arizona

*About the author . . .*

Clare Lee Tanner, who has studied the painting, crafts, and religion of the Indians of the Southwest for more than forty years, is the author of *Southwest Indian Craft Arts* and innumerable articles. She has traveled and studied extensively among the Southwest tribes, as well as in Mexico and Europe. A member of the anthropology department faculty at the University of Arizona since 1928, she has served on the juries for a large number of craft and painting exhibitions, and is much in demand as a speaker. She and her husband, John Tanner, at Gallup, N.M., in 1971, were awarded the fiftieth anniversary commemorative medal of the Intertribal Indian Ceremonial Association, "in appreciative recognition of extraordinary services to the nation's tribute to the American Indian." Mrs. Tanner is a Fellow of the American Anthropological Association, and an active member of several other professional societies, including the Society for American Archaeology, Theta Sigma Phi, Delta Kappa Gamma, Society of the Sigma Xi, and the National Federation of Press Women. In 1971 she was named Woman of the Year by the Arizona Press Women.

THE UNIVERSITY OF ARIZONA PRESS

I.S.B.N. 0−8165−0309−5
L.C. No. 74−160812

*To Sandy*

# Preface

The objectives of this new and much-revised edition of *Southwest Indian Painting* are twofold—to update the record of painters discussed in the first edition, and to record the names and activities of many of the Indians who have appeared in this art field in the interim. Emphasized again is the fact that this is a transitional form of art, not a full-blown fine art; it is a transitional expression moving from the craft arts at one end of the continuum to the fine arts at the other. This painting can be viewed, as some have attempted, in comparison with the high expressions of civilized societies, or, more realistically, it can be looked at for what it is—a development directly out of the craft field. By the same token, the fact that some 1965–1971 Indian art has a European focus, which is the end product of the white man's institutional training, is not overlooked. Perhaps this focus will be the last steppingstone along the path from native decorative art to the fine arts.

Many painters have been included who cannot be called artists in the strict sense of the word. However, they are part of the whole story of a form of art which is still heavily laden with the traditions of the crafts, with much flat color, rhythmic repetition, lack of perspective. It is possible that, unintentionally, some painters of note have not been included in this survey; to them, my apologies.

Throughout the text of this volume, paintings to which the artist has given a title are *italicized* to distinguish them from those that are simply referred to by a descriptive word or phrase.

No book ever saw the light of publication through the sole efforts of one person; to those who so generously contributed of their

time, efforts, and inspiration to the first edition—and most particularly to George and the late Ethel Chambers and Helen D'Autremont —again ¡salud y gracias! My deep appreciation to the many who have made this second edition possible, first to the Indian painters themselves (without whom this volume would never have been born) who have been the unfailing inspiration throughout; and to the following named as well as many unnamed individuals for their unflagging interest, their unfailing effort, and their unlimited cooperation—Paul F. Huldermann, James T. Bialac, Dr. and Mrs. Harlow Avery, Mr. and Mrs. H. S. Galbraith, and Dr. and Mrs. Byron C. Butler; to Tom Woodard, Jim Parker, Betty Toulouse, Charles DiPeso, Barton Wright, Wilma Kaemlein, Read Mullan, Iris Jackson, and Donald G. Humphrey. My thanks also to the School of American Research, Santa Fe, for making available to me its collections and those of the Indian Arts Fund; to the Amerind Foundation, Inc., Dragoon, Arizona; the Museum of Northern Arizona, Flagstaff; the Denver Art Museum; and the Heard Museum of Anthropology and Primitive Art, Phoenix.

Very special appreciation goes to my editor, Kit S. Applegate, for the endless hours and personal interest in helping to make the record as complete as it is herein and for her patience in the face of tedium of the many stages of making a book; my thanks also to Marshall Townsend, Director, and the other members of the University of Arizona Press whose enthusiasm and assistance helped to bring this book into being.

CLARA LEE TANNER

# Contents

# Indexed List of Illustrations

Paintings to which the artist has given a title are *italicized* to distinguish them from those simply referred to by a descriptive word or phrase.

xiv

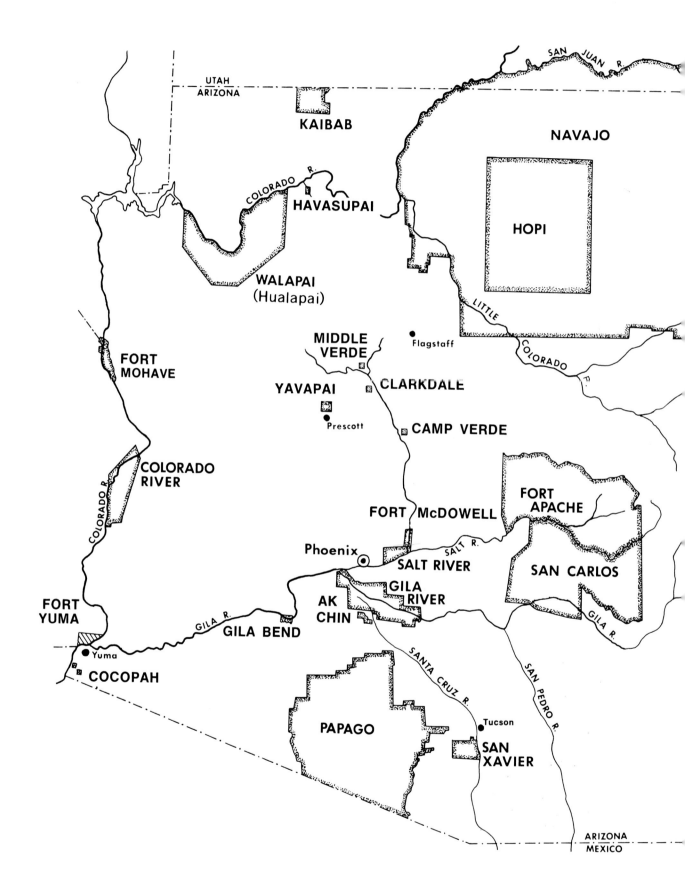

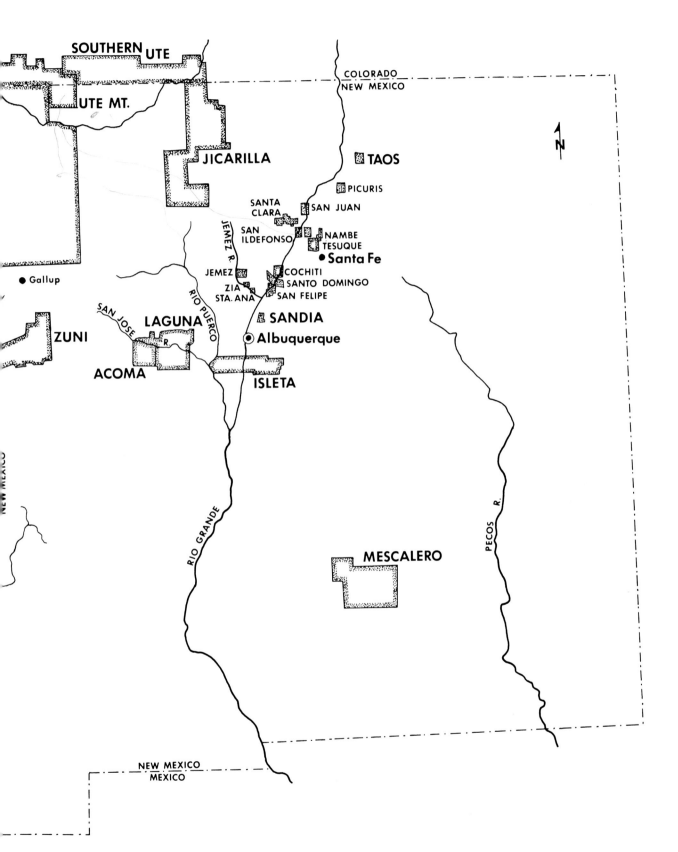

SOUTHERN UTE

UTE MT.

COLORADO
NEW MEXICO

N

JICARILLA

TAOS

PICURIS

SANTA CLARA

SAN JUAN

SAN ILDEFONSO

NAMBE

TESUQUE

Santa Fe

Gallup

JEMEZ R.

JEMEZ

COCHITI

SANTO DOMINGO

ZIA

STA. ANA

SAN FELIPE

ZUNI

RIO PUERCO

SAN JOSE

LAGUNA

R.

SANDIA

Albuquerque

ACOMA

ISLETA

NEW MEXICO

RIO GRANDE

MESCALERO

PECOS R.

NEW MEXICO
MEXICO

# SOUTHWEST
# INDIAN
# PAINTING

# Introduction

In the 1970s, Southwestern Indian easel art had reached the highest peak it had ever known. There were more outstanding individual painters, more tribes producing art, and more highly developed styles of painting than at any other point in the history of this unique expression. Too, within the preceding decade, there were more experiments with new media, more refinement in the traditional styles as well as experimentation with new ones, and more self-expression than ever before. Furthermore, in this same decade there had been more formal and advanced training of young, potential Indian artists than previously.

Predicting the future of this art is, obviously, not possible, but educated guesses as to what might happen can be based on full acquaintance with the past plus what has transpired during the 1960s and into the early 1970s. One opinion which probably has much validity is that expressed by Fritz Scholder, a part-Mission Indian artist of some note who has been and is continuing to be an influence on some of the young Indian students of art: "I believe that there is a new Indian Art emerging. It will take many forms and will be vital. A merging of traditional subject matter with the contemporary idiom will give us a truer statement of the Indian."[1]

As to the significance of this important development, there is, again, considerable uncertainty. Since Indian art has been of some consequence in the American scene in the past and has become more so in recent years, it is quite likely that it will continue in this direction in the future. Ewing suggests, relative to the new media and

new styles, that "whether the New Indian Art will be recognized as an important movement on the contemporary American scene depends, in large part, on the creative lives of the artists working in this style. Some of them will undoubtedly move into other fields of inspiration even as other artists will be attracted by the style. But at least the movement was born and exists as a very healthy and compelling infant."[2]

So much for the immediate present and the future. What of the past? Why is this art unique? What is "traditional"? How did it develop? And who are the artists? These questions, and others, will be answered in succeeding chapters, but here it is necessary to set the stage for the more detailed discussion of Southwestern Indian easel art that follows.

The American Indian has long been looked upon as a dying breed, as a people and a culture successfully conquered by Europeans. Quite the contrary is true. The history of Indian art reflects the attitudes of the American towards the native peoples and their way of life. First, it was push the Indians aside, whip them, and substitute our culture for theirs. Their art was seemingly destroyed. In the schools, they were taught either no art or the white man's styles only. Then the white man came of age culturally, developed a conscience, and decided to let the Indian have his own art; in fact, he encouraged it by purchasing it, by decorating his person and his home with things Indian. During this "sentimental" period the Indian went through a stage of producing "curio" art for the "tourist" trade. Finally some white men realized that the Indian was a human being, not a curiosity, and acknowledged him as such; they learned a bit about the first Indians and came to accept their capabilities and art styles at face value. The Indian now struck out in his own way, producing some of his finest art in both the crafts and in easel painting.

Through the millennia, the American Southwest has seen much change, both in environment and in culture. From the late glacial period into modern times, it went through several broad periods of abundant rain to the present semi-arid state. Certain life forms changed also; for example, when the greater moisture resulted in more plant growth, the latter in turn supported large mammals such as the bison and mammoth. Some parts of the Southwest did not know these lush conditions, and in such areas less growth and smaller animals prevailed. In time, of course, the entire region dried up and the great mammals disappeared.

Man's culture reflects these varying and changing conditions. First, it should be noted that man roamed widely throughout this entire Southwest territory. Some of these people followed the big game, killing the large bison and mammoths with finely chipped and

4

often large points. Others lived in areas of lesser game, and they hunted the smaller animals with inferior tools and gathered wild plant foods. It was the small-game hunter and gatherer who survived through the centuries and made adaptations to new circumstances. Because of his knowledge of grinding implements, probably used to prepare seeds, he seems to have been able to accept and develop corn when it came to the Southwest from Mexico. These men became the first cultivators of the soil in the Southwest.

In time, these farmers grew in numbers and in cultural stature. They developed the extensive cultivation of corn and other products, the building of villages, socio-politico-religious organization, and art in crafts and religious areas. Before and about the time of the opening of the Christian Era, three distinct cultures emerged in the Southwest: the Anasazi in southern Colorado and Utah and in northern Arizona and New Mexico; the Hohokam in southern Arizona; and the Mogollon in southwestern New Mexico. Each of these cultures began in relatively limited parts of the areas cited, but in time each grew, both in territory and in cultural accomplishments. During their respective histories, each borrowed from or was influenced by the others; much Mexican influence is to be noted also during prehistoric years.

Around A.D. 1400 a period of drastic change began in the Southwest, causing a decline in all three of these cultures. The Mogollon culture, as such, disappeared; the Hohokams dwindled culturally and in population; and the Anasazi people moved into fewer and larger settlements. Some of the Mogollon people may have moved into the Rio Grande area, to fuse with the already established Pueblo Indians there. Quite a few archaeologists believe that the Pima and Papago Indians living in southern Arizona throughout the historic period are lineal descendants of the Hohokam. And there seems to be little or no question that the modern Pueblo Indians—the Hopis of northeastern Arizona, the Zuñis of western New Mexico, and the people of the Rio Grande pueblos of New Mexico—are the direct descendants of the prehistoric Anasazi folk.

Thus, by 1540 when the Spaniards arrived in the Southwest, the area occupied by the settled Indians had diminished greatly from that of prehistoric times. Meanwhile, other Indians—the Apaches and Navajos—had drifted into this territory; when and how is not yet known. Eventually, some years after the coming of the Anglos, the Apaches were settled on reservations in north- and south-central New Mexico and in east-central Arizona, while the Navajos were placed on a vast reservation in northern Arizona and New Mexico, with small sections in Utah and Colorado.

Several other tribes also inhabited this Southwest area, including Utes and Paiutes scattered widely over northwestern Arizona,

western Colorado, Utah, and into Nevada. Along the Colorado River and into western Arizona and eastern California were the Yuman tribes: Yuma, Mohave, Cocopa, Hualapai, Havasupai, Yavapai, and the Maricopa, who moved to the Phoenix area around 1700.

From their ancestors these historic Southwest Indian tribes inherited a rich culture with, of course, some degree of variation; the highest at the time of conquest was the puebloan. These Indians lived in stepped, multi-storied adobe or stone unit houses which the Spanish labeled pueblos. A semi-subterranean, square or round ceremonial chamber called a kiva was attached, singly or several of them, to each village. The people cultivated corn, beans, squash, and cotton, some irrigating their fields, but all dependent on rain to a greater or lesser degree. Quite a bargain was struck between the Indian and the world about him: he felt that if he prayed and performed certain ceremonies that clouds, thunder, lightning, and rain would all respond; hence there developed a rich ceremonial pattern of dances, rites, small carving, painting, and other auxiliary expressions. Many of these forms of art still exist. Puebloan art was not confined to religion at this time of first contact; many fine craft expressions were at a peak although some had degenerated. Still important was the production of baskets, textiles, pottery, and various miscellaneous, lesser items. No metals had ever been worked by these people, no metal tools had ever been used.

The non-puebloans had essentially the same cultural items discussed above, with far simpler houses (no pueblos), and with the majority of crafts at a lower level at the time of the arrival of the Spaniards.

The Spaniards brought with them a great many ideas and some items of material culture. Cattle, horses, and sheep (the latter were to influence Indian weaving) were given to the natives; some new agricultural products and techniques were added; and a few items were introduced into their homes. The Spaniards demanded that the puebloans worship in Catholic chapels and made a strenuous effort to wipe out native religion. Thus, the greater Spanish influences might be summed up in a few basic points. Agricultural ways were but slightly affected, with corn remaining the basic food and the most significant product ritually; Spanish political officers for the villages were accepted outwardly but native religionists continued to rule; outwardly, too, Indians worshipped in the little chapels, but secretly they performed the age-old native rites in their own religious rooms, the kivas; and, largely, their crafts remained basically the same, for the Spaniards brought few substitutes for these. A pertinent area of interest might be mentioned here—Spanish influence on painting. Apparently the Indian decorated the village chapel on occasion,

either on his own or under Spanish supervision. Further, it is apparent in ceramic decorative themes, such as birds and flowers, that the Indian potter may have been influenced by Spanish designs.

The Mexicans, who acquired political control of the Southwest Indian area in 1823, had even less influence on the natives. They perpetuated Spanish policies in religion and political organization, but they brought to the Indian nothing new of particular significance; their major influence terminated with the acquisition of this territory by the United States in 1848 and 1854.

As far as the non-puebloans were concerned, some were not particularly affected either by the Spanish or by the Mexicans other than in the acquisition of material items and religion as mentioned above. To be sure, the Navajos did acquire the silver craft from Mexicans, after the mid-1800s. It is interesting to note in passing that, despite the acceptance of Catholicism, there seems to have been little or no artistic influence on the Papagos by the Spanish, either in their churches or elsewhere. According to Fontana, there are no known examples of Spanish easel art in early times in the Southwest.[3]

One incident followed quickly on the heels of another when the United States government acquired that part of the Southwest which was home to most of the Indians of this discussion. In the midst of this assumption of sovereignty came the 1849 gold rush, the establishment of reservations, starting in the late 1850s. Soon after that, the Homestead Act brought many people into the Southwest, with subsequent encroachment on Indian lands.

Many trading posts were established on the Navajo Reservation in the 1870s, thus introducing cloth in quantity, aniline dyes, and commercial wool, all of which affected weaving. The coming of railroads in the 1880s probably had the widest influence of any single incident up to this time, for the railroads brought more people, more material goods, and caused, directly or indirectly, many changes in the lives of the Indians. Many years later came the Indian Reorganization Act of 1934, a most significant occurrence. Prior to this date, the Indian had been told not only what to do but how to do it. After this date, tribal councils were established, with more or less self-rule; public schools appeared on reservations; and wealth came to some tribes through discovery of natural resources on their lands or from land-claims cases.

Perhaps the single most important event in the history of Southwest Indian painting was World War II. Many young men and some young women traveled to other parts of the country or even to far places in the world. It was impossible that they should return without changed points of view, without new vistas, without new ideas. And, interestingly, there were greater changes in the relatively

short span of time between World War II and 1970 than in all the preceding years of contact with Europeans. Radio and TV brought the world closer to an ever-increasing number of Indians. Pickup trucks enabled Indians to get off the reservation in larger numbers than the horse ever allowed. Higher education broadened their store of knowledge far beyond that of any earlier time; this includes advanced education in art as well as other areas of learning. To be sure, there were many who were living at the beginning of the 1970s much as their tribesmen had for a century or more, particularly those located in some far-off corner, plus a few who so chose to live.

Thus it is obvious that the culture of the Southwest Indian never stood still, neither in the distant past nor throughout historic times. As long as that culture has changed, so too has art fluctuated, sometimes going forward, sometimes degenerating. These responses to cultural change need to be viewed broadly at this point in anticipation of specific discussions in later chapters.

Painting by Southwest Indians began with the early hunters and food gatherers in the Southwest. Although only a little of this early work remains, such as geometric designs on wood and stone, it is the consensus that more existed. This may explain the prominence among the first settled farmers of painting on a variety of objects and in many areas, on baskets and small woven bands, and on rock walls. Most important of all was pottery, with so much and such a variety in colors, designs, subjects, and in styles of painting. Through the years at one time or another painting appeared on practically every material used by these ancient Indians, from shell, bone, wood, and stone to clay, fabrics, and even their own bodies. Although the painting was predominantly geometric, there was some naturalistic expression; in part this was a matter of tribal choice, in part it was tied in with materials or technology. Colors were, of course, limited to the natural materials which the people found about them, with red, yellow, brown, black, and white being the most commonly used; this is true even where firing in ceramic decoration caused some change of color.

At the time of Spanish contact, there seems to have been a fair amount of painting expressed by the native populations. Ceramic decoration was still at a high point among the puebloans, but it seems to have been at low ebb among the non-puebloans with the exception of the Navajos who were, at this time or shortly thereafter—particularly around 1700—doing the only ceramic decoration in color that they are known to have executed. Early Spanish reports of painting on native textiles would imply a peak in this expression, particularly among the Hopis; it is probable that there was much painting on skins also. Skin painting may well have been a forte of the

Navajos and Apaches, but the more nomadic ways of life of these peoples would have left little evidence of such an expression. Kiva walls were painted at this time, and, in turn, depicted in these murals are other objects which may have been decorated by painting, including rattles, containers, staffs, altars, shields, and items of personal adornment.

It was inevitable that some of these paint-decorated items should change or disappear through the years. Painted fabrics and skins tended to become obsolete, but many smaller objects, such as rattles, shields, and altars, continued to be decorated in this manner. Another area—wall painting—is more difficult to trace from the standpoint of time. Although unknown or unreported until the Mexican period, except for very early Spanish reports, the decorating of kiva walls may well have continued throughout this entire time; the secrecy of the rites, and complete exclusion of the Spaniards from the kivas, would explain a gap in knowledge here. There are cliff wall paintings, too, some dated in the mid- and late 1700s and into the 1800s, but what the situation was before these years is unknown. It is inconceivable that such a widespread and seemingly important expression as stone wall paintings could have been dropped with the arrival of the Spanish; it may well have continued for years thereafter. Some watercolor artists of the 1970s, particularly several Navajos, lay claim to wall painting among their first efforts.

The painting of kiva wall murals continued into the twentieth century; it is likely that they are still produced in some pueblos for certain ritual situations. Despite the fact that many other types of painting gradually disappeared, except for body decoration, masks, and ceremonial paraphernalia, painted craft ornamentation such as ceramic decoration lingered into the early years of the 1970s. One of the above exceptions is well represented by pueblo kachina dancers and Navajo yei performers and all of their equipment. A few new areas of painting also opened up along the way; for example, kachina dolls became popular in the late nineteenth century. Among types of painting that disappeared during these same years were shields, body painting for war ceremonies, and related expressions.

It is likely that there were slight Spanish influences on some ceramic decoration as intimated above; Mexican influences in the realm of painting seem to have been nonexistent; it was not until several decades into the twentieth century that Anglo-American contact was significantly felt in this area of expression. Generally the latter had the effect of simplifying ceramic painted decoration or, even, the substitution of decorative techniques other than in color. One might well entertain the thought that as ceramic painting degenerated, consciously or unconsciously the natives became eager

to find other outlets for this expression. Watercolor art was, perhaps, a natural substitute.

Thus, in the transition from the nineteenth to the twentieth century, the Southwest Indians, both puebloan and non-puebloan, were active painters in a variety of media on an even greater variety of objects. Painting was, however, basically a decorative expression as it had been for many centuries; the exceptions to this were some kiva and cliff wall murals.

At this transitional period the Indian met with, for the first time, a new medium—paper. He was also introduced to readymade paints, although on some occasions he has returned later to earth colors. Perhaps it is difficult for the reader to understand that for years many of these Indians did not have a scrap of paper upon which to paint or draw, much less any medium with which to do the painting or drawing. At first white men gave supplies to the budding artists; even in later years some artists still received their art supplies from interested outsiders.

Puebloans were the first Southwest Indians to be introduced to easel painting, and most important were the men of San Ildefonso. A few other Rio Grande pueblo individuals and several Hopis became involved at an early time. Then, with the development in 1933 of the art department in the Santa Fe Indian School, additional tribesmen were introduced to this new expression; foremost among these were more puebloans and Navajos and Apaches. Many of the first students in this school made painting a life career. No paintings by Pimas, Papagos, Utes, Paiutes, or Yuman Indians appeared among these first school efforts.

By the third decade of the twentieth century, distinct styles in painting began to appear. Again San Ildefonso was the leader in this matter: under the brush of Awa Tsireh there developed three styles which influenced not only the men of his village but young artists from other pueblos. Simply presented, these involved first, naive realism; second, the same type of realism modified by conventional themes; and third, conventional design which frequently verged on or became abstract. Obvious influences from the craft arts appear in these three styles which became traditional in terms of Rio Grande easel painting.

Two Hopi Indians living in Santa Fe at this same early time, Fred Kabotie and Otis Polelonema, set standards which became traditional for their tribe. Probably influenced in some measure by the developing Rio Grande artists, at least in subject matter and general presentation, these two men nonetheless added a few touches that became typical of the Hopi artists; these traits prevailed into the 1970s. Modeling in shaded color and the addition of bits of ground

and sometimes shadows were Hopi traits not used by the other puebloans. Ceremonial dancers were favored by all puebloans; in addition, scenes of everyday life about the villages were, perhaps, more common among the Rio Grande puebloans; and the kachina found the greatest favor among Hopi artists.

It was not until the Santa Fe Indian School art department established the studio, as mentioned above, that the Navajo and Apache Indians began to produce easel painting. From the beginning, the members of these two tribes were more inclined to emphasize different subject matter, such as horses and riders, although they also painted ceremonial subjects. Their approach was different also, with much more action and spirit in evidence in their style. As in the case of the puebloans, these features were lasting among the Navajos and Apaches; thus their traditional style, stressing horses, action, and ground lines with growth or rocks added thereto, was established at an early date in their efforts at easel painting.

Thus it can be seen that differing environments, the pueblo versus the Navajo, or changing circumstances, such as going to art school or riding horses, can and do affect culture and, in turn, the art expressions of these tribal groups.

There are further influences which have been brought to bear on all Southwest Indian painting. Foremost among these is the buying public: without a market, no painting such as this could survive. In the first days of this expression, the people of Santa Fe and environs became vitally interested, for this area was already art-oriented. Many travelers of note came to this section of the country, and some of them, greatly imbued with the importance of this new development, carried word of it in the form of exhibits throughout the United States and even to France as early as the 1930s. Then the collector appeared. In many respects, these two, exhibitors and collectors, have been in the vanguard, leading the Indian artist to ever-greater production. Unquestionably these same influences affected the development and retention of traditional styles in earlier years; new shows and collectors since 1960 have played a part in the development of both traditional and nontraditional styles.

Finally came the influence of higher education and the exposure of the Indian artist to new styles of painting. This was the first true tradition-breaker. Although some Indians had attended institutions of higher learning to pursue their art studies, the first important influence was the Rockefeller Indian Art Project at the University of Arizona initiated in 1960. Before this terminated, the Institute of American Indian Arts at Santa Fe was conceived. The staffs of both became vitally interested in introducing the native not only to the rich background of Indian art and world art but also in

acquainting him with the contemporary styles and trends in painting. The Indian was also encouraged to retain his rich and meaningful subject-matter background or other significant aspects of his native art. Out of this fusion have come new and promising paintings.

One major concept emerges as basic to the entire development of Indian easel art up to the 1960s: art grows out of culture, and the culture of those native Indians had dictated a decorative style of painting. Certain qualities evolved through the centuries in the decoration of pottery, baskets, ceremonial equipment of the Indian; they included, among others, balance, repetition, emphasis on form, discipline, flat and limited colors. These not only carried over into easel painting but dominated it for many years.

A second major thought to keep in mind is the fact that differing environments, history, and cultural developments contribute to variations in local arts. This can be illustrated in the Southwest from the contrasting tools of the hunter stage to the local varieties of culture, and therefore arts, of the Anasazi, Hohokam, and Mogollon, to the historic tribes and their respective styles. Despite a basic Stone Age culture for all these peoples, local variations led to what are called traditional styles in the easel art of the puebloan and non-puebloan folk.

A third point may be made to avoid the misunderstandings sometimes expressed by critics of Indian art. Southwest Indian art must also be viewed as a product of rapidly changing culture. This gives myriad facets to Indian art. The works of children and older students are interesting in that they reflect everything from a dominant teacher who demands that they paint in a specific way or another teacher who gives them some freedom, to the child who paints the way his artist father does, or the one who just paints. Then there is the adult painter who went to school and continued painting thereafter, developing certain aspects of style, while his tribal brother who never had a moment in an art classroom may do very different (or very similar) painting. And also there is the Indian artist heavily influenced by some Western European abstractionist. Too frequently the critic throws all of these into one pile and judges them by the same standards dictated by his Western European background, training, and vocabulary, much of which does not fit. Then, when an Indian artist finally paints in some Western European tradition—say, a specific abstract style—he has "arrived" for now the critic can judge the Indian in terms of the critic's background and vocabulary. This does not give any true presentation of Indian art from its inception to the 1970s; the Indian who paints in a neo-cubistic style is reflecting but one of the many facets of this expression today. The above would be in the same category as saying that the only good

Indian today is the young fellow who wears a white man's business suit! Further, if painting in Western European idioms is to be the only art expressed by these tribesmen, then this will be the end of Indian painting, for it will not be distinguishable from the expressions of the other proponents of a particular school of art.

A fourth idea which must always be kept at the forefront: this is a transitional art, which bridges the gap between the craft arts of the past and present and the fine art which it will become tomorrow.

This book pretends to be neither a critique nor a foretelling of coming events in relation to Indian easel art. It presents what happened and what has been done—where, when, and by whom. It includes the good, bad, and indifferent efforts along the way; it includes works of the trained and the untrained, the paintings of children as well as those of the artists who have "arrived" in the eyes of the white critic. Its coverage is broad, by plan and purpose, for it will be from this breadth of base, these many and varied forms of painting reflective of the transition from Stone Age to Atomic Age, reflective of the growing pains of a new-found form of expression—easel painting—that the Indian art of tomorrow will be melded.

In summary, it may be said that this unique expression, Southwest Indian painting, was born in the second decade of the twentieth century. Within a short time, Indian artists developed distinctive, traditional styles which were deeply rooted in their rich past and which became and continued to be dominant in all such painting into the 1960s. Practically all of the major Southwest tribes participated in this new venture, with puebloans and Navajos and Apaches the outstanding painters. This form of art, easel painting, certainly perpetuated many of the basic principles of craft decoration and design which, in turn, carry far back into prehistory. During the post-World War II years, new influences came to bear on the Indian and, in turn, on his art. Foremost among these were his own expanded experiences, new vistas, higher education, and—particularly in art—new and most active collectors, competitive Indian art shows that raised standards and the value of awards, and museum and art gallery exhibits. Southwest Indian easel art was riding a crest in 1971.

The following pages show the transition from decorative arts to easel art; they reflect the many remnants of the earlier forms in the later expressions. Perhaps it is proper that this presentation ends in the early 1970s, for this may be the beginning of the end of a distinctly transitional style of art, the end of the craft-dominated arts and an emergence into the realm of fine art.  ■

# PreHistoric decorative art

C onscious art was born in the American Southwest among a people reaching the dawn of their religious activity and thought, in the midst of the first cultivation of fields, and as an integral part of their craft expressions. What additional impulses motivated this art may never be known, for no written records exist to augment what can be read into the artifacts brought to light by the spade of the archaeologist.

Handed down through the centuries was the tradition of keen ability in forming and perfecting the hunting weapons which made life possible for the first peoples of the Southwest. Basic elements of art are to be noted in the exquisite symmetry and balance that so typify the splendid Folsom and Yuma flint points. Perhaps these dart points were but a prelude to the conscious art of later years;

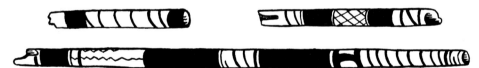

*Fig. 2.1    Painted dart shafts, Gypsum Cave, Nevada. (From M. R. Harrington, Gypsum Cave, Nevada.)*

certainly the qualities of harmony in form and rhythm in workmanship were here to stay, for they contributed to the effectiveness of the weapons. Mayhap they pleased the worker as well.

North America presents no example of a cave art that would compare with the splendid Paleolithic painting of western Europe. One small instance of painting does exist, however. This is the decorated shaft of the hunting weapon of the men who lived in Gypsum Cave,[1] southern Nevada (Fig. 2.1). Red and green colors were

applied over the cut-out areas or directly on the sticks, forming spirals, bands, lines, zigzags, and squares with dots in them. In addition, rare evidences of man's efforts to express himself artistically are found in the American Southwest and Midwest. These include the pigment itself—red hematite—with some of this rubbed off on a stone, and small pieces of stone and bone marked with simple incised lines or with cut edges.

Not until the pottery of the Estrella phase of the Hohokam at Snaketown[2] in southern Arizona, dated 100 B.C. to A.D. 100, and, to the east, in the early Mogollon wares[3] of about the same time, is the thread of decorative art once again picked up. Crude though they may be, the heavy lines, chevrons, and even occasional rudimentary scrolls painted on the pottery would seem to indicate that some other type of painting antedated other forms of decorative expression. If so, this may explain the ability and particular designs noted here, and the rapid development which followed in these and other areas of the Southwest in the ceramic field.

The first known expressions in decorative art of the settled farmers of the northern area, the Anasazi, are in basketry rather than pottery. Archaeologists have been amazed at the variety and complexity of designs in black and red on many of the large coiled basket trays and twined-woven burden bags. Both techniques and materials affected ornament in basketry and may have been responsible for the establishment of three elementary principles so important in the art of later years—symmetry, repetition, and contrast.

Several lines of evolution of design, with many and varied additions along the way, stem from these beginnings. In all but a few cases, this art flowed through the channels of craft expressions, which means that it remained an art of ornamentation, an art of design. This means, further, that it was design within predetermined space and was influenced by technology, for such is the fate of the craft arts.

Pottery did not appear in the Anasazi area until the early centuries of the Christian era; immediately it was affected by the already flourishing craft of basketry. In more than one instance there was a direct transfer of idea from fiber basket to clay vessel. But the potter, in the use of painted design, was freed from one of the controls of technique that limited the weaver—the brush can be made to produce a curved line as readily as a straight one, and at any point in the design.

Conventional art is typical in the Southwest. This quality may have its roots in the basketry arts, also, with encouragement from later development in an allied craft, textile weaving. Within the Anasazi area, further conventionalization may reflect the growth of

traits in social organization which placed emphasis on the integration of individual members within the group. Whatever the reasons, the art of painting became increasingly conventional as the years went by. Yet, within the realm of convention, high artistic attainment was the rule. Further, as Vaillant puts it briefly, naturalism "when it does appear, often reproduced life forms with a dramatic fidelity."[4]

The developments discussed below are obvious not only in basketry[5] but also in simpler pieces of weaving native fibers such as yucca and apocynum. Many design elements were established, to remain a part of the stock in trade of Southwest artists through the centuries. Among these are squares, rectangles, stepped or zigzag effects, diamonds, triangles, and simple but highly geometric figures of humans, birds, and quadrupeds. These were combined into a multitude of designs of simpler and more complex varieties. For example, zigzags appear in two simple parallel bands, or they swirl dynamically from a central circle to the edge of a basket. A feeling for color is also expressed (Fig. 2.2). Opposed and balanced triangles may combine serrate edges with an elaborate play of shifting red and black. At this earliest time, too, there are life designs such as rows

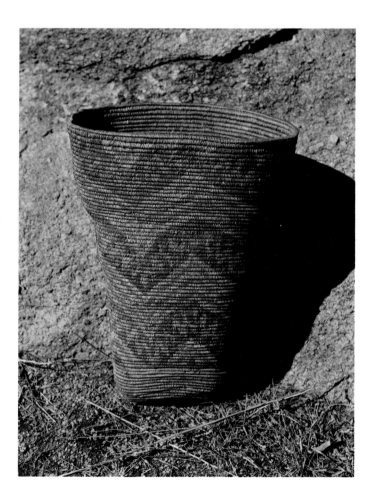

Fig. 2.2    Painted basket, Painted Cave, Arizona. Courtesy, The Amerind Foundation, Inc.
—Ray Manley Photography

of aquatic birds and butterflies in the same black and red colors on off-white or natural grounds. Designs are rarely painted on baskets.

Through the early centuries, certain basketry forms were perfected or changed to influence the history of this craft and others. From the simple forms of purely functional nature to highly esthetic shapes (and even with these latter the producers never lost sight of their ultimate uses), the basket weaver established forms of basic type: trays, bowls, miscellaneous small containers, storage vessels, burden baskets, and a water bottle.

With the development of textile weaving in cotton, new and varied potentials were offered, for far finer and more flexible elements were involved. Yet even within this new development there is little more than a growing multiplicity of pattern based on the geometric elements used by the preceding people in their baskets and native-fiber belts and bands. In some instances, allover designs, woven or painted on large blankets, seem but distantly related; however, an analysis of the most complicated of these reveals the elements listed above (Fig. 2.3).

It was in ceramic art that the hand and the brain had their greatest discipline in creating and executing design, and their most lengthy and varied experience with the brush and color. The quantity

*Fig. 2.3    Painted blanket, Painted Cave, Arizona. Courtesy, The Amerind Foundation, Inc.*
—Ray Manley Photography

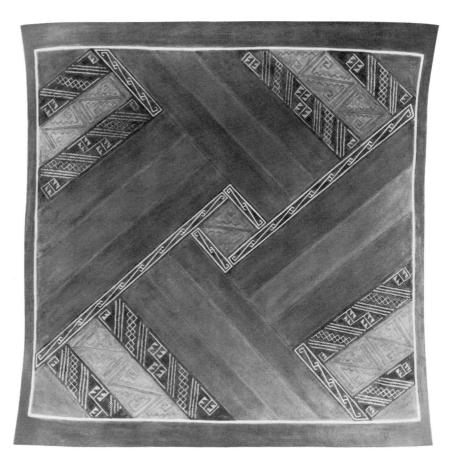

18

of painted pottery in the Southwest is in itself astounding; the quality surpasses that of any other peoples in the world in a like stage of cultural development. Most impressive are the unbelievable precision and intricacy with which the Precolumbian puebloan ceramic decorator drew lines on curved surfaces.

Despite the fact that there is an admitted interplay between the craft arts, the Southwest Indian was never an absolute copyist at heart. Then, too, the ancient people were not lacking in originality. Until the conventions of pueblo life became more pronounced, these early and experimental phases resulted in much versatility.

Holmes has commented that, "Elements of design are not invented outright: man modifies, combines, and recombines elements or ideas already in existence, but does not create."[6] This point, coupled with the fact that the technology of the ceramic art itself inspires few elements of design, may help explain the heavy borrowing from other expressions in painting in this craft. Form, design elements, and complete designs were borrowed. Even in the matter of the division of the design field, similarities between pottery and other craft arts are obvious in the Anasazi area.

Early in the decoration of clay vessels, designs assumed curvilinear form—whether by accident or intention is not known. The results are far different from any known contemporary forms in weaving. One is tempted to suggest that a slip of the brush in depicting an angle on pottery may have served as inspiration (or temptation!) to make curved lines. It is likely, too, that the potter, in addition to being freed from the technical controls of the older art, weaving, also was influenced by other fields of expression and attempted new ideas. Early in its history, too, there were influences reaching the Southwest from Mexico, possibly affecting the pottery craft as well as other esthetic expressions.

In the beginning, ceramic forms tended to be less specialized, and designs were experimentally generalized. With passing years, there was a tendency to stylize both form and design and an ever-increasing trend in the direction of highly localized types. This last inclination is still very much alive—localized or tribalized styles are basically characteristic of modern painting, whether pottery or watercolor. Localization is evidenced in the adaptation of design to certain areas of the vessel, in colors or color combinations, and in particular design styles.

A few regional styles may be cited to illustrate the versatility of the prehistoric pottery decorator. Color variation in the Anasazi reveals a wide knowledge of mineral paints coupled with an awareness of facts pertinent to firing techniques. Black, white, brown, buff, yellows, and many shades of red were combined in numerous ways.

19

Black designs on a white ground (the white itself often with a distinctly local flavor!) were ever popular. At the time of peak production in the Kayenta locale of the Anasazi culture, this color combination remained popular; likewise, it was handled expertly, artistically, and with considerable originality. This is particularly true of the "negative" wares,[7] a style in which matte black is laid on in such masses as to allow small white areas and narrow lines to show through, forming fine and meticulously executed designs (Fig. 2.4).

In other instances these same people favored polychrome mixtures, using red and buff with one or both of the above colors. Many of these artists were partial to a curvilinear wing pattern which they effectively painted in black lines above and on the rounded shoulder of a red-and-buff jar. Or, in another example, a black design might swirl over the entire surface of a great storage vessel of rounded form. Distinctly different is the use of the same theme by Chaco potters of northwestern New Mexico: the wing is angular and it is painted in black on a chalky white ground, often on an almost-straight-sided vase.[8]

A dominant motive in Southwestern art is well demonstrated in pottery—a desire to produce a balanced opposition of the principal decorative units. In St. Johns ware of the Little Colorado area

*Fig. 2.4    Kayenta negative black and white seed jar. Courtesy, Arizona State Museum, University of Arizona.*

—Helga Teiwes

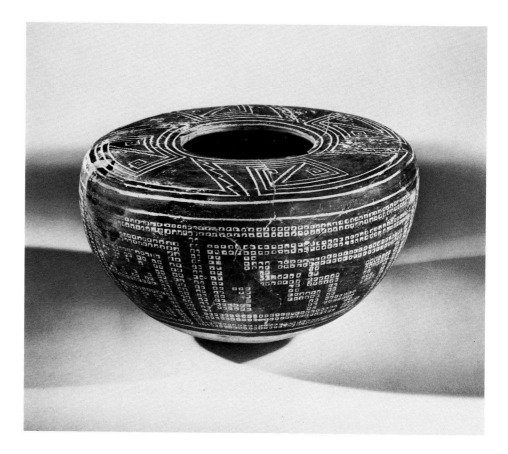

of Arizona, zones are created in which appear balanced solid and hatched scrolls, triangles, or stepped figures in black on a red ground. In some of this ware, the designs are so intertwined that no division *per se* actually exists, but clean-cut line, nicely spaced design, and rhythmic repetition reflect a well-ordered scheme in the mind of the artist.

A later ware of this same area often featured large asymmetric scrolls pendent from a rectilinear geometric unit.[9] Few peoples have equaled the attainment in design synthesis displayed here between angular and curvilinear geometric styles. Scrolls, allover wings, and some almost-realistic bird themes express the Anasazi's greatest fling in the direction of more flowing design and dynamic patterns.

Quite a different trend is obvious among the people to the south. In pointing up the contrast here, Amsden says that the Hohokam artist was "a master of the extemporaneous stroke, using her brush in truly creative delineation, whereas the Pueblo decorator used hers as a methodical generator of prim lines in formal geometric figures. The latter is a well-schooled draftsman, the former an unschooled artist."[10] This, in general, might well characterize the two styles of painting.

Hohokam colors, in most of the decorated pottery, were red on buff. "The small element, the life form, the curvilinear scroll, are the antithesis of rectilinear geometric textile ornament, and these very traits are the dominant ones of the early Hohokam," Amsden has observed.[11]

Further describing Hohokam pottery, Amsden says:

The best Hohokam lines are the shortest. . . . Flying birds are evoked with a Z and a horizontal dash, or two down strokes to form a curving V. Two squiggles make a swastika. . . . A dog's ear is cocked with a single cunning blob, his tail set for wagging by a touch of the brush. A bird's leg posed nervously for a forward step, a human arm caught in the rhythm of the dance, a lizard's pointed head—all are rendered with one simple stroke. Best of all are the birds; lanky road runners or fat little quail, they have individuality and life. The drawing is too free and joyous to be conventional, too simple to be realistic. Perhaps simplified realism best characterizes it.[12] [See Fig. 2.5]

Strangely, this free and simple style of painting of the Hohokams died an untimely death. Certainly their painting in the late prehistoric reflects a discouraged or stifled art form. Their historic descendants have produced no outstanding painting of any sort.

The pottery design of the Mogollons, which some believe to be the earliest in the Southwest, first presents allover patterns on bowl interiors in red on brown. Although poorly executed and confined to simple broad lines and solid triangles, the patterns reveal fairly well-balanced quadrate designs.[13] The artists of this area seemingly

21

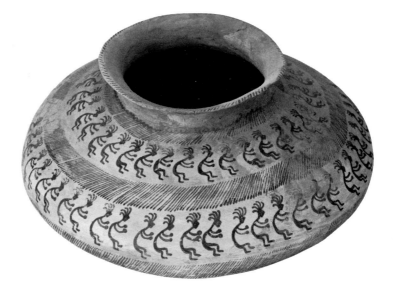

*Fig. 2.5    Hohokam red-on-buff jar from Snaketown. Courtesy, Arizona State Museum, University of Arizona.*

aimed at ever-greater contrast. A peak was finally attained in black and white colors. The best wares of the Mogollons reveal exquisite and often complex geometric patterning.[14]

Brilliant contrast was also an element in a still later ware of this same area, the Mimbres, which was decorated in life forms either in positive or negative styles.[15] Many of the Mimbres life forms have great charm, be they real or mythical creatures (Fig. 2.6). They are treated in a highly stylized or more realistic fashion. Occasional compositions are to be noted in this ware.

Except for mural decorations, compositions were unusual in the Southwest in prehistoric days and particularly uncommon on pottery. Therefore, the Mimbres examples are of special interest. Fred Kabotie,[16] a modern Hopi artist mentioned earlier, has felt that he recognized certain puebloan (Hopi) traits in these pictures. Further, he has suggested that some of the composite creatures were seemingly symbols of clanship.

Mimbres pottery decorated with life forms has been the center of considerable conjecture by the archaeologists. Kidder has voiced the opinion that these life forms were the inspiration of ''some forgotten individual genius, whose work so stimulated her contemporaries and successors as to result in the founding of a local school or tradition in pottery design.''[17]

Several summary points may be made about the ceramic art of prehistoric times. There is, throughout the Southwest, keen adaptation of design to form; there is great variety in design layout. The use of geometric elements is exhaustive. The Hohokam painted simple geometric and life designs with intuitive, creative delight and abandon; the Anasazi painted colorful geometric patterns with a

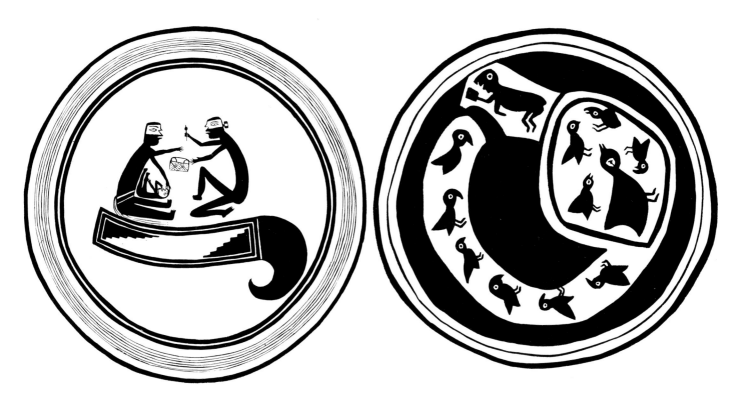

studied creativeness. And the Mimbres folk let their imaginations have full play in depicting real life forms and creatures of their fancy.

Another expression that may well have influenced the artistic heritage of the native Southwesterner includes paintings (pictographs), and peckings and incisings (petroglyphs) on cave walls and rock surfaces (Fig. 2.7). In the southern portion of the area, hard malapai surfaces allowed small opportunity for free delineation in petroglyphs. Yet even here the artist was making every effort to

*Fig. 2.6    Mimbres Black-on-white bowls. Courtesy, Arizona State Museum, University of Arizona.*

*Fig. 2.7    Petroglyph, dancing figures and sun symbol. (From Roberts,* The Village of the Great Kivas on the Zuñi Reservation, New Mexico, *Bureau of American Ethnology Bulletin 111.)*

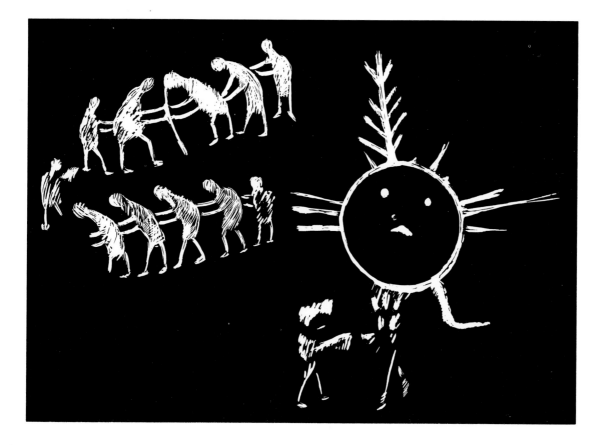

23

express his feelings; despite hard surfaces, there are rows of dancers with joined hands, there are animals whose outstretched but stiff legs both suggest and deny motion.

In the Rio Grande Valley, there are scenes of action in similar stiff figures. Here again is individual depiction, or arrangements which suggest complete hunting or other scenes. In some cave wall drawings, there are even more astonishing subjects. For example, on the walls of cavate rooms in Bandelier National Monument, Pajarito Plateau, north of Santa Fe, New Mexico, there are figures scratched into the plaster through the smoked surface of the wall, to be covered again through the years with more smoke. These drawings are old, but how old is not known. Chapman is of the opinion that many of them are definitely pre-Spanish and that some are early post-Spanish. Subject matter such as the horse and the Christian cross would obviously date a few within historic times.[18] Pre-Spanish subjects include the usual geometric designs and symbolic themes and, in addition, animal, human, and bird figures.[19]

There are several humans depicted in the Pajarito with square or round masks, with arms stiffly attached to the tops of angular bodies. An attempt at realism is suggested in the larger upper arm, the bulging calf of the leg, the small ankle. There is the vaguest suggestion of motion in the bent leg of one of the dancers. Kilt and sash appear on another figure, much too high on the body, but realistic in tassels on sash ends and design on the bottom of the kilt. In this same figure, the right arm crosses over the chest to the left side, and the hand holds a three-branched green bough. To the right of center in this grouping is a koshare (a clown) climbing a tree,[20] and a tree it would seem to be unless artistic license adorns the upper part of a pole with all too many branches. A dancer firmly grasps the pole, or trunk, with both hands. What happened to the legs of the fellow is not discernible. Bands on arms and body further identify this creature as a koshare, as does the rather leering look on his full front face which was probably painted on the dancer then as now for this very effect.

Although mammals are rare in the Pajarito scratched drawings, one in particular is remarkable for its simplicity and realism, an outlined figure of a mountain sheep. Chapman says that this creature perhaps "is the most remarkably realistic of all the animal figures recovered thus far in the Southwest. The incurved horn brought forward across the neck suggests a deliberate attempt at three-dimensional drawing in simple outlines."[21]

Painted Cave in the Lukachukai Mountains of northeastern Arizona presents a wide color range of earth pigments on its walls. The colors include light and dark red, several shades of yellow,

black, white, and an abundance of green.[22] The latter is of particular interest, for green is sparingly used in any art of the Precolumbian Southwest. Subjects at Painted Cave include a few animal figures; there are also some snakes. Human figures, which are fairly common, range from 6 inches to 5 feet in height. Earlier ones are square shouldered and rectangular or triangular bodied with some body detail; later types are smaller in size and usually have solid, oval bodies.[23]

A long time span is indicated in the cave and rock paintings in the Kayenta region of northern Arizona.[24] Here are found sheep, snakes, tailed anthropomorphs, humans, hand- and footprints, and some geometric patterns. One pair of figures shows a man with a bow in action, the great shaft of the arrow far longer than in reality. The arrowed end is effectively piercing a sheep. Another figure is unquestionably the hunchbacked flute player, a mythical character, with a few wavy, horn-like projections extending horizontally from his head. Several of the earlier Basket Maker men, as angular as at Painted Cave, have rather dramatic zigzag lines painted in several colors on the upper parts of their bodies. An interesting composition shows human footprints spaced out like those of one running along. Then, as though the individual jumped off the ledge, there are two footprints side by side at a lower level, then again they are spaced out as though the fellow was running once more.[25]

Pictures pecked on the surfaces of rocks in this same area offer greater variety and more varied subject matter. Birds are rare, certainly not as common as in other areas. However, two examples show long-legged creatures, one with a zigzag band terminating in an arrow point protruding from its neck. Larger figures of mountain sheep show more realism, as in details of the hoofs, ears, and open mouths; one has a small copy of itself directly beneath it, as though a lamb sought its mother's protection.

Of particular interest in the pecked figures are the humans that reveal such details as hairdress (which resembles the historic Hopi maiden's style), and fancy headdress. Many human figures stand alone, usually in symmetrical and balanced position. One seems to be lassoing an animal. Many are figures of the hunchbacked flute player; some of these are phallic. This fellow is represented from the northern part of the Anasazi area on south into northern Mexico. Perhaps the chief significance to note in connection with the pecked figures is that their aim is often that of storytelling. However, the potential of telling a story in painting was not realized until the new medium of watercolors was presented to the Indians in far later times.

Occasional examples of painting on small objects, such as shell (Fig. 2.8) and independent slabs of stone, have been found in prehistoric sites. One of the latter items, from Kinishba[26] in east-

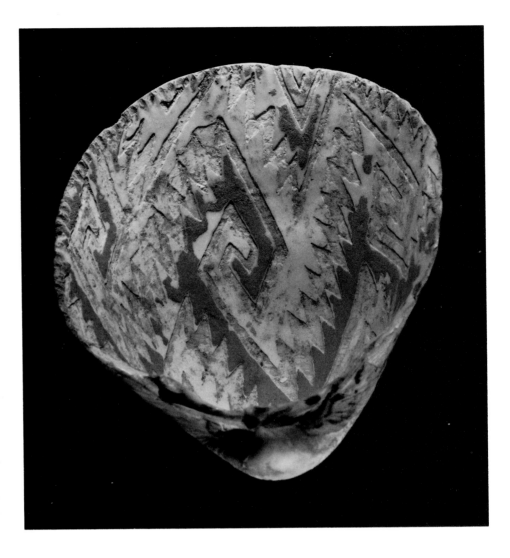

Fig. 2.8    Etched and painted
shell. Courtesy,
Arizona State Museum,
University of Arizona.

—Helga Teiwes

central Arizona, is kachina-like in its details. A painted slab from Point of Pines (Fig. 2.9), also in east-central Arizona, bears some striking resemblances to modern Zuñi kachina masks.

Unquestionably three of the greatest discoveries relating to this history of painting in the Southwest are the kiva decorations from two sites in Jeddito Valley in the Hopi area of northeastern Arizona,[27] similar murals from the ancient pueblo of Kuaua, a few miles north of Albuquerque, New Mexico,[28] and the site of Pottery Mound southwest of Albuquerque.[29] The Jeddito sites are Awatovi and Kawaika-a. Not only is there a wide range of color at all these sites, but also there is a great variety of subject matter and treatment.

Before describing these three most significant archaeological finds, it is pertinent to say a word or two by way of background in connection with wall paintings in general. The kiva evolved as a ceremonial structure, clinging to an older semi-subterranean type of construction which had been typical of the earliest home. Older

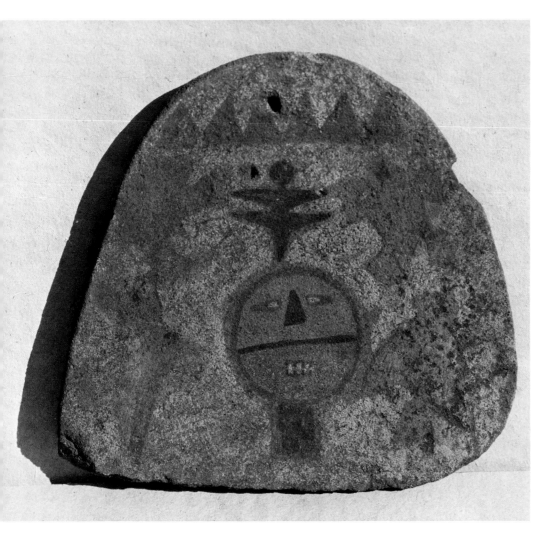

*Fig. 2.9  Painted stone slab,
Point of Pines, Arizona.
Courtesy,
Arizona State Museum,
University of Arizona.*
—E. B. Sayles

houses had been circular or rectangular in form; in some areas the
kiva was round, while in others it simulated the rectangular plan.
Eventually houses were built on the ground level, but the ceremonial
chamber remained basically underground in most pueblo villages.

Mural painting can be defined as a technique whereby the
artist paints a picture or designs in simple planes. In a mural there
is little or no range of penetration in space, for each item is brought
directly into focus on this common plane. This is particularly true
of Southwestern pictorial murals. Were it not for the extension of
space in the long and narrow mural panel, the artist would be unable
to tell his story or display his designs.

Just when kiva painting first appeared is not too clear. A few
crude wall decorations occur early in the pueblo period. These are
in the form of simple dados of a single color, or irregular bands of
color, or, in other instances, a mere dot outline of banded type. On
the walls of a kiva in Montezuma County, southwestern Colorado,[30]

successive layers of painted bands were executed from time to time, in white, brown, yellow, black, and gray. Created possibly a little later is the composition on a kiva wall in Chaco Canyon, northwestern New Mexico. This painting depicts "ten human figures, armed with bows and arrows, shooting deer or mountain sheep. All were solid white and very crudely executed."[31] These are drawn in a manner not unlike some petroglyph or pictograph subjects.

Elaborations of the simpler geometric schemes appear in time. For example, at Lowry Ruin, in western Colorado,[32] at least three different design styles appear on the walls of several of the kivas. One is a dark band around the bench structure that encircles the room.[33] In this band are double rows of vertical zigzags in white, each motif separated from the next by a vertical line. The drawing is irregular, the lines are in heavy white paint. Another kiva is decorated with vertical black panels with a row of white dots at the top of each.[34] Stepped patterns appear in several kivas;[35] their resemblance to the same motif on pottery is quite apparent.

Up to the later years of the prehistoric period, there continued to appear many simple and some more elaborate geometric wall decorations. The plain dado never disappeared. By degrees animal, bird, reptilian, and human forms were introduced and slowly became more popular. Incised or painted on the kiva wall, the life themes lost their resemblance to rock pictures or figures as the mural style of painting developed. Later work was often technically better and artistically more appealing. Seemingly there is more widespread distribution of the later drawing.

The period which spans the late prehistoric and early historic phases is of interest, for it was during these years that a great flowering occurred in kiva wall painting. At this time there was expansion in subject matter, technical treatment, and artistry. There was definite shrinkage of the occupied Southwest early in this period, with a subsequent concentration of population in three centers, the Rio Grande Valley, the Zuñi region of west-central New Mexico, and the Hopi area of northeastern Arizona. The first and last of these areas are of special interest because more examples of wall paintings have been found in each.

One wall painting only will be mentioned in addition to the Kuaua, Pottery Mound, and Jeddito murals, and that because of its resemblance to several historic types. This painting is on a kiva wall in the Rito de los Frijoles,[36] west of the Rio Grande River in New Mexico north of Santa Fe. Around the entire chamber is a 40-inch-high red dado, and above this a second dado 12 inches high. In the latter is a dim representation of the plumed serpent, so obscured by smoke blackening that colors cannot be discerned.

Kuaua unquestionably overlaps the late prehistoric and the early historic phases. It is possible that this site was visited by the Spaniard, Villagrá, in 1598,[37] and it is further possible that here were the paintings this early historian reports:

> On the walls of the room where we were quartered were many paintings of the demons they worship as gods. Fierce and terrible were their features. It was easy to understand the meaning of these, for the god of water was near the water, the god of the mountains was near the mountains and in like manner all those deities they adore, their gods of the hunt, crops and other things they have.[38]

In excavating one of the rectangular kivas at Kuaua, a worker noticed that there was a suggestion of color under the blank plaster of the exposed surface. Further investigation revealed that there were figures painted beneath the top layer. Before the job of excavation was completed, it was determined that there had been at least twenty-nine layers of plaster put on this wall from time to time, and that at least seventeen of them had been painted with figures.[39] Colors employed were black, white, red, yellow, and blue-green. Subject matter certainly had to do with the religious beliefs of these people, particularly with fertility and rain.

So important are these murals that a brief description of some of them is given here.[40] Unfortunately, the weathering of the ruin has been of such nature that the upper parts of the walls have disintegrated, and with them went many of the heads and masks of dancers and the upper portions of various other themes. This is a great loss, particularly in the case of the masks, for it is here that the artist so often expressed fine detail and executed his work most carefully.

Among the various subjects treated in the Kuaua walls (Fig. 2.10) are humans, largely, if not all, men; animals, including the buffalo and rabbit; fish, usually in highly stylized form; birds, which

Fig. 2.10   Reproduction of mural painting, Kuaua, New Mexico. Courtesy, Museum of New Mexico.

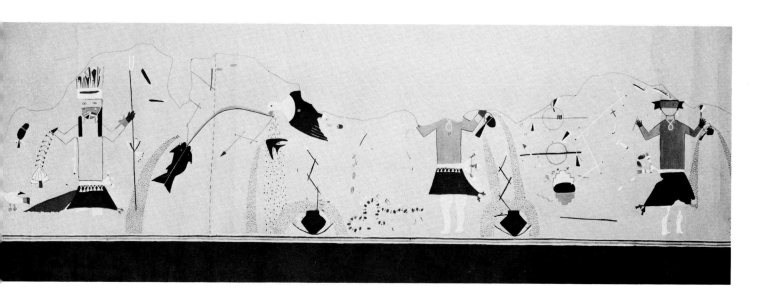

may be generalized or so carefully depicted that they can be identified; snakes; and plants, the cornstalk definitely, and possibly some evergreens. There are also altars and other ritual paraphernalia, such as clay vessels, clouds giving forth rain, quivers, staffs, netted gourds, cross-stick designs that may symbolize lightning, and numerous other objects that are often held by humans.

Treatment of detail is exceptionally fine in many instances. For example, one necklace worn by a figure is an eight-strand choker with one longer strand of red beads. The same figure wears red-and-white bead earrings. There are all-black kilts or all-white kilts, often with a contrasting sash. Sashes may or may not have tasseled ends. One garment is painted in such a way as to suggest that it was made of buckskin, even to the wavy lower edge which is not characteristic of the textile skirts. Mask and body reveal like detail. One great tall mask, the height of which is greater than that of the man wearing it, has horn-like projections on either side. Another strange and ghostly mask has all details marked in yellow, black, white, and red. A staff carried by a man is ornamented with black feathers with white tips and white feathers with black tips.

In the drawings at Kuaua, there is both naturalistic and conventional work, often with the two styles in combination. For instance, a man will be painted with rounded shoulders, his legs in profile and showing the constriction at the knee joint. Yet the body above the kilt is formless. Arms are perfectly balanced as both bend stiffly and at a sharp angle at the elbows. The elaborate mask rises directly out of a stiff and straight neck. The muralist at Kuaua often represented the legs in profile and the upper body and face in full front. The mask was more often represented than the face, and its treatment was formal.

One difference between the Kuaua murals and those of the Jeddito pertains to time. The former represent paintings from a single kiva and from a relatively limited period of time. The Jeddito murals were taken from eighteen different kivas in two villages and cover a longer time span.[41] They reveal a wider variety in design styles[42] and a greater range of subject matter, color, and design elements.

Colors employed in the Jeddito kiva decorations include yellow, red, orange, brown, maroon, black, white, blue, pink, green, and gray. All, save black, are entirely inorganic in origin.[43] Apparently the colors were ground and mixed with an organic oil or resin, the nature of which has not been determined. The fact that the modern pueblo artist usually chews an oily seed and employs the saliva as binder for paint on various objects of ceremonial nature may shed some light on this matter.[44]

Paints were applied to the smooth-surfaced, reddish-brown plaster of the kiva walls at Awatovi and Kawaika-a in several ways.

That a stiff brush was often employed is indicated in the presence of plainly visible striations.[45] It is possible that a brush like that of the modern pueblo potter was used—a yucca leaf chewed to remove the pulp, then the remaining fibers cut to the desired width. In other instances, areas of color were applied with the fingers. The tip of the finger, covered with paint, was also pressed against the wall in some cases in the Jeddito,[46] as it was elsewhere in kiva decorations.[47]

None of the prehistoric painting in the Southwest is true fresco, and the Jeddito examples are no exception. *Fresco secco,* as the technique described above is called (the application of the paint to the dry plaster), is technically simpler than true fresco.

Smith established four distinct layout groupings.[48] In time sequence, as based on pottery and dendrochronology (tree-ring dating), they are designated, in order from the most recent to the oldest, as Layout Groups I, II, III, and IV.

Layout Group I is "distinguished by having as an essential and constant element a horizontal band extending across the lower portion of the wall from end to end of the decorative area, and serving as a base out of which the decorative details of the composition 'evolve,' or upon which they stand."[49] Apparently there was but a single painting here which was completely intact to its original height; the evidence, however, points to an absence, in most cases, of upper bordering bands. The very nature of this grouping would deny any need for upper bands, for the baseband serves to unify the design. This layout grouping is interesting in its relation to one of the early styles of historic painting evolved at the pueblo of San Ildefonso, which will be discussed later.

Layout Group II "may be described as pictorial arrangements in which the principal figure or figures are naturalistic and are not tied together by a baseband or frame."[50] A lower line may be present, but it is not an integral part of the composition. Human and animal figures in this group are more freely and dynamically drawn and their execution less meticulous than in Group I.

In Layout Group III, "the entire surface or the principal portion of it is enclosed by a narrow framing line and treated as a unified field without subdivision into discrete decorational sections or panels."[51] In contrast to Layout Group I, where the band may have elements of design within it, or where the elements would lack relationship each to the other without it, in Group III this line never becomes an integral part of the whole pattern within it. A solid color fills this area and serves as the ground upon which appear several types of design—geometric themes, not too well arranged within the panel; conventional elements, some of which are "remotely derived from nature"; and "a more nearly unified design, composed of a highly stylized animal or shield-like feature, around which are added

31

minor decorative details in a symmetrical manner. . . . The frame is a mere outline."[52]

Layout Group IV is not unlike III save that it has no framing lines. The entire wall is the unit of decoration. A simple motif, either geometric and nonrepresentational or naturalistic, "dominates the space but does not literally fill it. . . ."[53] In contrast to Group II wherein the subjects are dynamic, the life figures of this last group are static and very simply treated.

Perhaps the most significant factor to be noted in relation to the Jeddito paintings, as thus analyzed, is that definite styles developed, and that there was much consistency within each of them. It is not surprising, then, to find the development of distinctive styles in the early years of the history of watercolors. Some of these have continued down to the 1970s.

There are many points of resemblance between the handling of color in the Awatovi-Kawaika-a murals and in modern watercolor paintings, particularly in the earlier ones. First, it is pertinent to note that "the paint is spread with strikingly uniform density and without shading, either intentional or careless."[54] This use of flat color is not only characteristic of much of the early watercolors, but it also was still appearing in the 1970s. There are rare examples of attempted perspective in the murals. One, in particular, shows several small salamander-like creatures behind a larger one. In painting the smaller figures, their color is stopped at the edge of the color of the larger amphibian. "All were obviously executed at the same time and with deliberate reference to each other."[55] True perspective is rarely attempted in early easel art.

Another point of interest pertains to outlining; herein the modern artist both delights and excels. The Jeddito painter likewise never wavered or hesitated in laying down a surprisingly precise, even outline. Seemingly, the ancient painter laid on the main portions of color, without benefit of guide lines, and then the outline was made at the edge of the color area with great care. Such freehand work is remarkably lacking in error, with but the rarest case of a mass color extension which is cut off by the outline in an apparent effort to keep the figure within a preconceived size. When the complexity of some of the figures is considered, this is a remarkable attainment. Outlines were usually in black, though white was also common; red was seldom employed. Over-painting was common, with as many as four colors one on top of the other![56]

Before leaving the Jeddito murals further reference should be made to subject matter,[57] much of which is found in modern easel art (Fig. 2.11). There is little difference between the preoccupation of the modern Hopi with ritual material and the same interests on

the part of his distant, prehistoric ancestor. Ceremonial kilts and sashes are very much alike in form and detail, and their decorative borders differ only in the manner in which the same elements are put together. Similar, too, or almost identical, are the bowls stacked high with what could be rolls of piki bread (paper-thin bread) or ears of corn; pahos or prayer sticks; the many ways of treating feathers, particularly the specific feathers of eagles, turkeys, and parrots; netted gourds, rainbows, and other details too numerous to mention. The human figure is common, and on it appear kilts, shirts, mantles, and belts; leg and arm bands; necklaces and other adornment; elaborate headdresses; and body and face paint. Mammals depicted make an impressive list—mountain lions and wildcats; dog, wolf, fox, and coyote; deer and antelope; badger and skunk; and the bear. Some quadrupeds are monstrous creatures of the imagination. Smaller life forms include dragonflies; butterflies; birds; frogs or horned lizards; fish; and a small, elongate, short-legged animal. Ceremonial paraphernalia and subjects of religion are many, including the above-mentioned pahos and feathers; the sun or sun shield; standards or altar slats and mounds or cones; blossoms and maize and other plants.

At the site of Pottery Mound,[58] the murals are late prehistoric in time; they appear on multiple layers of plaster on the walls of rectangular kivas. In many respects they resemble the paintings from

Fig. 2.11    Reproduction of mural painting, Awatovi, Antelope Mesa, Arizona. Courtesy, The Peabody Museum, Harvard University.

the above sites, Kuaua and the Jeddito. In general they present a great range of color and subject matter; they vary in style from geometric and abstract to realistic; outlining is the rule; and designs range from very simple to extremely complex. Ceremonial and symbolic design comparable to the same in modern usage appears not infrequently. Some decorative themes are Mexican-like, as they are in the Jeddito.

Throughout the series of murals, there are to be noted varying degrees of symmetry and balance, cruder and finer draftsmanship, an excellent sense of color, definite compositions, some attempt at perspective, and always *design.*

On the whole, the Kuaua mural style compares broadly with Layout Group II of the Jeddito. The Kuaua paintings differ in lack of arrangement, for they seem to be but the painting on walls of rows of figures and objects, lacking preconceived layout and design. In details, however, there are many points of likeness. One smaller point of contrast rests in the more popular treatment of the human profile in Jeddito murals, while at Kuaua the full front face was favored. A cursory glimpse of sample cases would tempt one to suggest that the Kuaua painters were more concerned with masks and could get more mask detail in full front view, while the Jeddito muralist varied the view depending upon the easier and more direct possibilities of presenting facial features, hair, mask, feather, or other ornamental detail.[59]

Withal, the kiva murals present the peak of attainment in Pueblo IV painting. Precise and beautifully executed, they perpetuated artistic ability which found expression in no other native work.

Throughout the many centuries which preceded the arrival of the Spaniards in the Southwest, in 1538–40, the native prehistoric population thus established and perpetuated many and varied art expressions which were to dramatically influence their historic descendants. These included the basic crafts and religious arts; fundamental forms, colors, and techniques of painting; and a wealth of subject matter and styles. A wide experience in handling color and design appears in ceramics and mural decoration; in these two expressions also there was a wealth of temporal and spatial styles. Geometric and life motifs, abstract to representational styles, repetitive geometric figures to limited storytelling compositions—all were within the experience of the prehistoric artists. Little or no perspective was attempted; flat colors were the absolute rule; outlines were common. Fundamental elements of painting, such as symmetry, rhythm, balance, and repetition were dominant in this prehistoric art.

All of these qualities and problems were perpetuated through the crafts and ceremonial arts of historic times to channel later the expressions of the first easel painting.　■

# Historic decorative art

From the standpoint of art, the prehistoric and historic periods merge gradually one into the other. There is no obvious change in subject matter, media of expression, or method of treatment. The year 1540 brought with it more in the way of outward destruction than inward change so far as the native was concerned. Villages may have been destroyed, but not the spirit of the people. Even when new political and religious forms were imposed on the natives, many Indians outwardly accepted them, but retreated quietly and secretly to the kiva to continue in "the old ways," the traditional ways.

During the historic period, there have been varying degrees of acceptance and rejection of the new way of life offered the natives by Spaniards and Anglo-Americans; the degree is reflected in changes in their craft arts. A brief summary of some of the known trends of arts as a whole and painting in particular from the time of the arrival of the Spaniards in 1540 up to the 1970s, and especially in late historic years, may add to the understanding of watercolors today.

Pueblo people had passed their peak in some cultural lines before the time of the arrival of the Spaniards and the subsequent conquest. Although there was a general tendency in the direction of degeneracy, there was no great internal decay of this civilization. When the Spaniards came, there were many folk living in concentrated pueblo areas, and many of them were producing fine pottery,

some basketry, and splendid textiles. And, from all accounts, their religion was not at all on the wane, for there existed a wealth of ritual material in the form of wall paintings, costumes, and body painting.

To this day some of the pueblo potters follow traditional and symbolic designs. Others have evolved new and often excellent styles, particularly in surface treatment, as at San Ildefonso. The first trend can be summed up in the words of Chapman:

A mistaken belief that pottery making was influenced by contact with the invaders was long current among those who based their convictions on nothing more tangible than the wide variance between the pre-Spanish and the later wares of each pueblo. The fallacy is now fully exposed, for Pueblo pottery of the past three centuries proves to be a normal development, in which scarcely a trace of European contact can be detected.[1]

Through the years tribal traditions guided most of the potters in matters of form and decoration (Fig. 3.1). Many elements of decoration have come out of the past. "The modern Pueblo potter has at her disposal one of the richest and most complete stores of design elements in the whole world. There is hardly anything from a Greek wave to a Norman dog-tooth to a modernist abstraction of a leaf that one cannot find."[2]

Too often it has been thought that puebloan life had and still has a strong tendency to make all members conform to a standardized way of life. This would be stifling to art. The very nature of native art denies this; rather do we find the evidence in favor of the working of individual genius within the range of group potentials. Nampeo of Hopi-Tewa fame had the imagination and courage to adapt designs which were more than five hundred years old but far superior to contemporary ceramic painting in her village.[3] María and Julián Martínez, of San Ildefonso,[4] did not feel any restricting bonds which would keep them from experimenting with both surface treatment and design. The result was a highly polished black ware with subtle and simple designs in matte black. Certainly this is the same individual genius which is responsible for much that is fine in modern easel art; too, it is difficult to believe that this spirit did not prevail in Precolumbian times.

Santo Domingo pottery illustrates several significant trends in the ceramic art. As a very conservative pueblo, the village continued to use through the years many of its native clay products for domestic purposes. The following points, summarized from Chapman's discussion,[5] refer to wares of recent historic years, probably well within the past century.

A black-on-cream ware predominated, although both black-on-red and black-and-red-on-cream types were produced. Definitive

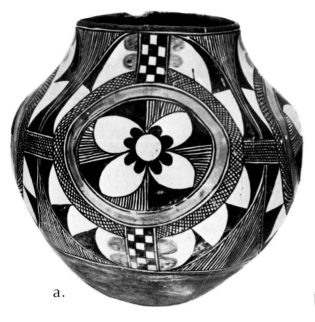

a.

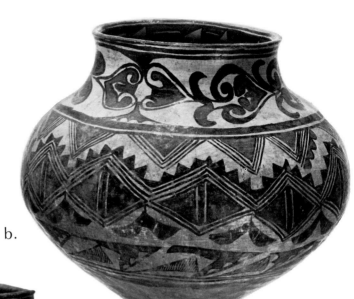

b.

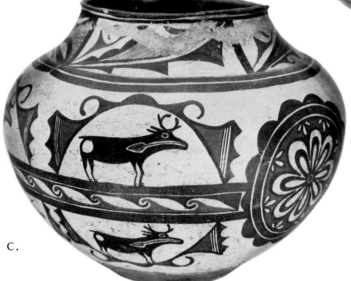

c.

Fig. 3.1 Historic Pueblo jars—
a, Acoma; b, San Ildefonso;
c, Zuñi; d, Hopi.
Courtesy,
Arizona State Museum,
University of Arizona.

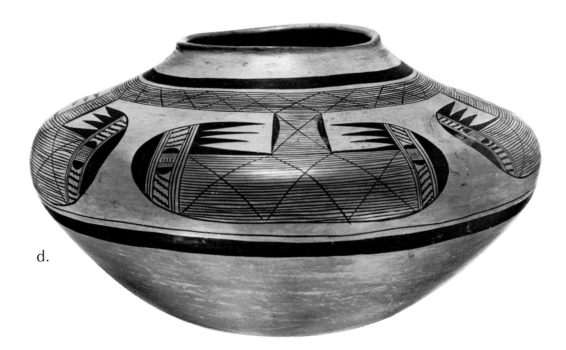

d.

areas of design were evidenced in single zone themes on bowl exteriors and double zones on jars, the latter for neck and body treatment. This demonstrates pleasing adaptation of design to the specific shapes of Santo Domingo vessels. Each of these zones may be divided further for careful placement of decorative details. Relatively few basic elements of geometric construction were used in building up both abstract and graphic motifs, with some elaboration of the latter in late years. Graphic motifs included both floral and life forms. Static and dynamic arrangements resulted from the use of limited and simple elements. Chapman believes that there is no evidence at Santo Domingo or at San Ildefonso (Fig. 3.1b) of any Spanish influence in pottery decoration; rarely is there any suggestion of infusion of ideas from other pueblos in the former village. It is possible that the bird and plant motifs may have come from another pueblo; certainly they are later than the abstract themes. However, this writer is of the opinion that most if not all of the more naturalistic bird and plant themes in pueblo pottery may well have been Spanish-inspired, perhaps by like designs on embroidered altar cloths.[6] It is likely, too, that certain Zuñi designs, such as the medallion on jars, were also of Spanish origin (Fig. 3.1c).

In pottery of other pueblos, the same meticulous care is reflected in the superior association of design and form. This may explain in part the high degree of skill expressed by the modern watercolor artist in design and arrangement of his subject matter, even though some of it is new to him. Likewise, the great variety of arrangements of a relatively few basic elements of design into exquisite and perfect compositions in ceramics has been influential in keeping watercolor art from becoming monotonously repetitious.

Hopi pottery (Fig. 3.1d) presents an interesting history that reflects another side of the capabilities of the pueblo folk. In the late 1890s Hopi ceramics were at a low ebb, with little or no artistic production in this line. Dr. Jesse W. Fewkes, an archaeologist-ethnologist at work among these Indians, was excavating Sikyatki, one of the ancestral homes of the Hopi. In his employ was an Indian from the village of Hano. The young man's wife, Nampeo, saw some of the pottery brought to light by the archaeologist's spade. Inspired by its beauty, she was determined to improve her own work; eventually Nampeo produced wares that became widely known for their pleasing lines and fine designs.[7]

In another craft, weaving, tribal fingers were kept artistically busy and artistic subject matter was perpetuated. Certainly in this field there was more painting in early historic times than is now the case, for Spanish records contain frequent references to painted fabrics. This would seem to be perpetuation of prehistoric textile trad-

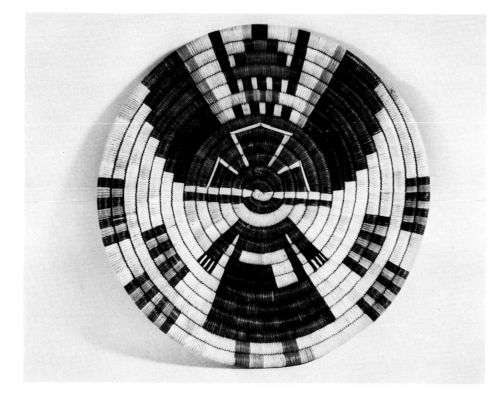

*Fig. 3.2    Hopi coiled basket,
Crow Mother Kachina design.
Courtesy,
Arizona State Museum,
University of Arizona.*
—D. Lindsay

ition. Even as new materials were introduced, there was a continuation of traditional subject matter and colors along with an occasional new element of design.

Strange it is that potentials in tribal art may be reflected in basketry. The Apache, for instance, particularly the bands of the Western reservations, struck out in new directions, and in later baskets there is a wealth of dynamic patterning where before there had been static simplicity. A part of this trend is the addition of such new subjects as life forms and geometric abstractions. Vitality and animation are expressed in the swirling designs which often cover the entire surface of the basket. Even the old, simple geometric themes receive this new treatment; in fact, it is the new kinds and varieties of arrangements that create this very dynamism. Certainly Western Apache basketry represents the height of attainment in dynamic, geometric, woven design in the Southwest. It is not surprising to find equally dynamic work in the watercolor art of this tribe.

The subject matter of Hopi basketry[8] serves to illustrate how true to tribal traditions this art may be (Fig. 3.2). Life forms are sometimes so highly conventionalized as to be almost unrecognizable, and in many cases it is difficult to say whether the artist meant to represent a bird or a geometric pattern. Subjects are largely religious, with emphasis on kachinas, but they also include clouds, rainbows, stars, sun, deer, and other significant elements. Of course, the very nature of most of these ceremonial subjects, to say nothing of technology,

39

would cast them in a conventional mold. Slight wonder that the first watercolors done by Hopis were of kachinas. Further, slight wonder that they continue to be favored, for obviously, of all this list of subjects, the kachina had the greatest appeal and potentials for painting. Tradition is strong among the Hopis.

A trend that parallels the Apache example in basketry is to be noted in Navajo rugs and blankets.[9] This art historically acquired by the Navajo appealed to him not only practically but also artistically. It did not take the Navajo long to strike out from traditional pueblo weaving, when he borrowed this craft, to experiment with new ideas or expand the old. On several occasions, he has displayed keen interest in native dyes, and in many instances he has introduced new elements of pattern. Both tendencies held considerable promise, and this promise found fruition among the Navajo, for he has expressed the greatest subtlety and sophistication in the handling of color and design. Vaillant says of Navajo rugs, "A beautiful talent for design has persisted in spite of abundant opportunity for the patterns to break down into the most vulgar 'novelty' work for the souvenir trade."[10]

The range of Navajo patterning is from the simplest lines to most complicated pictorial themes (Fig. 3.3); a complete design typical of this tribe is composed of a few elements only. "The essence of Navajo design [in weaving] is the arrangement and repetition of a few elements either in stripes or around a center, or else spotting them against a plain or striped background with that extraordinary sense of spacing which is innate in the American Indian."[11]

To be sure, not all Navajo weaving was, or is, sophisticated and superior in design. With his flare for new ideas, the Navajo weaver has often been caught between the good and the bad. Perhaps little credit beyond versatility can be given the weaver of such designs as the following: two trains complete with engines, and men, animals, birds, and geometric themes above and below,[12] a few embroideries on the side; "MIKE-$350"; animals, humans, and geometric patterns all confused in a single rug; and "ARBUCKLE'S COFFEE"!

Again there is reflected in these examples that innate ability of the Athapascan Apaches and Navajos who came late into the Southwest to adopt, adapt, and then branch out in their own inimitable way. Was it the lack of intense group consciousness, so typical of the puebloan, that gave the artistic souls of the Navajos freedom in all expressions, even in some measure in religious art? Or had they years, nay centuries, of training in art forms yet unknown to us? The explanation for great attainment on the part of these Athapascan tribes in weaving, silversmithing, sandpainting, ceremonial arts,

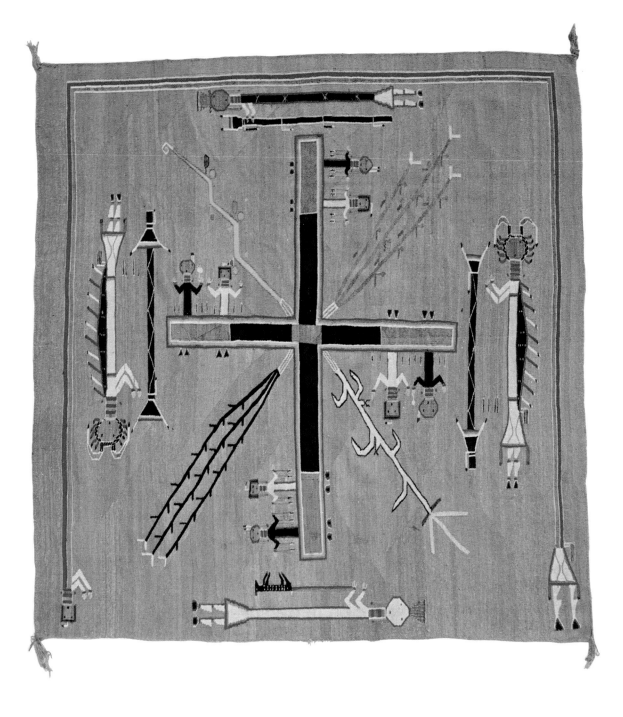

and last, in watercolors, may not be given as readily as we should like.

Hopi rug and blanket weaving[13] follows a different tangent, again more in keeping with tradition. Even after wool was introduced by the Spaniards, it was not used by the puebloan for the production of objects of ceremonial use; these had to be woven of cotton. Even though wool might embellish sash, kilt, or blanket, the designs were traditional and symbolic, with a rare intrusion of any but established themes. It is thought that these later embroidered and brocaded designs may have been the survivors of earlier painted patterns. If

Fig. 3.3    Navajo rug,
Whirling Log sandpainting
design. Courtesy, Mr. and Mrs.
Read Mullan.
—Arizona Photographic Associates

41

so, they would again testify to the predominance of angular geometric traditions of Hopi ceremonial expressions.

Body painting is not only among the earliest of art expressions but also one of the most difficult to trace through the centuries, for ancient people left no written records of their attainments. Occasional indications of this art form may be discerned in petroglyphs, wall paintings, ceramic decoration, or other secondary forms. Its importance and long life may be implied in its great symbolism today.

Temporary in nature, body painting lasts only for the ritual occasion or the duration of the war situation. As personal "property," too, a leader or ceremonial "owner" of such designs may take them to his grave. Also, such painting is subject to greater restrictions of subject matter and treatment than the other arts, perhaps in part because of its ceremonial nature. However, it is quite likely that body painting is far more important than is generally realized. Everyone sees the performer. Consciously or unconsciously, all drink in the essence and detail of designs. Tribal custom, centuries old, made real the necessity for the painting of rain symbols on the kilt or body of the dancer. The observer as a participating member of the whole village group on ceremonial occasions was aware of the designs and their meanings at all times. Motifs were thus kept alive which, through the centuries and particularly in more recent years of foreign influence, might otherwise have perished with ritual paraphernalia.

Body painting is extremely varied. It ranges from simple lines and bands to elaborate combinations of several geometric and life themes. Tribes which have little else in the way of decorative arts may develop face or body painting. For example, the Yuman Indians, who present such a paucity of art otherwise, had rather ornate facial patterns. Red, black, yellow, and blue were combined in bands, circles, dots, and triangles for such use. Much painting appears on kachina dancers; this is well demonstrated in the numerous examples of these figures reproduced in later chapters.

Parallel zigzags in white appeared on cheek and chin of Papago warriors. A red-white-red sequence of wavy bands crossed the face beneath the eyes of one Taos dancer. Tesuque buffalo dancers[14] blackened the upper and lower parts of the face, with a broad red stripe across the nose region. In general, body patterns are even more varied. Simpler ones include hands, bands wide and narrow, circles, crescents, simple and complex lines, and numerous additional geometric patterns. Striking indeed are the broad black and white horizontal bands painted over the head and face, the torso, and arms and legs of the pueblo koshare dancer. One Hopi Butterfly Kachina[15] has blue and yellow stripes down the arms and from neck

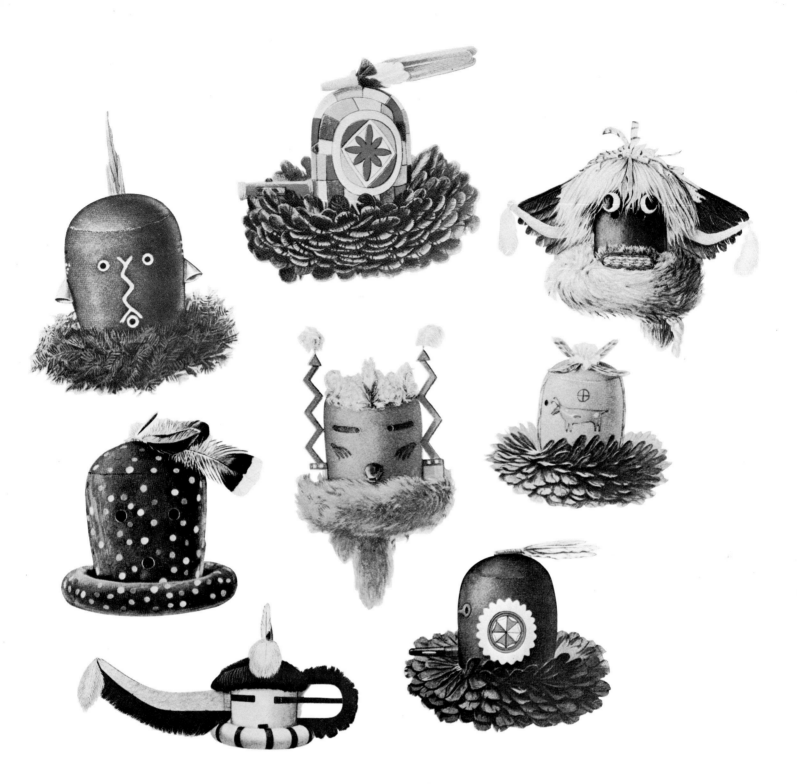

to waist on each side of the front of the body; their Left-Handed Kachina[16] has wide white bands painted on right arm and leg; the opposite members are unadorned.

Although masks combine many craft arts, painting is not the least of them; this is well illustrated in examples from Zuñi (Fig. 3.4). In the main, as compared with the Hopi, Navajo masks have fewer projecting snouts, ears, and other such devices, but there is greater interest in painted features. Symmetry is prevalent, although asymmetry in both color and design is often encountered. The mask of

Fig. 3.4   Zuñi masks showing variety of painted designs. From Stevenson, "The Zuñi Indians," Bureau of American Ethnology, Annual Report 23.
—Ray Manley Photography

43

Monster Slayer[17] is solid black with small white areas for eyes and mouth and a striking design on the left side of the face made up of five parallel white zigzag lines. A black mask has the Pleiades painted in white on the left side.[18] Talking God[19] mask has a centrally placed and realistically portrayed tall plant. The buckskin face- and head-masks of the Navajo are of interest because they are connected with another art expression of these people: Fr. Berard Haile has reported that figures in sandpaintings wear masks which resemble those of the dancers impersonating the gods.[20] In both cases the masks do not represent decoration of the gods' faces, but rather, the actual way the deity appears.

To the Hopis, the cult of the masked dancers is known as the kachina cult, and among these puebloans it is a complex expression. Numbering more than two hundred, the dancers who are the impersonators of supernatural beings wear varied masks that are the chief clue to their identity. The most characteristic Hopi mask is built upon a cylinder of rawhide to which may be attached many features, such as ears, eyes, nose, snout, horns, and so on. All of these are painted in varied and often bright colors.

The Hopi Owl Kachina[21] has great wings on the sides of its head, tremendous eyes made of black circles enclosing orange circles about a black center, and a protruding black-and-orange beak. The greater part of the face is painted to simulate feathers. Black Ogre Kachina[22] is well named, for his eyes bulge from a black face and are made to appear even more grotesque by painting heavy white rings around them. Between them is a turquoise anchor-like design painted on the black ground. A huge black "snout" with white teeth, and with the mouth rimmed in red, dwarfs the rest of the mask. Great horns in black and turquoise project from the ear region, curling upward and back to almost touch the top of the mask.

Thus a great many colors are combined to decorate the masks, usually in geometric or semi-realistic figures or occasionally in realistic subjects. There are half moons, stars, rainbows, parallel line marks of the warrior, and symbols of numerous other phenomena and ideas. There are flowers and seed pods; wolf, cat, and other tracks and paws; there are even horses painted on the cheeks of one mask! Numerous triangles, rectangles, squares, circles, dots, and other forms appear in countless arrangements and color combinations. Color and form are thus combined in simple or complex ways to depict the rich meaning necessary to make the mask a potent item of ceremonial costume.

Articles of dress are often painted. For example, the kilt of the Hopi Snake Dancer is decorated with sinuous lines which can only be interpreted as symbolizing the reptile itself. Time and again

this same theme appears on kilts of dancers in the Rio Grande, sometimes in more realistic fashion, again in conventionalized treatment. In the main, painting of garments has been supplanted by woven designs.

Colored designs painted on other ritual paraphernalia are too numerous and too varied to be described in detail. A few examples will indicate the vast variety of themes and methods of decorating in this line.

Rattles are carried by dancers of practically all Southwestern tribes. Many are plain. Others are carved, painted, incised, or may even have patterns worked out in holes punched into the thin wall of the gourd of which the rattle is made. Hopi Butterfly Kachinas[23] carry gourds which are painted all over in the same blue color as the face-mask. Other rattles have plain or designed bands in black and white, varicolored rain clouds with dripping water, or floral themes. Painting was the favored decorative technique for rattles.

No ceremonial object was too small, none too inconsequential to receive the attention of the decorator. Designs were well executed because they were part of the great prayer to the gods. Magic was part and parcel of the dance, of the dramatic performance, and each small item of paraphernalia had to bear its symbolic burden as a part of the whole. The painted design was perhaps the most efficacious of all, yet its form and color could be varied by the artist when dictated to him by the ceremonialist. Further, form and color were fraught with symbolic meaning.

The center of puebloan ceremonial activity to this day is the kiva. This structure is a direct descendant of a similar one of Precolumbian days. Here the men gather to prepare all the paraphernalia for the ritual; here they practice the songs and dances; here lengthy and secret phases of the dramatic performance unfold. Rituals outside this structure rarely last more than an hour or so. Hence there is concentration on the plan and details of the kiva, on the decoration of the walls or floor, or even, in some instances, on the ceiling beams. An altar at one end of the room receives careful decoration. It has been noted that a great gap exists in our knowledge about the early history of the native Southwesterners; the same is also true of wall paintings. There are brief records about them in scattered sources for the past one hundred years, but these are so few and so incomplete that mention of some of them will give but a partial insight into this story.

A few government surveyors and army officers were among the first non-Indians to enter a native kiva. Their recorded remarks are sketchy, but often valuable for their accuracy and because there are no others. In 1849, Lt. J. H. Simpson was at Jémez Pueblo, in

45

New Mexico. One of his men made reproductions of what are probably kiva drawings (Fig. 3.5), for each is labeled, "Copies of paintings upon the walls of an estufa [kiva] at Jémez."[24] Some of these are in the usual conventional style, while others are quite naturally drawn, in particular two startled blue deer (Fig. 3.5a)[25]. Simpson further reports that on the walls of the kiva he visited at Jémez were circles, semicircles, and barbed zigzags. There were other animals and birds and plants. However, he stressed the point that the drawing in none of them approaches the exactness exhibited in the case of the deer.

So similar to contemporary nonreligious drawings are the animals at Jémez that one is tempted to suggest that these may not have been as deeply religious in nature as the other figures. In 1952, Ellis reported the following about a current ceremony at this same village, Jémez, which may support this idea: "During the daytime ... men and boys who can handle a brush adequately are offered recreation in decorating the remaining walls with animals, sport and hunting scenes, and birds. . . . "[26] Other subjects in this same kiva reported by Ellis include "snakes, the sun, the moon, the stars, and two rainbows—painted with earth colors mixed with water on the north wall by the religious groups."[27] The occurrence of the nonreligious subjects may be explained, perhaps, by the fact that there is need for recreation on the part of certain individuals in the kiva, because they are not allowed to leave the ceremonial room during the rituals which sometimes last for days.

That late historic kiva mural painting is degenerate as compared with the Kuaua and Jeddito examples is indicated in further illustrations in the Simpson report. In one of two adjacent panels of a single wall appears a jumble of figures (Fig. 3.5b),[28] three black birds and a blue one, a pink (?) creature with four legs, a blue creature, a disc symbol, a vine, and concentric ellipses at the border. There is little thought given to arrangement, and the drawing is poor.

Another poor composition illustrated in the Simpson report is interesting for other reasons (Fig. 3.5c).[29] First, there is a reclining deer, a position not reported in other Southwestern kiva murals. Also, the deer has his head turned backward, seemingly to watch a hunting scene wherein a man with bow and arrow is shooting at three animals. One of the latter has apparently been killed, for it is drawn with feet in the air. Could this be a drawing done for recreation as mentioned by Ellis? Could it be this penchant for naturalistic drawing that flowered in easel art? Certainly a feeling for naturalism is manifest in both prehistoric and historic times.

Also pertinent to modern painting is still another plate from Simpson's report (Fig. 3.5d).[30] A four-color rainbow is arched above

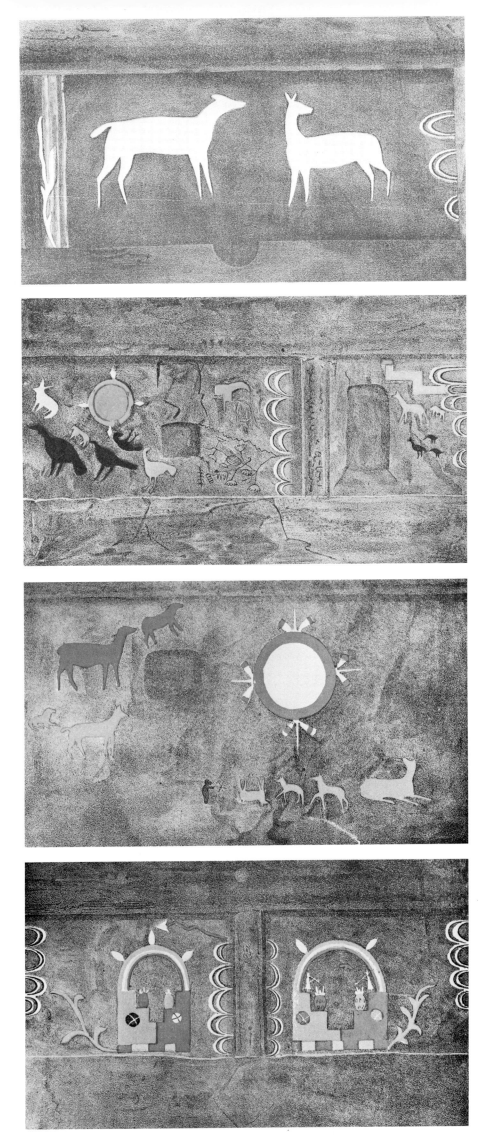

Fig. 3.5 Conventional and naturalistic paintings from kiva walls, Jemez Pueblo, 1849. From Simpson, "Report of an Expedition into the Navajo Country," U.S. Senate, 31st Cong., 1st Sess., Senate Executive Document 64.

—Ray Manley Photography

a double terrace to right and left. On the latter, and enclosed by the rainbow, are various figures, including humans, and jars with something coming out of the vessels—either fire belching forth or plants growing therefrom. One of the styles of watercolor painting developed at San Ildefonso, and discussed in the following chapter, may well have been inspired by just such kiva murals as this one.

It is possible that in addition to degenerating during the historic period, mural painting may have developed along new lines as well. There is a continuation of the usual symbols of heavenly phenomena and forces of nature. Many of these are recorded by visitors to the kivas from the time of Simpson's experiences up to the present.

Additional subject matter of considerable interest, and all "extremely well-drawn and faithfully colored," is reported by Bourke who was at Jémez in 1881.

Of special interest is his description of the following:

The second Estufa had pictures in large sizes ... of turkeys, two eagles fighting, hares, morning star, moon, dipper of seven stars, Bean plant, Watermelon vine, Deer, Lightning, Corn, Indians shooting turkeys (with bow and arrows)—the turkeys on a tree. Deer suckling fawn. Buffalo, Mountain Lion springing upon a Buffalo. An Eagle grasping a fawn in its talons; a star; another turkey; a man on horseback, a duck, and Eagle chasing ducks.[31]

One of the popular subjects of the early pueblo watercolorists was the plumed serpent. There are a great many references to snakes in early kiva-mural subject matter; there is also an occasional reference to the plumed variety. This creature is mentioned by Smith as having been found on the Jeddito murals.[32] It is mentioned in connection with the pueblo murals of Zuñi, Jémez, and Hopi. It appears in the Pajarito. That it was a sacred creature is suggested by its conventionalized treatment throughout time and areal distribution.

Kiva murals at other historic villages in the Rio Grande are not commonly mentioned, but that they did exist in many of the pueblos is unquestioned. In 1932 White reported for Acoma the paintings of "an eagle, a bear, cloud and rain symbols, a water snake, a koshare ... "[33] on the four walls of a ceremonial chamber. He also illustrated an interesting koshare—the body, face, and limbs of the kilted figure are black with narrow white bands at widespread intervals. The figure stands on a half moon and holds a corn plant in each hand. To right and left are four dark lines. Ceremonial symbolism is indicated in the caption, "Representation of a Koshare standing on the moon, holding corn in each hand. The four marks on either side mean that rain will fall for four days before and after each moon."[34]

Animals, plants, and symbols of natural phenomena are painted on the walls of ceremonial rooms at Isleta. No reliable data

exist for the pueblo of San Ildefonso. This is to be deeply regretted, for it was at this village that so much of the early movement in watercolors originated and developed.

Far more data exist for historic wall paintings at Zuñi and Hopi. Zuñi was visited and records first made of decorations on ceremonial chambers (not kivas) as early as 1879. From then to the present such paintings have continued to be made. In part, the story differs at Hopi: the first records of kiva murals date back to 1881, and from then on to the recent present a number of references can be picked up on the subject.

In her lengthy report on the Zuñi Indians, published in 1904, Stevenson illustrated a Zuñi wall decoration[35] that forms a part of the elaborate altar set-up for a religious society, the Sword Swallower Fraternity. Close to the top of the composition and slightly to the right is the Pleiades, with each of the seven stars drawn as a four-pointed design. Four snakes enter the picture from the sides, two near the top and two toward the center. Each snake is a different color —red, green, white, or yellow—each with black markings all over the body, and with a red forked tongue that continues on into the body of the reptile. The Knife Wing God, a mythical being with wings and tail of obsidian knives, dominates the center of the composition; he is painted red, green, black, and white. Above each of his shoulders is a disc, one symbolic of the sun, the other of the moon. Five animals, the Beast Gods, complete the picture, one figure at each side of the Knife Wing, two to the lower left, and one to the right.

All of the animals in this Zuñi mural are drawn in a simple manner, not unlike many of the small creatures at Awatovi. Two of the Beasts are black, two white and black, and one tan and black. Each has a red line painted from the mouth into the body. Mrs. Stevenson says that the Knife Wing God and "the animals are painted on paper and afterward cut out and pasted upon the wall. The snakes and stars are painted directly on the wall. . . . "[36] Of particular interest here is the painting on paper of designs later incorporated in the total composition.

Stevenson gives an interesting illustration of several pieces of painted paraphernalia used by this same Sword Swallower Fraternity.[37] These are two oblong boxes covered first with a coating of white. On one side of the smaller of the boxes are two animals with a star symbol between them. The larger box is decorated with five animals arranged around a figure of a Knife Wing God. All the animals are treated in a semi-naturalistic style, while the god is painted conventionally. This combination of styles resembles the treatment of the same subjects on the kiva walls described above.

Also at Zuñi is an effective portrayal of feathered serpents on the walls of the chamber used by the Rain Priests for their rituals.[38]

Two reptiles face each other, with their bodies stretched out horizontally. They are painted low on the wall of a small chamber which is on the ground floor and which can be entered only by way of a ladder. "Its walls are elaborately decorated with cloud symbols and two Ko'loowisi [plumed serpents]. The sacred frog, wearing a cloud cap with lightning shooting forth, stands with each [hind] foot on the tongue of a Ko'loowisi."[39] The snakes' dark bodies are covered with pairs of light crescents; sharp white teeth fill their mouths; their eyes are large, round and white; and each has eight feathers projecting from the top of its head. Although the figures tend to be conventionalized, clouds are realistically portrayed, unusual treatment for this age-old design.

In the volume by Smith on the Jeddito murals, described in the previous chapter, two interesting Zuñi wall paintings were published for the first time. One, photographed in 1899, shows rows of fairly realistically portrayed animals on three sides of a chamber[40] which was not a kiva. The second painting is on the wall of another non-kiva room, and shows two running Warrior Kachinas[41] (Fig. 3.6): here the left figure faces slightly more to the front than does the right dancer; arms are slightly raised, the left leg of one figure is a bit higher than that of the other performer; details of costume, headgear, and body designs are seemingly carefully and accurately done. This second painting was photographed about 1935, and in many of its characteristics compares favorably with watercolors from Zuñi which deal with identical subject matter.

The fate of the rich heritage of the Jeddito tradition in murals is a mystery. How much wall painting was done among the Hopis in early and mid-historic times is largely unknown. The thread of this development is picked up in the comments of Bourke in relation to a kiva decoration at Walpi: "On the east wall was painted a symbolical design or 'prayer,' representing three rows of clouds in red and blue, from which depended long, narrow, black and white stripes typical of rain, while from right and left issued long red and blue snakes emblematic of lightning."[42] These may be snakes, but if they are, they are so highly conventionalized as to be purely design elements as represented in Bourke's 1884 reproduction of them.[43] Surely this example indicates degeneracy in comparison with the late prehistoric murals.

In another kiva Bourke saw a symbol of the sun, apparently in conventional style. In contrast to these two, and in a third kiva, the same author saw realistic drawings of two antelope. "The artist had essayed his task with freedom and boldness, and in the execution of the larger had departed somewhat from the conventional outline tracing of the native races, and had made a representation of the

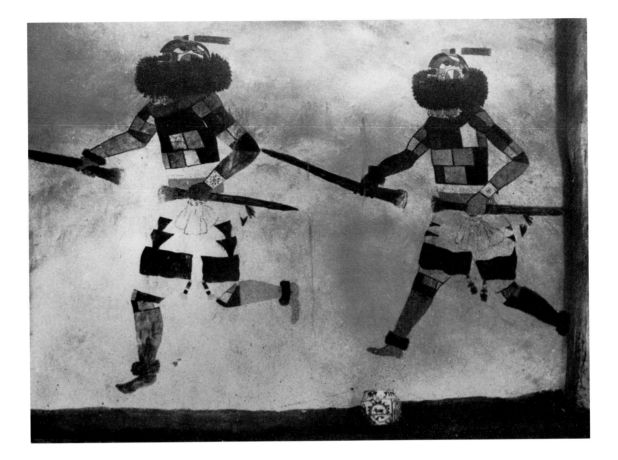

Fig. 3.6    Zuñi ceremonial
chamber mural, Salimopia or
Warrior Kachinas. Courtesy,
The Peabody Museum,
Harvard University.
—Alden Stevens

animal's hindquarters."[44] In fact, the reproduction in Bourke gives
one the impression that the artist may have been attempting to pre-
sent some perspective in the animal, for the hindquarter and lower
parts of the legs are represented in a lighter color. As in the represen-
tations of the Zuñi figures, these animals have a line drawn from
the mouth to a heart in the interior of the body, a feature often re-
ferred to as the "life line." On this same wall is a conventional sym-
bol which Bourke calls a cloud or rain symbol.

Of particular interest to this story is another kiva mural
reported by Bourke. In addition to cloud symbols, some with rain
falling from them, and zigzag lines that may be lightning, there is
a figure of the Kachina Alosaka, the Germ God,[45] which is still known
to the Hopis. There are many resemblances between this kachina
and drawings of the same made for Fewkes by Hopi men in the
1890s. Also, Smith likens the appearance of a masked and horned
figure in a wall painting from Awatovi to this same Alosaka.[46]
Feathers appear along the sides of the Awatovi mask, while in one
of the Fewkes' drawings there is a "topknot" of feathers. It is slight
wonder that Alosaka, an important personage in many Hopi cere-
monies today, has been the subject of artists over such a long period

51

of time. Further, Smith points out that Alosaka is related in legend and history to Awatovi.

The details of Hopi mural decoration recorded in writing or drawings might be summed up in a few comments. For the most part the treatment is conventional. Colors are consistently flat, and the artist dealt largely with black, white, blue, red, and yellow, rarely with any other colors. Preoccupation with the elements having to do with rain is evident—clouds with or without dripping rain, and lightning which is often tipped with a triangle, as is common also at Jémez. Various heavenly bodies such as the sun, moon, and stars are popular as are also constellations such as Pleiades and Orion. Kachina masks and kachinas are not uncommon; and, in one instance, there is a representation of the kachina house. A few plants, such as corn and sunflowers, are sometimes drawn realistically. Various animals are common. Snakes are painted. Many birds in the murals often can be identified, while some are too conventionalized to have distinguishing characteristics. And last are the paintings of blankets—one with a red and blue border—ceremonial kilts, and breechcloths. As separate subject matter they are important, for the modern Hopi artist has employed the same themes more than once in painting, and continues to produce the same pieces in weaving.

Another topic of significance in the realm of painting is hide shield decoration (Fig. 3.7). A number of Southwest Indians made and decorated shields, the majority of which seem to have been ornamented in solid color or in simple geometric designs; a few were more elaborately decorated. It is possible that some hide shield decoration[47] may have incorporated themes from painted walls of ceremonial chambers. Many of the pueblo religious groups were organized around the subject of war, and it is certainly reasonable to expect a carryover of design on religious paraphernalia to the equipment used in war. Wherever and whenever symbolic design was converted to curing rites, the war aspects and material objects of war rituals may have survived also.

One of the simplest shields observed is from Tesuque, and is decorated on the outside surface. A large central green circle takes up more than one-half of the shield area. Completely encircling it is a red band, and beyond this and to the edge of the shield is a yellow band. Heavy black lines appear at the outer edge and also serve as dividers between the three colors. Four elongated hexagons cut through the colored bands; they are white, outlined in black.

A second Tesuque shield exhibits an interesting theme (Fig. 3.7a). A red-outlined black snake covered with yellow dots extends above a central band. The horned reptile appears to be coming out of the waters, and is silhouetted against a white ground. The central

Fig. 3.7    Pueblo painted shields. Courtesy, Clay Lockett.

band and the lower half of the shield are black. The former is decorated with five red-centered yellow circles; the lower half has dim red zigzags radiating from the light line that separates this area and the broad band. Yellow dots appear on the upper edge of the black band, while red dots parallel them on the light portion of the upper part of the shield.

On other shields are four-pointed stars, buffalo horns, varicolored and parallel vertical bands (Fig. 3.7b), and much use of color. Not only in color and subject matter do these shields remind one of the murals, but also in such small details as bordering rows of dots and outlining in black. They are here presented as another link in the strong chain of painting, demonstrating not only the keen ability of these native artists, but serving also as another example of a probable carryover from one art to another.

Sandpaintings, or more properly, dry paintings, present a subject of considerable import in the story of easel painting. These unique expressions are made, or have been made, by a number of Southwest tribes, including the Papagos, Apaches, Navajos, and the puebloans.[48] The Navajos have not only perpetuated this art, but also have elaborated upon it. The story goes that they were inspired by the pueblo wall and floor paintings and altars. Restricted by his house type, with its curving timber walls and dirt floor, the Navajo turned to the use of colored sands on the floor. He combined all three pueblo ideas, the wall and floor paintings and the decorative altars, into one expression, the sandpainting. The imagination of the Navajo must not be discounted, because certainly it played its part in both

53

enlarging the size and increasing the subject matter and artistry of the dry painting.

Further, it might be asserted that the Navajo also put his imagination to work in giving an explanation of the origin of the paintings. One story goes thus:[49] The culture hero of the Navajo made a lengthy visit to the home of the gods, the yei. Among other interesting adventures, he visited the chamber where they kept their sacred designs. Upon shelves about the walls of this room were many fluffy clouds. One by one the gods took them down and unrolled them on the sacred floor. The lovely designs on the clouds and all the prescribed ritual were taught to the young hero. Returning to his people, he had to devise some means of teaching them the sacred pictures. The obvious was done—sand served to convey the designs to the Navajos. So sacred were these paintings that the young man told a select few that they must watch him most carefully, for he would destroy the paintings immediately. To this day, the Navajo medicine man makes the sandpaintings after the sun rises and destroys them before the sun sets. Yet the designs are familiar to many.

A more practical approach to origins may be given in the following comments.[50] Although pictographs and petroglyphs generally are not thought of as belonging to historic times, there are some in the Southwest dated from about 1550 to 1775 that are significant to this story. Among others, there are many in the San Juan drainage of northwestern New Mexico, created by Navajos who were residents of this area during the above years. These tribesmen left graphic representations on sandstone walls, in rock shelters, and on boulders. Many were executed in various combinations of black, red, green, pink, yellow, blues, and some orange; the paintings were concerned mainly with yei (spirits and gods) figures, although other subject matter pertaining to their religion was depicted. In addition to painting, some forms were pecked in outline or in solid fashion, sufficiently well executed to distinguish buffalos, deer, owls, humans, and altars, the latter with lightning shooting from their stepped arrangements. Rarely, yei figures were executed in a combination of painting and pecking. Perhaps the most important points to stress in relation to the painted yei, whether in more naturalistic or stylized fashion, are the depiction of excellent detail, the elongate forms, outlined figures, and a variety of colors. Both subjects and styles in these Navajo pictographs carry over into their later historic sandpaintings and, still later, into their easel art.

Navajo sandpaintings (Fig. 3.8) present a multitude of subjects, many varied colors, and great beauty in design. They present the growth of an art form within a specific group of people; they show

*Fig. 3.8   Navajo sandpainting showing four plants—corn, beans, squash, and tobacco.*
*Courtesy,  Arizona State Museum,  University of Arizona.*

—Helga Teiwes

the carryover from several art forms into still another; and they have been an inspiration to the modern watercolorist.

Formal and conventional design is characteristic of pueblo and Navajo sandpaintings alike. For example, the Hopis generally presented a few elements in simple fashion, such as four snakes bounded by a varicolored border. One Zuñi dry painting[51] shows small symbols of the sun and moon at the two lower sides, a curved white arrow between them, and a straight white line rising above the latter. Again, the "painting" may be nothing more than a cornmeal line, or meal and pollen footsteps, from the sacred altar to the door of the ceremonial room.

Navajo sandpaintings are rarely as simple as this. Circular, square, or rectangular in form, they are 5, 10, or even 20 feet across or in diameter. Many of them employ red, green, blue, yellow, black, and white in a single painting.

One sandpainting[52] features the four agricultural products brought back to the Navajos by the culture hero upon his return from a visit with the gods. In the center of the approximately four-foot-square painting are four joined squares, one black, one green, one blue, and one yellow. About the squares are "clouds," each consisting of a red and a blue rectangle separated and surrounded by narrow white lines. Each "cloud" supports a pair of deities, each a long and straight-bodied figure, much bedecked with arm bands, kilt, sash, ear pendants, and necklaces, and with various objects in their hands. The pair of deities to the east is white, the pair to the south is blue, the third in the west is yellow, and the fourth in the north is black. A great plant stands between the seated pairs of gods, or yei, as they are called—to the northeast is tobacco, and, continuing clockwise, corn, beans, and squash. These were the agricultural products of the native Southwesterners, later to be inherited by the Navajo.

The manner in which sandpaintings were acquired has been indicated above; the time is another story. When the Navajo entered the Southwest is still a question, but that it was definitely in Precolumbian times is implied perhaps in the fact that there are many points of resemblance between the Navajo dry paintings and the Awatovi murals. Birds, masked figures, animals, natural phenomena like lightning, plants, and many other subjects show similarities. Often the "drawing" is the same or similar, and the handling of colors is sometimes not greatly different.

Although the sandpainting is profoundly sacred to the Navajo, and highly symbolic, it has nonetheless been reproduced more than once in watercolors. The chances are that some small departure from the original was made, for that alone would protect the secular artist

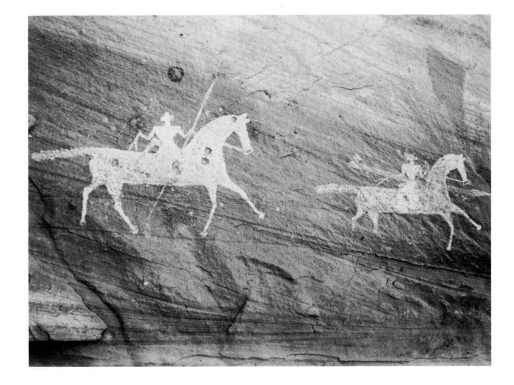

*Fig. 4.1   Wall paintings, Canyon de Chelly, Arizona, probably done by a Navajo. Courtesy, National Park Service.*

thought to belong to the 1830–40 period, it is likely that one group at least is of an earlier date. Woodward has this to say of a procession of Spaniards on horseback placed high on a cave wall in Canyon del Muerto, above the walls of Standing Cow Ruin:

> The Spanish procession will antedate 1830, I believe . . . the procession of Spanish horsemen is, in my estimation an earlier picture, and tradition ascribes it to the year about 1805 when Spanish soldiers went into the canyon looking for the Navajo and brought about the slaughter of the women and children in Massacre Cave. I have heard the arguments about the personnel of the painting; it has been the general belief that one of the men is a priest, but my theory is that it is a Spanish soldier with the cross on his cape denoting membership in a military order. All carry long flintlock guns and all have their hair in queues. No priests ever carried guns.
>
> . . . the hats are typical of the early 19th century Mexican-Spanish. [The] cloak of the rider with the cross is dark brown. This figure is the one alleged to be that of the Spanish priest but I think is an officer of the order of St. James, a military order.[2]

Although the coloring in the horses varies, there is a sameness of position that is expressive of an art not yet freed of traditional repetition. The lances of the riders impart a similar feeling, for they are all presented at about the same slant. Figures of men are definitely stiff. Each wears a hat beneath which is an indistinct face. One upraised hand holds the weapon. A great all-covering robe stiffly hides the rest of the figure save for a rigid foot dangling at the hem of the heavy garment. A number of the horses are also portrayed with a wooden feeling, but colors are as varied as their models doubt-

# A new start

The Indian arts of the present are rarely fully expressed, but remain dormant, waiting for some stimulus to call them into being."[1] So wrote Vaillant in 1939.

Aside from their own artistic merit, the craft arts kept alive potentials for the development of a new expression; watercolor was a challenge to these potentials. The challenge was accepted by many vigorous members of the Southwest tribes as an outlet for latent talents which could go no further in the age-old and restrictive craft arts of their respective groups. Tribal members found more and greater possibilities of development in new lines of art expression as a result of the first profound freedom offered them through the channels of easel art.

Let us turn now to some of the more graphic drawings of the historic period that are pertinent to the story of modern painting. These examples seemingly lack the use value of coexistent art forms. Subject matter is often new and different.

In the wall pictures described below it seems as though the Indian was groping about for an outlet, as though his contemporary media of artistic expression were not fully satisfying, or as though he must express himself in new directions. Thus, from the beginning there are a freshness and spontaneity in the new medium, watercolor, which bear witness to this artistic vigor and give fuller realization to these potentials.

Some of the drawings in color in Canyon del Muerto and Canyon de Chelly (Fig. 4.1) in northeastern Arizona are most important in this transition. Although many of these cave murals are

artisans who could band into guilds which could develop and perpetuate craft traditions of higher order. It was not until after the late 1930s that efforts of white men were realized in the organization of several guilds within Indian groups. By the late 1960s these had begun to bear fruit; surely the possibilities in this direction are most promising. School and private classes hold further potentials of group training or of individual effort in the realm of watercolor art.

Religion and mythology have been and still are vitally important motivating factors in Southwest Indian art. Religious themes are by no means confined to ritual objects; often they appear in partial or modified form in craft decoration. A Navajo may weave a yei figure in a rug; the figure may be taken from a more complex sandpainting design. The Knife Wing God of the Zuñi, which is painted on the wall of the ceremonial chamber for certain rituals, appears as a popular theme in decorative silver inlay pins made by the same tribe. The fact that native dances proved to be a popular subject to purchasers of the earliest Indian watercolors has not been an impediment to a continuation of this subject matter.

Finally, several qualities may be cited as characteristic of the art of these folk, particularly since they are to be encountered time and again in the modern watercolor efforts. Balance, order, repose, awe, and majesty are attributes which Vaillant[53] points out as having great significance in Indian art:

The American Indian race possesses an innate talent in the fine and applied arts. The Indian is a born artist, possessing a capacity for discipline and careful work, and a fine sense of line and rhythm, which seem to be inherent in the Mongoloid peoples. He has evolved for himself during many thousand years a form and content peculiarly his own.[54]

This is particularly applicable to the Indians of the Southwest.

These inherent qualities have fused with newly acquired ones in modern Southwest Indian easel painting.  ■

from the evil which might befall him for removing the complete patterns from their sacred context. Many individual themes from sandpaintings have also been reproduced on paper by the modern painter. In the main, however, sandpaintings are more important as a medium that has kept alive the ability and versatility of the artist. They have preserved designs among these semi-nomadic folk. The sandpainting has given them full opportunity to express their flare for color; it is limited by legendary subject matter; it is the essence of symmetrical design. Watercolor placed none of these bounds on the artist, which may explain in part the growing popularity of this medium.

In craft and ceremonial arts in general, whether executed in color or not, there is a most important background fact to be kept in mind in relating these to modern painting. Artistic thought and ability were constantly developing. There was continuous training in the expression of art motifs, whether they were to be woven into a rug or painted onto a piece of pottery. These were the constant reminders in their everyday lives, to all of the people, of the variety of art forms which belonged to them, of the particular designs which were essentially tribal.

Before ending this chapter, the characteristics of prehistoric and historic arts which have combined to influence the watercolor artist directly or indirectly should be summarized.

Neolithic people handled tools, materials, and technologies with great skill and mastery. With their exceptional abilities they carried their Stone Age expressions to levels seldom equaled in other parts of the world. Native craft arts have been and remain basically utilitarian; beyond question those objects made for native consumption have tended to preserve the best in craft expression. Today, as in the past, conventional treatment is the rule. This is surely to be expected in an art which is basically a decorative craft expression. The newest of their arts, watercolor painting, turned in new directions, yet it is not entirely free of this influence. In fact, in modern watercolors the artist borrows rather often from craft arts in both method of treatment and in themes.

As in the past, the art of the Southwest Indian today flows through the channels of design. Forms were created for utility, and generalized forms were perfected in the direction of a standard minimum. Design became highly adapted to the greatly specialized forms. As this synthesis became a reality, attention was concentrated on design itself. The result is the richest design in American Indian art.

Leisure and security are rare in neolithic societies. For these and other reasons, the Southwest Indian did not evolve any class of

less were. Several of the animals are much more naturally drawn, particularly one toward the front which is apparently meant to be a pinto. Further, there is presented a row of horses and riders in the foreground of the picture; above and back of them is another horse with a rider. To the rear of the group and also above it are two (?) other figures. Undoubtedly the latter are meant to be in the distance. There is no indication of ground lines or other features that would in any way suggest other perspective.

Still higher, and above the last figure(s) of the major procession, is what appears to be a rider with lance in hand. His steed, if painted originally, is missing now. Directly in front of him are two large designs, each made of a central circle with many small rays extending from it.

It is probable that this is the first real composition created by a Navajo artist in the Southwest. For that matter, it may be the first independent composition by any Southwestern Indian other than simple and often schematic hunting or religious scenes. It reflects many possibilities for the future—a free art; variation in color; new subject matter (particularly other than purely decorative or religious in nature); and the breaking with traditional methods of depiction in the lack of symmetry and exact repetition. Surely, above all, it is not design within predetermined space. Therefore, it moves a step beyond kiva mural art, for the procession might well have moved on and on for limitless feet! Thus it is an expression of art of free delineation in its asymmetrical character and in its dynamic unity. In a more consistent roundness and naturalness of figure it anticipates the accomplishments of years to come.

The wall picture of the standing cow, for which the ruin is named, also presents an interesting study. Ill-proportioned as the animal is, it is realistic in its general outlines, in the slightly lowered head, in the body which is fully rounded and quite natural in contour. The artist obviously had some difficulty in representing horns and ears, with the result that each is a pair of symmetrical and balanced additions on the top of the head, not unlike the shield symbols described above. Color was no particular problem, for the artist simply used what he had at hand and made the figure bluish-gray and dull cream.

Also from del Muerto is a group of antelope painted in orange-red, white, and black. These are not the better-known animals of the same species from Antelope House Ruin; the figures discussed here are some two miles away. Each figure is about one foot in length. Although the bodies are quite drawn-out, nonetheless they bear the unmistakable markings of this animal—the white belly, white rump, and lines under the neck. On one of the animals, the horns are very

properly represented, even to the lower, heavier construction out of which issues the lighter, curved portion of the horn.

Back of these two figures is a third animal, obviously a horse as indicated in different lines and coloring and, more particularly, in short ears, long tail, and large, single hoofs. The hoofs of the other two figures are cloven. Careful delineation of all these features—based on keen observation—remains a typical trait in Navajo painting to this day. Throughout the history of Navajo painting, these early subjects, horses and antelope, have remained popular.

A name which may be the first in the annals of Southwest Indian painting is Little Sheep.[3] Reputedly, Little Sheep lived in Canyon del Muerto in the early decades of the nineteenth century. He is credited with the painting of several horsemen low on the wall in del Muerto, below Antelope Ruin. One of the figures shows far more life and motion than the above horsemen and animals. A horse, which measures 32 inches from nose to tip of tail, is portrayed stepping along at quite a pace, left foreleg lifted and stretched forward in action, left hind leg back and also suggesting motion. The tail is flying almost straight back. Reins in the left hand of the rider pull the animal's head back and slightly downward. Much of this treatment is common in later Navajo watercolors.

Although the animal's body is too long, the rump and neck lines are rounded; the hind legs in particular show considerable improvement in form over the bent but stick-like legs of the earlier horses described above. An awkward and decidedly primitive representation of the man contrasts with the relatively good depiction of the horse. The full front of the rider's upper body is mindful of the same position so characteristic of Egyptian art, yet his legs are astride the horse. Triangular proportions of the upper body are also reminiscent of very early Basket Maker depictions of the human form. Only the Mexican hat saves this part of the figure from misidentification. Even the arms are balanced and symmetrical in the way that they are bent at the elbows and in their position. But the paraphernalia in the hands marks them as of a day far distant from the Basket Maker period. In the right hand is a quirt that urges the horse along in its already speedy journey; in the left hand are the reins, and an up-tilted spear. Horse and rider are both done in white against the red sandstone wall of the cliff.

This painting is dated between 1830–40 by the details so well depicted by the artist. This date is based on the hat type, the method of depicting horses' hoofs and the lance, and the iron jinglers on the bridle bit.[4]

Most interesting in this group is a small white figure; so different is its outline that it claims immediate attention. Close analysis

shows that it is in the tradition of the depictions of buffalo in sand-paintings. A bow-like curve forms the back and head. Four legs are shown in identical fashion, each a mere extension of the body, each in the same triangular proportions above, with straight lower leg bent out from the upper leg, and with no suggestion of right or left limbs. No details appear except a few heavy lines suggesting hair standing upright on the back of the neck.

The first authentically recorded name of a Southwest Indian artist, Choh, appears in the brief report of R. W. Shufeldt in an 1889 publication. The author tells of this Navajo lad who frequented a trading post at Ft. Wingate, always taking advantage of any opportunity to scribble with pencil—plain or colored—on any type of paper, wrapping or of better variety. Shufeldt reports:

> The first time I overlooked Choh to see what he was about he was laboring away at a gaudily dressed chief riding at full tilt upon his Indian steed. His work was rather above that of the average Indian artist, but as I had seen many of their productions before and watched many of them while they executed them, I paid no special attention to this additional example of an old story.
>
> Choh has been presented at various times with one of those red and blue pencils, when the results of his handiwork exhibit a striking appearance indeed. Flaming red frogs with blue stripes adown their backs and sides, with still more pretentious birds, will be found on every piece of paper that comes beneath the hand of this untutored artist.
>
> His figures of Indian men and women are particularly worthy of notice, and one in watching him carefully can gain some idea of the relative importance that he attaches to the various parts of their war and ordinary trappings through the emphasis with which he depicts some of them.
>
> But Choh is not much of a naturalist, as his woful [sic] delineations of birds and animals will testify. . . . [5]

Shufeldt describes with further detail how this young Navajo became engrossed in the drawing of a railroad train. "The effort

Fig. 4.2   Train drawn by Choh, a Navajo, around 1886. (From R. W. Shufeldt, "A Navajo Artist and His Notions of Mechanical Drawing," Smithsonian Institution, Annual Report, 1886, Part I.)
—Ray Manley Photography

attracted my attention at once, because an Indian's idea of a locomotive, drawn by himself without the object before him, was to me something certainly worthy of examination."[6] He goes on to tell how, in several drawings of trains, the Indian brought out many complicated details, everything from the telegraph wires along the way (even a bird perched on top of each pole!), bell, sandbox, steam chest, the driving gear of the engine, to the steam blowing off. He always placed two men inside the cab. Sometimes the tender was full of coal; other times it was left empty.[7]

Figure 4.2 is a reproduction of one of Choh's train pictures. Because of later Navajo tendencies in watercolor art, attention should be called to the lone bird. It hovers in the upper left corner of the picture, in the otherwise empty atmosphere above the train.

Commenting that Choh's "powers of observation have served him well," Shufeldt goes on to say:

> One of the most interesting things to me was to observe the great care he took to show the "bright line" on the smokestack [of a locomotive]. Not only that, but he was familiar with the fact that it did not show on the under side of the upper enlarged portion of this part of the engine....
>
> Moreover, it is not as if this man had the opportunity of studying a locomotive every day of his life, for the railway station is fully three miles from his Indian home, and there is nothing else to induce him to go there.[8]

This last remark is pertinent, for the Indian seems to acquire a permanent and detailed impression even when he has but a fleeting glimpse of the thing he portrays.

Some questions of interest are raised in connection with Shufeldt's remarks. For example, who were these other artists he refers to? What were the results of their efforts and where are their "many productions"? Further, the great versatility of the early Navajo painter, Choh, is worth mention: his remarkable memory; his keen ability, despite the lack of formal training; the accuracy with which he observed a new and strange cultural manifestation, all add up to something worthy of note.

A few years passed before another record was made of other Indian efforts in the new technique. The next reported attempts were in watercolor. The new medium offered far greater possibilities, particularly in matters of detail. While working among the Hopis during the late 1890s, Jesse Walter Fewkes,[9] an archaeologist and ethnologist, conceived the idea of having several Hopi men make drawings of the village kachina figures (Fig. 4.3). The result was the recording in color, to the minutest detail, of these exotic dance figures. A precedent was set in these drawings, for to this day one of the first things a Hopi will draw is a kachina.

Two Indian men were chiefly responsible for making the above record, Kutcahonauu (White Bear) and his uncle, Homovi.

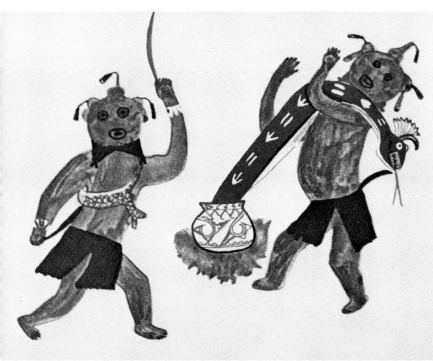

Fig. 4.3    Kachinas drawn by Hopi men for Fewkes in the 1890s. From Fewkes, "Hopi Katcinas Drawn by Native Artists," Bureau of American Ethnology, Annual Report 21.
—Ray Manley Photography

These two men were supplied with paper, pencil, brush, and pigments. In a surprisingly short while they produced several hundred drawings. The artists had few models for their paintings, since with such a large number of different kachinas there would be many that had not appeared in ceremonies for years.

Although the majority of the figures drawn by these two artists show strange, little short-legged, short-armed creatures, and other badly proportioned physical features, nonetheless they demonstrate the Indian's meticulous care in depicting detail. Time and again one can reconstruct from the minute features who each kachina dancer was, how their bodies were painted, what jewelry they wore—even to turquoise, shell, and coral objects——and what additional ceremonial paraphernalia was added to each dancer's costume. Clearly delineated are designs in sashes, embroideries on kilts, details of mask painting such as rain drops dripping out of a cloud. These drawings are discussed at greater length in the chapter on Western Pueblo artists.

In 1902 Dr. Kenneth Chapman of Santa Fe was visiting in the Navajo country and heard of a native "who did nothing. He is an artist." Following this vague clue, Dr. Chapman eventually came to the hogan of one Apie Begay, in the Pueblo Bonito area of western New Mexico, and found the Navajo anything but idle. He was sitting

on the dirt floor of his hogan, his legs straight out before him and under a makeshift table in the form of a wooden box with the sides removed. The Indian was attempting to reproduce his very colorful sandpainting art in but two tones, red and black. Dr. Chapman related that the Indian's eyes nearly popped out of his head when he saw the range of colors offered him in the box of crayons that the white man extended to him. Subsequently the artist continued to pencil in the outlines of figures, but added blue, red, yellow, and green to make more realistic the depiction of yei or spirit masks, kilts, garters, sashes, and other accessories of the sacred figures as he had doubtless seen them in sandpaintings.

The experiences of Apie Begay illustrate well the difficulties a primitive artist has in breaking away from established tools and materials and in attempting to use equipment and techniques that are partially or totally strange to him. In one painting[10] the man was experimenting with new subject matter. He had his troubles. Apie Begay did not solve his problems in the traditional manner always, but he solved them nonetheless.

First, Apie threw off the convention of unalterable rigidity and repetition of yei figures in sandpaintings (Fig. 4.4). There is a suggestion of motion in flying ribbons, not exactly duplicated in each instance. He added a quaint touch in the placement of "jaclas" (bead pendants), and a necklace at odd angles, with the latter completely on the chest—and not around the neck—of one figure. Perhaps the artist was unable to place it properly about the neck, but he did not omit the item because of difficulties of representation. Further, there is more naturalistic drawing in the figures on the paper than one would normally find in the original sandpainting.

It was at about this same time that the children of Zuñi were trying their hands at expressions that were far removed from traditional art styles. Using the media of paper and watercolor, some of them painted pictures full of vitality and motion. There is a smeared quality to much of this work, but the approach to the new problems betrays no hesitation. Some of the paintings bear the date 1905.[11] Several of them display complete scenes.

One such painting in the Denver Art Museum collection is signed C.D.T. (apparently one Tullma) and is dated 1905. A complete scene, in the European manner, it is labeled *Zuñi scene, Zuñi house, wagon and wood pile. Mountains in background with sun and moon.*[12] And that is just what it is! There is much—and poor— mixture of colors, often with a dirty or smeared quality to them. Detail is not lacking, however, for smoke comes out of the chimney and a ladder leans against the house. The childish quality in the drawing is epitomized in the wagon, with all four wheels showing completely.

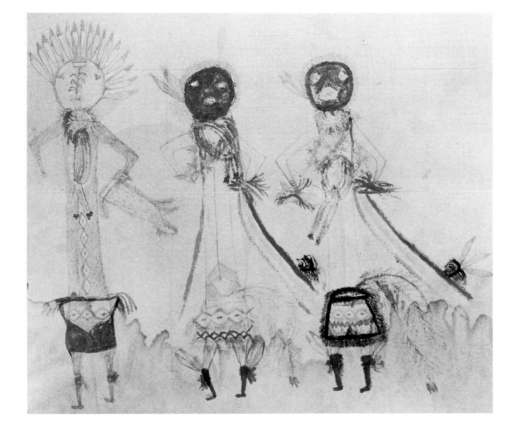

Fig. 4.4   Apie Begay, Navajo.
Sand Painting Figures.
Done in 1902 for
Kenneth M. Chapman.
Courtesy, The School of
American Research, Santa Fe.
—Laura Gilpin

Seemingly, this early work had little if any influence on the total development in the story of Indian art in this village. Frowned upon by the pueblo as a whole, the entire expression disappeared for some years among the Zuñis, insofar as is known.

The years between 1900 and 1910 saw similar artistic expression among Indians in the Rio Grande Valley. This was true despite general attempts in Indian schools to suppress efforts in the direction of "native" expressions and to substitute the white man's ideas. One teacher, however, had the courage to defy the attempts to quash native culture, and her efforts bore far more fruit in the field of painting than is generally realized.

In the day school at San Ildefonso, Elizabeth Richards let her children paint as they wished. She collected from her pupils a number of pencil and crayon sketches and several watercolors, and sent them to Barbara Freire-Marreco in England in February, 1911. These are discussed at greater length later. But it is important to note here that among them was a painting which Bertha Dutton, formerly of the New Mexico Museum, has identified as the work of Alfredo Montoya. A painting of an animal dance, it shows great promise in suggestions of perspective and in detail.

Alfredo Montoya, here represented by *Buffalo Dancer* (Fig. 4.5), certainly was painting at an early date but, unfortunately, most

67

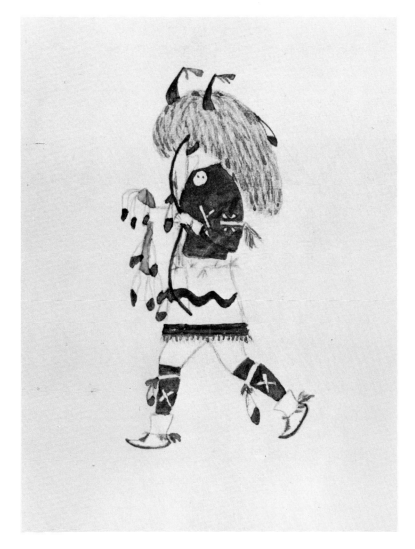

*Fig. 4.5    Alfredo Montoya
(Wen-Tsireh), San Ildefonso
Pueblo.* Buffalo Dancer.
*Courtesy, The School of
American Research, Santa Fe.*

of his efforts were lost to the general public until much later. In 1941 a brief note was published concerning a collection of several paintings by this San Ildefonso boy.[13] Mr. and Mrs. Fred Henry of Denver gave to the Museum of New Mexico, in Santa Fe, two paintings of Montoya's which they had acquired between 1908 and 1910 when they were connected with the field school in the Rio de los Frijoles, New Mexico. Certainly these paintings antedate the works of later artists of his own pueblo—the members of the so-called "San Ildefonso school" who are generally credited with the beginning of Indian watercolor art. Montoya's untimely death in 1913 may explain the absence of his name in many published accounts pertaining to this development.[14]

Between 1910 and 1920 there was great activity among several groups of Southwest Indians in consolidated movements toward a revival of painting as a general expression and in watercolor art as a relatively new thing. This activity centered in the village of

San Ildefonso and in the works of Crescencio Martínez, Alfonso Roybal, and Julián Martínez. Before the end of this period, several other names were added, including Fred Kabotie of the Hopi pueblos, Tonita Peña, originally from San Ildefonso and later of Cochití, and Velino Herrera of Zía.

Like many of the early artists, Crescencio Martínez was a pottery decorator. Mrs. Margretta S. Dietrich tells about his first painting:

> About 1910 Dr. Edgar L. Hewett ... found in San Ildefonso Pueblo one Crescencio Martínez ... drawing single figures of buffalo dancers, eagle dancers, on the pristine cardboard box ends. From the day that Dr. Hewett provided Crescencio with a box of school children's water colors and a pad of paper San Ildefonso began its career as the font of modern Indian painting.[15]

It is possible that this artist did not produce his works now found in various collections until a later date; certainly he had painted most of the costumed dancers of his native village before his untimely death in 1918. Through his prolific production, he established a subject that became most popular among the painters in the Rio Grande Valley—the native dances (see Fig. 5.2).

Awa Tsireh, or Alfonso Roybal, was painting before 1917, for Alice Corbin Herderson[16] relates her interest in his work at that time. Having seen several paintings he had produced before this date, she asked for more of them. He complied with her request with additional drawings of dancers and horses. This artist was the oldest of the early group. His formal education had not extended beyond the primary grades. Dunn[17] described his style as "decorative realism"; however, his versatility might better be expressed in more extensive terms. Awa Tsireh developed three styles: representational or semi-realistic (Fig. 4.6), representational plus conventional (Fig. 4.7), and abstract (Fig. 4.8). The representational style is basically a form of naive realism used to portray everyday and religious scenes, with the human figure predominant in these presentations. In the representational-plus-conventional style, humans and animals are presented with a larger or smaller amount of conventional or abstract design; often the life form and the design themes are directly associated in some way—for example, a man standing on a rainbow. The term abstract is used in a broad sense and does not imply the extreme modern art of this style; rather does it include, in the earlier Indian painting, more in the way of highly conventionalized design plus some that is more cubistic. In later years, the term abstract covers a still wider range in values, from conventional and cubistic to true abstraction.

Julián Martínez, like some others of his tribe, was a decorator of pottery. He ornamented the vessels made by his now-famous wife, María.[18] Julián attempted realistic subject matter in his watercolors,

69

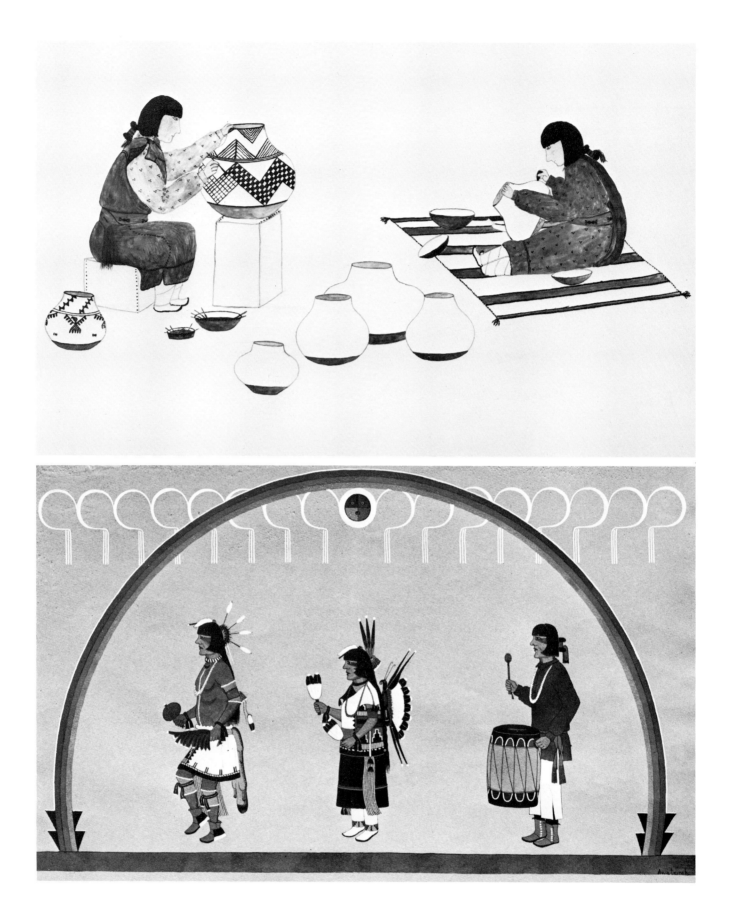

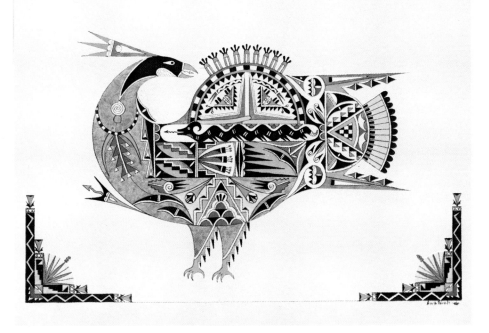

Fig. 4.6 *Alfonso Roybal (Awa Tsireh), San Ildefonso Pueblo.*
Decorating Pottery. *Courtesy, The School of American
Research, Santa Fe.*

Fig. 4.7 *Alfonso Roybal (Awa Tsireh), San Ildefonso Pueblo.
Untitled–Two dance figures and a drummer. Courtesy, The
Denver Art Museum.*
—Neil Koppes

Fig. 4.8 *Alfonso Roybal (Awa
Tsireh), San Ildefonso Pueblo.
Esoteric bird.
Courtesy, Popovi Da.*
—Laura Gilpin

but surely his forte was imaginative bird figures. The latter incorporated many of the design elements that appear on the pottery he so meticulously ornamented.

There is no way to state precisely the first date of the artistic attempts of these early men. It can be asserted that some were painting in the Rio Grande, and several of them at San Ildefonso, between 1910 and 1917. Enough Indian paintings were available to be exhibited in national galleries by 1919. In that year, John Sloan entered some of these native watercolors in the Society of Independent Artists show in New York City, not as Indian curiosities, but as works of art worthy of competition with other American expressions of like nature. By 1919 there was also a "showing of Indian water colors in the Arts Club of Chicago."[19]

Velino Herrera, also Velino Shije or Ma-Pe-Wi, was another of the earlier artists of the Rio Grande (Fig. 4.9). One of his paintings in the Indian Arts Fund collection is dated 1917 or 1918. From the village of Zía, he was one of three young men who were being encouraged in their efforts at painting while employed by the School

71

Fig. 4.9    Velino Shije Herrera
Ma-Pe-Wi), Zía Pueblo.
Pine Tree Ceremony. Courtesy,
The School of American
Research, Santa Fe.

of American Research, Santa Fe. The other two were Awa Tsireh and Fred Kabotie. These boys were allowed to paint two to three hours a day, and supposedly were not subjected to any white influences whatsoever. They developed their own styles and color sense, following mainly the themes of native dancers. Before their employment by the School of American Research, Ma-Pe-Wi, Kabotie, and several other Indian lads were encouraged in their art efforts by Superintendent and Mrs. J. D. De Huff, at the Indian School in Santa Fe.

Although there was no formal art instruction at the Santa Fe Indian School during the twenties, the children were given supplies and allowed to paint what they wished. Mrs. De Huff was most helpful at this time, as was Dr. Kenneth Chapman; both of them encouraged young Indians who showed artistic ability.

Many names were added to the list of Southwest Indian artists between 1920 and 1930. Perhaps starting as early as, or shortly after, the time of Fred Kabotie was another Hopi, Otis Polelonema. Both Kabotie and Polelonema have greatly influenced their fellow tribesmen (Figs. 4.10 and 4.11). Kabotie exerted a strong influence in modeling through shading and in the use of shadows in pictures, while

Fig. 4.10    Fred Kabotie,
Hopi. Ho-o-te Kachinas.
Courtesy, The School of
American Research, Santa Fe.
—Milton Snow
—Ray Manley Photography

Fig. 4.11    Otis Polelonema,
Hopi. Untitled—two dance
figures and a drummer.
Courtesy, The Denver Art
Museum.
—Neil Koppes

73

Polelonema affected many Hopis in his strange representation of exaggerated tribal physiognomy, particularly in an elongated and rather sad-appearing face.

Tonita Peña, who later married into the pueblo of Cochití, was painting at San Ildefonso during these early years. So too were Ricardo Martínez, Luis Gonzales, Abel Sánchez, Encarnación Peña, and Romando Vigil. Other villages were adding their share to the growing list of painters; for example, Tomás Vigil of Tesuque was painting in the twenties. At the pueblo of Zuñi, there were several artists who were depicting rather widely differing subject matter. Lawasewa was producing formal drawings of altars that demonstrated the meticulous detail so characteristic of puebloan work in general. Very different are the Patone Cheyatie dancers which, although in rather formal lines, suggest a break from the usual repetitive qualities of other art forms in slightly different positions of bodies and feet. Both of these men were painting in the late twenties.

It was also during the 1920–30 decade that great public interest was created in Indian painting. Many of the residents of Santa Fe became deeply involved with this development; some made speeches, some wrote articles, some encouraged exhibits. In 1923 a group organized itself as the Indian Arts Fund, with the purpose of preserving Southwest Indian arts, among them painting. Needless to say, all of this greatly encouraged and stimulated the young artists.

In 1932, a group of students, with some of the older artists and representatives of various tribes, painted murals on the walls of the Indian School at Santa Fe, under the direction of Olive Rush. The murals attracted national attention. They are significant in that they brought together the several styles of contemporary artists, and they depicted native subject matter in an invigorating manner. Certainly, they have been an inspiration to many a budding artist in succeeding years.

Late in that same year Miss Dorothy Dunn established an experimental studio in the Santa Fe Indian School.[20] Here she guided the art interests of forty young and aspiring students. The splendid results of this experiment stood in vivid contrast to what was going on in other Indian schools. Reflecting the latter, one Congressman said, "Who wants to go West to buy a picture painted by an Indian of three apples on a plate?"[21] As a result of Miss Dunn's efforts, "the department of painting in the Santa Fe Indian School was established by the U.S. Department of the Interior in December 1933, thereby marking the first time the Federal Government had officially recognized Indian painting."[22] Miss Dunn was justly rewarded for her efforts when she was placed in charge of this department of art, the first in any Southwest Indian school. An excellent record of this important period in the history of Indian art appears in her 1968 pub-

lication, *American Indian Painting of the Southwest and Plains Areas.*[23]

In succeeding years, departments of art were established at Albuquerque, Phoenix, Oraibi, and other Indian schools of secondary level. With this trend there developed a better attitude on the part of elementary schools toward encouraging expressions of art along native lines.

In the establishment of Indian school art departments, it was most fortunate that teachers who were employed often had a sincere interest in the perpetuation of native art. Both Olive Rush and Dorothy Dunn at the Santa Fe Indian School did much to encourage the budding genius of Indians along native paths, as did another teacher, Lloyd H. New (Kiva), at the Indian School in Phoenix. Many fine artists were developed by him.

An article written by Dorothy Dunn in 1935 expresses her understanding of the possibilities of the Indian artists. First, she was aware of the rich heritage of these people; she says, "The American Indian child, and particularly the child of the Southwest, inherits a clear, definite art tradition very different from the heterogenous cultural background of the average American child."[24] She made every effort to make the native child realize and appreciate his brilliant heritage if he had not already done so. In particular did she take her students to the Laboratory of Anthropology "to examine, sketch and study the finest and largest collections of Indian art. . . ."[25]

Miss Dunn further realized that Indian children were individuals and that each one who came to her had a different background and different traits of personality. It took understanding on her part to get the most out of many of these shy youngsters. Many of the more sensitive ones she guided into the bright world of self-expression. Her achievement is measured by the number of Indians who have grown into successful artists, men who are happier for their accomplishments and who have contributed richly to the American scene in art.

"The painting and design classes" did not exist "to teach any of these groups, but to guide, encourage, discover, discern,"[26] continues Miss Dunn. She also points out that the classes gave the Indian child the "stimulation of working with other artists, appreciation and encouragement of their individual manners of expression. . . ."[27] In connection with the latter thought Miss Dunn says, "If the Indian schools, through their art classes, should impose academic principles and techniques of painting and design upon these students, they would be engaging in the destruction of one of the world's unique and beautiful art forms."[28]

One of the problems Miss Dunn had to deal with was the conception in the mind of many an Indian as to what was good art.

Too many of these young people had been exposed to calendar and poster "art," and were often under the delusion that these were worthy examples to copy. Miss Dunn decried these and other "alien influences," and wished to rid the Indian of them, to have him produce only Indian art. However, it must be kept in mind that it would be expecting the impossible of the Indian for him not to be affected in some measure by his contact with the white man. It would be a static personality, indeed, which did not react in some manner to the changing society of which he was a part. And, of course, the Indian artist *was* influenced by white men.

The new art expression of watercolors was integrated with school life, in the school paper, in murals on the walls of various buildings, and in other ways in which the young Indian found that his effort became a living expression. This may well have been one of the most important aspects of direction on the part of the white teachers, for it aided in bridging the gap between the old art of utility and the new "art for art's sake."

Starting primarily in the Indian schools, the painting of murals greatly increased from the early thirties on. Inspired by the success of this type of work, a group of Indians at the Santa Fe school painted some panels that were exhibited in the Corcoran Gallery in Washington, D.C., at Rockefeller Center, and at the 1933 Exposition of Indian Tribal Arts, New York City. Not only were these acclaimed by the many white people who saw them, but they also created great interest on the part of the Indians of other tribes in the United States. These murals ranged in size from 8 x 10 feet to 8 x 16 feet. Comments about them indicate what an impression was made by the painting of these subjects freehand, without any sketch, and figure by figure, without any prior sketching in of the whole area.

In connection with this last thought, it is of interest to relate a brief anecdote concerning the Treasure Island Exposition of San Francisco, in 1949. An Indian was engaged to decorate the division where various tribal arts were to be displayed. This time a sketch was made beforehand; inadvertently it was thrown away, to the very great dismay of the white people involved. The Indian artist, however, seemed not in the least disturbed. He set to work, with no preliminary sketch before him. He caused further consternation when he started at one end of the panel and completed one figure at a time before moving on to the next. Needless to say, the white people were more than surprised—and gratified—when the panel was completed and all figures originally included found their proper niches in the whole creation. This is just another example of the mental picture the Indian has of the finished product. Whether potter or mural painter, these people have an uncanny ability to visualize the

completed design before they draw the first small line. And, further, that mental picture seemingly never fails them in the process of executing a design.

Their art abilities served the Indians well during Depression and post-Depression years—the public works programs of the 1930s did not exclude Indian artists. In fact, those excluded were Indians who made only a portion of their income from painting and were therefore not eligible. Many paintings were produced by Indians at this time and were widely circulated.

Exhibits in the Royal College of Arts, London, and elsewhere abroad, in Marshall Field's in Chicago, and in many art galleries throughout the country, continued to encourage, and spread the fame of, Southwest Indian art. Outstanding among these exhibits was one in Paris, at the Museum of Natural History, Department of Ethnology, in 1935. In the exhibit were a great many examples of American Indian art. The whole display was advertised by one hundred posters made by the students at the Indian School in Santa Fe. Perhaps better known in France than in America, except to a limited group, the paintings were featured in an outstanding French publication, L'Illustration.[29]

In the same year, 1935, the College Art Association organized an exhibition of children's art from all over the world. The only art from the United States was that from the New Mexican pueblos of San Ildefonso, San Juan, Santa Ana, Tesuque, and Taos. The children prepared their own colors from earth materials for these paintings. Their choice of subject matter was native. These paintings received favorable comment and created much interest in Indian art in general.

Many new names were added to the already sizeable list of painters during the 1930–40 decade. Waldo Mootzka, a Hopi, did most of his painting during these years.[30] Although he attended the Indian School at Albuquerque, it was prior to the establishment of their art department. He was as much a self-taught painter as were some of the first artists. Quite a number of Navajo artists appeared during these years. Outstanding among them were Quincy Tahoma (Fig. 4.12), Andy Tsihnahjinnie (Fig. 4.13), Gerald Nailor, Harrison Begay (Fig. 4.14), and Hoke Denetsosie. Most outstanding among the earlier Apache artists, and one who started to paint in this decade also, is Allan Houser (Fig. 4.15). Many are the names added to the pueblo list, but only a few will be mentioned here: Roland Durán (Tolene) of Picurís, Pablita Velarde of Santa Clara, and Pop Chalee of Taos.

The increasing frequency of exhibits and publicity inspired growing public interest that resulted in large sales of Indian paintings.

*Fig. 4.12  Quincy Tahoma, Navajo.*
Going to the Navajo Chant.
*Courtesy,* Arizona Highways.

*Fig. 4.13* *Andy Tsihnahjinnie, Navajo.*
Young Navajo Riders.
*Courtesy,* Arizona Highways.

More and more Indian artists painted more and more pictures during the 1940–50 decade. Most of the above-named artists accelerated their efforts, often in the direction of stereotyped paintings. Many names appeared for the first time or became prominent in this decade. Among these are Charlie Lee (Yel-Ha-Yah) and Beatien Yazz, both Navajos; Percy Sandy Tsisete (Kai-Sa), a Zuñi who made his home at Taos; Eva Mirabal of Taos; Gilbert Atencio of San Ildefonso; and J. H. Herrera of Cochití, son of Tonita Peña.

During the following two decades, 1950–70, there were trends in the directions of both decline (starting in the late 1940s) and advancement. After World War II, many changes occurred in Indian life to cause a temporary decline in painting—for example, wage earning, the acquisition of scientific knowledge, the feeling for the need of more education, and a greater acceptance of white man's culture. In the process of adjusting to these and other changes, some

Fig. 4.14    Harrison Begay
(Haskey Yah Ne Yah), Navajo.
A Fawn and Rainbow.
Courtesy, Arizona Highways.

80

Fig. 4.15  Allan Houser
(Haozons), Apache.
Apache Devil Dancer.
Courtesy, Arizona Highways.

Indian artists ceased to paint, while others temporarily withdrew from the art scene. Within the latter group, there were some who lingered, without producing, only long enough to get a second wind; then they, along with many new artists, forged ahead with renewed and greater vigor. The death of several of the outstanding older painters early in this period left a gap in production.

Well into the 1950s and through the 1960s, the artistic appetite of the Indian was whetted through both tribal and non-tribal trends. Internally there was a growing feeling of self-sufficiency and strength, particularly as some tribal councils developed and gave a feeling of greater economic well-being to their respective tribal members. Too, during the 1960–70 period there was an accelerated interest in the teaching of art in Indian schools. On the outside there was an ever-increasing interest in things Indian, manifested in many ways: a larger and more intelligent buying public, more and bigger exhibits of Indian art, and the creation and development of private collections, all of which increased sales and made painting a worthwhile venture. "Nothing succeeds like success," runs the old cliché; and this success may well account for the growing number of artists during these years, including, among many others, R. C. Gorman, Tony Da, Raymond Naha, Robert Draper, Helen Hardin, and Mike Kabotie.

Significant changes in these later years were directed by many factors, including more and better painting supplies, improved techniques, and expanding subject matter. Through broader experiences and education, the Indian also has been exposed to new approaches and encouraged to experiment. As a result, new styles of painting have developed. From the beginning of easel art after the turn of the century, through the 1960s, the Indian painter went from an overwhelmingly decorative style to, in some instances, extreme modern styles. The following chapters explore this transition, dwelling on the development of what became "traditional" to certain tribal groups as expressed by individuals within these tribes—the Rio Grande puebloans, Western puebloans, Navajo-Apache, and miscellaneous non-pueblo tribes. However, other styles expressed by individual Indians are also included. ■

# The Rio Grande

The Indian does not *say* anything about his culture, does no *instructing* about it, [he] just *lives* it, expressing it in drama, ritual, music, symbolism. . . . The Indian youngster, from the cradle board, assimilates the culture of his people as he breathes the breath of life.[1]

The transition from the developed styles of art, which had been a part of life for many hundreds of years, to a new expression, which continued to portray that which went on about them in a partially new technique and with new materials, was a natural trend among the San Ildefonso folk. Through the centuries, like other puebloans, they had displayed the ability to express themselves in new forms, in new techniques. They had demonstrated the ability more than once to achieve perfection in the use of new materials. They assimilated fresh ideas into the total of their culture, and lived these new thoughts.

Why, then, should not watercolor art become a happy medium in which further to reflect certain phases of their culture? The first schoolchildren of San Ildefonso who so quickly and aptly "took" to crayon and watercolor were but carrying on another age-old tradition, that of representing the life about them in rhythmic form and color.

It is a far cry from these first faltering, not-too-well-drawn sketches to the finished products of the 1970s, but the path along

the way has been clear cut and well defined. An exhibit of Indian art in 1945 brought forth the following comment:

If there is any one lesson to be learned from this exhibition it is that the numerous painters represented have *found a union* between their own native life and the movement of the civilization around them. Technically, most of the work is on a rather high plane, and emotionally, almost without exception, it occupies a place comparable with some of the best work being done by our American moderns.[2]

## San Ildefonso

The work of the children at the day school at San Ildefonso mentioned in the last chapter gave the first indication of the potentials in this pueblo. Isabelita Montoya—later to become the mother of Gilbert Atencio, a modern painter of some note—made pencil and crayon sketches of a Comanche dance and several scenes from the everyday life in the village about her. Among the latter was one depicting three women, two with jars on their heads. Sotero Montoya also did a Comanche dance and several kachina figures. Juan José Montoya, a cousin of María Martínez, likewise portrayed a Comanche dance.

Among these first "artists," if they may be so labeled, was José, the son of Anna and Crescencio Martínez. One is tempted to say that Crescencio may have been inspired by, or at least became interested in painting because of his young son. Another name which was to become famous at a later time, Alfonso Roybal (Awa Tsireh), is scribbled on several of these early school drawings. Several colors and pencil were combined by Reyes Pecos to depict the figures of two women dancers and a drummer. Not the least important of these works is the first known San Ildefonso watercolor done by Alfredo Montoya.[3]

Several of the schoolchildren's drawings show ground lines, and one gives a suggestion of perspective in the drawing of a ladder coming out of a square kiva. There is a simple attempt to express detail, though the results are in no way comparable with attainments of later years. Motion is suggested in bent knees, in legs in different positions. The animal dance portrayed by Alfredo Montoya shows more promise, exhibiting cleaner lines, more detail, and greater smoothness in transition from figure to figure.

Of the above names, only two became famous in after years, Alfredo Montoya and Alfonso Roybal. A Montoya painting, an animal dance, illustrates the characteristics of his work. Very light, delicate lines delineate the figures of two Deer Dancers at a slightly higher level, with two Antelope Dancers below. The latter are smaller in size. All four figures exhibit fair proportions, very good detail (even to the design of the white knitted stockings worn by the dancers)

and sustained action in the stiff but bent figures. The left leg is forward and fairly straight, the right is back and quite bent. Seemingly these set a pattern which was to be followed by artists for many years to come. "His [Montoya's] drawing tradition was true, symbolic, direct, extraordinary in color and movement [and] indifferent to European laws of perspective, placing simply that which was in the distance above that which was in the foreground."[4]

Alfredo Montoya (Wen-Tsireh, meaning Pine Tree Bird) was, perhaps, "the young man from San Ildefonso who initiated modern pueblo painting."[5] He married the sister of Crescencio Martínez. There was a probable influence here, for a description of an Alfredo painting might be applied equally as readily to one by Crescencio (Fig. 5.1).

It might be well to pause here and explain the name in parentheses in the above paragraph. Puebloans have native names; similarly, they have Spanish names received when they were Chris-

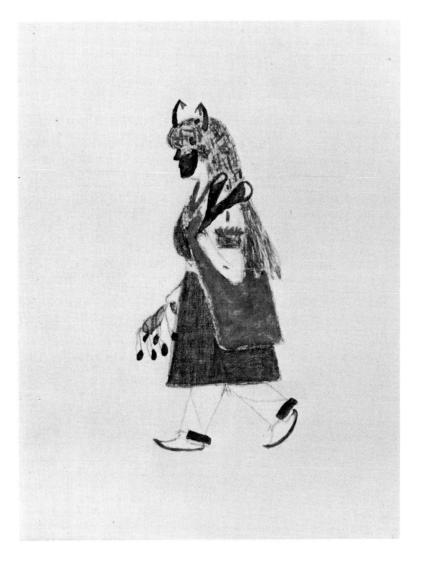

Fig. 5.1 Alfredo Montoya (Wen-Tsireh), San Ildefonso Pueblo. Buffalo Mother. Courtesy, The School of American Research, Santa Fe.

tianized. More recently, some of the younger folk have been given English names in the government schools. Demands from white men have brought about a more extensive use of Indian names on paintings. As a matter of fact, the idea of signing pictures was new to the Indian; some of the earliest paintings are not signed at all.

Many stories have been circulated about the first watercolor artists of the Rio Grande. One which is probably true concerns some Indians who were employed between 1909 and 1914 by the School of American Research on the archaeological digs in the Pajarito Plateau north of Santa Fe. These men undoubtedly saw the many decorations on the walls of the caves there. In some instances, as Chapman says, "The Pueblo Indians, employed by the School for several seasons in the nearby excavations, have also left examples of their handiwork in several caves...."[6] The story continues that as a result of this the Indians were asked by a member of the school to record some of their native dances in watercolor paintings.

The importance of this incident rests on two facts. First, it gives an approximate time for the probable beginning of modern painting by others than schoolchildren. Second, there is a possible link between the Pajarito drawings and the first watercolors; some of the obvious differences between the two can be related to different media.

The exact date when Crescencio Martínez (Te-e, Home of the Elk) began to paint is not definitely established. It is related that as early as 1910 he was known to be doing about the same thing as the Navajo, Apie Begay—painting single dance figures on the ends of cardboard boxes.[7] Alice Corbin Henderson reports that she purchased paintings from Crescencio in 1916.[8] Seemingly, there are no pieces dated earlier than 1917. It was at about this date, too, that Crescencio's extensive work was done for Dr. Edgar L. Hewett of the Museum of New Mexico and the School of American Research, Santa Fe.[9]

It is probable that Crescencio Martínez started painting sometime between 1910 and 1915. It is well established that he was painting during the first World War. Crescencio and his wife moved into Santa Fe during these years, and while busily engaged in grooming and feeding horses, he found some spare time in which to paint.

Crescencio left a significant record of all costumed dancers of the summer and winter ceremonies of his native pueblo.[10] These paintings are both artistically and ethnologically of importance. Hewett recognized this fact, implying that they would start a renaissance in Southwest Indian art.[11]

Several characteristics are outstanding in the works of Martínez. His draftsmanship was inferior, but he used color very effec-

tively. Generally, his colors are subdued, although at times a bright touch will appear in a woman's beads or in an arm band. Often the faces of dancers are very dark, even smudgy. The same quality sometimes appears in greater areas, rarely throughout an entire painting. Lack of finish is indicated in the occurrence of pencil lines which were neither covered with color nor erased. Often the hands and lower arms of the dancers are exceptionally small.

Generally, Crescencio Martínez used no background, no foreground, no ground line (Fig. 5.2). A dance figure, or several of them, appears on a perfectly blank, white sheet of paper. All original paintings by this artist that have been examined in this study were animal dancers, with Buffalo Dance groups shown most frequently. Although he lacked formal training in the art of painting, Martínez amply made up for it in his native ability and in his thorough knowledge of the minutest detail of tribal costume decoration. Pattern in knitted stockings, embroidery on kilt, headgear in the form of animals' heads, these and many another detail are carefully and accurately depicted. To be sure, there are instances in which these items are suggested more than delineated, but such is the exception rather than the rule.

Rhythm in motion, or occasional rhythmic repetition of figures, is to be noted in many of the Crescencio Martínez drawings. Perhaps his activity as a pottery decorator is reflected in these traits. It is also said that this man did not experiment with color or pattern once he had started painting;[12] perhaps this, too, is related to his

*Fig. 5.2   Crescencio Martínez (Te-e), San Ildefonso Pueblo. Mountain Sheep Dancers. Courtesy, The School of American Research, Santa Fe.*

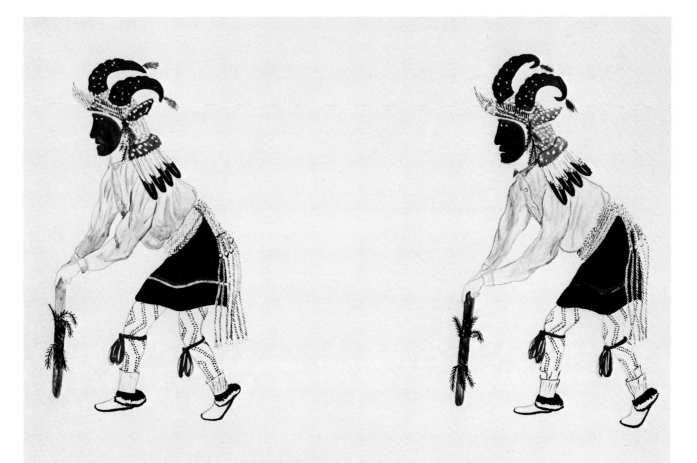

years of ceramic decorating, for the potter conceives the finished design before he starts to work, then unhesitatingly sets about to complete the pattern. Although Crescencio followed in the footsteps of Alfredo Montoya, he went beyond him in some measure.

Crescencio Martínez of San Ildefonso, then, was surely the first pueblo artist to paint extensively. Because of this and because of his direct contact with other developing artists, he became dynamically influential, setting certain standards in the realm of painting. His name was among the first to be known outside the Southwest, for he was represented in the American Museum of Natural History showing of San Ildefonso paintings arranged by Mary Austin in 1920.[13] His paintings were often displayed in the Museum of New Mexico in Santa Fe. Later, in 1927 and 1936, he was represented along with other Indian artists in the shows at the Corona Mundi International Art Center in New York City.

Perhaps all of this explains why Crescencio Martínez is considered the "father" of the modern movement. Crescencio died on June 20, 1918, a victim of influenza.

The School of American Research in Santa Fe played an active part in the next chapter of the development of art in San Ildefonso and in the Rio Grande in general. It was this organization which had encouraged Crescencio; it now furthered its efforts in the direction of providing employment for more budding artists. It is likely that the school provided materials, too, and also protected some of its protegés from well-meaning but diverting friends. One of the artists who came under this protective influence was Alfonso Roybal (Awa Tsireh), a nephew of Crescencio Martínez. A second was Velino Herrera (Velino Shije or Ma-Pe-Wi) of Zía, and a third was the Hopi youth, Fred Kabotie. In a relatively short while, these young men produced more than one hundred drawings of Indian ceremonies.[14]

Awa Tsireh developed three distinct styles, which have been mentioned in Chapter Four. His first style (see Fig. 4.6) was generally naïve realism, presenting genre subjects or ceremonial dancers in ranks and files. Often the perspective was of such nature as to suggest a view from a housetop. His second style (see Fig. 4.7), realistic plus conventional themes, had a "prop" in the form of landscapes of terraced mountains, or arching rainbows, or massed clouds; many of these were highly suggestive of ceramic decoration or murals. Against these "props" appear an animal, a hunter, or several figures, often portrayed with fine realism. In the third style, an abstract one (see Fig. 4.8), creative imagination plays a very significant part, with the result that esoteric drawings and composite monsters are commonly depicted.

Some of the early pieces in the first style of Awa Tsireh are dated at least approximately. For instance, a corn ceremony group,

dating from 1917 or 1918, shows alternate pairs of men and women dancers in six repetitive and rhythmic units. Alternate rhythm is further suggested in the dark upper bodies and white kilts of the men and in the light shoulders and dark dresses of the women. Exact duplication in costumes, identical positions of feet and hands, fine detail in dress and jewelry, the placement of the figure on the far side slightly above the closer figure, no ground whatever, and the use of flat colors—in all these traits Awa Tsireh was but reflecting the trends which had gone before in the decorative art of his tribal group. Some of his realistic paintings of ceremonies break the above rhythmic repetition (Fig. 5.3).

Awa Tsireh often portrayed group figures in a diagonal arrangement. In one painting there are two very straight double rows of men and women Corn Dancers arranged in lines from the upper right to the lower left corner of the picture. There is rhythmic duplication from one figure to the next in each row. But there is promise of a break from the usual stiffness and formality of arrangement of

*Fig. 5.3   Alfonso Roybal (Awa Tsireh), San Ildefonso Pueblo.* Shalako and Mud Heads. *Courtesy, The Denver Art Museum.*
—Neil Koppes

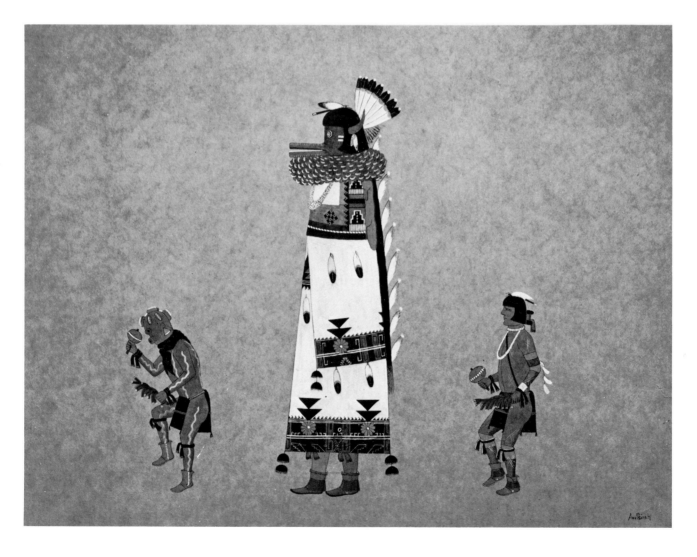

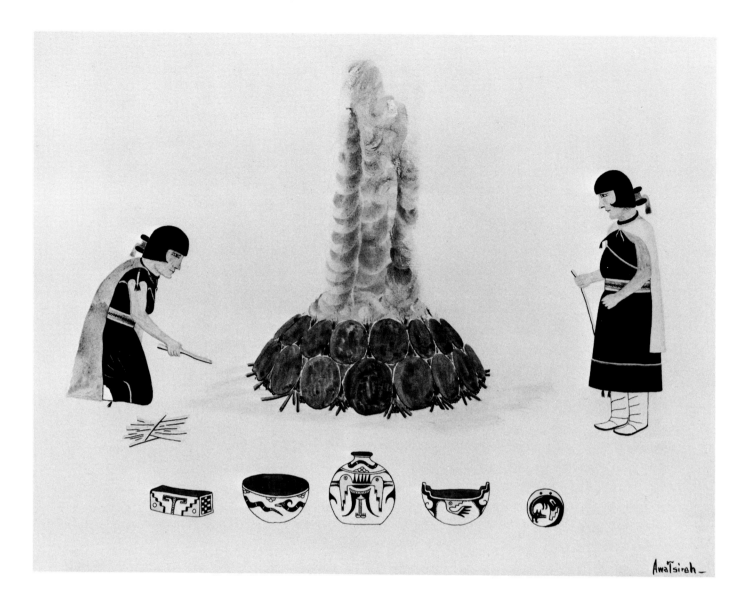

Fig. 5.4    Alfonso Roybal
(Awa Tsireh), San Ildefonso
Pueblo. Firing pottery.
Courtesy, The Amerind
Foundation, Inc.
—Ray Manley Photography

these characteristic dance groups even here, as four koshares are withdrawn to the extreme right. Here, as so often elsewhere, is portrayed the characteristic Awa Tsireh eye, a heavy circle with a crescent line above and below. Here, too, is seen the typical face portrayed by this artist, a face which has little of the "Indian" in it. The upper part is long and prominent, particularly in the nose, with the eye set far forward. A receding line is characteristic of the lower face, with a relatively thin and straight mouth line.

In some paintings of koshares climbing poles, known to be of earlier date (1917–1918), Awa Tsireh was guided primarily by alternate symmetry in the arrangement of these clown figures. This surely was a dominant trait in many of the early dance figure groups.

90

In one of these groups, a koshare is on hands and knees at the base of the pole, serving as a step for the last fellow going up the pole. Above the latter is a second climber also on the right side of the pole. Opposite these two, and at alternate positions, are two additional koshares. Here is a vertical version of the alternate and horizontal symmetry seen in the Corn Dance by the same artist as described above.

Most of the early ceremonial scenes or dance groups by Awa Tsireh do not express the depth and richness of coloring found in the work of Crescencio Martínez. The same is true of the scenes from everyday life painted by the former. One of these, dated 1917 or 1918, shows two women firing pottery. The scene is depicted with fidelity of detail, even to the designs painted on the vessels. A suggestion of balance lingers even in this instance: the two women face each other across a group of colorfully painted vessels which are scattered about on nothing. One woman sits on a rug, the other on a low stool, but neither of these objects has any fragment of substance upon which to rest. Like practically all of these early paintings, no ground line, not even the slightest patch of earth, appears beneath or around the figures. A variation on the firing pottery theme shows a slightly different arrangement of figures and pots (Fig. 5.4).

A 1922 publication reproduced an Awa Tsireh painting that reveals further traits of this artist. Labeled *Woman's Wheel Dance*,[15] the painting shows a tight and orderly cluster of women led by a drummer in front of them. Formalism and the flatness of Indian painting are obvious. Cahill says of this work that it "shows a remarkable manipulation of the blacks of the heads against the gorgeous close knit orchestration of color in the costumes."[16] This play of color is stressed by Cahill in reference to another Awa Tsireh painting, *Green Corn Ceremony*, reproduced in the same publication: "the yellow bodies strike in warm relief against the black skirts and hair"[17] of the dancers.

Like Crescencio Martínez, Awa Tsireh often portrayed very tiny hands on the men and women he painted (Fig. 5.5). In some instances, too, the lower arm is proportionately shorter. It could be that the older artist influenced his nephew quite directly in the latter's earliest efforts. It could be, too, that the nephew, like his uncle, was experienced in decorating clay vessels, for surely, as he depicts them in these paintings, the jars could not be more realistic in form, proportion, and design.

Before leaving the more realistic style of Awa Tsireh, it is of interest to quote the comments made by Hewett about one of his mural paintings as "a perfect composition of fifty-seven figures in unerring balance and rhythm and color sense; the place and poise

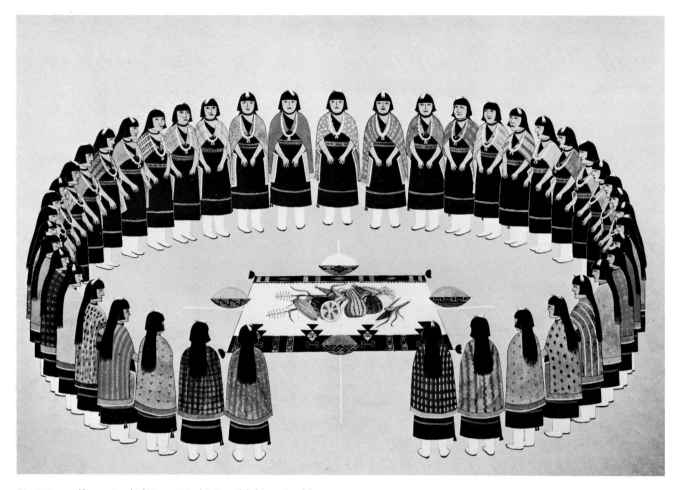

Fig. 5.5    *Alfonso Roybal (Awa Tsireh), San Ildefonso Pueblo.*
Harvest Dance. *Courtesy, The Denver Art Museum.*
—Neil Koppes

Fig. 5.6    *Alfonso Roybal (Awa Tsireh), San Ildefonso Pueblo.*
Two Rams. *Courtesy, The Denver Art Museum.*
—Neil Koppes

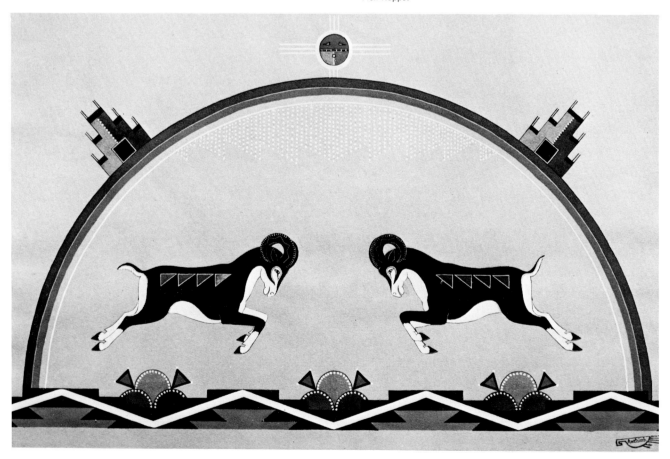

and purpose of every figure obvious; the whole an expression of a disciplined, harmonious mind...."[18]

The second Awa Tsireh style, realistic accompanied by conventional symbols, presents many variations between two extremes—one in which symbolic design is subordinate to the realistic (Fig. 5.6), and a second in which the abstract patterns dominate over the realistic themes. An example illustrating a fair balance between these two extremes is a drawing of two mountain sheep completely surrounded by a rainbow, clouds, and other symbolic patterning. The two animals are realistically drawn, even though both have geometric patterning on their sides. Absolute symmetry pervades the symbolic design which includes a variety of themes: a beautifully drawn rainbow-like pattern with a scalloped underband; clouds to left and right of center, along the top of the rainbow, symmetrical in form but slightly different in color; a round sun's disc directly overhead and centered. This balanced symmetry is further carried out in clouds at the lower, inner corners of the rainbow, each pierced by a series of four large triangles built one on top of the other. Color is more vivid in paintings of this type than in the realistic portrayals. The rainbow is red, green, and yellow; the sun has an upper green half, a blue and red lower half. Throughout there are sharp, clear-cut, contrasting colors. Although this example of Awa Tsireh painting is two dimensional, he did combine in a few pictures of this style flat painting in abstract or conventional themes and modeling in realistic subjects. Never did he become proficient in modeling in color.

The resemblance between this second style and certain recorded kiva murals is striking, particularly in the treatment of conventional detail (see Fig. 3.5). Some of the Jémez kiva murals described by Simpson in 1849,[19] and discussed in Chapter Three, are startlingly similar. Figure 5.7 shows another version of this favored theme.

More subtle in color usage and design is another decorative painting in which the realistic theme is predominant. Here a Comanche dance group is portrayed, with the standard bearer to front and left, followed by a woman dancer in the center and a drummer bringing up the rear. One sees how strong tradition is in this painting, for although there is a red band across the entire lower section of the picture, the feet of none of the dancers touch it. Realistic and symbolic elements complement each the other, but they do not serve otherwise than to decorate the whole picture. Graceful triangles with extended, curved ends are placed in the upper corners. A central sun, diminished in size but intense in colors, has emanating from it great white sickle-shaped designs with long "rain" pendent

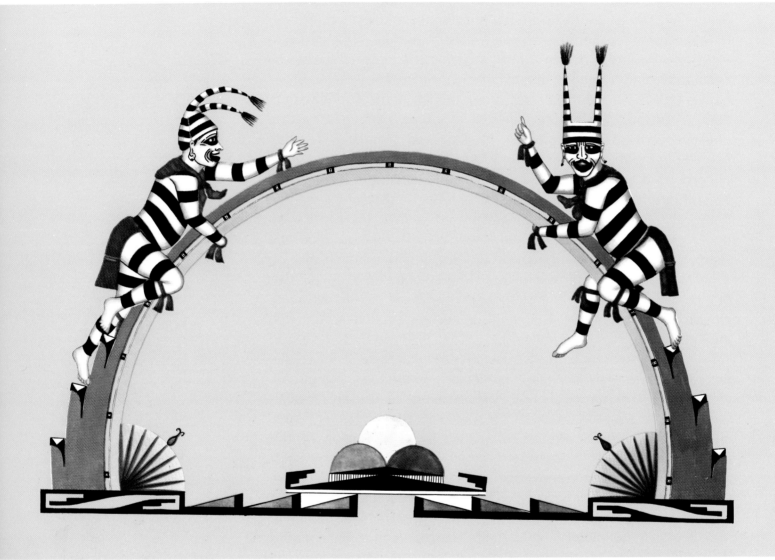

from the bottoms. These extend to right and left, the whole curving gracefully to meet conventional pillars or columns which rest on the lower red band. The subtlety of the whole painting is enhanced by the use of gray-green paper against which the colors of the figures and designs stand out in sharp contrast.

A rather unusual treatment in this style is illustrated in a decorative painting in the Indian Arts Fund collection of the School of American Research in Santa Fe (Fig. 5.8). Here a row of four highly conventional figures of Shalako dancers serves as a background against which are pictured five pueblo women, each with a meal basket. Treated in slightly more realistic fashion than the Shalako, the figures of the women are stiff; they are identical in their semi-profile positions, even to the arrangement of garments, position of hands and feet, and so on. Absolute duplication is avoided, however, in the varied colors of the shawls and in some alternation of basketry color and decoration. This is not true of the Shalako figures where duplication is found in color and form alike. Flanking the Shalako are two clowns, each sitting like a veritable jester upon a "throne"! The "thrones" are stepped arrangements with high backs, decorated

*Fig. 5.8    Alfonso Roybal (Awa Tsireh), San Ildefonso Pueblo. Decorative painting. Courtesy, The School of American Research, Santa Fe.*

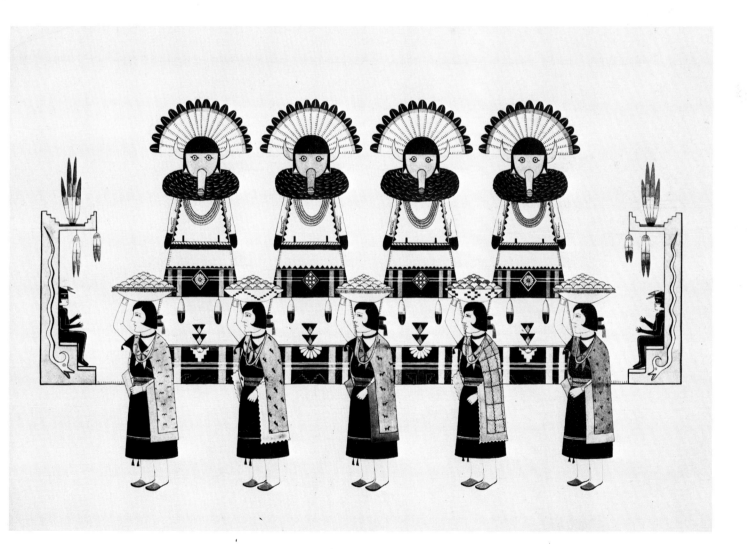

with horned serpents down the sides and with elaborate feather ornaments at the top. Withal, this is a highly decorative, colorful, and well-executed piece of work. Again it may be noted that this painting is very similar to some of the early kiva murals illustrated by Simpson[20] (see Fig. 3.5).

The most vivid color used by Awa Tsireh is found in the third style he developed, the abstract style in which his creative imagination frequently played with esoteric subjects and unusual or even composite monsters. In one of these creations, a great red-crested bird clings in an odd position to a perpendicular branch of a tree (Fig. 5.9). No new design elements are employed in this picture, but surely the "putting together" of them is new and weird, and the resulting bird is one which was never seen in real life. The whole view is in profile, with an outspread wing virtually sprouting from the back of the neck. The tail fans out in five long, black feathers. Actually the latter are nothing more than the elongate triangles so often seen in San Ildefonso pottery decoration. So, too, are all of the other elements that are carefully combined in the bird's body, head, and wings, all worked out in pleasant and contrasting areas of red, yellow, black, dark green, and white. The handling of color in this style is far superior to the first pictures described, for none of the color is smudged. Combined with greater brilliance of color, this would surely lead to the conclusion that here is a much later treatment by this artist, even though there are no actual dates on the pictures.

In summary of his work, it should be noted first that Awa Tsireh exerted a profound influence in the further development of

*Fig. 5.9    Alfonso Roybal (Awa Tsireh), San Ildefonso Pueblo. Bird. Courtesy, The School of American Research, Santa Fe.*
—Laura Gilpin

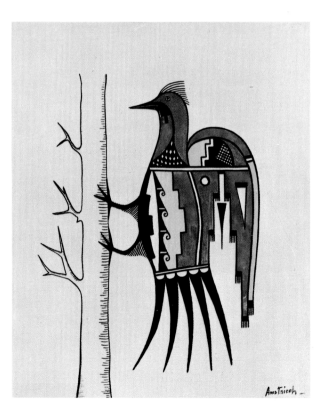

the art of San Ildefonso and of the Rio Grande Valley. From the standpoint of time development, he showed a preference for dance and genre subjects in his earlier works. Later, highly stylized treatment and esoteric themes appealed to him. Still later, he combined the wealth of all his experience to produce quite a variety of subjects, either strictly realistic or highly conventional, or combinations of these styles.

For the most part, there is no background in the works of Awa Tsireh. Even where terraced clouds or rainbows are used, they serve more as flat props than as true backgrounds. Perhaps it is the continued play of design, age-old among these puebloans, which this artist, as well as many another, is unable to throw off completely. Emphasis on *design,* primarily, would serve to eliminate the use of such features as true background.

Color variation is amazing in the works of Awa Tsireh. Starting out with the range and limitation of a schoolchild's box of watercolors, eventually he included most intense shades of a tremendous variety of colors. Some of it was Higgins ink; certainly this was an unusual effort on the part of this artist,[21] but one which probably appealed to him since it enhanced his clean-cut precise line work. Thus flat color was his forte throughout; the rare exceptions where he may have been attempting a little modeling in variation of color intensity seem to have discouraged him very much. And, although Awa Tsireh was capable of presenting a true composition, he did his best work in paintings which are more design than composition. Some of the dance and genre scenes from his village do display elements of planned groupings. More often, however, two or more dancers in a line, a broken series of alternating figures which seem to beat out the time of the dance itself in their positions—these and other paintings are essentially on the design side. This same tendency has continued to prevail in Rio Grande painting, even among some younger artists of the early 1970s who have had formal training.

Subject matter is as varied in the works of Awa Tsireh as was his rich tribal experience. Corn Dancers or koshares; a Matachini Dance with a Mexican woman standing by as a spectator; basket dances with separate rows of men and kneeling women; war dance groups, often with more action than is usual with this artist; subjects of unusual character such as the Tanoan peace ceremony; a rain cloud procession; and the many esoteric drawings—this range in subject was another of Awa Tsireh's contributions.

Exquisite outlines combine with fine detail to give delicacy to Roybal's drawings. Detail is expressed in many ways, in the slit of trousers and other features of costumes, in pottery and basketry designs, in graduated white shell beads worn by women dancers,

97

in braided sashes with balls and fringed ends, in the fruit (even tiny grapes!) at the top of the pole so eagerly sought by the koshares. Action is rather sustained for the most part, but in occasional and apparently in later works a koshare is running, or a ram is chasing a koshare. Often the men dancers may have the heel of one foot just slightly lifted, or perhaps one leg raised at the knee. Women dancers' feet are motionless, or at best just slightly apart. Sometimes the hands of dancers are in slight motion. In many cases figures would be practically motionless if it were not for the flow of line and color and rhythmic repetition of detail. And, in spite of a lack of actual movement in figures, much of the work of Awa Tsireh has an alert vitality.

Awa Tsireh was early recognized beyond his native world as an outstanding Indian artist. His watercolors were sent by Alice Corbin Henderson to the Arts Club of Chicago for a special exhibit in 1920.[22] His paintings appeared in early exhibits in Santa Fe, and he was among the several artists to receive prizes at the first Southwest Indian Fair in the same town.[23] In 1925, the Chicago papers were generous in their acclaim for his exhibit in the Newberry Library.[24] The Exposition of Indian Tribal Arts, New York, in 1931, included Awa Tsireh paintings, and his work appeared in many subsequent shows. Today he is represented in many private and public collections. Awa Tsireh died early in 1955 when he was about sixty years of age.

In 1890, María Montoya of San Ildefonso was visiting Spanish-American friends with her own family in Chimayo, in northern New Mexico. There María saw and admired a painted chest which the father of the Spanish woman had made years before. When María married Julián Martínez in 1904, the chest was given to her as a wedding present. She relates that when Julián first saw the chest he knelt beside it and looked at it carefully. "It is beautiful," he said. "All those flowers and designs. I'd like to paint things like that."[25]

The spark of an artist was very much within Julián Martínez (Po-Ca-No), who was born in 1879 at San Ildefonso. For many years it found an outlet in painting pottery made by his famous wife, María. Encouraged by white men, Julián joined others in painting pictures before 1920. He was doing a large amount of watercolor art at the time of his death in 1943.[26] Although Julián attempted realistic subject matter, certainly his best work is in the mythical birds and other esoteric creatures which he did with great aplomb.

In the naturalistic field, Julián Martínez made no particular contribution to either San Ildefonso or Rio Grande art. He stuck rather rigidly to typical conventional pueblo depictions, such as the Snow Bird Dance, or a pueblo woman, or a koshare figure. The draw-

ing in these is not too good, yet outlines are often perfectly done, perhaps reflecting the beautiful line work of the skilled pottery decorator that Julián was. Color was handled in the usual pueblo manner; for example, a row of three Buffalo Hunt dancers is done in two-dimensional, flat style. Julián's touches are to be noted more in a certain lilt in both feet and in the more projecting features of the facial profile, and in deer dancers' figures, "in forward bending attitude, usually with one foot swinging out backwards."[27] Too, there is the simple detail and rhythmic repetition of other early works.

On the other hand, no one in the Rio Grande excelled Julián in the creation of imaginative birds, animals, and other creatures. One of these paintings shows a plumed serpent and an antelope. The snake figure fills the greater part of the space in dynamic manner. The tail is to the left and in the air, head to the right, up and turned back with its great tongue nearly touching the running antelope. Decoration on the serpent is rather simple, and is conventional and geometric except for the sinuous body; here are found the same motifs which Julián used in ceramic decoration. The antelope is far more realistically treated, and rather ill-proportioned, as are many of the life figures painted by Julián Martínez. Even in coloring there is a great contrast between the realistic form and the imaginative one. The snake is a vivid green with sharply contrasting black marking; the antelope is an indistinct brownish-gray color.

A relationship between this snake-dominated drawing and similar themes on hide shields can be suggested (see Fig. 3.7). Even the inward-turning of the reptile at either end may be a concession to the round shape of the shield.

Two other glorious creations by Julián Martínez are in the collection of the Indian Arts Fund in Santa Fe. One is *Plumed Serpent* (Fig. 5.10), the other a mythical bird. On dark green paper, black, rust, yellow, and white are combined in the snake and in the conventional designs above and below the creature. Again, the serpent's body is simply but effectively decorated with stepped patterns, lines, and varied curvilinear elements. The peaked head, terminating in a triple fork, is turned back toward the center of the picture. Out of a vicious-appearing, saw-toothed mouth protrudes a tongue, the long end of which is pointed like an arrow. Certainly Julián Martínez drew heavily upon his ceramic experiences for many of the design elements used in painting (Fig. 5.11). Simple sophistication characterized his ceramic effort; brilliant and appealing elaboration typifies both the snake and the bird.

Occasionally Julián attempted to represent animal forms in less stylized fashion, but his success was no greater in this than in other efforts to depict life subjects. He had considerable trouble with

99

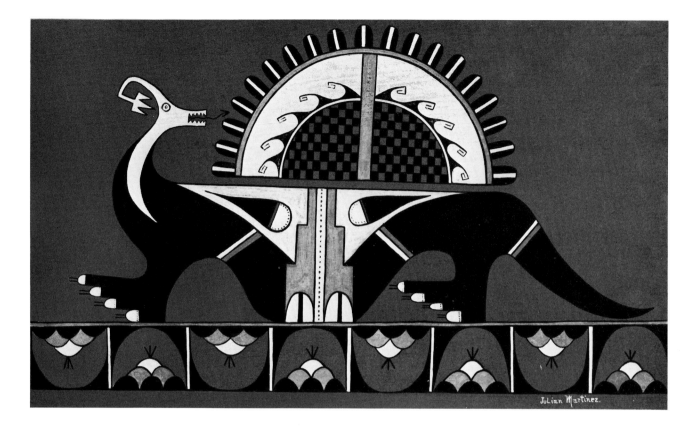

Fig. 5.10    Julián Martínez
(Po-Ca-No), San Ildefonso
Pueblo. Plumed Serpent.
Courtesy, The School of
American Research, Santa Fe.

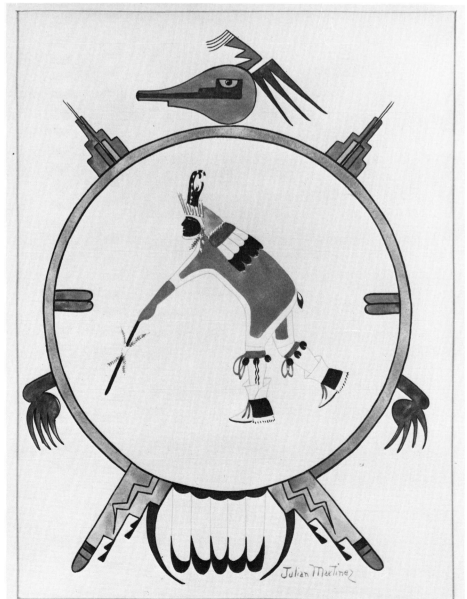

Fig. 5.11    Julián Martínez
(Po-Ca-No), San Ildefonso
Pueblo. Mythical bird and
Antelope Dancer. Courtesy,
Woodard's Indian Arts
Collection.
—George Hight Studios

proportions of horses, and no less with those of their riders. However, he did infuse great activity into some of the scenes in which he used such subject matter, despite his failings otherwise. Details are poorly represented in drawings of this type, also. It would seem that the brush, so well disciplined with many years of practice and experience in producing geometric lines, could not readily shift to free delineation. Despite their greater successes in watercolor art, none of Julián's contemporaries excelled him in ceramic decoration.

Julián Martínez exhibited widely, usually with other artists. His paintings were hung at Corona Mundi International Art Center, New York City, in 1927, at the Fair Park Gallery, Dallas, in 1928, and elsewhere.

Tony Martínez (Popovi Da or Popovi), the son of María and Julián, was popular, active, and a leader in his village, having several times been governor. He also established a gallery in San Ildefonso, thus furthering art in his village.

Painting in watercolor, Popovi Da treated a wide variety of subject matter, from native dances such as the Comanche and Mountain Sheep (Fig. 5.12) to miscellaneous topics such as deer, horses, skunks, and chickens. For the most part his drawings are poorly proportioned and lack the finish, the fine detail, and the inspiration of the works of his fellow tribesmen; they are, however, more clean-cut than the paintings by his father. There is much convention in his work. Like his father's work, though not to the same degree, his symbolic, geometric designs are better than his realistic life forms.

In the late 1950s and through the 1960s, Popovi Da did a little in the way of abstract painting, frequently reflecting his ceramic abilities in these efforts. Far more varied are his ceramic designs which he continued to apply to the pottery made by his mother, María Martínez; she was still doing some ceramics in early 1970. With her and his son, Tony Da, Popovi Da exhibited in Washington, D.C., in 1967, at the Department of the Interior Gallery;[28] the show was well received. In Popovi's paintings of realistic subjects, formality and a strong element of design are expressed. Popovi died quite suddenly in October, 1971.

Abel Sánchez, or Oqwa Pi (Red Cloud) as he also signed his pictures, was born about the turn of the century and painting not later than 1919. There is a work of his in the Indian Arts Fund collection, Santa Fe, thus dated. It is a Watermelon Dance group, with five figures in a straight line, no ground line, no background nor foreground. The figures are stiff, and there is little motion beyond that suggested in the slightly separated feet and the upraised right hand of each dancer with a gourd rattle in the position of action. Rhythmic repetition is suggested, however, in the fairly exact duplica-

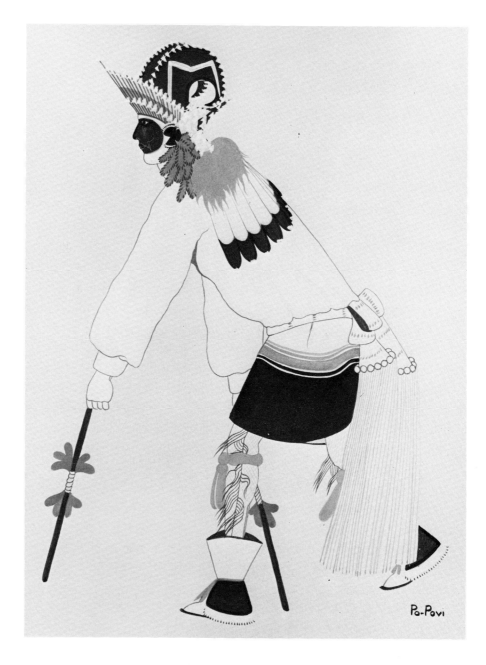

*Fig. 5.12    Tony Martínez
(Popovi Da), San Ildefonso
Pueblo.* Mountain Sheep
Dance. *Courtesy, Dr. and Mrs.
Byron C. Butler.*
—Neil Koppes

tion of details of costume. There is some delicacy in this drawing, particularly in the treatment of the green bough around the neck and in the left hand. Some proportions in the figures are rather poor; for example, heads are too large for the bodies and almost without a neck in between. The feet are encased in amusing, tiny, black-soled white moccasins. Arms, hands, and legs have the appearance of being too small.

Some of these difficulties Oqwa Pi overcame in later years; others remained a part of his "style." Large heads are quite characteristic. In some of his paintings, there is little or no difference between the head of a man and that of a woman. For instance, in

a painting of a pair of Corn Dancers, a man and a woman, if the costumes were blocked out it would be difficult if not impossible to tell which is which. There are some similarities between the heads of this painter and those done by Crescencio Martínez: there is a fairly large nose, the upper face juts out beyond the lower. The jaws in the Oqwa Pi faces are somewhat stronger.

From the beginning Oqwa Pi attempted some modeling in his painting. In a 1919 piece, there is attempted modeling in the flesh. In later examples there is considerable modeling in fabrics as well as flesh, in buckskin garments, cotton shirts, and wool blanket dresses. Adding to the effect of modeling in color, Oqwa Pi created an uneven skirt or kilt line, thus making his work more realistic. In a Corn Dancer pair, the sash ends of the man's costume do not hang straight as they so often do in the works of other early artists. This small touch, this lilt in the sash, also gives the effect of motion. In both of these Oqwa Pi paintings, the 1919 painting and the Corn Dancer pair, there is no ground line of any description; this is true of a great deal of his work.

Many of the paintings by Oqwa Pi are in the realistic-plus-abstract style. One example (Fig. 5.13) depicts three rainbows which both support and enclose life figures; those on top of the rainbows are more realistic while the enclosed forms are highly conventionalized. In another similar painting by Oqwa Pi the three rainbows serve as a stand for three figures, and the central and larger arch frames a fourth figure beneath it. Following the form of the central rainbow is the outstretched figure of an Antelope Dancer in full profile and facing to the right. To the left and facing the latter is the hunter, partially kneeling on one of the smaller arches. To the right is Buffalo Mother, standing at full height with her back to the viewer. A Deer Dancer performs directly beneath the central arch and the Antelope Dancer. This Deer Dancer is the only one that gives any semblance of motion. A goodly amount of varied color further enhances the qualities of this painting.

One of the finest pieces of work done by Oqwa Pi is a three-quarter view of a charging buffalo. Coming ''full tilt,'' the head is lowered, nostrils dilated, the tail flying. Although the animal is not perfectly proportioned, there is good detail in short, black horns, great cloven hoofs, the coarse curly hair of the head, and the thick hair of the shoulders. There is great simplicity in the drawing, with a heavy black outline for all but the deep hair regions. Despite the total absence of any ground, the single figure makes for a pleasing and satisfying painting.

Although he had little formal training—a few classes at the Indian School, Santa Fe—Oqwa Pi is important in the history of

painting in the Rio Grande Valley. He preserved and carried on many of the trends that might be thought of as "native," inasmuch as they were developed by Indians without any instruction. He added to this basic work through experimentation with figure arrangement and by bringing in a great deal more action than appeared in the works of the earliest artists. Most of his painting, particularly in earlier years, is flat, although some modeling occurs. He perpetuated the stiff rows of dancers, and his perspective is often poor, but he also attempted arrangements of more striking nature, some of them resulting in pleasing compositions. Details are not as exquisite as in the works of some others, but he faithfully depicted native costume and custom, particularly in the dance figures and groups. He expressed considerable originality in the use of symbolic and legendary figures in his painting. Conventionality and simplicity may be stressed as characteristic of his painting. Occasionally he combined these qualities in pleasing compositions, such as *Harvest Dancers* (Fig. 5.14).

Oqwa Pi's later life was spent in his native pueblo after some years away. He was a farmer, but spent part of his time painting, earning enough from his art to support a large family. At one time he was lieutenant governor of his village. He had exhibits in many places, including the Milwaukee Art Institute, Yale University, Museum of Modern Art in New York City, Stanford University, and the Gallery of Fine Arts in Muskegon, Michigan. The fresh color and

*Fig. 5.13    Abel Sánchez (Oqwa Pi), San Ildefonso Pueblo. Decorative painting. Courtesy, The School of American Research, Santa Fe.*

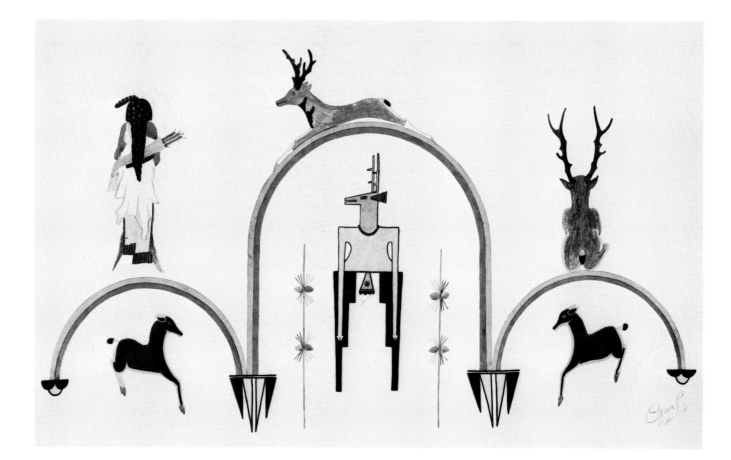

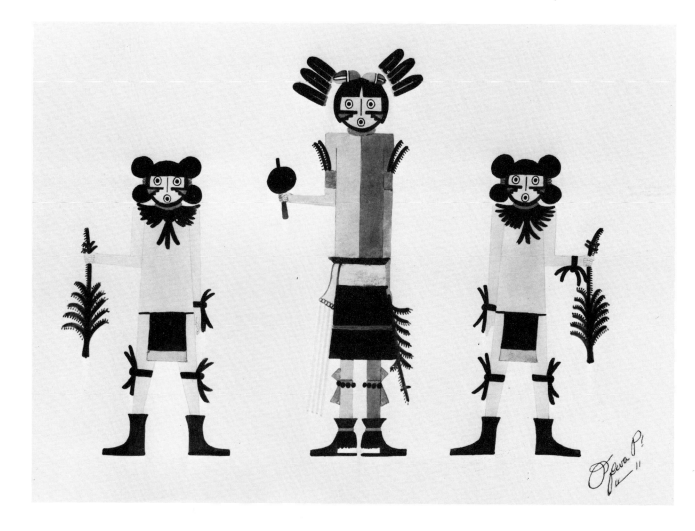

action and the great simplicity of his paintings made the works of Oqwa Pi well received in all these exhibits. He painted less and less toward the end of the 1960–70 decade, perhaps in part because he became more and more active in his village. Abel Sánchez died in March, 1971.

Fig. 5.14   Abel Sánchez (Oqwa Pi), San Ildefonso Pueblo. Harvest Dancers. Courtesy, James T. Bialac. —Neil Koppes

Another San Ildefonso Indian who carried on his pueblo tradition in painting was Romando Vigil (Tse-Ye-Mu), who was born in 1902. His chief interest was in native dance figures. His treatment was basically stylized, but he demonstrated more than once that he was capable of breaking away from his traditional style, as noted in a highly conventionalized bird (Fig. 5.15). Often his work is very neatly executed; characteristically there are no background or foreground lines. His coloring is usually very good, though seldom rich. He attempted some portraits, but they tend to be of generalized types rather than of specific individuals.

In some of his earlier paintings, as in one of a Basket Dance, Tse-Ye-Mu reflected the trends of his time. For example, a row of

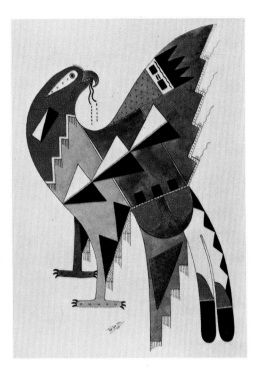

dancers will be placed woodenly and identically in a line, varying only in small patches of color. Arms, legs, body, head, eye—all will be duplicated in size, shape, position. The head is too large, the face non-Indian. Sometimes he gives these stiff figures more life, disarranging the formal line, lifting a foot in a dance step, moving an arm to shake a rattle—but the large un-Indian heads, the flat coloring, the two-dimensional drawing are still there.

One of the most interesting of Tse-Ye-Mu's paintings is *San Ildefonso Woman's Dance* (Fig. 5.16), an oil on a large canvas, 8 feet 5 inches wide by 5 feet 5 inches high. Three rows of dancers are depicted in a tight formation as seen from a rooftop. Six dance figures are in the two back rows, five in the front row, with a drummer leading the group. All of the dancers are women, and all have their arms extended in front of them. Great monotony is avoided in the variation in color of the shoulder shawls and dresses that the women wear. The colors used by the artist are not too brilliant, but they are bright and stand out effectively against the soft tan of his canvas. Detail is well executed, in spite of the large size of the painting. Oil was seldom used by Southwest Indian artists in these earlier years; yet when it was, some painters displayed an amazing ability in handling the medium whether in large or small areas.

In still another painting by this artist, many of his traditional methods disappear and an interesting composition results. One theme is a San Ildefonso Scalp Dance. Highly stylized, conventional clouds with dripping rain and a rainbow decorate the upper portions of the painting. A pole, with several scalps attached, is drawn off-center, and about it are grouped nine warriors. These figures are scattered in such a fashion as to avoid even the slightest suggestion of symmetry. They face in various directions; likewise, each man has different weapons, some holding them in different positions. Further, costumes and body paint differ in each case. All of these things contribute to a dynamic, active, rhythmic portrayal.

In contrast to the above groups of figures, Tse-Ye-Mu also painted individual dancers. One such is merely labeled *Pueblo Dancer*. It is a centered, full-front figure, and, except for one raised arm, it is symmetrically balanced to right and left. In some figures there is complete balance and conventionalization, as in Figure 5.17. This symmetry and balance are also true of individual figures in some group arrangements. For example, in *Antelope Dancers*, in which there are five repetitive figures in a row, each is perfectly balanced except that one arm of each dancer is raised across the body and all feet are turned in the same direction. Faces and hands are very non-puebloan, the former a cut-off oval with circles for eyes and

mouth, and hands more like a cogwheel than a human feature. There is a very modern feeling to this painting, despite the flat color and the lack of back- or foreground. Quite a contrast to this balance appears in a painting in which miscellaneous game animals scattered over the paper move toward a hunter at the far right (Fig. 5.18).

Tse-Ye-Mu used oil paints when he helped produce the mural decorations for the 1933 Exposition of Indian Tribal Arts at the Corcoran Gallery, Washington, D.C. These large paintings, from 8 feet by 10 feet to 8 by 16 feet, represent a composite effort, with several other Indian artists participating, including Oqwa Pi and Ma-Pe-Wi. Tse-Ye-Mu exhibited in several prominent galleries, including the Museum of New Mexico, the Fair Park Gallery, Dallas, and Corona Mundi International Art Center, New York City. He is represented in numerous private and public collections, including the Riverside Museum, New York City.

Withal, Tse-Ye-Mu's work reflects simplicity and dignity of line and mass; thus his painting becomes effective for murals. He continued to paint in the traditional pueblo manner even though he left his native village to live in California. Still living in Los Angeles at the end of the 1960s, he was doing little painting.

In the 1940s, one of the youngest of the San Ildefonso painters was Gilbert Atencio (Wah Peen), nephew of María Martínez. In his youth he had two years of art in the Santa Fe Indian School. By the

*Fig. 5.16   Romando Vigil (Tse-Ye-Mu), San Ildefonso Pueblo. San Ildefonso Woman's Dance. Courtesy, Mr. and Mrs. C.T.R. Bates.*
—Ray Manley Photography

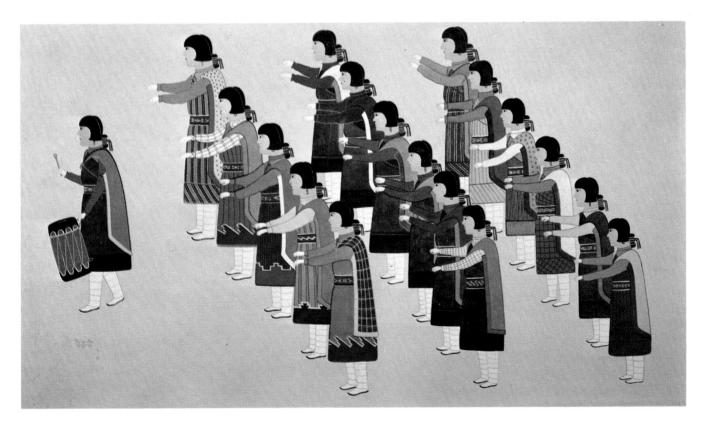

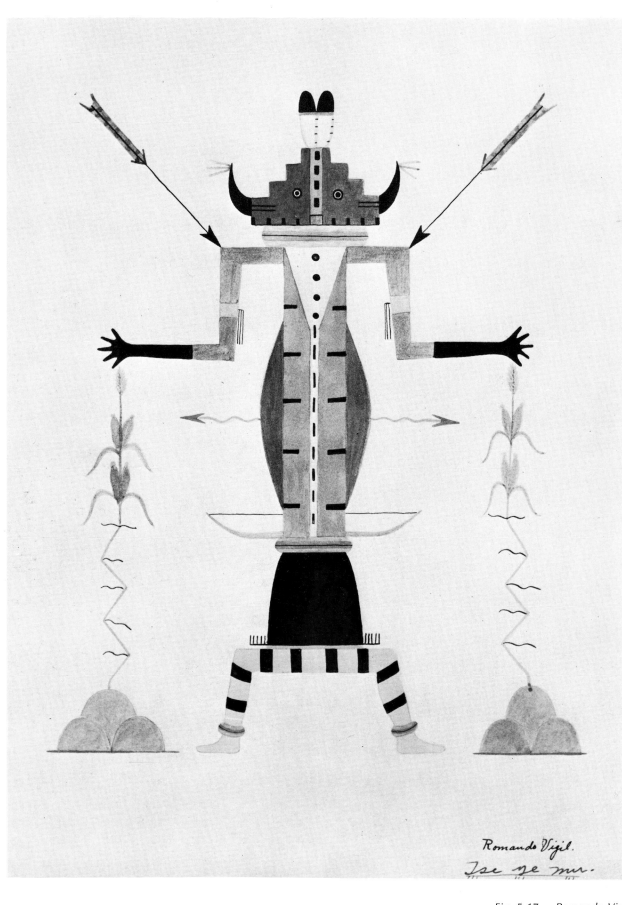

Fig. 5.17    Romando Vigil
(Tse-Ye-Mu), San Ildefonso
Pueblo. A conventionalized
dance figure. Courtesy,
Woodard's Indian Arts
Collection.
—George Hight Studios

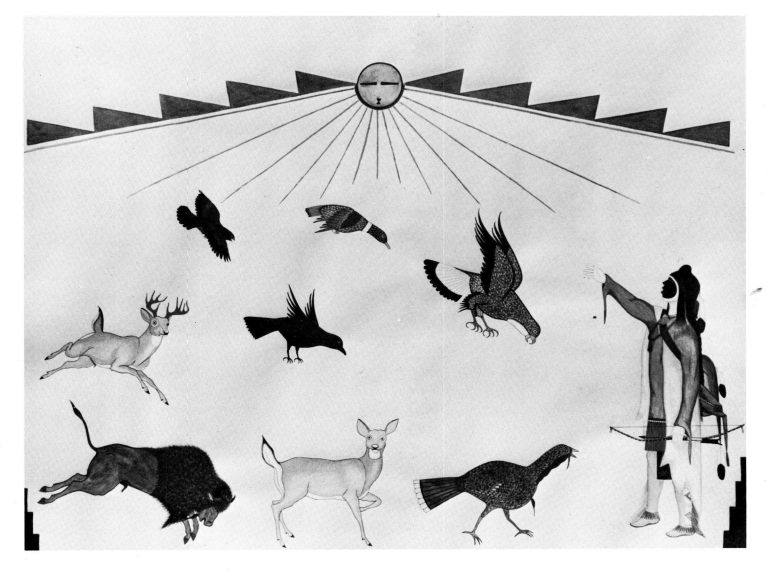

*Fig. 5.18    Romando Vigil
(Tse-Ye-Mu), San Ildefonso
Pueblo.* Legend of the Game.

109

time he was twenty he had exhibited at the Santa Fe Museum, in Gallup and Albuquerque, and at the Philbrook Art Center in Oklahoma. He had been awarded six first prizes, six second prizes, and five third prizes by 1949.

During his youth, Atencio carried on largely in the traditional manner of San Ildefonso painting. Dance figures were his favorite theme, and quite generally they are drawn without any ground lines (Fig. 5.19). Often he resorted to colored paper, choosing blue, pale yellow, light tan, or off-white. Sometimes he used colors which are so intense that they look as though they came directly from the paint tubes; again, they are delicate in value, indicating some use of Chinese white. His drawing is consistently neat, outlines tend to be fine, and often there is much delicate modeling and shading. Flat color work was done, too, and detail tended to be good; later it became superb. Many of these qualities were advantageous in some of his work. For example, one of the most interesting pieces done when this artist was young is a portrait study of María and Julián Martínez. Until the late 1960s, portraits were rare in Southwest Indian art and good likenesses practically nonexistent. This one is very good, for the two people are recognized immediately by anyone acquainted with them. Julián stands on the left, showing his wife a tall-necked jar. María is seated on something which rests on thin air, for again there are no ground lines. Costume is well delineated; for example, Julián's long hair wrapped in green ribbons, his embroidered shirt, trousers with bead work down the sides, and silver loop earrings. María's costume is likewise represented with great accuracy, from her hair bobbed in front to her woven, dark, blanket dress, silver "butterflies" (large brooches) on her skirt, and articles of personal adornment. In fact, meticulous care is shown in treating all details of costume and jewelry, and there is a fair amount of modeling in color in the facial features.

In one of Gilbert Atencio's paintings done in the early 1950s there is much unusual detail. This depicts a woman's dance, and the setting is the pueblo plaza with portions of the village painted in the background. Doors and windows are represented, with flowered curtains and potted plants in the latter. Various individuals are sitting or standing around. Perspective is suggested by simply diminishing the size of distant figures. The dance group is made up

*Fig. 5.19    Gilbert Atencio (Wah Peen), San Ildefonso Pueblo. Agapito. Courtesy, Mrs. Thomas E. Curtin.*

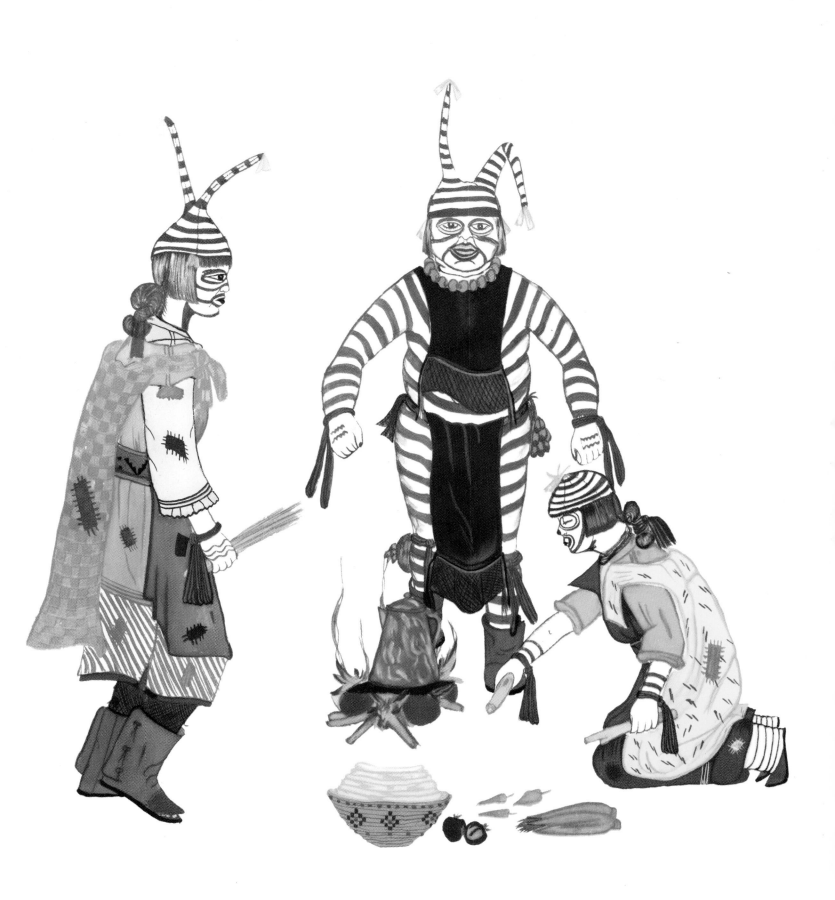

Gilbert Atencio
'46

of a cluster of women, with a drummer and several girls; two of the figures have baskets on their heads and in the baskets are vegetables, canned foods, and so on. So carefully is the detail accomplished that carnations are painted on the individual cans of milk! The same care is taken with other minutiae. Monotony is relieved by variations in shawls, native and cotton print dresses, and in the position of hands and bodies in the dance movements.

In the early development of Southwest painting, an artist would rarely attempt a still life, and when he did it was more often a combination of still life and a life form. Later this latter trend gained some momentum, not particularly to the credit of the Indian artists. Once in a while such pieces are touched with a bit of humor. Such is the skunk and still life done by Gilbert Atencio. A conventional sun ornaments the center top of the picture. To the left is an appealing little skunk with bushy tail in a great S-curve, his head lowered. Before him, scattered about in space, are a melon, a squash, and some corn. To balance the high-flown tail, there is a large San Ildefonso jar on the far right. The design on the vessel is well executed.

In connection with an early exhibit of paintings, one writer commented that "Gilbert Atencio's work is vivid in color, but each color patch is held within the over-all design and becomes an integral part of the whole. He has utilized contemporary subject matter, and he has intensified his papers through this approach."[29]

Through the 1950s, Atencio tended to paint in the traditional manner of his native pueblo, San Ildefonso—single or multiple figures (Fig. 5.20) done in flat tempera or watercolors, without background, and with his usual exquisite detail. This style contined into the 1960s, even into the 1970s. However, along the way Atencio added other details—in some instances, a ground line with bits of growth or other conventional foreground. Secondly, he added abstract background, either a little of it or a complete coverage of the paper. An example of the latter is *Mother and Child* (Fig. 5.21), with the woman, her child, and the dog all silhouetted against a complete background of soft-toned, abstract, angular cloud and rainbow symbols, rounded earth areas with corn and other plants painted flatly against them, and several round clouds. The dog is drawn in semi-abstract manner, the woman and child are semi-realistic; coarse-textured paper adds to the allover pleasing effect.

Another abstract painting by Atencio, *Spring Fertility Maiden,* presents a centered and almost perfectly balanced, elongated figure of the dancer with traditional coloring in her dress and headpiece. The entire background is done in turquoise, blue, yellow, peach, a medium green, and tan, with black and white edgings to the abstract

elements. Another of his paintings in this style features a comparable background against which are depicted two potters in dress of traditional style and color (Fig. 5.22).

Atencio is one pueblo artist who has lived up to the prediction that the abstract or semi-abstract is a natural potential for the painting efforts of the Southwest Indian artist. Inasmuch as a number of·these artists are moving in this direction, a summary of the trends in Atencio's paintings is pertinent. A dozen paintings in a private collection well illustrate how he developed into the abstract style. Herein are demonstrated the transition from a single or several figures on blank paper, to the same type of dancer or dancers with one or several simpler or more elaborate conventional themes above and/or below (Fig. 5.23), to a complete background of conventional or abstract nature against which appear more or less realistic life subjects (Fig. 5.24). Throughout the years, Atencio has featured the use of water-based media. His subject matter has centered about the ceremonial and secular life of his village, with little in the former category escaping his brush.

When he was only fourteen years old, it was said of Atencio's *Corn Dance* and *Wedding,* in the Annual Indian School Exhibit in Santa Fe, that they were perhaps the two most outstanding paintings

*Fig. 5.20    Gilbert Atencio (Wah Peen), San Ildefonso Pueblo.* Basket Dance. *Courtesy, Mr. and Mrs. Read Mullan.*
—Arizona Photographic Associates

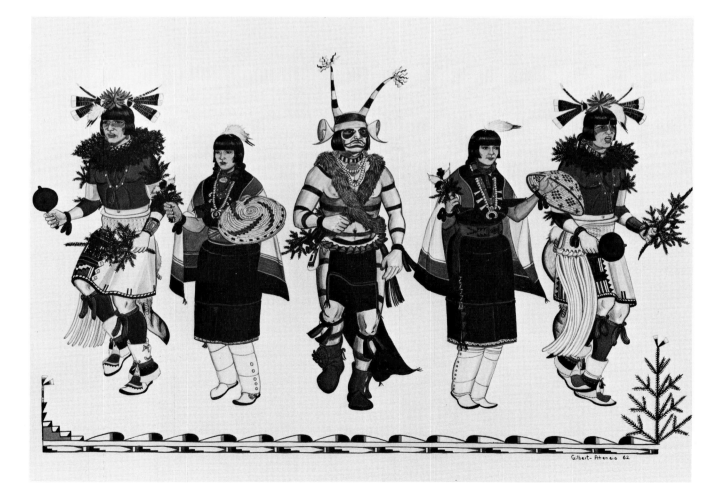

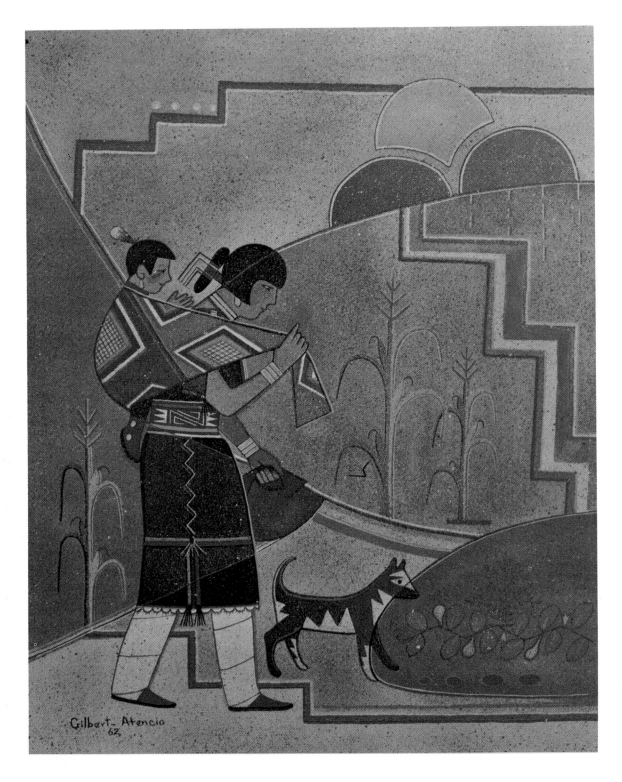

Fig. 5.21 *Gilbert Atencio (Wah Peen), San Ildefonso Pueblo. Mother and Child. Courtesy, James T. Bialac.*
—Helga Teiwes, Arizona State Museum

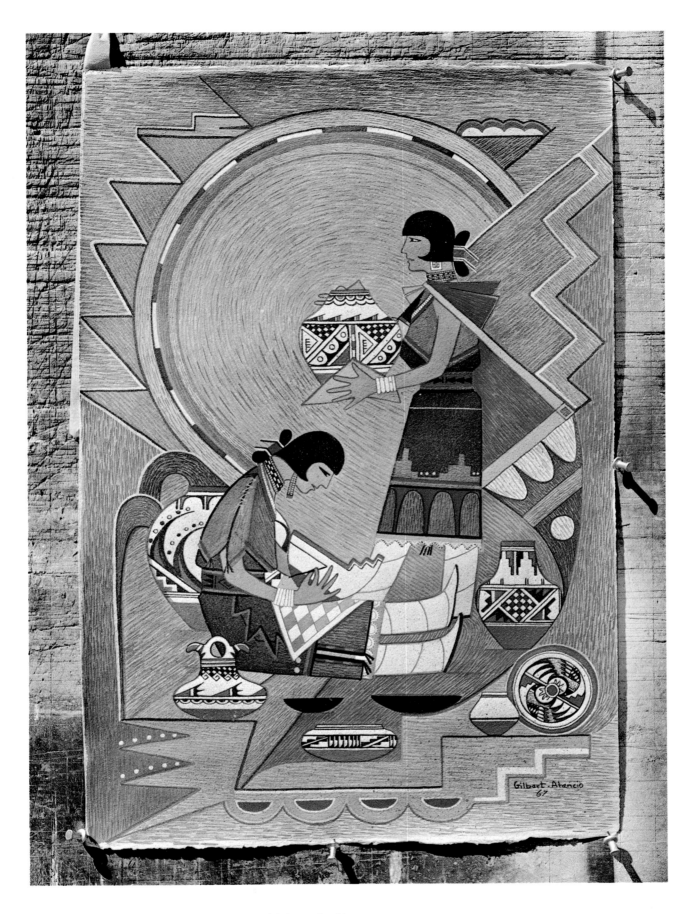

Fig. 5.22    Gilbert Atencio (Wah Peen), San Ildefonso Pueblo.
San Ildefonso Potters.    Courtesy, the Avery Collection.
—Howard's Studio

of the show. In the years following, he lived up to this promise, winning the grand prize at the Inter-Tribal Indian Ceremonial at Gallup in 1949 with a painting of koshares. Frequently, Atencio has deviated from the usual flat and stylistic portrayals of the pueblo painters, and often his paintings are more lively than dignified.

Through the 1950s and into the 1960s, Atencio increased the number of places where he exhibited and the prizes he won. Foremost among these were Philbrook, where he took the Grand Award in 1964; Scottsdale, where he won a special award in 1965 and firsts in 1962 and 1963; the Gallup show, which awarded him a first in 1965 and a second in 1967; and the Santa Fe Art Museum, Albuquerque State Fair, and others. He is well represented in permanent collections, including among others that of the Indian Bureau in Washington, D.C., and the De Young Museum, San Francisco. He had a one-man show at the Heard Museum in 1969.

Richard Martínez (Opa Mu Nu) was one of the early San Ildefonso painters; he was still painting in the 1950s but did less and

*Fig. 5.23    Gilbert Atencio (Wah Peen), San Ildefonso Pueblo. Eagle Dancers. Courtesy, Dr. and Mrs. Byron C. Butler.*
*—Neil Koppes*

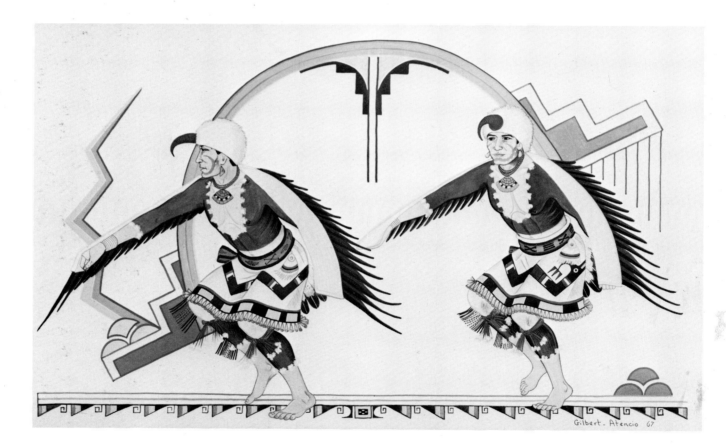

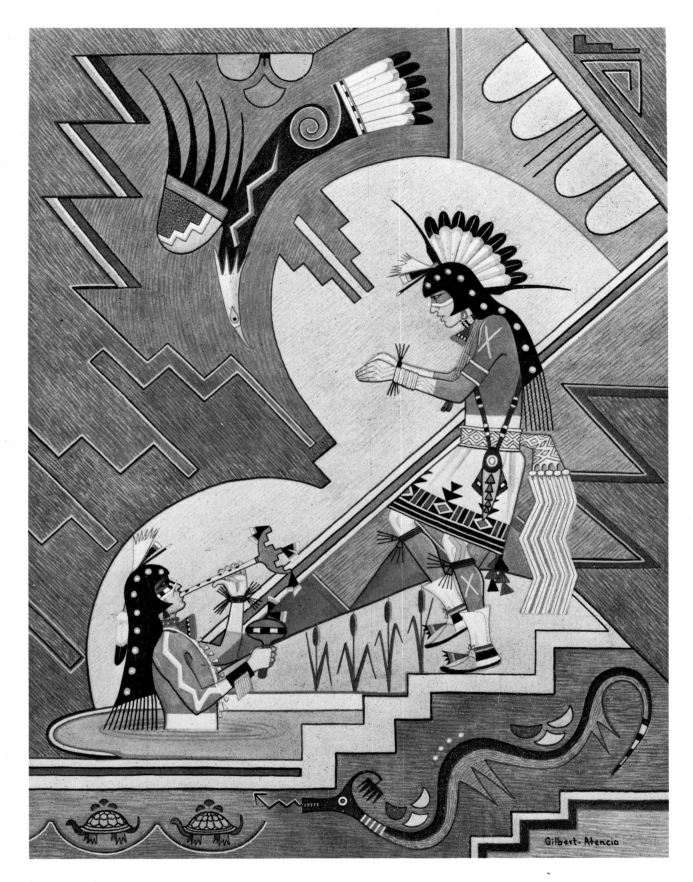

Fig. 5.24    *Gilbert Atencio (Wah Peen), San Ildefonso Pueblo.*
Flute Player Arising from Sacred Waters. *Courtesy, Mr. and*
*Mrs. Read Mullan.*
—Neil Koppes

less in the way of art production into the 1960s. From his first years of painting, he was versatile in subject matter, in approach to his problem, and in the use of color. He favored mythological and ceremonial subjects, and judging by the variety of each, Richard must have been well-versed in the lore of his people. Too, this artist was greatly influenced by Awa Tsireh and his three styles, painting in all of them.

Realism-plus-abstract themes appealed to Richard Martínez, for it gave him great freedom for his apparently vivid imagination. Painted in this style are three running antelope with most elaborate symbolic patterns above and simpler ones below. Among the upper designs are cloud crescents with pendent rain. His palette is more direct and primary in the symbolic themes, but less so, and also spotty, in naturalistic subjects.

He did not handle esoteric subject matter with the finesse of Julián or Miguel Martínez, but it was equally fantastic (Fig. 5.25). Another colorful subject, labeled *Avanyu* (Plumed Serpent), is coiled around in such a way as to give it a distinctly Hopi flavor. Detail

*Fig. 5.25 Richard Martínez (Opa Mu Nu), San Ildefonso Pueblo. Abstract. Courtesy, Dr. and Mrs. Byron C. Butler.*
—Neil Koppes

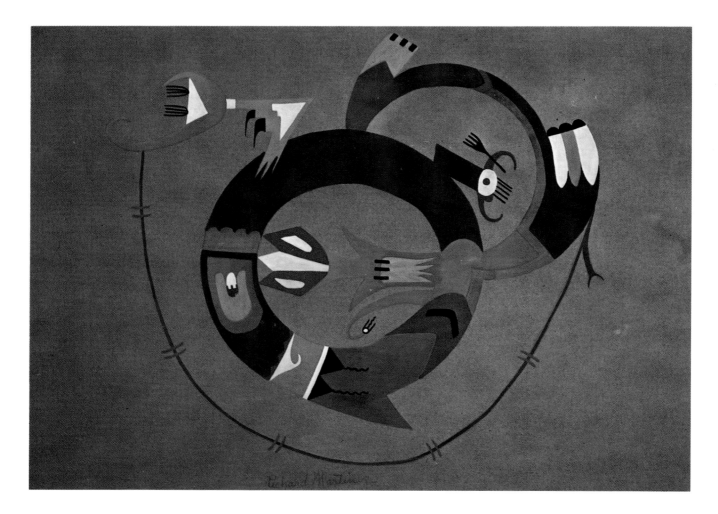

is neither exquisite nor refined. Color is varied, but heavy on the muted tones and not too pleasingly handled. Single or limited numbers of ceremonial dancers were painted by Richard Martínez, with the figures presented in the traditional groundless fashion and often with conventional themes, the latter usually at the top of the paper. Ceremonies and myths were still the subjects of his brush into the 1950s. In a conversation with the author, James Bialac said that, although still living at the beginning of the 1970s, Richard Martínez was no longer painting.

A little-known San Ildefonso artist is Encarnación Peña (Soqween). One of the early artists, he produced little through the years. Like so many others, he was greatly influenced by the more outstanding men of his village, particularly in delicacy of style in painting dancers (Fig. 5.26). He is represented by a Snake Dancer figure in the Laboratory of Anthropology collection. Typical of so much pueblo work, the figure dominates the otherwise blank paper. Also typically puebloid is the pose of the dancer, one foot slightly raised. His abstract bird and serpent motifs have a particular vigor. Soqween is well represented in the Denver Art Museum collection.[30] It is said that Soqween had revived his interest in art and was "painting like mad" in 1967.

Another of the early, but less well-known, artists is Luis Gonzales (Wo-Peen, which means Medicine Mountain), who was born in 1907. He belonged to the early group of artists now considered the San Ildefonso School. Like the others, he was untrained. He had exhibited quite widely before 1930, first at the University of California, thereafter in most of the western galleries and in many of the art centers of the east. He was represented in the Exposition of Indian Tribal Arts in New York City.

Many esoteric and symbolic paintings were executed in abstract style by Wo-Peen. These savor of age-old religious forms, featuring clouds, rain, lightning, sacred birds, and feathers. Often Wo-Peen used color straight from the palette, frequently employing absolute balance in design in varying color arrangements. Neatness of line is characteristic in most of these paintings. Occasional outside influences, perhaps from Awa Tsireh, appear in the Wo-Peen drawings of esoteric-naturalistic type. The above qualities are apparent in his seven murals in the Lodge of the Seven Fires, a YMCA college freshman camp at Springfield, Massachusetts. Painted in oils, these, too, are predominantly geometric, symbolic designs and esoteric themes. A great thunderbird is vitalized with spectacular, slightly curved rays issuing from its head, and straight rays from wings and tail. Color is bright and pleasingly balanced. A rather different version of the plumed serpent, here labeled a flying water serpent, is outfitted

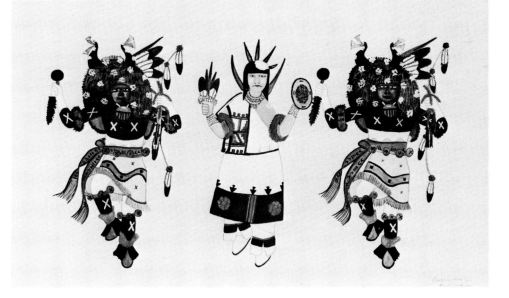

*Fig. 5.26 Encarnación Peña
(Soqween), San Ildefonso
Pueblo. Buffalo Dancers.
Courtesy, Mr. and Mrs.
H. S. Galbraith.*
—Neil Koppes

with clouds, a face in a great coil of the creature's body, and wings of sorts. Again, design tends toward absolute balance but is relieved by lack of the same in the handling of color.

Withal, Wo-Peen's painting is purely Indian in the usual two-dimensional and flat technique, and he clings to native subject matter in symbolic designs, birds and animals (Fig. 5.27), and ceremonial dance figures. Outstanding characteristics are fine outlining and a delicacy in his brush work, regardless of subject matter. Also typical is his absolute balance in composition but not in color. Most of Wo-Peen's painting was done in earlier years; later the problems of making a livelihood claimed much of his time. Nonetheless, in the mid-

*Fig. 5.27 Luis Gonzales
(Wo-Peen), San Ildefonso
Pueblo. Leaping Deer.
Courtesy, The School of
American Research, Santa Fe.*
—Laura Gilpin

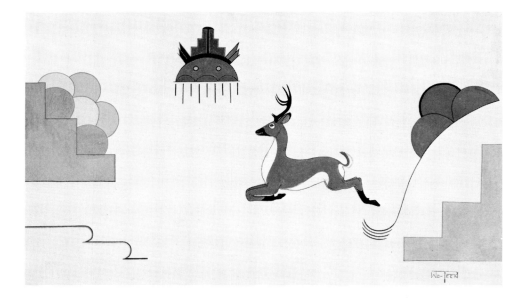

*Fig. 5.28    Luis Gonzales (Wo-Peen), San Ildefonso Pueblo. Rearing Horse. Courtesy, Mrs. Marion Foote.*

and late 1950s, Wo-Peen painted horses in many powerful and dramatic poses (Fig. 5.28). They were done largely in silhouette, although fine touches or larger areas of white or other colors made them, along with their active poses, live creatures. He was not painting in the late 1960s.

Albert Vigil, son of Romando Vigil, painted partly in the traditional San Ildefonso manner (Fig. 5.29). For example, *Turtle Dancers,* done when he was seventeen years old, lacks background and foreground; it shows some brown shading in garments, poor detail, and motion in right foot slightly raised. Later dance subjects show improvement. Animals which he painted at the Indian School, Santa

121

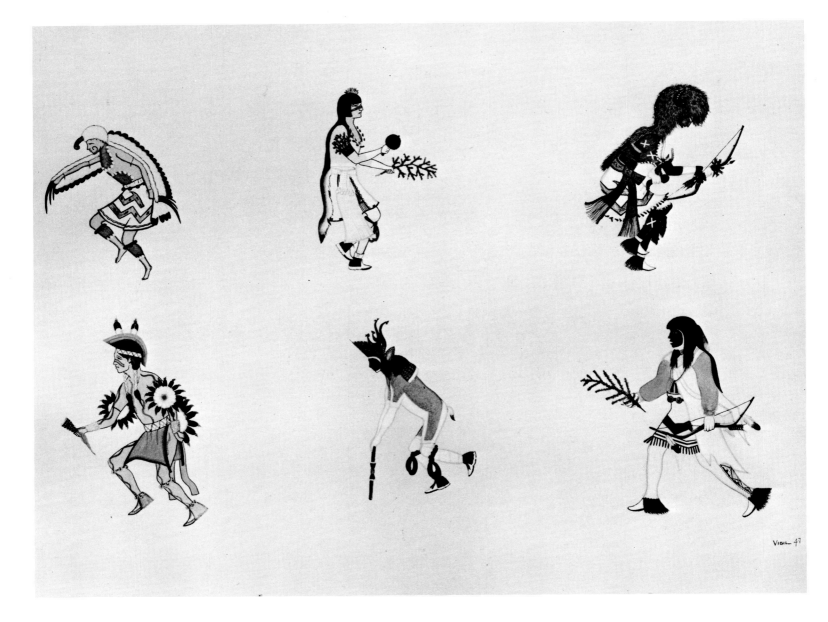

Fig. 5.29    Albert Vigil, San Ildefonso Pueblo. Six Pueblo Dancers. Courtesy, Museum of Northern Arizona.
—Mark Gaede

Fe, at about the same time, are rather rugged appearing, pouchy-jowled, heavy-legged; they are too short and ill-proportioned in general, and exemplify the usual inability of the puebloan to foreshorten.

One artist who demonstrated the break from the traditional in a rather more extensive as well as intensive manner is Tony Atencio (Su Ta); a brother of Gilbert Atencio, he was born in 1928. Through his attendance at the Indian School, Santa Fe, about 1945, he absorbed many of the traits of the Navajo and Apache artists. Of fourteen of his drawings seen at the school, not one was of dances. Most of them had to do with animals, particularly deer and horses. About the only stylization is in the treatment of greenery and rocks, and when this occurs it is in the direction of Navajo traditions. This artist has stressed realistic treatment, often with poor results. His coloring is not the usual direct, strong type so typical of puebloan painting; Tony Atencio was definitely influenced by the Navajo painters in depicting lavender rocks and blue horses. These trends are bound to occur; the surprising thing is that there are not more Tony Atencios. He has done little or no painting since the 1950s.

One of the most important of the Southwestern Indian artists emerging in the 1960s was Anthony (or Tony) Da. Born in 1940 at the village of San Ildefonso, he was blessed with considerable artistic heritage through his father, Popovi Da, and his grandparents, Julián and María Martínez. Except for living in an artistic atmosphere and learning from his famous relatives, Tony has had no formal training. He was in an art class in college but, he has said, he "did not take it seriously."

After serving in the armed forces for four years, he returned in 1964 to his native village still not knowing what he wanted to do. Painting pottery with his father gave him the inspiration and initiative to continue in this endeavor. It should be mentioned in passing that Tony Da has proven to be a fine potter and pottery decorator in his own right. At the Gallup Indian Ceremonials in 1968, his ceramic exhibit was so outstanding that all of it was removed from the regular competition and given several special awards; then, in addition, still another award was created by the judges for his excellent work. Tony has also gone into ceramic sculpture, a field in which he has never failed to take prizes.

This, then, has been part of the background for Tony Da. Natural talent far beyond the average, plus a dedication to his work, have combined with his birthright to produce one of the outstanding artists at the end of the 1960s.

Tony Da has painted primarily in casein, although he had done some work in pen and ink. A striking portrait of his grand-

mother, María, with several beautifully decorated San Ildefonso pots in the background, testifies to his ability in the latter medium.

In his painting, he frequently has portrayed traditional pueblo figures against an abstract background. The figures may be more or less realistic or they may be conventional (Fig. 5.30), semi-abstract, or fully abstract. Like so many of his contemporaries, he has borrowed subject matter from the very fruitful prehistoric Mimbres area and has combined this in some of his paintings.

Tony Da paints with enthusiasm and imagination. His line work is precise and perfect. His colors are subdued or even dim as befits the portrayal of prehistoric themes, or brilliant to faithfully present a rainbow or colorful costume (Fig. 5.31).

In 1959 Da did an abstract which foreshadowed many such paintings. Against a background of curving lines that emanate from the upper right-hand corner is a great scorpion-like figure surrounded by a half dozen diminutive Mimbres life designs plus a few tracks and a few geometric themes.

More sophisticated are later abstracts. *Sacred Bison* (Fig. 5.32) depicts a nonrealistic version of this animal in black, against a red sandstone wall with dimmed Mimbres themes scattered over the surface. *Deer Dancer* shows an unreal and elongate dance figure forming an arc against a dark abstract ground of indistinct squares and related forms. *Messenger Kachina* (Fig. 5.33) reveals the dancer's body bent into a half-circle, with dancing legs at the bottom and the turquoise masked head facing earthward at the top; paralleling and emphasizing the arch of the body is a repeating arc of red, white, and black feathers; this is painted against a background of two large squares overlapped in the center and extending almost to opposed corners. Da paints one of the most effective combinations of native subject matter in the abstract style or with individual stylization.

The year 1967 was outstanding for Tony Da. He won two firsts at the Gallup show, one at Philbrook, and two seconds at Scottsdale. In the later 1960s, Da did little or no painting. However, in early 1970 he returned again and with renewed vigor to easel painting.

Although he did a bit of painting in the 1930s, J. D. Roybal (Oquwa, Rain God), who was born at San Ildefonso in 1922, was

*Fig. 5.30    Tony Da, San Ildefonso Pueblo. An abstract. Courtesy, Mr. and Mrs. Clay Lockett.*
—Ray Manley Photography

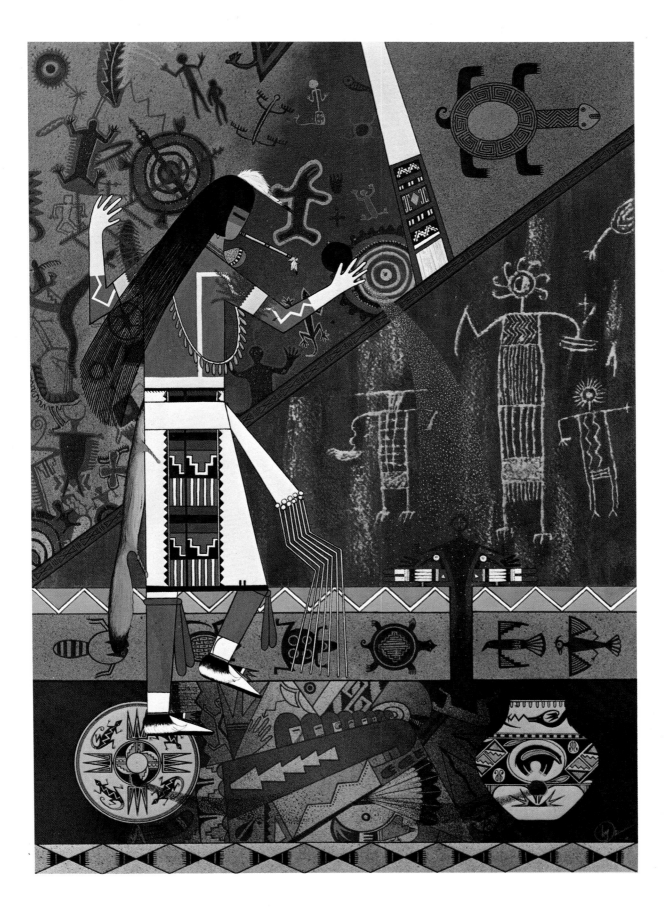

not really productive until the late 1950s. His work was exhibited more and more frequently throughout the 1960–70 decade.

A nephew of Alfonso Roybal, J. D. Roybal has painted primarily in the traditional pueblo style while adding touches that are distinctively his own. For example, in using realistic and symbolic themes together, often he adds a touch of humor (Fig. 5.34). In another similar painting, *Koshare and Rainbow,* there is the usual conventional rainbow with two angular sacred serpents beneath it. Three clowns on the rainbow and three wrestling with the snakes suggest much joviality in their actions and facial expressions. Thus traditional subjects and conventional design are typically combined. Another beautifully executed *Koshare* painting which took a special award in the 1969 Gallup show is more serious; in it are presented a straight line of twelve pairs of clowns plus four other figures in more discreet poses along the top of a straight band. These clowns, and often other humans, have characteristically wide-open mouths.

Obviously influenced by his famous uncle, J. D. Roybal has used water-based paints. In most of his work there prevail fine color,

*Fig. 5.31    Tony Da, San Ildefonso Pueblo.* Spring Blessing. *Courtesy, the Avery Collection.*
—Howard's Studio

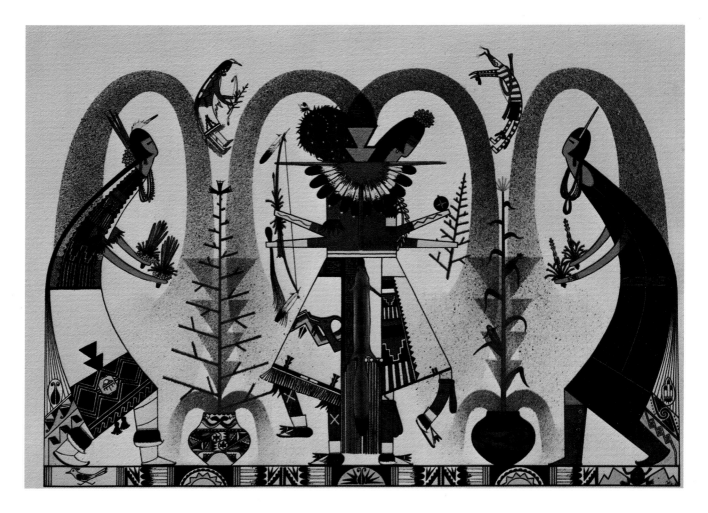

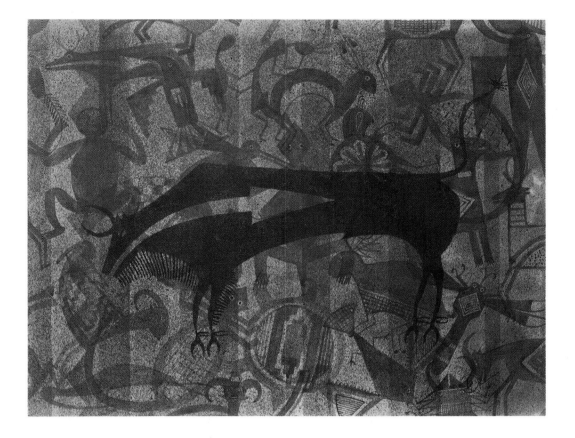

excellent detail, small and fine outlines, gesturing figures, and a pleasing combination of heavy conventional themes with realistic subjects, as in *Harvest Dance* (Fig. 5.35). Color in this painting is beautifully controlled, from the warm tones of the pueblo and kiva walls to the rich and varied colors of costume and ceremonial objects. The decorative band at the bottom of the painting, on which the dancers perform, is mindful of a comparable feature in prehistoric kiva murals. Roybal placed in the 1968 Scottsdale show, and received an honorable mention in the 1971 Red Cloud Indian Art Show at Pine Ridge, South Dakota.

Another San Ildefonso artist, Ralph Roybal (Ma-Wholo-Peen), has painted in very much the same way as J. D. Roybal—traditional subjects, no background, no foreground, but with some modeling. *Antelopes at Rest* (Fig. 5.36), exhibited at the 1970 Heard Museum Guild Show, illustrates the traditional association of these animal dancers beneath a decorative theme which is more suggestive of a cliff than a rainbow. A slight variation from the traditional treatment is to be noted in that the other dance figures are beyond and not on the dividing motif.

Ma-Wholo-Peen was born November 15, 1916, in San Ildefonso; he attended the Indian School at Santa Fe and St. Louis

*Fig. 5.32 Tony Da, San Ildefonso Pueblo.* Sacred Bison. *Courtesy, the Avery Collection.*
—Howard's Studio

127

University. In his painting he has used both oils and water-based media; he has also worked in leather and wood. Among other places, Roybal has exhibited at the Heard Museum and Scottsdale shows, taking an honorable mention at the latter in 1966.

José Vicente Aguilar (Suwa), half San Ildefonso and half Picurís, was born January 8, 1924. His education beyond elementary school was largely in California, although he did go to the University of New Mexico. He served in the U. S. Army during World War II, in Europe. For the most part, he has been employed as a commercial artist. He has exhibited widely in the Southwest and to a smaller degree in California; too, he is represented in both private and public collections, and has received numerous awards.

Although he started out painting in the traditional ways of his pueblo, and the Santa Fe Indian School (Fig. 5.37), he was greatly influenced by Joe H. Herrera in his later semi-abstract work. A 1957 casein tempera painting, *Stampede,* portrays a herd of buffalo in profile—but one above another—against what appears to be a background of earth, yet is not. This typical Indian presentation of the

*Fig. 5.34    J. D. Roybal (Oquwa), San Ildefonso Pueblo. Clowns. Courtesy, Mr. and Mrs. H. S. Galbraith.*
—Neil Koppes

*Fig. 5.33    Tony Da, San Ildefonso Pueblo.* Messenger Kachina. *Courtesy, the Avery Collection.*
—Howard's Studio

129

Fig. 5.35 J. D. Roybal (Oquwa), San Ildefonso Pueblo. Harvest Dance. Courtesy, C. Richard Le Roy.

animals against a semi-abstract background anticipates his later emphasis on the latter, usually involving Indian themes.

Like so many ''unknowns'' in Southwest Indian art, Po-Ye-Ge of San Ildefonso did one ambitious job and then, apparently, dropped out of sight. He illustrated the book, *American Indian Dance Steps*, by May and Bessie Evans, which was published in 1931. Quite naturally his subject matter was basically native dances. All color is flat, and although some effort was made to show folds, as in a kilt, there is no real modeling. Action is more suggested in postures than realistic. Much of Po-Ye-Ge's work is poor, even childish in execution, yet the overall effect is good.

In summarizing the San Ildefonso development as a whole, it can be said that the first Indian artists of importance came from this pueblo. This village set the standards for the Rio Grande in sub-

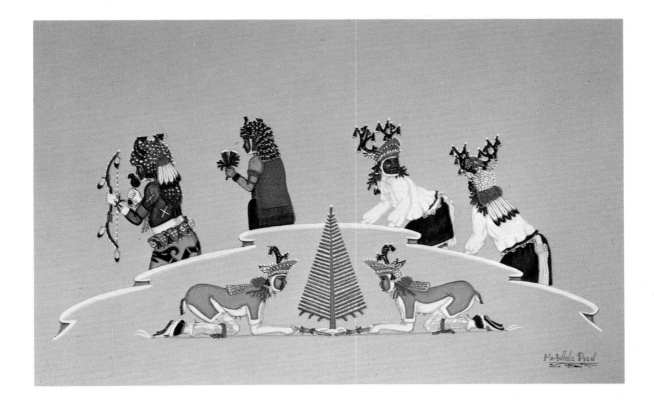

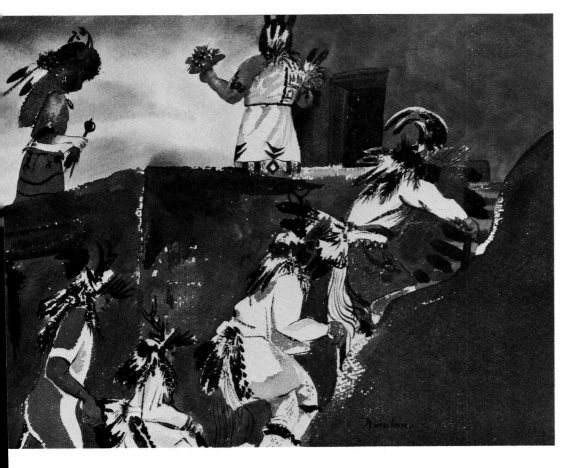

Fig. 5.36    Ralph Roybal (Ma-
Whola-Peen), San Ildefonso
Pueblo. Antelopes at Rest.
Courtesy, the Avery
Collection.
—Neil Koppes

Fig. 5.37    José Vicente
Aguilar (Suwa), San Ildefonso
Pueblo. Animal Dance.
Courtesy, James T. Bialac.
—Neil Koppes

ject matter, general treatment, and styles. Within this pueblo, too, there was a fair amount of experimentation along new lines, with new media, as seen in the use of oils by Tse-Ye-Mu, or new subject matter, as in Gilbert Atencio's portrait, or new styles, as reflected in the modern treatment in Tony Da's work. The influence of the San Ildefonso movement has never waned; however, more formal training and wider experiences introduced young Indian artists of the 1960s to the newest media, the latest styles of painting, and to extended subject matter. Toward the end of the 1960s, there were not as many outstanding San Ildefonso artists as in earlier years, but several were equal to the best among native Southwestern painters.

### Cochití

The transition from San Ildefonso to Cochití might be made by way of the marriage of a member of the former village to a member of the latter village. Tonita Vigil left San Ildefonso when a young girl and married a Peña at Cochití; thereafter she was called Tonita Peña (Quah-Ah). She had started painting at San Ildefonso, and the influences from her natal village remained with her always. She established her own characteristics in painting at San Ildefonso, took them to Cochití, and retained most of them without much influence from the latter pueblo.

Although she had no formal training in painting, Tonita had been in direct contact with it from many angles. First, she was a cousin of Romando Vigil; then she became active in the San Ildefonso movement, the only woman painter of this early group. Further, she came under the watchful eye of Dr. Edgar L. Hewett of Santa Fe. Later still, she was fortunate in having the attention and interest of Dr. Kenneth Chapman directed toward her work.

Quah-Ah started painting a little before 1920—one painting in the Laboratory of Anthropology collection is dated 1919. At that time, as later, her subject matter centered about the dances of the local village, although on several occasions she was induced to make drawings of pottery. Ceramic pictures are faithful reproductions from the standpoint of relative sizes, shapes, and designs. Like so many of the early artists, she had had much training in ceramics, and like them, she was able to transfer the decoration from pottery to paper with great facility.

A list of the subject matter of dances painted by Quah-Ah would parallel a list of the works of the early artists of San Ildefonso. Tonita's usual treatment is concerned with two or three dance figures in a line followed by a drummer (Fig. 5.38). Chanters are often present. Generally there are women in her pictures, and, as a rule, these

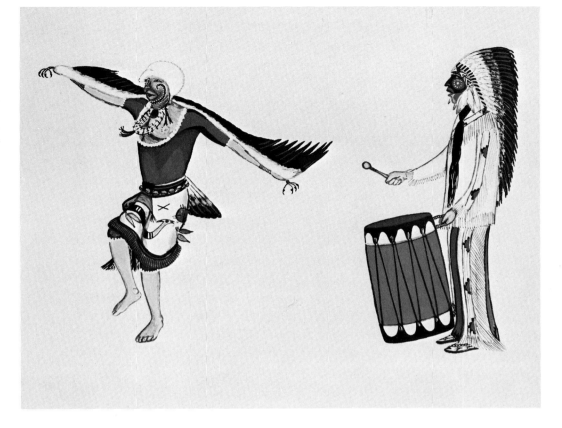

*Fig. 5.38 Tonita Peña (Quah-Ah), Cochití Pueblo. Eagle Dance. Courtesy, The School of American Research, Santa Fe.*

women are taking a definite part in the dance as shown in the action in the feet. Quite consistently the feet are lifted higher than in the drawings of many other artists. And the feet of the men, too, are more active, often to the point of appearing to hop along. This type of action is one of the traits peculiar to Tonita.

Figures tend to be in straight lines, with most of them done in profile. Tonita acquired an ability to turn figures in many and varying poses, and to arrange them at different levels in a group. In this way she breaks the monotony so much more characteristic of the men painters. It is possible that the traditional ceremonial painting done for centuries by the men had its influence on this new art, and particularly on those who were touched by it directly in their ceremonial participation.

As Tonita Peña varies position, she also breaks the identical repetition of arm, leg, and head arrangement, thus getting more of a feeling of motion. In addition, she resorts to such devices as flying feathers, jiggling necklaces, swinging sashes, and uneven kilt lines to add to this feeling of action. None of these qualities detract from a splendid dignity and a peaceful feeling which pervade her painting. Fine detail is represented by Tonita, to make of her paintings the same excellent ethnological records that are the case with so much

133

of this Indian art. To the last small element, the embroidery on skirt or kilt is represented. A shell inlay pendant will have each separate small fragment of turquoise carefully drawn. Each feather in the Eagle Dancer's wing and tail pieces will be painted separately. So, too, will careful depiction bring out the stringing of a drum, the design in a basket, the braiding in a belt.

Facial treatment is very distinctive as executed by Tonita Peña. Often the mouths of the drummer and chanters, and sometimes of the male dancers, will be open in song. When open, they are open with verve. When shut, the men dancers' mouths, and always the women's mouths, are thicker-lipped than they are when depicted by other Indian artists. A heavy crease is often added to the face from the nose to below the lip. The treatment of the eye is slightly different, too—a half crescent with the eyeball toward the open end. Very heavy outlining is also a characteristic trait, appearing about the face, body parts, and often garments.

In handling paints, Tonita used everything from perfectly flat color to modeling techniques. The latter varied from an occasional line in a skirt or on the face to fairly elaborate modeling in color for flesh and garments. Intensity of color is not great, but frequently smaller or larger bright areas appear. Usually more subdued tones are to be noted, although in the shirts and buckskin trousers of the drummers and chanters color is often brilliant. There is great truth in color rendition in many of the Peña paintings. She favored transparent watercolor over tempera.

Some further details of treatment by Tonita are important. Faces of the dancers are often more Indian-like than the faces painted by her contemporary tribesmen (Fig. 5.39). She stressed vertical lines, seeming to take joy in painting and accenting in color the vertical stripes in blankets, the vertical and narrow panel down the sides of Plains-type trousers. The Eagle Dancer's arm is brought straight down with the white top emphasized in the vertical by its proximity to the black feathers. Even fur pieces hanging at the back of the waistline and sashes pendent at the side have a way of becoming longer than usual under Tonita's brush.

Tonita Peña was said to have taken the San Ildefonso movement with her when she went to Cochití. She was recognized from the beginning as one of the outstanding pueblo painters, and was mentioned in writing and in public lectures along with other outstanding artists. Her pictures were exhibited along with the best. She received monetary rewards as well as fame for her work. In 1925, in response to an order from New York, pictures by Tonita Peña, Fred Kabotie the Hopi, and Velino Shije of Zía were sold. Certainly these young Indians were discovering that painting was a good

source of income. Tonita's paintings continued to be popular up to the time of her death in September, 1949. Because of their appeal, her paintings were often favored for exhibitions in Santa Fe, and were shown in many of the major galleries throughout the country. She is also represented in permanent collections, at the Laboratory of Anthropology and School of American Research in Santa Fe, Philbrook Art Center in Tulsa, and in many private collections. La Fonda Hotel in Santa Fe has her paintings in many of its rooms. The products of Tonita's brush were always in demand during her lifetime; since her death many private collectors have made efforts to include her work, considering it an essential part of the story of Southwest Indian painting.

Perhaps Tonita's major contribution to pueblo art can be summarized by saying that she was the first woman to throw off the shackles of sex-determined art forms and express herself in new and multitudinous ways. Traditionally, women were restricted to certain forms of craft art. In turn, those very crafts restricted them to more geometric art styles. Tonita painted as she wished; she painted as an individual; she paved the way for many further developments in pueblo art. Last but not least, in her son, Joe H. Herrera, she gave

*Fig. 5.39     Tonita Peña (Quah-ah), Cochití Pueblo. Green Corn Dance. Courtesy, Mrs. Muriel Thayer Painter.*
—Ray Manley Photography

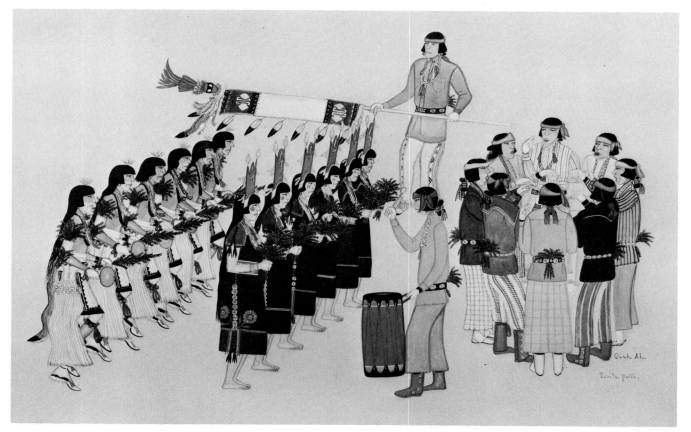

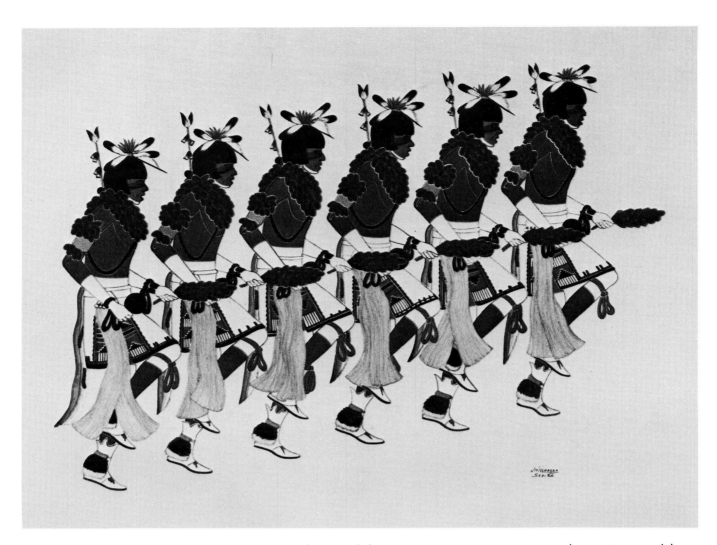

*Fig. 5.40 Joe H. Herrera (See-Ru), Cochití Pueblo.* Cochití Basket Dancers. *Courtesy,* Arizona Highways. —Ray Manley Photography

to the art world one of the most promising artists in the entire pueblo field. He carried on the family honors in painting, having perfected his expressions even further than his famous mother.

Born into a rich art inheritance through his father's pueblo of Cochití and his mother's village of San Ildefonso, Joe H. Herrera (See-Ru) was painting before he entered the Indian School in Santa Fe. Not only did he receive a rich tribal background from his mother, but also she gave him thorough training in the art abilities which he inherited from her.

He graduated from the Santa Fe Indian School in 1940. He served in the United States Army, largely in Puerto Rico, until the end of World War II. Upon his return to New Mexico he married and established his residence in Santa Fe. For a time, he worked at the Laboratory of Anthropology, reproducing pueblo pottery designs for Dr. Kenneth Chapman. Later he went to the University of New Mexico where he worked for a degree in art education.

However, after receiving his education, he gave practically all of his time to painting for some years; therefore Herrera has much

work to his credit. He exhibited widely after his school days at Santa Fe and Albuquerque. Often his watercolors appeared in the Museum of New Mexico; there he had a one-man show of his abstract paintings in the summer of 1952. Exhibits appeared in many galleries from coast to coast, including Paul Elder's Book Store, San Francisco, the Denver Art Museum, and the Museum of Modern Art, New York. Likewise, Herrera is represented in many permanent collections, including the Colorado Springs Fine Arts Center, Philbrook Art Center and Thomas Gilcrease Foundation of Tulsa, the William Rockhill Nelson Gallery, and the Museum of New Mexico, as well as a number of private collections.

Herrera has won many prizes, but 1952 marked a high point of attainment for him. In that year he won the one hundred dollar purchase prize in the Annual National Exhibition of Indian Painting at the Philbrook, two first prizes at the Gallup Inter-Tribal Indian Ceremonial, and high commendation for exhibits of his abstracts in the Museum of Modern Art, New York, and the Denver Art Museum.

Joe Herrera developed three outstanding traits which are reflected in his work—one in which there is a perfectly delineated single dance figure, the second a dance group, and third an abstract style utilizing native designs. In his execution of the group and single dance figures, there is no competitor for perfection (Fig. 5.40). Often he has used a colored paper to complement the tones in which his subjects are painted. He further enhances the excellent color contrasts by doing very fine work. For example, he did a Comanche drummer on a dusty pink paper, with white buckskin shirt and moccasins, heavy-feathered headpiece and roach down the back, and large blue drum with black skin stretched over both ends. All offer pleasant contrast to the paper color. The outlines of the figure are clear and clean, all detail is neatly and accurately depicted. The style is, withal, conservative and decorative.

In most of the single-figure drawings there is little or no action. For example, in a Buffalo Dancer figure there is but the gentle flick of the end of a necklace to suggest movement. In a Bow Dancer painting, the necklace and sash ends swing in motion. Herrera uses more brilliant color in these paintings but in the same restrained manner in which he suggests action. For instance, a Deer (or Antelope) Dancer painted on blue paper, with much use of soft colors and a great deal of white, has bright red ties at the knees as a point of color emphasis. Again, orange arm bands of dyed skunk fur and intense yellow for the fore part of moccasins impart the same emphasis in a small way on the figure of a woman Corn Dancer. In these single figures there is a great charm in the handling of color, so often pleasantly balanced or contrasted. Too, all interest centers

in the figures, for there are no ground lines and no background. *Jemez Dancer with Drum* (Fig. 5.41) illustrates these traits.

Herrera is capable of putting action into his figures whenever he wishes. For instance, there is the painting of a *Yellow koshare and goat,* as it is labeled. In front is a childlike, yellow figure with black stripes (with pink-soled feet!) followed by a running goat. There is nothing formal about this presentation.

In the mid-1950s, Herrera developed a style which was encouraging for the future of Indian painting.[31] The rich design-lore of the past and much that is prevalent in religious forms today he combined into abstract painting (Fig. 5.42). Again it is the clever manipulation of the age-old and omnipresent themes—sun, moon, clouds, rain, lightning, kachinas, birds, the sacred serpent. Sometimes they are blended with pictographs, sometimes with pottery designs. The end product is essentially Indian; it is also modern, for abstract art is preoccupied with form and color and pattern.

The materials—casein tempera in natural-toned palette—and methods—spray and brush—used by Herrera in his abstract work, are likewise familiar to the Indian artist. In fact they are close to or identical with the traditional among his people, for the paint is not greatly different from the earth colors which are centuries old in the art of the Southwest. The antiquity of the brush goes without saying.[32] Spraying, with the mouth used as atomizer, was possibly known in Precolumbian times; at least a spatter technique is suggested in Awatovi painting.[33] Ancient pottery also indicates the use of this spatter-type decoration.

Herrera's imagination, plus his meticulous line work and some anthropological investigation, combined to produce this abstract form of art (Fig. 5.43). Also, as a student at the University of New Mexico, Herrera was unquestionably influenced in some degree by the modernist, Raymond Jonson. Jonson's palette, clean-cut line, and well-ordered composition are much in evidence in Herrera's work. Obviously these items were not entirely Jonson-inspired, for Herrera had inclinations in certain of these directions long before he went to the University of New Mexico, particularly in the matters of color and line. The subtle humor of Jonson's work never appeared in the painting of Herrera.

A further word about Jonson may be added here, despite the fact that the degree of his influence cannot be measured. Above all, he is imaginative. One critic analyzed his abstracts as "compositions of order, balance, and rhythm, [they] ... are deep in color, and possess a decided spiritual quality. Others are brilliant and gay. In all of them there is exactness. These paintings are structural and

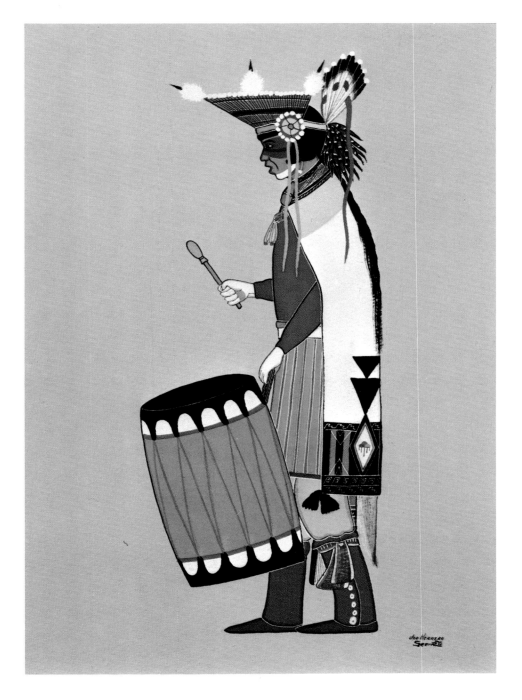

*Fig. 5.41    Joe H. Herrera
(See-Ru), Cochití Pueblo.
Jémez Dancer with Drum.
Courtesy, James T. Bialac.*
—Neil Koppes

emotional."[34] Much said here could also apply to the paintings of Joe Herrera.

One is tempted to believe that the influence of Jonson on Herrera has been most profound in those areas where the two artists developed common traits before they met. Jonson affected Herrera more by bringing out and emphasizing qualities peculiar to both artists, qualities deep in Herrera's native background. It is apparent

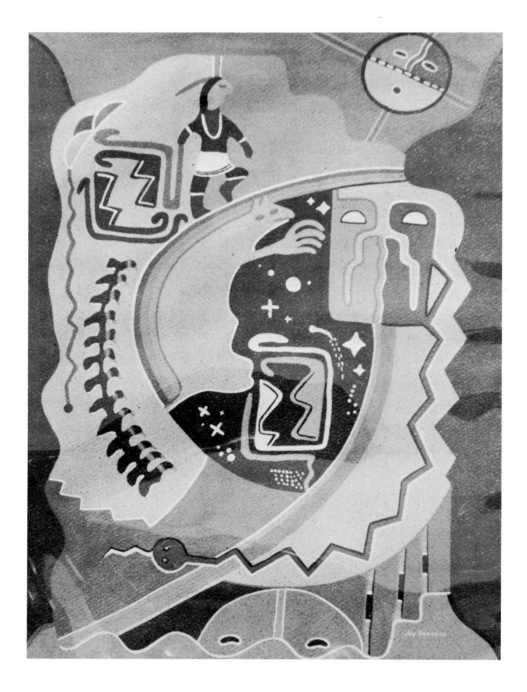

*Fig. 5.42    Joe H. Herrera
(See-Ru), Cochití Pueblo.
Symbols of Fall Ceremony.
Courtesy, Charles H. Cole.*

that Herrera rejected or was unresponsive to those traits of Jonson's which did not appeal to him.

Herrera accomplished in painting what his people have done in the craft arts. In the latter, conventional forms occur over and over, with the individual contributing in the realms of pattern arrangement and sensitive execution. So, too, this artist has excelled in the execution of a figure style commonly portrayed by his fellow tribesmen, a figure style long since perfected in many hundreds of representations, but never so delicate and refined as in the portrayals by

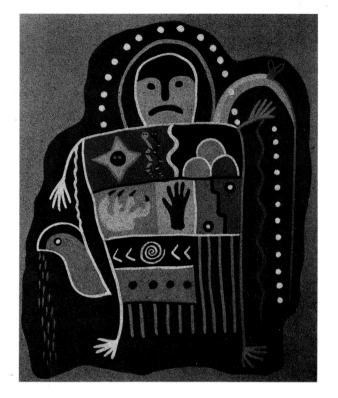

*Fig. 5.43 Joe H. Herrera (See-Ru), Cochití Pueblo. Pictograph Altar. Courtesy, The Denver Art Museum.*
—Neil Koppes

Herrera. He has exceeded his pueblo's accomplishments through the freshness and new vigor he has given to old and traditional art forms in his most sophisticated expressions, abstract paintings.

In 1956, Herrera became associated with the Education Division of the state of New Mexico. Soon after this, his production declined, and for years he produced virtually no painting.

Hester Jones has summed up Herrera's chief characteristics in a few words, characteristics which apply to his work early or late, to the single dance figure or the abstract composition. She said that See-Ru follows "the tradition of his mother, Tonita Peña, in keeping to the simplest form of Indian painting. . . . His drawing and color, his sense of rhythm and design are superb."[35]

The pueblo of Cochití has contributed another artist to the Southwest scene, Theodore Suina (or Ku-pe-ru), who was born in 1918. Fate played a part in the beginning of Ku-pe-ru's career. In an accident he received a broken neck, and while recovering he amused himself by painting. It was after this that he attended the Indian School at Santa Fe, studying art under Mrs. Montoya and graduating in 1942. Like other students at this school, Suina was encouraged to keep his native style, subject matter, and approach to art. Still later he spent three and one-half years in the United States Army. He has exhibited in the Southwest, winning second prize at

141

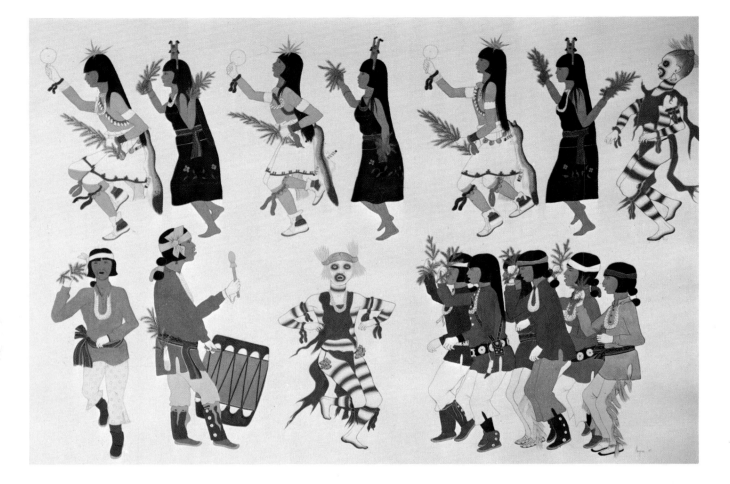

*Fig. 5.44    Theodore Suina (Ku-pe-ru), Cochití Pueblo. Cochití Corn Dance. Courtesy, The Denver Art Museum.*

—Neil Koppes

the New Mexico State Fair in 1946; he is also represented in several permanent collections. In 1950 Ku-pe-ru attended the Hill and Canyon School of the Arts, in Santa Fe, under the G.I. Bill.[36]

Suina has painted in tempera and particularly in Shiva. One favored color, a blue-gray, would seem to have a great deal of Chinese white in it. It is used for both body color, as in a Buffalo Dancer, and for garments, as for a woman's shawl. Most of the color employed by this artist is medium in value, although there may be small touches of brighter red or orange or green, for example, in a rattle, a belt, a green bough. Flat color is more commonly used, with modeling suggested in heavy lines. This artist has featured children as Buffalo, Corn, or Eagle Dancers; these have a charm all their own.

Ku-pe-ru presents a fair amount of activity in his semi-naturalistic paintings, his major style. In a Buffalo Dance, the men personating the buffalos will have feet moving, arms slightly raised, and bodies bent to the tune of the rattles and drums. Likewise, although dancers often form a more unified group, seldom are they in single and ordered files. In one Buffalo Dance, two men, dressed as the animal, dance toward each other in the center of the picture;

they are backed up by the Buffalo Mother on the left, while the hunter is on the right. This presents considerable contrast to the formal and unwavering lines of dancers of the earlier artists.

The Buffalo Dancers portrayed by this artist are made more realistic by the addition of much shaggy hair suggestive of this animal, with great pieces of the stuff tied at the knee, ankle, and elbow; generally the irregular ends are long and flying in all directions. This feature has been greatly exaggerated at times by Ku-pe-ru, so much so, in fact, as to become a trait quite his own.

In addition to other dancers presented individually or in small groups, Suina has painted a multitude of subjects, including scenes of everyday life of the village, such as animals, running antelope, women grinding corn, and dances (Fig. 5.44). Generally, in most of these earlier paintings, particularly in the dances, there is no ground, but in some of the other scenes a ground line may be introduced. In one scene of running antelope there is an irregular patch of ground and a bit of growth, both looking like a poor copy of the same done by some of the Navajo men. No doubt Ku-pe-ru has been impressed by the painting of these other artists. Another influence which is doubtless from the same source is seen in the antelope. Groups of "waves" of intermediate tone, characteristic of much Navajo painting, are used where the brown and white of the animal's body join.

A 1962 painting by Ku-pe-ru exhibited at the Scottsdale National show indicated a trend in the direction of his contemporaries. *Koshare in Prayer* presents an abstract background of clouds and rainbow against which the koshare appears. To the left, and lower in the picture, is a conventional representation of corn.

Another popular trend of the 1950s and 1960s was the painting of petroglyphs. Ku-pe-ru participated in this expression relative to this prehistoric subject also, using spatter paint to make rocks appear more natural. Into the 1960s, he continued to paint traditional semi-naturalistic native subjects, still featuring koshare with flying bits of skin tied at ankles, knees, and elbows. But he also seemed to be intrigued with the modern trends, and frequently he no more than suggested this different style in gracefully curved bodies of dancers. There is a suggestion of this curvature in two figures of *The Flute Rhythm of the Remote Past,* a casein-tempera painting which won Ku-pe-ru a second-place award at the Philbrook 1967 show. In 1968 he took second place for a watercolor in the Heard Museum Fair competition.

General trends in Ku-pe-ru's work are indicated in several of his later pieces. One was a painting of a *Chaparral,* a charming design, exhibited at the Scottsdale National in 1970. In another 1970 example, he used gesso on board, with emphasis on white relieved

by soft colors. Gone are the flying bits of buffalo skin which characterized his earlier work; rather is there a quiet sophistication in this later painting. Another of this type, but in deeper colors, appeared in the 1970 Heard Museum Guild Show (Fig. 5.45).

Like many of his contemporaries, Ku-pe-ru has used colored and textured papers for certain effects. Many of them are quite

*Fig. 5.45    Theodore Suina (Ku-pe-ru), Cochití Pueblo. Flute Chanter. Courtesy, Mrs. William G. Holiday.*
—Neil Koppes

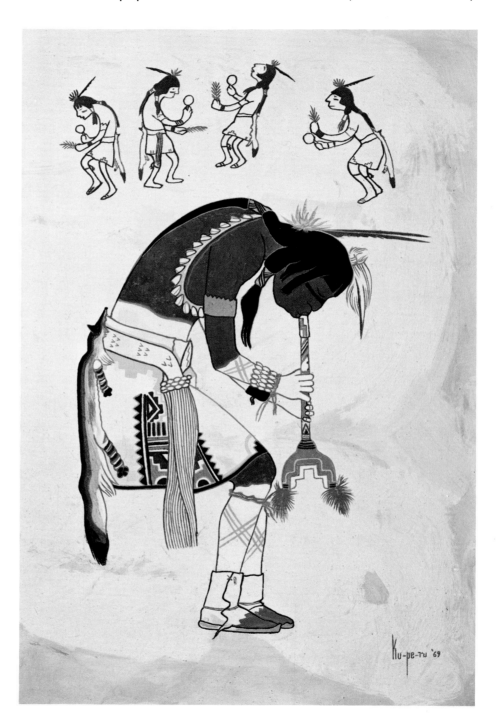

impressive, for Suina has the Indian sense of color which is usually unerring.

The life of one of the most promising of the Cochití artists, Ben Quintana (Ha-a-tee), was cut short by World War II. Although he was only twenty-one when he was killed in combat on Leyte on November 9, 1944,[37] he had already won national recognition for his painting. When he was a student at the Santa Fe Indian School in 1940, Ben was awarded a $1,000 prize in a nationwide contest sponsored by the *American Magazine*. More than fifty thousand students entered this contest. The title of his piece was *My Community, Its Place in the Nation*. The painting is a beautiful synthesis of the life of his people and the country in which they live. It is well designed throughout. The background runs from pale blue sky, through far ridges, to barren hills closer to the pueblo, all simply but effectively done. Brown pueblo houses and a kiva appear in the background, also a church and a schoolhouse. In the center is a pueblo woman putting bread in a great round oven. In the foreground are the fields which are the life of the pueblo, yielding corn, melons, and pumpkins. To the right are a typical pueblo man and woman, the latter with a piece of Cochití pottery on her head.

This sensitive artist neglected no small detail in his painting. An American flag flies on the schoolhouse; children are playing in the school yard. On the top of the church is a cross; a string of red chili peppers hangs on the side of the brown house; a koshare figure is placed on top of the kiva, two drummers stand below. The "type pueblo man" wears turquoise earrings, a turquoise and shell necklace. Colors employed by the young artist are soft and pleasing throughout, and his treatment is direct and honest. Despite the amount of detail, there is no cluttered feeling to this creation.

Some of the other paintings by Ben Quintana, which are largely pueblo dances, reveal many of the same characteristics mentioned above. For instance, in a Buffalo Dancer figure soft dark colors prevail. In another painting on the same subject, there is much modeling in the flesh. Detail is very good, clean, and clear. In one of these Buffalo Dance groups, Ben Quintana used the large fuzzy buffalo heads, and large pieces of buffalo skin with shaggy hair much as they were used later by Ku-pe-ru. The former artist displayed action in his figures similar to that in Ku-pe-ru's paintings. It is likely that Ku-pe-ru was influenced by Quintana. The flying pieces of skin are more simply represented in a painting by Quintana, *Two Koshares and a Burro* (Fig. 5.46); so too, is there a pleasant sense of humor in this portrayal.

At the time of the New Mexican Cuarto Centennial, in 1940, Ben Quintana also won the first prize for his poster which was then

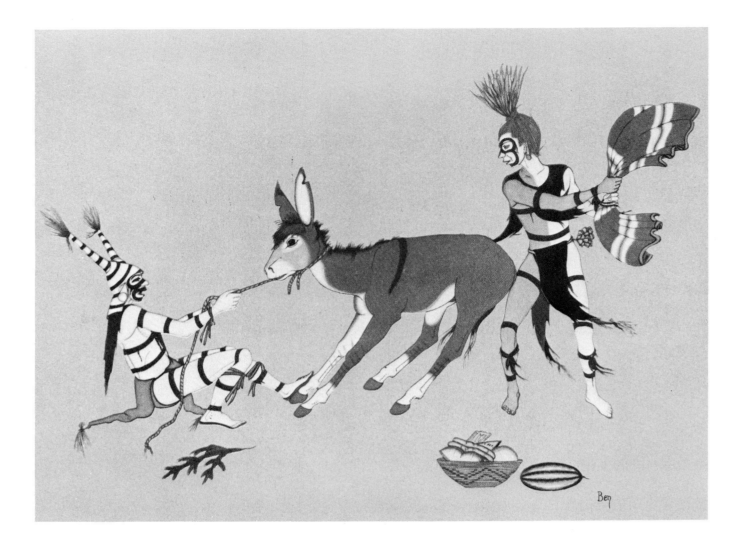

Fig. 5.46 *Ben Quintana,
(Ha-a-tee), Cochití Pueblo.
Two Koshares and a Burro.
Courtesy, Mrs. Thomas E. Curtin.*
—Ray Manley Photography

used in national publicity for this important event. Reputedly, the young artist started "playing with paints" when he was in the third grade, so his interests in art were keen. He hoped to continue his studies in this line. The seriousness of this young fellow is reflected in the fact that he spent his poster prize money for further study; it is also reflected in a comment about one of his paintings, an Eagle Dancer, as a "single, soberly beautiful"[38] figure.

Quintana's work has been exhibited in a number of important galleries. He also did murals for the Indian schools at Cochití Pueblo and Santa Fe, and for an Indian trading post at Albuquerque.

Quite a number of other young people from Cochití started painting at the Indian School in Santa Fe; among them was Joe A. Quintana. He did several paintings with the title, *My Community—Its Place in the Nation* for the same *American Magazine* contest. In one of them, men and women in typical pueblo dress and jewelry are going about their daily activities; there are also suggestions of ritual

activities. A small pueblo is pictured with a large symbolic rainbow overhead. A second painting of the same title is more preoccupied with outside contacts; for example, there are pictured a schoolhouse, a church, flagpole, and other evidences of outside influence.

Joe Quintana also painted individual village scenes, such as *Kossa Leading Corn Dance* (Fig. 5.47). Seemingly, he did little or no painting after he left school.

A few Cochití students continued their painting after leaving the Santa Fe Indian School. Bob (or Manuel) Chávez (Ow-u-Te-wa), who was born in 1915, painted in the traditional manner, then turned to a style all his own. For a time he used black paper, and outlined figures of animals in brilliant blue, green, turquoise, or red. Some of these are more active, others are in stiff-legged, traditional style, suggesting Navajo trends. Later Chávez changed his manner of painting, expressing a variety of styles that included everything from a simple, naïvely realistic presentation of a blanketed, white-haired woman on a blank paper, to more realistic portrayals of dancers (Fig. 5.48), to a complicated semi-abstract, symbolic theme, such as one involving three human figures and two cornstalks on black paper.

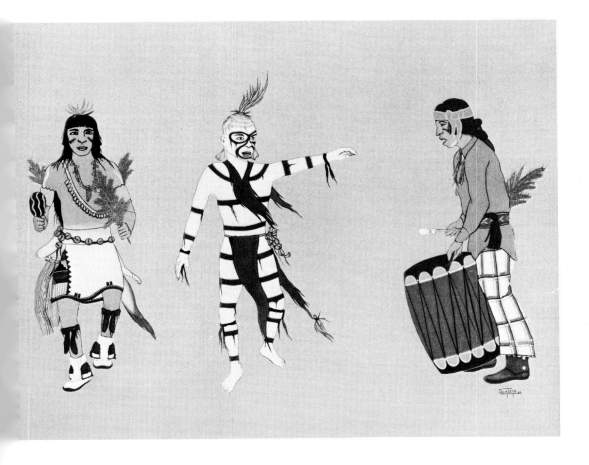

*Fig. 5.47    Joe Quintana, Cochití Pueblo. Kossa Leading Corn Dance. Courtesy, Mrs. Thomas E. Curtin.*
—Ray Manley Photography

147

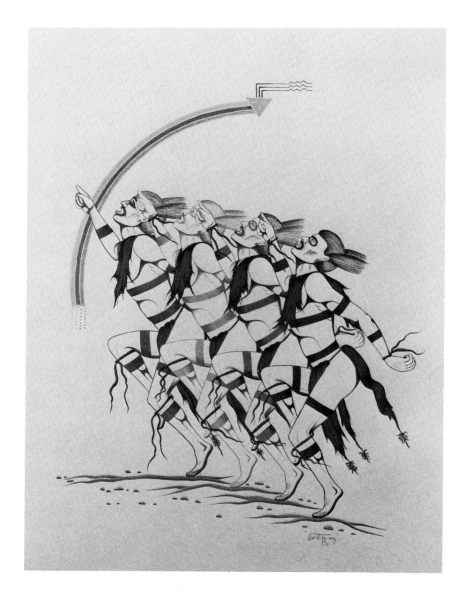

*Fig. 5.48 Bob (Manuel) Chávez (Ow-u-Te-wa), Cochití Pueblo. Koshares. Courtesy, Inter-Tribal Indian Ceremonial Association, Gallup, N.M.*
—George Hight Studios

A comparable style is represented in *Corn Spirit* (Fig. 5.49). In 1970 Chávez was painting a great deal.

Cipriana Romero had a tendency to balance her early compositions; they were usually in flat colors. Andy Trujillo painted rather extensively at the Indian School, featuring native dances. He demonstrated potentials in good and clean outlines, modeling in lines, and in a pleasing handling of color; sometimes he produced a facial type which suggests the work of Tonita Peña. Sam Arquero likewise painted native ceremonial performers, often depicting them in clean-outlined, flat-colored, and nicely detailed figures. Sometimes Arquero's faces are not convincingly Indian (Fig. 5.50).

Justino Herrera (Stimone) also painted a *My Community—Its Place in the Nation,* which, although not so well integrated as Ben

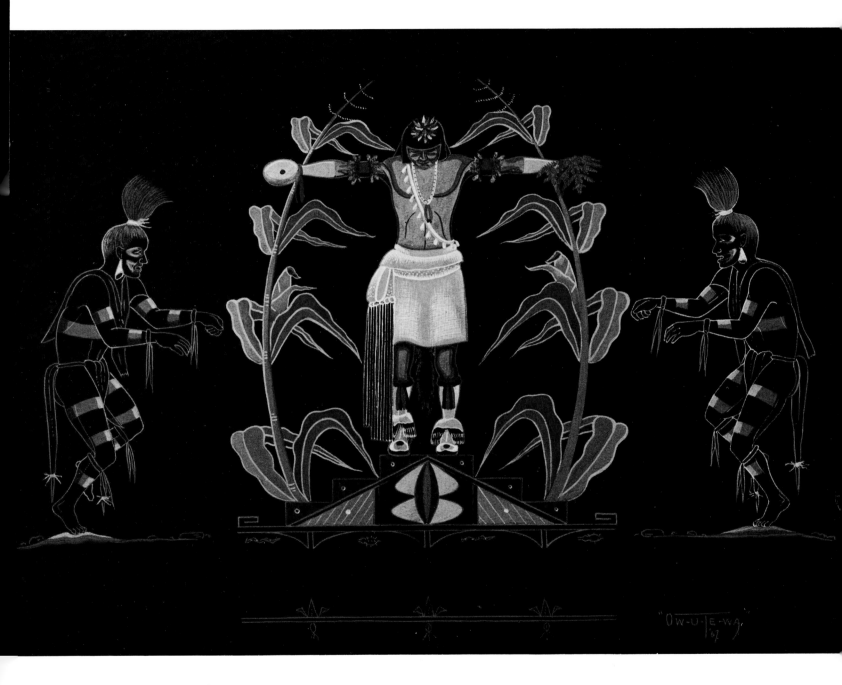

*Fig. 5.49  Bob (Manuel Chávez (Ow-u-Te-wa), Cochití Pueblo. Corn Spirit. Courtesy, Mr. and Mrs. H. S. Galbraith.*
—Neil Koppes

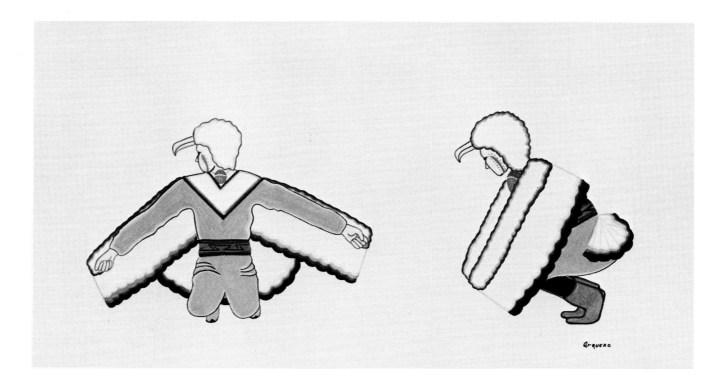

Fig. 5.50    Sam Arquero,
Cochití Pueblo. Eagle
Dancers—Cochití. Courtesy,
Dr. and Mrs. Byron C. Butler.
—Neil Koppes

Fig. 5.51    Justino Herrera
(Stimone), Cochití Pueblo.
Red Buffalo Dancer. Courtesy,
Mr. and Mrs. John Tanner.
—Ray Manley Photography

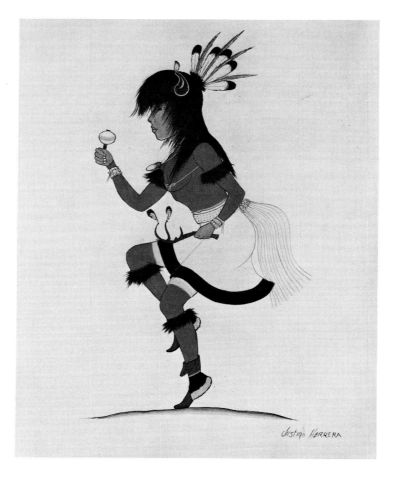

Quintana's, is interesting nonetheless. It is a montage, bringing together wheels and more wheels, a skyscraper, bus, tractor, streamliner, Indian faces in the clouds, an Indian boy and girl standing on two huge books, and numerous other details. Certainly he did not lack imagination! Traditional subjects were also treated by this artist, as can be seen in *Red Buffalo Dancer* (Fig. 5.51).

Stimone, who was born in 1920 and served in the United States Army during World War II, has exhibited throughout the Southwest, including Santa Fe and the 1962 Scottsdale National. Some of his work showed little progress beyond his earlier painting.

Cochití's greatest contributions in the field of Southwestern Indian art have certainly come through Tonita Peña and her son, J. H. Herrera. Both have done important work in carrying on the traditional pueblo style of presentation—the single dancer or group figures, generally without any ground lines whatsoever, with fine detail, excellent color, and with certain individual traits in evidence. Had Ben Quintana lived, unquestionably he would have equaled these two.

## Zía

Among the pioneer painters of the Rio Grande Valley was Velino Herrera (Velino Shije or Ma-Pe-Wi) from the village of Zía. Born in 1902, he was painting by 1917, along with Awa Tsireh and the Hopi, Fred Kabotie, all three under the wing of the School of American Research in Santa Fe. Ma-Pe-Wi had an elementary education, but no formal art training. He was in the fifth grade at the Indian School in Santa Fe in 1922.[39] Proud of the fact that he was self-taught—and justly so—he became a leader in the whole Rio Grande movement in developing this native art. His works have been shown in Washington, New York, Denver, Gallup (grand prize in 1948), Santa Fe, Europe, and many other places.

Watercolor, Shiva, tempera, and oils, all have been mastered by Velino Herrera. He has painted murals in homes and in public buildings; particular mention should be made of his fine work in the Department of the Interior, Washington, D.C. His work is done in a flat style, or with a little shading, or in full perspective. Full realism to abstract painting were developed by Ma-Pe-Wi; frequently the two styles appear in the same picture. Subject matter varies from the old way of life to modern portraits. Native dances, such as *Hopi Indian Dance* (Fig. 5.52), and everyday life of the pueblos have claimed his first and most capable attention; horses and other animals have been popular subjects with him. Qualities of his work will be discussed further in a brief summary based on a few dated pieces.

A Velino picture, dated 1917 or 1918, depicts a spring dance. Two Indian maidens face each other, filling the greater part of the

151

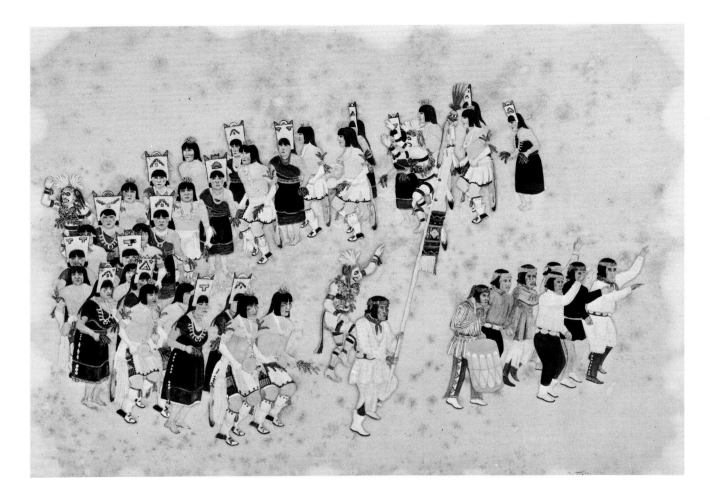

*Fig. 5.52 Velino Shije Herrera (Ma-Pe-Wi), Zía Pueblo.* Hopi Indian Dance. *Courtesy, Mr. and Mrs. Read Mullan.*
—Neil Koppes

space from top to bottom. There is great delicacy in the drawing of feathers in the ornate headpieces. One figure is slightly shorter than the other. The placement of the hands and feet differs slightly. So, too, is there a suggested difference in the hair and ribbons which hang down the dancers' backs. Coloring tends to be quiet; outlines are delicate and soft. There is no background, no foreground.

One of the most interesting of all of Ma-Pe-Wi's paintings was done about 1920. Pach refers to it as an example of the work of a primitive artist in the true sense, wherein there is the "instinctive rendering of things seen."[40] This is the *Legend of the Deer.* Back of the painted legend is, briefly, this story. There was no food. A beautiful maiden went into the forest and, by her singing, brought the deer back to the places where the hunters could get them. In the painting, Ma-Pe-Wi stresses the sudden appearance of the animals by indicating, out of white space, their horns, faces, feet, and so on, those things which were essential to represent these creatures as they were in the artist's mind.

A third dated work is of the year 1922. This is a Zía Corn Dance. Two rows of twelve dancers face each other. To the right

are a cluster of six men, a drummer, and a standard-bearer, with the latter facing the dance group. Two very active koshares are on the right side, also, and they present more motion than was customary at this early time. Some colors are brighter than usual, such as pinks and greens. Outlines are carefully painted.

Another Ma-Pe-Wi painting, dated 1934, shows an early attempt at portraiture. This is the bust of a girl holding a kachina doll. The skin is very dark, the eyes and mouth appear quite Oriental, the hand is well drawn. The girl's face is very sweet, but it does not portray the depth and character, and the excellent delineation of skin, which this artist is capable of, and which he consistently did in later years.

By 1936 Ma-Pe-Wi was painting a variety of subjects. At that time he frequently combined several styles in one painting. A buffalo hunt serves to exemplify this. In the upper left and right corners there are conventional clouds; to the lower left is a straight line out of which grow three conventional sunflowers; and dominating the center of the picture is a diagonal line of five highly stylized buffalos. The animals are practically the same, but their placement and their repetitive sameness give a feeling of rhythm. Into the herd ride two hunters, plunging their spears into the animals. Horses and men are represented in more realistic style. Color is good in this picture, action excellent. This whole treatment bears little resemblance to the comparable Awa Tsireh realistic style with its abstract symbols.

Using this same theme for another picture which he executed in 1941, Ma-Pe-Wi exhibits still another trend in his painting. The conventional sun and floral elements have become greatly subordinated in importance to the figures of the buffalo. There are five of these animals in the front row, four in the back row. Now they have become somewhat geometric in character. The great heads are black with blue triangular markings into which are set the eyes. Red and black bodies are great sweeping, curved lines. The two men on horseback who brave this strange herd are less realistically portrayed than in the above described hunt.

Thus Ma-Pe-Wi developed through the years, adding constantly to his repertoire in color, subject matter, and treatment, becoming bolder and more definitive all the while. Into the early 1950s he painted most dynamic hunts, with snorting buffalos, beautifully formed and exquisitely colored horses, and riders whose bodies are modeled in color to the last muscle. Action in such a scene will run from one figure to the next in rhythmic, flowing lines. It is seen in the outstretched body of the quarry, in the flying run of the pursuing horse, in the bent back of the rider, the pulled bowstring. Color is rich in many of these later works. Fine line and detail have not

been exceeded by any other artist. Herrera's action portrayal is as vigorous and virile as any, often more so than that of Awa Tsireh.

Hewett intimated that in his earliest work Ma-Pe-Wi was inspired by Crescencio Martínez.[41] Certainly some of the subject matter, media, and methods of working indicate that he went far beyond Crescencio, that he developed his own style, his individuality in painting. If anyone influenced him in earlier years, it was more likely Awa Tsireh.

It was in 1922 that the first annual Southwest Indian Fair was organized and held in New Mexico. Among the first-prize winners at this important event was Ma-Pe-Wi. A few years later, 1925, his paintings were among those sent to New York City to fill one of the first orders for Indian work. From this date on his paintings were included in the most important Indian exhibitions, at Corona Mundi International Art Center in New York in 1927, Fair Park Gallery in Dallas in 1928, and others too numerous to mention.

Ma-Pe-Wi had a studio in the State Museum at Santa Fe in 1932. So famous was he by this time that he received honorable mention in the *New York Times* in its review of Indian art. It was said of one of his paintings that "the vivid colors were blended as only the Indian artist can blend them."[42]

In 1936 Velino was teaching in the painting department of the Albuquerque Indian School.[43] Two years later, in 1938, he fulfilled two important art commissions. One was the reproduction, in fresco, of one layer of the scenes on the kiva walls at Kuaua, near Bernalillo, New Mexico.[44] The other was the production of murals in the Department of the Interior Building, Washington, D.C. For part of the latter he used the theme of a buffalo hunt; for another scene, Zía women making pottery. In the latter scene Ma-Pe-Wi depicted, with unerring accuracy, the exact designs on several large jars in the foreground of the picture. There is no true perspective; the vessels are to the front and lower, the women in the center and higher up in the picture.

Ma-Pe-Wi also illustrated a number of books. Along with several other artists, he did some of the illustrations for Dr. Ruth Underhill's *Workaday Life of the Pueblos* and *Pueblo Crafts;* simplicity in drawing and clean lines make his work a helpful and instructive addition to each volume. His imagination had more opportunity to express itself in the illustrations for three additional volumes by the same author, *Singing for Power, The Papago Indians of Arizona,* and *People of the Crimson Evening.* Although these three books are concerned with an entirely different tribe, and largely with a long-ago time, he captured the spirit of Papago tribal customs and lore, portraying them with considerable detail and feeling in his line drawings.

He also illustrated *Young Hunter of Picuris,* a child's book by Ann Nolan Clark.

In his painting of the late 1940s and early 1950s, which represents his peak, Ma-Pe-Wi perfected his brushwork. This, combined with realism, modeling in color, perspective, and perfect technique gave complete naturalism to much of his painting—one can virtually feel the texture of an animal's hair, the softness of hand-woven cotton fabrics (Fig. 5.53). Like so many of the better Indian artists, he moved gradually from an earlier design-oriented style, to stylized realism, to ever-greater naturalistic realism, and this despite a retention of heavy symbolic design in some of his late efforts of higher quality.

In 1932 Hartley Burr Alexander paid tribute to this important pueblo artist:

The art of San Ildefonso, for example, has certainly been more affected by the work of Velino Herrera than by any other single external influence .... It is to Velino that are due the introduction of the highly conventionalized cloud crescents, with pendant rain ... to Velino again is due the popularity of the pinto pony as a decorative figure; and Velino and Fred Kabotie are the real developers of the modeled figure in Pueblo Indian art.[45]

A preserver of pueblo tradition, such as portrayed in *Eagle Trapping* (Fig. 5.54), a developer of new ideas, Ma-Pe-Wi painted both in the traditional manner and in his own style. Ceremonial, traditional, and genre subjects were produced by him in endless numbers, not only in reference to Zía, but to other Rio Grande pueblos as well. There is good reason why Ma-Pe-Wi is perhaps the best known of the pueblo artists, why he is internationally known. Although Zía has frowned upon creative painting less than some of the other pueblos that have opposed the depiction of ceremonies, nonetheless she has produced few artists. Ma-Pe-Wi is their only great artist as of the early 1970s. He left his native village some years ago, yet he continued to be identified with Zía, bringing honor to this village through his painting until an accident in 1955 which claimed his wife's life and seriously injured him. Since that time Velino has done very little painting, and most of it is vastly inferior to his earlier work.

Ignacio Moquino (Waka-yeni-dena) was born in 1917, in Zía Pueblo. He began his painting career during his two years of graduate work at the Santa Fe Indian School. For a time he painted quite a bit; as a result, he is well represented in both public and private collections. After he married—into San Juan Pueblo—his responsibilities kept him from painting except for occasional pieces.

A word about two of his pictures will indicate the directions in which Moquino was heading. One, a Corn Dance, is a very balanced, early pueblo-style painting. In the center is a large, somewhat

155

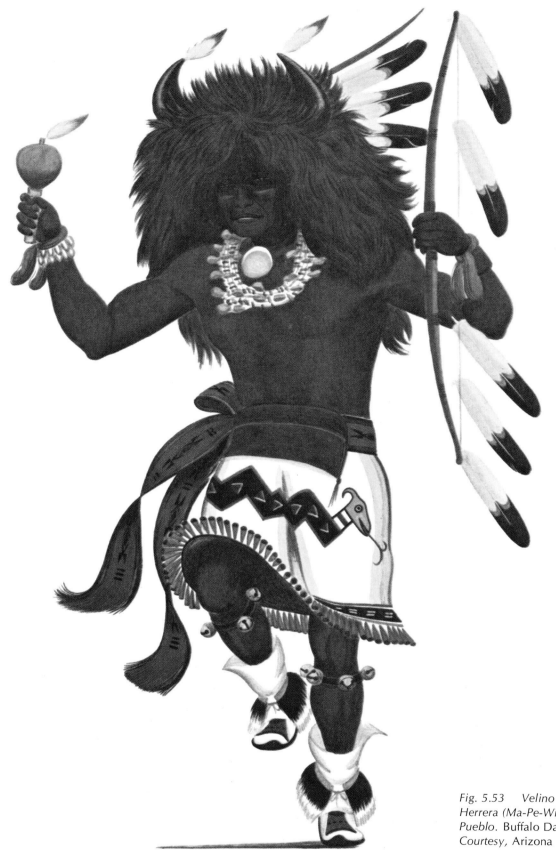

156

*Fig. 5.53    Velino Shije Herrera (Ma-Pe-Wi), Zía Pueblo. Buffalo Dancer. Courtesy, Arizona Highways.*

157

Fig. 5.54 *Velino Shije Herrera (Ma-Pe-Wi), Zía Pueblo. Eagle Trapping. Courtesy, The School of American Research, Santa Fe.*
—Laura Gilpin

conventionalized cornstalk with cloud and rain symbols above, a drummer sitting on each side of the cornstalk, and a dancer also on each side of the central theme. The second painting, *Two Great Hunters,* quite definitely reflects Navajo ideas, from hills in the background and ground lines to the outstretched bodies of the horses racing downhill, with their riders shooting antelope on another hill. Another antelope hunt is represented in Figure 5.55. Moquino was among the Indians who painted the murals for one of the halls of the United States Office of Indian Affairs at the Golden Gate International Exposition in San Francisco, 1939.

Rafael Medina (Tee-ya-cha-na), born in Zía Pueblo in 1929, studied at Albuquerque under Velino Herrera and José Rey Toledo. Encouragement in his art work was given him by Mary Mitchell in Santa Fe. He has painted largely in the traditional manner, with a few variations. For example, his *San Felipe Woman Dancer* presents the subject of his title in the center of the painting performing controlled dance steps, with two male dancers higher up in the picture and smaller in size—so like earlier pueblo styles. Colors are true to original dress and paraphernalia. There is no background, no foreground. Another painting in this traditional style is *Zia Planting Dance* (Fig. 5.56). Quite different from this is *Crow Dancer,* an almost solid-black figure which fills the paper, with a conventional cornstalk in the opposite lower corner. Somewhat mystical and quite effective is his casein painting, *Four Moons and Koshare God Looking Down Blessing the Earth and His Children* (Fig. 5.57). On black paper are painted the four moons, each a little dimmer from front to back, and the large figure of the black-banded, white-bodied koshare standing on the edge of the moon, looking down.

For the most part, Medina has employed water-based paints and caseins, particularly; but he also has worked with scratchboard. A feeling of a monotone study pervades his paintings in many instances; even where he uses several colors, they tend to be in limited areas. Frequently detail is quite good, for example, in ceramic and ritual designs or costume minutiae; withal, Medina's work has a distinctively pueblo flavor. In a painting which he entered in the 1969 Scottsdale show, titled *Desert Antelope Dance,* detail was quite improved and there was good modeling in the flesh and ceremonial garments of the performers. This painting also had a heavy sun-cloud symbol over the dancers. *Bird Society Dance* is quite perfectly done, and is faultless in detail. Thus detail, modeling, and color are frequently beautifully expressed by Medina in his later work.

Another of his paintings which combined symbolic design and dance figures, *Answered Prayer,* merited the Grand Award at the 1966 Philbrook show. Medina also took a top award at the 1967

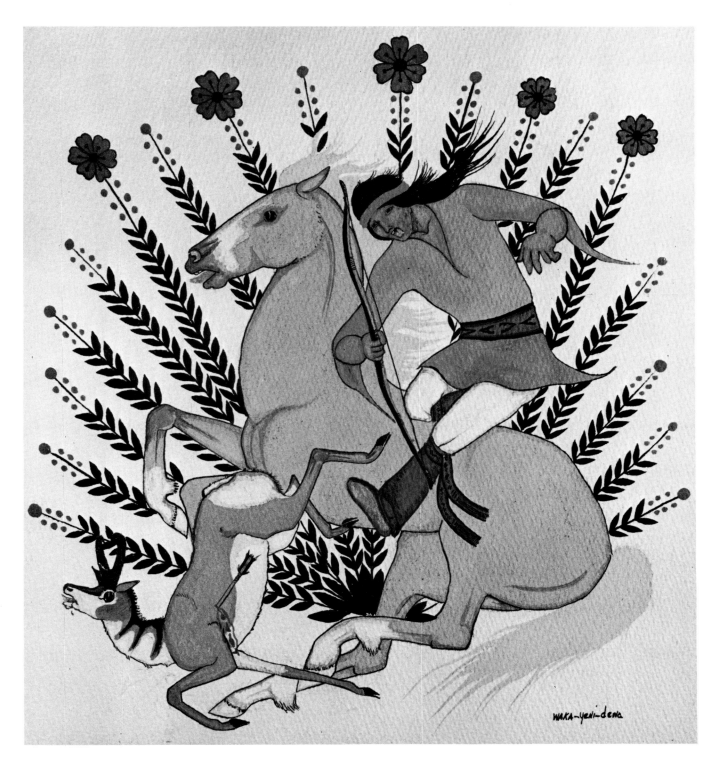

Fig. 5.55    Ignacio Moquino
(Waka-yeni-dena), Zía
Pueblo. The Antelope Hunter.
Courtesy, The Heard Museum
of Anthropology-Primitive
Art, Phoenix.
—Neil Koppes

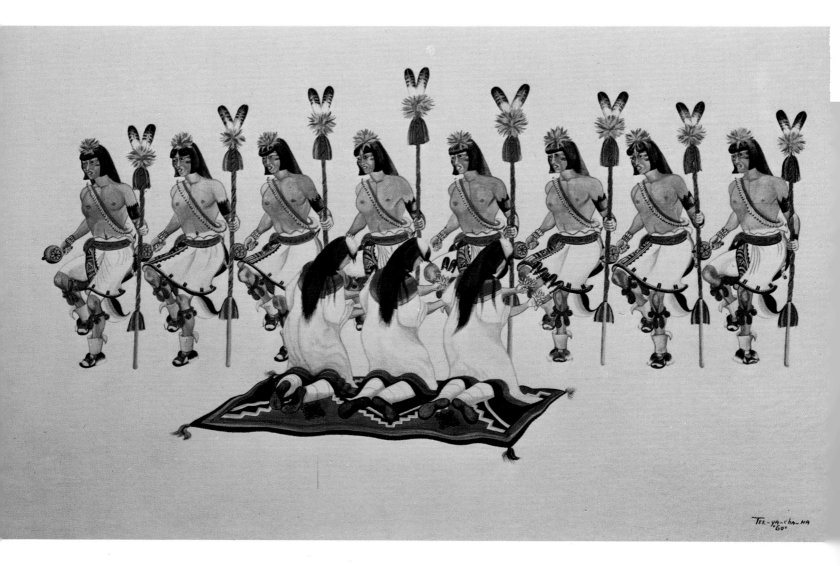

Fig. 5.56    Rafael Medina
(Tee-ya-cha-na), Zía Pueblo.
Zía Planting Dance. Courtesy,
Rafael Medina and Dr. and
Mrs. Byron C. Butler.
—Neil Koppes

160

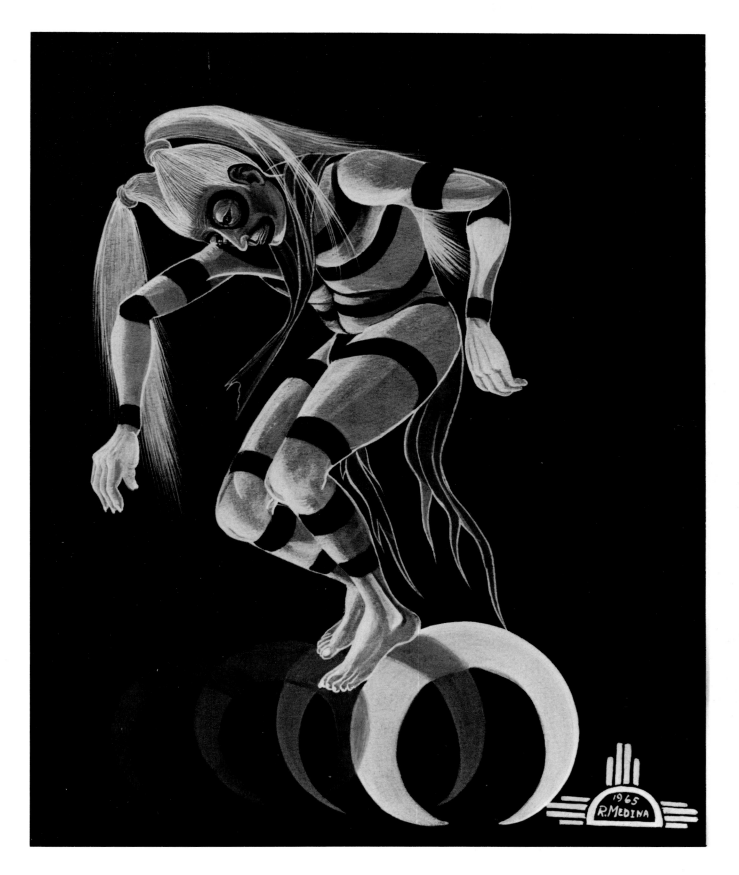

*Fig. 5.57    Rafael Medina (Tee-ya-cha-na), Zía Pueblo.*
Four Moons and Koshare God Looking Down
Blessing the Earth and His Children.
*Courtesy, Rafael Medina and the Avery Collection.*
—Howard's Studio

Scottsdale show, an honorable mention in the Heard Museum Arts and Crafts competition in 1969, and the same at the Philbrook 1970 show. At the 1971 Scottsdale National he received the first award in the watercolor classification for his *Initiation of the Spruce Society* (Fig. 5.58).

The last Zía painter to be mentioned, José D. Medina, has featured the pueblo style in his watercolors. The brother of Rafael

*Fig. 5.58    Rafael Medina (Tee-ya-cha-na), Zía Pueblo. Initiation of the Spruce Society. Courtesy, Rafael Medina and Collection of Richard L. Spivey.*
—Robert Nugent

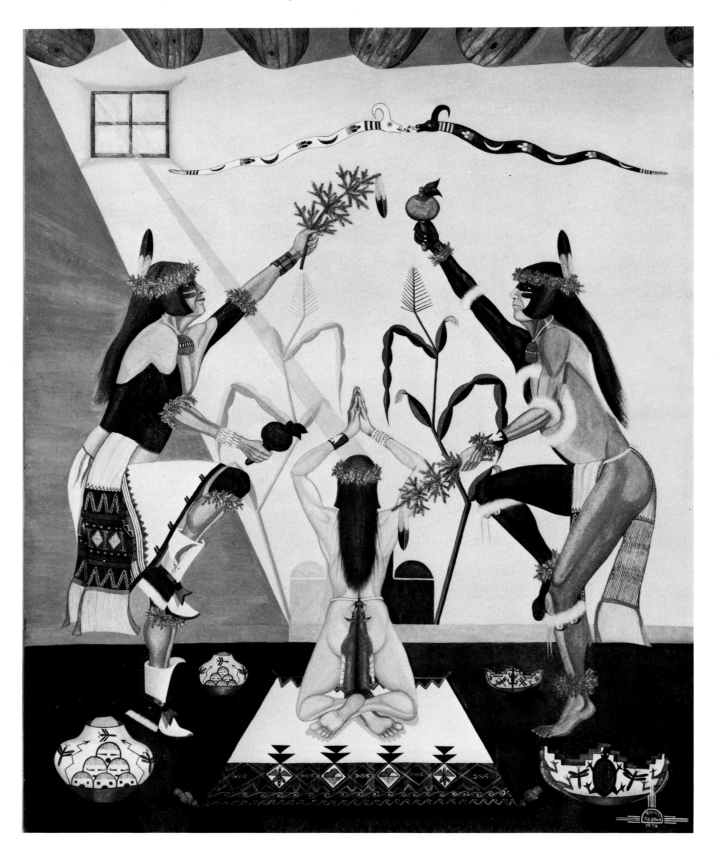

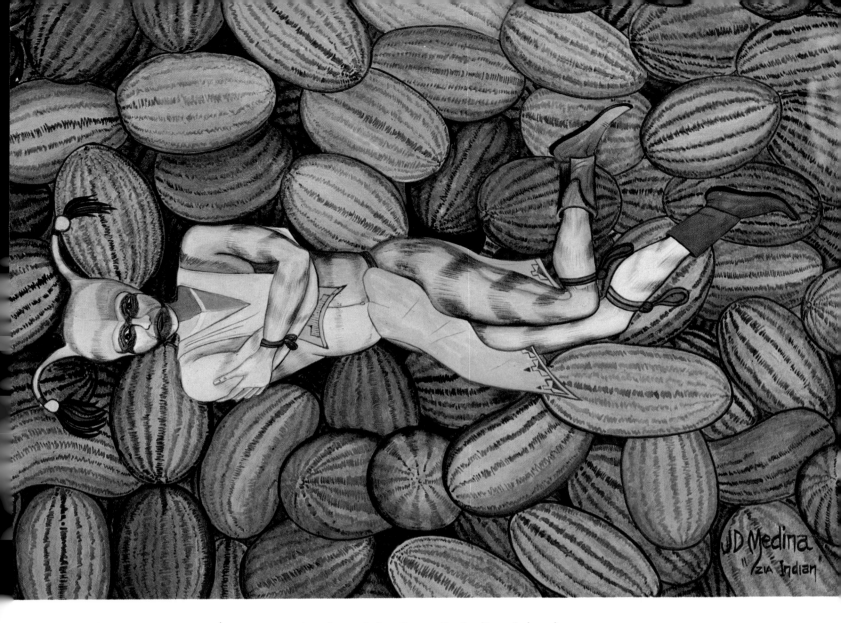

Fig. 5.59    José D. Medina,
Zía Pueblo. Harvest Year.
Courtesy, James T. Bialac.
—Neil Koppes

Medina, he attended Zía Day School, and the Santa Fe Indian School from 1949 to 1953, during which time he began painting. He ceased painting in 1953 but took it up again in 1958. It was presumably during this period that he served four years in the Marine Corps. Later he attended the Institute of American Indian Arts. Watercolor has been his basic medium.

One casein painting titled *Northern Wind* shows the dance leader alone struggling with the ritual banner atop a long pole. Banner and pole bend to a strong wind. The man's figure and banner fill most of the paper; in the far distance are dwarfed pueblo houses. This is a pleasing composition, color is quiet, and detail is excellent. A 1967 painting, *Harvest Year* (Fig. 5.59), is resplendent in the brilliant greens of watermelons. Birds and animals have been well portrayed by J. D. Medina.

Zía Pueblo has produced a limited number of artists. Most outstanding is Ma-Pe-Wi; unquestionably he contributed much to the

163

growth of the Rio Grande pueblo art and influenced his own and other tribal artists both during and after his most productive years. An important later artist, Rafael Medina has perpetuated much of the Rio Grande traditional style into the early 1970s. He and J. D. Medina both hold promise for the art future of Zía Pueblo.

### Jémez

Not many artists had developed up to 1970 in the pueblo of Jémez. Formerly craft arts were highly developed, but no great amount of production has been in evidence for some time even in this line. There is surely latent ability here, however, for many of the children in the elementary school have displayed for years a great amount of talent. Certainly the recorded kiva murals from this pueblo also bear witness to artistic potentials.

José Rey Toledo was born at Jémez in 1915, but he has been away from his village for many years. He had some training in fine arts and art education, and later received an A.B. degree in the latter subject from the University of New Mexico. At the same time he assisted in arts and crafts at the Indian School in Santa Fe. After graduation, he became head of the art department of that institution. He has exhibited at the Santa Fe Fiesta, Gallup, the New Mexico

*Fig. 5.60    José Rey Toledo, Jémez Pueblo. Zuñi Shalako Dance scene. Courtesy, Inter-Tribal Indian Ceremonial Association Gallup, N.M.*
—George Hight Studios

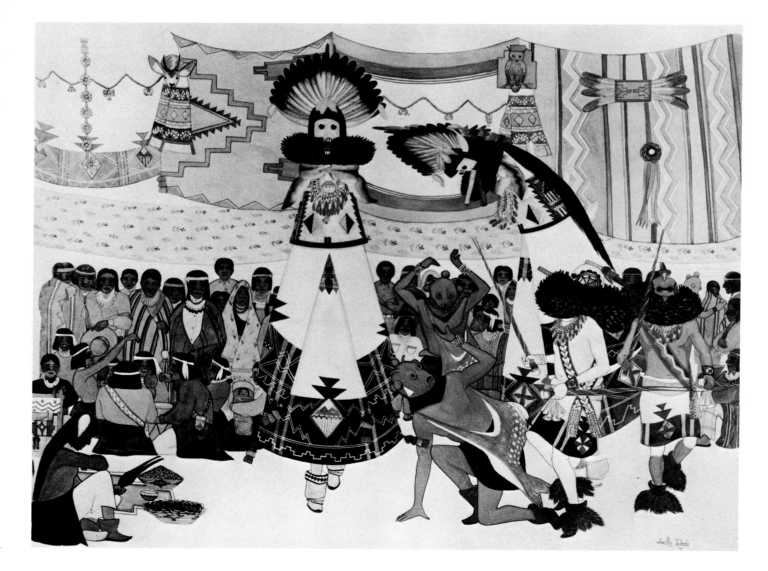

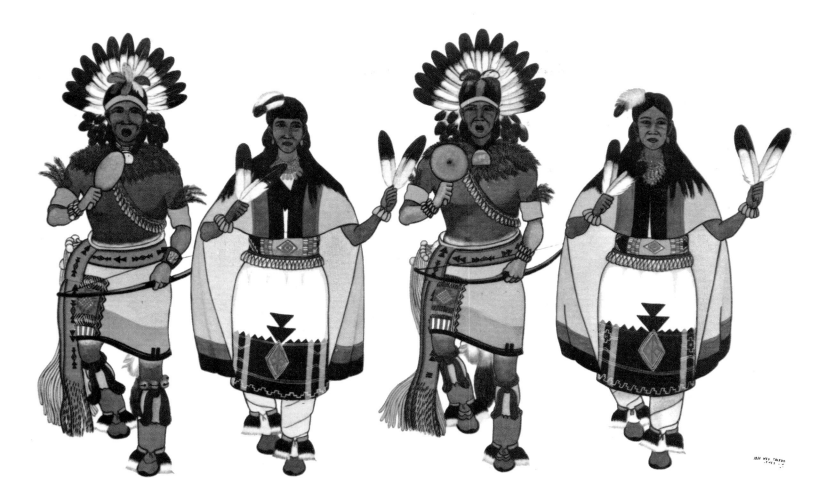

State Fair, the Golden Gate Exposition in San Francisco, and at Phil-brook where he won the First Purchase Prize in 1947; also he has won prizes at other shows.

Using watercolors and Shiva in particular, Toledo has fol-lowed traditional Rio Grande and other tribal subject matter in many of his paintings—single or group dance figures and village scenes. Many small conventional elements linger in his paintings, but there is also a great deal of activity even in religious scenes (Fig. 5.60). Often there is no background, just flat figures against a plain sheet of paper, or there may be a background of conventional trees or other features against which semi-realistic dancers perform. In some paint-ings there is great attention to minutiae. Good, rich coloring appears in his work (Fig. 5.61).

In a single dance figure, done in 1939, there is an attempt at shading. Excellent detail is expressed in costume and jewelry, and motion is evident in the flying necklace and yarn bands at the knees. The same splendid qualities are evident in the prize-winning picture

*Fig. 5.61 José Rey Toledo, Jémez Pueblo.* Pueblo Dancers. *Courtesy,* Arizona Highways.

165

exhibited at Philbrook in 1947. This is titled *Dancing Spirits* and portrays a Zuñi Shalako ceremonial dance. In the background are four excessively tall Shalako figures, the one on the far left bending slightly out of line to break the monotony of the repeated figures, and incidentally to peck at one of the "heckler" mudheads in front of him. To the lower left front are three of these mudhead dancers, each in a different position. Then come three unmasked dancers with yucca whips in their right hands. Balancing the cluster of mudheads is a group of chanters in the lower right-hand corner, and directly behind them are several masked guardians of the gods, also equipped with yucca whips to carry out their duty of seeing to it that the relatives of dancers are reverent throughout the ceremony. This is a splendid composition as a whole, showing a great deal of balance without the usual exact duplication of figures. Combined in this painting are traits from early years and a new vigor and strength. It is pieces like this which indicate a continuing native art in the Rio Grande. Also, the same piece demonstrates that this art is not a static but a changing expression.

Toledo developed an abstract style which is very different from typical Indian work, and it has won recognition for its unusual and well-executed qualities. One painting of an old theme, a Rain Dance, serves to illustrate this different approach. A highly stylized figure of a single dancer dominates the whole picture. To the right is an unusual abstract drawing of a cloud and rain symbol made up basically of three round lines for the piled-up clouds, but set at an angle. The rain issues from them, also at a slant. The mere placement of the cloud at this angle makes it far more dynamic. In solid colors, rich and deep in quality, the dance figure is done in straight, wavy, and zigzag lines, in parallel lines and bands, and with diamonds and triangles for everything but the hair. The latter is done in large conventional but quite graceful locks of a curved nature. Even though the bands which make up the figure are "wooden" in themselves, they make the painting quite dynamic and add great rhythm and flow of line. This is well demonstrated in the lines of the belt fringe, in the repeated hair locks. This painting would seem to culminate an interesting change through the years, from a dominantly conventional and generally schematic treatment, to a well developed and realistic dance figure style, to a last phase where the dance figure is again—but differently—conventional and highly stylistic in treatment.

In the late 1960s, Toledo took up painting for a second time, after many years of inactivity. Again he used water-based paints. In his *Zuni Shalako, 1967* (Fig. 5.62), a bare suggestion of modeling appears but flat color dominates, heavy outlines are common, and details in jewelry are good. However, in the portrayal of feathers

there is more of a suggested than a realistic quality. There is the possibility that he will develop a new style after he once again cultivates a long-inactive hand.

Emiliano Yepa attended the Indian School in Santa Fe and is listed by Dunn as one of the outstanding artists of the studio group within the 1932–37 period. In some paintings by Yepa color is gay, and in some of them swift action is dominant. An example of the latter pictures two antelope as they are overtaken by a horseman riding bareback. The general feeling is neither pueblo nor Navajo, but two perfectly balanced plants in the lower left- and right-hand corners favor the former. Despite the action, the animals are rather wooden. Balance dominates in his compositions.

When a student at Santa Fe, Yepa participated with others in painting murals on the walls of the social sciences building. Like the work of so many others, a conservative style was suited to the portrayal of village ceremonies and genre scenes, yet his palette frequently was brilliant. Yepa painted but a few years for he died when relatively young.

Several students from the day school at Jémez of the mid- and late 1960s should be mentioned, for they have shown considerable

Fig. 5.62   *José Rey Toledo, Jémez Pueblo.* Zuñi Shalako, 1967. *Courtesy, James T. Bialac.*
—Neil Koppes

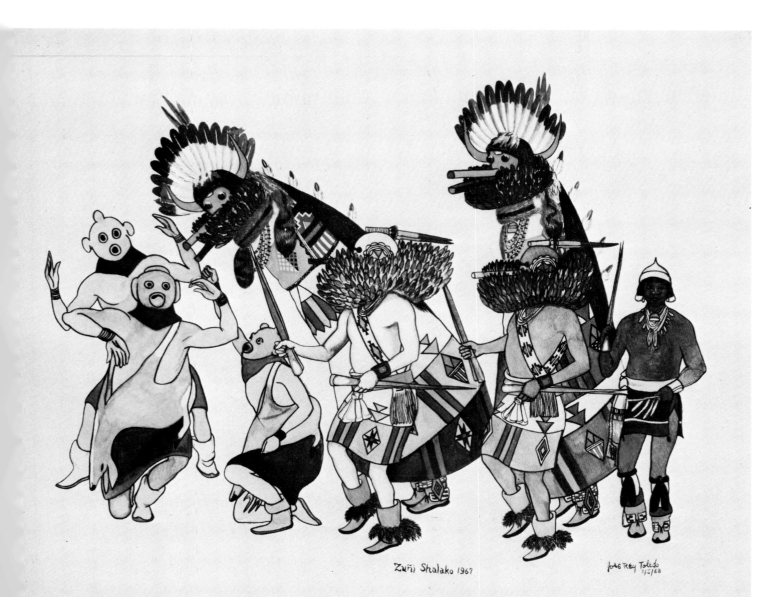

Zuñi Shalako 1967

José Rey Toledo 3/2/68

promise. These and many others from the school, under the capable direction of Al Momaday, a Kiowa Indian, have been producing rather outstanding quality in their painting, in color, design, and draftsmanship. Watercolor is the medium used by these students.

Raymond Chávez has done single dance figures or heads of dance figures in the traditional or in conventional manner; usually in contrasting colors, they are large, simply but accurately drawn (Fig. 5.63). Clara Shendo painted a turtle in tempera which fills the paper and is symmetrical; she also has employed rather vividly contrasting colors. María Chinana has evidenced a good hand for design as exhibited in her more imaginative *Turtle* (Fig. 5.64), but less ability in composition in relation to dance scenes, as noted in her *Horse Drummer*. A number of Chinanas, including Larry, Paul, Felipe, and Christina, began to exhibit in the late 1950s and 1960s, particularly at the Museum of New Mexico Fine Arts Show. Paul Gachupin has demonstrated potentials in the abstract field in his painting of very red hands on a background of broad black and blue bands. Mary Gachupin, although heavyhanded in the use of color, has shown a flair for design in several paintings (Fig. 5.65).

Jémez has contributed one important artist, José Rey Toledo, to the Rio Grande scene. He has perpetuated the general concepts of the traditional style of this area, particularly in his dance figures; he has also given a certain spark of originality to other creations. It is unfortunate that he was not able to give more time to art. Judging by the number of talented young schoolchildren from Jémez, it would seem that there is a bright artistic future ahead, in both the traditional and modern styles of expression.

## Santa Clara

Despite its proximity to the artistically active pueblo of San Ildefonso, and despite linguistic ties between the two, Santa Clara has produced a relatively small number of painters. Certainly the outstanding individual from this village is Pablita Velarde (Tsan).

Pablita Velarde was born in Santa Clara Pueblo in 1918. She attended the U. S. Indian School at Santa Fe where she studied art under Dorothy Dunn, graduating in 1936. She has had no further instruction. Later she did some teaching of drawing at the Santa Clara day school. In 1938, she toured the Middle West and East as the guest of Mr. and Mrs. Ernest Thompson Seton. Then she built her own studio and continued to paint in her native village. Later she moved her studio to Albuquerque and has lived there for many years, educating her two children in this New Mexican city. Her desire has been to perpetuate the traditional art of her people, painting basically

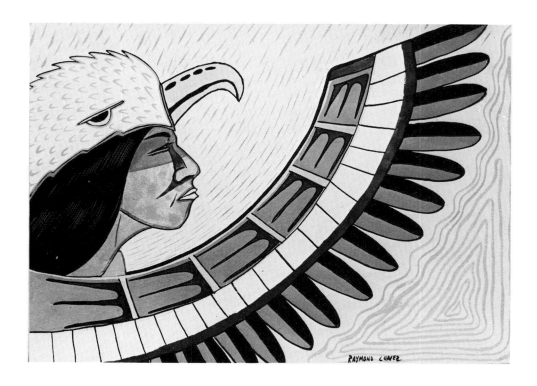

Fig. 5.63 Ray Chávez, Jémez Pueblo. Eagle Dancer. Courtesy, Dr. and Mrs. Byron C. Butler.
—Neil Koppes

Fig. 5.64 María Chinana, Jémez Pueblo. Turtle. Courtesy, the Avery Collection.
—Howard's Studio

Fig. 5.65 Mary Gachupin, Jémez Pueblo. Bird Design. Courtesy, the Avery Collection.
—Howard's Studio

in the style of her contemporaries and improving it whenever possible; through the years she has experimented with new ideas.

One of the most interesting accomplishments of Pablita Velarde is the series of paintings she did for the museum at Bandelier National Monument in New Mexico, a short distance from her native village. This ambitious project gives vivid glimpses into the daily life of the puebloans of the Rio Grande, including seasonal and other ceremonies, religious and political organization, aspects of everyday life and crafts, and a composite view of the pueblo. All of the paintings exhibit an extraordinary amount of fine detail, and in this respect are valuable ethnological studies. Whatever the particular group, there is the proper costume detail from hairdo to moccasin. Prior to this undertaking, Pablita had concentrated on simpler and more limited subject matter, primarily the household activities of the women of her village.

A wealth of native lore is given in the Bandelier paintings. Color, directional, and other types of symbolism are cleverly worked into seasonal dances. For instance, associated with summer are the south, the lynx, the fir tree, and the color red. These and other composite pictures required a great depth of vision in their creation, as well as detailed knowledge.

In craft art representations, familiarity with detailed processes is well demonstrated in the Bandelier drawings showing drum making, smithing, tanning and dyeing of buckskin, beadwork, basket making, drilling and stringing turquoise beads, and other minor crafts. In her composite picture of pueblo life nothing is left out, although quite a lot of the work is more suggestive than completely drawn. Men's and women's activities are particularly interesting as ethnological studies, for they show everything from details of costumes to sex division of labor. Indeed, one is assured that the artist is thoroughly familiar with every aspect of the life of her village, and that she has partaken of it fully; research alone into her village background could not account for these understanding portrayals of such varied subjects. Very interesting is the series of drawings by Velarde on the use of plants by the Indian. Here are shown cultivated plants, the wild varieties used for food, plants that have ritual significance and use, and the various uses to which plants are put for craft purposes.

A clever group of these paintings shows the inner workings of the pueblo order, in particular, how the native priest is the real controlling factor in the villages. Interior scenes in the ceremonial chamber—the kiva—are given, one of them with twenty-six individual figures represented! A very colorful drawing in this group, and one full of a great deal of action, is a ceremonial rabbit hunt.

Ground, sky, rocks, brush, all are shown, as well as the many men with guns and the old-style curved rabbit sticks. This is one of few drawings in the entire series which has perspective; it is complete with background and foreground.

Last in the series are a number of drawings of ceremonies. Here Pablita Velarde, true to her puebloan traditions, does her best work. There are no backgrounds or foregrounds. But there is excellent detail in costume, and there is, in general, rather restrained action. Withal, her work expresses basic integrity, a faithfulness to her people and to her culture.

Pablita Velarde did these paintings between 1939 and 1948. It is quite obvious which are her earlier efforts, for faces are poor, proportions not so good, and the work quite sketchy in general. Later paintings reveal good composition, excellent faces and figures, shading in garments and skin, and far finer detail. Pablita never drew convincing horses.

In 1939, in cooperation with several other Indian artists, Pablita aided in decorating the façade and entry to the Maisel Building in Albuquerque. Her casein tempera mural, applied in fresco secco, *Santa Clara Women with Pottery,* is typical of much of her work—a massive, simple design which, says Dorothy Dunn, "evokes the poise and gentle strength of Pueblo women."[46] The eight women, despite the fact that they are presented in a line, are not monotonously repetitious, for facial expression varies and each wears a differently patterned dress. Pablita delineates with care and exactitude the checks, figures, and flowers of each costume.

Pablita did two more murals in the late 1950s, one in Houston, Texas, and the second in the Western Skies Hotel, Albuquerque. In the early 1960s she painted a mural in a bank in Alamos, New Mexico.

Pablita Velarde has painted in casein and tempera all through the years; occasionally she has used oils; and in her later work, particularly in the late 1950s, throughout the 1960s, and into the 1970s, she has used earth colors frequently. As she has said, she picks up the latter materials when and where she finds them, grinds them, and mixes them with a fixative when she uses the soft and lovely colors. Practically all subject matter featured by puebloans has been done by Pablita in casein tempera—the genre scenes and ceremonials of her own people and other tribesmen, prehistoric motifs, all sorts and sundry life forms, and Indian legends and myths. Because of her more limited use of oils, her subjects in this medium have also been more restricted; typical would be pueblo subjects portrayed in murals. Her use of earth colors has been most effective

171

Fig. 5.66    Pablita Velarde
(Tsan), Santa Clara Pueblo.
Polychrome and Mimbres Motifs.

in abstract painting, combining native geometric and life themes of both prehistoric and historic origins (Fig. 5.66).

There has been considerable development of Pablita's abilities from early years to the late 1960s. This has been mentioned above in relation to the Bandelier museum murals; in the twenty years following their completion she attained still greater heights in sophistication of painting. She moved rapidly from childish portrayals in simple colors that were design-like to a broadened palette and subject area, and to creative compositions which lost the formal balance of earlier years. Along the way she experimented with three-

172

dimensional painting, including shading, background, and full perspective. *Her First Dance* (Fig. 5.67) reflects these better qualities. But her best work remained basically two-dimensional. Her earlier efforts had charm and delicacy as, for example, when she portrayed "a pleasant and rhythmic design of corn grinding."[47] Later her work

*Fig. 5.67    Pablita Velarde (Tsan), Santa Clara Pueblo.* **Her First Dance.** *Courtesy, The Denver Art Museum.*
— Neil Koppes

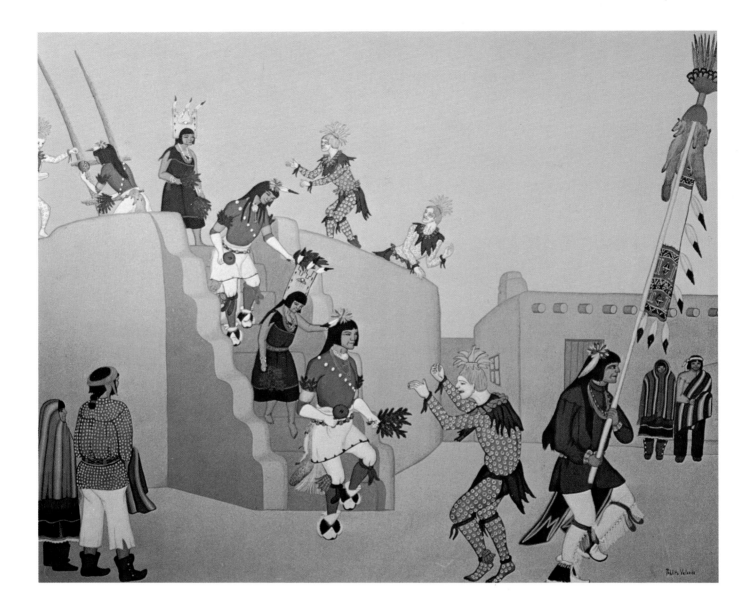

combined strength, dignity, glowing color, poise, naturalness and "the deep rich symbolism of Pueblo life itself."[48] An early version of this aspect is to be seen in *Green Corn Dance* (Fig. 5.68).

To be sure, certain qualities label some of Pablita's painting "Indian," such as harmonious colors (particularly pleasing in earth paints), symbolic design, semi-realistic emphasis, naïveté, flowing rhythm, flat colors, little or no perspective, sophisticated design, and excellent treatment of minutiae. And, perhaps, her high attainment in abstracts may also be "Indian"; particularly in earth colors, which are featured in this style, has Pablita reached a peak, both in handling her medium, in integrating her subjects into effective and unusual compositions, and in creative painting. Splatter-brush technique is most skillfully handled by Velarde.

A cross section of her mid- and late-1960s painting runs the gamut from typical pueblo semi-realism through full abstraction. An example of the former, *He Became a Giant,* shows a huge koshare dominating the center of the picture with three normal-sized figures exclaiming in gestures over the phenomenon. More stylized is a figure of *Sun Priest* which fills the full, long paper; there is some slight background detail, in abstract designs. Fully abstract and muted in color are *New Beginnings* and *Reflections of Elements.* Sheer design mindful of ceramic decoration is to be noted in her *Rain Bird.* In the 1969 Scottsdale show she won a second-place award for her well-executed *Quirana Dancers* in earth colors. Figures, composition, play in the soft earth tones—all come up to her usual high standards in this painting. Excellent color was also featured in another of her paintings in this exhibit, *Herd Dance,* done in earth media. Extension of subject matter beyond pueblo life is to be noted in *Apache Devil Dancers* (Fig. 5.69).

Pablita has exhibited and lectured widely throughout the United States. After writing a book based on tribal legends, *Old Father the Story Teller,* she became even more popular as a speaker. She did all of the illustrations in this book;[49] one in particular is

Fig. 5.69   *Pablita Velarde (Tsan), Santa Clara Pueblo. Apache Devil Dancers. Courtesy, The Amerind Foundation, Inc.*
—Ray Manley Photography

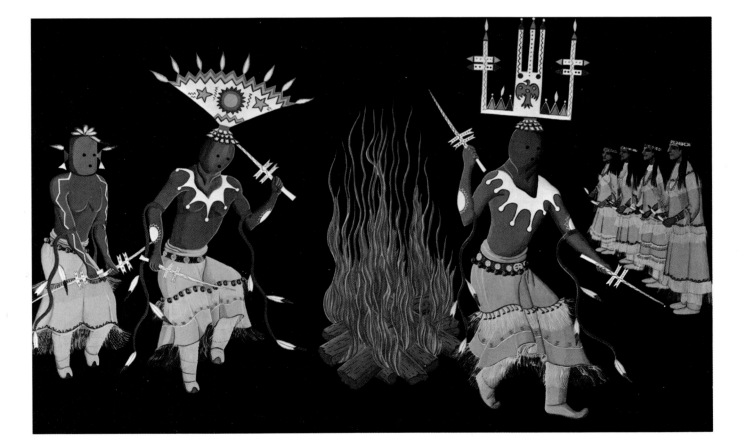

perhaps the finest painting she has ever executed. This is the *Old Father* (Fig. 5.70), and it shows the elder sitting in the plaza telling stories to the many children surrounding him. Their rapt faces are held by the story told and by the Milky Way and various constellations that form the distant uppermost backdrop against which the migrating ancestors are pictured. Pueblo designs and various animals, a spider, birds, and the extended village are likewise effectively woven into this background. Muted browns, tans, and grays are used in the dominant figures of the foreground and the Milky Way, all against black paper. Only in the geometric designs are other colors allowed—pale shades of yellow, blue, and soft reds. A feeling of mystical light is effected in the handling of these pale colors.

In all of the major exhibits of Indian painting Pablita Velarde has taken top prizes. She has won many competitive prizes, among others the Scottsdale Grand Award in 1965; at Philbrook the Grand Award in 1953 and the Trophy Award in 1968; and firsts at Gallup in 1969 and 1971. She has been recognized with many special awards, in particular the Walter Bimson Grand Award at Scottsdale in 1969, and the French government's Palmes de Académiques. She is represented in major public and private collections of Indian art throughout the United States, including, among others, such museums and galleries as the Philbrook Art Center and Gilcrease Foundation, both in Tulsa, Oklahoma; in Santa Fe at the Art Gallery of the Museum of New Mexico; the De Young Museum, San Francisco; Denver Art Museum; Central Museum, Orlando, Florida; and the Desert Museum, Palm Springs, California.

Pablita Velarde has long and rightfully been the leading Indian woman painter of the Southwest. Her place will be strong in the history of art in this area. Posterity's debt to her will be great, for she has sensitively communicated through her painting a wealth of pueblo lore, from everyday living, through ritual life, into the significant fields of myth and legend. In some of her late-1960s works she gave a new sophistication to the old style. In 1970 she was still exhibiting and placing in the major shows; she was awarded two honorable mentions in the Scottsdale show of that year, one for a watercolor and one in the miscellaneous media class.

Helen Hardin (Tsa-sah-wee-eh), the daughter of Pablita Velarde and an Anglo father, was born on May 28, 1943. She spent her childhood in her native village and her youth in Albuquerque where her mother had established a studio. Growing up in this atmosphere, she started painting at an early age, quite naturally in a simple and childish manner, and in watercolors.

Helen attended the special art school for Indians at the University of Arizona in 1960. As a result of this training, and as

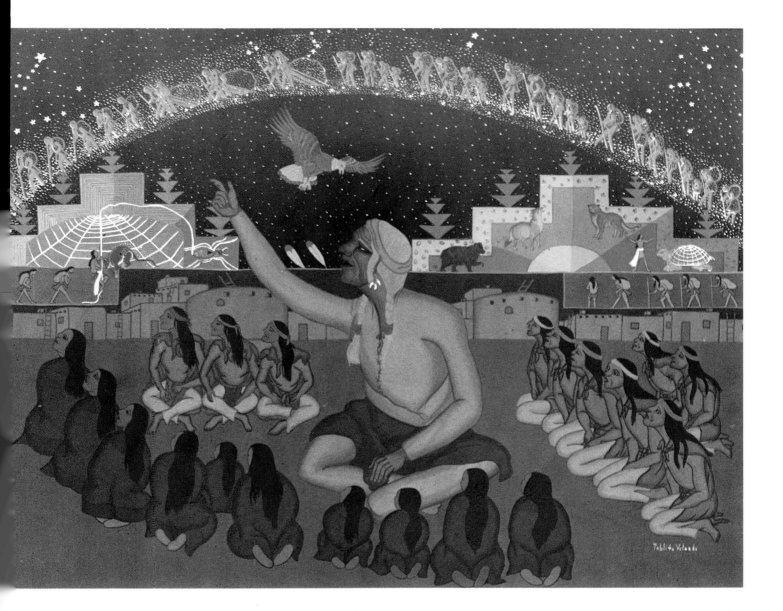

Fig. 5.70    Pablita Velarde (Tsan), Santa Clara Pueblo. Old Father. *Courtesy, Pablita Velarde.*
—Buddy Mays

the daughter of Pablita, she experimented widely and fruitfully with various media and styles. Since attending the special school she has grown in stature as an artist. A 1968 one-man show in Bogotá, Colombia, pointed up her diversity, for there she exhibited casein, earth, and other media; traditional and abstract paintings and line drawings; and a variety of Indian subjects derived from both her contemporary background and from prehistory. One traditional painting with village and mountain background (Fig. 5.71) in European style shows another combination not infrequently painted by Hardin.

It was after the Colombia show that Hardin began to experiment with acrylics, in some instances using them as a sealer for casein layers, then scraping back to give an almost antique effect.

177

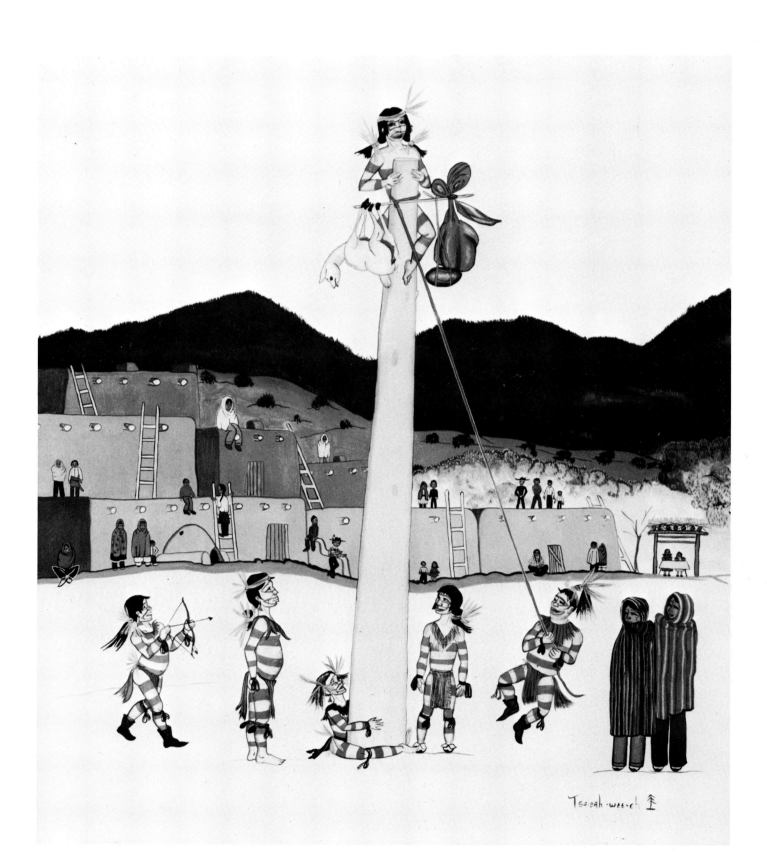

*Fig. 5.71    Helen Hardin (Tsa-sah-wee-eh), Santa Clara
Pueblo.* San Geronimo Day at Taos. *Courtesy, James T. Bialac.*
—Neil Koppes

This proved interesting for subjects drawn from prehistoric kiva murals. Other muting of colors favored by Hardin includes the use of fine spray, often light, over partial or complete surfaces.

Although Hardin has used abstract backgrounds against which traditional subjects in traditional pueblo styles are sometimes painted, she has concentrated on the abstract alone in some of her work. One painting, titled *Medicine Talk* (Fig. 5.72), reflects this trend. The viewer is well aware of the close-drawn figures of three men but

*Fig. 5.72   Helen Hardin (Tsa-sah-wee-eh), Santa Clara Pueblo.* Medicine Talk. *Courtesy, James T. Bialac.*
—Helga Teiwes, Arizona State Museum

179

these can quickly be lost in the swirls of color which comprise their unrealistically long robes. Color is handled effectively in the use of both light and bright yellow and fairly strong blue, and more subdued greens and reds in this painting.

An example of one of her traditional subjects painted in the pueblo style combined with a more impressionistic background is *Visitation of Towa and Talavi.* A man of pueblo proportions and dress squats in an equally puebloan manner near a mesa-top edge. In the far distance and coming from behind a mountain are the sun's disk, in masked form, and a kachina figure, both indistinct representations. Even more impressionistic is a full-paper figure, *Spirit of Fertility,* done in pale and most delicate shades of greens, yellows, orange, and tan. Pleasingly abstract is her *Sacred Paths of the Oh-Kwoo-Wa,* which features pueblo masks, a sash and kilt, and geometric forms in richer, deeper tones than in the previously described picture.

Hardin exhibited widely through the 1950–60 and 1960–70 decades. Her paintings appeared in the Scottsdale National, Gallup Ceremonials, and other Southwestern shows with increasing frequency during the later 1960s. She entered watercolor, polymer, and mixed-media classes in the Scottsdale show in 1969, winning an honorable mention in the first of these categories. This study, *Fathers and Sons of the Mimbres,* pictures prehistoric, conventional life figures against an abstract background in the light colors which predominate in so much of Hardin's work. Helen Hardin was one of the most promising of young painters at the opening of the 1970s. She expressed great delicacy and refinement, and frequently used charming colors, particularly in some of her adaptations in Mimbres life forms.

Teofilo Tafoya (Po Qui) another artist from Santa Clara, born May 15, 1915, according to Snodgrass, was one of several from that village who painted murals at the Santa Fe Indian School in the 1930s. Like so many Indians who show promise in art abilities, Tafoya has been too busy with too many other things to paint. For one year, 1947, he was instructor in painting at the Indian School in Santa Fe.[50] His style was simple traditional as exemplified in *Buffalo Dance* (Fig. 5.73).

In the early 1950s Tafoya was writing a thesis on Indian painting for his master's degree at the University of New Mexico. Thereafter he taught art at the Albuquerque Indian School and was again there in the late 1960s. He has sent commendable student work to various competitive exhibits in the Southwest, such as the Gallup Ceremonials.

Mark Silva, born at Santa Clara in 1921, had a one-man show at the gallery of the Museum of New Mexico in 1948; he exhibited

at the 1962 Scottsdale show and the 1970 Heard Museum Guild Show. He has painted typical Rio Grande subjects, such as *Pueblo Buffalo Dance* and *Sunrise Eagle Dance* (Fig. 5.74). Dark colors were used in the former painting which included two large buffalo, deer, antelope, and Mountain Sheep dancers. Considerable improvement was evidenced in this later work over an awkward, ill-proportioned *Buffalo and Deer Dance* of 1941.

Santa Clara can lay claim to the greatest woman artist of the Indian Southwest, Pablita Velarde. Despite limited training, she has progressed through the years, contributing firmly to the traditional style and developing along original lines with earth painting. Her daughter, Helen Hardin, bids fair to continue the family and pueblo tradition, branching out into abstract painting and experimenting successfully with new media.

*Fig. 5.73     Teofilo Tafoya (Po Qui), Santa Clara Pueblo. Buffalo Dance. Courtesy, James T. Bialac.*
—Neil Koppes

181

Fig. 5.74    Mark Silva, Santa Clara Pueblo. Sunrise Eagle Dance.
Courtesy, Dr. and Mrs. Antonio J. Castillo.
—Neil Koppes

## Tesuque

Among the remaining pueblos of the Rio Grande there are several additional artists, but only a few whose stature is equal to the greater ones so far described.

A painting dated 1920 and signed "Pan-Yo-Pin" is credited to Tomás Vigil of Tesuque Pueblo, who was born around 1889. Subject matter is two women firing pottery; this is not unlike a similar painting by Awa Tsireh done several years earlier. In the later painting the figures are larger in proportion to the total picture, and they are placed closer together in the composition. The figures in general

and the faces in particular are done in very much the same manner, but without the better detail of the Awa Tsireh drawing.

In general, the works of Tomás Vigil show indistinct outlines. However, there is much contrast in color value in his paintings. Some of his figures make up in action for what they lack in detail. Faces are not too good. Generally there is no modeling, and when it is attempted the results are very smudgy. Backgrounds are absent. Certainly it can be said that his was a primitive style, in simple, two-dimensional painting, as represented in *Buffalo Dancers* (Fig. 5.75). Pan-Yo-Pin died in 1960.[51]

Juan Pino of Tesuque apparently had no art ambitions. However, while delivering wood one day to a white artist, he was cajoled into trying his hand at a block print. Seemingly, he was intrigued with the idea but did not produce for some time. Eventually he brought forth a print; through the months he improved to the point where he received some recognition. One example of his prints, *Deer Dancer* (Fig. 5.76), shows some slight improvement over his first efforts.

Pino was accorded a special exhibit in Chappel House, Denver Art Museum, an exhibit which created a considerable

*Fig. 5.75 Tomás Vigil (Pan-Yo-Pin), Tesuque Pueblo. Buffalo Dancers. Courtesy, James T. Bialac. —Neil Koppes*

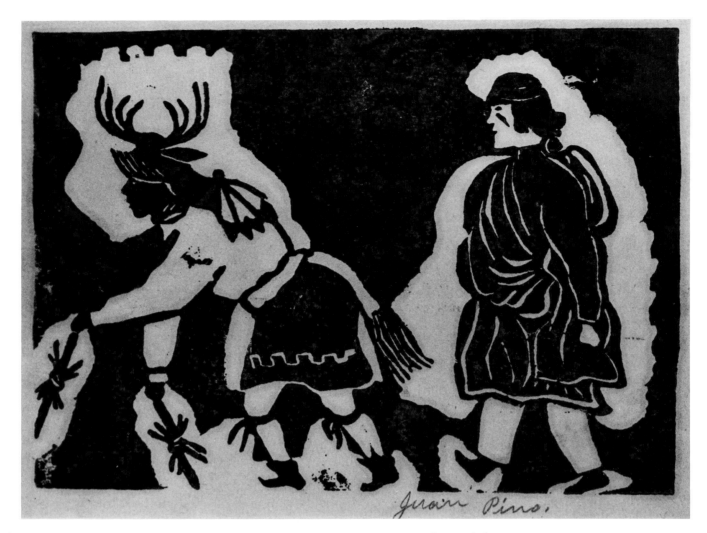

amount of interest. His prints elicited from one reviewer comments on "the apparent ease with which they were executed, the flowing rhythm in the lines and the composition. In the animals, especially, Juan has displayed the Indian's exact powers of observation, and the poses of these animals, their anatomical correctness, and their vivid action would be a credit to many artists."[52]

José E. Durán, Po-ve Pien, has painted in two styles, the old and traditional puebloan, and a modern commercial style.[53] His *Basket Dance* (Fig. 5.77) presents an interesting and simple painting of this subject. In 1939, Durán was one of three Indian artists painting the murals for the U.S. Office of Indian Affairs at the Golden Gate International Exposition in San Francisco. His paintings, in strikingly vivid colors, were from the Corn Dance and the Winter Dance of his village. He has not been represented in major exhibits in many years.

Unquestionably the outstanding Tesuque Indian painter in the early 1970s and one of the most outstanding of all the pueblo artists

was Patrick Swazo Hinds who often signs his name "Swazo." Born in Tesuque Pueblo in 1929, Swazo when nine years of age was introduced to the broader ways of American life through his adoption into a California family. However, he returned every summer to his native village. Most of his education was in public schools; later he received his B.A. degree from Oakland's College of Arts and Crafts; still later he took additional training at Mexico City College and the Chicago Art Institute.

Swazo has exhibited too extensively, had too many one-man shows, and won too many awards to enumerate all of them, yet a few should be mentioned. He has exhibited very widely in the West, with many general or one-man shows in Berkeley and San Francisco, and in Arizona, New Mexico, and Oklahoma. Among other places, he has had one-man shows at the Heard Museum, Phoenix, the Pacific School of Religion, Berkeley, and the Beaux Arts Gallery, Oakland—all in the 1960s—and another special show, and a very superior one, at the Heard in 1970. Still another was at a Taos, New Mexico, gallery in 1971. First and Purchase awards have been given frequently to this artist; he also won the Grand Award at the Scottsdale Art Exhibition in 1966. Although Swazo did not take any awards in the 1969 Scottsdale National, he did exhibit some interesting work in oils and mixed media. In one painting, *We the People*

*Fig. 5.77    José E. Durán (Pove Pien), Tesuque Pueblo. Basket Dance. Courtesy, Museum of Art, University of Oklahoma, Norman.*

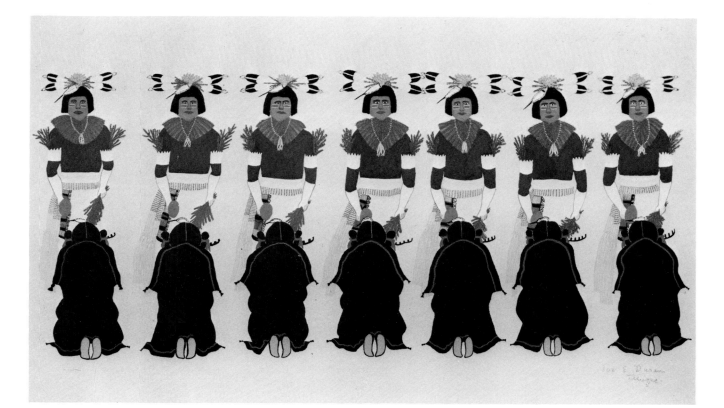

*Fig. 5.78   Patrick Swazo Hinds (Swazo), Tesuque Pueblo.* Pueblo Motif. *Courtesy, Mr. and Mrs. Irvin H. Solt, Jr.*
—Jim Parker

*of the Earth,* he built up in slight relief with gesso the facial features of four singing figures, then painted over with polymer-like water-colors or oils. In a second such painting, an abstract titled *Pueblo Motif,* the raised areas are painted with oils and acrylics (Fig. 5.78). He took a first award in oils at this same show in 1970 for a lovely and ethereal *Council of the Corn Maidens,* done in muted colors (Fig. 5.79). In the Scottsdale National of 1971 Swazo received many awards, among them the Phoenix Gazette Special Award in oil paint-ings, and a first award in graphic arts.

In addition to his career in painting and his activities in a prog-ressive young artists group in the late 1960s, Swazo has participated

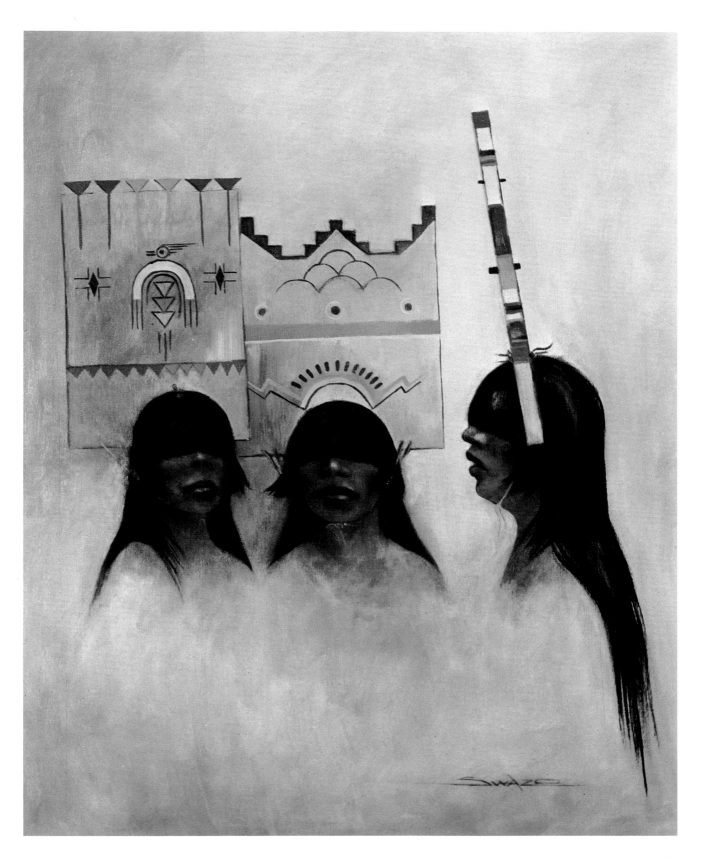

Fig. 5.79    *Patrick Swazo Hinds (Swazo), Tesuque Pueblo.*
Council of the Corn Maidens. *Courtesy, James T. Bialac.*
—Neil Koppes

in many related fields such as judging shows and in giving critiques and demonstrations. As a painter in both the Indian traditional and modern styles, he has lectured on these two aspects of Indian art.

Swazo's Rio Grande Pueblo Indian style has taken on new dimensions that reflect potentials in the development of traditional painting of this area. For example, two semi-realistic Eagle Dancers in the usual poses are done in a muted palette (except for a few bright touches) against a background of still more limited nature. Yet there is a new and appealing beauty, an aura of diffused light, a color peak not attained heretofore by any of the pueblo artists. The same diffuse quality is exhibited in a more abstract painting, *Chant to Kachina Gods,* an oil on canvas. Limited colors, dominantly yellow and blue, appear again in the background against which an indistinct number of kachina masks are painted. Again, there is the same quality of transmission of light, but in the masks there is a greater variety of color, some more brilliant, some less so. One of Swazo's most magnificent creations is *Chant of the Buffalo Spirit* (Fig. 5.80), the epitome of all of the above characteristics.

In his *We Shall Become One Person,* several faces are virtually swathed in filmy garments and drapery-like affairs. All faces concentrate toward a central point; embracing arms and virtually embracing fabrics give meaning to the title. Most delicate colors are used except for an almost-black background in the upper part of the picture. This modern style of painting, so frequently impressionistic, is completely non-Indian. Another example of this type, *Council of Forgotten People,* shows faces over the entire paper, with a fadeout of some of them stressing the semi-abstract feeling in the painting.

Perhaps Swazo's combination of the traditional with fresh spontaneity and more modern styles accounts for his wide appeal and his great success as an artist. He has happily combined a native American Indian inheritance by birth with education and association with the broader American scene. Potentials for further growth of this artist are great. The range in his painting might be summed up in his own words, from "Indian theme to nonobjective abstract." He has worked in a variety of media and techniques, including palette knife, oil on paper, drybrush, soft brush with spatter, and mixed

*Fig. 5.80    Patrick Swazo Hinds (Swazo), Tesuque Pueblo.*
Chant of the Buffalo Spirit.
*Courtesy, Dr. and Mrs. David I. Olch.*
—Ray Manley Photography

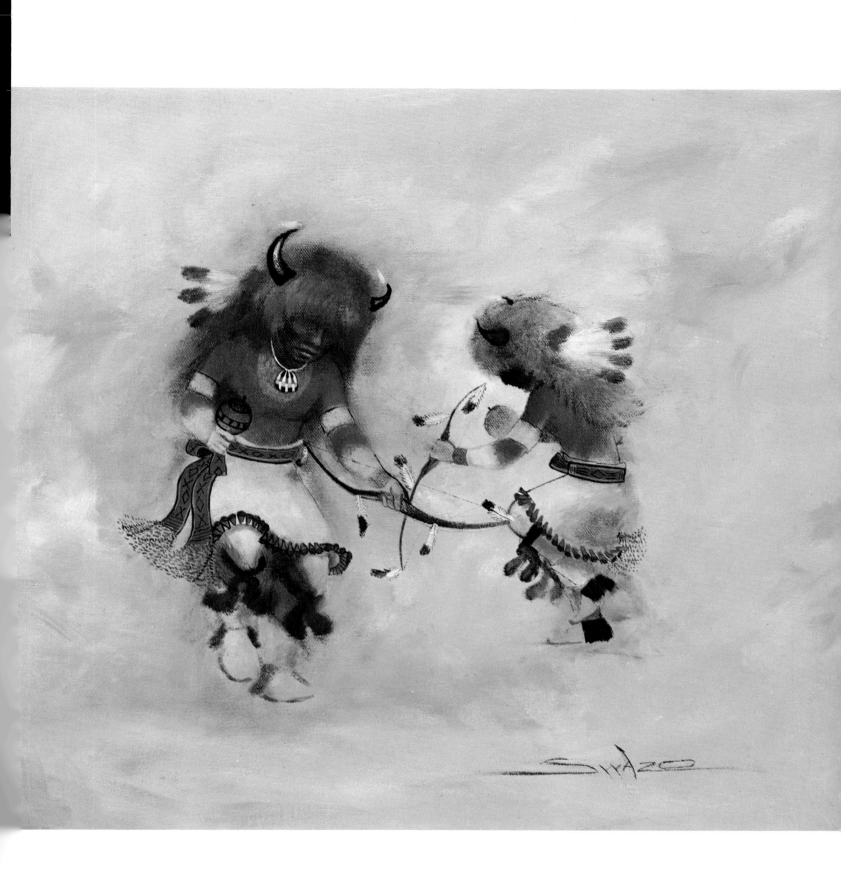

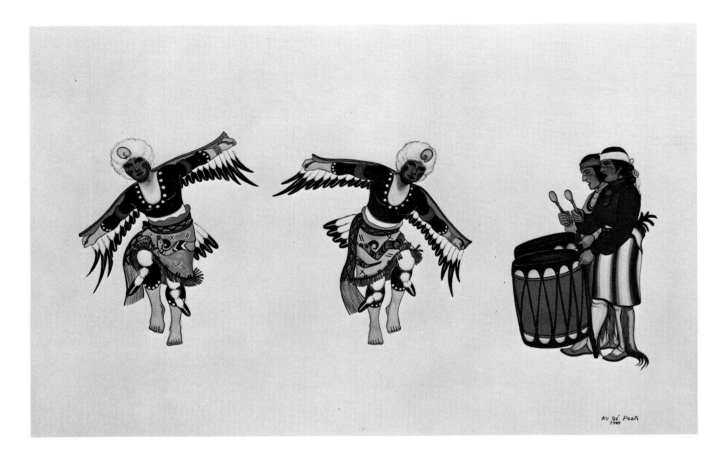

media. He has striven to keep tonality and harmony of colors; mag-
nificent color is frequently found in his abstracts.

Swazo has been making a living by painting.

Tim Vigil (Ku Sé Peen, "Rocky Mountain"), according to the
record is the son of Tomás Vigil. The younger painter has exhibited
at Philbrook and the Scottsdale National. His work is sometimes on
the light side, as to be noted in *Baby Sitters,* a 1965 effort which
shows a deer licking the bare feet of an Indian baby on a cradle
board. His *Tesuque Eagle Dance* (Fig. 5.81) reflects the traditional
style which is characteristic of his watercolors; done in the old style,
the figures are placed against a blank background.

Very few painters have come from Tesuque, but certainly this
pueblo has made a worthy contribution to Southwest Indian art in
the person of Patrick Swazo Hinds. He is a good example of an
Indian raised in an Anglo culture who developed a keen and percep-
tive artistic sense which has found fruition in a highly individualized
style of modern painting, frequently expressed through the use of
native subject matter.

San Juan Pueblo is the birthplace of Gerónima Cruz Montoya (Potsunu). In 1937, as Gerónima Cruz, she began assisting Dorothy Dunn at the Santa Fe Indian School and had charge of the younger children in the painting classes. She had been a student there but a short time before.

Alfred Morang, in reviewing the Annual Indian Art Exhibit at Santa Fe in 1940, gave high praise to the work accomplished by Mrs. Montoya as an instructor, commenting that "the teacher has a rare grasp of the problems involved. She does not force the work into any preconceived pattern. She obviously allows the student to project his own ideas upon paper, and simply guides him into a more rounded development of his initial creative impulse."[54] Certainly Mrs. Montoya was living up to the high standards set by Dorothy Dunn in the teaching of art to young Indians.

Again in 1946 Mrs. Montoya was commended for perpetuating the high standards of Indian painting at the Santa Fe Indian School where she was in charge of the art department. After a short absence, Mrs. Montoya returned to the school, and once more received high praise for the fine results displayed in the student paintings on exhibit at the Museum of New Mexico. As in the case of Miss Dunn, so too with Mrs. Montoya—many students under her direction have become famous in after years.

In the Margretta Dietrich collection there are several of Geronima's paintings done in 1938. One, *Pueblo Crafts,* is painted in the usual pueblo manner, with no ground lines. Various individuals are making pottery, weaving a belt, embroidering a white robe—and the equipment and tools of each craftsman are scattered about on "thin air." The second painting, a Harvest Dance, shows a line of seven men and women. The painting is simple and in flat colors, and the action is stiff.

Too busy with teaching and other activities, Mrs. Montoya has done little painting through the years. However, she has been a "now and again" painter; into the 1950s, and particularly in the 1960–70 decade, she produced some most interesting art. One example of traditional style is a single dance figure inspired by the Blue Corn Dance—the woman dancer is presented in full front and is quite balanced to left and right; there is fair detail. There is, of course, no background and no foreground. This is not greatly different from another *Blue Corn Dance* done in 1943 (Fig. 5.82). Traditional also is a turkey theme borrowed from Mimbres pottery and flanked by a rainbow on either side. Neither traditional nor contemporary is her painting, *Mountain Sheep from Pictographs,* done in 1966 (Fig. 5.83). Although she has continued the traditional style, she has directed some of her efforts into more abstract channels. For example, a *Kossa*

San Juan

191

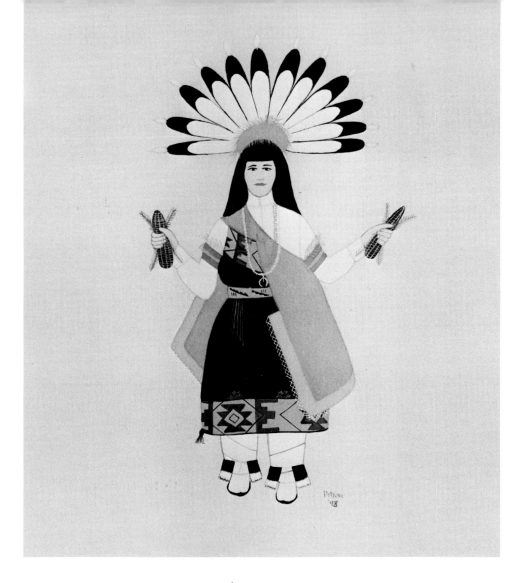

Fig. 5.82    Gerónima Cruz
Montoya (Potsuna), San Juan
Pueblo. Blue Corn Dance.
Courtesy, Dr. and Mrs. Byron
C. Butler.
—Neil Koppes

Fig. 5.83    Gerónima Cruz
Montoya (Potsuna), San Juan
Pueblo. Mountain Sheep from
Pictographs.
Courtesy, Martha Rust.
—Normal Camera Craft

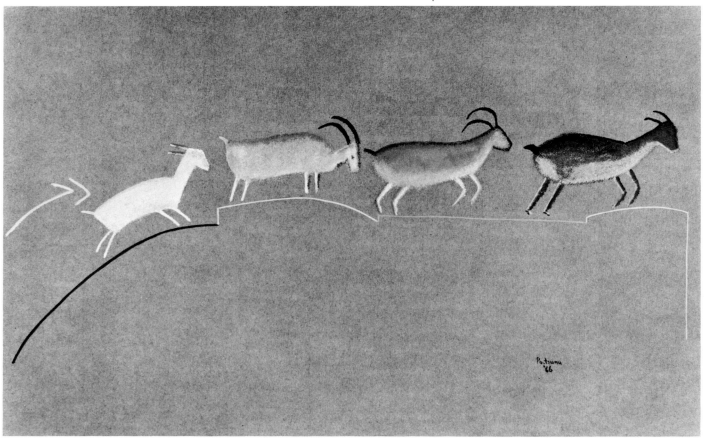

(clown) painted in the early 1960s in the abstract manner is most effective in all blacks and grays and in its angularity. Other work in the contemporary manner was done in the 1960–70 decade.

As a student Mrs. Montoya often used earth colors for painting native subjects, such as basket dancers or simple design motifs borrowed from tribal or prehistoric sources. These subjects have remained popular throughout her career; simplicity but strength of line have likewise been characteristic of much of her work early and late. She has used tempera and gouache that feature earth colors or more brilliant tones; too, she has produced some block prints. Over the years Mrs. Montoya's paintings or her prints have appeared occasionally and in limited numbers in the usual exhibits; this continued to the end of the 1960s. She had a one-man show in Santa Fe in 1959 at the Museum of New Mexico.

Several additional San Juan names may be mentioned briefly. Joe Jaramillo, who went to St. Catherine's in Santa Fe, has a few colored pencil drawings in the collection of the Museum of New Mexico. His painting, *Kachinas* (Fig. 5.84) reflects his simple and

*Fig. 5.84 Joe Jaramillo, San Juan Pueblo. Kachinas. Courtesy, James T. Bialac.*
—Neil Koppes

childish style; unusual as compared with most early pueblo painting is the full front depiction of the three figures.

Manuel Trujillo (Peen-Tseh) is better known; he is also represented in the collections of the Museum of New Mexico. Born in San Juan in 1927, he graduated from the Santa Fe Indian School in 1947, after serving in the U.S. Army for several years. He has exhibited at Philbrook (where he won an award in 1954), at Gallup, and in special Indian exhibits in New York and Arizona. His watercolor, *Bucking Bucks* (Fig. 5.85), shows a typical balanced portrayal of two deer against stylized growth.

San Juan has had a most limited number of artists none of whom has risen to high position. This would not be the case, surely, if Mrs. Montoya's time had been freer so that she could have pursued a painting career.

## Santo Domingo

Santo Domingo is one of the most conservative of the pueblos of the Rio Grande. It is not surprising to find that there have been no outstanding artists from this pueblo, for surely it would be frowned upon to leave permanent records, such as paintings, of village activities. In particular would this be true of the ceremonial dances.

There is so much artistic talent at Santo Domingo, as expressed in pottery and other crafts, that it is a pity so few have used this new form of expression.

One exception to this general statement is Charles Lovato who was born at Santo Domingo in 1937. The grandson of Monica Silva, a well-known potter, he has said that he makes paintings from her bowl designs. He attended St. Catherine's in Santa Fe as well as the Santa Fe Indian School, and studied art under José Rey Toledo at the latter place.

Lovato frequently titles his paintings in a most poetic fashion, such as *Earth Blessed with Abundance, My God and Yours, And He Bestows Upon the Earth Another Night, Moon in God's Hands, He is Pouring out Stars,* and *Death has no Particular Color.* His titles are expressive of the painting's content; for example, *In Search of Food* shows deer tracks followed by mountainlion tracks, and that is all. As implied in this last example, many of Lovato's paintings are very simple as well as telling a story. In another painting, *With the Sunrise Comes the Sounds of Life* (Fig 5.86), these characteristics are well illustrated—yellow flames emanate from one of three native pots, and there are tracks of humans, animals, and birds, and some geometric designs and lines. This casein painting won the Bialac Purchase Award at the Heard Museum Fair in 1968. Lovato also took a second and a special award at the Gallup Ceremonials in 1969 in the abstract field for his painting *And He Made Man.* The composition is better in this than in most of his paintings—footprints, fish, antelope, and large chunks of pottery and turquoise cascade over the dark-brown paper from top to bottom.

Lovato received the top award in the Southwest Artists category at the 1970 Philbrook show, for his acrylic, *Sunrise, the Gift No Gem Could Equal* (Fig. 5.87). This abstract surpasses most of his work in composition, in strength and dynamism, in maturity and symbolic unity. He took a third place at the Scottsdale 1970 show for his *Peace and Solitude;* he received second awards at both Pine Ridge, South Dakota, and Gallup in 1971.

Surely conservative Santo Domingo could not be offended by the Lovato paintings, for one could read his own meanings into these titles and pictures that are often more in the Christian tradition or the everyday life of all men than in the native Indian way of living. It is only in themes, in symbolic and other designs, that he has borrowed from his native pueblo; the rest is imaginative creativity.

A few drawings by children from Santo Domingo, all of early date, were in the Indian School collection at Santa Fe. Several dealt with realistic subjects, mainly horses, while others were concerned with highly stylized trees, corn plants, and birds. Color was none

too good, the drawings tended to be stiff, details were poor, the painting sketchy. One drawing of *Today's Challenge to American Youth* displayed fair draftsmanship, but there was no imaginative quality in the work, no potential for further development. At the beginning of the 1970s, the Lovato paintings remained the sole contribution of Santo Domingo to easel art.

*Fig. 5.86    Charles Lovato, Santo Domingo Pueblo. With the Sunrise Comes the Sounds of Life. Courtesy, James T. Bialac.*
—Neil Koppes

*Fig. 5.87    Charles Lovato,*
*Santo Domingo Pueblo.*
Sunrise—A Gift No Gem
Could Equal. *Courtesy,*
*Philbrook Art Center.*
—Bob McCormack

## Nambé, San Felipe, Picurís, Sandía, and Isleta

In the three pueblos of Nambé, San Felipe, and Picurís relatively little painting has been done. As early as 1930, Roland Durán (Tolene) of Picurís Pueblo was doing some painting. Although he produced after that date, he did not excel. Some of his early work shows great vigor and much action, good detail in headpiece and costume of dancers, but body proportions are only fair (Fig. 5.88). Tolene otherwise painted in the traditional pueblo manner. He died about 1961.[55] His son, George Durán, who attended the Santa Fe Indian School in 1946–47, did not show as much talent as had his father; too, George was definitely influenced by Navajo subjects and details. However, he did paint traditional pueblo subject matter (Fig. 5.89). Both Duráns had stopped painting by the early 1950s.

The three pueblos, Nambé, San Felipe, and Picurís, were represented by paintings in the collection of the Indian School at Santa Fe of the late 1940s. In general, drawings showed poor and often shaky outlines but spirited figures. Action was indicated perhaps even more commonly than in the earlier works of better artists. Background was generally absent, but when attempted it was usually poorly depicted and reflected an influence of Navajo treatment. Subject matter was conspicuously on the side of animals, such as deer

*Fig. 5.88    Roland Durán (Tolene), Picurís Pueblo. Picurís Pueblo War Dance. Courtesy, The School of American Research, Santa Fe.*
—Laura Gilpin

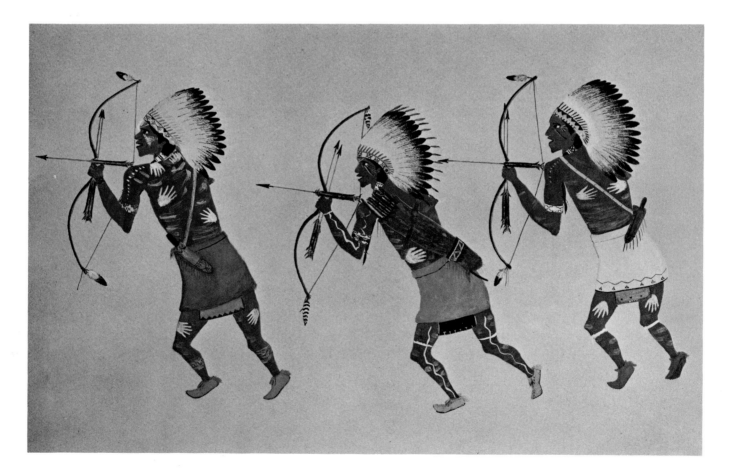

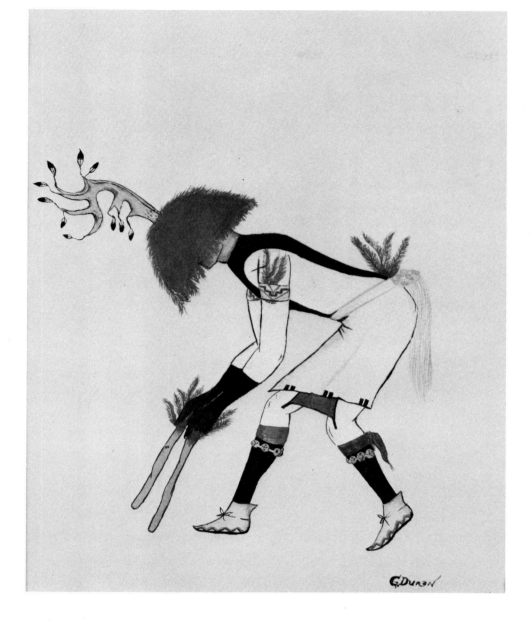

*Fig. 5.89    George Durán, Picurís Pueblo. Pueblo dancer. Courtesy, Inter-Tribal Indian Ceremonial Association Gallup, N.M.*
—George Hight Studios

and horses, rather than the ceremonial or native dance. Composition was poor or mediocre when attempted. Calvin Fenley Chávez, half San Felipe, half Laguna, is discussed under the latter pueblo.

Sandía and Isleta have produced no artists of the Rio Grande type. One man at Isleta, Joe Montoya, painted still life in non-Indian fashion, but apparently he did not continue this style for long.[56] He stopped painting entirely in the 1950s.

Little or no art work of superior quality has come out of the five pueblos—Nambé, San Felipe, Picurís, Sandía, and Isleta. Again it may be noted that the work of children is rather significant: usually there is no spark of hope for future development in their artistic endeavors in these pueblos.

**Taos**

Taos, the northernmost Rio Grande pueblo, reflects some very interesting trends in the total art history of the pueblo area. Some developments have been directly and heavily influenced by European techniques. The results should scarcely be classed as works of art. On the other hand, several of the women who belong to this pueblo have developed within the Rio Grande native style and have produced outstanding works of art. In the latter category is Eva Mirabal. Pop Chalee adhered to neither of these trends—she has developed a style all her own.

A few words should first be said about the European-influenced drawings which were done in early years of this development. The works of Antonio Archuleta and John Concha will serve as illustrations. Both artists are represented in the Laboratory of Anthropology collections. John Concha painted a complete mountain scene, from sky to individual blades of grass in the foreground, in an attempted European style. Many slopes are represented; on each are trees of varying sizes and of several varieties. The general feeling is one of smudgy painting, even to the large deer resting in the grass in practically the exact center of the painting.

Archuleta executed a similar type of work. One of his paintings depicts two Indians on horseback, and there are the same complete background and foreground, sky and all. Brushwork is poor

*Fig. 5.90    Merina Lujan (Pop Chalee), Taos Pueblo. Four Mythical Horses. Courtesy, Dr. and Mrs. Byron C. Butler.*
—Neil Koppes

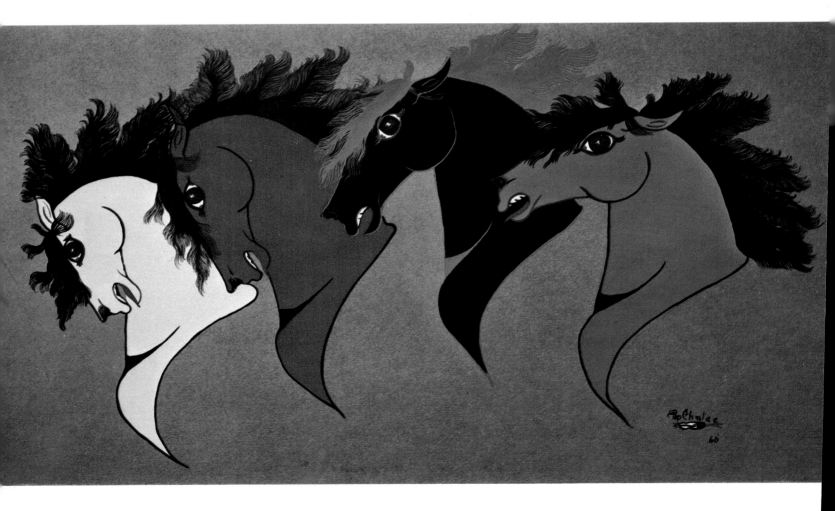

throughout. There is a suggestion that some Plains influence came to bear on this artist, particularly in the drawing of the horse. Otherwise, there is no Indian "feel" to the paintings of these two men.

The versatility of the Indian painter is demonstrated in the work of another Taos artist, Albert Looking Elk.[57] In a large number of drawings he illustrated a creation myth that he wrote out to accompany the pictures. The drawing is sketchy throughout, but a great deal of imagination was unleashed in a number of the scenes. When needed, filmy clouds are introduced out of which step deer and buffalo. A convenient mesa top appears upon which to sit while watching a sunset. A small patch of ground emerges out of which corn might grow. Colors are light in most instances, proportions are very poor, perspective depends more on imagination than on reality. But withal, as illustrations of a myth, the series has its merits.

Merina Lujan (Pop Chalee) has developed several styles. In one, delicate forest scenes are portrayed wherein the trees are lacy and the birds, animals, and butterflies more fanciful than real. In a second style, horses are drawn with great sweeping manes and tails. The latter style she used in murals in Santa Fe and Albuquerque.

A blue horse which Pop Chalee labeled *Taos Legendary Horse* illustrates the second trend. Since the artist used dark gray paper, the lighter blue of the animal stands out pleasingly against this ground. The horse has white spots. From yellow mane and tail, which are painted in solid color, fine lines in yellow, green, and red swirl all over the paper. The horse is in a stiff and stilted pose, with legs sticking straight out and terminating in pointed hoofs. This painting was done in 1940.

An earlier painting by Pop Chalee shows a lack of this exaggeration in position, mane, and tail. Against a background of four trees runs a herd of twenty horses. Small in size, they are painted in appealing shades of lavender, green, mustard, tan, gray, brown, and blue. Manes and tails are fairly full, and legs are long. There is no real ground line, but there are tiny flowers scattered all about.

Another Chalee painting which features horses, done in 1960, is labeled *Lineup*. Except for spaced and scattered small clusters of grass over the lower half of the paper, there is no background. Across the middle of the painting is a line of five horses; below them are two smaller ones. All are colorful wooden creatures, each one looking like it had just stepped off a merry-go-round as manifested in stiff legs, arched tails, open mouths. Nonetheless, the painting has appeal in its colors, its imaginative qualities. More realistic is another 1960 painting, *Four Mythical Horses* (Fig. 5.90).

One forest scene typifies many. Painted in 1937, one such scene has a background of staggered trees; the tiny bright leaves,

201

in several shades of green, red, and yellow, stand out more vividly on the black paper used by Pop Chalee. Many blue birds flit about between the trees. Below are shrubs and small, colorful flowers. Amidst all this are greenish antelope, blue-gray rabbits, brown bears, squirrels, and porcupines. Figure 5.91, *The Black Forest,* is another version of this subject which she continued to paint through 1970.

In general, Pop Chalee has displayed extreme delicacy in drawing and a delightfully imaginative touch in her creations. Highly stylized though much of her drawing has become, charm remains in the exquisite touch of lacy trees and the filminess of horses' manes and tails. Certainly this is not in the Indian tradition. Even when she treats of pueblo subject matter, she is not apt to be accurate as to detail. Many of her paintings are amusing; many are naïve compositions. These words could be applied as aptly to those in Chalee's one-man show at the Heard Museum in 1970 as they could be to her earliest work.

Born Merina Lujan in 1908, in Castle Rock, Utah, of a Taos father and an East Indian mother,[58] Pop Chalee has spent a goodly portion of her life away from her ancestral pueblo, much of it in Santa Fe. For several years she lived in Scottsdale, Arizona, where

*Fig. 5.91    Merina Lujan (Pop Chalee), Taos Pueblo. The Black Forest. Courtesy, Arizona Highways.*

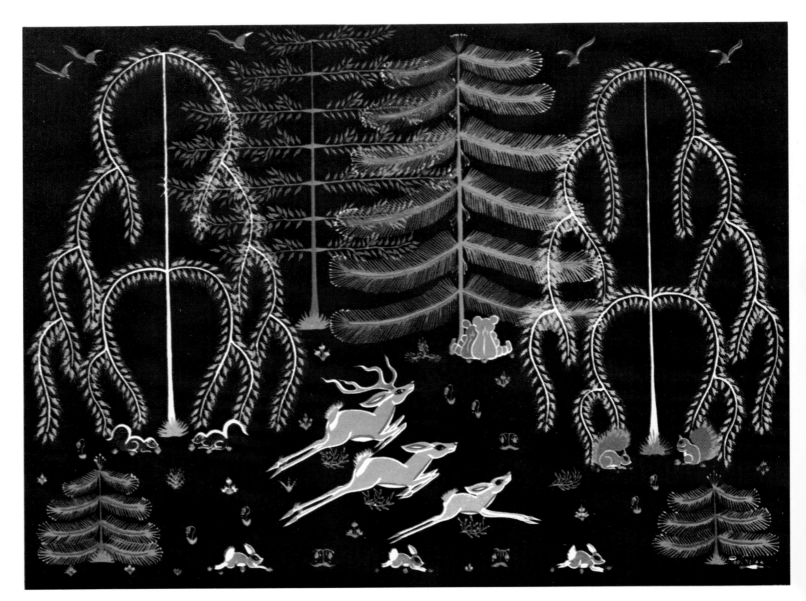

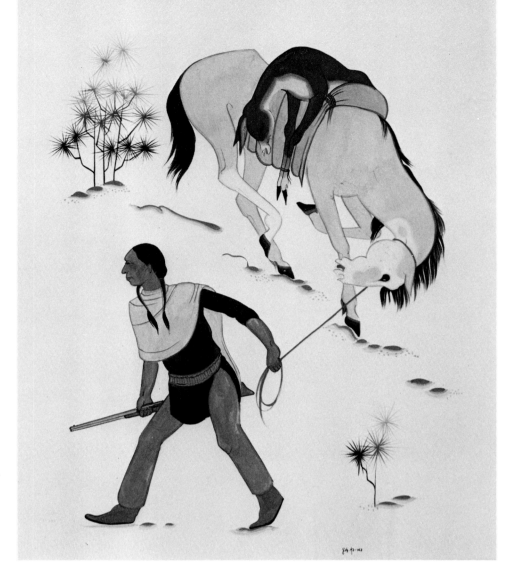

*Fig. 5.92    Eva Mirabal (Eah-Ha-wa), Taos Pueblo.* The Returning Hunter. *Courtesy, Mr. and Mrs. H. S. Galbraith.*
—Neil Koppes

she and her Navajo husband, Edward Lee, had a craft shop. Late in the 1960s she was in Long Beach, California, painting in her imaginative and decorative style, and in her favorite medium, tempera. Pop Chalee has exhibited throughout the Southwest and elsewhere in the United States, and has received national recognition for her painting.

Eva Mirabal (Eah-Ha-wa), who was born in 1923, was educated in Santa Fe, having graduated from the Indian School and, for a time, continued with postgraduate work there. She was a WAC during World War II. For a short while, she was Artist in Residence at Southern Illinois University. In 1949 she studied at the Taos Valley School.[59] Her painting does not show any great influence from this contact; her deep interest in the culture of her native village may well account for this. Genre scenes about her native village have been featured by Eva Mirabal, although she has depicted various other subjects, including leaping deer, hunting scenes (Fig. 5.92),

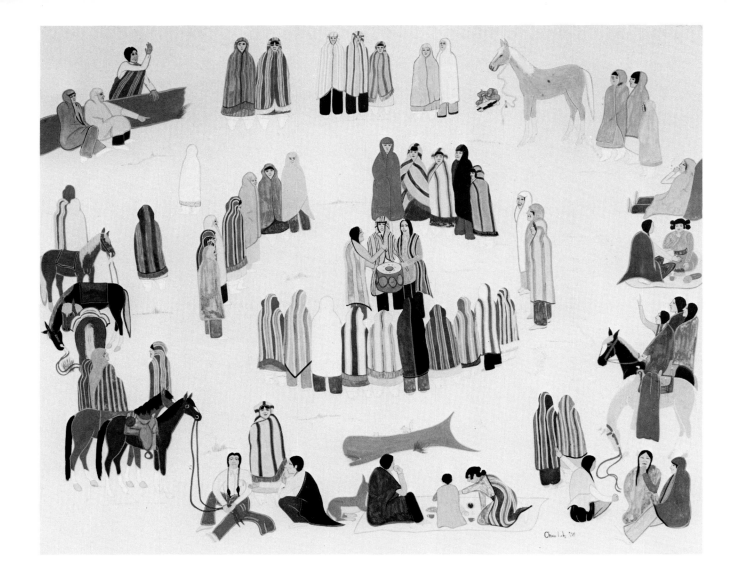

Fig. 5.93    Vicente Mirabal
(Chiu-tah), Taos Pueblo.
Taos Round Dance. Courtesy,
Dr. and Mrs. Byron C. Butler.
—Neil Koppes

men on horseback, and symbolic themes; she has also done murals. She has painted in Shiva, casein, and tempera, favoring the latter. Eva Mirabal has exhibited at the Santa Fe Museum Art Gallery, Philbrook Art Center and the Gilcrease Foundation in Tulsa, and in Taos. She has taken several prizes at these exhibits. While raising a family and thereafter, Eva Mirabal painted infrequently. By 1970 she was doing abstracts.

One of the most promising of the younger Taos artists, Vicente Mirabal (Chiu-tah), was in World War II and was killed in 1946 while still in the service. He had been an assistant instructor of painting in the Indian School at Santa Fe where he was graduated.[60] When he was a teacher he won an Indian poster prize contest for the San Francisco Golden Gate International Exposition. The theme of his poster was the Taos Turtle Dance. In another *Turtle Dance* there is a large yellow church like that at Taos. Forty-two figures, heavily blanketed, stand against the walls watching a line of eight dancers with tall headfeathers and varicolored kilts. The painting is in the pueblo style with no background. Pastel colors predominate in blues,

204

purples, rose, and lavenders; contrarily, he often used rich tones on colored papers to portray ceremonial or genre subjects. *Taos Round Dance* (Fig. 5.93) is typical of the extreme simplicity of his early work.

Tonita Lujan, another Taos artist, has several paintings she did in 1935 in the Dietrich collection. One is *Husking Corn,* with a group of small figures of women around three delicately colored piles of corn. The women's dresses are bright. This and other paintings by Tonita would not rank with the works of the greater pueblo artists, but with limited and simple strokes she can tell a story. Possibly for this very reason Ann Nolan Clark chose her to illustrate a book of stories of Taos for children, *Little Boy With Three Names.*

In simple lines, Tonita Lujan pictures a great domed oven with a Taos woman sitting before it making bread. There is no ground or sky. In equally simple lines she creates another and more elaborate scene, two boys riding bareback, a sheepherder, two clusters of sheep, several dogs which look more like wolves (of sorts), mountains, and even sprigs of grass. Tonita also shared in the painting of a frieze in the classrooms of the Indian School at Santa Fe. After these efforts Tonita Lujan did little painting.

One other Taos artist, Lori or LoRee Tanner (Pop Wea), painted some rather dramatic pictures, frequently in nontraditional style. One in particular, *Taos War Dance,* combines some Plains-like

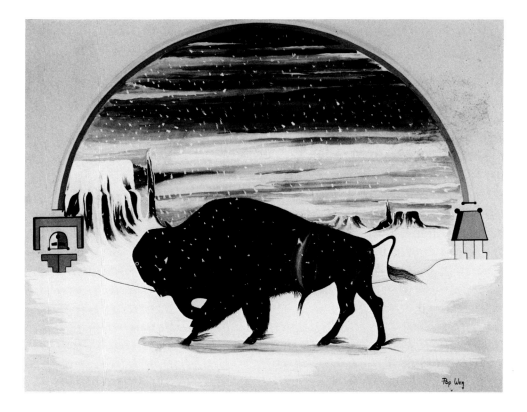

*Fig. 5.94    Lori Tanner (Pop Wea), Taos Pueblo. Buffalo in snow. Courtesy, Mr. and Mrs. H.S. Galbraith.*

—Neil Koppes

205

features with some new ideas. The dancer is painted in gold colors on black paper; gold lines emanate from the figure to all edges. The latter feature is certainly an innovation for Southwestern painters! Costume and the stance of the dancer are Plains in feeling. Titles of other pictures indicate further painting in a non-Indian style; however, *Buffalo Hunt* and others are more in the traditional manner. Occasionally she combined the traditional and symbolic motifs; such is a painting of a buffalo in snow (Fig. 5.94). She took a First Award at the 1965 Scottsdale show for her *Eagle Dance*.

Lori Tanner died in 1966.

Taos Pueblo has been unfortunate in the early death of several of its most promising young artists.

Although not in the full traditional Rio Grande style, Pop Chalee's paintings have found favor with many; her delightful and imaginative horses and forests are uniquely her own.

## Acoma, Laguna

Not a great deal of artistic activity in the field of painting has occurred at Acoma and Laguna. The two pueblos seem to be intermediate between the Rio Grande villages on the east and the Hopi on the west, not only geographically but also in the general trends of the development of watercolor. It is surprising to find so little painting in Acoma and Laguna, for both villages have reached a high level of attainment in several craft arts.

One exception to the above general statement, regarding a Laguna, is Calvin Fenley Chávez, born in 1924 of a San Felipe father and a Laguna mother. This man has shown a great deal of promise in handling not only tempera but also oils. He studied at Northern Arizona University and with John R. Salter, both in Flagstaff. His teachers tried conscientiously not to influence him in the direction of European styles but, rather, to bring out the best in his native work. Nonetheless, in tempera in particular, he exhibits something of the Renaissance in his work, a dark moodiness in both subject and treatment. For instance, in the head of an Indian which is definitely done in the European style there is much modeling, texturing of skin and clothes, and a complete background, even to sky. Choice of colors stresses soft, deep browns, reds, and black. There is a fair amount of detail in this painting, in the silver worn by the Indian, the bun of hair at the back of the head, the striped blanket around the shoulders. This piece, like others by Chávez, has depth.

In several additional paintings, Chávez reveals the same general traits. He also puts in many details of distant background which show through a doorway or a window. For instance, in one

picture there are a church and some buildings which are too generalized to say whether they are pueblo structures or not. This is very much in the European style. A third, showing a native woman with a child on her back, is labeled *Sleep My Little Owlet,* and this too shows the same European treatment of background. This time there is no doubt about the pueblo in the distance as seen through the doorway.

Chávez has also painted native rituals. In one such scene a corner of the plaza is pictured with a number of villagers sitting about. Seven kachinas, in about three-quarter view, are performing in the center of the picture. Carrying out the idea of full perspective, Chávez shows mountains in the background. Detail is fairly well expressed, although not as well done as in some other Rio Grande figures where there is so much more concentration on detail. Comparable to this painting is a plaza end scene in which Chávez shows pueblo dancers again with a background of villagers, house wall, and mountains (Fig. 5.95).

Despite the fact that Chávez has lived most of his life in Winslow, Arizona, and not in an Indian village, he has done a fine job of presenting village subject matter, whether in European perspective or in the traditional manner. He has used tempera and oils for the latter style as well as the former; dances and genre subjects are treated in the more traditional style also. Semi-realistic figures are done with full-round modeling. As in his treatment in the European

*Fig. 5.95    Calvin Fenley Chávez, Laguna Pueblo. Pueblo dancers. Courtesy, Mr. and Mrs. H.S. Galbraith.*
— Neil Koppes

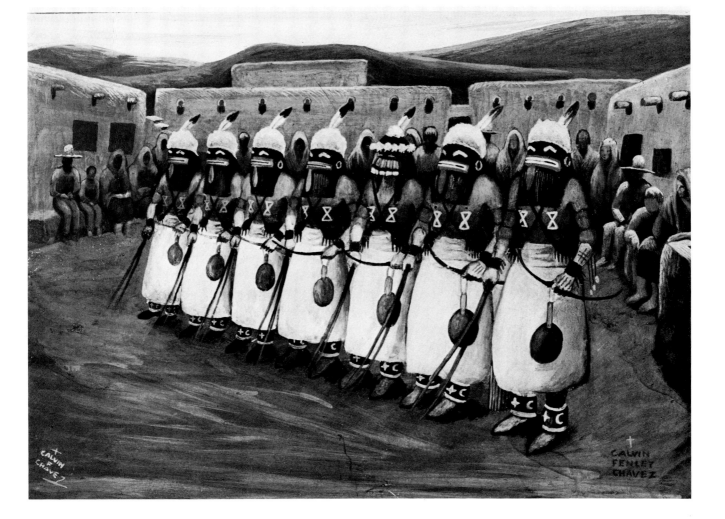

manner, so too in his traditional Indian work has Chávez favored dull colors. Background features are so simplified in the traditional style that sometimes they seem to be nonexistent; ceremonial subjects are restrained, more reserved, more formal; on the other hand, everyday subjects frequently reveal more action, more realism, and sometimes touches of bright colors.

In spite of the aforementioned moodiness characteristic of so much of his painting, a sense of humor appears now and then in the works of Chávez. For example, in one fine *Eagle Dance,* where two of these figures dominate the entire canvas, there is a scalloped, board-like affair at the bottom of the picture with four little scared rabbits crouching beneath it. The realistically portrayed bunnies seem well aware of the dancers above even though the dancers' feet never touch the board! Or perhaps it is the rabbits' fear of real eagles so beautifully symbolized by the two dancers.

Chávez has exhibited widely, with one-man shows at Philbrook in Tulsa and at Flagstaff. His paintings have won many prizes including some at the Gallup Ceremonials, at the Arizona State Fair, and in California exhibits. He is represented in many permanent collections. As is so typical of pueblo painting, Chávez' works are fine ethnological records in their faithful portrayal of subject matter and in some detail. Chávez was painting in Albuquerque in 1970. In addition to his usual work, he did illustrative cartoons.

One Laguna boy, Paul Satsewa, when a student at the Albuquerque Indian School in 1938, exhibited both ability and imagination. He drew a sketch for his school magazine of his idea of Coronado's first night at the village of Zuñi. So good was the drawing that the Coronado Cuarto Centennial Commission of New Mexico used it as a part of their advertising material for their elaborate celebration.

Wayne Henry Hunt or Wolf Robe Hunt (Ke-wa) was born in 1905 on the Acoma Reservation. He attended high school in Albuquerque, studied art under Karl Reiden at the University of New Mexico, and under Frank Vonderlachen in Tulsa. For years Hunt has had his own Indian arts shop near Tulsa.[61]

Formerly Hunt did many paintings in oil, but in 1969 he said that he was then painting entirely in casein, and in the traditional Indian style: "I used casein in all my illustrations for my book titled *Dancing Horses of Acoma,*" he added.[62] However, there is a special quality distinctive of Wolf Robe Hunt in many of his otherwise traditional paintings, particularly of ceremonial dancers. One reviewer has expressed this difference as follows: "The stylizations of faces and bodies are most interesting as they are classicized, generalized, summarized to typical racial characteristics and express the general

rather than individual Indian. Faces and figures are almost carica-tured in their simplification."[63] The same reviewer also stresses the fact that Hunt catches characteristic moments in the dance in his figures as well as in the Indian's stoical set of chin and jaw.[64]

Subjects painted by Hunt have featured the native ceremonial dances, although some legends and some sheer design themes also appear. *Pottery Birds in a Tree* exemplifies the latter; it is nothing more, nothing less, than what the title indicates. Abstract design occurs in combination with some of Hunt's highly stylized subjects, as illustrated in *Primitive Deer Dance*. Herein are two stylized deer pursued by an equally stylized hunter with bow and arrow. A sun, complete with a face and rays, is balanced by abstract designs, all at the top of the paper. Large darkened and mottled areas occur to right and left. In some of his paintings these mottled areas contrast interestingly with adjoining areas of flat color.

In many of his subjects, Hunt has featured an odd color in the bodies and faces. Sometimes the shade is more dull yellow, sometimes more green. Bucklew[65] aptly describes one example as mottled moss-green-over-ochre. Despite color and stylization, such figures may appear in the traditional manner, a row against blank paper. Three such figures in *Warbonnets on Tall Acoma Dancers* (Fig. 5.96) are created in the angular lines so characteristic of Hunt, yet action and detail are good. Fine conventional birds fly above the dancers, ribbon-like forms appear below.

Hunt has exhibited in the usual galleries, among them at the Heard Museum and Philbrook in the 1960s (at the latter he was a Grand Award winner in 1967), at the Gallup Ceremonials since 1936, and in 1969 at the Scottsdale National. His paintings appear in representative collections. He has also exhibited in Spain, France,

Fig. 5.96 *Wayne Henry (Wolf Robe) Hunt (Ke-wa), Acoma Pueblo.* **War Bonnets on Tall Acoma Dancers.** *Courtesy, Dr. and Mrs. Byron C. Butler.*
—Neil Koppes

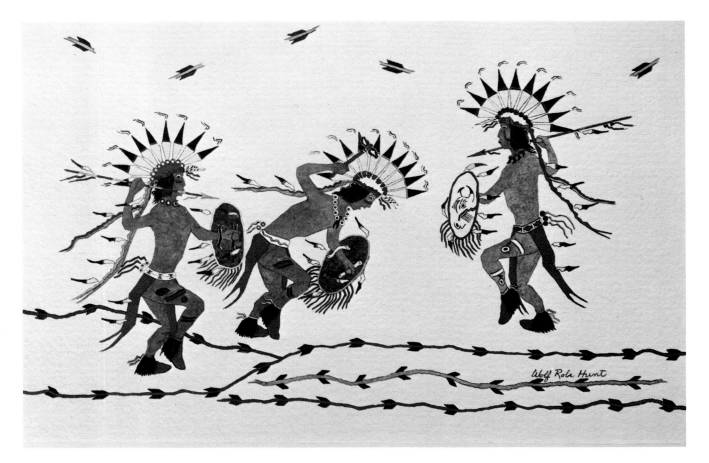

England, and Germany, countries in which he traveled for the U.S. Departments of Commerce and Agriculture.[66]. He was still actively painting in 1970, and exhibited several pictures in the Scottsdale show of that year.

Considering the overall Rio Grande area in summary, it can be said that San Ildefonso was indeed the birthplace of the watercolor movement. It was nurtured through the years in this same village, with occasional but important influences coming from other pueblos, such as *Zía*, in the work of Ma-Pe-Wi, and from Cochití, earlier through the painting of Tonita Peña and later through Joe H. Herrera. Moving westward to the pueblos of the distant tributaries of the Rio Grande, the development weakens.

No distinctive art style has developed in Acoma and Laguna. Hunt has reflected some influence from the traditional in his lines of dancers but they become different in color and form under his brush. Chávez' dark paintings in European style are far removed from the Rio Grande traditional.

Withal, Awa Tsireh established three styles—whether entirely on his own or partially influenced by others such as Ma-Pe-Wi, Tse-Ye-Mu, and Tonita Peña—which were recognized and followed by many in the Rio Grande, to become in time what is now called traditional in this area. To be sure, these styles were not born completely under the brush of these artists; rather, they also reflect centuries-old tendencies of the native populations in such qualities as flat colors, and a greater range of tones and shades. New traits incorporated with the old to make something different of this expression include the use of paper, commercial paints rather than native ones (although the artists adhered basically to media most similar to familiar materials—water-based paints), and emphasis on subject matter not previously featured, such as dancers, animals, and other life or realistic themes. Thus it was a blending of old and new that created what is commonly called traditional Rio Grande easel painting.

Interestingly, it was again in the 1960–70 decade that more painting was done in the Rio Grande that was still closer to the native styles—a return to geometric and highly conventional themes as sources of subject matter. Even this latest trend might be labeled traditional to some degree.

Perhaps the greatest accomplishment of the Rio Grande in this 1960–70 decade could be summarized in the refinement of the established traditional, as expressed by Gilbert Atencio and Pablita Velarde, plus trends expressed in Swazo's work. The latter artist used old subjects expressed in extreme subtlety of color, with the addition of equally subtle background, in exquisitely delicate drawing, and in either realistic or nonobjective styles.     ■

# The Western pueblos

To the west of all the Rio Grande Pueblo country is the home-land of Zuñi and Hopi Indians. The former occupy an area along the Zuñi River of western New Mexico, having retreated from their former mesa homes during historic years. West and north-west of the Zuñis are the Hopis; many of this tribe still occupy their ancestral mesa homes while others have found it more fruitful to move closer to their farmlands at the base of the mesas. Hopis and Zuñis have been in close contact for many centuries which accounts for numerous cultural similarities.

Hopi

For hundreds of years the ancestors of the Hopi have been living in and around the mesa land which they presently call home. Dry, desert land it is, with no permanent streams; therefore, the Hopis are dependent largely on rain for the cultivation of their crops. Waters of temporarily swollen washes can be diverted, but the source of those waters is, as the Hopis know, the heavy and sudden showers which are all too few, as well as spotty and unpredictable. Some water is available at springs, but even these sources dry up when there is no rain for many months.

Thus, among the Hopi, rain ceremonies are second only to fertility rites. After planting the seed, the Indian hopes that it will grow. The vagaries of nature may strike again, and the Hopi knows it, so he plants an extra seed for the winds that may blow the corn to ribbons, one for the cutworms, and one for the mice . . . and then several more, praying that one will grow to maturity. Also he plants

211

two plots of ground, for he has learned through the centuries that this procedure may assure him of *one* harvest.

No wonder, then, that the Hopi, as Mrs. Hattie Green Lockett said of him, spends most of his time getting ready for, having, and getting over dances.[1] Many of these ceremonies are elaborate prayers for rain and fertility.

As significant as the ceremonies is the philosophy[2] that the Hopi has developed in response to life in this beautiful but not-too-kind country. To the Hopi, the world is an absolute, ordered system, functioning under a definite set of rules. All things are related and mutually dependent. Through orderly cooperation, good will come to man, the animals, plants, the lands, and the supernatural. Through regulation of his thoughts, emotions, and behavior, man can exert a measure of control over his environment.

Set patterns of reciprocal behavior regulate the life of each Hopi, from the family and clan to the universe about him. Responsibilities of the individual increase with age, reaching a peak in ceremonial participation. So devoted are the Hopis to their philosophy of reciprocity between all things that they believe that if they perform the proper rituals the sun will shine, the rain will fall, and the crops will grow.

The Hopi ceremonial year is divided into two parts, the summer and winter, by the solstices. Winter rites are concerned primarily with fertility and, to a lesser degree, with rain-getting; summer rites are fewer and concerned basically with rain. The kachina enters into the winter rites at many points, in secret initiation ceremonies, and in the public performance in the pueblo plaza. A kachina is, among other things, an ancestor, a water spirit, an intermediary between man and the gods. When he appears to the Hopi he is masked and costumed. When he is not in the Hopi villages he lives on top of the San Francisco Peaks near Flagstaff, or on other mountains.

A Hopi father carves a wooden figure, paints and bedecks it after the fashion of a given kachina, and presents it to his little daughter. This doll the child will generally hang on the wall of her home, often observing the details so that she will know the original kachina when he appears as a dancer in the plaza.

Thus, to the Hopi, his religion is with him always. The ceremonial cycle presents one colorful pageant after another, combining "rhythmic movement, singing, impersonation, painting and other creative media.... "[3] The ceremony is certainly one of the most integrating forces in Hopi life.

For centuries, apparently, the masked dancer has been an important part of the ritualism of the Hopis. As previously mentioned,

masked figures are to be noted in prehistoric wall paintings and pictographs and—particularly significant in connection with the Hopis—in the Jeddito murals. Here some of the masked performers are not unlike the modern versions of these Hopi personages, the kachinas.

Three Hopi men were commissioned by Fewkes in 1899 to make colored reproductions of all the contemporary kachinas. The best artist of the three was one Kutcahonauu, or White Bear. He had had some slight training in art at Keams Canyon, a Hopi Reservation school in northeastern Arizona, but it is thought that this did not influence him in any measure. White Bear's uncle, Homovi, was another artist chosen for this task. Completely untrained, his drawings are in the same style as those of his nephew. The work of the third artist, Winuta, was likewise "unmodified by white influence."[4]

Fewkes provided the Indians with paper, pencils, paints, and brushes. The only instruction he gave them was to draw and identify the kachinas he wished to have reproduced. Returning to their homes, these fellows quickly created a half dozen pictures. So accurate were they, and so well done, that Fewkes encouraged them to continue the project. Not only did they paint all the figures asked for by the archaeologist-ethnologist, but also some others about which he knew nothing.

Using the paintings to check the symbolic details by showing them to numerous other villagers, Fewkes found them most accurately reproduced, even in the case of kachinas that were extinct. "This independent identification was repeated many times with different persons, and the replies verified one another almost without exception," Fewkes reported.[5] Thus, it would seem, all reproductions were authentic in their careful rendering.

These kachina figures are painted as independent dancers against a flat background (Fig. 6.1). Rarely, an object accompanies

*Fig. 6.1a*

*Fig. 6.1 A few of the kachinas drawn for Fewkes by Hopi artists. From Fewkes, 1903.*

—Ray Manley Photography

213

the dance figures, it is usually a piece of ritual paraphernalia necessary to the performance in question. Each is placed as unconcernedly against the blank background as the dancers themselves. Small rows of red piki bread (wafer-thin ceremonial bread) hang—from nothing—above the dance figure Aya.[6] A small cornstalk grows near a kachina which obviously has connections with this product, for a stalk of the same is also represented on the median line of the figure's mask, and ears of corn appear at the sides of the mask.[7] In another painting, between the two kachinas, Kerwan and Mana, there is a basket of bean sprouts which have been grown rapidly under excessive heat and moisture in the kiva.

Fewkes remarked that,

> When a Hopi draws a picture or cuts an image of a god, either a doll or an idol, he gives the greatest care to the representation of the head. The symbols on the head are characteristic, and its size is generally out of proportion to that of the other parts. When these same gods are personated by men the symbols are ordinarily painted on masks or helmets of personators.[8]

Perhaps it is a combination of the several facts embodied in this quotation that would explain the dominant trait in most of these first drawings—a head greatly out of all proportion to the rest of the

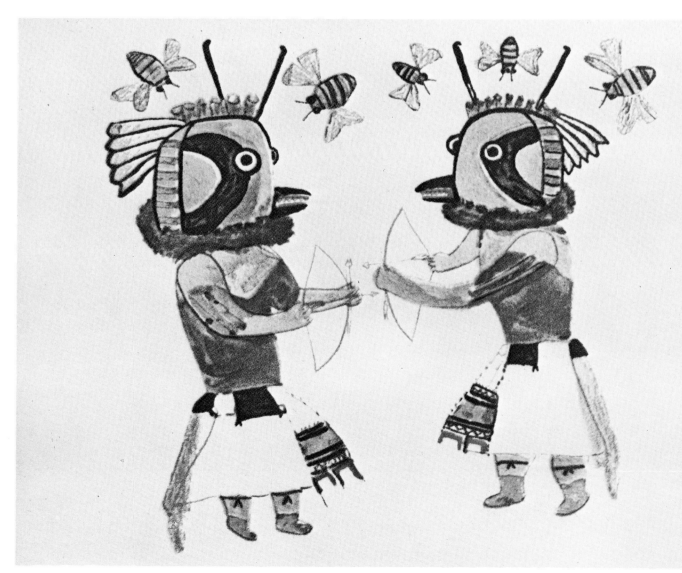

*Fig. 6.1b*

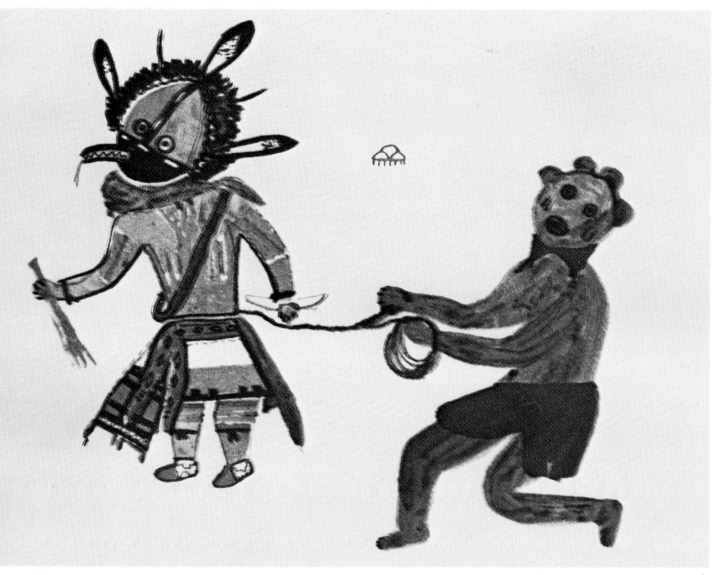

Fig. 6.1c

figure. Also, the heads are more carefully depicted; the precise draw-
ing of the mask adds to a static quality that often contrasts with the
lively little figures beneath their burdensome faces and headgear. The
dignity of the spirits is ever-present in these masks; the warm, danc-
ing bodies of the personators are often made real in moving arms,
bending bodies, or running feet.

Details on these Hopi paintings are quite well executed. In
general, such features as the following can be determined at a cur-
sory glance: knitted cotton stockings; kilts and blankets with various
types of decoration or embroidered sash; necklaces and earrings of
turquoise, shell, and coral. So carefully reproduced are these details
of jewelry that the individual stones in a small mosaic can be
counted. The Kachina Yohozro Wuqti, Cold-Bearing Woman,[9] wears

215

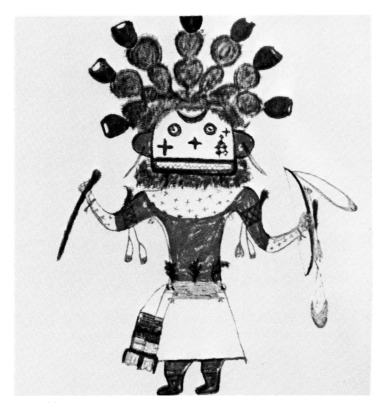

Fig. 6.ld

Fig. 6.le

a pair of old-style earrings in which tiny pieces of turquoise are embedded on a square base of black wood. Certainly one could gain a thorough picture of jewelry styles of late nineteenth-century Hopis through a careful study of these kachina drawings!

Splendid indeed are the representations of symbols on the masks and headgear, with proper coloring to depict the major features of the deity personated—the flat green leaves topped with red fruits realistically symbolizing the Yuña or Cactus Kachina;[10] the disc-shaped mask of Tawa or the Sun Kachina;[11] rain clouds on the cheeks of the masks of the Telavai Kachinas[12] who also aid in the distribution of the miraculous bean sprouts.

The drawings in the Fewkes report reveal varying degrees of artistic ability. Unquestionably this is due, in part at least, to increased proficiency as the painters learned to handle the new medium as well as to the individual abilities of the several artists involved. The feet of Turkwinu Mana are mere extensions at the bottoms of his legs, poorly drawn, badly colored.[13] In two figures of the Paski (Planter Kachina)[14] there are short black lines added to suggest toes. The moccasins and heavily wrapped leggings of Alo Mana[15]

216

are neatly drawn, but the artist had trouble with the full-front representation of the foot.

Seemingly, the majority of the small figures were first sketched in pencil and then filled in with color. Some few appear to have been painted without benefit of prior sketching; this would be more in keeping with the traditional, as noted at Awatovi. Some outlines are well defined and clean; some are poorly done; some are very heavy. Obviously much of the small detail was added without previous sketching, as, for example, jewelry, details of costume, some mask features, and much of the body paint.

Position of the figure seems not to have bothered these first Hopi artists. The characteristic pose is head full front, shoulders, arms, and body the same, and lower legs and feet in profile. Occasionally the body is in three-quarter view, or the head may be in profile; otherwise there is no variation.

Although the head and mask are characterized by a stiff, unmoving pose, now and again the artist could not resist giving them some more active part in keeping with the body. For instance, two Tatacmu Kachinas[16] are represented playing a ball game, and so intent are the players that their masked heads are bent groundwards at quite a sharp angle.

Rarely is any headpiece out of line. The exception is that of the Kachina Turkwinu Mana:[17] the stepped superstructure of the mask definitely tips to the right. Further indications that this was a first drawing, or one done by a less-experienced artist, include color that overlaps beyond the drawn lines or does not quite fill them in, or color omitted entirely in one cloud decoration, or less-well-executed drawing throughout the mask.

There is much sloppy work in coloring the figures, although here again better work is found in the mask. Smudged surfaces are to be noted in a few masks, such as in the two green ones of the Nakiatcop Kachinas.[18] The body of the dance figures and all-over work on garments are more often poorly done, as in the case of the Paski or Planting Kachinas.[19] Not only does the actual color of the bare bodies vary, but also it seems that the artist went back over his work more than once, leaving areas of heavier paint running in all directions. This is not an effort in the direction of modeling; in fact, every brush stroke is aimed at a flat treatment of all parts of the body. Flat color is the rule on the carved kachina dolls that precede and follow in time the reproductions under discussion here. The same is apparently true of the body paint on human dancers who impersonate kachinas.

In summary, it may be said of the first important venture of Hopis into the realm of an independent art expression that the results

217

are indeed commendable. The strange little figures, static or running across blank pages, were thus "put to paper" for the first time in Hopi history; they lost nothing in small detail, despite their artistic shortcomings. They are still the sturdy creatures of mythology which they had long been in the person of the dancer and in murals, or in the carved and painted wooden doll.

Thus, in this ambitious publication of Southwest Indian art, *Hopi Katcinas,* this tribe really established the first "school" in terms of setting standards in subject matter, in the handling of color in some measure, in the method of depicting the figure, and in fine detail. To this day, a Hopi child reputedly draws a kachina *first* and *best* of all subjects. Mature artists have dealt with kachinas more than any other single subject.

There is a long gap between the collective effort described above and the next Hopi artist. There is mention of a Hopi painting purchased from an Indian boy by Mrs. Barbara Aitkin in the year 1912, "a painting of a Snake dancer done by him on wrapping paper."[20] Nothing more is heard of this tribe as artists until Fred Kabotie appears upon the Santa Fe scene about 1917.

> Fred Kabotie, the Indian illustrator, is a jolly High School boy, who plays on the football team and whom all the children of Santa Fe call to as he passes. He is a natural artist and has taught himself from within all that he knows of art. Modest and retiring, he objects to being mentioned here.... [21]

Such was the introduction of Fred Kabotie to the realm of art. Great has been his achievement beyond the simple drawings made for the child's book *Taytay's Memories,* in which the author, Elizabeth Willis De Huff, wrote of him as quoted above. Kabotie has never lost his sense of humor, and he has remained modest and retiring. He has, however, augmented his native ability with formal training. Constantly he has reflected inward growth in his art which has won him national acclaim.

Fred Kabotie was born in the village of Shungopovi on Second Mesa, in Hopiland, in the year 1900.[22] His parents were typical Hopi people who brought their son up in full pueblo tradition.

The Hopi world is a changing world. The family of Fred Kabotie has been involved in the struggle of the old and traditional competing with the new. During the artist's earliest years his conservative family felt keenly the innovations that the United States government was attempting to make in Hopi life. As a result of this, the family, along with other conservatives, moved to the tribal village of Oraibi. It was while at Oraibi that Fred's first artistic inclinations began to appear. He and other boys of the village drew sketches on slabs of stone, using earth colors.

Again the conflict between conservatives and progressives forced another move on the part of the Kabotie family, this time to Hotevilla. It was but a year later that the government sent some of these folk back to Shungopovi, Fred Kabotie's family among them.

It may be that the next move in young Fred's life came as a direct result of these incidents. Against his family's wishes, and his own, too, he was sent to the boarding school at Santa Fe, more than a comfortable (in the official mind!) 250 miles from his conservative home. Doubtless this was an expression of current feeling on the part of the government to draw the Indian away from his hundreds-of-years-old culture by putting him in new and different surroundings.

Quite the contrary influence came into the life of Fred Kabotie in Santa Fe. His immediate associates in the classroom were other Indians, many sharing the same longing for their home villages and camps. This situation made the "weaning" process less final than was the intention of those who removed the Indian from his native habitat, and also less painful than the Indian had feared.

The Laboratory of Anthropology at Santa Fe has a great many of the original pen-and-ink sketches and several colored drawings with which the book, *Taytay's Memories,* was illustrated. The lively drawings and paintings were made before Fred had received any formal training in art. Mrs. De Huff reports that the illustrations represent the Hopi Indian's own conception of the stories. Delightful and charming, they reveal less constraint than much of the later work of Kabotie. Subject matter, to be sure, may play a part here.

Throughout, the drawings reveal the richness of pueblo life that had been the full measure of the growing Hopi boy in his native village. From the twist of an Indian man's hairdo to the costume and painting of a ceremonial dancer, minutiae and details are sketchily but accurately portrayed. Expressions on the faces of animals and birds are well done. Many Indian stories imply that animals are like humans; in some instances, in this book, the animal removes his skin and *is* a human. Perhaps this concept made more convincing such sketches as the one captioned, "Then the Puppy went wagging his tail in friendly fashion up to a group of little boy Crows"!

*Taytay's Memories* set the pace for illustrations, and in 1927 Fred Kabotie produced another series of drawings, this time for *Swift Eagle of the Rio Grande,* also written by Mrs. De Huff. The original pencil and crayon drawings for the book are also in the Laboratory of Anthropology in Santa Fe. The legends related in this volume, although from the pueblos of the Rio Grande Valley, were familiar to Fred Kabotie; he did a commendable job in his sketches for them. For instance, in one sketch Swift Eagle is digging for a rabbit—this is a theme as close to the heart of a Hopi as to that of any other

219

pueblo boy. In another scene women are carrying full baskets atop their heads. The women's blanket dresses, their woven belts, their moccasins, hair bobbed and queued—all are details well within the understanding of one reared in the pueblo tradition, differing in small points only.

At about the same time, the young artist illustrated the story, "Five Little Kachinas," which ran in *Holland's* magazine as a serial. Later this story was published in a book form. Here the delightful and appealing mudhead clowns are represented, as Kabotie says, "just like the Hopi kids," playing over and under wagons, sticking their heads in ollas, and otherwise getting into childish mischief.

After graduating from high school in Santa Fe, Fred Kabotie spent some time at numerous tasks in and around this New Mexican town. He and two other Indians were employed in the School of American Research where it was made possible for them to paint, along with other tasks.

These young men were far from being absolutely free from white influence, for, as Kabotie has remarked, "there was painting and other forms of art all about us!" It should be stressed, however, that those who were conscientiously trying to give these Indians every opportunity to develop naturally saw to it that they received no formal instruction. But to keep them from any outside influence whatever would have meant sealing them in a vacuum. Further, these young men, Fred Kabotie no less than the others, were not so unworldly that they did not learn at this time that the buying public makes certain demands of an artist.

During these several years in Santa Fe, Kabotie also did a bit of tourist guiding and played in several orchestras. These contacts with the general public further influenced the attitudes of this Hopi artist. A short sojourn at the Grand Canyon and a year at his native village were followed by a return to Santa Fe.

On his second visit in Santa Fe, Kabotie was commissioned by the Heye Foundation of New York City to record in painting the tribal dances of his people. He devoted the whole of 1929 to this worthwhile project. At the termination of the year of concentrated painting, Kabotie returned to his home village to be initiated into a Hopi men's secret society. This determined his future, for he remained in Hopiland from that year on except for brief intervals. During the prolonged period of his initiation he also painted, filling orders which had accumulated through the years. He learned that his own native surroundings were conducive to good painting as well as greater peace of mind.

After his initiation, in 1931, Kabotie married Alice Tala of Shungopovi. Shortly after their marriage, the Kaboties went to the

Grand Canyon where both were employed by the Fred Harvey Company for several years; among other things he painted murals in which conventional themes were featured. Little time was available for painting, and that largely at night, a situation that proved no more successful than life away from the Hopi country. The couple willingly and happily returned to their home in the summer of 1937, when Fred was appointed instructor in painting and drawing at Oraibi High School. Thus through his teachings, as well as in his painting, he has been a strong influence on Hopi youth. Fortunately for these youth, Kabotie has encouraged them to paint in what might be called a tribal style. In other words, as he has said, he has not encouraged the European style of painting. Instead, he has urged his students to paint their pueblo life. Surely the best of his students' works are those in which the subjects, as again Kabotie has put it, "follow the events of the Hopi calendar year." As with their teacher, this is what they know best, this is the subject matter they can understand.

When asked what media his students used in the classroom, Kabotie replied, "whatever medium they can get!" Whenever circumstances have permitted, watercolors have been preferred, for this is the medium closest to the painting traditions of these people. This is also the medium most often used and best handled by Kabotie.

The fast tempo of life caught up with Hopiland and, like the rest of the world, Kabotie has often sighed and complained about the shortness of the days. And slight wonder, too, for in addition to his teaching duties, he assumed many another heavy obligation.

In 1946 a group of fourteen Hopi G.I.'s was organized for the purpose of pursuing the craft of silversmithing. Fred Kabotie was put in charge of the designing for this group, while the technical training was placed in the hands of another Hopi, Paul Saufki. Native designs were used in this work. Design motifs were borrowed from pottery or basketry or any Hopi source; then they were adapted to use in the new medium, silver. Many splendid craft pieces resulted, all the products of fundamentally good design. After the abandonment of this program, and particularly during the mid- and late 1960s, Kabotie directed the Hopi Arts and Crafts Guild on Second Mesa. Thus it can be understood quite readily why he did little painting after the late 1940s.

The earliest work of Fred Kabotie established a precedent in subject matter seldom broken by this artist. Throughout the many years he has painted, he utilized ritual material, as exemplified in an early painting, *Hopi Butterfly Dance* (Fig. 6.2). It has been said of him that he has painted almost every ceremony of his people. The rows of dancing figures followed the already established Hopi trends in the direction of repetitive design, but Kabotie made the

221

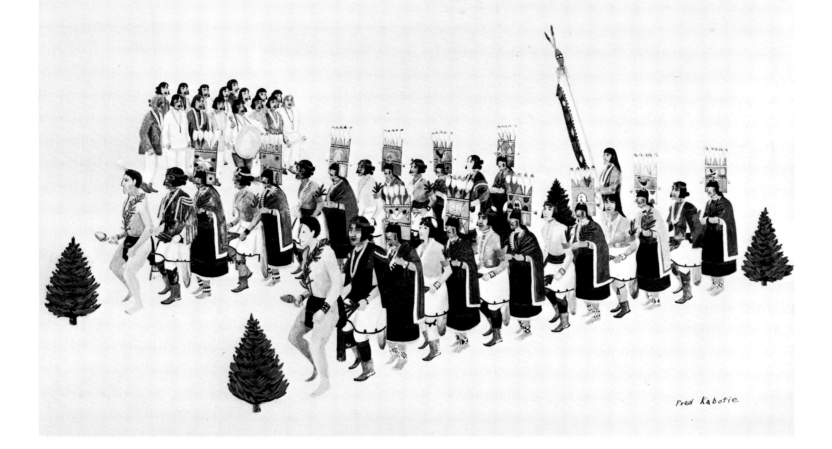

Fig. 6.2    Fred Kabotie, Hopi.
Hopi Butterfly Dance.
Courtesy, The School of
American Research, Santa Fe.
—Kenneth Schar

monotonous and repetitious figures impressive in form and color. Too, the nature of these subjects influenced Kabotie to the extent that he became a master of detail. A static quality characterized his early work, but through the years he developed mobility in his dance figures, whether there were two or many, as his later *Supai Dance–Santa Clara* (Fig. 6.3) shows in contrast to the above *Butterfly Dance.*

Fred Kabotie was the first of his tribe to receive national and international recognition as an artist. Between 1917 and 1925, shows including his works were given in both Europe and America. During this period and since then, his paintings have been exhibited in France and Spain and from coast to coast in the United States. In this country he has exhibited, among many other places, in Santa Fe, in Gallup at the Indian Ceremonials, at the Philbrook Art Center, Tulsa, in New York at the Grand Central Art Galleries, Corona Mundi International Art Center, and the William Rockhill Nelson Galleries, at the Society of Fine Arts, Palm Beach, Florida, the Denver Art Museum, and the Bakersfield, California Art Museum. He is represented in many permanent art collections including the Gilcrease Institute, Heye Foundation, and the Museum of Modern Art, New York. Outstanding among his one-man exhibits was the show at the Museum of Northern Arizona, Flagstaff, in May, 1947. This show created a great deal of interest and comment throughout the state.

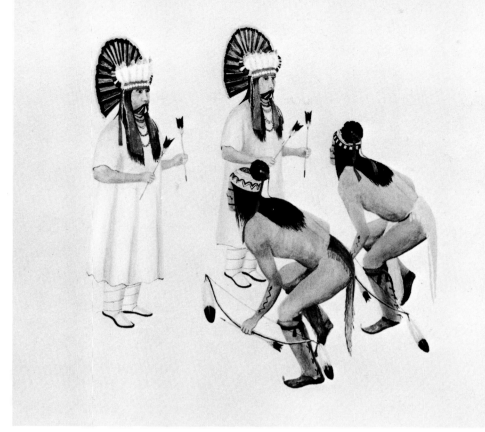

Fred Kabotie

Fig. 6.3    Fred Kabotie, Hopi. Supai Dance—Santa Clara. *Courtesy, The School of American Research, Santa Fe.* —Kenneth Schar

In the summer of 1947, one of Kabotie's paintings, *Home Kachina Dance* (Fig. 6.4), was featured in an exhibit of Southwestern painters in the Dallas Museum of Fine Arts. The sixty-four artists exhibiting represented the states of New Mexico, Arizona, Colorado, Oklahoma, Arkansas, and Louisiana. In the brochure for this splendid collection it was noted that "very important to remember in any survey of American art is the growing number of Indian artists. . . . "[23] Herein, too, Kabotie is referred to as one of the leading contemporary painters in Arizona. This *Home Kachina Dance* painting shows many points of contrast when compared with his early work. There is still the rigid and formal line of dancers, faithfully portrayed to the last detail. However, there is European perspective in the plaza surrounded by pueblo houses, people sitting about, eagles on rooftops, and clouds in the distant background. All of this is done in realistic painting and is as informal as the dancers are formal, even to a lazy dog sleeping in the sun!

Perhaps this painting is a good example of the meeting of the Indian-old and the Anglo-new influences in Fred Kabotie's life. Undoubtedly the conflicts in his boyhood days, between the conservatives and progressives among his own people, sowed a seed which his way of life has nurtured.

Many honors came to Fred Kabotie during his thirty active years as the leading painter of his tribe. In 1945–46 he was awarded

223

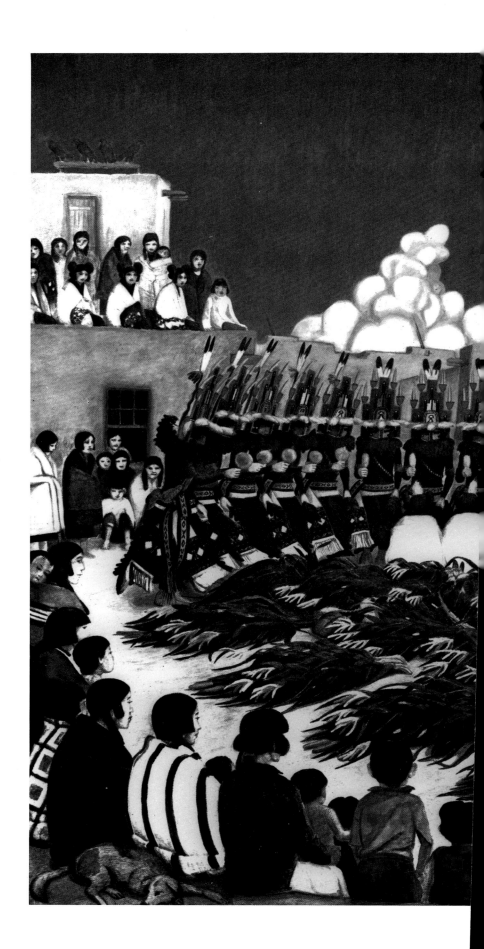

Fig. 6.4    Fred Kabotie, Hopi.
Home Kachina Dance.
Courtesy, Arizona Highways.
—Milton Snow

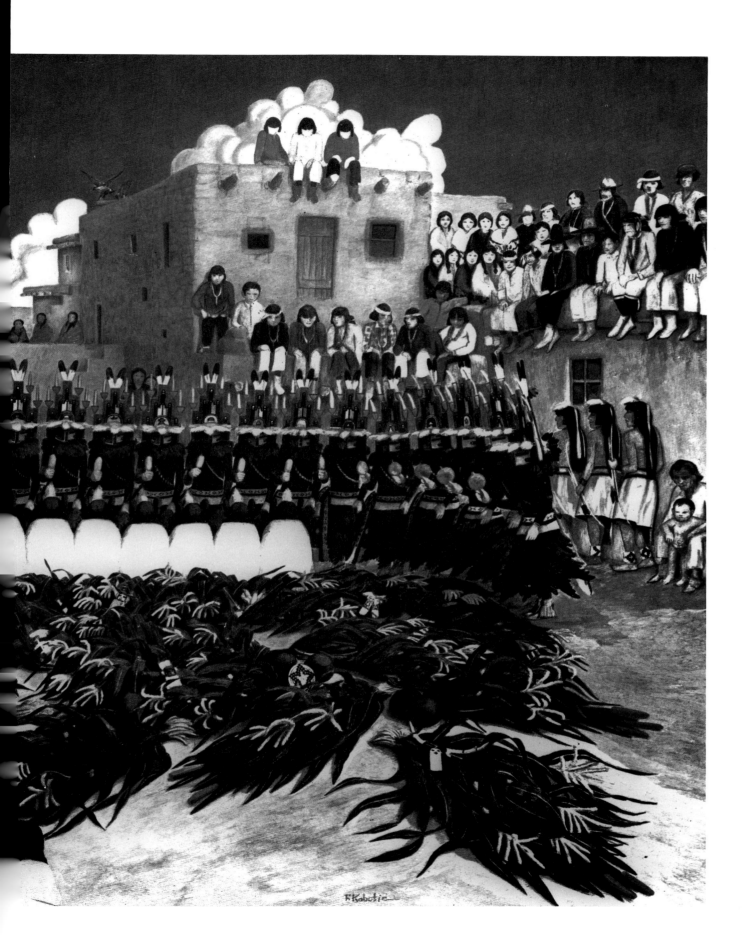

F.Kabotie

a Guggenheim Foundation Fellowship in recognition of his high artistic attainment.[24] The chief project attempted by Fred Kabotie as part of the fellowship was a book on the interpretation of prehistoric Indian designs. This interesting work, *Designs From the Ancient Mimbreños,* was both written and illustrated by Kabotie. In this book are faithful reproductions of the prehistoric designs of the Mimbres people. Kabotie states,

> Pueblo culture has been a living thing in the Southwest for at least two thousand years. While archaeologists and other students are working on the outlines of its history, making it clearer year by year, they cannot completely appreciate the feelings and responses which come instinctively from one who has lived in that culture.[25]

Interesting indeed are the interpretations which follow, well-seasoned with a measure of reflection that could come only from being born into and reared within pueblo life.

On American Indian Day, at the Chicago Railroad Fair in the summer of 1949, Kabotie was accorded a second outstanding recognition, the Annual Achievement Award of the Indian Council. This was the first such recognition of an Indian artist, and Kabotie was the first Hopi to receive the award. It was but one of many honors which came the way of Fred Kabotie. The year 1946 was outstanding. In that year Kabotie received the grand prize at the Gallup Inter-Tribal Indian Ceremonial Exhibition. At the Arizona State Fair he received a special award in the Indian arts and crafts section, and was awarded first prize in the fine arts section where his painting was the sole Indian entry and competition was with outstanding Southwest artists. During the same year he received the first Grand Award given by the Philbrook Art Center, Tulsa, where the works of many American Indian artists were entered in competition. Kabotie has not entered competitive exhibits since the 1950s.

Many and varied have been the commissions he has received. During the Depression years the Fred Harvey Company employed him to decorate the Hopi Indian Tower on the south rim of the Grand Canyon. This painting combines several legendary personalities and numerous symbolic designs, which are done in typical Hopi colors. Some of his murals are in traditional style, some are greatly simplified, and some are like kiva murals. The same company commissioned him to paint murals in one of their dining rooms at Painted Desert Inn. These reveal some of the Hopi ideas relative to the sacred, such as an eagle shrine and a trek to the salt lakes near Zuñi.

During the late thirties The Peabody Museum of Harvard University was excavating the important prehistoric and early historic site of Awatovi in the Hopi country.[26] It was very necessary that the murals on the walls of the kivas be faithfully recorded as they were

removed layer by layer. Fred Kabotie, under the direction of the Indian Arts and Crafts Board, reproduced several of these paintings in original size on panels in fresco; well qualified was he for this job for he had painted numerous murals, as indicated above. (Figure 6.5 is a painting in this style.) The reproductions were later exhibited at the Museum of Modern Art, New York City, and in other leading museums throughout the country.

Kabotie has told of an amusing incident that occurred in connection with one of the many art commissions which he has received. For a spot of advertising, a national American corporation asked him to do a painting that would be representative of Arizona. Kabotie obliged with an interesting drawing on buckskin. The painting told the story of the germination of corn, the staple food of all Arizona Indians. The work was executed in conventional Hopi style and in flat colors. A full-color reproduction appeared in both *Time* and *Fortune* magazines. Keeping a serious face, Kabotie said that later one of these magazines carried an article about this painting.

*Fig. 6.5    Fred Kabotie, Hopi.* Germinator. *Courtesy, Arizona Highways.*
—Milton Snow

In it was the full story of how he had killed the deer, tanned the skin, and painted the picture. With a twinkle in his eye, Kabotie ended his story—"And I *bought* that buckskin for $45.00!"

Fred Kabotie's influence has been far-reaching. Not only as a teacher, but also in his original paintings, he has affected Hopis and other Southwest Indian artists. Modestly, he once told of overhearing some Rio Grande artists expressing the desire to meet "this Fred Kabotie" whose art had influenced theirs. And laughingly he related that when he revealed he was the man of their discussions, they were quite taken back, for they had thought him to be a much older and more pretentious fellow.

Thus has lived this quiet, generous man, without fanfare, in his native land. By standards of his tribe his art has given him a good living. And he has given back in equal measure through his teaching, his designing, his painting.

Fred Kabotie has been one of the most capable artists of all his tribesmen; he is outstanding among all Indian artists; and he has an acknowledged niche in American art as a whole. All this has been accomplished through his faithful portrayal of his people in their everyday life in all its variety. He has painted women's household activities, the varied roles of men, the fascinating ceremonies. He has painted pairs of dancers with the same intensity and devotion to detail as in the more dramatic lines of dancers (Fig. 6.6 and 6.7). One can visit a pueblo, and paint it, too, but never with the warmth, never with the meaningful fidelity, never with the exquisite and rich detail portrayed by Kabotie. He has left a refreshingly truthful ethnological record of his people.

In his painting, Kabotie has achieved a fine balance of figures, often not too realistic; formal composition is usual. Of one of his Snake Dance paintings it has been said that it forms "one simple and impressive rhythm."[27] He has ranged from the use of flat color to much shading, particularly in modeling figures; from no ground lines to European perspective; from highly stylized and conventional design to complete realism. His subject matter is basically Hopi, and endless within the experiences of his tribe, but he is also familiar with and has painted rituals from other pueblos (Fig. 6.8).

Kabotie has said that he quit painting while teaching in 1959[28] (although he recalls doing one in 1959 or 1960 and another in 1966). His earlier works remain popular and are eagerly sought by collectors

*Fig. 6.6*    *Fred Kabotie, Hopi.* Couple of Squirrel Kachinas. *Courtesy,* Arizona Highways.
—Milton Snow

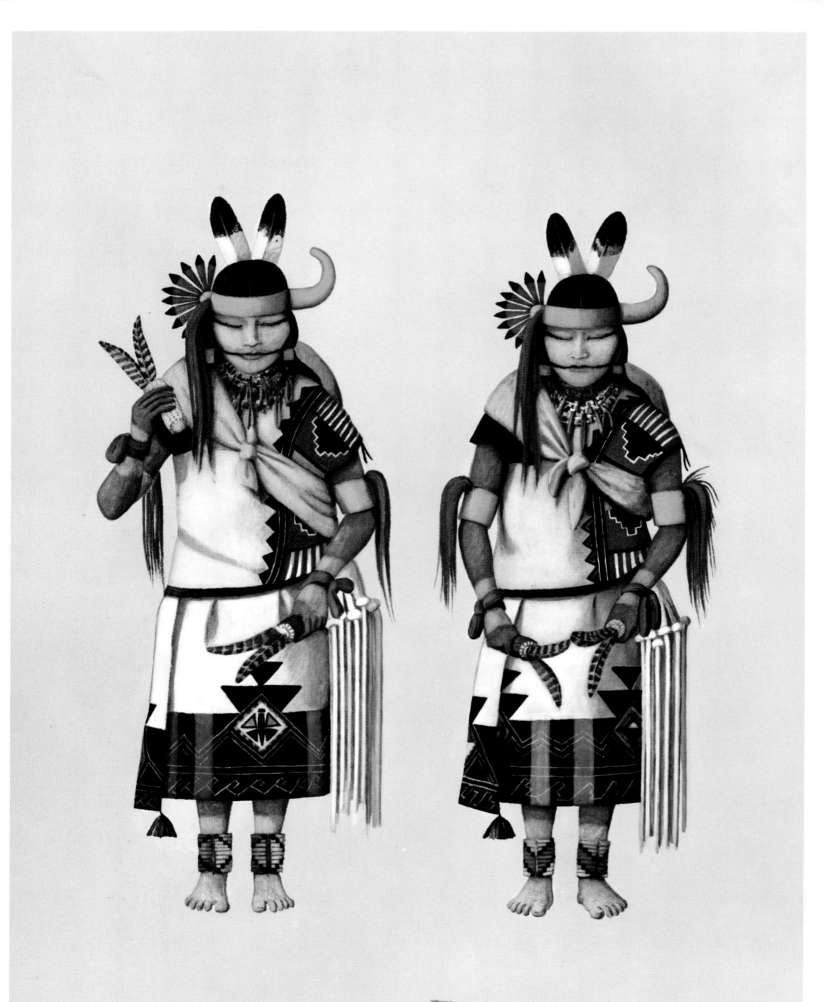

F. Kabotie

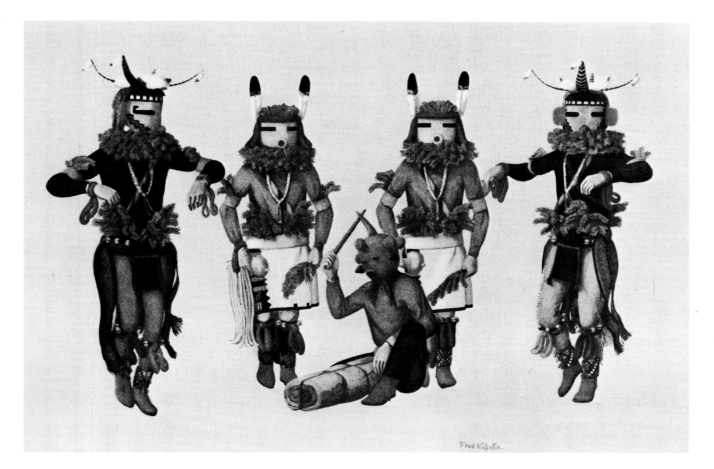

and for collective exhibits. In 1963, one of the latter brought together the paintings of Kabotie and other early pueblo artists for a U.S. Information Service tour in the Old World, from Athens through southern Asia. These exhibits received high acclaim.

Whether or not he ever again touches brush to paper, Fred Kabotie's name will live on as the first of the great Hopi easel painters, and, perhaps, the greatest of the conventional, traditional artists.

Another Hopi artist, Otis Polelonema, who was born in 1902 in the village of Shungopovi on Second Mesa, had the early childhood of a normal Hopi. Later he was sent to Santa Fe where he attended the Indian School, painting part of the time with Fred Kabotie. He returned to his native village in 1921. As an active member of his own society, he was able to reflect in his painting

231

much of Hopi culture, often with documentary realism. An excellent weaver, he has also participated extensively in the ceremonial life of his pueblo, particularly in the activities of the Snake Clan.

Polelonema was painting as early as, if not earlier than, Fred Kabotie. Some of his paintings have been dated between 1915 and 1921; closer to the later date would seem more logical. His name is mentioned along with Kabotie's shortly after this time as co-illustrator for a child's book. He and Kabotie are also listed as among the prize winners at the first Southwest Indian Fair, Santa Fe, in 1922. Polelonema's paintings have been exhibited widely, including a 1927 show, with other Southwest Indians, at the Corona Mundi International Art Gallery, New York City, and at Fair Park Gallery, Dallas.

A summary of the characteristics of Polelonema's paintings follows. Perspective is simply delineated. Often there is excellent detail in costume, painted in clear, flat color. Sometimes flesh tends to be smudgy when the artist attempted to suggest form through shading; he overcame this difficulty in later years and has done fine and quite realistic skin portrayals as well as excellent representations of hair, fur, and other such detail. A trait most peculiar to this artist is to be seen in the faces, long and heavy-jawed and large-nosed, made even more unreal by the addition of too-long bangs over the forehead and bobbed hair down the sides of the face (Fig. 6.9). These faces are extremely sad in many of the Polelonema paintings.

A Polelonema painting which is probably of early date is a representation of a New Year ceremonial. Dancers are presented in

*Fig. 6.9    Otis Polelonema, Hopi.* Wedding Procession. *Courtesy, The School of American Research, Santa Fe.*
—Laura Gilpin

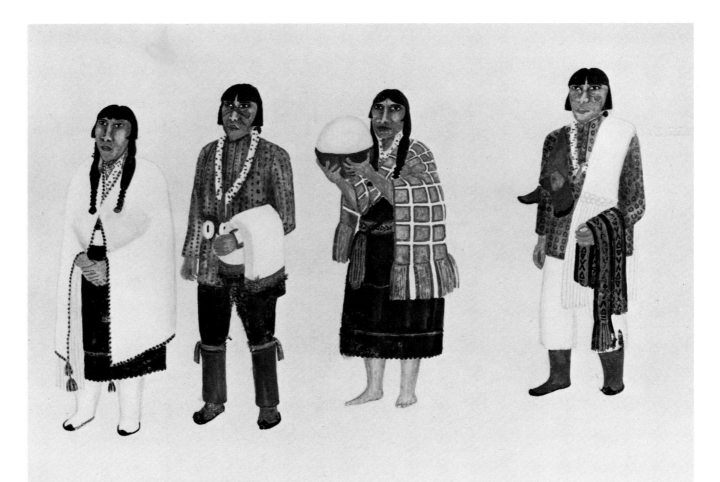

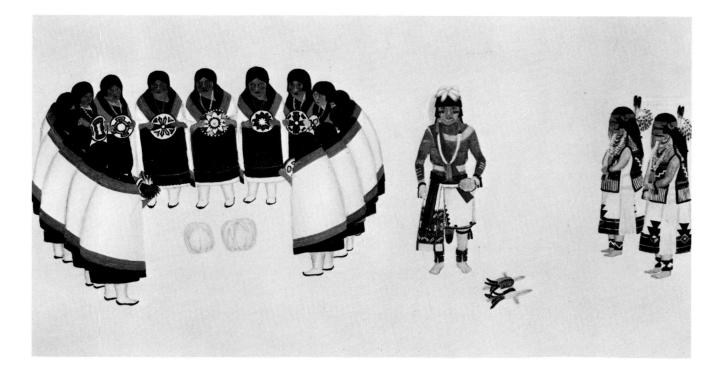

Fig. 6.10    Otis Polelonema,
Hopi. Hopi Women in
Ceremonial. Courtesy, The
School of American Research,
Santa Fe.
—Laura Gilpin

a wide horseshoe arrangement. Across the back each dancer in the line is individually represented, but along the two shortened sides figures become confused and less distinctly drawn. The perspective here is very much like that of the early San Ildefonso School, as though one were viewing the performance from a rooftop (Fig. 6.10).

Otis Polelonema reveals many qualities similar to those of Kabotie; he also has developed some traits quite distinctly his own. Blue shading on white grounds seems to have been borrowed, as does the attempted modeling in color. Subject matter is often similar.

A series of four paintings done during WPA days, and obviously planned for a mural, reflects many of Polelonema's capabilities.[29] In a sense, these paintings are more in the way of realistic documents than works of art; nonetheless, they show improvement in several respects over the earlier works of this artist. Throughout this series, the rich legendary lore and the life of the Hopi Indians become vibrant and meaningful in color as the artist has set them down in combinations of conventional and realistic themes. The effective meeting of the two, the conventional and the realistic, is well handled by Polelonema; detail is prefected, and composition is better than in many of his earlier works. He also has produced realistic paintings of village life telling of the activities of his people; such is *Water Carrier* (Fig. 6.11).

One painting done about 1947 shows Polelonema's great ability to do exquisite kachinas. Here are pictured two dancers, sans

233

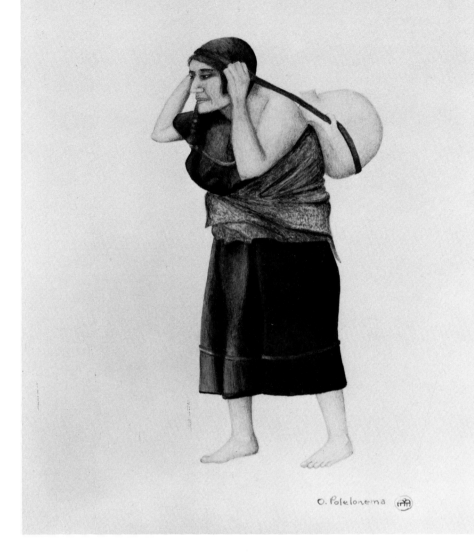

O. Polelonema

*Fig. 6.11    Otis Polelonema,*
*Hopi.* Water Carrier. *Courtesy,*
*The Amerind Foundation, Inc.*
—Ray Manley Photography

background. The characteristic pose is with one foot upraised. Masks, headdresses, blankets worn by the dancers, green boughs carried by them, all show fine handling of the brush and choice of rich color by the artist. It is in such dance figures as these that Polelonema has done his finest work. This high quality of painting continued into the 1960s (Fig. 6.12).

In the early and mid-1960s, and to some degree into the late 1960s, Polelonema was painting excellent kachina figures, either individual ones or groups of these dancers. The individual figures usually were painted with little or no additional detail in the way of background. Group scenes, on the other hand, might be complete, with dancers and other ceremonial figures occupying the center of the painting (Fig. 6.13), or in the background might be the pueblo village or part of it, men sitting on the rooftops, villagers standing about the plaza, and other detail. Although these group scenes, such as *Corn Dancers* (Fig. 6.14), were painted with great care and fine

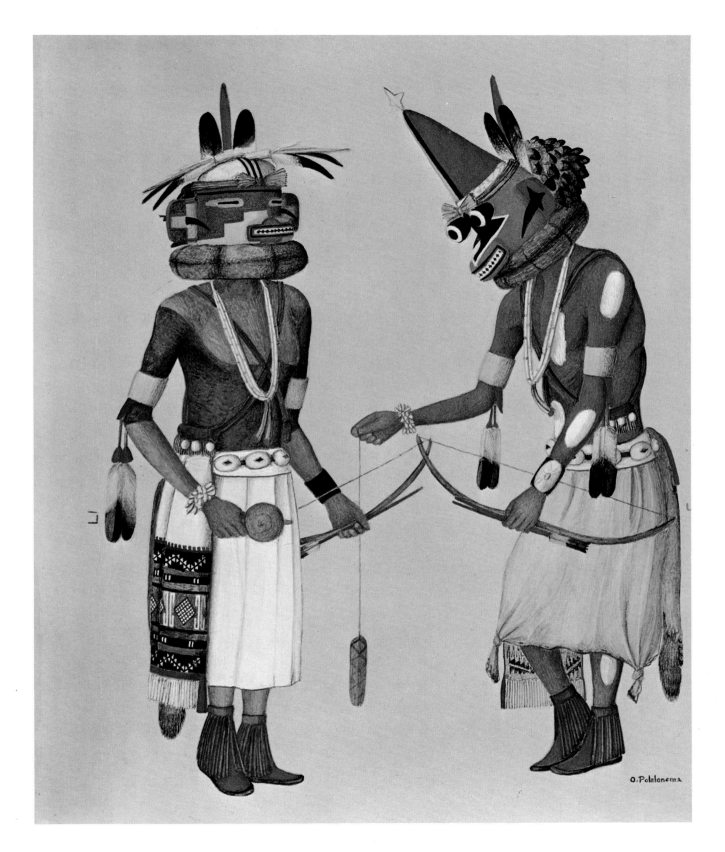

*Fig. 6.12    Otis Polelonema, Hopi.* Loquan Dancers.
*Courtesy, The Amerind Foundation, Inc.*
—Ray Manley Photography

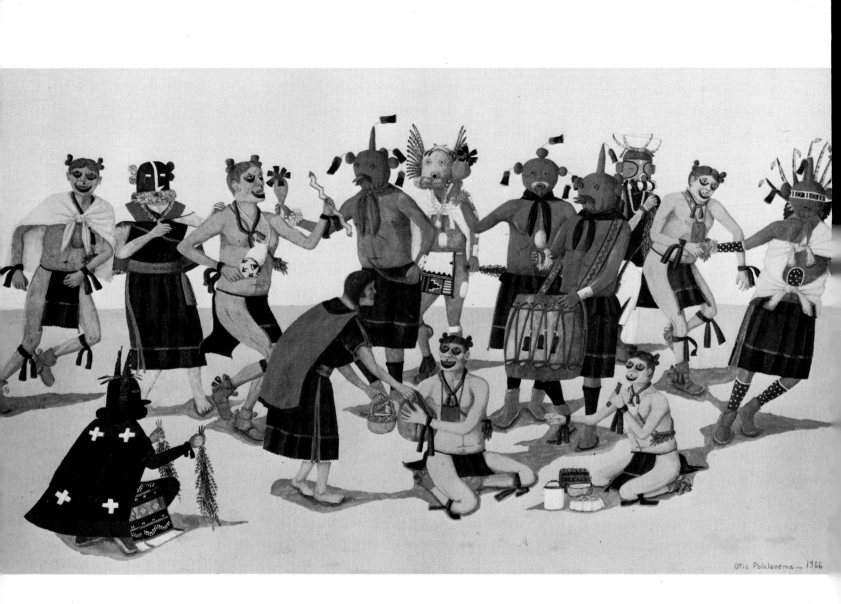

Otis Polelonema — 1966

detail, with sharp and clear-cut lines, and were excellent compositions, none came up to the best of the individual or pairs of masked dance figures that were done in such exquisite detail, with such refinement, and in such color harmony. Both styles exceeded the attainments of Polelonema's early naïve works.

In the late 1960s the quality of some of Polelonema's work began to degenerate; nonetheless, he did receive a first award at the Phoenix Museum Guild Show in 1969, and a special award at the 1970 Scottsdale National for one of his kachina paintings. Generally, however, group scenes lost their compositional quality, and figures suffered in loss of detail. Color, too, was not as rich as in the best of Polelonema's painting. One interesting painting, an oil done in 1966, is a full village scene with a diagonal line of ceremonial figures dominating the composition and with villagers scattered about on benches and on rooftops. Detail in dancers' costumes is very good

but not up to his peak attainment. Polelonema continued to paint in this style to the end of the 1960–70 decade. He ranks with Fred Kabotie as one of the great Hopi traditional painters.

Through the years Polelonema participated more and more in the activities of his village; as a result, he painted less and less. Despite this, he improved with the passing of the years until the late 1960s, as discussed above. However, he has never conquered certain idiosyncrasies established early in his painting years—for example, the odd representation of the face. As noted, his early figures are small and large-headed, heavy-faced; through the years, he achieved better proportions, but the heavy, almost grotesque-featured, solemn-

*Fig. 6.14   Otis Polelonema, Hopi. Corn Dancers. Courtesy, the Avery Collection.*
—Howard's Studio

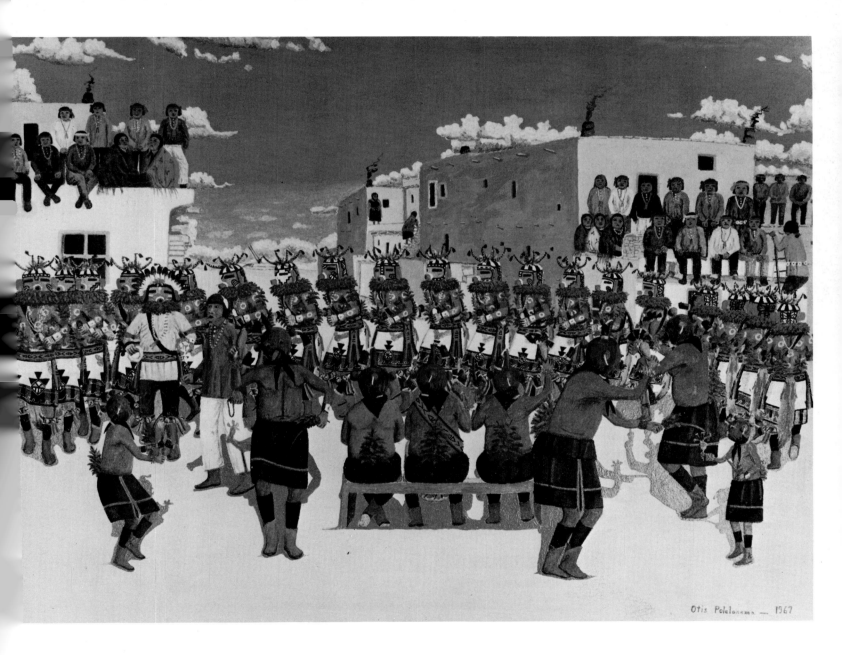

Otis Polelonema — 1967

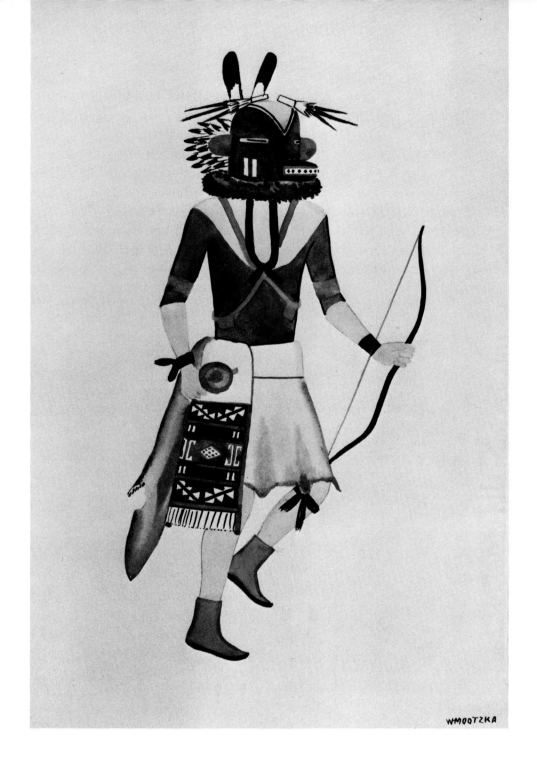

*Fig. 6.15    Waldo Mootzka,
Hopi. Dancer. Courtesy, The
Amerind Foundation, Inc.*
—Ray Manley Photography

countenanced individuals still mark paintings as peculiar to
Polelonema. But no Hopi has excelled this artist in depiction of dress,
especially in details of native design. His paintings are often rich in
ceremonial pattern, also. Polelonema has excelled in the presentation
of the masked dancer, minus any features of European perspective.
In his watercolors he has attained great delicacy in the treatment of
detail and figure. Now and again he attempted to use oils, but often
without the success that was his in the lighter medium. Along with

Kabotie, Polelonema should be given much credit in the establishment of the Hopi manner of painting.

Waldo Mootzka[30] was born near the Hopi village of Oraibi in 1903.[31] He attended the U.S. Indian School in Albuquerque before art was taught there, then returned to Oraibi.[32] Although he painted alone a great deal, much of his work is like that of Fred Kabotie.

During the 1930s Mootzka was in Santa Fe. He painted in part for John Louw Nelson, who also employed other Indians to depict native life for him. Many of Mootzka's works appear in the volume *Rhythm for Rain,* by Nelson, as do paintings by Kabotie and several other Hopis.[33] One painting by Mootzka that appears next to a Kabotie in this volume seems to justify the statement that Mootzka was influenced by Kabotie. There are similarities in the handling of outlines, in proportions of extremities in general, and in sizes of hands and feet in particular. Even the treatment of fringes on moccasins is alike. However, Kabotie shows stronger and more definitive lines, greater strength in general, more positive handling of color, and a greater promise as a whole for future attainment. In general, Kabotie also shows, in other comparative paintings in this volume,[34] better compositions and more solid grouping of multiple figures; Mootzka has a tendency to scatter individuals about more, or to place them in a straighter line, with figures rather far apart.

It was while he was in Santa Fe a second time that Mootzka came under the influence of the late Frank Patania. The latter employed the Indian, teaching him the craft of silversmithing, although the artist continued to paint during this period. Early in 1940, Mootzka was in an automobile accident that aggravated a tubercular condition that, in turn, caused his death in less than a year.[35]

The paintings of Mootzka combine artistic quality with true recordings of Indian life. Figures are well drawn, displaying a neat and even fragile quality in outlines. Composition of dance groups is fair. A neat separateness of line-work may be said to characterize Mootzka's painting. Lemos speaks of Mootzka's pictures as "beautifully composed."[36]

Subject matter treated by Mootzka is quite varied, despite his ever-Hopi emphasis on kachinas, which he presents singly (Fig. 6.15) or in groups. Animals, everyday scenes about his village, and, most particularly, legendary subjects, all received his attention at some time in his career. Although well drawn and beautifully colored, animals depicted by Mootzka are stiff and conventional. In one painting of a running deer, the single figure is lavender in color with white used to bring out the natural markings of the animal; black, yellow, and white are employed for border emphasis. The stiff-legged crea-

ture is made all the more unreal by a rainbow-like affair in conventional treatment arching over the animal. In the symbolic device, color is pleasingly handled, with pink and yellow predominating. Although this description may seem to echo a Rio Grande style, actually there is little in the way of comparison between the two.

Mootzka was influenced by European tradition in techniques of painting, particularly in the matter of modeling in color and in some three-dimensional portrayals. In a scene from Walpi, one of the old villages of East Mesa, the jutting, narrow neck of mesa land with its picturesque pueblo atop, loses its dynamic qualities of natural brilliance of color because it is portrayed in pastel shades. As in the above-described animal, again the artist used a palette heavy with lavender. Perspective is stressed in distant hills, in the arrangement of the pueblo village with room above room, and in several minute human figures placed in the distance.

Perhaps Mootzka was at his artistic best in the painting of ceremonial and mythological scenes. Certainly he carries one to imaginative heights in such portrayals. Here the artist could—and did—give full vent to his flare for color, vivid or subdued, and to a feeling for the mystical and the symbolical. One painting of this type is replete with kneeling figures, one holding cornstalks topped with yellow pollen, a second figure, also kneeling, in front of the first and holding censers. Smoke from the burning substance goes up in a twining, vine-like manner. Rainbows with rounded clouds beneath them fill the lower left and right hand corners. Back of the figures, and above all, are great sun rays.

The mystical is further stressed in another of these paintings by the addition of strange bubbles of varied colors serving as background to the three main figures. These pollination scenes, for such they are, fraught with all the implication of sun and rain and fertility, were "grist for the mill" of this Hopi artist. An exceptional example of this is *Pollination of the Corn* (Fig. 6.16).

Mootzka drew figures alone or in groups in very much the same way. Slightly bent knees, or a slightly raised foot may be the only suggestion of motion. In other instances, a performer is running full tilt, with sashes, ribbons, and other loose ceremonial paraphernalia flying.

What he lacked in matters pertaining to background and perspective, Mootzka compensated for in color and splendid detail. Not

*Fig. 6.16    Waldo Mootzka, Hopi.* Pollination of the Corn. *Courtesy, Pat and Hazel Patania.*
—Ray Manley Photography

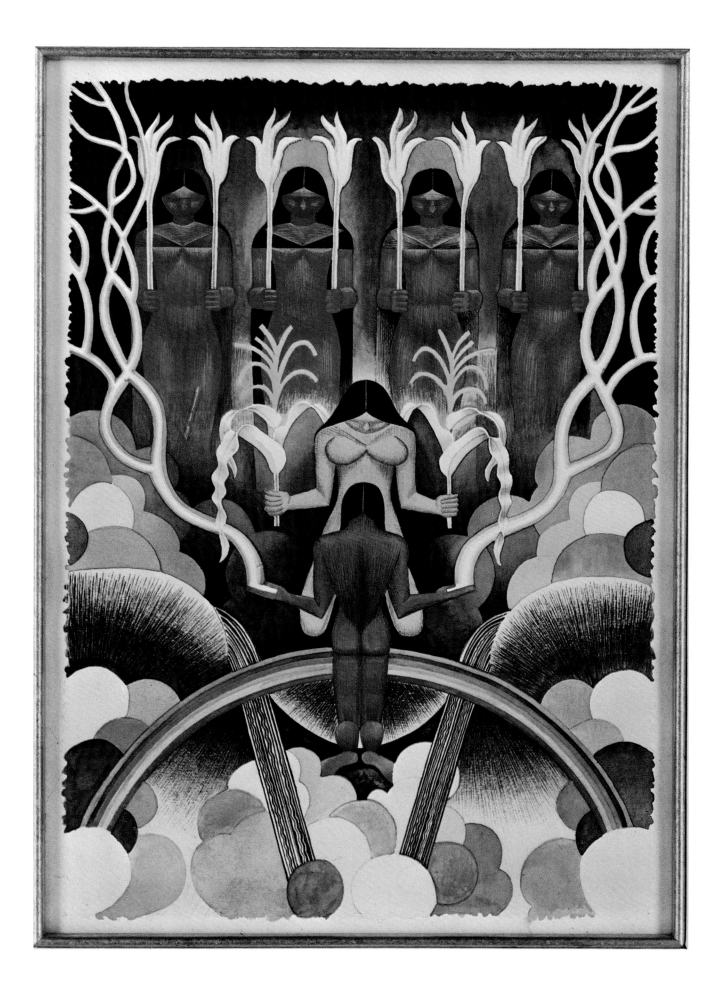

only did he employ numerous colored papers for the sake of variety, but also he used a full palette. Although pink seems to have been a favored color, it was well handled. Pink mudheads or pink masked kachinas are balanced by kachinas of varicolored masks and costumes, all equally vividly portrayed. In other pictures, colors may be subdued or even faded. All of this leads up to a trait which makes Mootzka's work outstanding. Many Indian artists tend to establish a style and technique and adhere rigidly thereto in most of their paintings. Mootzka seems to have been more experimental, particularly with color. There is a great range in his pictures, in color and tone. In one picture color will be bright and flat with no sign of modeling, while in another a few purple lines will suggest modeling. In a third, shading of all colors will appear, to suggest form in flesh, garments, moccasins, and other details. Outlines vary also, from dim and indistinct ones to heavy purple lines or clear-cut and clean black lines.

Paintings by Mootzka occasionally reflect the whimsical humor of the Indian. In one of the Hopi rites, a race is held to help speed the growth of the crops. Mootzka gives a faithful and interesting presentation of this performance; the masked figure, with a great pair of scissors, has caught his victim and holds up his hair, ready to cut it off. This humor was unusual with Mootzka; more frequently he presented the single or multiple kachina figures in a formal style.

Lewis Numkena, Jr., a Hopi who also has signed his name (as the mood strikes) Lewis Numkena Junior, or Lewis N. Junior, was born in Moenkopi village, west of the tribal mesas, July 24, 1927. He studied for two years at the Indian School in Santa Fe, and has exhibited at the Hopi Craftsman, an annual show at the Museum of Northern Arizona, Flagstaff, and at Tulsa, Oklahoma. At the former show he has won a first prize. He has also exhibited at the Art Gallery, Museum of New Mexico, Santa Fe, where his work received high praise.

Numkena uses the most vivid of colors, as illustrated in his *Hopi Kachina Dancer* (Fig. 6.17). Whiting[37] reports that his solid, rich colors are derived from the use of straight Shiva paint. Often Numkena piles it on so thickly and heavily that it resembles oils. In one instance, Numkena shows a dancer holding a small tree, and the tree is so laden with paint that it has a suggestion of low relief about it; in fact, to the touch there are definite heights in the heavily applied paint.

Numkena is indeed at his best when doing kachinas, such as the *Comanche Kachina* (Fig. 6.18). Whiting requested that this artist do a figure of a hunter, thus to reveal the face of the man minus a mask. The face in no way resembles that of a Hopi Indian; in fact, it is none too human. It is a rare thing to find the human face

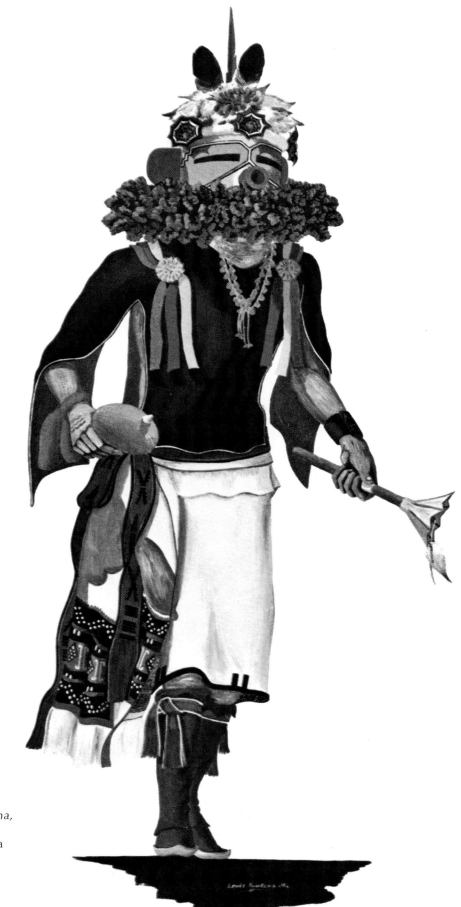

Fig. 6.17   *Lewis Numkena,
Jr., Hopi.* Hopi Kachina
Dancer. *Courtesy,* Arizona
Highways.

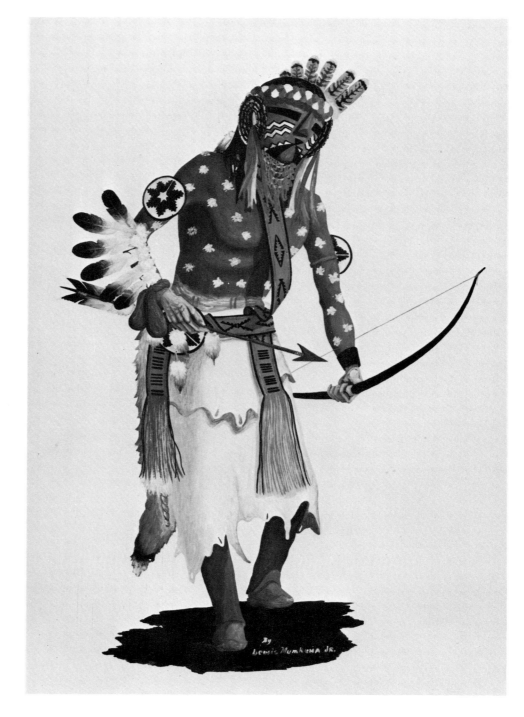

Fig. 6.18    *Lewis Numkena, Jr.,*
*Hopi.* Comanche Kachina.
*Courtesy, Mr. and Mrs.*
*Read Mullan.*
—Neil Koppes

depicted with any semblance of realism in Hopi art, past or present. The human face at prehistoric Awatovi is poorly done: if in profile, there is little more than angular beak and chin; if full front, it is a round or oval area with geometric features.[38]

This painting of a hunter is very interesting. Numkena said that the costume was portrayed as dictated by his father. The hunter stands with one foot on a rock, the other on the ground, a typical

244

Numkena pose. A rabbit stick (a slightly curved stick still used by this tribe) is carried in one hand, and a bow and three arrows in the other hand. The man wears a pair of pants which would seldom be seen in Hopiland today; they are short, with a slit on the outer side of the lower leg, and with the most amazing red and green and yellow and green flowers all over them. These flowers are painted with so much verve that they appear to be embroidered. Doubtless they were one of the many varieties of calico formerly so popular among the Hopis for gentlemen's trousers. The rest of the costume is well depicted—black velveteen jacket, jewelry, hair banged at the front and queued at the back, and kerchief about the head.

Numkena has had considerable trouble with perspective. In one painting he did a most realistic portrayal of the Hopi Snake Dance, an August ceremonial for the purpose of bringing the needed late rains for the maturation of crops. Members of the Snake Society, assisted by members of the Antelope Clan, dance about the village plaza, carrying snakes in their mouths. Each carrier is closely followed by a "hugger," a man with a feather in hand with which to soothe the snake if necessary. The artist has caught the moment in the dance when the last two are going about the plaza. In the background is a Hopi woman; her position is indicated solely by the fact that she is smaller in size and higher up in the picture. Although the woman is poorly presented in relation to the other figures, the details of her costume are accurately and carefully depicted. Her black, native-woven dress with the characteristic deep-blue border; the red, green, and black belt; her hair in heavy rolls down her shoulders, symbol of her matronly status—these and other details are well done. Equally fine detail is expressed in the costumes of the two performers. Even the snake in the hands of the dancer bears the markings on back and underside and the rattles which identify it beyond question. Its fangs are exposed; its tongue hangs out. In this dance any kind of snake may be used; the artist shows another rattler and a black-and-white snake on the ground.

The *kisi,* a green bower of cottonwood branches where the snakes are kept until a dancer is ready to remove one, is to the right. It is solid green in color, except for a few branches on the side. Lack of realism in painting the *kisi* reflects again the rarity of any naturalistic representation of flora in Hopi art; the exception is evergreens in the hands or about the necks of the dancers. The most conventional manner possible is the rule for the treatment of other plants.

Numkena did a series of six paintings on heavy board, depicting the hunter mentioned above, a Hopi maid, and four kachinas. These six illustrate the general characteristics of this artist. In all six paintings, color is as vivid and fresh as the medium used would

245

allow, be it Shiva or casein. Occasional shadows are purple, toned down with some Chinese white. There is a great deal of modeling in garments.

One could make an excellent ethnological study from these paintings, for their larger size allows the most minute scrutiny. Masks are carefully done, with cloud-rain-lightning symbols on the cheek, black slits for eyes, long cylinder for nose—or whatever the particular details may be. One kachina has three spiderwebs decorating the forehead and sides of the mask; each one is obviously made of yarn wound to form the web, and each combines lines of green, black, white, red, blue, and yellow. This artist neglected no opportunity to use his full palette, not even in delicate lines. Several of these kachinas have yarn wrist and knee ties, and each strand of yarn is again carefully and separately drawn, always in bright colors. For the most part, the hands of the kachinas are as wooden as the face of the hunter, but on one in particular they are very well done, even to the fingernails.

Numkena adds to the strength of bright, true color and fine detail by avoiding problems with which he could not cope. Single

*Fig. 6.19   Eric Humetewa, Hopi. Hemis Dancers. Courtesy, James T. Bialac.*
—Neil Koppes

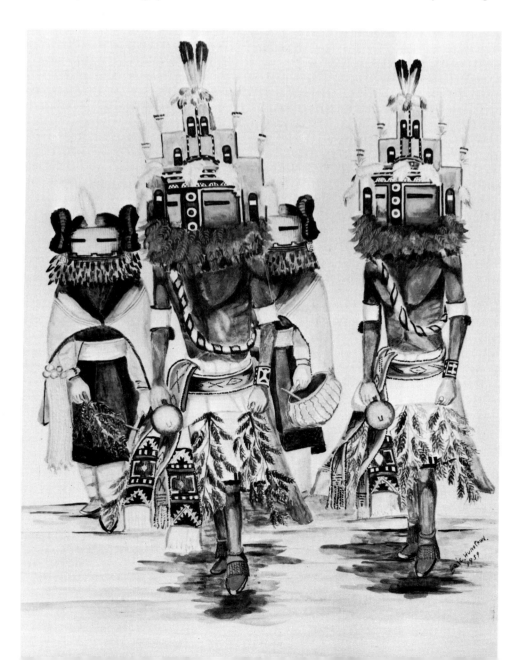

246

figures, so often featured by him, do not present problems of composition and other interrelationships. Most of his figures face full front or just slightly to one side, a good pose for masked representation. Except for a small bit of ground for the dancer to stand upon (or above), the artist is not concerned with anything but the figure itself. Numkena was painting at Moenkopi in 1970, according to Barton Wright.

Standing in contrast to Numkena is Eric Humetewa. This is particularly true in the matter of color, for Humetewa's colors are as delicate as Numkena's are vivid. For this reason, if no other, the paintings of Humetewa are not as dynamic as those of Numkena. The use of colors which verge on the pastel may contribute to the feeling that his work is not as characteristically Hopi, that they also lack the vitality and strength of the usual work of this tribe. Humetewa is Hopi, however, in his treatment of small and fine detail. *Hemis Dancers* (Fig. 6.19) illustrates these qualities.

Sometimes he painted a solid green background to about the ankles; the paper was left white from there down. In other paintings, there is a pale tan wash below a horizon line, a pale blue wash above. This detracts more than it adds. Occasionally a small patch of ground or a slight suggestion of background is added. Proportions in a dancer's body are often poor; in particular the lower part of the leg may be too short. Often a painting has the appearance of being hurriedly done. Eric was not painting in 1970.

James Russell Humetewa, Jr., a nephew of Eric Humetewa, is, like his uncle, from Tuba City, and was born near there in 1926. But, unlike his uncle, the younger artist left his native haunts to seek a career elsewhere. For some years James worked in the Museum of New Mexico, Santa Fe, painting there part of the time and working as an assistant in the museum the rest of the day. This may explain in some measure why he has presented a great variety of subject matter, for he has been exposed to the works of numerous other Indian artists. James studied art under Fred Kabotie, and also attended the Santa Fe Indian School. He has exhibited through the school.

Although much of the earlier work of James Humetewa is immature, some of these paintings held promise for the future. Not only did he express the Hopi penchant for fine detail, but he also demonstrated some ability in the realm of originality. The latter quality is illustrated in his unusual handling of color as well as in subject matter. A feature which Humetewa has stressed is the outlining of his figures, with either fine or heavy lines. In *Harvest Dancer* (Fig. 6.20) the lines are rather fine, while in *Pueblo Eagle Dancer,* a neat and accurate rendering of this subject, the lines are fairly heavy. In another case, an Indian runner, there is a very indistinct outline done

247

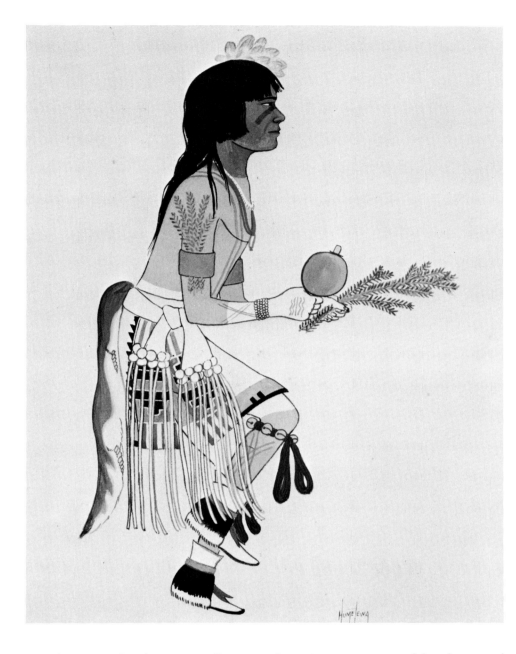

*Fig. 6.20    James Russell
Humetewa, Hopi.* Harvest
Dancer. *Courtesy, The School
of American Research,
Santa Fe.*
—Laura Gilpin

in ink. Here the figure is silhouetted against an unusual background of conventional design, angular hills, and rounded cloud-like formations. Such schematic themes are not unusual for this artist, serving as a backdrop for, or complement to, human or animal figures.

Later, Humetewa continued to paint dancers of his tribe, horses and deer, and varied Hopi subject matter. He seemed not to forget the small detail of kachina and costume, the variety of dances, the small parts of Hopi living. His wider contacts beyond his tribal lands added greatly to subject matter and manner of treatment in his painting; but in some ways this caused him to spread himself too thin rather than to become proficient in any one area of painting.

In 1947, Humetewa had his first one-man show, at the Art Gallery in Santa Fe. Again in an exhibit at the Art Gallery in June, 1949, he was given high praise for his paintings, a critic saying that his tempera dance figures and animals were "done with great skill and sensitive feeling."[39] He has also exhibited in San Francisco.

One of the most promising of the young Hopi artists had his life cut short by tuberculosis. Harold Timeche was born January 23, 1924, and died March 7, 1948.[40] His mother reported that he attended the Phoenix Indian School from 1938 to 1941. A frail, timid boy, he studied under Fred Kabotie from 1941 to 1943. At various times he was in the tubercular sanatoriums in Phoenix and in Winslow, Arizona. When the latter closed about 1947, Timeche returned to his home. It was after this that he did most of his painting.

Timeche had a painting in one of the Junior Art shows at Flagstaff, Arizona. In both 1946 and 1947 he exhibited at the Arizona State Fair, Phoenix. He did many kachinas, none particularly distinctive. It was late in 1947 that Whiting first contacted this young artist[41] and shortly thereafter sent him supplies so that he might continue painting. Whiting received three paintings from Timeche, two in January, 1948, and a third just before the young artist died.

Timeche's kachinas have little to recommend them, except that they reflect the perpetuation of the traditional Hopi style through another artist. More interesting, however, are the elaborate compositions that this artist created, following in general the European traditions of painting. All of his pictures in semi-European perspective which the writer has seen, have been concerned with the life of his people, either scenes of everyday activities or ceremonial events.

*A Hopi Scene* is an ambitious depiction of the typical life about a Hopi village, portraying chickens, a donkey, a Hopi boy, and a small section of a house in the upper right corner of the picture. Timeche attempted to represent the ground in pale mottled colors, the sky in still paler blue. Two cocks are realistically portrayed, slightly apart, heads down, ready for a fight. The feathers of these two birds are particularly well done. A stiff-legged black donkey is eating out of a purple container, with melon rinds and blue corncobs scattered close by. The barefoot lad, clad only in bluejeans, wears the typical Hopi bob over his forehead, with long and loose hair down his back. There is attempted modeling in muddy color on the boy's naked upper body. All the life forms cast shadows. Like the works of Greek artists, the face of the boy makes him but a little old man. The face created by Timeche is one of the saddest in all Indian art, full of grief and tragedy.

Timeche's last picture, which demonstrates this facial feature, was a portrayal of the *End of the Race*, and was painted several

months before his death. To the Hopi, the "End of the Race" is the termination of a rite in connection with harvest events. This painting depicts the end of the race to the fields in the early morning to gather the first fruits. Corn, melons, and beans are portrayed in the picture, some of it on the ground, some in the arms of the lads who have just brought it to the spot. These youths, with a medicine man, several matrons, a babe in arms, and four maidens (each of the latter indicated by her special hairdo) are all congregated on a ledge near the top of the trail leading to the village. Here the women and medicine man have met the runners as they returned from the fields.

The women wear native blanket dresses, with varicolored and smaller blankets thrown about their shoulders. Some are barefoot. The two runners and the medicine man wear black breechcloths. Four other youths wear kilts and have tufts of downy white feathers in their hair. There is a total of eighteen figures in this main group. All detail is well executed. The great sadness of the faces is stressed in large proportions and in their extreme length. It is possible that Polelonema had some influence on this lad. The mouth on a Timeche face is disconsolately down-turned.

In the far background of *End of the Race* is the pueblo. Smoke from early morning fires blows toward the center of the picture. So detailed is this painting that in the distant village one can see windows and doors in the houses, and ladders sticking out of the kivas. There are several figures on top of a roof, several more apparently leaving the village. All of this appears in a painting that measures 19 ½ × 26 ½ inches, yet there is no feeling of crowding. Throughout the painting, as in many another, Timeche used brown and more brown. Often it is a muddy color; and often it is more smeared on than painted on. The choice of this color and the particular way in which Timeche handled it add further to the rather doleful tone of the picture. There is never a flaw, however, in the story told by the artist. Another version of this same scene is depicted in Figure 6.21. It is a pity that this young man did not live to become a mature artist, for he expressed great potentials in his painting.

Bruce Timeche was born in 1923 at Shungopovi, Second Mesa. He is another Hopi who has been influenced by the European tradition in the painting of portraits. This may be explained by the fact that he graduated from a school of art in Phoenix. Suffice it to say that some of these portraits are commendable indeed. Otherwise, Bruce Timeche has done much painting in the tradition of his tribe, both in subject matter and in style. Oil or tempera may be employed in the traditional subject area.

In a 1967 painting, *The Offering,* he delineated a maiden and several kachina figures with excellent detail; in particular is the girl's

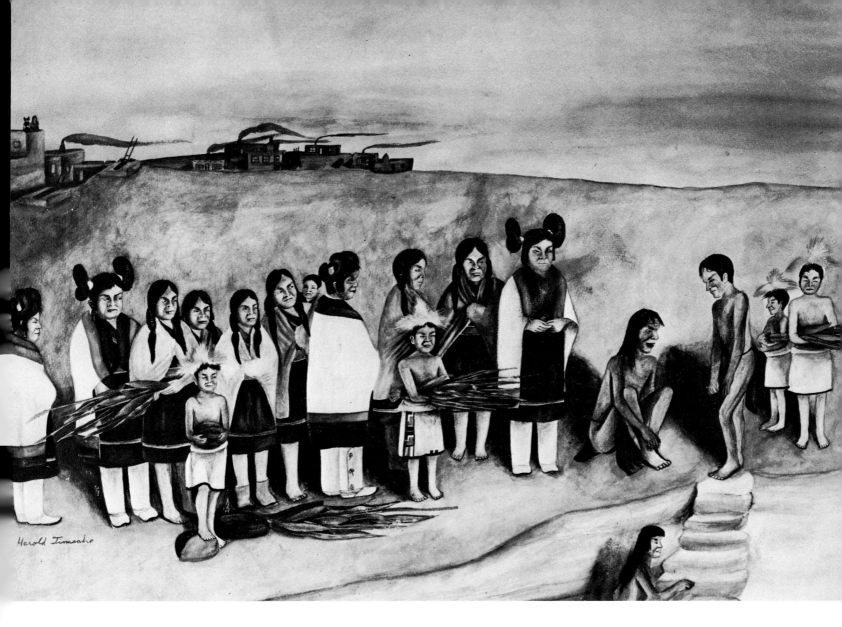

Harold Timeche

face well modeled. Typically, there is but a small patch of ground for the figures to stand upon. Most of Bruce Timeche's painting has been directed toward individual kachinas; needless to say, they are done in traditional style, as seen in *Long Haired Kachina* (Fig. 6.22), and *Ahoté—Black Cow Kachina* (Fig. 6.23), with excellent draftsmanship and fine as well as trustworthy detail. Although he has not exhibited as widely as many other painters, Bruce Timeche has received recognition in competitive shows for his abilities. In 1964, the Gallup Ceremonials awarded him both a second and a special prize in the Pueblo class, traditional painting.

In 1970, Bruce Timeche was still painting.[42] His kachinas and portraits remained his best work; landscapes were not as commendable. He has exhibited more widely in the West than in the East; too, he is represented in both private and public collections.

Homer S. Cooyama was educated in schools of his native Hopi villages and in the School of Applied Arts, Bear Creek,

*Fig. 6.21    Harold Timeche, Hopi.* The End of the Race. *Courtesy, Mr. and Mrs. H. S. Galbraith.*
—Neil Koppes.

251

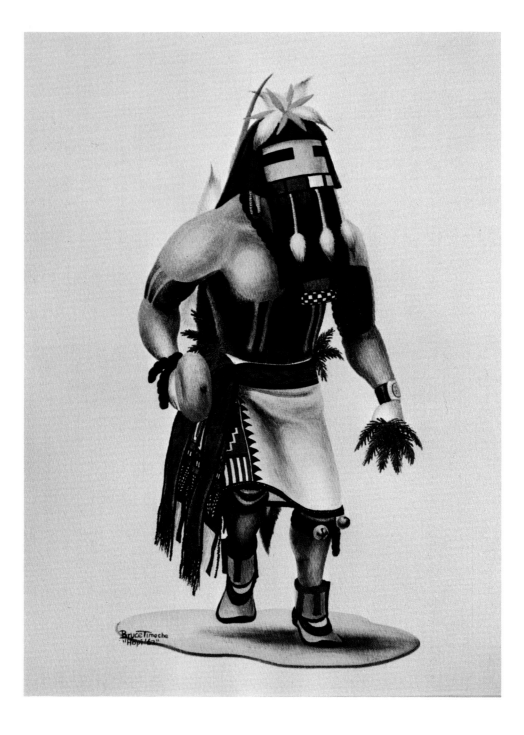

*Fig. 6.22    Bruce Timeche,*
*Hopi.* Long Haired Kachina.
*Courtesy, Dr. and Mrs.*
*Byron C. Butler.*
—Neil Koppes

252

Michigan. Largely self-taught, although he had a year's instruction in art, he has made arts and crafts his career.

An Indian painter with a fair command of oils, Cooyama's reputation is also well established, and he often has received good prices for his paintings. Of the few pictures observed, certainly the oils done in European style are by far the best. He has done commendable paintings of traditional subjects in the traditional Hopi

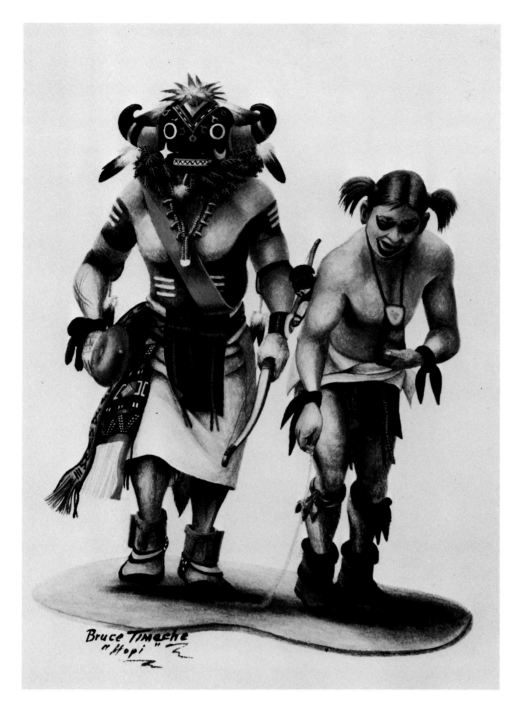

*Fig. 6.23 Bruce Timeche, Hopi.* Ahoté—Black Cow Kachina. *Courtesy, James T. Bialac.*
—Neil Koppes

manner (Fig. 6.24). In one watercolor, the work is very splotchy. The pencil outlines of the figures did not serve the artist too well, for time and again he ran outside these marks. Even the pencil lines are poorly executed, for often they do not meet. Colors are dull, and fine detail is absent.

On the other hand, when Cooyama has turned to oils, he has done a far better job in this medium than most Indians. Not only

253

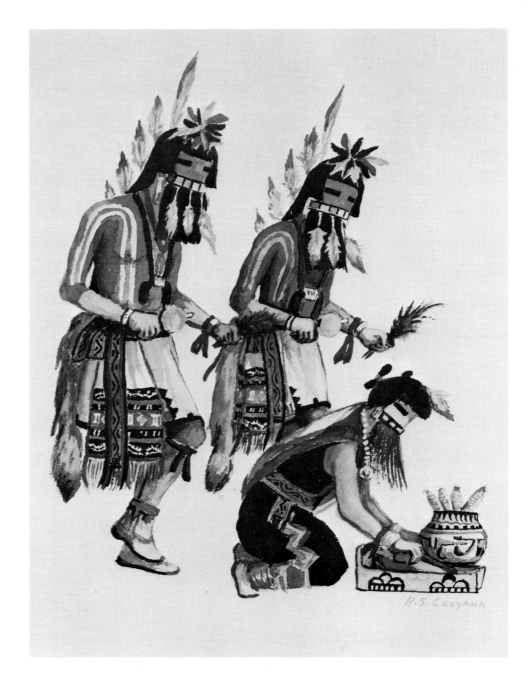

*Fig. 6.24    Homer S. Cooyama, Hopi.* Hopi Corn Dance. *Courtesy, The Amerind Foundation, Inc.*
—Ray Manley Photography

254

has he mastered many of the tricks of the European tradition, such as shadows, perspective, and shading, but also he capably applied his acquired abilities to native subject matter. One of the most convincing pieces painted by this artist is a scene in his native pueblo. Labeled *Dance in Pueblo,* it is about 5 × 7 inches. Despite the small size of the picture, there are more than twenty figures portrayed in the corner of the village plaza and on the rooftops. Also, in spite of the obvious small size of the figures, one can discern that four of the dancers wear white kilts edged in black with blue belts, and

that animal tails hang down their backs. Their moccasins are turquoise in color. Three of them also wear elaborate headdresses of feathers. The costumes of the other dancers vary, kilts are blue, moccasins red, and the men sport but a limited number of feathers in their hair. This same picture shows far better handling of color than the first one described. The plaza floor and house walls are rich in color, the sky is a clear Arizona blue, shadows of the projecting roof beams are a darker tone. Part of the pueblo wall casts a heavy shadow. Due consideration is given to this fact in the colors and tones employed for the figures in the darker and lighter areas.

In about 1927 Cooyama painted the drop curtain for the stage of the Western Navajo Indian School. It depicted a view from the foot of Navajo Mountain, looking towards Navajo Canyon. At the time he did this, he was commended for his remarkable rendering of distance.[43] From this time on he painted, and was still doing so in 1970.[44]

He has rarely been represented in public exhibits, for most of his painting has been done for special orders. Much of his late work still was concerned with landscapes.

The paintings of Richard S. Pentewa, another Hopi artist, are fresh and varied in subject matter and treatment. Pentewa, whose Indian name, Sit-Yo-Ma, means Pumpkin Flower, was born at New Oraibi on April 12, 1927. He studied at Oraibi High School, concentrating on art for three years. He has exhibited at the Inter-tribal Ceremonial at Gallup, New Mexico; at the Arizona State Fair, Indian arts and crafts section, where he took a first prize; and at the Museum of Northern Arizona, where he won a third prize. In 1967 he was represented in the Hopi Craftsman Show, Flagstaff. He has also exhibited at Tulsa, Oklahoma.

Pentewa has painted an endless number of kachinas and many ceremonial dancers. In kachina drawings (Fig. 6.25) there is generally no background. Typically Hopi, certainly, is the fact that Pentewa's masks are consistently the best parts of all these paintings even when other features of the figures may be poorly drawn. Secondly, sashes, kilts, and other details of costume tend to be better drawn than other parts of the figures; however, they are often sketchily done, whereas the masks are carefully painted. Despite these traits, it may be said that detail in kachinas varies tremendously; in some cases there is the barest suggestion of such. In others, detail is so carefully executed that it can be readily determined that a necklace was made of shell disk beads and chunk turquoise; or the number of turquoise settings in a concha belt can be counted.

Color is handled in multitudinous ways by Pentewa, including everything from pale washes to vivid tones. In one painting, pale

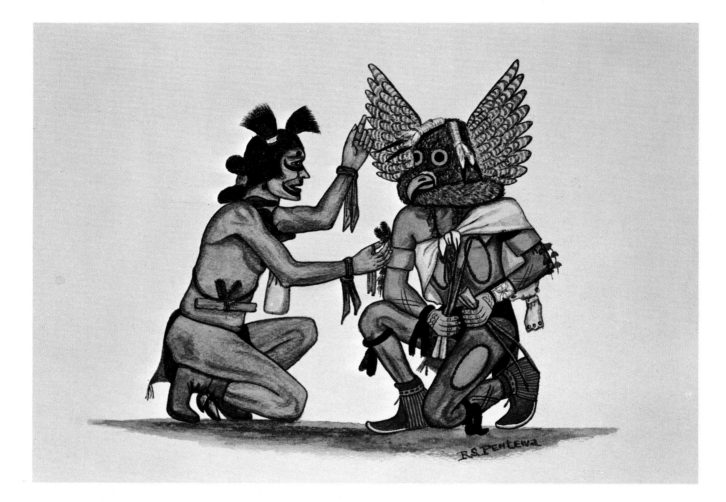

*Fig. 6.25   Richard S. Pentewa (Sit-Yo-Ma), Hopi. Medicine Man with Owl Kachina. Courtesy, Mr. and Mrs. H. S. Galbraith.*
—Neil Koppes

pinks and blue predominate; in another will be bright reds, greens, blues (especially a brilliant royal blue), and other colors. Shading and modeling are equally varied, or there may be none at all; this painter may use a few lines, light or dark, heavy or fine, to suggest modeling. In many of his later works, and particularly in his landscapes, there is much shading in color, typically European in style.

Pentewa's greater interest in motion is reflected by his portrayal, rather often, of clowns from some ceremony. Clowns are often concerned with mimicking the motions of the kachina—in one painting Pentewa shows a clown throwing pollen on the crowd. Much of the detail is entertaining, such as the painting on the clowns' faces which is repeated on the face of the doll carried by one of them, the exaggerated hairdo, and the paratrooper boots worn by another.

In *Feeding Clowns* a complete village scene is depicted. Many figures of men, women, clowns, and houses colorfully fill the entire area of the 11 × 15-inch paper. The clowns are a bilious yellow color. They wear bags around their necks marked "salt." One has a ginger ale bottle in hand, another takes bread from a woman. This

picture is on the impressionistic side, with much detail sacrificed to action and to the allover general composition.

Pentewa has done a number of scenes, some Hopi, some Navajo, and some generalized landscapes. For the most part, these reflect European influence in execution, yet he employs a heavy out-lining in color for most of his figures. The further removed he gets from native subject matter, the further removed he is from native technology and styles in painting. Sometimes he has combined the European styles of painting with a native subject. This reflects the more experimental nature of Pentewa.

One picture, done while Pentewa was still a schoolboy, retains much of the stiffness of the kachina paintings but shows some originality. There is little or no modeling in this picture, yet there is fine detail, such as the brand on the steer and the individual hairs of rider and animal. In this early painting Pentewa also demonstrated a proclivity for horizon lines that are wondrous and varied in his many paintings of this type. Here they are very conventional, in light and dark lines; there is a row of small and conventional trees along the top of the picture. Pentewa was still painting in 1970.

The meteoric career of Charles Loloma, a Hopi from the vil-lage of Hotevilla, has not been in painting particularly but in the arts as a whole.[45] In 1939 he painted some murals in the Indian Building at the San Francisco World's Fair. Two years later he painted murals in the Phoenix Indian School and in the Teachers Club at the high school in Oraibi. These are simple, realistic, and strongly patterned; executed in a flat style, they appear to be almost in silhouette. These wall paintings, which deal with subjects pertaining to native life, are well adapted to the rooms in which they are located, adjusted to the doors and windows, and even tied in with the furnishings. Loloma demonstrated control in drawing, and better perspective than is the rule in Hopi painting.

Although Loloma did relatively little painting other than mur-als, he exhibited at the Hopi Craftsman Show in Flagstaff. Later his interests changed.

With a scholarship and money from service in World War II, he studied ceramics at Alfred University in New York.[46] He returned to Hopiland, then later went to Scottsdale, Arizona; in both places he pursued the potter's craft, using a wheel, a kiln, and sometimes producing a glaze for the decoration of his fine pottery. During the late 1950s he gradually turned to jewelry making, and concentrated on this exclusively into the 1970s, producing exquisite and original pieces in turquoise and silver or occasional pieces in precious metals and stones. Before the 1970s began Loloma had ceased painting, but in this decade he developed his studio near Hotevilla.

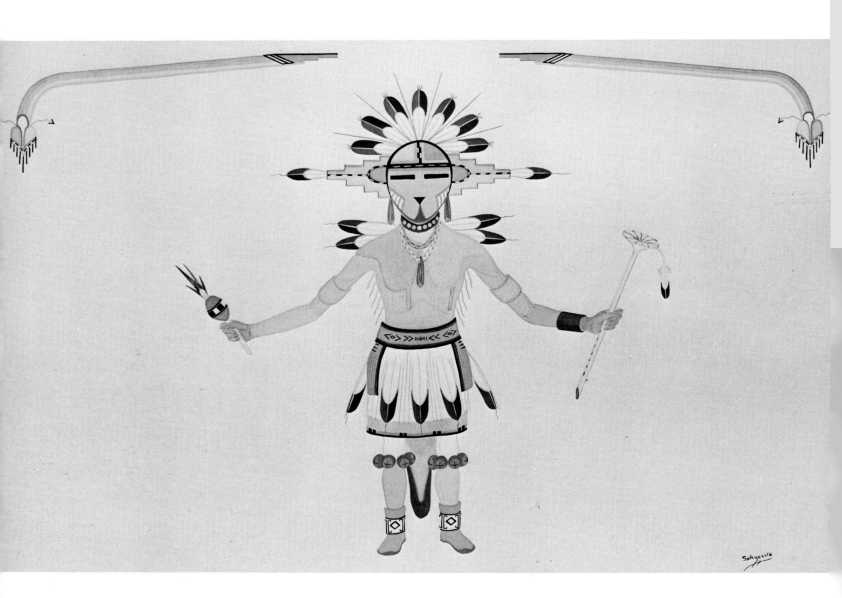

258

The following artists, mainly older men at the time of writing, for the most part painted in the 1930s and 1940s; they are included for the record. Some produced paintings as students and stopped at that point; others had no training; some have painted irregularly. Some are better known than others.

The work of Harry Sakyesva of Hotevilla, who was born in 1921, expresses a strong feeling for design, whether it features pure design or kachina figures. One painting entitled *Sun* exemplifies his work. Here is a centered sun pattern with stylized feathers, balanced rounded clouds above, and balanced angular clouds below. Many subjects are edged with contrasting color, another Sakyesva feature. Another painting depicts the figure of an Eagle Dancer, with a rainbow above. Not only do the wings of the dancer repeat the lines of the rainbow, but also the color tones are repeated in the two areas.

In a painting simply labeled *Dancer,* a kachina figure forms as much of a design as do the clouds and half-rainbows of the picture. Proportions in the figure are quite inexact, with arms much too long and hands much too large. The position of arms, hands, legs, and feet contributes further to the feeling of balanced symmetry. This description also applies to his *Flute Kachina* (Fig. 6.26). Sakyesva exhibited at the Art Gallery, Museum of New Mexico, in 1949. He was praised for his capable handling of color and for the original designs and backgrounds.[47] He is represented in several public and private collections.

Raymond Poseyesva, a very old Hopi in the early 1950s, lived at one time in Winslow, Arizona. According to Snodgrass he was originally from Shungopovi. He did kachina figures in the typical Hopi style—sans background (Fig. 6.27). Although not too well proportioned, the figures of the dancers nonetheless show much modeling, intense color, and a great wealth of detail. Describing two of his paintings, Whiting[48] said that they were characterized by the forceful action of the kachina subject; both were done in strong colors, were rounded in form, but showed no shadows.

Leroy Kewanyama, born in Shungopovi in 1922, has done his best work when painting kachina figures in the conventional manner. His earlier paintings are not outstanding; they tend to be more static than some of his later work. There is little modeling, generally no ground, and the figures have a feeling of flatness. Despite their shortcomings, many of them reveal a wide range of kachina subjects and much of the small detail which is of ethnological interest.

In his later work, up to 1970, Kewanyama demonstrated considerable improvement, reversing most of the above; there is modeling in kachina bodies and garments, action in the hands and dancing feet, excellent detail in dress and ceremonial paraphernalia. Usually there are no ground lines, no patches of earth (Fig. 6.28).

Qotskuyva, another Hopi, did a most interesting series of drawings, five "ethnological studies" they might well be called. Each measures 11 × 14 inches. Each has a black bordering line about one inch from the edge of the paper—a rare feature in Indian painting. Drawing is meticulous, colors are direct and intense, detail is perfect. Some of the work reflects a three-dimensional feeling. Three in the series have to do with Hopi costume. In one of these, the costume alone is represented in great detail to the left of the picture, and an Indian wearing the same is represented on the right. Qotskuyva also painted kachinas in the traditional manner (Fig. 6.29). He is represented in a few public and private collections.

Louis Lomayesva has featured brown in his painting, with kachinas his chief subject (Fig. 6.30). Although he uses color a great

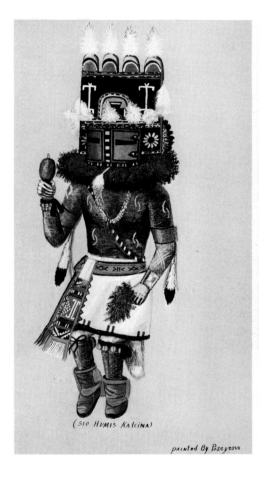

(SIO HUMIS KATCINA)

painted By Poseyesva

Fig. 6.27   Raymond Poseyesva, *Hopi.* Sio Humis Katcina. *Courtesy, Dr. and Mrs. Byron C. Butler.*
—Neil Koppes

259

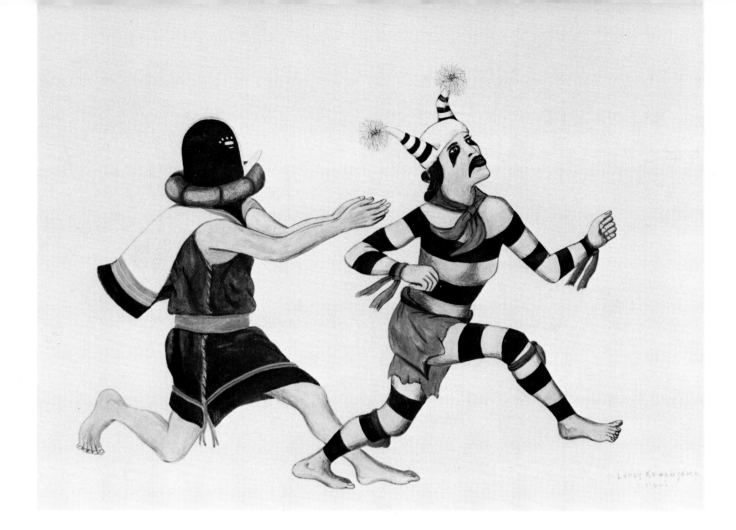

Fig. 6.28    Leroy Kewanyama,
Hopi. Ko Ko Pel Mana
Chasing Hano Clown.
Courtesy, James T. Bialac.
—Neil Koppes

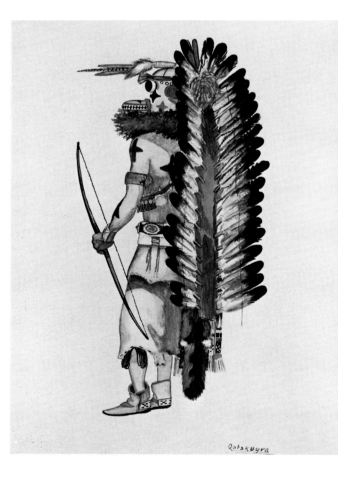

Fig. 6.29    Qotskuyva, Hopi.
Ho-té Kachina. Courtesy, The
Amerind Foundation, Inc.
—Ray Manley Photography

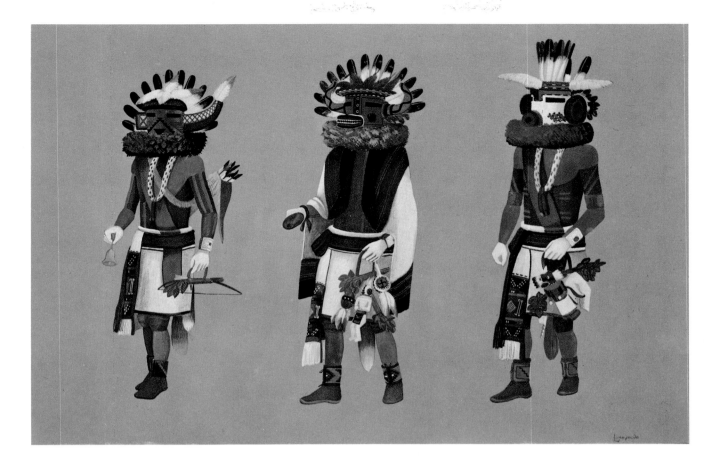

deal in modeling, the general effect of his work is weak, perhaps because his colors are rather "washed out." In his earlier work, detail is not too good, although it is accurate insofar as it goes. Later he improved in these matters. He is represented in a number of public and private collections. He was born in the 1920s and lived in Old Oraibi, according to Snodgrass. In 1970 Lomayesva was in Santa Fe, New Mexico.

Tawakwaptiwa is the name that appears on a painting in the collection of the Denver Art Museum,[49] dated in the early 1900s (Fig. 6.31). The name, according to the accompanying legend, means Sun-Down-Shining. The painting is interesting for several reasons; one is that it is probably one of the earliest of Hopi paintings.[50] This is indicated in the age of the collection (the early 1900s); it is further implied in the characteristics of the painting itself. All of the figures in the group are like those of the Fewkes collection in the long-waisted, short-legged proportions of the bodies, and in the handling of color throughout, which is quite smeared. Too, faces are just outlined. Another painting by this same artist is labeled *Tawakwaptiwa, Sun-Down-Shining, dressed as a dancer in the Poli-Tiwa (Butterfly Dance). Painted by himself, Hopi, Arizona.* Again the same features

*Fig. 6.30    Louis Lomayesva, Hopi.* Kachinas. *Courtesy, James T. Bialac.*
—Neil Koppes

261

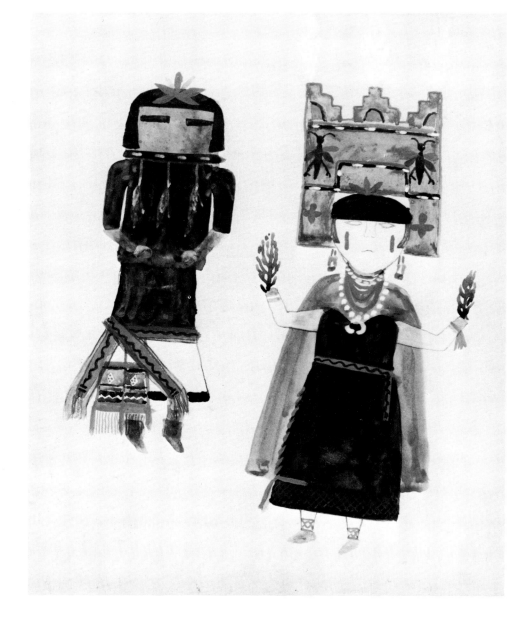

characterize this painting, with much detail but no fine delineation of line such as is encountered in later Hopi work.

Gilbert Harrison made a sketch of a Hopi boy that Whiting says is the "only portrait, that is, a specific likeness of an individual, that I have seen, by a Hopi."[51] (This, of course, was before the time of Bruce Timeche and others.) The artist used notebook paper, drawing the features with a pencil and filling them in with colored pencils. The subject resembles an Indian more than is usual in the paintings by Hopi artists.

Hansen Twoitsie is represented by two observed paintings, one in the Dietrich collection, the other in the Museum of Northern

Arizona. The first, *Climbing Polacca Hill,* is ambitious in subject matter, showing a winding trail with five wood-laden donkeys, a man, and a dog going up the path. Neatness, a suggestion of action, and simple flat colors characterize this picture. Convention asserts itself in a sun symbol in the upper right corner. The second picture reflects a feeling of balance and symmetry in the arrangement of figures and in color.

Logan Dallas attempted a number of kachinas and landscapes in oils. He received an honorable mention at the Hopi Craftsman exhibit in Flagstaff in 1947. One picture, which is exceptionally well done, was painted largely in blue tones. It is an early morning scene, with the first light of the sun striking the village and the rocks close by. Dallas painted in oils consistently through the years. His *Snake Dance at Old Oraibi,* painted in this medium, is very good. Another Snake Dance (Fig. 6.32) is also painted in oils, and although not too

*Fig. 6.32    Logan Dallas, Hopi. Snake Dance. Courtesy, Mr. and Mrs. H. S. Galbraith.*
—Neil Koppes

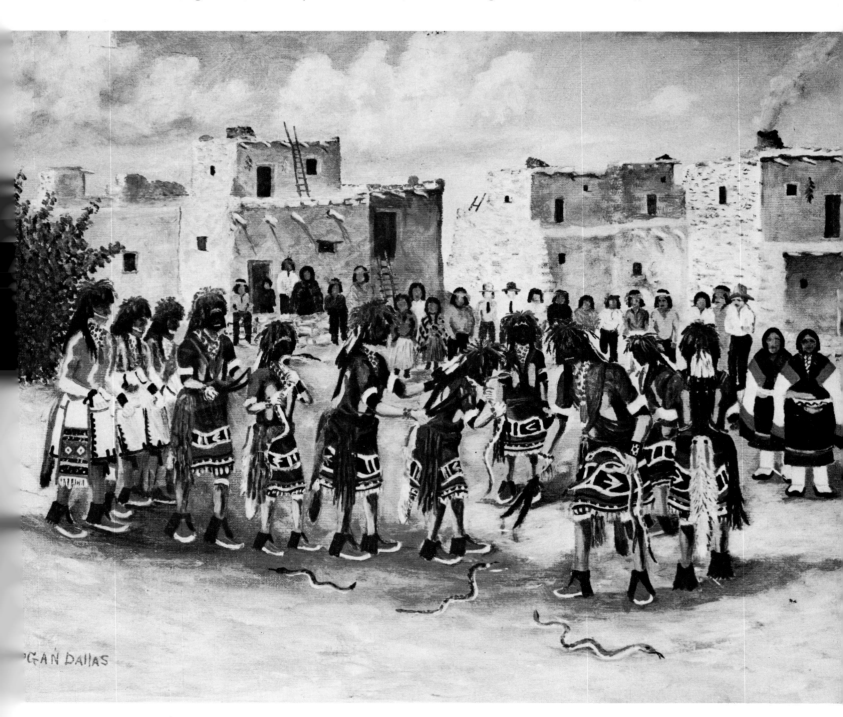

'GAN DALLAS

well done, it gives one a feeling of the ceremony. In 1970, according to Barton Wright, Dallas was painting kachinas and village scenes "with great regularity."

L. Goya painted two running deer in the more realistic Navajo style. Blood drips from the side of one of the animals where an arrow found its mark. The heads of the animals are poorly done, looking more like calves than like deer. There is no modeling, no perspective, in spite of the suggestion of much ground in small patches. Varied growth literally pops out of these small ground areas.

Lawrence Outah, from Oraibi, showed a fair amount of promise when he was a sixteen-year-old student at the Indian School in Santa Fe in the late 1940s. One picture he did at that age shows three masked dancers, each in a slightly different position. The proportions of his figures are not too good, but the general outlines are more realistic than some. Hands are too large, but there is realism in the woman's more rounded bosom, in the suggestion of form in arms, hands, knees, and legs. Outah used color quite heavily to suggest modeling.

Perhaps the most promising of Outah's several paintings done at the Indian School, and at the age of seventeen, is that of a bearded masked dancer. There is good detail, bright color, and an unusual suggestion of motion in objects on the dancer that are flying in the breezes. In the Indian School exhibit at the Museum of New Mexico, Santa Fe, in 1948, Outah, along with several others, was cited for

*Fig. 6.33    Lawrence Outah, Hopi.* Snake Dancer. *Courtesy, Museum of Northern Arizona.*
—Mark Gaede

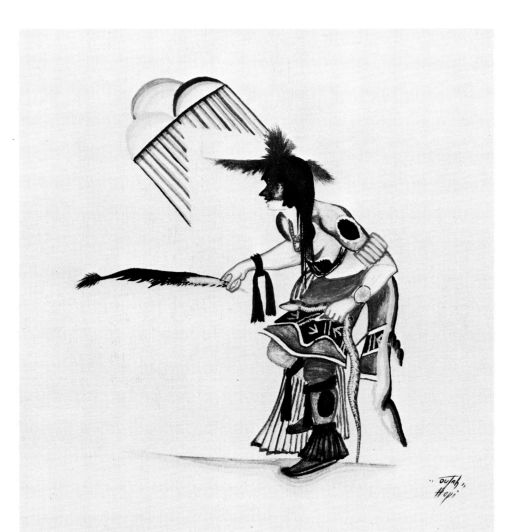

264

''outstanding ability.''[52] He continued to paint after that date; kachinas and dancers (Fig. 6.33) represent his best work.

Kyrate Tuvahoema was born in 1914, at Old Oraibi on Third Mesa. He attended Indian schools on the Hopi Reservation, then at Albuquerque and Santa Fe. In the late 1930s he was producing kachina figures that were tall and lean, but with good detail and color in costume, mask, and paraphernalia. Many of these have been reproduced as silk-screen prints. Attempted modeling was poor but his draftsmanship was precise. His *Pooley Mana the Butterfly Maiden* (Fig. 6.34) reflects these qualities; it also shows the rather strange proportions in the human body as expressed by Tuvahoema.

Tuvahoema contracted tuberculosis and spent his later years in sanitariums. He died in 1942.

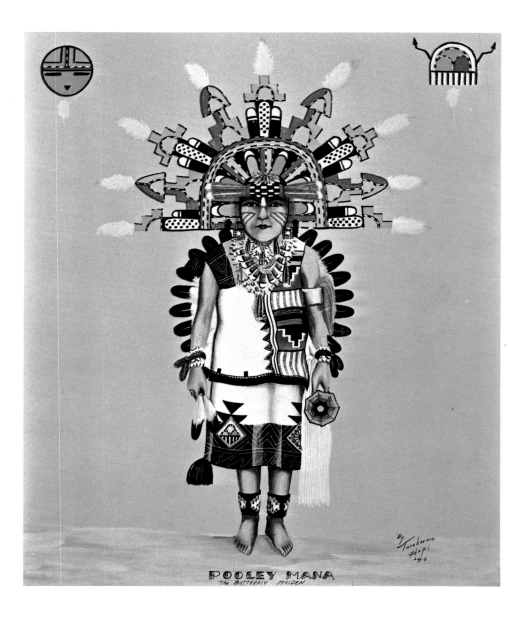

*Fig. 6.34    Kyrate Tuvahoema, Hopi.* Pooley Mana, the Butterfly Maiden. *Courtesy, James T. Bialac.*
—Neil Koppes

265

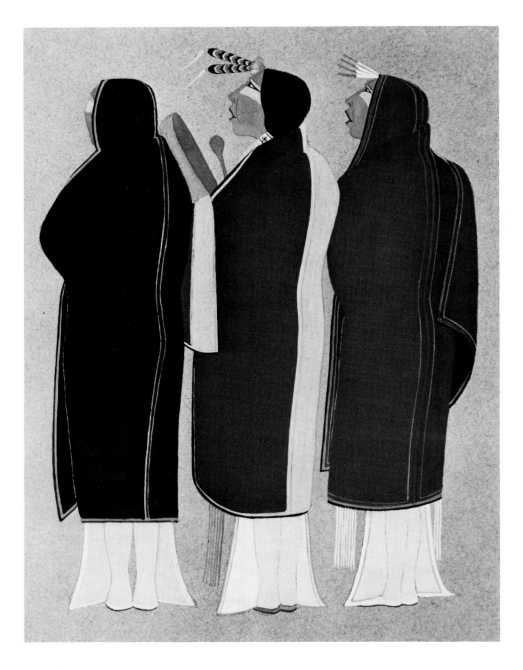

*Fig. 6.35 Riley Sunrise (Quoyavema), Hopi. Three Taos men. Courtesy, The Denver Art Museum.*
—Neil Koppes

Another of the earlier Hopi artists, Riley Sunrise (Quoyavema) worked with Fred Kabotie and Mootzka in illustrating John Louw Nelson's *Rhythm for Rain.* He is also known as Quoyavema or Kwayeshva, according to Nelson. His paintings are comparable to Fred Kabotie's, with some of them showing more action and most of them revealing less detail. His untitled picture of three Taos men (Fig. 6.35) shows elongate figures from the back with two heads in profile. The simplicity in this watercolor is appealing.

Sunrise is represented in the collections of the Denver Art Museum, Gilcrease Institute (Tulsa), and the Southwest Museum. The

Museum of the American Indian in New York has an extensive collection of his paintings of native Hopi dances.

Several vigorous and promising Hopi artists appeared on the scene late in the 1950s and during the 1960s. Interestingly, they began to bridge the gap between the strictly traditional kachina-figure art of the Hopis and more modern art. For example, Raymond Naha can be as traditional as any in his kachina figures, but he also has introduced new concepts in composition, perspective, play of light, humor, and other qualities seldom or never realized in earlier work. Mike Kabotie has been developing abstract styles that represent an extension of and new dimensions in the same type of art expressed earlier by his father, Fred Kabotie.

These two, and other less well-known younger men, or some relatively new to the art field, are discussed below, both for their potentials in the field of art and for the record.

Mike Kabotie was born September 3, 1942, at Keams Canyon, Arizona, of Hopi parents, Alice and Fred Kabotie of Shungopovi, Second Mesa.[53] He attended reservation schools, graduating from Oraibi High School where he studied art under his father, Fred. When initiated into Hopi secret societies in 1967–68, he was given the name Lomawywesa, which means Antelope-walking-in-harmony. Mike attended the 1960 Indian Art Project at the University of Arizona, then, in the late 1960s, he pursued his studies in the art department at the same institution.

With his father as teacher, it is slight wonder that Mike has, in his own right, become a well-known artist. Too, since he started on his career at such a young age his potentials were greatly enhanced. He took a first-place award as a juvenile at the Gallup Ceremonials in 1959, and has continued to exhibit there through the years, receiving a first award in the Pueblo adult category in 1968, and a merit award in the same class three years later. He had a one-man show at the Heard Museum in 1966. At the Scottsdale National he won the Kathryn Harvey Award in 1964; each year since then he has exhibited there, receiving further recognition in 1969 for an abstract watercolor. Kabotie has also been represented in the Philbrook shows (beginning in 1959), and in the Washington, D.C., Arts and Crafts Board painting shows.

He has used casein to a great extent, featuring earth colors; he added acrylics and polymers as additional media in the late 1960s. His chief subject matter can be summarized as abstracts with native themes. His paintings run the gamut from formal, large-element, balanced or semi-balanced abstracts to completely asymmetrical creations. An example of the former, *Untitled* (Fig. 6.36), reveals a balanced, roughly oval theme that serves as a background

267

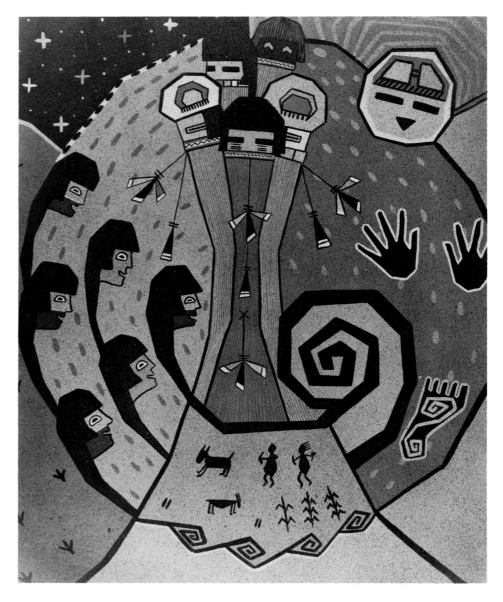

against which are featured a number of small elements. To one side
are masked heads with hair curving toward the center. Opposite are
blue-outlined black hands, a mask at the top, a grotesque footprint
at the bottom. Many small elements are scattered throughout the
painting, particularly tadpole-like themes and a group of tiny life
forms at the bottom of the oval. Soft tans, browns, yellows, and blue
are dominant in this painting. The asymmetric abstract style is rep-
resented by a 1966 painting, *Guardian of the Water*. A more realistic
than mask-like face has, nonetheless, the rectangular eyes and mouth
with bared teeth of the mask, and a great superstructure with feathers,
horns, and with geometric decoration. One arm projects unrealisti-
cally to touch a snake. One leg appears abruptly and at an awkward
spot in relation to the total figure; the second foot barely shows as

it projects beyond a flowing sash that is exaggerated in size. There is enough design to make it Indian, enough overexaggeration and displacement to make it modern abstract.

Mike Kabotie exhibited a number of paintings in the 1969 Scottsdale National. They were executed in oils or watercolors and were in an abstract or highly conventionalized style. Figure 6.37 is an example of the latter style. The entries in this show demonstrated progress on the part of this artist, particularly in composition, in more varied media and subject matter, and in the handling of color and other technical problems. In the 1969 Gallup show he exhibited works with a new slant—heavy-lined, semi-realistic paintings of dancers. He received a second-place award for his acrylic, *Mixed Dance*,

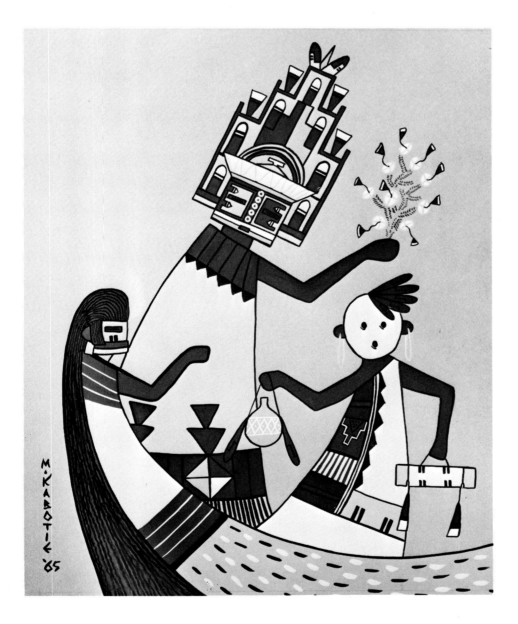

*Fig. 6.37    Mike Kabotie (Lomawywesa), Hopi. Purifying and Blessing. Courtesy, Museum of Northern Arizona.*
—Mark Gaede

269

and an honorable mention for *Hopi Design in Relief,* in mixed media, at the 1970 Philbrook show. In the 1970 Heard Guild Show he was given a first award in water-based media for his *Shalako and Aholas* (Fig. 6.38), a highly conventionalized and bright-colored rendition of this subject matter.

Raymond Naha, a Hopi-Tewa Indian, was born at Polacca, Arizona, on December 5, 1933, and attended Polacca day school. His great natural talent was developed and encouraged through a year's study under Fred Kabotie at Oraibi High School and—on his own initiative—through the pursuit of several correspondence courses. Naha's only other formal training was at the Phoenix Indian School. Like so many artists of his age group, Naha served in the Army for four years during World War II.

This artist is not to be confused with another "Ray Naha" from the same village, Polacca. Painting by this second Naha is vastly inferior to that of the well-known Raymond Naha.

Although he has said that he paints "most of the time,"[54] Naha has had to seek other employment to support his wife and four children. He has been quite prolific in quantity of production and most

Fig. 6.38 *Mike Kabotie (Lomawywesa), Hopi.* Shalako and Aholas. *Courtesy, Mr. and Mrs. Read Mullan.*
—Neil Koppes

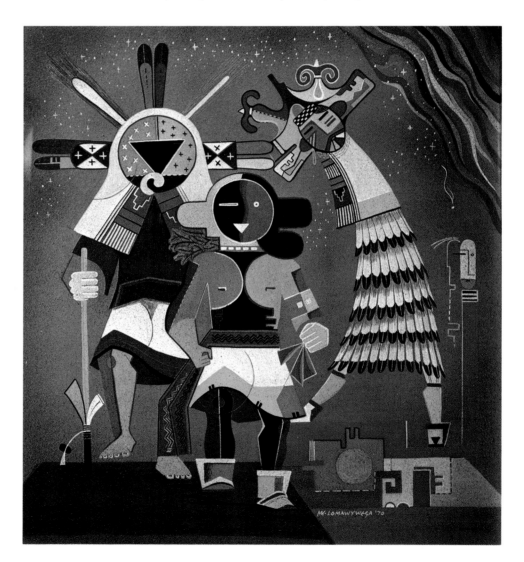

ambitious in his large paintings with many figures in them. Casein has been his chief medium, although he has produced work in oils, pastels, ink, and, in the later 1960s, almost exclusively in acrylics.[55] He combines both flat painting and modeling in color in the traditional Hopi manner, adding much perspective in more ambitious pieces. Sometimes his modeling reflects a quality more European than Indian. Frequently Naha has used black or dark paper and often his brush tends to be on the dark side; he has painted many night scenes that allow him full expression along these lines. Despite these aspects of his painting, Naha has also used lighter colors and, occasionally, there is some levity in spirit and humor in his work. The latter qualities are well illustrated in tumbling dancers whose exposed moccasin soles display holes in them, or in entertaining tricks played on one dancer by another performer.

Hopi and Zuñi kachinas and ceremonies have been favored by Naha although now and then he has turned to other subjects, such as a *Kiowa Hoop Dance,* a *Buffalo Dance,* or rabbit hunts. Occasionally he has depicted general village scenes. Ritual participants preparing for a performance in the kiva, dancing in the plaza, figures scattered about rooftops or emerging from or going into a kiva, a line of dancers or just four of them in a formal row—these are but a few of his portrayals.

A description of a few of his paintings will better indicate the variability of Raymond Naha's work.

In a 1962 painting on black paper, koshares are depicted in pale blues and grays to emphasize the night scene. These clowns are painted all over the paper in scattered, helter-skelter manner. One of the men holds the feet of a second one, a third walks on his hands. Subjects and their antics allow for a big display of fun, humor, and great merriment. Another 1962 painting, *Buffalo Dance,* shows fine detail in the four large, active and colorful dancers; a group of chanters and drummers to the right of the scene; and a sepia background of the village houses with people on them, all in mere outline.

Although Naha often scatters his dancers over his paper, he also does the opposite on occasion. This *Buffalo Dance* gives the feeling of a cluster of dancers pictured against the distant village with tiny figures near the walls and still smaller ones on rooftops. Even in the more clustered group, as one looks closer, each dancer is an individual, and there is still enough space between performers so that each is represented separately.

A favorite Naha theme is a group inside a kiva preparing for the dance. A 1967 example of this shows men in various stages of dressing and of painting their bodies. Some men sit, some stand. Facial expressions are varied—older men, particularly, are serious

271

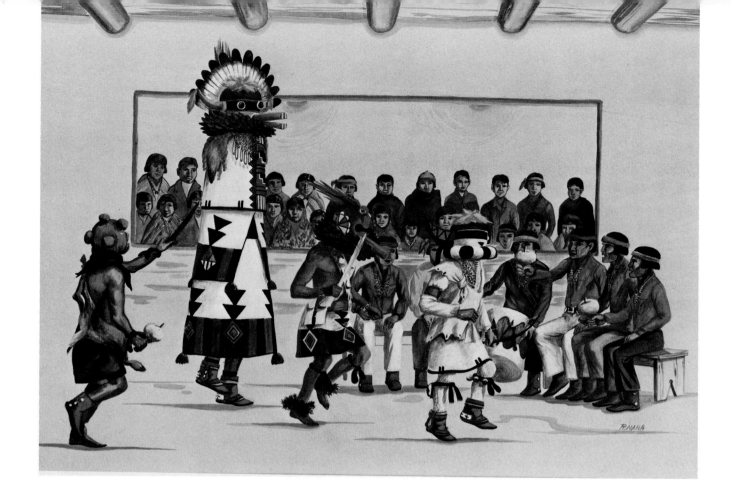

while the faces of the younger fellows may reveal happiness, or suggest that they are joking. Detail is perfect; there is full perspective. Much in the room interior is depicted. A comparable theme is a Shalako group inside a Zuñi ceremonial room (Fig. 6.39), with spectators looking in through a great window.

In another mood, Naha can reflect the old Kabotie style of a few dancers painted on a blank paper except for the barest suggestion of a small patch of ground. He is not prone to present these in a straight, repetitive line; rather are they in slightly different poses and angles, from semi-profile to full front. In such presentations he is apt to express the most perfect detail, so perfect, in fact, that one can almost feel the cloth in kilt and belt, the greenbough about the neck, the buckskin of moccasins; such detail as downy feathers and fingernails may be exquisitely done. Here too, Naha tends to do his best modeling. Often these more formal rows of dancers reflect far less in the way of action; in fact, this quality may be confined solely to slightly moving legs and arms.

As was true of so many of the kachina paintings done by early Hopi artists, so too with Naha's—they serve as fine ethnological studies from the masks to costume, jewelry, paraphernalia carried by the dancer, and body paint. Accuracy of color depiction is also a feature of Naha's work. Body proportions are good, although some-

times they are on the lean side; also his hands are frequently disproportionately large (Fig. 6.40).

One of the best of Naha's works is *Night Dancers at the Kivas at Walpi,* an ambitious 30 × 40-inch painting (Fig. 6.41). Emphasis on the fact that it is a night scene is to be noted in moonlight touching heavy clouds and details of village structures, or light from within rooms shining on men's bodies and masks, bringing out the full color in their costumes. It is a quiet, serious scene, yet full of vigor and meaning. The acrylic paints Naha has used result in a tremendous range of color, from the pitch-black night sky to rich reds in sashes, purple in a shirt, and red-brown in moccasins. An amazing amount of detail is seen in houses along the cliff ledges and in costumes.

Naha's compositions vary considerably, from loose and scattered arrangements to tight, closed lines of dancers. Despite these extremes, one is seldom critical of either, for the subjects comfortably fill the space available and the action or lack of it, or the nature of the subject, counters any undesirable effects of figure placement.

In 1969, Naha entered seventeen paintings—watercolors and polymers—in the Scottsdale National. Although he received no nod from the judges, these paintings revealed some improvement over his lesser efforts of the preceding several years. The styles described above were repeated, with emphasis on modified European perspective; details were excellent, as demonstrated in costumes in *Apache*

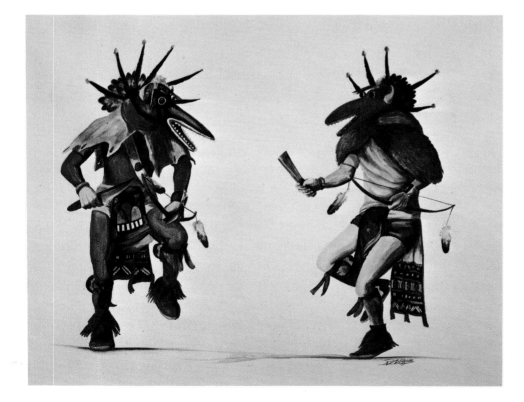

Fig. 6.40 *Raymond Naha, Hopi.* Whipping Kachinas. *Courtesy, Dr. and Mrs. Byron C. Butler.*
—Neil Koppes

273

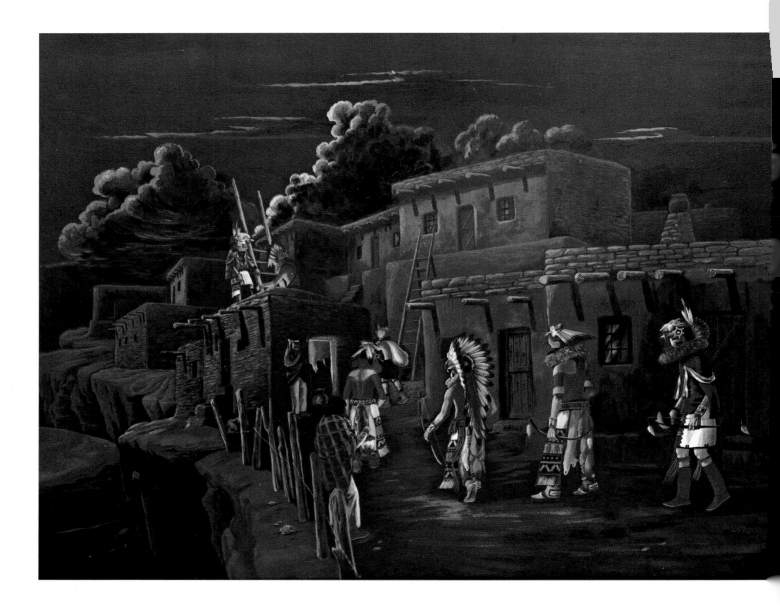

*Crown Dance*; his humor came out in the hairy legs of men taking the part of women in *Hopi Dance;* and action and power were frequently present, as exemplified in *Medicine Man,* wherein this fellow seems to be exorcising the devil himself.

Naha has exhibited both widely and frequently. He has been represented with several entries at the Philbrook shows every year since 1960; he won a first award there in 1965, again in 1966, and both a second and an honorable mention in the same show in 1970. In 1962 he received the Indian Arts Fund Award in Santa Fe. The Bimson Grand Award was given to him at the Scottsdale National in 1966, and he won a third place in polymer paintings at that show in 1970. He has been well represented at the Gallup Ceremonials through all the years that he has painted, winning first awards there

in 1965, 1966, and 1967. And, of course, his works appear in the best of private and museum collections.

Terence Talaswaima was born on Hopi Second Mesa in 1939. His elementary and some secondary education was in Hopi Reservation schools, with some work under Fred Kabotie. He was in Tucson for part of his high school years. In 1960 he attended the University of Arizona Indian Art Project session, and continued his formal education in regular classes at this university through the 1960s. He has admitted to a Kabotie influence in some of his work.

Talaswaima has used water-based paints primarily, with some work in chalk. Although not favoring bright colors, he has experimented with them to some degree. Some of his colors are on the muddy side. Primary earth colors or, as he has said, "bold patches of contrasting colors,"[56] may be used.

Subject matter is varied, with kachinas favored. These subjects may be handled in several ways—a single dance figure centered on the paper, in flat color, and with no background; or a centered figure flanked by one other on each side and with some small background detail; or a group of kachinas in a row. Other Indian themes, of course, have also been painted by Talaswaima, such as a *Navajo Squaw Dance* in which a large group of people are presented with space relationships suggested by overlapping of figures, a background of the prominent monuments of the reservation presented so they vary in size and in spacing, and a very colorful sky. There is a free and expressionistic feeling about this painting, with no trace of the traditional. Much of the work is smudgy, but colors are rich, dark, and bright. A group of women wrapped in their colorful blankets (Fig. 6.42) is treated in more realistic fashion.

Talaswaima has also experimented with an abstract or semi-abstract style. In some of these works he uses masks and/or parts

*Fig. 6.42 Terence Talaswaima, Hopi. Navajo women. Courtesy, Desert House Crafts.*
—Ray Manley Photography

275

of decorations on masks, and apparently adds kachina body-decoration designs and ceremonial paraphernalia to create his entire composition.

Although he has not exhibited continuously, nor as widely as some Indian artists, Talaswaima has won first awards at both the Arizona State Fair (1959) and the Navajo Fair (1964).

One of the Hopi artists showing promise, Milland Lomakema, appeared on the scene in the late 1960s. Born at Shungopovi, Second Mesa, in 1941, Lomakema attended elementary school on the Hopi Reservation, then completed the tenth grade in Idaho. He has had no formal art training, but has said that he received encouragement from Byron Harvey of Phoenix, to whom he sold his first painting; thus he became seriously interested in art. Lomakema has painted in acrylics and various water-based media, employing flat colors that vary according to the style used. In more abstract work the colors tend to be softer. His subjects are taken from the life of this native tribe with emphasis on kachinas and symbolic design. He was doing mostly abstracts in 1970.

In his abstracts, which show considerable influence from Mike Kabotie, he is at his best. An example, *Two Long Hair Kachinas,* exhibited at the Guild Show at the Heard Museum, Phoenix, in 1968, reflects the happy combination of well-chosen harmonious colors, left-right balance, and a rhythmic flow of line. In addition to the two large kachina heads, there are many symbolic representations, including water themes (clouds and tadpoles), and phallic, corn, and

*Fig. 6.43    Milland Lomakema,*
*Hopi.* Three Turtles.
*Courtesy, Milland Lomakema.*
—Neil Koppes

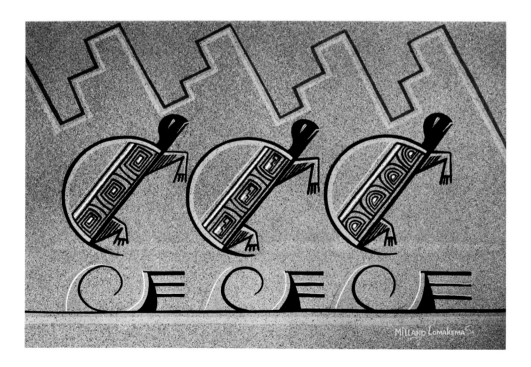

276

star designs. Referring to his paintings of this type, Lomakema has said they show "abstract design in traditional style."[57] And how true this is of so much Indian abstract art, for many of the themes are repeated in modern art in forms that have been familiar to the Hopi tribe for centuries, to say nothing of their appearance in the early watercolor movement as expressed by many pueblo artists. High conventionality is also a long tradition among his people; *Three Turtles* (Fig. 6.43) shows these creatures in a delightfully conventional style against a background of geometrics.

Lomakema has also exhibited at the Gallup Ceremonials and at the Arizona State Fair, and has won several prizes in these competitions. An abstract of two masked heads took second prize at the 1968 Arizona State Fair. This painting was not balanced as was the one described above; it was pleasing in the handling of dusty pink, turquoise, dull yellow and green, a light brown and black; and it combined the masks with such symbols as feathers, clouds, and fertility designs. For his *Sea, Serpent, and Sun,* an abstract in water-based paint, he won a second place at the Heard Museum Guild Show in 1969; at Gallup in 1971 he received both second and third-place awards for his typical modern painting.

Another full-time Hopi artist from Second Mesa was Bevins Yuyaheova (Lomaquaftewa), born on December 11, 1938. He won a first award in the abstract class at the Arizona State Fair, 1968. In that same year he also won a second-place award at the Heard Museum Guild Show. Like Lomakema, apparently he was strongly influenced by Mike Kabotie; as a matter of fact, he started painting at Mike's suggestion. Abstract themes borrowed from Hopi symbolic design and expressed in soft colors are typical of Yuyaheova. Sometimes he used brighter colors equally effectively, as in the abstract painting, *Day Rain Spirits* (Fig. 6.44). Another example of his work is presented in *Clowns,* wherein faces and hands are combined with geometric themes. Yuyaheova entered one watercolor of a kachina in the 1969 Scottsdale show. In this, as in much of his painting, colors are delicate. Bevins seems to have had his start in painting kiva murals, then was influenced to move on to easel painting. He was killed in an accident in September, 1969.

Arlo Nuvayouma, a Hopi from Shungopovi who was born in 1923, did some most interesting primitive sketches to illustrate the booklet, *Antelope Boy, A Navajo Indian Play for Children,*[58] written by Joy Harvey and published in 1968. Despite their great simplicity, the sketches tell the story effectively and with charm. Interestingly, all village and interior scenes are Hopi, and dress and hairdo are also—perhaps because the Hopi Indians also have a legend of a boy becoming an antelope and because the pueblo and Navajo Indians

277

*Fig. 6.44    Bevins Yuyaheova (Lomaquaftewa), Hopi.* Day Rain Spirits. *Courtesy, Mr. and Mrs. H. S. Galbraith.*
—Neil Koppes

*Fig. 6.45    Arlo Nuvayouma, Hopi.* Left Handed Kachina. *Courtesy, James T. Bialac.*
—Neil Koppes

have long been closely associated. Nuvayouma has also painted kachinas (Fig. 6.45) in a very simple style.

Another older Hopi, White Bear (Oswald Fredericks), who was born in 1906 at Old Oraibi, exhibited some interesting work in the 1962 Scottsdale show. Two of his paintings featured reproductions

of the prehistoric murals from Kuaua and Pottery Mound, both in New Mexico. Kachinas served as his other subjects. Color was handled well, and was particularly bright in the Pottery Mound mural reproduction. Much detail was presented in the kachinas, with especially good work in a Niman Kachina. His *Pollen Girl Ceremony* (Fig. 6.46) has some features of murals; it is poorly executed but is an interesting composition.

Bert Preston, a Hopi born at Hotevilla in 1930, has often signed his paintings "Uytima." He has done traditional subjects in flat color in water-based media and, occasionally, has used pen-and-ink with a color wash. A 1967 example of the first medium, *Hopi Corn Dance,* shows three dancers to the left and three mudheads to the right, each group facing toward the center. The top of a kiva on a hill is depicted in the background. All figures are outlined in black; the painting is clean and clear cut. In earlier years Preston exhibited in the Philbrook Art Center competition and won a first prize; in 1965, he received honorable mention at the Scottsdale show. At the 1970 Heard Museum Guild Show his several paintings reflected his abilities in the line of portraiture. One, titled *Hopi Elder* (Fig. 6.47), is a typical face of one of these tribesmen. Preston was teaching art in Tuba City, Arizona, in 1970–71.

Peter Shelton (Hoyesva) was born and received his early education in Oraibi. Later he attended the Santa Fe Indian School. His brother Henry is a fine kachina carver who does not paint, while Peter is better known as a painter but has carved some dolls. Indeed,

Fig. 6.46    *Oswald Fredericks (White Bear), Hopi.* Pollen Girl Ceremony. *Courtesy, James T. Bialac.*
—Neil Koppes

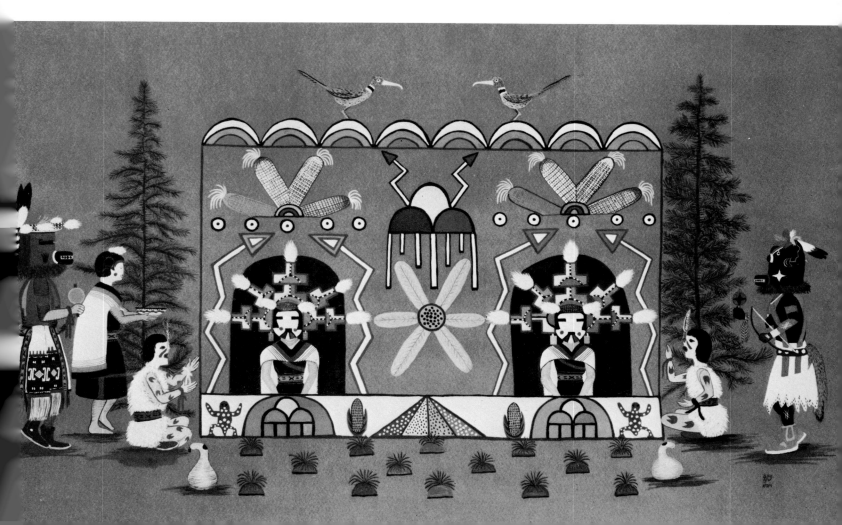

there is a suggestion of the kachina doll in some Peter Shelton paintings, for example, in the stance of the wolf. Colors in his water-based paintings are more subdued but equally rich and as varied and bright as the poster paints used on the dolls (Fig. 6.48). Shelton uses modeling in his painting figures, particularly in the body. Detail is excellent, as seen in the designs on kilts and other ceremonial dress,

Fig. 6.47    Bert Preston
(Uytima), Hopi. Hopi Elder.
Courtesy, Leonard Theran.
—Neil Koppes

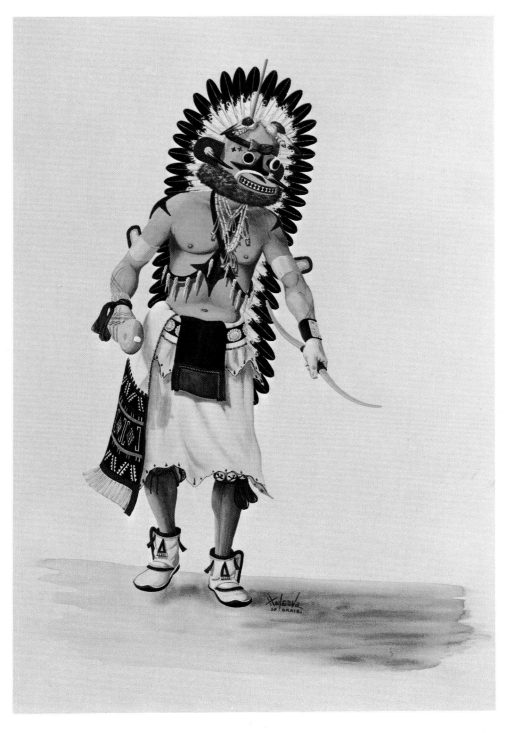

Fig. 6.48    Peter Shelton
(Hoyesva), Hopi. Hoté.
Courtesy, Dr. and Mrs.
Byron C. Butler.
—Neil Koppes

and in the hair and claws on the Wolf Kachina. His kachinas are often quite long-legged and slender. Some abstract painting has been done by Shelton in which he used Hopi symbolic designs.

Tyler Polelonema, the son of Otis, was born January 24, 1940, at Shungopovi, Second Mesa. Attending high school in Stewart, Nevada, he had no formal training in art, but he did take the arts and crafts classes there. In his painting, he has used water-based media almost exclusively, with Hopi kachinas and designs the subjects of his brush. In 1970 he said that he was "painting all the time"—which expresses, apparently, his love of doing just that. Because he has been living in Phoenix, he has exhibited largely in that area.

Into the early 1970s, Tyler was painting in abstract or semi-abstract style. In the latter he uses Hopi motifs in a pleasing fashion (Fig. 6.49). In 1970 he did quite large but fairly well-executed kachinas, such as Velvet Shirt and Antelope kachinas.

Lynn Albert, from Hotevilla, is a Hopi painter who is but slightly known, perhaps because he has lived and exhibited almost

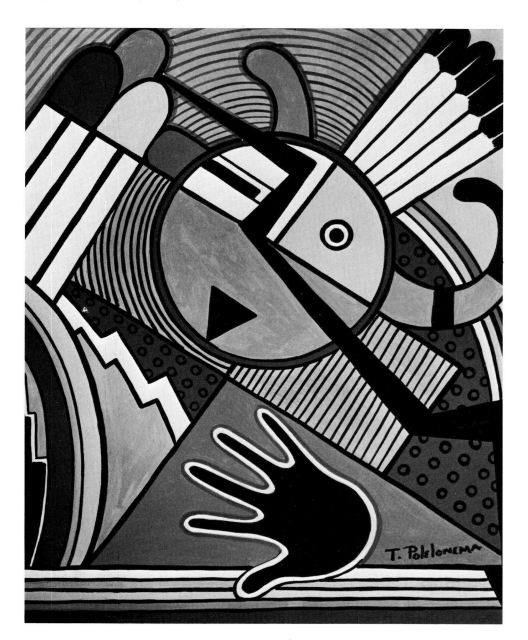

Fig. 6.49  Tyler Polelonema, Hopi. Rain Sun God Lighten Spirit. *Courtesy, Tyler Polelonema.*
—Neil Koppes

281

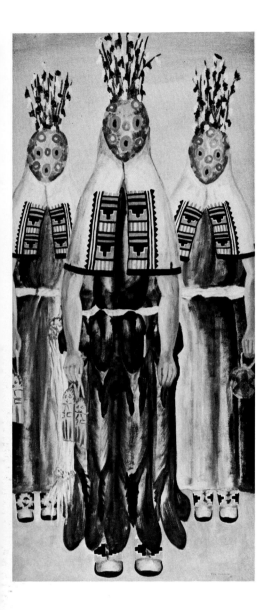

exclusively in California. He has featured kachina dancers who frequently perform above a slim line that serves as a piece of ground. The dancers are presented as large figures, full front to profile, with fair action and detail.

Delbridge Honanie, who was born on Hopi Second Mesa at Shungopovi in 1946, attended Phoenix Union High School. He studied art for four years at night school under Winton Cose, then later attended the Institute of American Indian Arts in Santa Fe. At the latter place, he concentrated on traditional Indian painting.

Honanie has demonstrated versatility in the use of media and in subject matter. To traditional water-based paints he has added acrylics, oil, and latex; his subject matter has ranged from landscapes and abstracts to kivas, native design motifs, such as the sun and tadpoles, and kachinas. The figures in one painting, *The Three Old Kachinas* (Fig. 6.50), look like ghosts in Hopi trappings because of the elongation of their bodies.

In 1968 Honanie received an honorable mention in water-based media at the Heard Museum Guild Show, and in 1969 the same recognition for a painting in oils. He exhibited at Scottsdale, Philbrook, and the Heard Museum in 1970, and at Gallup in 1971.

Two other Hopis named Honanie (but often spelled differently, such as "Hohnanie"), Alton and Ramson, have painted but occasionally since the 1920s, doing good, standard kachinas in water-based media.

Manfred Susunkewa, another of the many Hopi artists from Second Mesa, was born in 1940. He has had a broad art education, including study at both the University of Arizona and the Institute of American Indian Arts in Santa Fe. Some of his painting is in a semi-traditional style, such as *Maidens of Shungopavy;* in which a row of repeated figures is presented, with emphasis placed on elongation of lines. Even more elongate figures are painted in semi-abstract fashion in *Zuñi Shalakos* (Fig. 6.51). Susunkewa went into commercial art and has won several prizes for textile design.

*Fig. 6.50 Delbridge Honanie, Hopi.* The Three Old Kachinas. *Courtesy, Dr. and Mrs. Byron C. Butler.*
—Neil Koppes

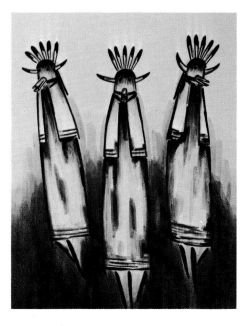

*Fig. 6.51 Manfred Susunkewa, Hopi.* Zuñi Shalakos. *Courtesy, Manfred Susunkewa.*
—Neil Koppes

Neal David, one of the most promising of the young Hopi artists at the beginning of the 1970s, is from Sichomovi on First Mesa. He attended the Institute of American Indian Arts at Santa Fe for three years before going into the Army. Back in his native land again following his discharge, he was beginning to reestablish himself in 1971. Since this date he has demonstrated considerable growth.

Native subject matter and water-based paints have been basic in David's paintings. However, he has experimented in oil, pen and ink, and in crayons. In the treatment of subject matter, he may pose a line of kachinas in a stiff and more traditional style, or he may create a composition of great activity, with clowns in many positions, running and tumbling all over his paper. One painting of the latter type is done in many shades of gray, ranging from almost-white to black, all emphasizing the night scene portrayed. Another pleasing composition of this type, a Tewa Kachina Bean Dance (Fig. 6.52), is also a night scene with miscellaneous figures dancing, coming out of kivas, or performing other activities.

In another watercolor, *Animal Dancers,* David depicts the line of dancers in the traditional Rio Grande style, even to sickle-shaped

*Fig. 6.52 Neal David, Hopi. Tewa Kachina Bean Dance. Courtesy, Mr. and Mrs. H. S. Galbraith.*
—Neil Koppes

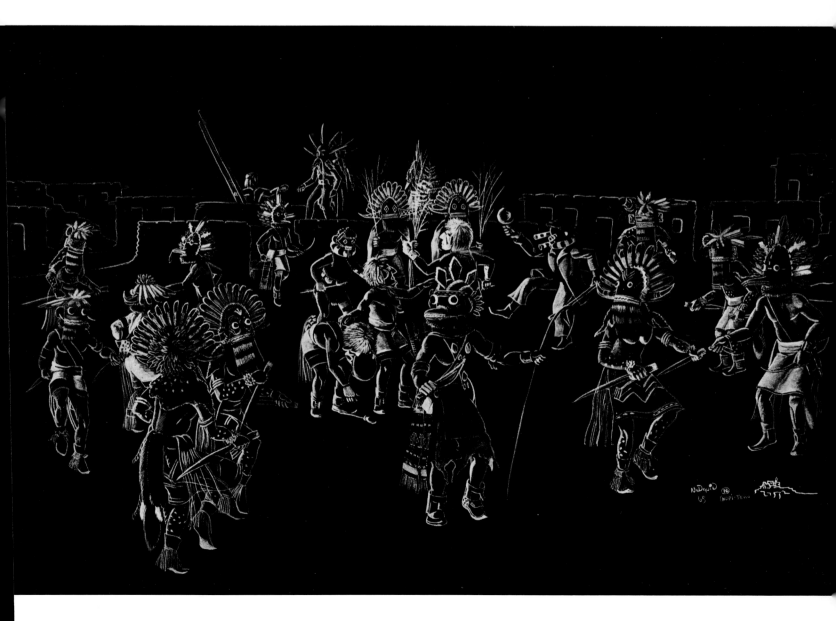

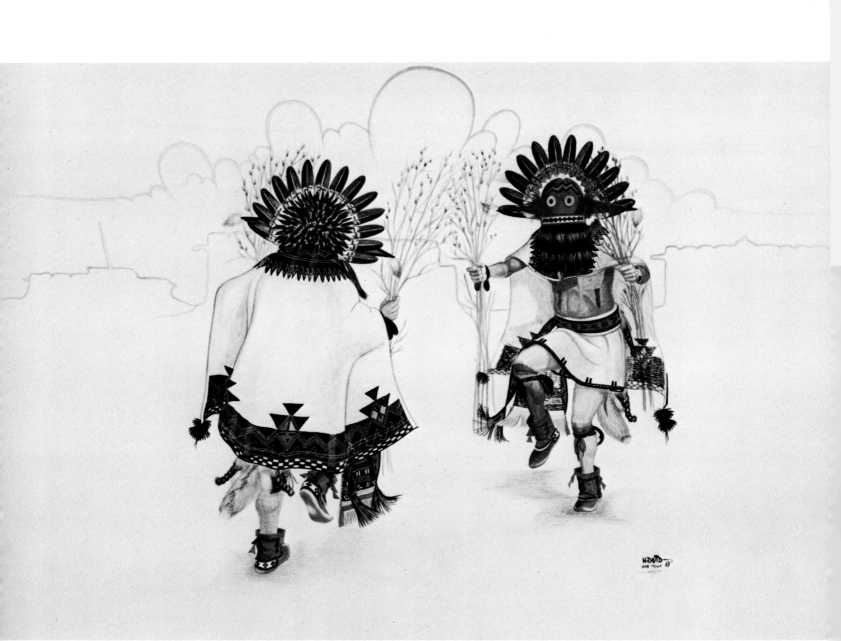

*Fig. 6.53    Neal David,
Hopi*. Hona-u Kachinas.
*Courtesy, James T. Bialac.*
—Neil Koppes

clouds above the figures. Two Zuñi kachinas dance face to face in
still another watercolor. In both these paintings there is much bright
color and excellent detail in costume and jewelry. In *Hona-u
Kachinas* (Fig. 6.53), two figures are also dancing toward each other.
Detail is very good.

While a student at Arizona State University, Dennis C.
Numkena was awarded a scholarship by the American Institute of
Architects. After graduating in this field, he opened an Indian-
oriented architectural firm in Phoenix. During 1970–71, he was
awarded two outstanding contracts. Painting and writing are two
additional accomplishments of this Hopi from Tuba City. Oils and
polymers have been equally well handled by Numkena. He has

received recognition for his work—at the Heard Museum in 1969 he was awarded a second place for his *Sipapu, the Place of Emergence,* and he took two honorable mentions from the 1970 Scottsdale National. Like so many of the younger Indian artists of the early 1970s, he leans heavily in the direction of various forms of abstract painting, as his *Cliff Dwellers* (Fig. 6.54) indicates.

Al (Alfonso) Sakeva was born in Winslow, Arizona, on January 20, 1952, of Hopi-Tewa parents. He attended Polacca schools through the eighth grade, then went to Ganado High School on the Navajo Reservation. Seemingly, he was interested in the dances of his tribe and in art from the time he was very young, a combination that led directly into his chosen career. From 1968 into 1971 he was at the Institute of American Indian Arts in Santa Fe where, along with several other students, he painted murals. Early in 1971 he reported that he planned to enroll at Arizona State University where he would continue in the fine arts.

Sakeva has exhibited rather widely. He won the Heard Museum Guild Award in 1970 as the outstanding student entrant in

*Fig. 6.54    Dennis Numkena, Hopi.* Cliff Dwellers. *Courtesy, Boyd Prior.*
—Neil Koppes

that show. His *Hopi Shalako Dancers* (Fig. 6.55), done in traditional style, shows ability beyond his years in good detail throughout the two figures, and excellent masks. He also received a second-place award for his *Deer Dancer* in the 1970 Gallup Ceremonials show. He exhibited in the 1971 Scottsdale National, in the Red Cloud show at Pine Ridge, South Dakota, and at Gallup, taking a third place in oil and acrylics at Pine Ridge, and a first and merit awards in juvenile classes at Gallup.

Cliff Bahnimptewa, whose home village is Old Oraibi, Hopi Third Mesa, was born about 1937. He has had no formal art training, except a little when he attended the Phoenix Indian School. He was induced to paint 264 kachinas after the plan of Colton's *Hopi Kachina Dolls* (1959). This project, which took more than two years, was completed in 1970. He has combined the rich knowledge that his clan and ceremonial affiliations have given him with that of a kachina carver to give authenticity to his paintings.

Bahnimptewa used watercolor and tempera in these kachina paintings, each of which is 15 × 20 inches. Rather than dolls, these kachinas are the dancing performers, full of action and vigor, although there is more constrained movement in the earlier figures. Too, he tempered action to the nature of the kachina—for example, *Sun Kachina* (Fig. 6.56). Much fine detail is given, both in color and form, in costumes, body painting, and ceremonial paraphernalia. Monotony is avoided in these paintings because he faces the figures in different directions or adds another kachina, a child, or some ceremonial item. Forty-eight of these paintings were reproduced in a 1971 publication, *Dancing Kachinas,* along with a complete list of Colton's 264 dolls and a word about each.

Preston Monongye, although first and foremost an outstanding silversmith, has displayed innate talent in his painting, as well as also being a sculptor, potter, and kachina maker. Born in Los Angeles in 1927, he was brought to the Hopi Reservation at an early age and has spent most of his life there. He has been completely indoctrinated into full Hopi life through his Hotevilla family, the Monongyes. In addition to attending Hopi schools, he did some advanced work at Haskell and at Occidental College, taking two years of law. He served in the military during World War II from 1943–46.

Monongye has been painting for many years, generally using acrylics in an oil technique on canvas. This is well demonstrated in

*Fig. 6.55    Al Sakeva, Hopi.* Hopi Shalako Dancers. *Courtesy, F. W. Feighan.*
—Neil Koppes

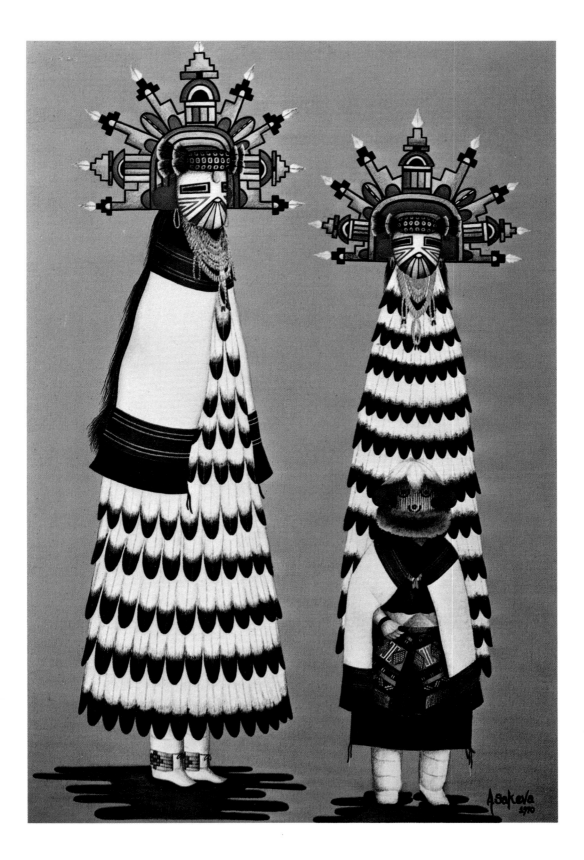

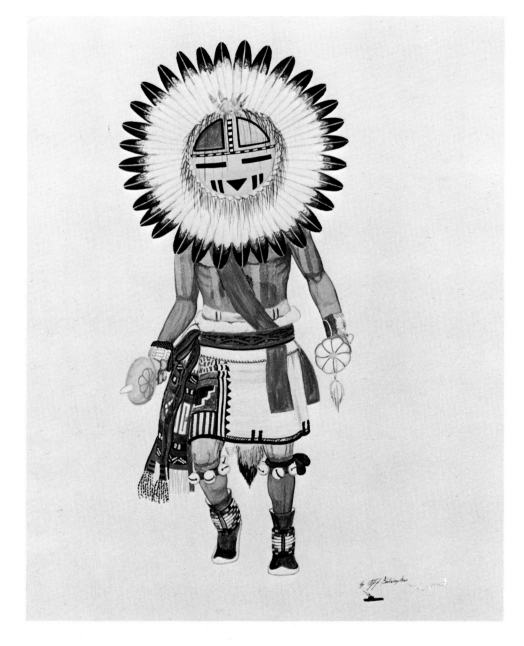

*Fig. 6.56    Cliff Bahnimptewa, Hopi.* Sun Kachina. *Courtesy, Dr. and Mrs. Dean Nichols.*
—Neil Koppes

his *Hopi Shalako* (Fig. 6.57), a painting exhibited in the 1971 Gallup Ceremonial show. In this same show he received a first award for his abstract, *Bear Spirit,* a work he also entered in the 1971 Scottsdale National. His *Harvest* received the only award in the Traditional Pueblo class at Gallup in 1970.

In *Hopi Shalako,* Monongye presents a traditional subject in a traditional manner, with the figure painted with the finest of detail, in direct colors, and without benefit of any background. Contrarily, in *Bear Spirit* he has used a very light touch in both paint and draw-

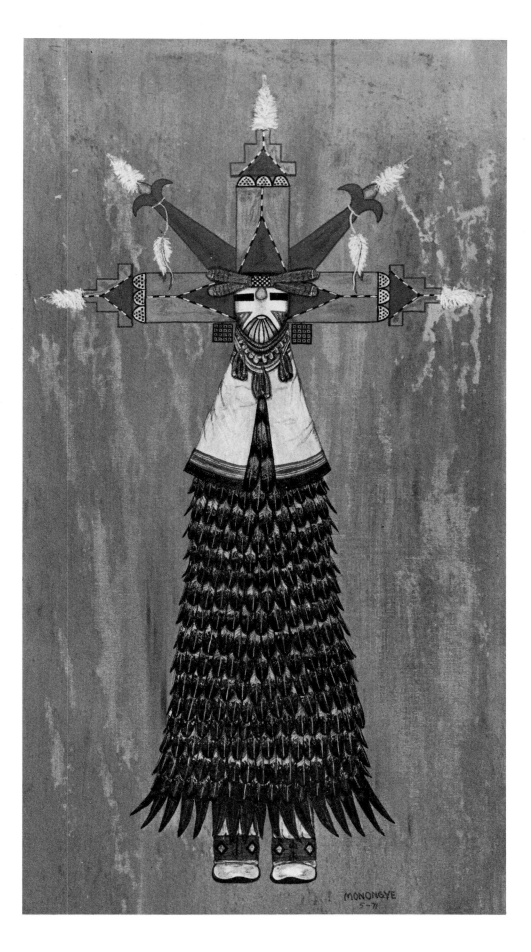

Fig. 6.57    Preston Monongye,
Hopi. Hopi Shalako.
Courtesy, the Avery Collection.
—Howard's Studio

ing, with additional lines to create abstractly the spirit of the more realistically portrayed animal.

In the early 1970s Monongye was making his living at silversmithing, and thus entered his paintings in only a limited number of shows.

Summarizing Hopi painting through 1970, it may be said that Fred Kabotie, Otis Polelonema, and Raymond Naha were the outstanding Hopi artists. The best and most characteristic Hopi work is that which deals with native subject matter, particularly the kachina, done with shading and often with perspective. Both traits were developed by Kabotie and Polelonema, with Naha adding more action, perspective, and greater breadth in materials and methods of painting. Mike Kabotie and other younger artists have added another dimension—abstract painting, sometimes with European overtones, and frequently a simpler cubistic style.

## Zuñi

Zuñi has a painting history that is long in time but short on artists. Seemingly, the village fathers have frowned upon the production of this type of art, and particularly so when the artists touched upon the ceremonial. With few exceptions, youngsters in school who used watercolors were prone to portray genre subjects rather than ceremonial.

The first name encountered in Zuñi art history is Tullma. In the Denver Art Museum collection are several of his paintings, dated 1905. Three ambitious portrayals attributed to him are quite different from traditional Zuñi painting. One was briefly described in Chapter Four. Another, labeled *Zuñi Animals,* shows a sketchy tree to the left, a coyote-like figure running toward it, and a black creature not unlike a pig running after the first animal. The drawing is very poor. The third picture, *Zuñi House, Tree With Nest and Birds,* shows a clear-cut, angular house, a hazy tree, one big bird on a limb with something in its beak, and a second bird flying toward the tree. The nest is invisible. What Tullma lacked in artistry he made up for in variety of subject matter. Tullma is not heard from again.

The next dated piece of Zuñi work we know of is from about 1918. On the back of an unsigned painting in the Indian Arts Fund Collection is the following note: "Painting made at Zuñi Pueblo about 1918. Painting was forbidden at Zuñi at that time and apparently the artist wished to protect himself by leaving his work unsigned."[59] Perhaps this may also explain the lack of names on

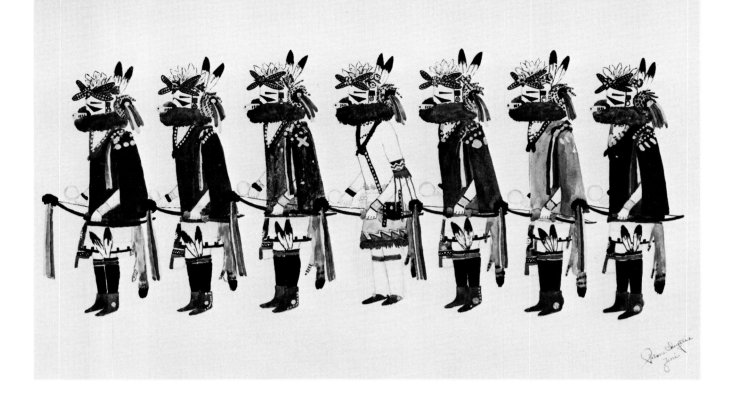

other paintings in the same collection. The 1918 painting shows two kachinas full front except for the masks. Some detail is presented, but in general the kachinas are rather poorly done. There is considerable color variation, and no perspective. The work seems to be that of a less-experienced and less-capable person than was the rule in the Rio Grande at this time.

A Zuñi who signed his name Newmi (or Newini) painted several ambitious kachina scenes,[60] one of them dated 1927. *Zuñi Corn Dance* is the subject of one which has an unattractive background in the form of splotches of blue wash for a little more than the upper half of the picture, with a dull brown below. Figures were penciled in, then painted. Careful detail, bright colors, and fair composition are evident. The dancers are stiff-legged, their raised feet are wooden in feeling, but some action is suggested. The latter seems to have been an early trait at Zuñi.

Painting shortly after the time of the above artist was one Patone Cheyatie. One of his pictures is dated 1928, another 1929.[61] Both of them show rows of dancers, much more in the tradition of the Rio Grande than anything yet mentioned from Zuñi. Both are Mountain Sheep Dancers, and are in flat colors with no background; details are fair. One breaks the more typical, absolute repetition of the Rio Grande by placing the feet of some dancers farther apart, by varying the position of the arms, and in other small ways. Color is profuse, but there is not the same pleasant handling of it so typical of many Rio Grande artists. Colors are apt to be applied in a sloppy manner; they are often too bright and jolting to the senses. Figure

*Fig. 6.58    Patone Cheyatie, Zuñi. Zuñi Rainmakers. Courtesy, Museum of Northern Arizona.*
—Mark Gaede

291

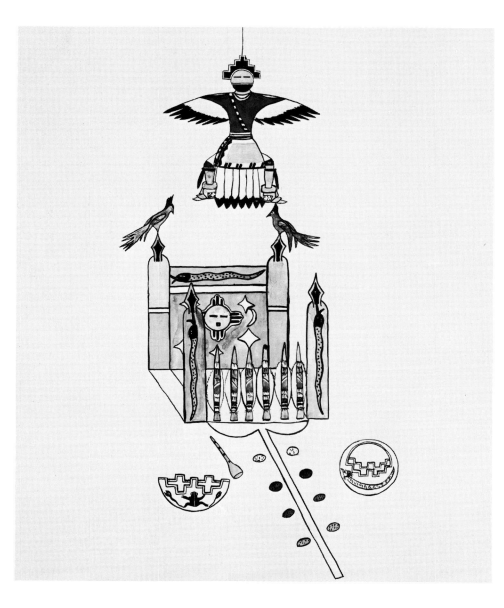

6.58 is another example of a typical line of dancers as painted by Patone Cheyatie.

At this same time another Zuñi, Lawasewa, depicted a number of slat altars[62] (Fig. 6.59). These are strictly formal presentations of the sacred altars, done in a rich blue and black with a few touches of green or orange. All of the details of the carved and painted pieces of wood, forming the three-sided altars, are carefully and meticulously presented, as are the additional wall pictures behind them, the small dry painting on the floor, and the ritual paraphernalia distributed about the altar. No matter how small in size, the latter ritual objects are carefully portrayed.

Characteristics of this early Zuñi painting may be summarized as follows: pencils were used freely, both in the original sketching

and in adding details to the finished picture. Colors have a tendency to be very bright and often in strong contrast, such as orange and green, in Cheyatie's work. Zuñi work presents everything from no perspective to a European type. Outlining is common, both in pencil and color, but it is rarely if ever as carefully delineated as by other puebloans. Rarely, too, is there modeling in lines. Detail is never as exquisitely done as elsewhere. There is much poor drawing, much smudgy painting. A few shadows appear, generally on the messy side. There is greater variety in position of individual figures, and more feeling of motion. Seldom is there beautiful and rhythmic flow of line. Moreover, there is not the careful draftsmanship found among most Southwestern artists.

Two Zuñis whose work deserves further comment are Teddy Weakee and Percy Sandy. Weakee, one of the earlier Zuñi artists, did an occasional painting in watercolor or oil. *Old Zuñi Rock,* in the latter medium, is done in European perspective. It is somewhat better than most Indian paintings in this medium and manner. Weakee died in 1965.[63]

Percy Sandy, or Kai-Sa, or Percy Sandy Tsisete, as he has variously signed his paintings, was born at Zuñi in 1918. He attended elementary and secondary schools in that village; then he went on to Santa Fe to take a year's postgraduate work in art at the Indian School. Taos Pueblo became his home after he married a Taos girl.

Kai-Sa has exhibited widely in Santa Fe, Albuquerque, Taos, California, Texas, Oklahoma, and Toledo, Ohio. At the 1948 Third Annual Exhibition of American Indians, Philbrook Art Center, Tulsa, he won second honorable mention. He has also received a Denman Award at Gallup as well as a New Mexico State Fair Award. In Taos he worked at the Blue Door Gallery where his paintings have been featured.

Although he has employed European perspective, Kai-Sa has done his best work in painting genre scenes, or dance figures in the pueblo manner, or deer and other animals in Navajo style. In his kachina dancers, the pose is like the active depictions of the Hopi. One painting of a kiva god does not have the cluttered feeling of much early Zuñi work, but it does have more background detail than is common to Hopi kachina painting. Another Kai-Sa painting, of a Shalako, is done in a more crowded manner, even to a church in the background.

Kai-Sa was surely influenced while at the Indian School in Santa Fe, either by artists he met there or by paintings he saw in collections at the school. The conventional plants of Navajo artists appear in his paintings, for example. Another Navajo influence is seen in a buffalo hunt. In swirls of dust, the rider is off his mount

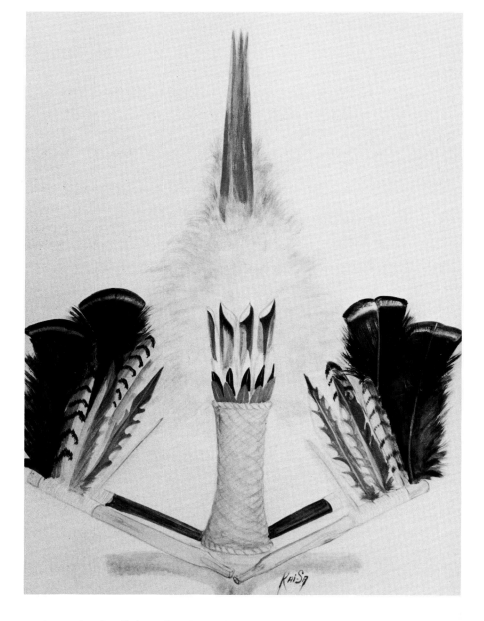

and on the buffalo's back with his spear stuck in the side of the great beast. Some influence from the Taos artist Pop Chalee is revealed in a great blue-and-black horse with mane and tail in lighter blue, the hair flying and very heavy.

Kai-Sa has combined puebloan trends, both Hopi and Rio Grande, with Navajo-Apache styles. His handling of color varies from flat treatment, stippling, or line modeling, to full modeling in color. In outlining he either adheres to the typical Southwestern fine-line type, or employs a heavier line; in some instances he uses no outline whatsoever. His paintings vary from almost absolutely balanced and symmetrical single figures to fairly pleasing group compositions. Kai-Sa has even experimented with modern abstract, but as yet he has attained no proficiency in this style.

Through the years, except for occasional lapses, Kai-Sa has continued to paint in several styles, although in the 1960s he veered

toward more kachinas and symbolic themes. Of six paintings in the 1962 Scottsdale National show, four were kachinas, one was of clowns, and one the Life-Giver Plumes of Zuñi. Interestingly, another *Life Giver Plumes of Zuñi* (Fig. 6.60), of later date, is beautifully and delicately executed. In analyzing these paintings it appears that Kai-Sa had changed even less in his quality of painting, for they would rate technically from poor, through fair, to good. Other paintings show good kachina-costume detail.

Another group of four Kai-Sa paintings well illustrates his characteristics: three are kachinas and one a ceremonial object—a fetish of the Zuñi version of the plumed serpent, Koloowisi—coming through a turquoise-colored tablita. This latter painting reflects excellent detail and design. Two of the kachinas are heavy-set, one of them, *Cow Dancer,* being particularly short and gross in proportions. The third kachina, the *Fire God* who appears at Shalako time and who is represented by a lad at Zuñi, is much slighter in build in this painting. Detail is good in all these kachina costumes. Another painting, *Zuñi Corn Dancer and Mudhead Meet Rainbow God* (Fig. 6.61), combines some of these traits in a most effective composition.

One collection of forty-seven Kai-Sa paintings is representative of his characteristics through the years, down to 1970. The majority

*Fig. 6.61    Percy Tsisete Sandy (Kai-Sa), Zuñi. Zuñi Corn Dancer and Mudhead Meet Rainbow God. Courtesy, Dr. and Mrs. Byron C. Butler.*
—Neil Koppes

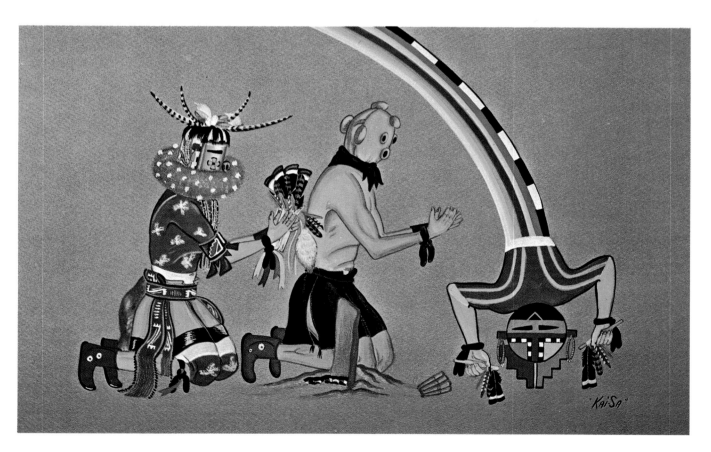

of the paintings are of dancers, usually with one figure, although there may be two or three in a single painting. Generally there is no background; often there is a little patch of ground. Subjects are mainly Zuñi. Frequently figures are on the heavy side, a trait typical of this artist, although he paints slight figures equally well. Many of Kai-Sa's figures are active, but never violent. Details may be excellent or they may be simply presented; the latter seems more a whim of the artist than lack of ability. Color is often true to the original, particularly in the portrayal of animals. Much ceremonial paraphernalia is depicted by Kai-Sa, not only as carried by the dancers, but also as presented in separate paintings. Watercolor was used for all pictures in this collection; a favorite of his, it was the medium he used in three paintings exhibited in the 1969 Scottsdale National.

Kai-Sa illustrated Ann Nolan Clark's book, *Sun Journey*. He has also done murals at the Zuñi and Black Rock schools.

Roger Tsabetsaye, another Zuñi, was born in 1941. He attended the University of Arizona Indian Project in the summers of 1960 through 1962, then went to and graduated from the Institute of American Indian Arts, Santa Fe. He has exhibited widely, and has received many awards, among them the Poster Contest Award at the Gallup Ceremonials in 1959; the governor's student award and a second prize at the Scottsdale show in 1962; a first prize at Philbrook in 1963; and, in Gallup, a first award in 1964, a second-place in 1965, and a third in 1966.

Tsabetsaye has leaned heavily in the direction of abstract or semi-abstract painting; he has been greatly influenced by cubism. For example, his *Returning Home* done in 1962 shows masked dancers coming up over some clouds toward the center of the picture; to the left are mudheads, lying down; all is done in abstract style. Colors are not too attractive; blues, pinks, and greens are emphasized. This abstract is the one for which several Scottsdale show awards were given in 1962. Tribal design elements are used by Tsabetsaye for his abstract paintings. He has often been at his best in portraying religious subject matter in an abstract or semi-abstract style. In *Yei Masks* (Fig. 6.62), he carries the viewer into another world, both in the mythical presentation of them and in the motion that suggests extension beyond the edge of his paper. When Tsabetsaye does traditional painting, the results are not as strong or as effective as in his abstracts.

A few additional Zuñi painters should be mentioned here; some have been painting for some time, while others were just getting started in the late 1960s.

One who seems to have considerable talent is Delano Tsikewa. He served in the Marine Corps, and in 1968 was enrolled in an engineering drafting school in Denver. He has exhibited in that

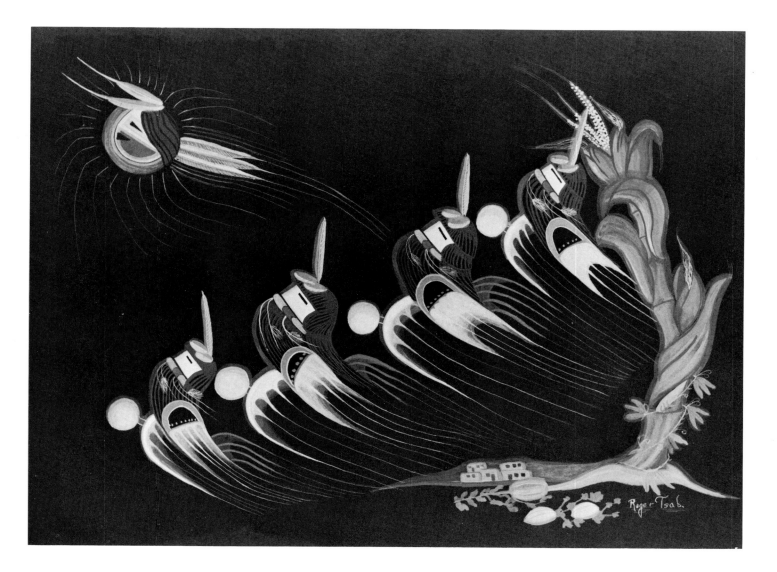

city. Among other media, he has used black scratchboard, on one occasion depicting white buffalo on this dark ground.

Three additional Zuñi painters are Anthony Edaakie, Paul Edaakie, and Theodore Edaakie. Anthony usually has created kachina figures in felt, feathers, and watercolor. However, in a painting done in the 1940–50 period, *Comanche Speaking,* the figure is very large, filling the paper. Ground and flesh are smudged, yet some detail is very good, such as a concha belt, a bowguard, and bracelet. The very conventionalized figure has a heavy quality to it.

Paul Edaakie has followed the usual Zuñi trend; in one painting he featured the ever-popular Shalako, two mudheads, and a warrior figure. He received a second-place award at the 1966 Gallup Ceremonials.

With a limited palette, Theodore Edaakie presents rather heavy figures in representational style and in opaque watercolor (Fig. 6.63).

297

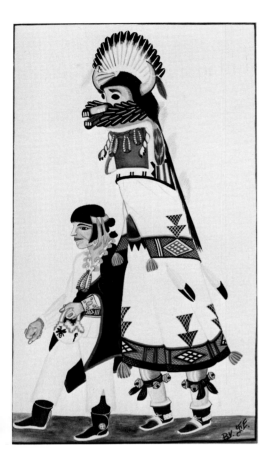

Fig. 6.63    Theodore Edaakie,
Zuñi. Zuñi Shalako and Man.
Courtesy, Museum of Northern
Arizona.
—Mark Gaede

Fig. 6.64    Sullivan Shebola,
Zuñi. Two Mudheads.
Courtesy, Woodard's Indian
Arts Collection.
—George Hight Studios

He is represented in the collections of the Museum of the American Indian, New York, and the Museum of Northern Arizona.

In 1964 Sullivan Shebola, also a Zuñi, received a second-place award in student paintings at the Scottsdale show fo his *Cow Dancer*. This was done in the traditional flat, two-dimensional coloring and in water-based paints. His kachinas are often painted in the typical pueblo style, with good detail and in a typical stance, with one foot raised (Fig. 6.64). Another Zuñi, Dixon Shebola (or Shebala) was educated in Santa Fe and Albuquerque. He received a special award from the Gallup Ceremonials for his *Skin—Zuñi Helea* in 1964; his painting is frequently exhibited.

Two other Zuñi painters are Don Dewa, a student in 1967, and Duane Dishta. Dewa has done traditional Zuñi work, as his three entries in the 1967 Gallup Ceremonials indicate—*Zuñi Jewelry*

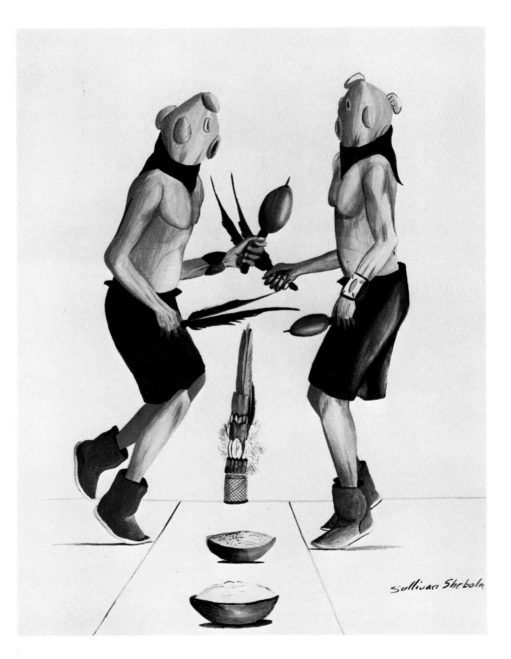

298

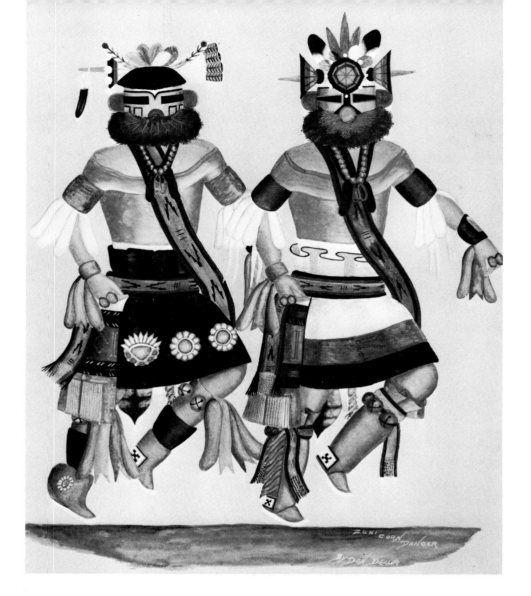

Fig. 6.65    *Don Dewa, Zuñi.* Zuñi Rain Dancers. Courtesy, James T. Bialac.
—Neil Koppes

Fig. 6.66    *Duane Dishta, Zuñi. Mixed Dance at Zuñi.* Courtesy, Mr. and Mrs. H. S. Galbraith.
—Neil Koppes

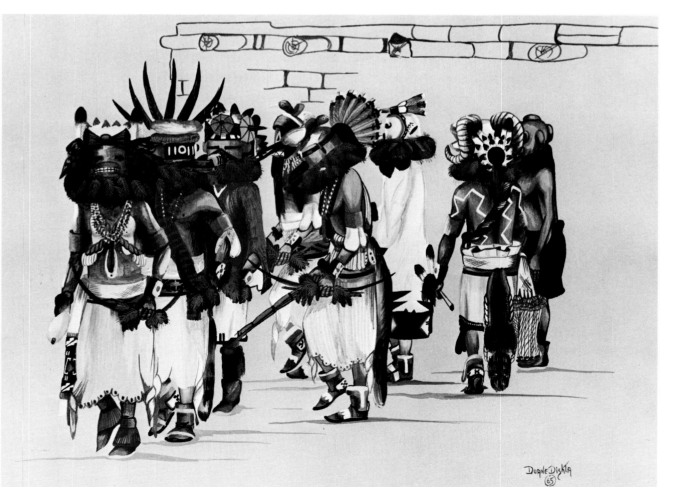

*Design, Votive Ritual,* and *Zuñi Traditional.* These, and another watercolor, *Zuñi Rain Dancers* (Fig. 6.65), reveal immaturity but do show promise for future development.

Traditional, too, are the paintings of Dishta; at the Scottsdale show in 1968, his *Jemez Kachinas and Kachin Manas* reflected clean and clear-cut detail in mask and costume. His portrayal of a Mixed Dance at Zuñi (Fig. 6.66) reveals fair composition. Dishta is represented in a few private and public collections.

The pueblo of Zuñi, then, has not yet evolved a style which can be called its own. There has developed here no "school" that has added to, or contributed in originality to the Southwest Indian art development as a whole. Zuñi artists have been influenced by members of other tribes. That there is talent here, however, is indicated in the work of Kai-Sa.

Over the long time span, two basic traits have related the art efforts of the Hopis and Zuñis to each other. One is subject matter—kachinas—which have claimed the interests of Zuñi and Hopi artists alike from the beginning to the present. The second—general treatment—also relates these two tribes, for, despite some deviation on the part of the Zuñis, the basic style involves slightly modeled figures, little or no background, simple patches of ground for figures to stand upon, and occasional shadows.

Perhaps the conservative Hopis have adhered more consistently to these ideas than have the Zuñis, as demonstrated in the works of such older artists as Fred Kabotie and Otis Polelonema, as well as later ones like Naha. In like vein, it is not surprising to find that nonobjective painting, as exemplified in the work of Mike Kabotie, has appealed to the Hopis, for they have retained and developed so much of their native decorative art. Despite these comments, it may be said in passing that the best of Zuñi painting has been channeled in comparable directions, as illustrated in the kachinas by Kai-Sa and the abstracts of Tsabetsaye. ■

# Navajos, Apaches, and others

N avajo painting has a longer recorded history than that of any other Southwest group. The cave murals of the 1830–40 decade, mentioned in Chapter Four (see Fig. 4.1), which promised much in the way of new subject matter and treatment, stand as a prologue to the development of this painting. Horses and men, done in several colors, reflect a realism and virility not before expressed in the Southwest. Choh followed (pre-1889), painting realistic portrayals of trains (see Fig. 4.2) and other objects. Then, at the turn of the century, came Apie Begay, with his strangely vivacious yei (see Fig. 4.4). Additional Navajo artists appeared during the period from 1930 to 1940, and new ones have consistently emerged through the years thereafter.

Apache painting is dealt with in this chapter because it has many of the same qualities as the art of the Navajo. Both arts are more dynamic, while that of the pueblo is usually more static. Both treat of varied subject matter, particularly horses, deer, and other animals, while the pueblo artist has been preoccupied with the dance figure. Other non-pueblo tribes are also included in this chapter.

Navajo

Perhaps the best known of the Navajo artists is Harrison Begay.[1] Born November 15, 1917, Begay lived but a short while in his natal village, White Cone, Arizona. His mother belonged to the Red Forehead Clan; his father adopted the Zuñi Deer Clan. Harrison

301

has said that his father was a relative of the famous Navajo medicine man, Manuelito.

In 1927 Begay went to school at Fort Wingate, but stayed only one year. From 1928 to 1934 he was either in a hospital from which he ran away, he said, or at home. When at home, he helped care for the family sheep and studied. He had books at home and managed to learn much from them; thus in 1934 he was able to go back to school, this time in Santa Fe, graduating from high school there in 1939. He spent a postgraduate year at this same school. Begay studied art under Dorothy Dunn all through his years in Santa Fe. He has said of her that she did not want the Indians to be influenced by European or any other art, and that she encouraged her students to stick to traditional Indian expressions. The Indian is justly appreciative of the splendid efforts of this most influential of all the teachers of the Southwest's native children and young people in the realm of art.

During 1940–41, Begay was enrolled in Black Mountain College in Blueridge, North Carolina, where he studied some architecture but took no work in art. He has said that he has made no further study of art except for a brief period of tutoring under an artist in Denver, Colorado. Beginning in 1942, he served for three and one-half years in the U.S. Army, where, like so many other Indians of the Southwest, he was in the Signal Corps. He served in the Normandy campaign, as well as in Iceland and continental Europe.

Following his discharge from the Army in 1945, Begay returned to Santa Fe. The next year he went to Denver where he stayed until September of 1947. After that he divided his time between Tucson, Arizona, where he painted at Clay Lockett's shop, and Santa Fe, where he painted at Parkhurst's. Occasionally he freelanced. Then he returned to the Navajo Reservation, to spend most of his time there during the 1960s and into the 1970s. During part of 1969–70 he painted at Woodard's shop in Gallup, New Mexico. Begay is one of the few Southwest Indians who have supported themselves by painting.

On one occasion Begay ventured into the silkscreen reproduction of his paintings with Tewa Enterprises, Santa Fe. Although the works of other Indian artists have been reproduced also, including those of Pop Chalee, Tsihnahjinnie, and Gerald Nailor, none have been so well and widely received as have the Begay prints. He assisted in cutting the screens for his reproductions. His simple, fine-lined and flat-color work proved highly adaptable to this kind of duplication. Some criticized Begay for this venture, but certainly the far lower prices of the serigraphs have made his ever-popular work available to many who could not pay the price of an original painting.

Once when asked what he liked to paint, Begay answered with vigor, "Anything that sells." This may explain his penchant for the always-saleable horse and colt and deer and fawn pictures. It may also explain his preference for watercolors through the years. He has confessed to a desire to experiment with oils, but in the same breath has added that he did not have time to do it. Further, he has asserted that he would like to add some symbolic designs here and there (and he has done so on occasion), but felt that the other subject matter sold better. Begay has always enjoyed painting—a fact revealed in his words, his pictures, and his moods when working. And, with a twinkle in his eye and never-failing Navajo humor, he says, "It is easier to do than anything else!"

In his early years on the Navajo Reservation, Begay saw many sandpaintings made by the medicine men of his tribe. He has implied that it was these designs, probably, which he reproduced. At first he did not paint scenes from legends because—he has admitted frankly—he was not familiar with them. In his earlier days he painted war and hunting scenes from the old days, giving his hunters and warriors bows and arrows and other equipment, but no shields. Warriors as subject matter did not appeal to him as much later on as they did before he went to war. During the 1960s and into the 1970s he painted more genre scenes and added legendary subjects.

A series of paintings by Begay, ranging in time from 1935 to 1969, points up the main subject matter and artistic characteristics of this Navajo artist.

In the Indian Arts Fund Collection, Santa Fe, is one of the earliest of Begay's paintings, dated 1935. A very small piece, 3¾ × 5¾ inches, it is labeled *Navajo Archer*. The pose of the single figure set a standard for many of Begay's paintings over the years. The figure is running, but the then young artist stopped the action momentarily in such a way as to give it a feeling of the static. The details of costume are good, and the proportions of the figure are better than in some later examples. There is no ground line, and a plant in the lower right-hand corner grows "out of the nowhere" in a symmetrical and balanced fashion.

Progress is shown in a painting done two years later entitled, *Night Chant Gods*. Characteristic of Begay is a symmetrical hill drawn below center of the picture and used as a "stage" for his figures. Here a line of six yei runs up one side and down the other. A yucca plant grows almost in the center front, below the hill line. The varicolored masks, gray, red, and blue, add much solid and rich color to the picture, as do the multicolored, fringed kilts.

Harrison Begay has painted a great many scenes connected with the weaving industry of his tribe (Fig. 7.1). In a 1938 version

303

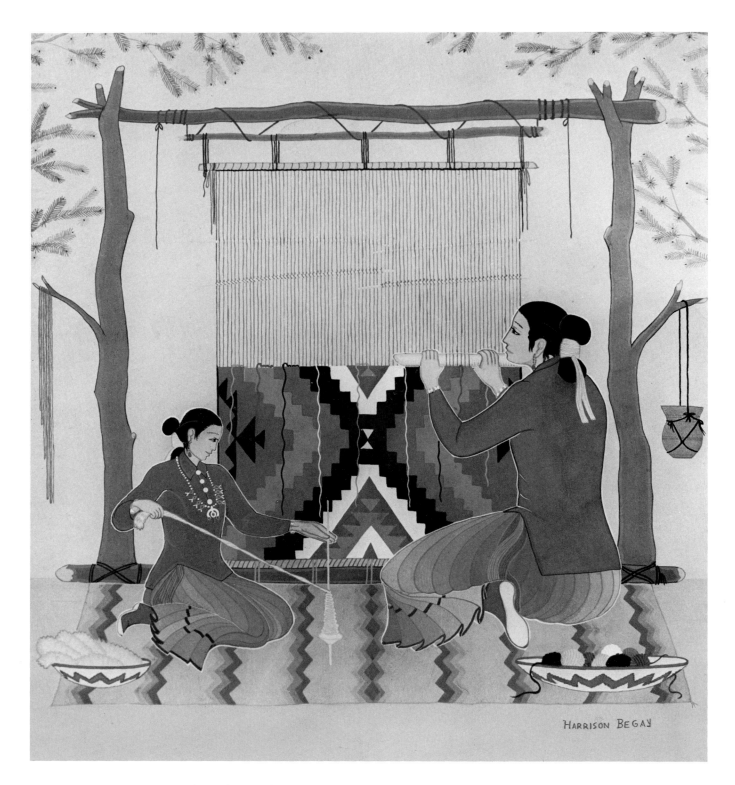

Fig. 7.1   *Harrison Begay (Haskay Yah Ne Yah), Navajo.*
Navajo Weaver. *Courtesy, Philbrook Art Center.*
—Bob McCormack

his subject was a Navajo woman weaving, with a young girl sitting beside her spinning. There are soft colors in the women's dresses; modeling is suggested only in the use of lines. Detail is carefully depicted, a quality which is typical of this artist and one which he has developed to an extremely high point.

Another subject for which this artist is justly renowned, *Rounding Up Wild Horses,*[2] also was painted in 1938. This early painting has more freedom, more freshness than many later pictures of the same or related subjects. However, here again are seen traits which are to be noted in the painting of Begay for years to come. The horses are varicolored and many-sized, and are presented in many different running positions. Horses are all over the paper, with little or no thought of composition. In later years when Begay has treated a similar theme, he has shown no particular progress in this matter, although the arrangement has its charms.

A subject favored by Begay is illustrated in his *Navajos on Horseback.* Painted on black paper, which the artist has rarely used for this or any other subject in later years, the figures are represented in full profile. The horses are delicately colored, one mauve with a reddish tail and mane, the other tan with almost-white tail and mane. Both creatures are spotted; spots are in the form of waves of increasingly darker color from center to outer edge.

Popular also with Begay as a subject is the antelope or deer; this subject is typified in a painting called *Antelope Grazing,* done in 1939. Both the deer and the horse lend themselves beautifully to the softened colors and delicate lines that connote "Begay" in the realm of Indian art. In the painting of the antelope, the figures are placed in two parallel rows running diagonally from upper left to lower right, with little or no thought of interrelationships. The animals are not very well proportioned. There is a conventional sun design in the upper right corner.

To the Navajos, a dance, or a "sing" as they call it, is an event of considerable significance. Begay has painted this subject many times, particularly the summer "sing," or Squaw Dance; Figure 7.2 gives a simple presentation of this event. Another of these portrayals, done in 1939 and titled *Navajos at a Dance,* was painted

*Fig. 7.2  Harrison Begay (Haskay Yah Ne Yah), Navajo.* Squaw Dance. *Courtesy,* Arizona Highways.  *(next page).*

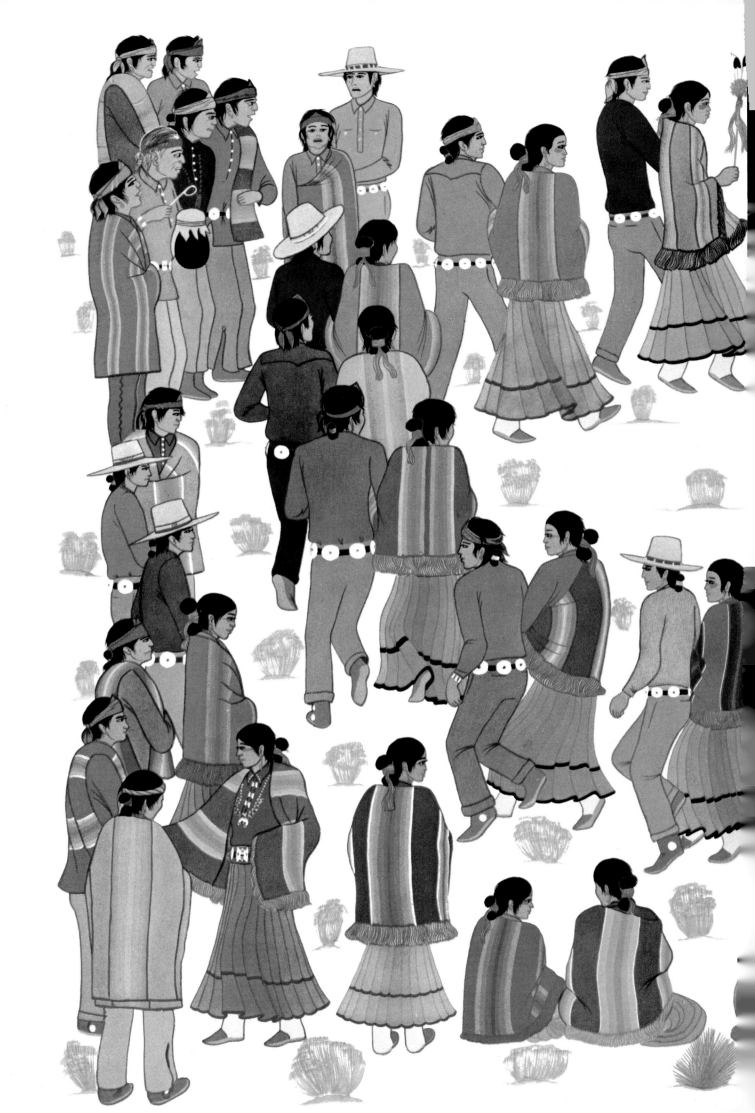

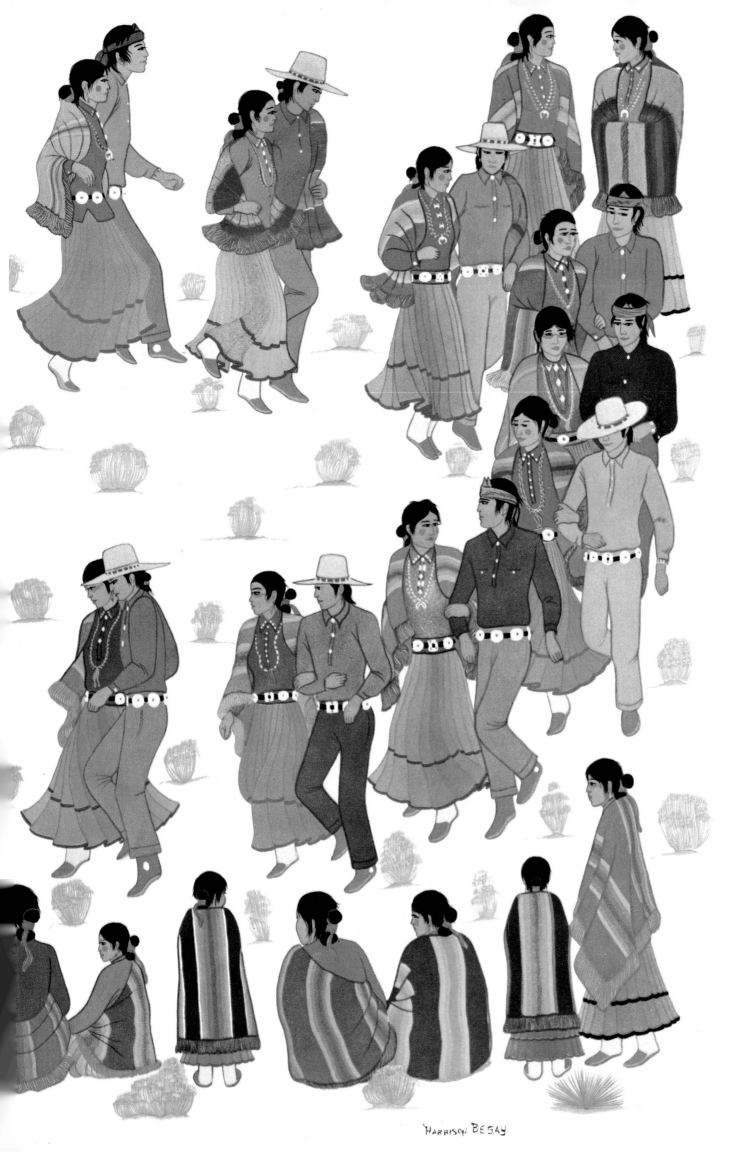

HARRISON BEGAY

on a large sheet 21½ × 13½ inches, in very bright colors. Although the figures are small and quite delicately drawn, they fill the paper. A circle of men with drummers in their midst dominates the center; all about are other men, women, wagons, and horses. Bright colors are used in this painting, much brighter than are typical in later Begay pictures.

One of the most beautiful creations by Begay is a painting done in 1947. It shows a deer and fawn silhouetted against three delicately-leaved bushes, rounded to form a conventional ground against which the animals hardly show. The coloring in this painting as a whole is almost ethereal; so delicate is it, in fact, that it has been impossible to obtain a reproduction which does justice to the original. The whole painting has a feeling of gray and mauve tones, yet the leaves and stems of the bushes are actually painted in pale tones of green and yellow.

Another theme popular with Begay is a Navajo girl and sheep. Here again, all of the charm expressed in delicacy of line, in quietness of pose, finds an outlet in this subject. Colored paper is typically employed as a background for the centered figure of the girl who often stands on a rounded hillock, holding a lamb in her arms. Usually she is symmetrically flanked by a sheep on either side. In one example, conventional clouds in the form of three billowing outlines back of the girl, delicately lined earth upon which she stands, and three clumps of rabbit brush add to the feeling of symmetry; this feeling is relieved slightly in the positions of the sheep, one looking up at the young shepherdess, the other grazing.

When Begay paints a hunting scene, there is rarely any of the gore so characteristic of Tahoma, another Navajo artist. For example, in *Shooting Deer* the stage is set for just that, but the action is stopped. The bow is pulled but the arrow is not released; the animals are as free as they were the moment the artist conceived the picture. Three figures in this picture form an equilateral triangle, thus creating a weak composition. Much Chinese white is used, as it is in so many Begay paintings, to accentuate the quality of softness, whether it be in skin or hair of animals, flesh of man, dress, or plant life.

One of the most interesting pieces of work ever done by Begay is a set of four paintings[3] executed in 1959. Each painting depicts the creation of one of the four sacred mountains—one for each of the four cardinal points of the compass—that mark the geographic extent of the Navajo country as defined by these tribesmen (*North Mountain,* Fig. 7.3). All the mythological detail pertaining to the creation of each of the mountains is beautifully portrayed in the paintings —the plants, animals, lightning, clouds, rainbow, sun, a pair of mythical personages for each, and some lesser items. There is much sug-

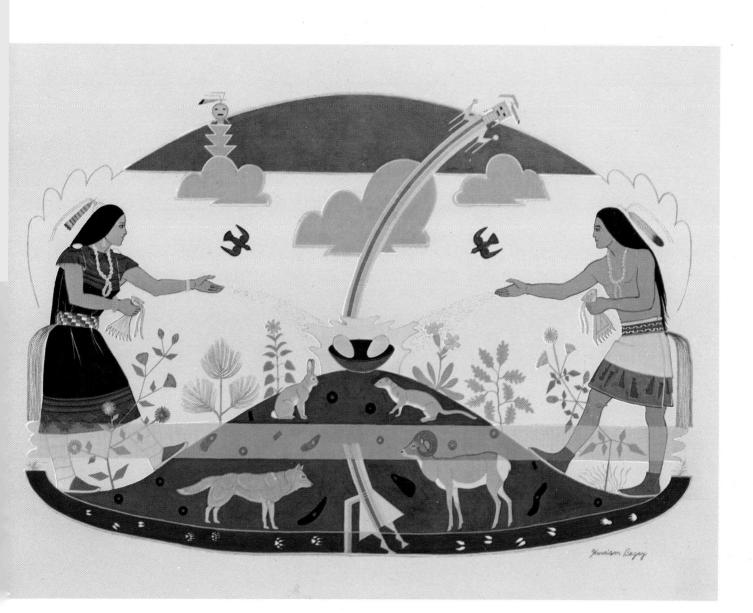

Fig. 7.3　Harrison Begay
(Haskay Yah Ne Yah), Navajo.
North Mountain. Courtesy,
Museum of Northern Arizona.
—Horizons West

gested left-right balance, some repetition, fine draftsmanship, and excellent, warm and pleasing color in all of these paintings.

This last group completes the major areas of subject matter as treated by Harrison Begay. He has, of course, varied each and every one of these themes from the specific examples mentioned above; needless to say, each represents an ethnologic gem in color as set down by the sure and accurate brush of this artist. There are certain qualities which are to be noted in Begay's work both early and late. Yei figures may not change at all (Fig. 7.4), and certainly peace and tranquility are always uppermost in his wildlife scenes (Fig. 7.5). A list of a few additional paintings reflects something of the variation of his subjects: *Navajo Mother and Daughter on a Donkey, Deer and Duck, Horse and Colt,* and one revealing a touch of Begay's quiet humor, *Papoose and Lamb and Kids—The Puppy Is a Baby Sitter!* Others include *Playful Colts, Finished a Blanket* (a

309

woman is letting a blanket down from the loom, a favorite subject with Begay), *Navajo Boy and His Horse Resting on a Journey*, and *Night Chant Dancer*.

Some 1968 titles included *Squaw Dance, Shepherdess, Navajo Family, Navajo Yei-be-chai Dance, Going to Trading Post*, and *Teaching Ceremonial Sandpainting*. These examples again demonstrate the continuity through the years of subjects favored by Begay.

In the Southwest, Begay has been a top prizewinner for many years, particularly at the Gallup Ceremonials, the Arizona State Fair, and at Philbrook; in 1967, he took a first award at Gallup; and the same year and again in 1969 an honorable mention at the Scottsdale show; in the latter year, at the Gallup show, he won both a first and the Elkus Special Award. He has also exhibited widely in the East, particularly at the Museum of Modern Art, New York City. The French Government recognized Begay in 1954 by awarding him the Palmes de Academiques. Begay received an honorable mention at the 1970 Philbrook show, and another first at Gallup in 1971. He is represented in innumerable public and private collections.

Begay's return to the reservation in 1959 seems to have given a new vigor to his painting, despite the fact that he continued to

*Fig. 7.4   Harrison Begay (Haskay Yah Ne Yah), Navajo. Yeibechai Dancers. Courtesy, Arizona Highways.*

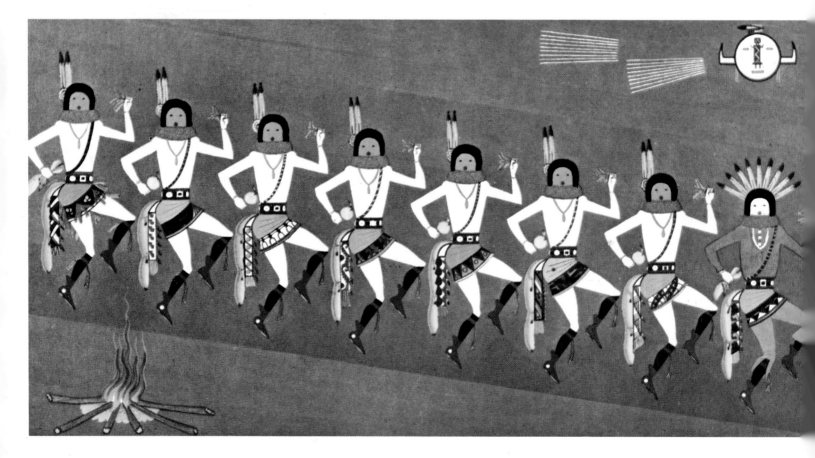

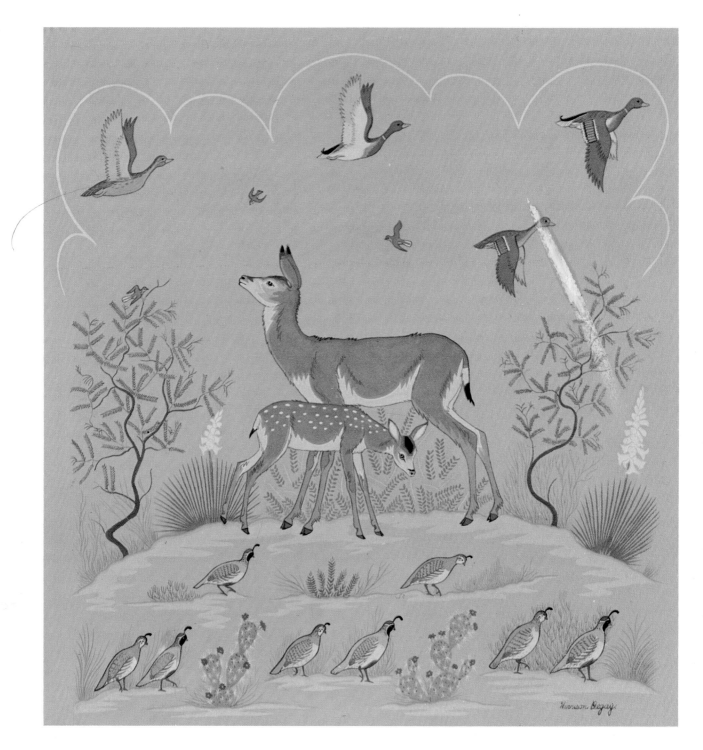

Fig. 7.5    Harrison Begay
(Haskay Yah Ne Yah), Navajo.
Desert Dwellers and Migrants
Passing By. *Courtesy, The
Amerind Foundation, Inc.*
—Ray Manley Photography

use the same medium, casein, that his style remained the same, and that his subject matter continued to feature the many-faceted ceremonial and everyday life of his tribe. To the end of the 1960s, the same compositional ideas were expressed, from well-ordered figures to animals and plants repetitiously scattered all over his paper. Also, some of his compositions continued to be almost perfectly balanced. If possible, he improved the delicacy and refinement of his line work. In a 1969 Scottsdale show entry, his expression of gentle charm, his fluid lines, his fresh and clear colors are, perhaps, more in evidence than ever before. Eyes seem brighter, bodies display a little more vigor. Both large and small symbolic themes appear more frequently in his 1960 creations. Certainly he was at a peak in his painting in 1968–71.

Extreme delicacy becomes uppermost in this artist's works with lines so fine that it seems impossible that they could have been made with a brush. Coupled with this are the keen powers of observation of which the Indian has more than his share. In Begay's work there is often the disciplined balance between the heavy formalities of inherited tradition and a warm realism which developed within a very short span of years. Too, Begay evolved a style that is essentially his own, a style which influenced others, but which has not been equaled in perfection by any of those he has so greatly affected. Lines that breathe rhythm; clean, cool, and sensitive coloring; a gentleness of figure; peace and calm throughout, from facial expression to composition; impeccable drawing, the best in Navajo art; simplicity coupled with realistic detail; few and conventional plant forms or other background effects; harmony and serenity—these and other more elusive traits and qualities are combined in the inimitable Begay manner.

One of the most versatile of all Southwestern Indian artists, Andy Tsihnahjinnie,[4] a full-blooded Navajo, was born near Chinle, Arizona, in 1916. He spent his early years on his tribal reservation. Later he was sent to the Indian School at Fort Apache on the Apache Reservation; from this school he ran away, going all the way back to his own reservation, he has said. Nonetheless, he completed his elementary education at Fort Apache. Later he went to Santa Fe, graduating from the Indian high school in 1936, after which he went to Window Rock, Arizona, the agency center for the entire Navajo Reservation. Here he served as illustrator for the Indian Service; perhaps one of his most interesting assignments there was to illustrate the charming Navajo child's story, *Who Wants to Be a Prairie Dog?* by Ann Nolan Clark.

Some wandering about, with odd jobs along the way, was Tsihnahjinnie's fate until war broke out. He volunteered for the

Marine Corps, spending most of his three and one-half years of service in the Pacific. Among the many places he was stationed was Tokyo, and close to this city he reputedly decorated a Japanese bar. More important, he was exposed to Chinese and Japanese art during his stay in the Orient. Although this may not have affected him directly, certainly some of his postwar paintings have a decided Oriental flavor. In time he returned to his own style, altered somewhat, but more Navajo than Oriental.

For a time after World War II Tsihnahjinnie concentrated completely on art, establishing his own studio in Scottsdale, Arizona. He made his living solely from the sale of his original works and doing murals and other special assignments until his marriage; then he had to supplement his income from painting with other jobs. For some years he remained in the Scottsdale area; in 1968 he became an instructor in the experimental school at Rough Rock on the Navajo Reservation, and in 1970–71 he was an instructor at Navajo Community College.

Tsihnahjinnie's ability as a painter was recognized when he was in elementary school. This was one of the reasons he went to Santa Fe. In the late thirties he won a competition prize offered by the *American Magazine.* During his school years and shortly thereafter, he did several outstanding murals, one at the Phoenix Indian School, one in the sanatorium in Winslow, and a third at the Fort Sill school in Oklahoma. Through the years Tsihnahjinnie has painted many other murals, a large number of which are in the Scottsdale-Phoenix area of Arizona, with some also in Japan, New Mexico, and California, among other places. These murals treat of a variety of subject matter, from strictly conventional ceremonial subjects to semi-realistic humans and animals.

An early painting done in 1935, while he was in school at Santa Fe, shows a Navajo woman spinning yarn. She is in a sitting position, feet under her. She sits upon nothing, with two balls of wool in front of her. Although the painting has little "Indian" feel to it, it does have a Tsihnahjinnie touch in warm colors, in active pose, and in the absence of conventional motifs.

About 1935 Tsihnahjinnie did one of the most spectacular Fire Dancer paintings of his career. This subject has been a favorite of many Navajo artists, for it satisfies their desire for color and action. In this painting, performers are naked save for a breechcloth, a band about the hair, and sometimes moccasins. Their bodies are painted white. Each man lights a cedar-bark brand at the great central fire, and then runs about, striking one another with the flaming torches. This painting is done on black paper, with the white bodies making an interesting contrast against the dark color. Even more spectacular

313

are the curling white smoke and red flames. He has done this same subject many times since, in lighter colors on white paper, and in other combinations.

One of Tsihnahjinnie's finest paintings, *The Gamblers* (Fig. 7.6), depicts a typical tribal scene of four groups of card players gathered about blankets to pursue their favorite pastime. The scene is a complete one, set in the open Navajo country with buttes and pinnacles in the far distance. Men and two women are sitting in groups of eight around three blankets, with nine around the fourth, all intent upon the game. As can be noted in the reproduction, the blankets are spotted over the paper almost as though they had been laid out flat and symmetrically on the paper surface, an odd but not unusual perspective. The scene is Navajo-complete, with Indians sleeping or curled up in blankets or dozing against a tree, others standing by watching the game, and with horses and horsemen in the background.

Delightful portrayals of Navajo characteristics appear throughout this painting. Soft colors give the full range in costumes of such a grouping of this tribe. Designs in the blankets are representative of this tribe. Details, although sometimes sketchily presented, are typical of this artist and can be noted in large, upturned-brim hats, some at rakish angles, and disheveled and flying hair; these, too, have a feeling so typical of the Navajo Indians. Unmistakably Navajo, also, are the facial features, despite the fact that they are ashen in color and outlined in heavy red lines.

Tsihnahjinnie has gone through many moods, solidifying a style momentarily, then turning to something new and utterly different. Almost always his subject matter centers about the life of his people, either an incident of daily life or some ceremonial activity, such as *Wedding Ceremony* (Fig. 7.7). Horses have been of particular interest to him, and he has painted them in every conceivable color, size, and shape.

One Tsihnahjinnie mood led him, in the early 1960s, into the painting of several Navajo scenes in which more than one hundred tiny figures are scattered widely over his paper, which is 15 × 20 inches. Despite their small size the figures are outlined in black, with detail sufficiently good to give one the feeling of Navajos and a gathering typical of this tribe. In another comparable painting, a Fire Dance executed in the same light palette, the artist evokes a feeling of great cold in tightly blanketed figures and in streaks on the ground that suggest snow.

Now and then Andy has gone in for symbolic design, letting it dominate the picture or take over completely. One such painting, done before 1940, shows a stockily built and poorly proportioned

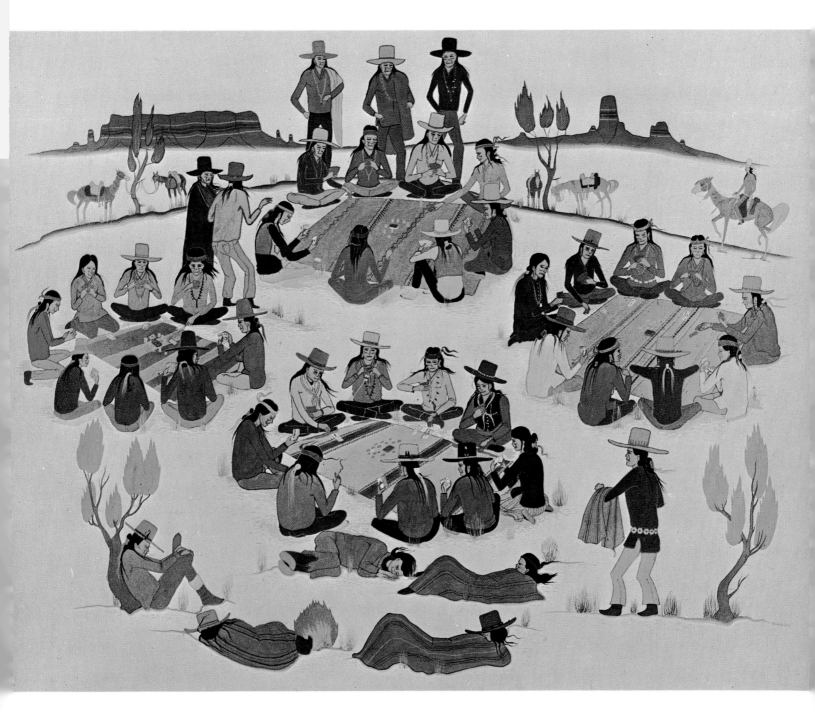

Fig. 7.6    Andy
Tsihnahjinnie, Navajo. The
Gamblers. Courtesy, Mr. and
Mrs. John Tanner.
—Ray Manley Photography

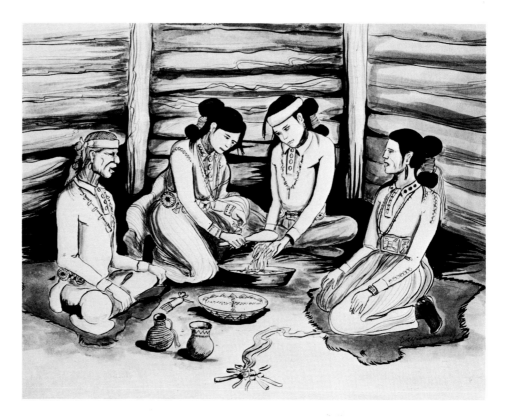

*Fig. 7.7    Andy Tsihnahjinnie,*
*Navajo.* Wedding Ceremony.
*Courtesy, Mr. and Mrs.*
*H. S. Galbraith.*
—Neil Koppes

man on horseback, a great lock of hair flying before his forehead. In his left hand he holds a gray bowl out of which comes a solid shower of color in waves of dark-to-light pink and lavender. The horse slides down this showering mass, its mane an unreal and wispy trail of purple and lavender. A great horned and rayed symbol appears in the lower left corner.

Much later, in 1962, he painted another symbolic subject, *Slayer of Enemy Gods—Nayeinezani,* one of his finest paintings (Fig. 7.8). Two central figures, the young gods, stand in a shower of rays from the sun, their father. The latter is represented in conventional form, near center, with a Rainbow Goddess close by. Below the feet of the lads are contiguous circular bands of bright to light blue, through the center of which are visible, far below, tiny hogans with smoke coming from each one; this feature, too, adds to the full symbolism of the picture. Both light and bright rich blues predominate and are still richer for the dark paper on which they are painted. This painting took a first prize in the 1962 Scottsdale National.

Tsihnahjinnie is chameleon-like in his ability to change, in his response to new influences. Another picture painted after his experiences in the Pacific reflects this quality. It is entitled *Deer and Fawn in Tropical Growth,* an old subject in a new environment. And that environment is a South Sea island, with the two deer standing in a cove-like area, surrounded by tropical growth and what appear to

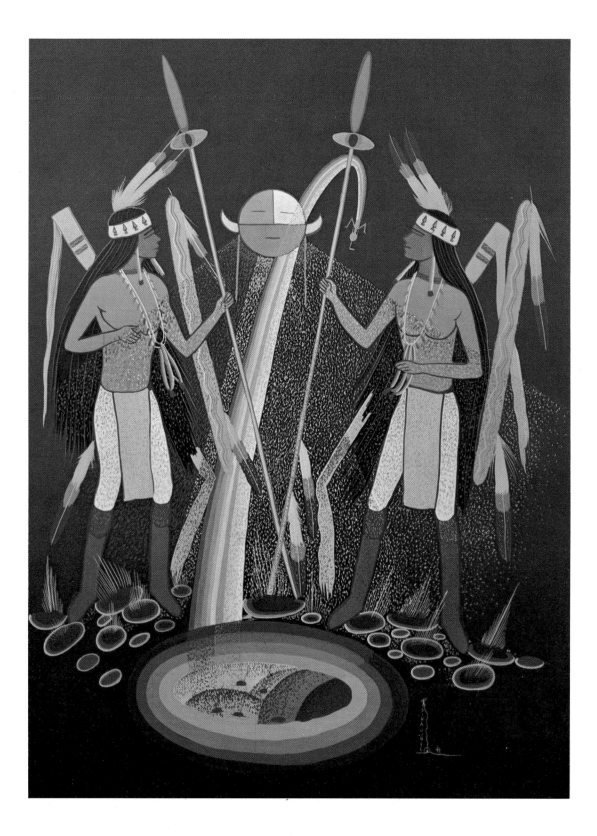

*Fig. 7.8    Andy Tsihnahjinnie,*
*Navajo.* Slayer of Enemy
Gods–Nayeinezani. *Courtesy, James T. Bialac.*
—Helga Teiwes, Arizona State Museum

be rocks. Above is a series of waves, like those of the sea, and at the top center is a cluster of tiny palm trees on a hill-like affair. All is done in various shades of blue except for the deer which are tan. All of the drawing is stylized; the arrangement is more abstract design than a composition of realistic elements.

Another mood of Tsihnahjinnie's is one in which sketchily drawn subjects, usually men and horses, are done with great verve. The flesh of humans is executed in vivid terra cotta tones, horses are of any color that may occur to the artist. Much outlining and modeling are done in heavy lines and in contrasting colors. At another time Andy painted great lumbering horses so completely out of proportion that they are recognized as horses only because they could be nothing else. Their tails are heavy masses, the animals are gray, one outlined in orange, one in black. On the long back of one horse are three children, a fourth child sits on the other horse, with a fifth just getting up, aided by a sixth youngster. A suggestion of background appears in the form of a small, flat-topped butte in the distance.

Throughout the 1950s and 1960s Tsihnahjinnie continued painting with great versatility, although much of it was very poor. Some of his work was excellent, however, as cited above, and as seen in a group of horses, so massed and so painted in bright colors as to be gem-like; or in several racing horses or wild horses (Fig. 7.9), presented with great color range and with all the vitality and spontaneity of which Tsihnahjinnie is so capable. The poor work during these years reflects sloppy draftsmanship and painting, exaggerated positions and proportions, and careless composition. In the 1969

*Fig. 7.9    Andy Tsihnahjinnie,*
*Navajo.* Wild Horses.
*Courtesy, the Avery Collection.*
*—Howard's Studio*

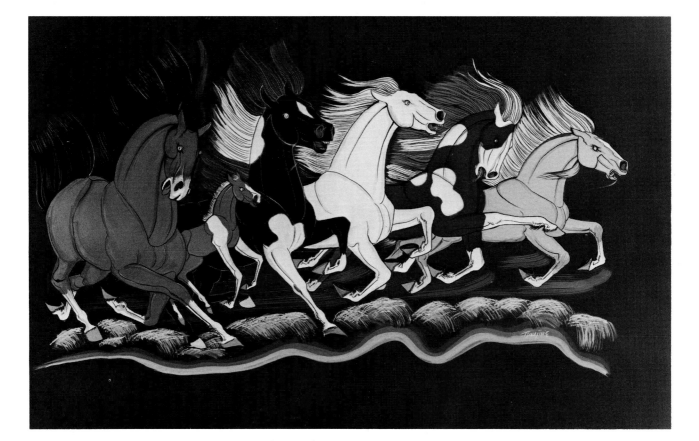

Scottsdale National, Tsihnahjinnie entered several watercolors; one of these, *Dancers*, reflected some improvement in better detail on the blue-faced, blue-bodied, and heavily outlined figures.

Although Tsihnahjinnie seldom has attempted abstracts, it was during the above period (in 1965) that he produced a most exciting one, entitled *Enchanted Forest* (Fig. 7.10). Painted on black paper are five larger blue-and-red but most slender trees and a cluster of several line-thin white ones. Against these and crossing the paper vertically is a great zigzag of white, gray, and pale yellow, with extensions of the latter at two points. It is indeed an enchanted forest!

One of the most peaceful and interesting of Tsihnahjinnie's paintings is *Purification Ceremony* (Fig. 7.11). This recorded his own cleansing rite after his return from World War II. Present at the ceremony were his mother, the medicine man, and Andy, the three sitting about a central fire. Andy's duffel bag, uniform, and gun hang on a "sky hook" at the center top of the picture. Soft colors dominate.

From early years Tsihnahjinnie painted in tempera and oils, the former most common for the majority of his work. He has done scratchboard and pen-and-ink, the latter sometimes combined with a thin wash. His early work, which was childish but promising, anticipated the fruition seen in the fine work he did during the 1950s and 1960s—sporadic though his best efforts may have been.

Originality is surely one of Tsihnahjinnie's chief characteristics—originality in subject matter and treatment thereof, and in color. His unconventional palette complements his delightful imagination in ever-new creations. Violent action, sustained motion, or peaceful inertia—he lets the brush follow the mood of the moment. Fine lines, coarse lines—alone or together they can portray the artist's whims.

A few of the many awards won by Tsihnahjinnie reflect some of his peaks of attainment in painting. He received a Grand Award at Philbrook in 1962 and a first there in 1960, and first awards at Scottsdale in both 1962 and 1965.

Among his artistic efforts during 1971 was the illustration of a book, *Navajo History,* written under the direction of the Navajo Curriculum Center at Rough Rock Demonstration School, Chinle, Arizona. Since this volume is concerned with Navajo origins, mythical characters, and monsters, it gave Tsihnahjinnie an opportunity to let his imagination have full play. Much of his work is vigorous and entertaining, particularly in his creation of the Twin War Gods ridding the earth of monsters so that the Navajos could survive. One of his most appealing sketches in the series is Talking God bending over a baby protected by a Rainbow Goddess.

One of the most dynamic, imaginative and gifted of Southwest Indian artists was Quincy Tahoma. He also revealed in his works

*Fig. 7.10    Andy Tsihnahjinnie, Navajo.*
Enchanted Forest. *Courtesy, the Avery Collection.*
—Howard's Studio

the extreme rhythm and decorative feelings that are essentially Indian. Born in 1920 in Tuba City, Arizona, Tahoma lived the life of an average Navajo boy, herding sheep and riding horseback. Realistic paintings of horses reflect much of his early life, plus the Navajo's unfailing love for this animal. No matter how violent his portrayals became in later years, Tahoma still painted horses with affection and great beauty.

Tahoma attended the Indian high school at Santa Fe from 1936 to 1940, and during these four years he studied art. He also took some postgraduate work in art at the same school. When World War II broke out, he volunteered and saw active service overseas.

Most of his adult years, however, were spent in Santa Fe, either in his own studio or working for others.

Three paintings by Tahoma, all dated about 1935, foreshadow the potentials of this artist. One of these is the essence of peace and quiet, a man watering his horse. Less capably drawn than later pictures, this has a feeling of sustained action, the quiet drinking before the rider mounts and moves on. There is a feeling of symmetry and design here, too, in the repeated waves of the water running from edge to edge of the paper. Dismounted rider and horse stand in the center of the picture. The reeds which grow at the two sides of the water are conventional but not symmetrical. The foreshortening of

horse and man, drawn three-quarters front, is not too well done. Color is varied, but in bright hues.

Action and vitality characterize the other two pictures. One is a buffalo hunt, the other portrays men chasing horses. Although the proportions of the animals are poor, the pictures appear cluttered, and colors are not intense, nonetheless these paintings show fast motion and varied positions of the animals; they reflect a tenseness and suspense which was perfected in later years. In both paintings there is a lingering touch of conventional design, a cluster of growth in one, red cliffs in the other.

Tahoma was not all wildness and action. Early and late he lapsed into quieter moods, producing as peaceful scenes as Begay or any other of his tribesmen. One painting, *Wildlife* (1937), is the antithesis of his hunting scenes. A delicate tree dominates the center of the picture; other subjects include many bright-colored flowers with butterflies on them, three deer, and birds overhead.

He was represented in the 1939 Annual Exhibit of the Santa Fe Indian School at the Art Gallery of the Museum of New Mexico. In reviewing the exhibit, one critic remarked, "Tahoma's unerring brush and powerful sense of design should make him a fine painter. He is held back, however, by his use of detail."[5] The latter, the critic noted, detracted from the vigor of the overall design.

Tahoma had considerable difficulty with perspective in his early painting; this is well demonstrated in *Antelope Hunt*. Twenty-three of these animals are represented as bounding stiff-legged over a rounded hill, tails in the air. They are pursued by two hunters, riding bareback and dressed in the old-style Navajo buckskin breeches and red moccasins. Stiff little yucca plants dot the hillside, with tiny hummingbirds hovering over their blossoms. The whole creation is highly stylized but presents dramatic action. By the time he painted this picture in 1941 Tahoma had developed a trait that remained peculiarly his own: in the lower right-hand corner of this picture is a thumbnail sketch of the action that immediately follows that of the main scene—here the hunter successfully spears an antelope. The artist's name appears directly beneath this sketch.

One of the most charming of Tahoma's paintings is that of a Navajo bride and groom. Like so many of his works, it is a large

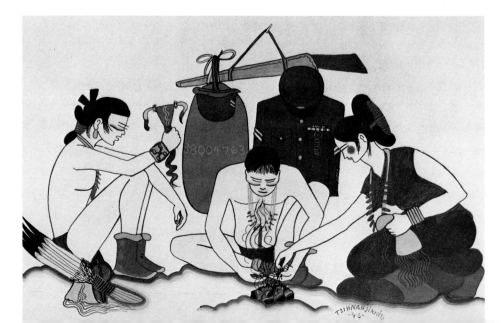

322

picture, measuring 20½ × 27½ inches. The stage is set for the two and their companion by the drawing of several horizon lines. A far line supports colorful buttes and pinnacles in the deep reds so typical of these formations in the Navajo country. Between this and a lower line is a distant hogan (Navajo house) with a man watching for the travelers. Dominating the picture are the man on his horse, the woman directly behind him on hers. The groom is dressed in old-style buckskin, and as he rides along he plays a pottery drum and sings lustily, with his mouth open wide. The bride's costume, an old-style, hand-woven blanket dress, is caught at the waist with a native red-and-black belt. She, too, sings. The other man, who, the story goes, is a slave, sits on top of a great bundle on the back of a donkey. In fact, the fellow shares this precarious seat with a huge Navajo cooking jar. This man is more scantily clad than the other, but he, too, sings lustily as he plays a similar pottery drum. The horses are equally alive, the front one with open mouth and dilated nostrils. It is an altogether dynamic and dramatic picture, despite the more than static growth and cliffs. The thumbnail sketch supports the bride-and-groom idea, for here they ride in peace and obvious happiness side by side.

In many of his earlier paintings, Tahoma used colored paper. Toward the last few years of his life, most of his work was done on large white sheets. Later, too, his palette became vivid, the treatment of his subject matter dynamic. Furthermore, about 1945–46, Tahoma leaned more heavily in the direction of wilder and bloodier subject matter. Hunting scenes, war scenes, any subject which offered the opportunity to depict "blood and gore" seemed to appeal to him at this point. Still later, however, he painted more scenes featuring quiet and peace.

In a buffalo hunt painted by Tahoma, two men are closing in on a great beast which is rearing and wild-eyed with fright. The massive-shouldered animal is mottled in color almost as if it were the graying king of the herd. To the far left is an archer pulling the bow. Perspective is rather good in this figure. The man to the right front is on an immense horse which is virtually "putting on the brakes" in an effort to stop abruptly. Foreshortening in this animal is not good, a technique Tahoma never completely conquered, although he attempted it frequently, sometimes with more or less success. The horse's eyes and nostrils are dilated, the teeth are bared, and the extreme tension of muscles can almost be felt. The man is ill-proportioned, for his upper body is too large and heavy. In another buffalo hunt (Fig. 7.12), Tahoma depicts the same violent action.

One of Tahoma's most beautiful compositions is a colorful wild-horse hunt. In the center background is a flat-topped, sheer-

sided mesa. Above are two entirely different cloud treatments; one is comprised of simple and blue-outlined, billowing masses, the other red-orange, flat-bottomed, and round-topped streaks. One blends into the other. Against this background is a herd of running, wild horses, centered and going off to the left. Animals are varicolored, a red-and-white pinto, and dappled blue-and-gray dominating the scene. To the far right is a Navajo on the wildest horse of all; the animal is rearing almost straight into the air, with but one foot almost touching the ground. This belly view is not uncommon for Tahoma, in spite of the fact that he has some of the same difficulties of foreshortening here that he does in other poses. The man atop the horse is heavily built; his hair is blowing wildly. He has lassoed an animal in the herd.

Color is most pleasingly handled in this painting, from the blending clouds above, through the varicolored horses, to the conventional growth of the foreground. Movement is synthesized effectively too, in the billowing clouds, with emphasis on the arrangement of animals, and into the very conventional shrubbery of the foreground; Tahoma has effected dynamism in the latter by placing rabbit brush in three crescent-shaped rows in the immediate foreground.

Quincy Tahoma painted proud people and majestic horses. One such painting, *Going to the Navajo Chant* (see Fig. 4.12), depicts a Navajo family on its way to a tribal affair. Conventional themes frame the main subjects. On a palomino is the wife and mother, dressed in an old-style blanket dress and moccasins with high tops. She carries her infant on her back in a baby cradle. A little behind these two is the husband, proudly riding a blue horse that contrasts effectively with the red buckskin boots and tan buckskin trousers and jacket that he wears. The horses lift their feet and arch their heads as though they were the finest of show stock. The man and woman both reflect great pride in their erect postures, in their heads held high, in the very manner of holding the reins of their fine steeds.

Regardless of subject matter, Tahoma painted in harmonious and rich colors and in clean-cut and graceful lines; his draftsmanship was impeccable. His use of paper or mat board with tempera colors makes a happy combination for his brilliant paintings, whether depicting the quiet native scenes he favored in the late 1940s and early 1950s or the violent hunting or war scenes so popular with him during previous years.

Tahoma never posed his subjects artificially; each and every one is an active participant in the scene portrayed. Muscles are taut, as in a crouching mountainlion. Facial features reflect the situation of the moment, whether the pleasure of a singing bridegroom or the tenseness of the hunter as he makes his kill. This trait was developed

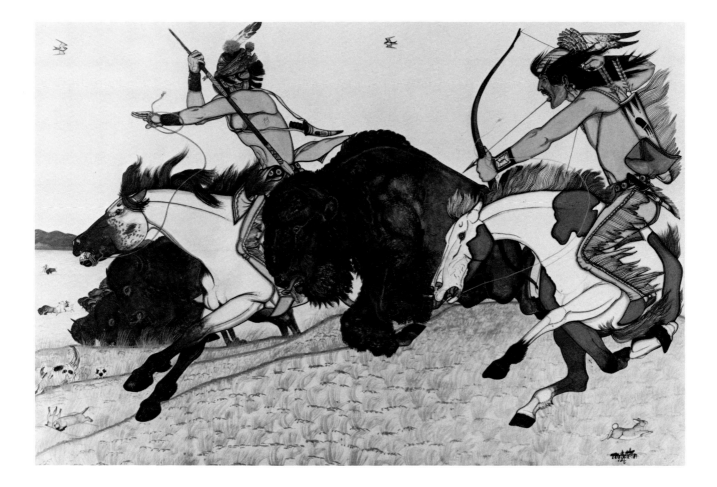

Fig. 7.12    *Quincy Tahoma, Navajo.* The Early Days of
American Indians. *Courtesy, the Avery Collection.*
—Howard's Studio

through the years and reached a peak in the late forties. Tahoma
broke away early from the two-dimensional treatment characteristic
of the puebloans; through the years he developed perspective (Fig.
7.13). On the whole, he was more proficient in depth perspective
than most Indian artists; he definitely influenced other Indians in this
respect.

Tahoma's sense of humor appeared often in his painting. In
one instance a distraught bear flees from a mass of bees. The furry
animal's tongue hangs out, his ears are down, and his feet carry him
as fast as they can. Some of the bees are already on his nose, on
his head, his back. A successful getaway is eventually made by the
bear, as the artist tells in the thumbnail sketch. Another entertaining
subject that he painted effectively is *Tourist Season* (Fig. 7.14), with
the inevitable white woman in shorts, and the white man armed with
a camera, the Indians happily posing, enjoying their gifts of ice cream
cones. It is also interesting to see an Indian's idea of Early Man as

325

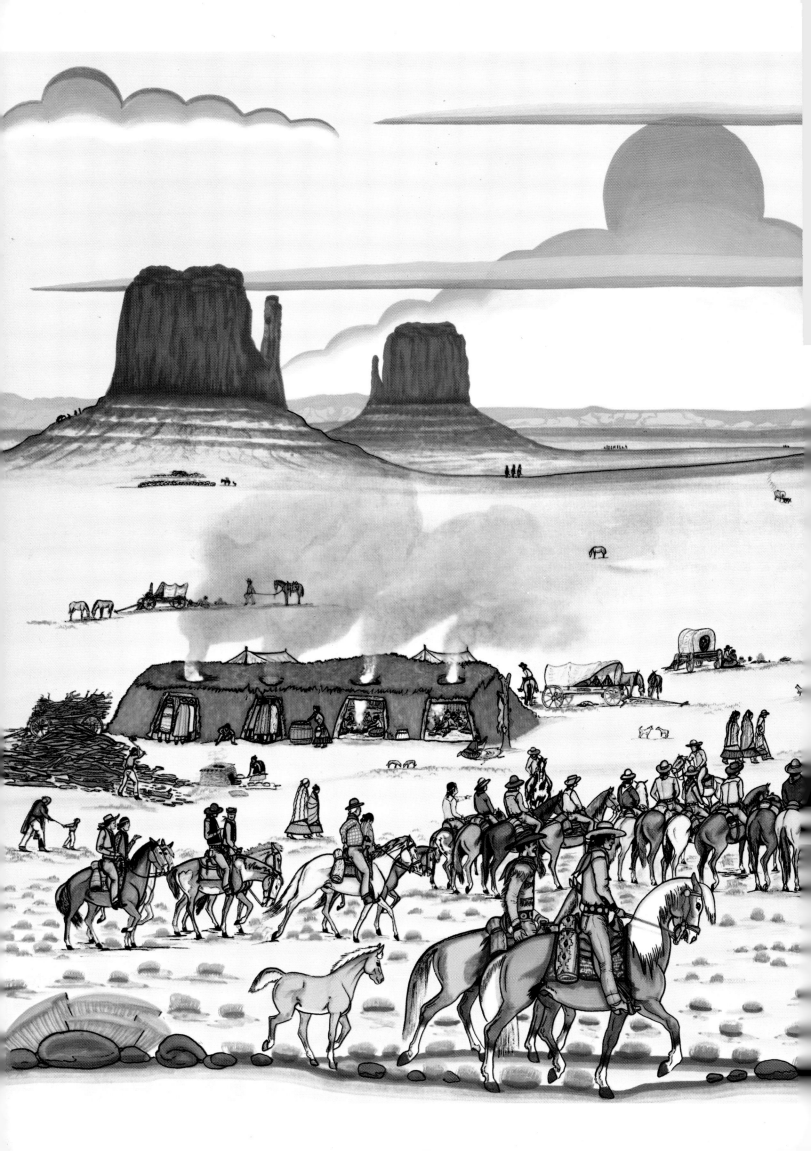

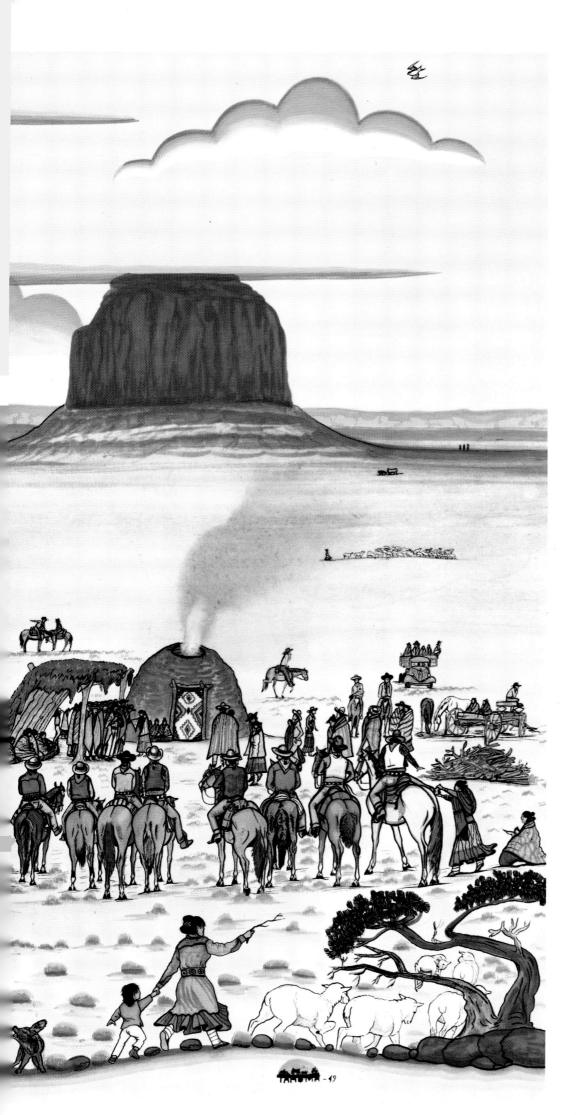

*Fig. 7.13    Quincy Tahoma,*
*Navajo.* Navajo Sing.
*Courtesy,* Arizona Highways.

327

Fig. 7.14    Quincy Tahoma, Navajo. Tourist Season.
Courtesy, Dr. and Mrs. Byron C. Butler.
—Neil Koppes

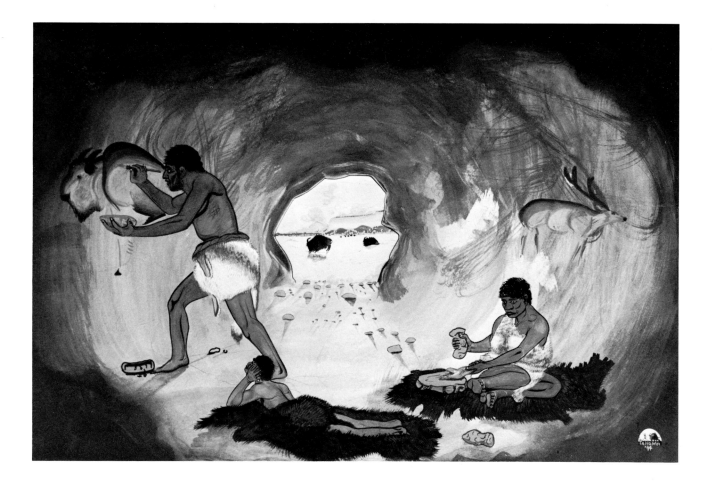

depicted in *Cave Dwellers* (Fig. 7.15); this is a most unusual subject for Southwest Indian artists.

Quincy Tahoma exhibited all over the United States in the better art galleries and museums. He won many prizes for his pictures. He is represented in the *Junior Encyclopedia Britannica,* 1946 edition, with a reproduction of one of his watercolors. Tahoma died in November, 1956.

A great blow was dealt Southwest Indian art by the death of Gerald Nailor (Toh-Yah, Walking by the River) in August, 1952. Although less well known than some of the other artists, he was surely one of the finest of Indian painters. Born near Crownpoint, New Mexico, in 1917, he attended public school in Gallup on a scholarship. Later he studied at the U.S. Indian School in Santa Fe, coming under the influence of Kenneth Chapman and Dorothy Dunn; still later he studied under O. Nordmark in Oklahoma. At the time of his death, Nailor was living in Taos with his wife, a native of Picurís Pueblo.

Gerald Nailor exhibited widely, throughout New Mexico and Arizona, at the Denver Art Museum, and the Museum of Modern Art, New York City. He produced a number of murals also.

*Fig. 7.15    Quincy Tahoma, Navajo.* Cave Dwellers. *Courtesy, Dr. and Mrs. Byron C. Butler.*
—Neil Koppes

329

Fig. 7.16    *Gerald Nailor (Toh Yah), Navajo.  Yei Dancer. Courtesy, Woodard's Indian Arts Collection.*
—George Hight Studios

Generally working in tempera, Nailor also painted in water-color, oils, and for some of his murals, fresco. Whether working in earth-derived or water-based paints, he had a facility in handling them exceeded by few other Indian artists. Hester Jones has summarized his paintings quite adequately: "He produced compositions integrating combinations of symbols with such originality and refinement that they often equalled or surpassed the best modern art."[6] His subjects, which are combined with symbolic motifs in such a manner as to suggest the beauty of Navajo poetry, included many facets of Navajo life (Fig. 7.16) but featured horses and riders (Fig. 7.17).[7]

An unfinished painting, now in the Laboratory of Anthropology collection in Santa Fe, which Nailor produced in 1934, foreshadows many of the outstanding qualities that he developed through the years. Three antelope dash magnificently across a dark green sheet. Heads high, feet long and slender, exaggerated markings on the necks, and with simple conventional designs above the animals, the Nailor style is established. Through the years he changed little, save to perfect the delicacy of his work and, if anything, to decrease the quantity of line work. Simplicity is the keynote of the work of his later years, and it is the exaggeration of this simplicity which gives to his works a feeling of power and stateliness.

Symbolic decoration was featured by Nailor. Never is this symbolic patterning overpowering; on the contrary, it tends to enhance rather than detract. No other native Southwestern artist has combined this element with realistic themes so effectively, both in color and as part of the composition. Too often, as expressed by other Indian artists, symbolic pattern is an afterthought, added at the last moment.

When he was twenty-two, Nailor took part in the decoration of the Recreation Room of the Department of the Interior Building in Washington, D.C. One picture is an interesting ethnologic study, showing three women of his tribe before a loom. Details of the rug and of the women's dresses are good; the hair style is slightly exaggerated. Shading is done in this picture, which is not true of many of Nailor's paintings. Familiarity with tribal traditions is revealed in another of the murals in the group by Nailor. During the yeibechai, a nine-day healing ceremony, some of the costumed and masked

Fig. 7.17    *Gerald Nailor (Toh Yah), Navajo.* Navajo Woman on a Horse. *Courtesy,* Arizona Highways.

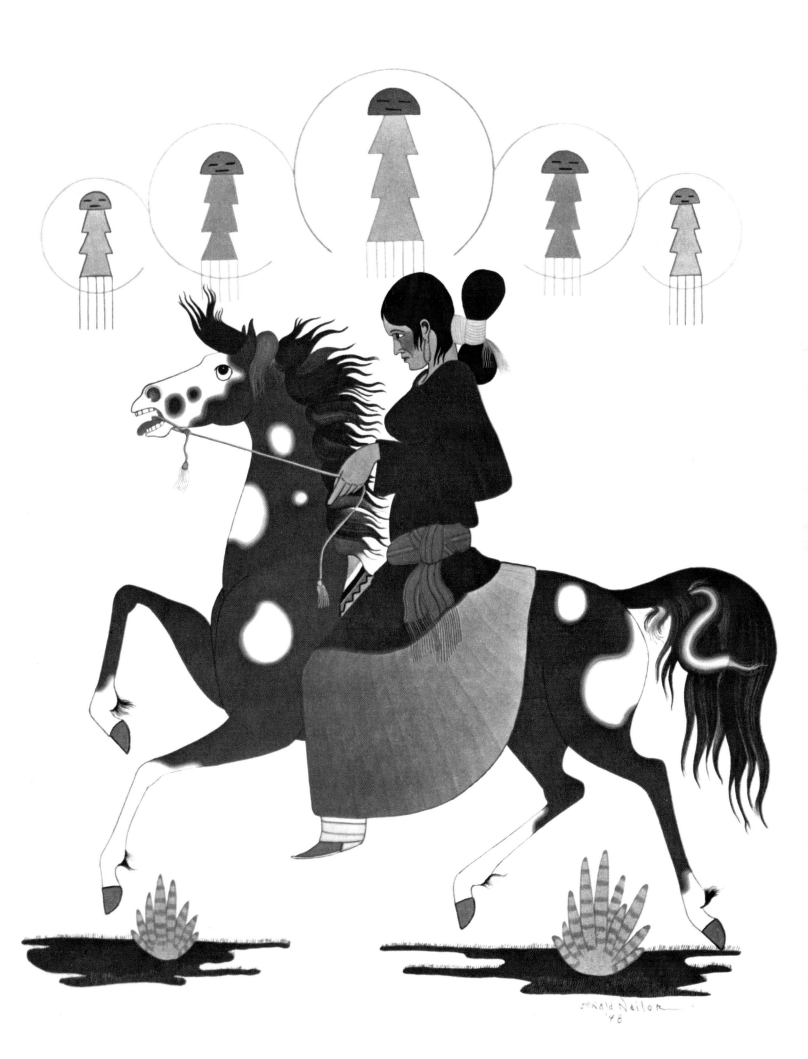

dancers make a lasting impression on children by whipping them with yucca whips. In the scene portrayed, a kneeling dancer grasps a child by the ankle just as he reaches for his mother's skirts.

Also on the neutral tan walls of this building, in "low-keyed oils...of sandpainting hues" and in almost-life-sized figures, he depicted "well composed, deftly drawn and painted *Antelope with Birds and Corn.*"[8] Many of his murals reflect Nailor's penchant for design.

Frequently Nailor expressed a delightful touch of humor. In one painting, *Navajo Debutante*, a young tribesman on horseback passes four young girls going in the opposite direction. One laughs in the characteristic Navajo fashion, with her hand over her mouth; the debutante blushes. Another example of his humor is to be noted in *The Frolicking Navajo Girls* (Fig. 7.18) wherein three young ladies mock the serious dance steps of their tribesmen.

*Two Navajo Ponies* reflects the vigor and spirit for which Nailor strove from the beginning of his artistic efforts. Two magnificent creatures, no less spirited than Pegasus, race we know not where, without touching their feet to the ground. The spotted animals run open-mouthed, with nostrils dilated, manes flying.

Gerald Nailor had an unerring sense of line and color. Featured in his paintings are rich dark browns and reds. His primary interest in design extended to the use of figures of humans and animals. In the arrangement and action of life forms he shows pattern. He expresses the great pride of his tribe in beautiful and dignified women riding high-stepping horses. Rhythmic motion is ever-present in the horses, from forelock to tail, in the prancing and saucy colts. Some flow of line carried over into conventional plants, or even on up into the more conventional design motifs at the tops of his pictures; so too did color and delicacy of line.

Some of Nailor's paintings were reproduced by Tewa Enterprises, the group mentioned in connection with Harrison Begay. One set of four serigraphs depicts birds, two doves, and two quail, done

*Fig. 7.18    Gerald Nailor (Toh Yah), Navajo. The Frolicking Navajo Girls. Courtesy, Mrs. Hall Adams.*

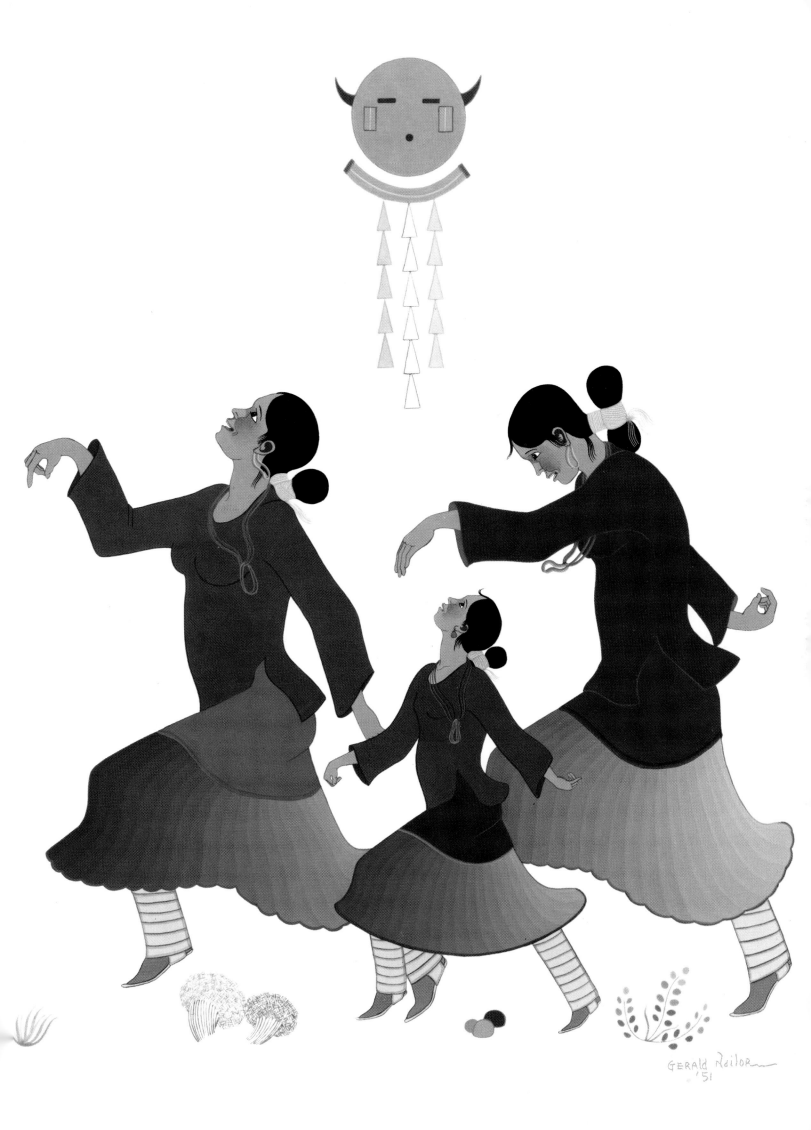

GERALD Nailor
'51

largely in grays and browns. Another depicts two deer (Fig. 7.19). All are exquisitely detailed, and certainly represent one of the outstanding examples of sheer design wherein Nailor demonstrated so much ability and artistry.

Despite his early death, Gerald Nailor will rank among the best of traditional Navajo artists. He is represented in many private and public collections alike; too, examples of his painting have been published. His work will be remembered for its fragile delicacy, its exquisite coloring, its sophistication, and its expressive and finished line work. His decorative style and his proud horses and riders were to influence many a later Navajo painter.

One Navajo artist whose paintings never fail to appeal in their quiet tone and delicacy of color is Charlie Lee.[9] "Yel-Ha-Yah" is his signature, and he has explained it as a shortening of Hush-Ka-Yel-Ha-Yah, meaning "warrior who came out," a name given him by his grandmother. And a more peaceful warrior never existed. Quiet and as retiring as a mortal can be, Lee has made his chosen profession that of a missionary to his own people; in this capacity he has served for many years.

Lee was born in western New Mexico on April 14, 1926, near Red Rock, Arizona. He started school at the age of seven, attending at one time or another St. Michaels Catholic Indian School, Southern Ute Indian School, Red Rock Day School, and Shiprock School. At the last place he completed his junior year of high school. Here, too, he made designs for silversmiths, designs which claimed the attention of officials who were responsible in turn for his attending the Santa Fe Indian School during his senior year.

Rich are the childhood memories of this Navajo artist. When he was but nine or ten years old, Charlie Lee often took care of his grandfather's horses. It must have been a magnificent string of animals, or perhaps the memories of childhood have expanded. At any rate, Lee has often spoken lovingly and proudly in the same breath of the long line of palominos, pintos, buckskins, and a burro at the end, going to water. Of his favorite in the string, he said, "That big old stallion, he was quite a hero."

Navajo children are expected to help in many of the daily chores of family life. One of the duties most commonly turned over to youngsters is the herding of a flock of sheep, a task that takes them far from home and leaves them with time on their hands. To many, this is not a burden, as is reflected in the words of Charlie Lee: "One of the most beautiful sights is when the sheep are in the shade of a piñon tree at noon." Herding helped develop a healthy imagination, too, for he has said, "When you herd sheep, you get to know a certain rabbit, or chipmunk, or fat prairie dog; you get

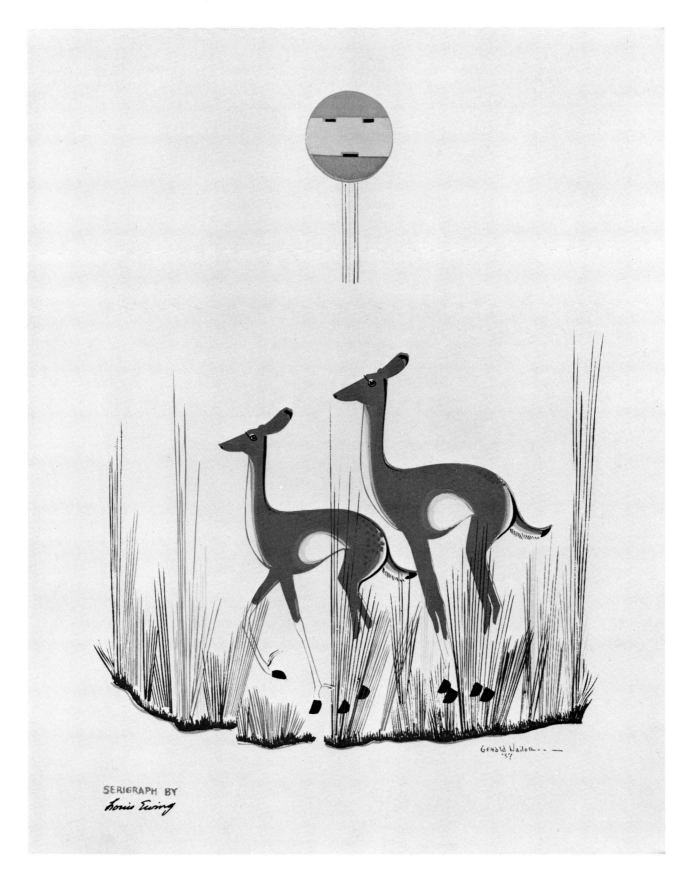

*Fig. 7.19    Gerald Nailor (Toh Yah), Navajo. Two Deer.*
*(From a serigraph by Louis Ewing.)*
*Courtesy, Mr. and Mrs. John Tanner.*
—Ray Manley Photography

so you feel that they are like people. These animals were my playthings."[10] Thus Charlie Lee grew up in the full richness of Navajo life, experiencing the breadth and depth of his beautiful lands. He combined the reality of his life with his imagination in the creation of such paintings as *Friendship* (Fig. 7.20).

In his senior year at the Santa Fe school, Lee took art under Gerónima Montoya. Upon his graduation in 1946, he returned to the Navajo Reservation. Because he "did not feel at home at all," he returned to the school in Santa Fe and took some special work under another Indian instructor, Teofilo Tafoya. Along with these art studies, he took special training in voice and piano, becoming the soloist for the fifty-member choir at the school. It was at this time that Lee heard the preaching that led him eventually into missionary work. He later attended the Central Bible Institute in Springfield, Missouri, then returned to his people to fulfill his desired mission in life.

While in Santa Fe in 1945, Lee met Harrison Begay. Although he has said that he tried to do some work in the Begay style but that "it was no go," he was, nevertheless, greatly influenced by the better-known artist. Horses are his favorite subject. In his earlier work, he did not use symbolic designs, for—he has said—he was not familiar with the ceremonies of the Navajo. The great ceremonies of his tribe are held in the winter, and only during the summer months did Lee have much time with his people in his younger days. Later, as a missionary to his people, he spent all seasons among the Navajos; his painting reflects this in broadened subject matter.

Lee has said that he looks upon the art of his fellow Indians as "cluttered up." Perhaps this explains his preference for a single figure. Often there is but one peacefully grazing animal, or a lone man perched on a small hill. Occasionally, however, there are more figures, such as a mare and colt, or a deer and her fawn. Rarely, and usually not until the 1960s, did Lee depict three or four animals in one picture.

Yel-Ha-Yah did much painting in 1947 and even more in 1948. By this time he had settled into his stride and reached a peak insofar as his own style was concerned. During 1947 he produced one of the most beautiful of all his paintings, a running deer. The figure is in soft mauve tones, with white markings. Delicacy is the keynote of Lee's work; herein delicacy of line and color reach an acme of perfection, in the fine outlines of the animal's body, the individual and fine lines for each hair, the equally delicate sprays of plants in soft greens, with just-red tips. A great deal of Chinese white is used in this painting, to point up all the tracery of line.

Charlie Lee's horses are wonderful, varied, and many-colored. There is his justly famous blue horse, apparently painted for the first

Fig. 7.20    Charlie Lee (Yel-Ha-Yah), Navajo. Friendship. Courtesy, Mrs. Katie Noe.
—Ray Manley Photography

time in 1947.[11] A palomino colt is accurately and delicately colored red, with its lighter tail blowing across its rump. A *Startled Horse* is light mustard yellow, with gray legs and black mane and tail. Another dark-red animal has three white feet and a rather startling white streak down its very straight face. Many of Lee's horses are dappled, and wherever the two colors join there are waves of shaded tones. Never is a horse by Lee lacking in life (Fig. 7.21); even when standing quietly by, the head will be raised or some small trait will indicate that the animal is definitely alive, despite the lack of much action. Thus this artist has portrayed the animal he loves so well. Even when Lee has attempted more action, as he did in a mid-1960s buffalo fight, there is a strong Begay-like feeling of constrained movement; here a wagon pulled by running horses moves quietly.

Often there is little or no modeling in the figures painted by Lee. The casein colors he uses are never brilliant or harsh; more often they are softened with smaller or larger quantities of Chinese white.

With few exceptions, particularly in the late 1960s, perspective is not attempted except for a simple ground line. Most often this ground line is a series of wavy and graduated bands of color, decorated with a few unreal and softly rounded rocks and equally unreal and conventional patches of growth; all of these traits he borrowed from Begay. Occasionally he used full European perspective.

In *The Gold Stallion,* a 1967 painting exhibited at the Gallup Indian Ceremonials, there is portrayed a single animal surrounded by conventional outline—clouds and ground growth; this example shows little or no progress beyond his earliest work. In contrast to this, a few paintings of the mid-1960s and several Christmas cards that Lee produced at the same time feature much in the way of foreground and background details including more realistic yucca, piñon trees, cliffs, and sky with semi-realistic clouds. Perhaps more progress in painting was exhibited by Lee's entries in the 1969 Scottsdale show than any before. All were watercolors; several portray the usual genre scenes. Of these, *Mother and Daughter,* depicting a woman leading a donkey with a little girl on its back, is one of his most pleasing treatments of such subject matter. Several portraits of Navajos in this same show reflect a different trend in Lee's painting—they show modeling in skin, texture in fabrics, and better and more realistic color rendition than is usual with this artist.

Although not an outstanding artist, Lee is a good example of an Indian who started painting in the Navajo traditional style and then developed an occasional flourish in the direction of more realism. His late-1960s painting demonstrated more ability and versatility than are to be noted in his earlier efforts.

Yel-Ha-Yah has exhibited extensively in the Southwest. He has won various prizes, including two firsts at the New Mexico State Fair in Albuquerque in 1947. Later recognition of his better work includes a Scottsdale second award in 1963 and a third prize at the 1969 Gallup show. At exhibits, he has been commended often for his traditional paintings, one critic noting, for example, "His color is toned with individual taste of special merit."[12] More stylization appeared

*Fig. 7.21    Charlie Lee (Yel-Ha-Yah), Navajo. Horses. Courtesy, Museum of Northern Arizona.*
—Horizons West

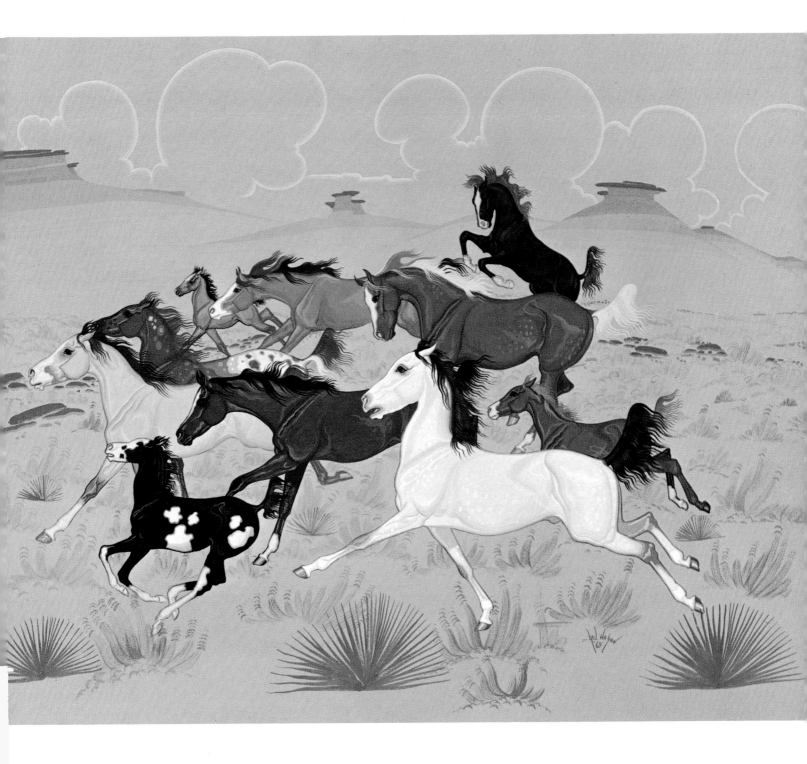

*Fig. 7.22    Charles Keetsie Shirley, Navajo. Navajo Man. Courtesy, Museum of Northern Arizona.*
—Mark Gaede

in some of his 1970 painting, yet occasional horses were more vital than ever.

Charles Keetsie Shirley,[13] an artist of great capabilities, has had to curtail his painting because of the pressures of making a living for his family. A skilled draftsman, he has also demonstrated his ability to handle several media with equal ability, whether it be pen and ink, tempera, or a pencil sketch. On occasion his paintings display a lack of imagination, but this is natural after his many years of commercial drafting. Nonetheless, given the opportunity to paint, he reflects the rich legendary background of his tribe.

Shirley was born on the Navajo Reservation, in the vicinity of Aspen Water Springs, in March, 1909. His mother died before he was a year old, and he was raised by her younger sisters. When he was seven years old he was sent to school, but it never appealed to him, and more than once he ran away. During his boyhood, Keetsie drew pictures and carved figures of animals, particularly horses. If there was anything he liked better than drawing horses it was to ride one, a delight seemingly shared by all Navajo lads. Before he finished the seventh grade, Shirley was sent to Haskell Institute

in Lawrence, Kansas. His long-established habit of running away, and his love for his own lands, caught up with him again, and he left this larger school without permission in 1924.

He spent the following year on the reservation, herding sheep and participating in all the activities of his people with his father. But he was not too occupied to think, and he began to miss the life that school offered him. So back to school he went of his own volition, entering the Albuquerque Indian School in the fall of 1925. He graduated in the spring of 1929 as an auto mechanic, but realized his limitation in this field. Encouraged by friends who recognized his artistic abilities, he drove a truck for a time, saved his money, then studied in the art department at the University of Denver. Keetsie profited by all of these experiences. Then, as a result of training that he received at Ft. Defiance, and practical experience on the reservation between 1939 and 1942, Shirley was employed as a draftsman at Williams Field, Arizona. Here he became head draftsman during the war, and continued in this profession; as a result, he stopped painting. In the meantime, Shirley married a Navajo girl. He decided that his children should be brought up in white man's society, to be better equipped than was their father to face the problems of a changing Navajo world. Certainly this was modesty on his part, for he made a splendid adaptation to a difficult situation. In 1970 Shirley was once again working in the Window Rock-Gallup area.

Shirley painted in both watercolor and oil. According to Lockett,[14] he never used the flat perspective so characteristic of modern Indian art. He also worked with pen and ink (Fig. 7.22), illustrating short stories in this medium. Among these were the illustrations for a fantastic witch and wolf-men story which appeared in the *Desert Magazine* in 1948, written by Van Valkenburgh.[15] Although one of the drawings is a realistic portrayal of several of the wolf-men sitting at the mouth of a cave with a sandpainting before them, and is thus full of mystery in subject matter, it lacks imagination. Too, it seems to carry in detail something of the experience of the draftsman, in stippling and fine line techniques.

One of the most appealing of Shirley's works was a mural which he did in Tucson in October, 1947.[16] Painted in pleasing and not too brilliant colors, it told the story of how the Navajo first acquired sheep. Riding their spirited horses without benefit of saddles, young fellows cut a few animals from the herds of the more peaceful pueblo folk. Shirley showed this with great verve, two riders waving saddle blankets to urge the sheep along, the second rider following the leader on a rearing horse. The scene was replete with foreground and with cliffs and hills in the background. Sheep ran rapidly ahead. All the animals were white save one in the center

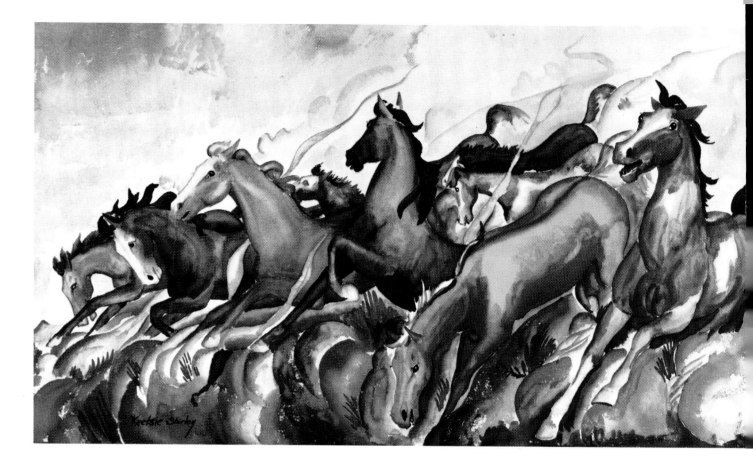

Fig. 7.23 *Charles Keetsie Shirley, Navajo. Stampede. Courtesy, The Denver Art Museum.*

foreground which was black. Action was splendid; modeling was simple but effective. Another fine action painting is *Stampede* (Fig. 7.23); little or no evidence of the draftsman appears in this portrayal.

Beatien Yazz is a Navajo artist who received great acclaim when he was but still a lad. He is known by several names, including Jimmie Toddy and Little No Shirt. Like so many of his tribe, the exact year of his birth is not known, though it is thought to be 1928 or shortly thereafter.[17] At an early age he made the acquaintance of two traders at Wide Ruins in northern Arizona. Quickly recognizing his artistic possibilities, these traders, the Lippencotts, made available to the boy scraps of paper and other equipment so that he might scribble in color whenever he wanted to. Many of these first efforts, of which Figure 7.24 is an example, found their way into private and museum collections. Hannum reports that Beatien showed an early interest in paper textures as well as colors, and that he rescued from the Lippencotts' wastebasket red Christmas cards or blue note paper.[18]

"Always he had used colors arbitrarily and, as he grew, he began making abstractions of reality—experimenting with the idea—touching it in little ways," says Hannum.[19] Then came several

non-Indian artists to visit at Wide Ruins. One of them tried to teach Beatien but succeeded only in bewildering him; the young Navajo boy "went completely to pieces."[20] The trader's wife hung Beatien's own pictures about the corner frequented by the Navajo lad, and in time he regained confidence. She took him to Santa Fe to see his people's art; after this experience he became "bold and sure" in his work.[21]

Then Alberta Hannum's *Spin a Silver Dollar* was published, a book that told a great deal about Beatien Yazz. As a result of growing interest, his paintings were very much in demand and his exhibits increased throughout the country. After the first years at the trading post, Beatien Yazz went to the Indian School at Santa Fe for a year.[22]

In his earlier paintings there is little in the way of adjustment of figure or figures to space: more often the single human or animal, or group of them, will appear centered, generally filling the piece of paper. The first signed and dated painting (April 1941)[23] is that

Fig. 7.24 Jimmy Toddy (Beatien Yazz), Navajo. A painting done when a child. Courtesy, Mr. and Mrs. John Tanner.
—Ray Manley Photography

343

of a rabbit which nearly fills the entire piece of paper. In another instance, two dance figures stand motionless and in Egyptian fashion on the greater part of the upper two-thirds of a sheet. In time, Yazz learned better spacing, as well as more pleasing combinations.

Yazz had difficulties with proportions in his early work. In one instance, a colt is short and so plump that its natural shape is disguised. Detail is usually lacking in the earlier pictures. Smudged paint could hardly be interpreted as modeling; there is not so much as a line to suggest the folds in a garment. Color is usually dull and poorly handled. There are no backgrounds, no foregrounds.

Despite these weaknesses, the early works of Beatien Yazz have something to recommend them. They are fresh and uninfluenced. Some action appears, such as in the running colt and horse. Plant growth is much more naturalistic than in later paintings. And there is a wide range of subject matter from the start—everyday scenes, ceremonial subjects, and a variety of the natural life of the reservation lands.

A 1947 or 1948 painting by Yazz, of a masked dancer,[24] shows the great improvement that came with the passing of the years. The figure is well delineated in fine outline, there is quite a bit of shading in color, and there is much fine detail in costume and mask.

Beatien served with the Navajo Signal Corps of the U.S. Marines in World War II. After returning to civilian life, he attended the Chicago Institute of Art and a college in California for further

*Fig. 7.25   Jimmy Toddy (Beatien Yazz), Navajo. Yei Dancer. Courtesy, Dr. and Mrs. Byron C. Butler.*
—Neil Koppes

*Fig. 7.26   Jimmy Toddy (Beatien Yazz), Navajo. The Forest. Courtesy, Woodard's Indian Arts Collection.*

art training. Also, he married and found himself embroiled in all the complications of Navajo social organization, some of which confused and distracted him. Lapses in both production and quality of his painting often reflect these frustrations of one truly caught between two cultures.

Despite his problems, Beatien branched out in his painting in both subject matter and treatment. He has adhered basically to casein and tempera, seldom using any other media. His coverage in subject matter has been broad, including many aspects of Navajo daily life, ceremonies, crafts, delightful portrayals of the wildlife of his native land—often with a humorous touch—amusements, and symbolic design. In a private collection of thirty-two of Yazz's paintings, five are concerned with simple everyday scenes involving one to several individuals; five are ceremonial or dance subjects; ten portray animals and birds, and the remainder involve horses alone (one) or Navajos and horses (eleven). Keen ability is reflected in the versatility of his work developed in variety of painting ranging from notepaper and charming illustrations for children's books to sophisticated easel painting; all of these qualities are portrayed in this collection.

Beatien has developed no single style in his painting although, in general, traditional treatment has been uppermost. He has leaned heavily in the direction of creating more in the way of scenes with suggested perspective, often attaining this end in the simplest possible manner—natural features in the background, and/or a sunset, or various figures placed in different positions or represented in different sizes. His compositions are good, his overall style is frequently vigorous. Sometimes the reserve in his dance figures is mindful of Begay, as are the same body proportions and positioning (Fig. 7.25), yet the face and small touches that are suggestive of more action deny this influence. Again, one sees Tahoma in some of the more violent action of Yazz's animals, or in the flat-bottomed conventional clouds; or a forest scene (Fig. 7.26) is mindful of a Chalee style. Too, there are lingering reminders of craft-art qualities. For example, occasionally there is a feeling of symmetry in Yazz's painting, as in several dance figures performing in front of a left-right balanced fire; there is repetition in rows of trees or almost-duplicated cornstalks blowing in the wind. There is humor, too, as noted in *Tribal Council* (Fig. 7.27)—four delightful owls in a tree hole, each wrapped in a blanket, and each looking very wise.

Originality characterizes much of Beatien Yazz's painting. Also, his colors frequently are strong and contrasting—they are seldom muted; and rich combinations of colors are typical. With little effort he attains a feeling of action, sometimes as dramatic but not quite as brutal as that of Tahoma. In one *Fire Dance* (Fig. 7.28)

Fig. 7.27  Jimmy Toddy
(Beatien Yazz), Navajo. Tribal
Council. Courtesy, James T.
Bialac.
—Neil Koppes

painted in the first half of the 1960s, the flames enter from the edge of the paper, the six figures running toward them; this is an old theme but a version revitalized by the details of this composition.

Beatien's versatility is well demonstrated in his portrayals of horses (Figs. 7.29 and 7.30). They stand limp in inaction; they walk quietly along, unobtrusively allowing their riders a slow chat; they trot as only an Indian horse can trot; they race madly in the hunt or on the warpath; they buck delightedly at the unseating of an unwanted rider.

Although Beatien has always favored the traditional manner of painting, nonetheless he has attempted other styles. Occasional abstracts again reflect his ability in handling form and color. In his

347

Fig. 7.28 Jimmy Toddy
(Beatien Yazz), Navajo. Fire
Dance. *Courtesy, the Avery
Collection.*
—Howard's Studio

Fig. 7.29 *Jimmy Toddy
(Beatien Yazz), Navajo.*
Rustling. *Courtesy, the Avery
Collection.*
—Howard's Studio

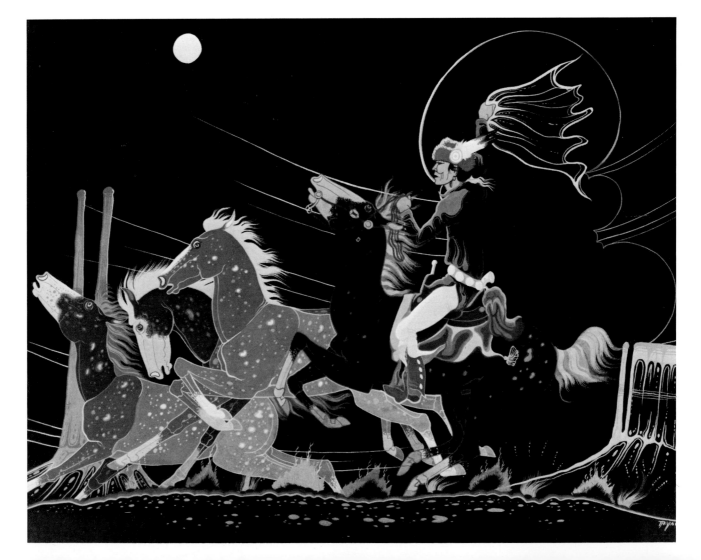

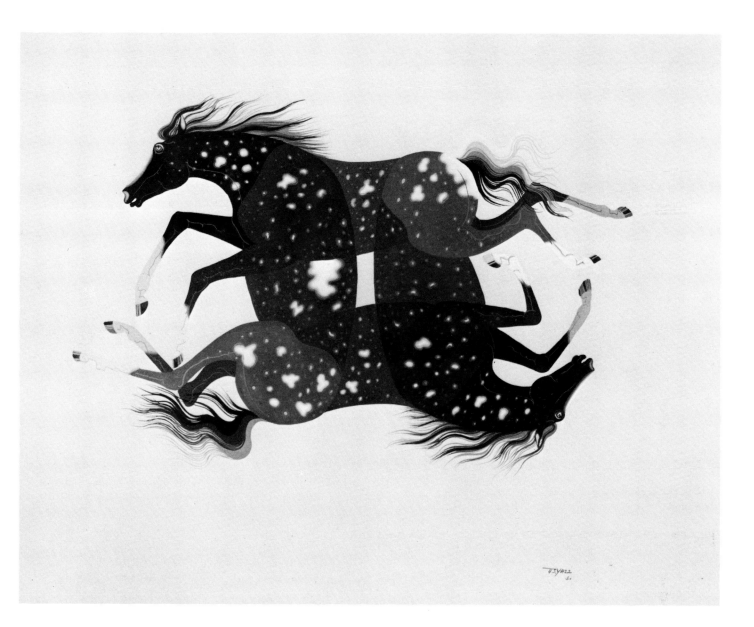

watercolor, *Navajo Fire Dance,* exhibited in the 1969 Scottsdale show, there is a cubistic background against which appear cubistic figures with some more realistic faces, hands, arms, and legs, all in blues and grays. It might be added that in his traditional work there is considerable variation in the matter of style: a horse and rider can be fully realistic, while a deer, on the other hand, may be stopped in its running by stiff-legged conventional drawing; a woman stands motionless in a semi-naturalistic portrayal, or she and her sheep sweep along, blown by the winds, taking the sheep home—all in a fully realistic expression.

Beatien Yazz has exhibited widely and is represented in many collections. His paintings are in the permanent collections of the Philbrook Art Center, Tulsa, Oklahoma, the Museum of New Mexico,

*Fig. 7.30    Jimmy Toddy (Beatien Yazz), Navajo. Rotating Horses. Courtesy, Woodard's Indian Arts Collection.*
—George Hight Studios

Santa Fe, as well as in many other public and private collections. He has won many prizes for his painting at the Gallup Inter-Tribal Indian Ceremonial, where he received first awards in both 1964 and 1965, second and third awards in 1967, and two seconds in 1971; he also was given a second prize at the Philbrook in 1964, and a third prize from the 1963 Scottsdale National. He has, of course, received many other prizes for his painting. In the 1970 Scottsdale show, Yazz entered some paintings that were interesting combinations of abstract backgrounds with semi-realistic and conventional themes. It might also be mentioned that for some time he has painted peyote dreams and other peyote subjects. In this Scottsdale show he received a first award and an honorable mention in the polymer class; the painting receiving the latter award, labeled *Still Life,* illustrates his more abstract painting.

A last comment about Beatien Yazz should be made relative to the fine display he had at the 1971 Scottsdale show. Further growth was noted in several of these paintings, not only in added subject matter but also in quality of painting, in colors, and in detail such as the faces which were more Indian than in his previous work. He still featured water-based paints as he has through the years.

Mention should be made here of Marvin Toddy, the son of Beatien Yazz. Although he was only fourteen years old in 1968, at the Gallup Ceremonials show in that same year he exhibited some astonishing work for one so young. Here, and in other paintings, are represented all the styles and general subjects done by his father during his many years of painting. There are snow scenes made the colder by painting them in blues, white, and grays. There are birds, a variety of them done with efficiency and realism and in good colors. There are equally well portrayed animals, such as two bears finishing off the contents of several tin cans. And, of course, there are men on horseback and ceremonial scenes—Fire Dancers and even a *Peyote Meeting.* Often Marvin attains a marvelous feeling of texture, in an animal's hair or fur, or in a rock.

To be sure, there are not the finesse, the good composition, the properly proportioned figures, and other attributes of his father's work in all his painting, but Marvin has demonstrated a remarkable talent. Some of his work could be mistaken for the painting of Beatien Yazz.

Marvin Toddy was recognized for his outstanding work in 1968 by several special prizes at the Gallup show. At the same show in 1969, he received both first and second awards for two of his entries, while two years later he won two firsts and two seconds. In 1970 he took an honorable mention at Philbrook. His brother Irving gave him a bit of competition in the 1970 Scottsdale National

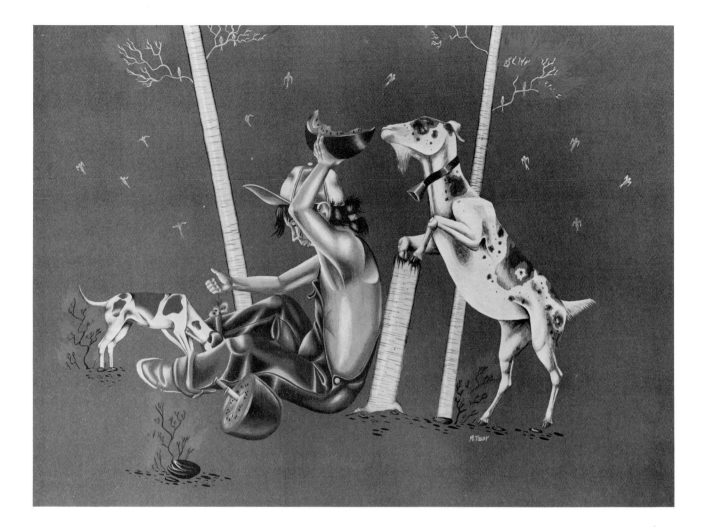

Fig. 7.31 *Marvin Toddy,
Navajo.* Watermelon Fun.
*Courtesy, Woodard's Indian
Arts Collection.*
—Bob McCormack

by winning several prizes. Marvin was again recognized in a special student award at the 1971 Scottsdale show for several of his paintings, including *Watermelon Fun* (Fig. 7.31).

Stanley Mitchell (Che Chilly Tsosie, Slim Curly Hair), a Navajo, has had a career full of varied experiences. When he was a child he herded sheep and in his spare moments carved pictures on the canyon walls of his tribal lands. He was born about 1918,[25] and attended the U.S. Indian School at Santa Fe. Mitchell has painted several murals and has exhibited fairly widely. His best work features native dances (Fig. 7.32) and the natural life of his land.

One of the earliest of Mitchell's paintings (Dietrich Collection) is done in rather bright pastel colors. The scene is that of a Navajo Squaw Dance. Lacking any ground line, the small figures are arranged in successive rows, one above the other. Much detail in costumes of men and women is achieved in another painting, a *Night Chant* scene; here he depicts small figures of men and women on horseback and in a buckboard, outlining all in dark and light tones.

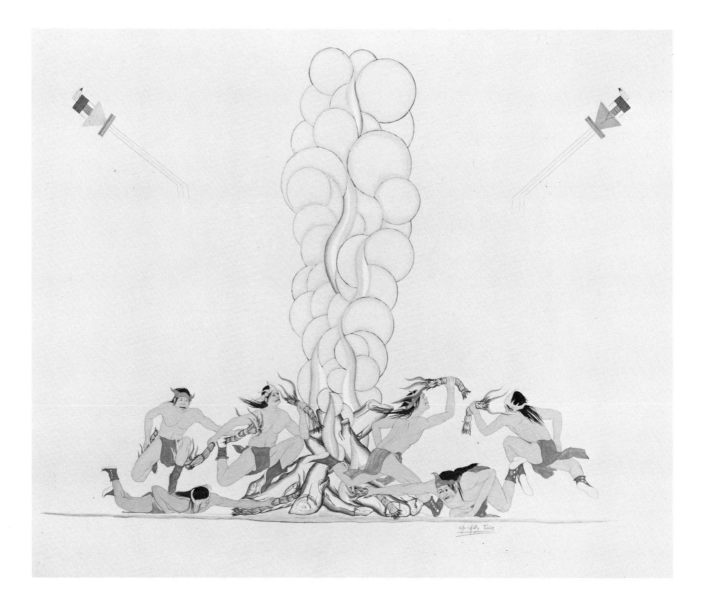

Fig. 7.32   Stanley Mitchell
(Che Chilly Tsosie), Navajo.
Navajo Fire Dance. Courtesy,
The Amerind Foundation, Inc.
—Ray Manley Photography

Mitchell demonstrated his tribe's ability to render careful and accurate detail in blankets, jewelry, horses, and humans. Brighter colors continued to be a feature of his painting.

Mitchell exhibited an ambitious painting at the Arizona State Fair in 1948. This was an oil of a Navajo woman with a child on a cradle board. Although the figure of the woman takes up the greater part of the picture, the artist slipped into the European style in adding a pale blue sky, sandy ground, and a slight hill in the background. In its presentation, the painting is realistic—but stiffly so—realistic in the touch of a smile on the woman's lips, in the child sucking his thumb. Modeling is attempted throughout, from the face and hair to the folds in the skirt. Detail is good, as in the turquoise and shell necklace, silver ornaments, the woven belt. In fact, Mitchell often has received praise for his very fine treatment of detail, particularly

bridles and other horse trappings—possibly because he was a silver-smith. Mitchell has done little or no painting since the 1950s.

Hoke Denetsosie (or Kiya Ahnii, Slim Navajo) was born on the western part of the reservation in 1919[26] or 1920[27]. In 1926, when he was about six years old, he was rounded up with other lads near Cameron, Arizona, and sent to school at Leupp, also in Arizona. He was there but two years, then was sent to Tuba City. Since he liked to draw and showed talent, he was given paper, pencil, and crayons. Still later he decided he wanted to study agriculture, so one day he hopped a bus, not knowing where it would go. It took him to Phoenix, where eventually he took a postgraduate course in art.[28]

Toward the end of his studies, Hoke had the good fortune to come in contact with Lloyd Henry New, who had just been appointed art director at the Phoenix Indian School. New became a guiding light to many of the young Indians at the school. He was particularly influential with several of the young fellows who have become outstanding artists, Tsihnahjinnie and Denetsosie among them.

Hoke discussed his problems at length with New, indicating that he wanted to do more than native dances and ceremonies.[29] Then came his opportunity—he was asked to illustrate the four books of the "Little Herder" series.[30] These small books, written by Ann Nolan Clark, were published by the Education Division, Office of Indian Affairs, to aid in the teaching of English to Navajo children. The text of each is written in both English and Navajo.

Because Hoke had done no work in black and white before he made the illustrations for the "Little Herder" series, he had to develop a new technique—which he did as he proceeded.[31] "The style is the artist's own, and is neither the flat stylized drawing of many Pueblo artists, nor the minutely shaded drawing of the white man. The artist was chosen because he possesses a sure skill and inquiring mind," Mrs. Clark wrote.[32] Hoke has said that he was handed the manuscript and told to see what he could do.

A carding scene[33] will serve to illustrate his work for these books. Under a juniper tree—and it could be no other—sits a Navajo woman on a goatskin. Her daughter is stretched out on a rug near her. A sack of wool rests against the tree. Moccasins, full skirts, velveteen blouses, necklaces, buttons, and earrings—all this detail is simply but effectively portrayed. A few sheep graze in the far distance, and two men ride in on horseback over the horizon. As a Navajo familiar with all aspects of the life of his tribe, and as an illustrator, he did a masterful job.

Denetsosie has been particularly fond of painting horses. Even in his early portrayals of them, where the animals are none too well

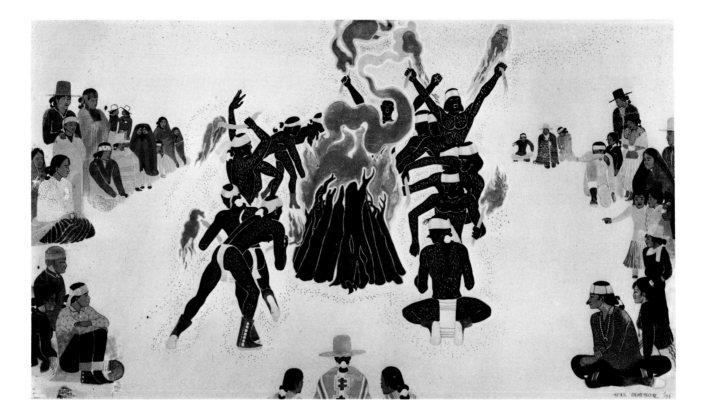

Fig. 7.33    Hoke Denetsosie
(Kiya Ahnii), Navajo. Fire Dancers.
Courtesy, James T. Bialac.
—Helga Teiwes, Arizona State Museum

proportioned, there is a lively quality about them. Spotted animals seem to be his favorites. A few stylized rocks and plants and a bit of stylized ground suffice for the animals' hoofs. Modeling is generally accomplished in a few well-placed lines. Horses and subject matter pertaining to the life of his people are characteristically done in watercolors (Fig. 7.33).

After Denetsosie left the Indian School in Phoenix, he went to the Indian Service at Window Rock where he was employed in the visual education division for four years. After this he worked at numerous jobs, as a logger in a lumber camp in Utah, and as a commercial artist—then he disappeared from the art scene for a long time. A few of his paintings again appeared in exhibits in the 1960s, displaying much of his old vigor, charm, and whimsy. He was represented in a 1967 exhibit at the Heard Museum, Phoenix.

Narciso Abeyta (Ha-So-De, or Ha-So-Da, which means Ascending) was born in Correo, New Mexico, in 1920.[34] He studied at the Indian School in Santa Fe and, after service in World War II, at the University of New Mexico. Exhibits of his paintings have appeared throughout the United States and in Paris; he won a second prize for his poster for the San Francisco Fair. Both a first and a second prize were awarded him at the New Mexico State Fair in Albuquerque in 1947. Even his early painting showed promise of

prize-winning attainment. Much of Abeyta's work does not resemble the usual Navajo style, even though his subject matter is Indian. In particular, his colors are more apt to be on the somber side, for he features blacks, browns, burnt ochre, and reds. For example, in the painting *Chicken Pull,* three men mounted on strongly proportioned horses are done in browns with some soft reds for relief. In *Antelope Hunt,* Abeyta exhibits another trait which characterizes his work, a high stylization of animal and human figures and natural growth. Here the antelope, in particular, have excessively long legs. In this relatively early work by Abeyta (1938), there is a certain sophistication and a pleasing rhythm in flowing lines, perhaps doubly pleasing when done in contrasting black and white. Many of his early and uncluttered compositions have dynamic rhythm, with a beautiful flow of line and color, as illustrated in *Corn Ceremony* (Fig. 7.34).

It is reported that Ha-So-De first drew in charcoal on canyon walls; also that "his first conception of color value was gained from the many-hued sands used in the dry paintings of the medicine men of the Navajos."[35] By the time he was fifteen, he had illustrated the Hoffman Birney book, *Ay-Chee, Son of the Desert,* a Navajo story for children.[36]

In his later work, Ha-So-De adhered to many of the individual principles he established early in his painting career. He was more interested in bold effects than in minute detail on any of his major figures, much less with any of the typical Indian finesse in such matters. Rather he has cluttered many of his later paintings with trees and leaves, or even with meaningless abstract elements. The cool and spontaneous pleasantness of simplicity in his earlier creations is lost in his paintings of the 1960–1970 decade. His earlier subjects were largely Navajo people, women on horseback, groups of women, and other quiet scenes. In the 1960s, he continued with some of this subject matter, as illustrated in his *Kneading Cake,* which won him the Chamber of Commerce Award at the Scottsdale show in 1962. More common, however, would be strong mythological or legendary subjects, such as *Sun Carrier Herds Horses Home* (Fig. 7.35). Ha-So-De has exhibited widely; in addition to the Scottsdale show, his work has been seen at the Gallup Ceremonials where he won a third award in 1964, at Philbrook where he took a second award, and the Fine Arts Gallery in San Diego. Ha-So-De did not paint very much in the late 1960s.

Mary Ellen is a name that should stand out in the annals of Navajo painting, since she is one of the very few women of this tribe who have ventured into watercolors. Despite a touch of the conventional in all of her paintings, she created delicate compositions. That she was influenced by the design styles of her tribe cannot be denied,

*Fig. 7.34    Narciso Abeyta (Ha-So-De), Navajo.* Corn Ceremony. *Courtesy, Alice G. Howland.*

for there is often the pleasing balance of the sandpainting and the delicacy of line of the same. Too, there is a bit of the whimsy of a dreaming child in her creations.

She gave the same attention to detail typical of the men of her tribe. In a painting of a Navajo woman, the pleated skirt, the concha belt set with turquoise, and earrings are carefully delineated. There is some exaggeration of the tribal coiffure—the "chongo," or figure eight. This hair style was the inspiration for one of the oldest of Navajo designs—it is found carved on rocks in the Gobernador region of New Mexico, the area occupied by this tribe in the early 1700s.

In Navajo art, there is both vertical and horizontal symmetry. Mary Ellen expressed this in a painting in which a combination of realistic figures (two women) and conventional themes (Rainbow Gods and plant growth) are featured together. A nicety of touch, emphasis on small and carefully executed elements, a great emphasis on conventional and stylized themes are the traits that best characterize the painting of this modest and little-known Navajo artist (Fig. 7.36). Often her work combined the conventional and realistic.

Mary Ellen attended the Santa Fe Indian School for at least one year, 1936–37. Her work has appeared in a few exhibits, among them the American Indian Exposition and Congress, held in Tulsa in 1937, and the "Contemporary American Indian Painting" show at the National Gallery of Art, Washington, D.C. She is represented in a few public and private collections. Apparently she did not paint after 1950.[37]

Another Navajo artist who attended the Santa Fe Indian School in 1936–37 was Wade Hadley (To'dachine). In a biographical

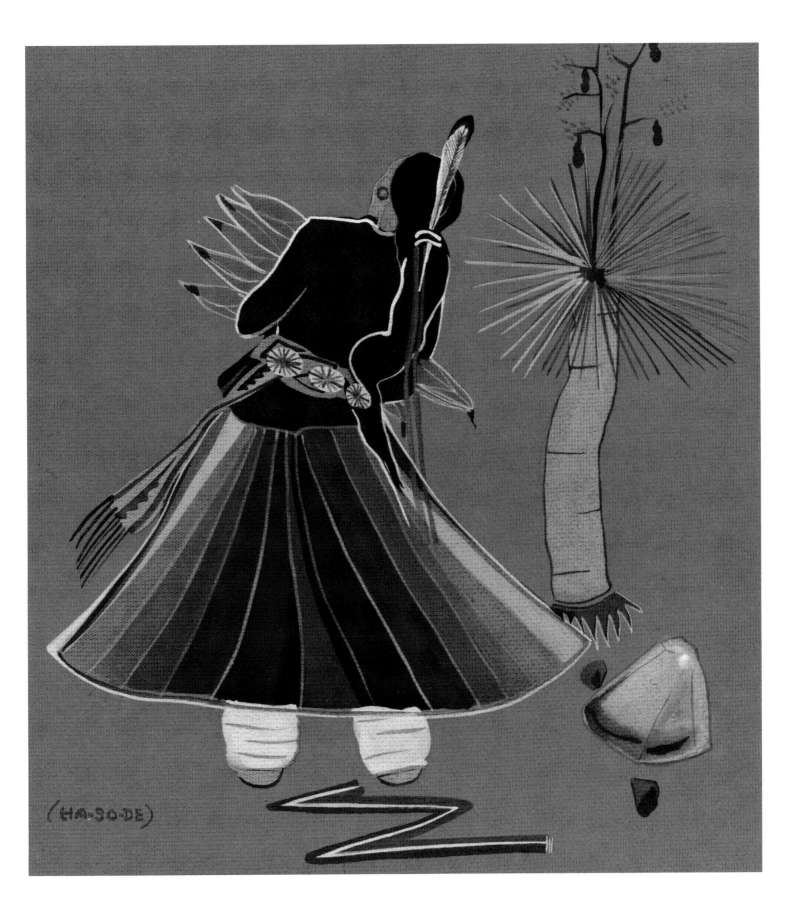

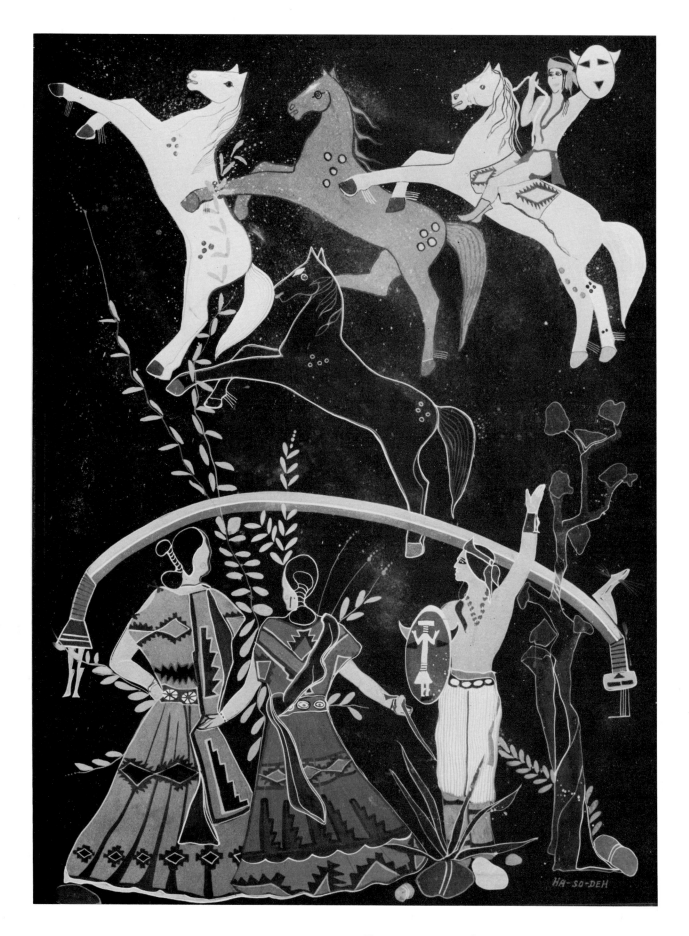

*Fig. 7.35    Narciso Abeyta (Ha-So-De), Navajo. Sun Carrier Herds Horses Home. Courtesy, James T. Bialac.*

—Neil Koppes

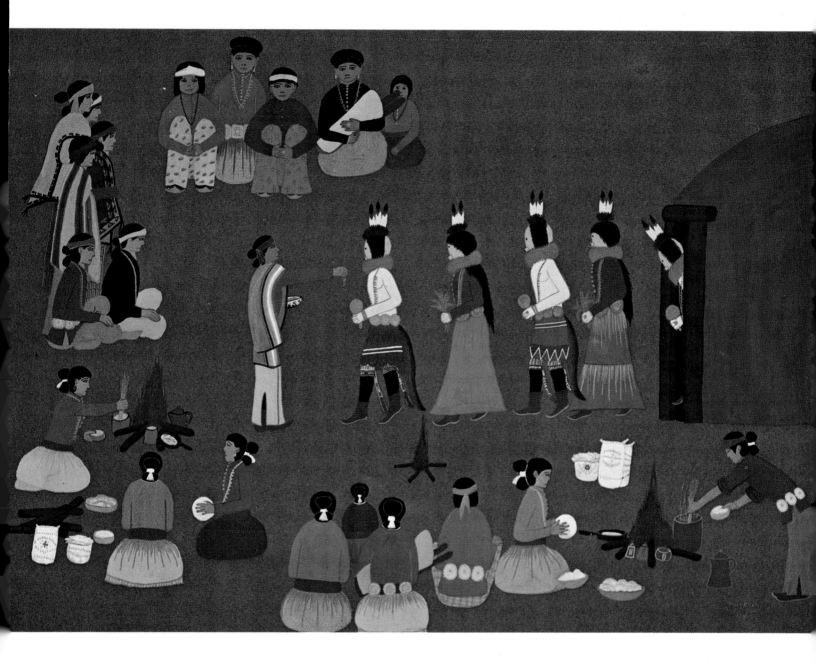

Fig. 7.36    Mary Ellen,
Navajo. Navajo night scene
with Yeibechai and
Medicine Man.
Courtesy, Mrs. Keith
Wofford.
—Laura Gilpin

sketch accompanying the serigraph reproduction of his painting *The Forest* (Fig. 7.37), Mrs. Margretta Dietrich wrote:

> Wade Hadley was drafted before Pearl Harbor, and was in the Pacific theater for the entire period of World War II. From time to time he sent home humorous pen-and-ink sketches of his army life. One, entitled *Why Don't You Paint?*, represented a worried G.I., paint brush in hand, before his easel, bombs bursting about him, a large shell hole through his painting. In another, called *Yanks in the Tropics*, the G.I., in underwear and helmet, covered with very decorative camouflage designs, is sitting on a tin of K-rations in the thin shade of a bending palm up which a large serpent is climbing, its head toward the unconscious soldier who is being attacked on the other side by an exquisitely-drawn mosquito. The sky is patterned with bombs and over all is a large and smiling symbolic sun.

Seemingly, Hadley returned to the Navajo Reservation, worked for a trader, and was not again heard from in the art world. His delicacy of touch, his sense of humor could have contributed much to the development of his own style.

His early work is poor in composition and figure proportions. In some of his later paintings there is much decorative detail, a suggestion of the imaginative, a sense of rhythm and balance, and potentials in composition and execution. His colors are limited, as he featured browns, grays, and greens, with occasional touches of brighter tones.

Sybil Yazzie, a Navajo, attended the Indian School in Santa Fe for several years. In the annual exhibit of the school for her last year, her paintings received favorable criticism for the development of a miniature style of great beauty. She favored horses as subject matter; the same critic of this show compared them in their sturdiness to Chinese pottery horses of the Chou dynasty.[38]

In one painting, *Navajo Na-Da-A* (Squaw Dance), she pictures a circle of pairs of dancers with chanters in the center, and a greater circle of horsemen and horsewomen, and a cluster of women looking on. The animals are varicolored, which lends rhythm to the picture; they are short from head to hind quarters, heavy bodied, and proportionately short legged—again the Chou dynasty-type horse. Even though perspective and drawing are not too good, the whole composition is pleasing. Browns are used with a heavy hand, but balanced with many pleasing and subdued colors, and set off with an occasional brighter touch. A sense of design and an expression of color values are revealed in this picture.

Although Sybil Yazzie did not always get as much detail in her watercolors as others do, she gave the impression of doing so

*Fig. 7.37    Wade Hadley (To'dachine), Navajo.* The Forest.
*(From a serigraph by Louis Ewing.)*
*Courtesy, Mr. and Mrs. John Tanner.*
—Ray Manley Photography

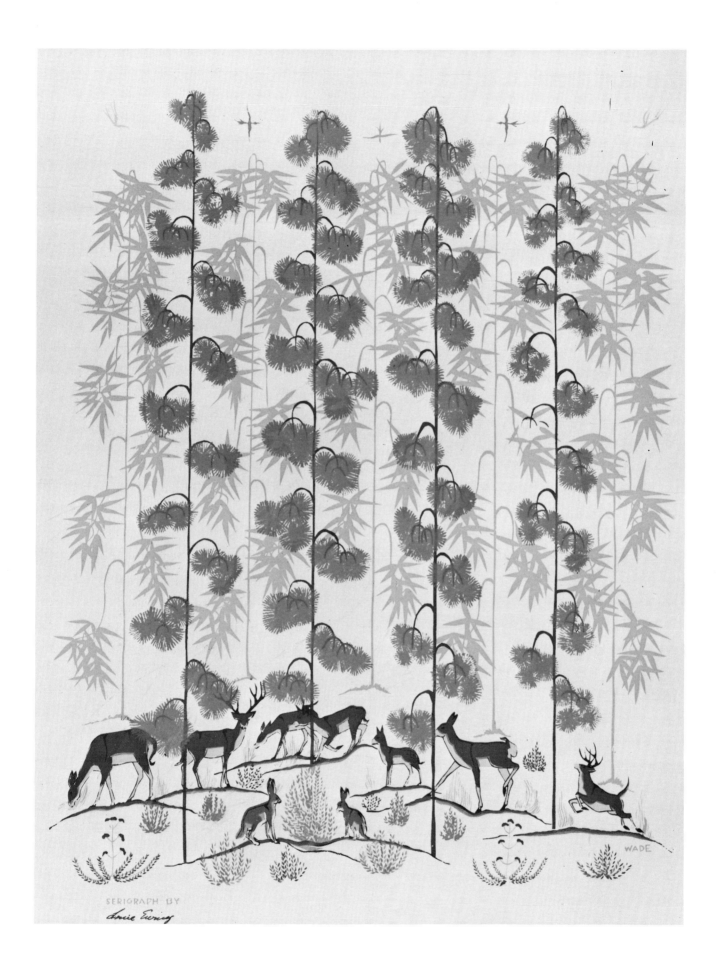

SERIGRAPH BY
Louie Ewing

in her quick lines of color. More often than most Indian artists, she has painted women. In particular, she has done charming and sensitive portrayals of Navajo women carding and spinning wool or riding horseback. Seemingly, she painted little after she left the Santa Fe Indian School.

Imagination among the Navajo is not confined to experiences with the real and the imagined worlds of his land. That same imagination expresses itself in relation to the new experiences brought about through contacts with a foreign people, the white man. Shortly before the end of World War II, Myron Denetdale painted a picture that he titled *Prayer for Peace* (Fig. 7.38). To be sure, the sentiment is directed into a new channel, but the impression is couched in strictly Navajo terms. A dark-skinned woman, dressed in full Navajo style, holds a basket in her left hand. From the basket she has taken a pinch of cornmeal which, as she sprinkles it from her right hand held high in the air, falls in graceful and rhythmic cascades. Color, symbolism, and rhythmic flow of line hold a prayer for white men; they hold a promise in the painting of a little-known Navajo youth of another flowering of their art in a new medium, watercolor.

There are quite a few Navajos who have matured as artists or who have started painting and attained some prominence since the late 1950s, and others who blossomed in the 1960s. Some of these have followed traditional Navajo styles, as is exemplified in part by Robert Chee's work; some have broken completely with tradition and paint in modern European ways, as seen in most of R. C. Gorman's painting. Then, too, there are the "in-between" painters who have been somewhat influenced by the old methods while at the same time they add touches of new ideas.

Further, at the beginning of the 1970s there was an encouraging crop of students who promised the continuation of Navajo art, at least for some years to come. The youngest and one of the most promising of these, Marvin Toddy—the son of Beatien Yazz—was mentioned above. By the time he was fourteen, he had experimented with most of the styles developed by his father. Then there is another group made up of other students, or beginners, or "sometime painters" whose names will also appear in this section on the Navajos; their art efforts are varied.

Frank Austin (Bahah Zhonie) was born in 1938 in Tsegi Canyon, northeastern Arizona. He attended Phoenix Indian school and the Southwest Indian workshop at the University of Arizona, Tucson. For some years he was a textile designer with Lloyd New (who was then known as Lloyd Kiva) in Scottsdale, Arizona. In 1962 Austin was honored by the American Institute of Interior Designers for his

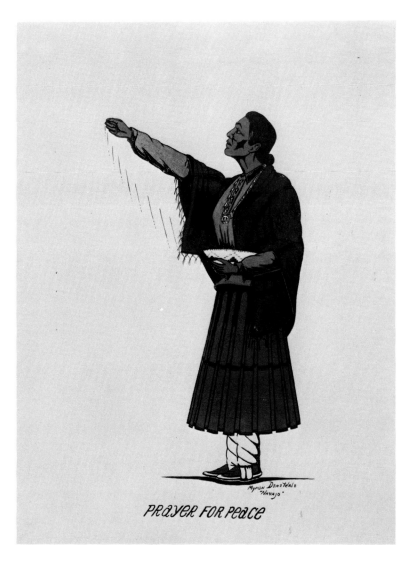

PRAYER FOR PEACE

*Fig. 7.38    Myron Denetdale,
Navajo.* Prayer for Peace.
*Courtesy, Inter-Tribal Indian
Ceremonial Association, Gallup, N. M.*
—George Hight Studios

"creative fabric design called 'Cactus Flowers.'" He has also received other awards for his textiles.

Austin has exhibited widely and has won many prizes. Among other places, he has shown at the Heard Museum, Phoenix, in 1967; at the Scottsdale National where he won the grand prize in 1962; and at the Arizona State Fair where he won a first in watercolors in 1960 and the same for a portrait in 1962. Watercolor has been Austin's chief medium. His style of painting has varied from realistic, active figures of warriors to abstracts of kachina figures or kachina masks. It was the latter subject, a medley of masks in a medley of colors in a long slender panel, that won Austin the grand prize at the Scottsdale National. Most pleasing colors and design are featured by this artist. He has also done some fine wildlife portrayals, such

363

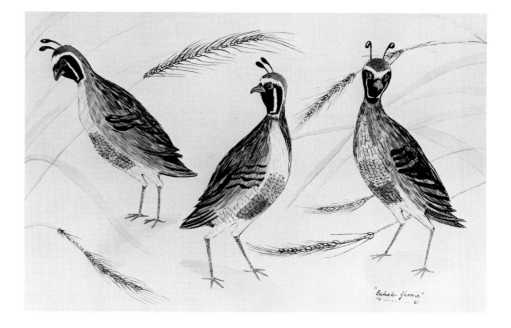

Fig. 7.39   Frank Austin
(Bahah Zhonie), Navajo. Three
Quail. Courtesy, Dr. and Mrs.
Byron C. Butler.
—Neil Koppes

as his *Three Quail* (Fig. 7.39), in soft colors and in a naturalistic style. Late in 1971 it was reported that he had opened his own shop in southwestern Colorado.

Carl N. Gorman (Kinya-onny-beyeh) a Navajo, was born in Chinle, Arizona, in 1907.[39] After his schooling on the Navajo Reservation, he served in World War II, then he attended the Otis Art Institute on the G. I. Bill. He also studied under Norman Rockwell, Joseph Magnaini, and Nicolai Fechin. For a time Gorman was technical illustrator and draftsman for Douglas Aircraft; he also served for several years as head of the Navajo Arts and Crafts Guild.

Gorman has followed neither a single medium nor a single style. He has said that he enjoys all media and that in each case he has used the particular one which best suited his desired expression, choosing largely from watercolors, oils, casein, or encaustic paints. In addition to painting, Gorman has done mosaic designs and textiles, silver, silk screening, and block printing. In the 1963 Scottsdale National show he received a first award for a painting with a new vista. In one painting, *The Gamblers,* a wash on paper, Gorman shows a typical Navajo scene, recognizably tribal, of a group sitting around a blanket. Lines are simple, composition pleasing, color is flat, there is little detail; these traits are also expressed in *The Third World* (Fig. 7.40). His paintings in modern style are not up to the attainment of his son, the well-known R. C. Gorman. A second son, Alfred Kee, also showed great promise, winning a first place in the six-to-ten-year-old group and a special award in the 1964 Gallup show. Tragically, he died in 1966.

Robert Chee, who was born at St. Michaels, Arizona, in 1937, received part of his education at Intermountain Indian School, Brigham City, Utah, where he studied commercial art under Allan Houser for two years. He was in the United States Army from 1957 to 1960, during which time he continued to paint.

Chee came into prominence in the late 1950s and remained so through the 1960s, as is indicated in his many awards at exhibits. A few of these include first prize at the Navajo Fair in 1959 and at the Gallup Ceremonials in 1966, third prize in the Navajo-Pueblo class at the Philbrook in 1960, a third in the Navajo class at the Scottsdale National in 1962, and a special award at Gallup in 1969. Chee painted in traditional flat colors in water-based paints, and often in casein.[40] Frequently he used dark or black paper against which he portrayed active figures in endless storytelling scenes and in a variety of colors. He often favored a combination of blue and white on dark paper, thus effecting a feeling of cold and snow or moonlight in the depth of night. Often subdued tones of varied colors are equally well handled with a spot or two of very bright colors here and there to give the picture more life. To be sure, he handled a wide range of colors equally effectively on white or light-colored papers, here again stressing intensity of tone in small areas in a Begay-like manner. One painting, *Coming Home*, is startlingly Begay-like in the soft colors and forms of the shepherdess and her sheep and all the growth. This painting deviates from the work of

Fig. 7.40    Carl N. Gorman (Kinya-onny-beyeh), Navajo. The Third World. *Courtesy, Dr. and Mrs. Byron C. Butler.*
—Neil Koppes

the older artist only in the lack of refinement and very un-Begay-like buttes in the background.

In much of Chee's earlier work there are no ground lines; later he added bands of color to suggest ground and hills and sprigs of growth, these combining sometimes to give a limp type of perspective. He also has used conventional clouds.

Many of Chee's paintings include symbols which, reputedly, reflect his familiarity with the sandpaintings of his tribe. This is not improbable for his grandfather is said to have been a medicine man.

There is spontaneity in Chee's painting, expressed in a variety of ways, from his ever-Navajo facial expression to body movement. Not infrequently, however, his compositions are poor; for instance, there may be nothing but a burning fire or wide empty space between clusters of figures to right and left. On the other hand, there was some improvement in this matter during the 1960s, with a tendency to make his groups somewhat more cohesive. Frequently his abstract elements are superior to his human and animal figures.

The storytelling subjects of Chee's paintings relate a variety of tribal experiences. Favorites include, among others, the Indian moccasin game (Fig. 7.41), a Squaw Dance, Navajos playing cards, an old tribal storyteller, the Fire Dance, yei gift-givers, or yei chasing youngsters. And, of course, there are shepherdesses and sheep, Navajo riders, single or multiple figures, an old man gathering wood, and animals in more conventional poses and drawing. Now and then

*Fig. 7.41    Robert Chee,
Navajo.* Moccasin Game.
*Courtesy, James T. Bialac.*
—Helga Teiwes, Arizona State Museum

Fig. 7.42    Robert Chee,
Navajo. The People Watching
the Medicine Man. *Courtesy,
the Avery Collection.*
—Howard's Studio

Chee shows a man asleep on the ground in the great mesa country;
his dream is represented in filmy outlined figures in the upper part
of the picture. Or, in one painting on deep blue paper, *The People
Watching the Medicine Man* (Fig. 7.42), there are three large yei
figures dimly outlined in white above a row of very-much-alive
masked figures and the medicine man.

Early in 1969, Chee began to make some changes in his paint-
ings. Black paper was sometimes replaced by grays or even white;
colors became much softer; and better composition gave a com-
pletely different feeling to his watercolors. There is still much action,
symbolic design, and whimsy in the unmistakably Navajo faces.
Chee's human figures are usually presented in a lazy, limber, slender
version of the Navajo Indian.

Design is uppermost in a Chee painting titled *Fire Dancers.*
Done on black paper, there are only three figures, all white and all
running and whirling their burning brands so as to create circles of

367

fire, the largest in the center. The two smaller circles at the sides are not the same; thus this is not an absolutely balanced composition. It is, nonetheless, somewhat different from the usual Chee creation.

Withal, Chee showed considerable potential which was never fully realized. He died late in 1971.

Robert Draper, a Navajo born at Chinle in 1938 of a Navajo mother and a Hopi-Laguna father,[41] received his elementary and secondary education on the reservation. Married, he has made his home on the reservation. Since 1963 he has had occasional instruction from teachers at the boarding school at Chinle; he also studied under George Fox in Salt Lake City, Utah.

Draper has concentrated on painting in European or semi-European perspective. His favorite in this style has been the beautiful and colorful mesa-and-canyon land in which he has spent his life (Fig. 7.43). Executed in oils or water media, colors are equally brilliant for the rock formations. Contrast is frequently stressed in canyon floor or flat lands covered with dead white snow or with green trees or other growth, or in shadowed cliffs pitted against those in full sunlight. Draper did a large canvas mural as background for programs and plays at the Chinle Boarding School. There is more variety in these paintings than one would expect in the treatment of these cliffs as subject matter; hogans, prehistoric ruins (Fig. 7.44), tracks in the snow, horseback riders, and other secondary subjects keep the red cliffs from becoming redundant in their repetition.

In 1968 Draper executed two interesting paintings—both large oils—one an interior of a hogan and a second, *Navajo Warriors of the Night*. The latter won first prize in the Arizona State Fair competition in that same year. Both are done in European perspective. The first is executed in a simpler realistic style, in soft colors; it shows the complete hogan interior, details of costume and food and food containers as the five figures sit on the dirt floor of the room to eat a meal in the customary Navajo manner. The second painting is an excellent study largely in blues and grays. Although painted in full perspective, it reflects the Navajo love for horses, and their innate ability to paint them with great vigor and life. One feels that these are warriors on steeds that are equally aware of and active in some vital and significant incident.

Draper has exhibited extensively. However, he has shown primarily in the Southwest, in such exhibits as the Gallup Ceremonials, the Navajo Tribal Fair at Window Rock, at Philbrook where

*Fig. 7.43   Robert Draper, Navajo. Sand Dunes at Canyon de Chelly. Courtesy, James T. Bialac.*
—Neil Koppes

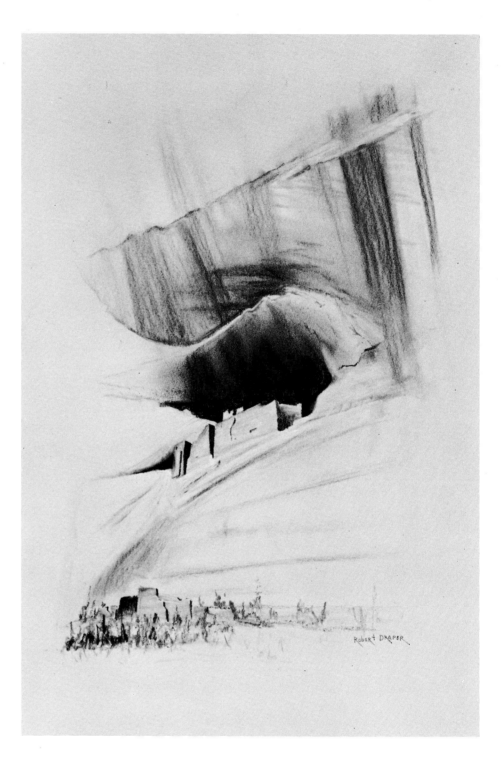

Fig. 7.44   Robert Draper,
Navajo. White House Ruins.
Courtesy, Mr. and Mrs.
H. S. Galbraith.
—Neil Koppes

he took a first place in 1966, and at the Scottsdale National. In 1969 he entered at Scottsdale in the classes of watercolors, oils, polymers, and drawings, winning in the second medium. Like his expanding subject matter, these indicate some experimentation with varied media beyond watercolor that he used almost exclusively in his earlier work. By 1969, Draper was showing signs of joining the ranks of so many of the artists of his tribe in depicting a wide variety of subject matter. Among other subjects were prehistoric pictographs (a 1970 version is in an extreme modern style), conquistadors, historical depictions—particularly the "Long Walk" during the centennial year commemorating the return of the Navajos from captivity in New Mexico to their homeland—and endless scenes of Navajoland. By 1970 some of his work was abstract. However, little if any of this work has yet equaled his excellent realistic or semi-realistic portrayals of his native land. In the 1971 Scottsdale show he had a remarkably realistic corner of a Hopi village for which he received a first award in the polymer class. Further honors came to Draper at the 1971 Gallup Ceremonial Show, where he took all four prizes in the landscapes—all tribes category.

R. C. Gorman[42] is one of the most dynamic of the young artists who became well known in the 1960s and who moved steadily toward non-Indian art techniques. His education in art influenced these trends—for example, his studies in Mexico City (on a tribal scholarship). Admittedly, he was influenced by Orozco, Siqueiros, and, in lithography, by José Sánchez. He studied art first under his father, Carl Gorman, and later at Northern Arizona University, Flagstaff, and at San Francisco State College.

Born at Chinle, Arizona, in 1933, R. C. Gorman lived on the reservation the early years of his life, completing his secondary education at Ganado Mission High School. After this, he left the reservation to pursue further art studies in the United States, Mexico, and on Guam. Eventually he settled down in a penthouse in San Francisco, hoping never to have to return "to a real hogan with dirt floor and sheepskin."

In use of materials and in subject matter, Gorman has been extremely versatile. Among the various media and methods he has employed are oils, polymers, pastels, pen and ink, lithographs, sand, woodcut, and linoleum blocks. One of his graphics, *Three Taos Men* (Fig. 7.45), reflects his abilities along these lines.

His entries in the 1969 Scottsdale National demonstrated further experimentation with various media. One fine panel, of mixed media, combined the use of copolymer and gold leaf; pale champagne tones dominated and unified the long, slender panels of abstract patterning. Although Gorman has followed modern trends

371

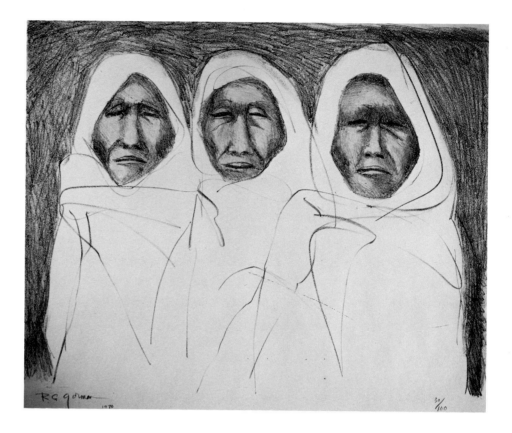

*Fig. 7.45    R. C. Gorman,*
*Navajo.* Three Taos Men.
*Courtesy, Mrs. H. M.*
*Rubenstein.*
—Neil Koppes

in the use of these media, his subject matter is largely from his Navajo background and includes a variety, from rug designs and sandpaintings to portrayals of his tribesmen. At a 1967 exhibit his style was labeled neo-primitive, in response to which he said, "I like that." Two of his polymers took first and third awards in the 1969 Scottsdale show, one a semi-abstract of a Navajo rug, the other an extreme abstract; at the same show he also won a second-place award for a drawing.

Of particular interest, in connection with Gorman's style, is the possibility of some influence from the late and famous German artist, Kaethe Kollwitz, whose drawings are well known in America. Her work in pencil, charcoal, pen, and with the brush, in sepia or wash, shows many qualities that are paramount in certain of Gorman's work:

Form, power, and beauty—and the touch of the unfinished—give the illusion that the drawing is finished . . . omissions, shortcuts, and simplifications . . . to keep everything to a more and more abbreviated form . . . all the essentials . . . strongly stressed . . . inessentials almost omitted.[43]

These quotes might apply in some measure to Gorman as well as Kollwitz.

Many of Gorman's works display the above qualities. A grease-pencil labeled *Man* portrays in sparse lines considerable emotion in clenched hands, in stretched neck, closed eyes, slightly parted

lips. Even more limited in line work is the portrayal of an *Old Woman,* yet one feels her age in twisted fingers, in her squinting eyes and parted lips. *Grief* is made real in a charcoal sketch, in stiff arms and taut body, open mouth, closed eyes, head back.

In 1968 the Navajo tribe celebrated its one hundredth anniversary of reservation life. Emphasized in the observances was the "Long Walk," a tragic incident in tribal history during which many Navajos died in the trek from Arizona to eastern New Mexico. Gorman emphasized tragedy in bodies and faces, drama and suffering, when he featured this incident in some of his 1968 paintings. Dull colors, particularly grays and blacks, add to the feeling of tragedy. In his Long Walk subjects he had full opportunity to portray starvation in big deep eyes, the aged, bent figures, the anguished postures of fatigued bodies, the gaunt faces and boney hands, suffering bare feet. Quite a contrast is the wash of a *Navajo Mother and Child*—bare feet and legs thrust forward in complete relaxation as the woman sits on the ground to nurse her babe. Although there is great simplicity of line and detail, there is no doubt about the full-skirted dress, the bundle-wrapped baby, the full breast, the woman's Indian face.

A most charming crayon on paper is titled *The Parasol and the Cloud,* "a speck of pink cloud in a tiny bit of blue sky in the

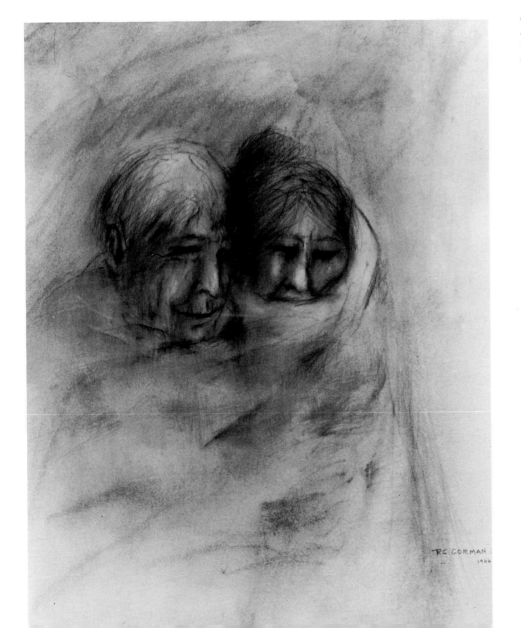

Fig. 7.46   R. C. Gorman, Navajo. Happy Old Navajo Couple. *Courtesy, the Avery Collection.*
—Howard's Studio

373

far upper right and two tiny figures of Navajo women, one with a parasol, in the far lower left corner. All the rest is blank paper!"[44] Yet this unusual composition is most pleasing. Gorman can be as disarming and peaceful as he can be dramatic and hopeless. His *Happy Old Navajo Couple* (Fig. 7.46) shows two such individuals in the full contentment of white hair and wrinkles, confident in their happiness as they reflect two lives welded through the years together. Sorrow as well as joy are mirrored in the strength in their faces.

*Fading Rainbow People* (Fig. 7.47) is an appropriate title for an abstract painting by Gorman, with a blotched background of rainbow colors against which are painted two elongated, weak, tilting rainbow-like figures. This painting lacks the strength of most of his work, but it is pleasing in color.

In a 1967 exhibit at the Heard Museum, Phoenix, Gorman titled most of his works *Fragments*. Basically they were Navajo rug designs executed in ink, wash, and acrylics, and in the modern manner of bleeding, washing away, repainting, and fading in color and texture. Obviously these were representative of some of Gorman's most modern painting. Despite his emphasis on brevity of line, Gorman can be most detailed, as his *Happy Old Navajo Couple* reveals in realism down to the last wrinkle! In the 1970 Scottsdale show Gorman took a second place in oils for his bright-colored *Night of the Yeis*.

Gorman has painted, then, in a flat style, in full perspective, or in the abstract that may or may not combine both. His colors range from black and white to dull grays to subtle or brilliant and vibrant tones. He may be frugal or generous in detail and line, whether working in pastel, oils, pen and ink, charcoal, or other media. He may reveal the fullness of the Navajo woman's figure, the grace of the bent body, emotion in clenched and oversized hands, or give a modern feeling to old tribal design through clever manipulation of media. Often his strokes are bold and masterful, whether done in brush, palette knife, or pen.

A most active exhibitor, Gorman has displayed his work throughout the western states, particularly in San Francisco and other California cities. Many of these exhibits have been one-man shows; suffice it to say that he has won more than his share of awards, for he has received many first-place and other prizes from all of the large competitive shows. He is also represented in large numbers of private and public collections.

Certainly, R. C. Gorman is representative of the Indian artists who are bridging the gap between the tradition- and design-laden Indian style of painting on the one hand, and the European styles of fine-art painting on the other.

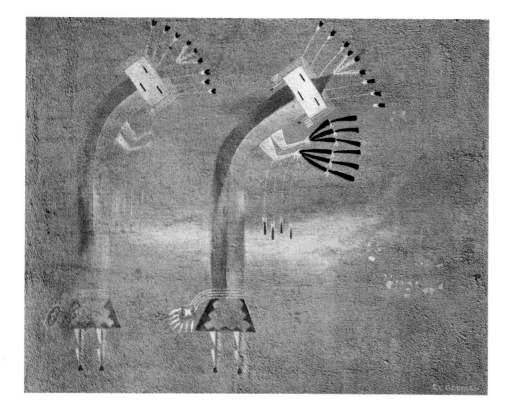

*Fig. 7.47   R. C. Gorman, Navajo.* Fading Rainbow People. *Courtesy, The Avery Collection.*
—Howard's Studio

In 1970–71 R. C. Gorman had his own studio in Taos, New Mexico, and continued to exhibit widely.

Gray Cohoe[45] has been basically a print maker, working in a variety of materials, including zinc, copper, and aluminum—for his etchings—as well as wood and linoleum for printing, and plexiglass. Although most of his work is naturally in black and white, now and again a bit of controlled color is used. Water-based paints were his early medium, following his childhood attempts at sketching. He has also worked in oils and acrylics.

Cohoe was born at Tocito, New Mexico, in 1944. The first formal training he received was two years at the Institute of American Indian Arts at Santa Fe. He also had a summer's training at Haystack Mountain School of Crafts, Deer Island, Maine. During the late 1960s he attended the University of Arizona, taking studio art; he graduated in the spring of 1971. He had a one-man show at the Arizona State Museum, Tucson, in 1967 and again in 1971, and one in Farmington, New Mexico, in 1969. He was also invited to show his prints at the Smithsonian Institution, Washington, D.C., in 1967. In other exhibits he has been recognized with numerous prizes and awards; for example, he received a special award for printmaking at the Scottsdale National in 1967. *Yei* (Fig. 7.48) is representative of this type of work.

Cohoe has done abstracts which bring into focus Indian subject matter including sheer design or bird-snake or buffalo motifs,

375

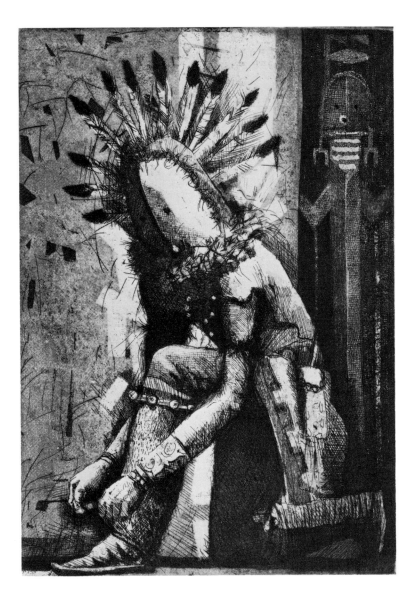

*Fig. 7.48    Gray Cohoe,
Navajo. Yei. Courtesy, Mr.
and Mrs. John Tanner.*
—Ray Manley Photography

or occasionally other themes, such as flowers. He has also featured more realistic subjects. The latter are of particular interest for they reflect some of the feeling and strength discussed in connection with the painting done by R. C. Gorman. One human head, for example, shows a profile with a wrap enclosing the head and clutched by a hand which is large and massive as it dominates the center front of the picture. Like some of Gorman's work, this lithograph reflects sadness in the face, strength and power in the hand. Like Gorman, too, Cohoe's work has been transitional between the tradition-bound Indian painting and a new style that is on the fringe of the fine arts. And again like Gorman, his subject matter is Indian-dominated, despite media and styles far removed from the traditional. In one abstract painting, with pleasing shades derived from yellow, green, and brown, the only recognizable objects are arrow points. In 1971

Cohoe was moving forward rapidly in his abstract prints and bidding fair to become one of the outstanding Indian artists of the Southwest.

It is interesting to note that Cohoe has been recognized for his outstanding expressions in creative writing in both prose and poetry, as well as in painting.

Bobby Hicks, who was born in 1934, spent his early days on his native Navajo Reservation. Then, during the 1950s and 1960s he divided his time between independent painting and formal training at Northern Arizona University, Flagstaff, and the special summer school for Indian artists at the University of Arizona, Tucson. Hicks has used various media, featuring watercolor and oils, and a variety of subjects and styles. He received honorable mention at the Philbrook in 1958; in 1969 he entered several graphics in the Scottsdale National. Hicks may employ a full European background in his paintings; his style may be fully realistic, or more schematized or impressionistic. He has used both flat color and modeling in color. A few or many colors may be used in a single picture. Some of his paintings are neutral in color, while others may be dark and somber. Hicks has featured Navajo subjects; also, he may paint anything from a portrait to a canvas full of too many figures. Sometimes facial or mask features are clearly delineated, again they may be omitted entirely, or represented vaguely in impressionistic fashion (Fig. 7.49).

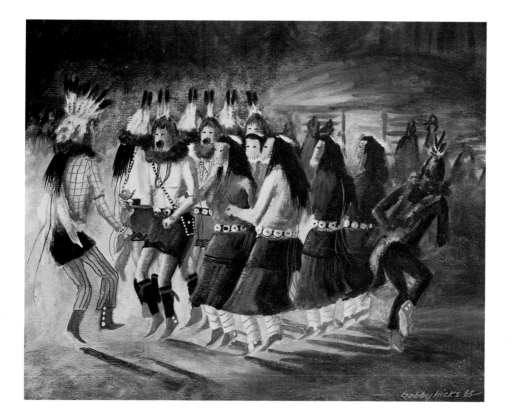

Fig. 7.49   Bobby Hicks, Navajo. Yei Dancers. Courtesy, Mr. and Mrs. H. S. Galbraith.
—Neil Koppes

377

Hicks seems to have been constantly experimenting with his painting. Despite the fact that he had been painting for some years by the end of the 1960s, he had not yet found himself. Nonetheless, he taught both painting and craft arts in Indian schools and continued to produce his own works of art into the early 1970s.

Adee Dodge, another Navajo, was painting in the late 1950s and into the 1960s. He became fairly well known for his horses, one of them blue, which tended to have unrealistic manes and tails. Heavy proportions are typical of the animals, as is great animation. Much stylization appears in Dodge's painting. His penchant for blue was extended to other subject matter; for example, a leaping mountain sheep outlined in this color, with a blue bird in the same painting; even the distant hills are outlined in dark and light shades of blue. He exhibited at the Heard Museum, Phoenix, in 1967.

Small touches of conventional or abstract patterning occur frequently in Dodge's painting, often to serve in place of a bit of ground. Occasionally the entire background may be made up of abstract themes.

This artist has exaggerated form and motion in much of his work; for example, a mountainlion stands upright on his hind legs, with a distorted, snarling mouth. Dramatic poses are fairly common in his figures, as, for example, in the women in *Feeding the Multitude* (Fig. 7.50); or in a deer with its head back and its forelimbs drawn

*Fig. 7.50    Adee Dodge, Navajo.* Feeding the Multitude. *Courtesy, Adee Dodge and Dr. and Mrs. Byron C. Butler.*
—Neil Koppes

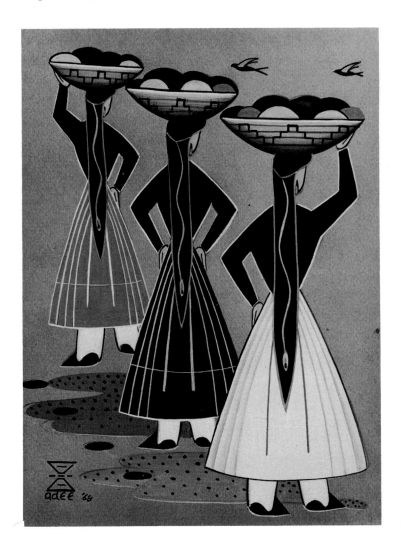

378

under; or fiercely charging bulls with heads down; or a Navajo shooting a bow in an exaggerated half-kneeling position and with flying long hair.

Other paintings by Dodge are as quiet and peaceful as the above are dynamic and dramatic. *The Helping Hand* depicts a young lady's face and upper body, with an arm and hand coming from the top of the picture to touch the girl's hand. Another painting that is sheer design, *Rainbow God,* depicts elements borrowed straight from sandpaintings: a yei figure is dominant, and close to it is a sun symbol from which radiate the four plants sacred to the Navajos—corn, beans, squash, and tobacco.

Thus, animals, humans, and ceremonial designs seem to be dominant in Dodge's painting. No distinctive style has been developed by this Navajo, unless it is his heavy-muscled horses with flying manes and tails.

Richard Taliwood, a talented Navajo who has combined part-time painting with architectural drafting, was born in 1940 at Ft. Defiance, Arizona. He went to the Phoenix Indian School, later attended the 1960 summer Indian Art Project at the University of Arizona, then went to the Ray-Vogue art school in Chicago.

In his painting, Taliwood has used watercolors and sand, with subject matter taken primarily from Navajo tribal life and religion. In the 1965 Scottsdale National, he received special recognition, the Elkins Memorial Award, for his painting, *I Dream of the Long Walk.* The previous year he received an honorable mention for an abstract painting. Taliwood was represented in the 1970 Scottsdale show by an abstract of a yei figure. Illustrative of his abstract style is *The Fire Dance* (Fig. 7.51).

As of 1971, Taliwood was venturing into avenues of new expression. Among other things, he was combining abstract and realistic in a single painting. One good example of this is *Yei-bi-chai* (Fig. 7.52), consisting of six realistic yeibechai figures arranged in diagonal fashion against an abstract background. Interestingly, the long and narrow yei figures of the sandpainting are blended into the background; at first glance, they are hardly noticeable because of their soft colors. The only sharp color is in the vivid blue of the masks. Old as Navajo easel art is the arrangement of the six yei, yet this painting has a fresh, new approach because of the treatment of the individual figures, because of colors, and because of the background. Taliwood entered in several classes in the 1971 Gallup Ceremonial show, winning a third-place award in mixed media.

Tony Begay was born on the Navajo Reservation in 1941. After high school graduation in 1959, he attended the American School of Commercial Art in Dallas, Texas, for one year. Following

379

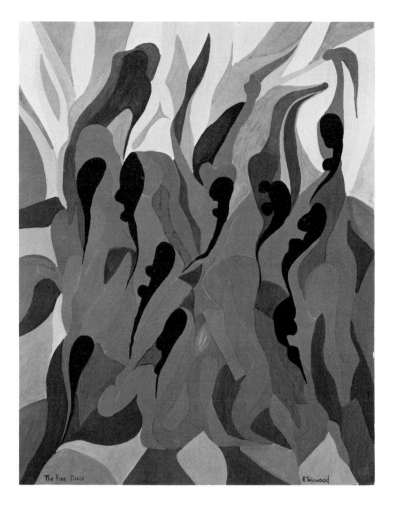

Fig. 7.51    Richard Taliwood,
Navajo. The Fire Dance.
Courtesy, Museum of Northern
Arizona.
—Mark Gaede

Fig. 7.52    Richard Taliwood,
Navajo. Yei-be-chai.
Courtesy, Desert House Crafts.
—Ray Manley Photography

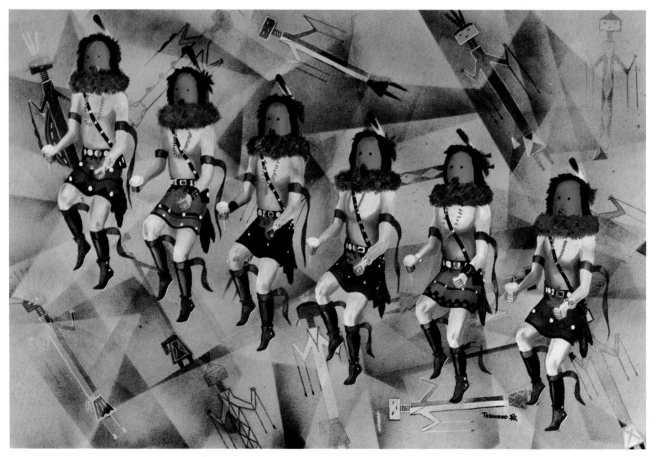

a five-year tour of duty with the U.S. Marines, he became staff artist for Navajo Community College, a position he still held in 1971.

Painting Indian and western subjects, Tony Begay has used acrylics, oils, and pastels, often with the usual background and frequently combining conventional themes with his major subject. In the 1969 Gallup Ceremonial show, he was given a first prize and a special award for his *Yei-Be-Chai Ceremony in Hogan*. This ambitious, large painting presented the medicine men against the wall, with the sandpainting on the floor before them, a difficult perspective to achieve. Colors were on the dark side for the hogan wall but light for the sandpainting. Detail was good, particularly in the intent faces of the medicine man and in the floor painting. For his oil, *Navajo Wedding,* he received honorable mention at the Scottsdale National in 1970.

Despite such achievements, as of 1971 Tony Begay had not yet established a distinctive manner of painting—he had said earlier that "I'm still looking for that certain style." This attitude continued through 1970 and 1971, for at exhibits during these years, he entered in almost every category. For example, at the 1970 Gallup Ceremonials, he not only entered but also placed in these classes: traditional, portraits (Fig. 7.53), landscapes, and abstracts. Late in 1970, Begay

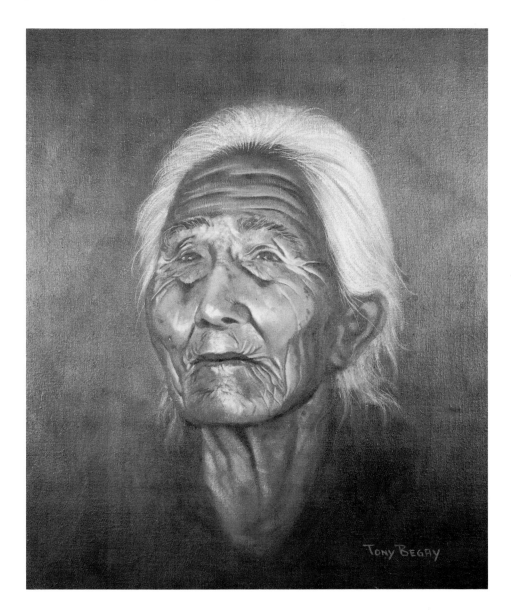

*Fig. 7.53    Tony Begay, Navajo.* Old Woman. *Courtesy, Woodard's Indian Arts Collection.*
—George Hight Studios

381

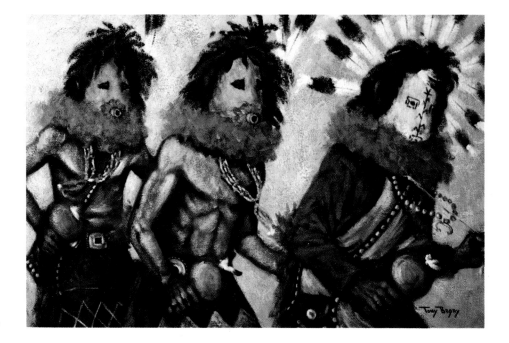

had a one-man show at the Heard Museum. Among others in the usual variety of his painting was *Ye-Bi-Chi* (Fig. 7.54), three dramatic and compelling figures done in oils. Colors are soft yet rich. This painting took first award in its category in the 1971 Scottsdale National, where he placed in every category in which he was represented. Here his entries were equally varied—with an addition of a typical Plains style! His *Yeibechai Dancers* (Fig. 7.55) shows his

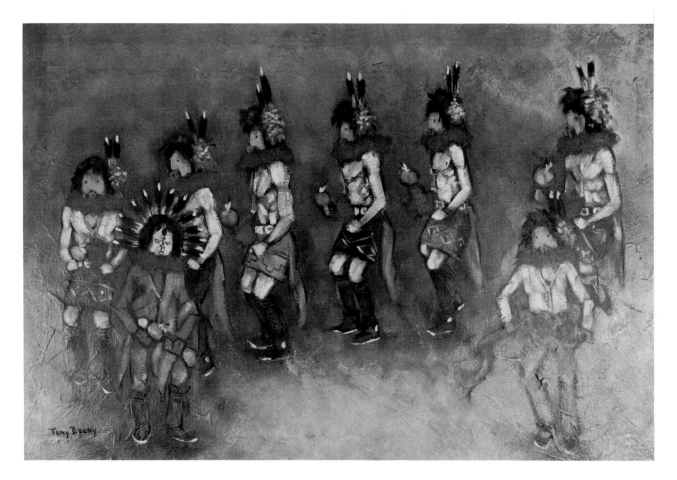

ability in the way of more realistic portrayals, yet it combines a feeling of the mysticism of this very significant ritual of the Navajo.

In the 1971 Red Cloud Indian Art Show, Pine Ridge, South Dakota, his *Resting* took the Best of Show Award, and he also received an honorable mention in water-based media. His prizes continued with a first in portraits, a second in graphics, and a merit award in the oil or acrylic class at the 1971 Gallup show. Rightfully, Tony Begay was taking many prizes at these 1970–71 shows, for he was proficient in all of the styles in which he painted. His brushwork is clean, his colors rich; in graphics he has proven equally capable, whether handling pen and ink or charcoal.

Harry Walters (Na-Ton-Sa-Ka), born in 1943 of Navajo parents, attended the Institute of American Indian Arts, Santa Fe, in 1962–63. He has exhibited at the Art Gallery of the Museum of New Mexico, at Philbrook, Scottsdale, and Gallup. When a student he won several honors at various shows, including a second and third place and an honorable mention at Gallup, for traditional-style painting. Walters has also painted in a nontraditional and mystic manner, as exemplified in *Earth Mother—Navajo Myth,* an odd presentation of a woman whose upper body forms part of a tree trunk. The figure of a man dressed in the old style seems to burst forth from the tree. All are silhouetted against a mottled background. The painting is entirely in black and grays; composition is fairly good; and the semi-abstract, almost impressionistic style gives an ethereal feeling to the picture. Many of these same qualities can be noted in *Medicine Man and Patient* (Fig. 7.56). Walters has also painted in full European perspective. He was actively painting and exhibiting into the 1970s. Walters took a third-place award in polymers at the 1971 Scottsdale National.

Stanley Battese (Keh-do-yah), whose late 1950 painting seemed to hold promise, had realized some of this potential by the late 1960s and early 1970s. Some of his work is sheer design, combining traditional geometric themes and life forms. Occasionally the life form predominates, with the conventional theme relegated to an area overhead, as in *Navajo Shepherd* (Fig. 7.57). His subjects have included forest animals, horses, and Navajo genre scenes.

Battese has changed little through the years. Perhaps the greatest change has come in extended subject matter; too, he has picked up some of the traits of Navajo artists featured in the 1960s, such as buttes in the distance. In pictures exhibited at the Heard Museum in 1967, and in the 1969 Scottsdale show, his paintings revealed the above features.

Ed Lee Natay was born in 1915 of full Navajo parentage; his father was a medicine man and his mother a weaver. After teaching

at the Santa Fe High School for a short period, he turned to crafts and painting. Natay exhibited widely but took few awards, possibly because he was also interested in several craft arts. His horses, such as in *The Desert Rider* (Fig. 7.58), are slightly suggestive of those painted by Pop Chalee, particularly in the manes and tails.

In 1962, Natay exhibited several paintings at the Scottsdale National, all executed in his favorite medium, opaque. These entries reflect both his subject matter and a few points relative to his style. *Eagle Dancers* presents two large figures in conventional poses and executed in deep colors; *The Flute Player* is an example of his poorer drawing. A mountainlion jumping from a conventional tree onto a

384

Fig. 7.57    Stanley Battese (Keh-do-yah), Navajo. Navajo Shepherd. *Courtesy, Mr. and Mrs. Read Mullan.*
—Neil Koppes

Fig. 7.58    *Ed Lee Natay, Navajo.* The Desert Rider. *Courtesy, Arizona Highways.*

turkey in *The Last Call* shows action; and *Affection* is a simple and peaceful portrayal of an Indian woman with her baby in her arms.

In summary, it may be said that Natay was not an outstanding artist but he painted in the tradition of his tribe, although lacking, generally, the details and the refinements of the better painters of his day. Natay died in Phoenix in 1967.

Johnny Secatero, a Navajo who was in his early twenties in 1971, has painted in several styles of his tribe, and in casein. Sometimes he has painted in the pueblo design style. In the traditional manner is *Goat After Yei,* with a pink and geometric-edged patch of ground for these two figures and a dog, all painted so like Chee that it might well be taken for his work at first glance. A butte and a tree edge the ground patch in the far distance. Blue-outlined conventional clouds are pleasantly effective on the brown paper. Some of his early work shows shading in bands of color; regular modeling in the flesh appears in some of his 1970 painting.

Another Secatero watercolor, *Sandpainting of Sunflower Gods,* with a man at each of the four corners, is Harrison Begay-like. The viewer looks down from above on the entire scene. To be sure, there is none of the finesse of Begay in this painting. Soft colors predominate in the sandpainting, but there are a few bright tones in the garments of the men.

All of Secatero's entries in the 1969 Scottsdale show were done in watercolors. Again, Begay-like touches appear; for example, in *Young Squaw* there is a Rainbow Goddess above a woman on horseback and a feeling of balance in a butte on each side of the background.

His version of a *Navajo Fire Dance,* done on dark paper for contrast with the light and blue figures and red flames, is quite childish in the drawing and has but the barest suggestion of action as the dancers throw the burning brands about. The same immature drawing appears in *Young Squaw.* But, like most Navajos and Apaches, Secatero does a good job when painting horses. He placed third in the Navajo-Apache category at the 1966 and 1969 Gallup shows, and won an honorable mention in the 1967 Scottsdale show. Secatero demonstrated little improvement in drawing in his entries at Scottsdale in 1970, but his work was varied in subject matter.

By 1971 Secatero showed considerable improvement—as his *Delight Maker Caught* (Fig. 7.59) indicates—in composition, color, and fineness of line. At the 1971 Gallup show, his *Shalakos Arriving* took a first award in the traditional-representational category, and a grand award.

Benjamin Martínez, a Navajo student at the Institute of American Indian Arts, Santa Fe, in 1969, exhibited some interesting prints

at the Scottsdale show that same year. *Goats*, a simple but pleasing and quiet representation of these animals feeding or resting, received honorable mention at this show. Another interesting print, *Hippies, Yippies, American Teens*, was done in abstract style.

Fig 7.59   *Johnny Secatero, Navajo.* Delight Maker Caught. *Courtesy, Desert House Crafts.*
—Ray Manley Photography

Mary Bercier Morez (she no longer uses the ''Bercier''), a Navajo, was born in Tuba City, Arizona, and went through high school at the Phoenix Indian School. The Bureau of Indian Affairs sent her to the Ray-Vogue School of Fashion Art in Chicago. She also attended the Southwest Indian Art Project at the University of Arizona.

Although Morez has favored pen and ink, she has been quite versatile in other media, working in oils, watercolor, and chalk. Preferring natural colors, she has frequently used yellow, browns, orange browns, and black. She has developed no particular style; she has done abstracts but seems to favor pen-and-ink portrait sketches of her tribespeople and other Indians. It has been said of her that she has been so many years away from the reservation that her Indians have grown too pale; and, it may be added, they are non-Indian in features. Many of these sketches, a profile of an Apache girl, for example, have no particular merit, for they are just simple sketches. Morez has exhibited largely in the Phoenix area, including the Scottsdale National in 1966. At the same show in 1969 she entered nothing but drawings. One of them, *Prodigal Daughter Comes Home*, portrays the child and parent in a close embrace. Fine

387

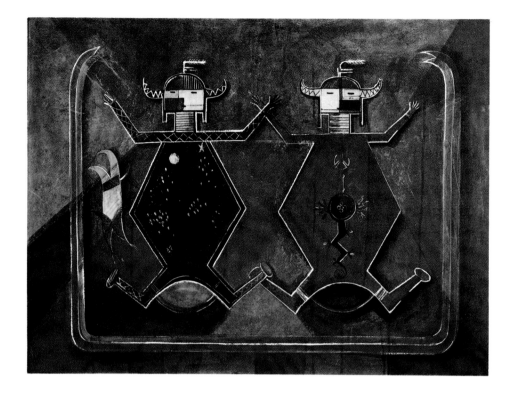

*Fig. 7.60 Mary Morez, Navajo.* Father Sky—Mother Earth. *Courtesy, Eugene B. Adkins.*
—Neil Koppes

lines seam the older face but, although it is well modeled, it is not Indian. Morez had a one-man show at the Heard Museum early in 1970.

Toward the end of 1970 and into 1971, Mary Morez began to change in her painting style, turning from portraits of non-Indian types to portrayals of Indians and to the presentation of more Indian subject matter. One oil of hers, *Father Sky—Mother Earth* (Fig. 7.60), took an honorable mention at the 1970 Heard Museum Guild Show; it is appealing in its rich, soft, earthy tones. Morez took both a first award and an honorable mention at the 1971 Red Cloud show.

In the late 1960s two Navajo brothers, Roger and Ernest Lewis,[46] were just embarking on painting careers. Both were born on the Navajo Reservation, Roger in 1948, Ernest in 1950. Both attended the Gallup, New Mexico, schools, and both have exhibited in the usual shows in the Southwest—Scottsdale, Gallup, and the Navajo show at Window Rock. Each won a second place in the Scottsdale student competitions in 1968. In addition, Roger Lewis ventured a little farther afield, entering his work at Philbrook, where in 1967 he took an honorable mention in the student class. Ernest has been recognized in the same way at Scottsdale, in both 1968 and 1969; he also won a second place in the student classification at the 1967 and 1969 Gallup shows.

Both Lewises have painted traditional subjects in casein. For example, Roger's *Falling Star,* painted on black paper, shows a figure

of a white-outlined Navajo sitting at a red campfire in the dark of night, with smoke curling to the top of the paper, and with the star shooting across the black heavens. A second painting of his, *Moving the Herd Home,* depicts the typical Navajo rounded hills and a slash of orange sunset in the far distance, with a horseman silhouetted against the latter. Detail is good, the ''Navajo feeling'' typical. Roger's men are unmistakably Navajos. Also typical of the Navajo, humor comes out in some of his paintings (Fig. 7.61).

Ernest Lewis also has displayed a delightful sense of humor in some of his paintings. *The Big Race,* for example, a 1968 entry at the Gallup Ceremonials, depicts two rabbits, two lads on horseback, a blue Chevrolet pickup, and a dog, all racing. Drawing is more childish in this and other of the earlier paintings—frequently of animals and birds—by Ernest. Like his contemporaries, Ernest adds typical features of the Navajo country in some of his paintings (Fig. 7.62). Both he and Roger have shown much promise, as indicated in an honorable mention for Ernest in the 1970 Philbrook student competition, and in the third-place award in water-base media he received at the 1971 Red Cloud show, Pine Ridge, South Dakota. Roger's entry into the armed services in 1969 curtailed his activities as a painter for a time. He resumed painting in 1971, upon his return from the service, and also entered the Red Cloud show. Both Lewises

*Fig. 7.61    Roger Lewis, Navajo.* Leaving the Trading Post. *Courtesy, Woodard's Indian Arts Collection.*
—George Hight Studios

389

exhibited at the 1971 Gallup show, although neither received a nod from the judges.

Chee Benally was born in Blackrock, New Mexico, in 1947. He attended elementary school on the Navajo Reservation, secondary at Gallup, and graduated from Nebraska Wesleyan University in 1971. Two years were also spent at an engineering and drafting school in Denver, Colorado; this prepared him for his employment in the summer of 1971 as an illustrator in a plastics firm in Lincoln, Nebraska. At that time he reported that he hoped to continue advanced studies in education, and planned to return some day to the Indian country to teach in the fields of education and art.

Benally has used a wide variety of media in his art expressions, including among others acrylics, oils, watercolor, pastel, and charcoal. He has painted both traditional and nontraditional subject matter, as titles of several of his pictures indicate: *Hoop Dance, Fire Dance, Shiprock,* and *Tear Drop.* Much of his work is in a semi-European or almost-traditional style, while in others, such as one of his Hoop Dance paintings, his approach is abstract.

This artist has received a nod from judges on several occasions. At the White Buffalo Council in Denver, he was awarded a first for a scratchboard and a second for a watercolor; his painting has won many honorable mentions, for example at the Red Cloud Indian Art Show (Pine Ridge, South Dakota), Scottsdale, Tulsa, and

the Gallup Ceremonial show. At this last, he also received a third-place award in graphics in 1971. His *Forever Eminence* (Fig. 7.63) treats of an eagle in a cubistic manner, keeping native design elements very much in focus.

Nelson Bichitty, a Navajo from Indian Wells, was a patient at a hospital for Indians in Tucson in 1965. Encouraged to paint, he entered the Scottsdale National that same year and took a second prize for one of his collages. His work has been more in the pueblo tradition; for example, Eagle and other dancers and single figures on a small spot of ground.

A little-known Navajo whose talents have not yet been explored is James C. Joe. His *Night Sky of the Hail Chant* is an elaborate design incorporating themes from ceremonial and symbolic sources. It depicts gods' heads (yei masks) in a simple manner, and floral patterns, all in a sandpainting-like arrangement. *Water Creatures* presents a two-headed, square-check-bodied monster embellished with Navajo sandpainting cloud symbols. Such arrangements and symbols are to be expected in Joe's work since he is primarily a sandpainter.

Frank Begay did an *Enchanted Mask* (Fig. 7.64) which is quite appealing. In shades of gray, with cloud-like fillers in the back-

*Fig. 7.64    Frank Begay, Navajo.* Enchanted Mask. *Courtesy, the Avery Collection.*
—Howard's Studio

*Fig. 7.63    Chee Benally, Navajo.* Forever Eminence. *Courtesy, Red Cloud Indian School.*

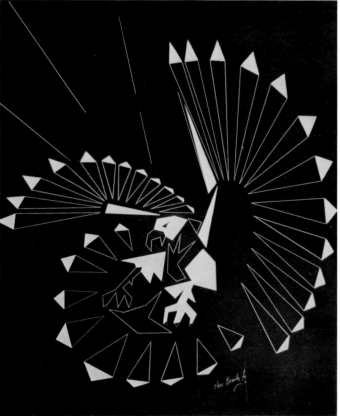

ground, it lives up to its name in a feeling of the unreal, yet it is beyond doubt a mask. Simple lines describe the geometric eyes, the bulbular nose, the rounded mask, and even the ubiquitous feathers atop the latter.

Raymond Johnson, whose Navajo name is Ne-Chah-He, has painted the usual subjects favored by artists of his tribe. Some of these, exhibited at the Scottsdale show in 1969, include a buffalo hunt, yeibechai dancers, and several portrayals of marriage rites, all in watercolors. *Marriage Rite #1* presents an interesting composition despite its childish execution. The boy and girl enter from the extreme sides, a line of yei dancers and other ceremonialists dominates the center of the picture, and the inevitable butte appears in the background. Some of this painting is childish in nature. The ever-popular *Card Game* (Fig. 7.65) is portrayed in a slightly different manner with some of the participants sitting under a ramada.

Eugene Holgate, Jr., a Navajo born in 1938 in Utah, was educated at reservation schools, then attended Phoenix Indian School. He has done traditional, three-dimensional, and abstract paintings. Perhaps his favorite subjects have been the animals of the Navajo Reservation with red rocks and hazy blue mountains in the background. His portrayal of a seated shepherdess (Fig. 7.66) shows a vast panorama beyond and in front of the Navajo woman to the

*Fig. 7.65 Raymond Johnson (Ne-Chah-He), Navajo.* Card Game. *Courtesy, the Heard Museum of Anthropology-Primitive Art, Phoenix.*
—Neil Koppes

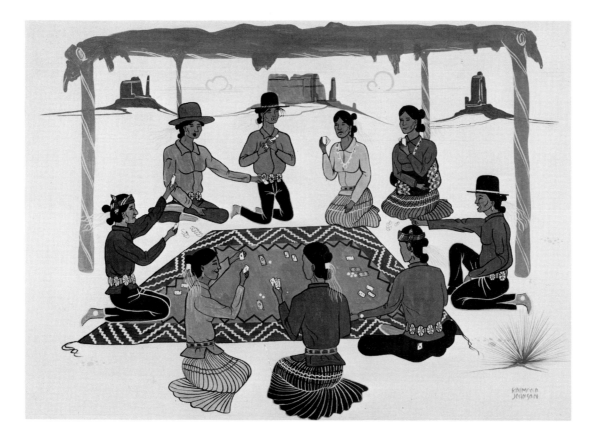

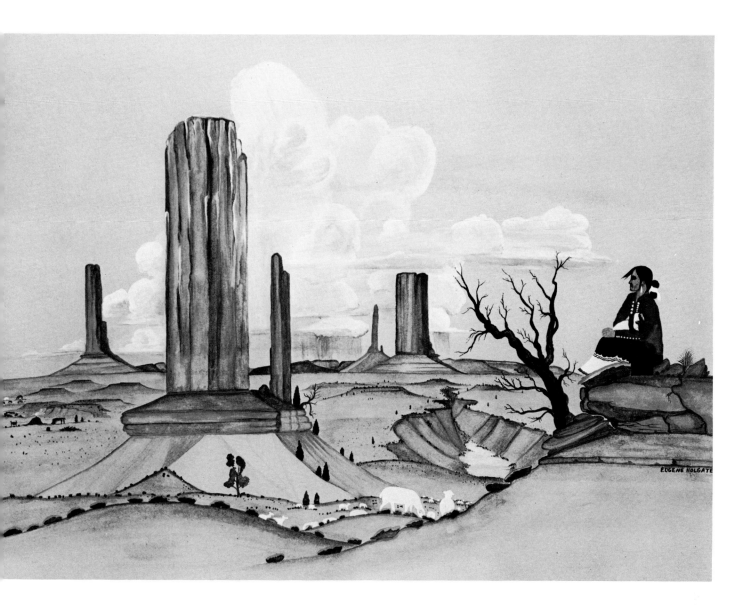

Fig. 7.66 *Eugene Holgate, Jr., Navajo. A sitting shepherdess. Courtesy, Mr. and Mrs. H. S. Galbraith.*
—Neil Koppes

far right. Holgate has exhibited and won prizes at the Arizona State and Navajo Tribal fairs, and at Scottsdale and Tulsa. Abstract backgrounds appeared in some of his 1968 work.

Angelo Marvin John, who was born in Winslow, Arizona, received his secondary education at Ganado Mission on the reservation, and at the Institute of American Indian Arts, Santa Fe, where he studied under Allan Houser. Following graduation in 1970 from Arizona State University where he had enrolled in the Air Force R.O.T.C. program, he was commissioned a second lieutenant and in the fall of 1971 received his pilot's wings; reputedly he is the first American Indian pilot in the U.S. Air Force.

Casein paintings, done in the traditional style, generally have featured Navajo subjects. However, because of his pilot's training, it is not surprising to see airplanes in his paintings now and then.

393

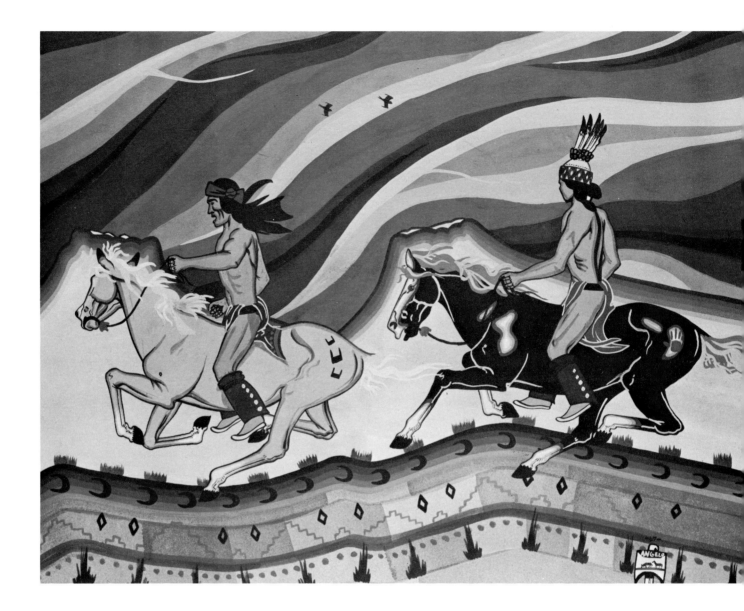

Fig. 7.67 Angelo Marvin John, Navajo. Ride in the Wind. Courtesy, The Heard Museum of Anthropology-Primitive Art, Phoenix.
—Neil Koppes

As he has said, ''I paint to satisfy my creative desire and also to identify with my culture.'' Much creative imagination is displayed in *Ride in the Wind* (Fig. 7.67).

John's paintings generally are large, ranging from 18 × 24 inches to 4 × 5 feet. He has admitted to a Tahoma influence which is well exemplified in *All or Nothing*. This painting depicts a horse attacked by a mountain lion, with a Navajo off to the side shooting at the lion with bow and arrow—all very Tahoma-like. Good detail is to be noted in the man's jewelry and dress and the design in the saddle blanket. At the Scottsdale National, John earned an honorable mention in the student class in 1963 and a special award in adult painting in 1968. He continued to enter this show through 1970.

Franklin Kahn, who painted in the late 1950s and sporadically into the 1960s, showed great promise, as indicated in a third-place

award he received at the 1962 Scottsdale show in student competition. However, two watercolors in the Scottsdale show in 1969 did not reveal fruition of this promise. Preoccupation with making a living has undoubtedly hindered this Navajo in his art efforts. His medium has usually been casein, his subjects generally Navajo genre or scenes; one of the latter, *Spring in the Mountains* (Fig. 7.68) is rather idyllic. His brother Chester Kahn has also painted; he attended the University of Arizona Indian Art Project in 1960 and 1961. He

*Fig. 7.68    Franklin Kahn, Navajo.* Spring in the Mountains. *Courtesy, Mr. and Mrs. H. S. Galbraith.*
—Neil Koppes

has exhibited rather widely and has been recognized through awards. Much of his effort has been directed toward commercial art.

Jay de Groat (Joogii), born May 16, 1947, was educated in Gallup public schools and attended Highlands University, Las Vegas, New Mexico. He has painted both Navajo and Apache subjects. In one effort, he shows Apache Crown Dancers (Gans) in bands of color (Fig. 7.69). Another painting of a Gans group presents four conventional figures dancing across the blank white paper, filling it completely. The Gans are painted in rather stiff postures and without benefit of much detail. A Joogii painting which is almost cubistic has a mottled background. In *The Weaver,* the Navajo woman's skirt is done in vertical bands of color, a subtle type of suggested modeling that seems to be one of Joogii's strong points. Elaborately angular are the bands used to depict *Womanhood* (Fig. 7.70). Watercolors that he entered in the 1969 Scottsdale show gave evidence of some variety in both ceremonial and genre subjects. He won an honorable mention in the 1969 Gallup show.

John Claw, Jr., a Navajo who attended the Tse Bonito School at Window Rock, Arizona, has painted realistic genre and ceremonial tribal scenes or designs. His detail is excellent; his colors combine dark and bright tones.

Boyd Warner, Jr. (Black Hair), born at Tuba City in 1937, has studied interior decorating, but has had no formal training in painting. Done in a variety of media—acrylics, opaque, oils, sand, and tempera—his paintings are largely in the traditional Navajo style, but sometimes an almost-full perspective is attained. All of his 1969 Scottsdale National entries were in watercolor, and included a variety of Navajo genre and ceremonial subjects, as well as a bit of abstract

*Fig. 7.69    Jay de Groat (Joogii), Navajo. Apache Crown Dancers. Courtesy, the Avery Collection.*
—Ray Manley Photography

*Fig. 7.70   Jay de Groat (Joogii), Navajo.* Womanhood. *Courtesy, Mr. and Mrs. H. S. Galbraith.*
—Neil Koppes

painting. Warner has received recognition at both the Arizona State and Navajo fairs for his painting; too, he is represented in several permanent collections. In 1970 he exhibited an abstract in the Scottsdale show, and a *Navajo Yei (Food Collector)* (Fig. 7.71) in the Heard Museum Guild Show. He received a merit award in the mixed-media class at the 1971 Gallup show.

In 1969 Thomas Harrison, another Navajo, was studying commercial design at the California College of Arts and Crafts. He has painted in oils—using cool colors—explaining that with acrylics he got too messy!

Paddy Morgan is a typical Navajo as reflected in the choice of the horse as a main theme for painting. In one instance, he used scratchboard for *The One Called "Ruff Neck"* (a wild one!), while pastels were employed for *Appalosa* (sic). Although immature, his work shows promise.

Jerry Lee, a Navajo born at Wide Ruins in 1944, has painted both the subject matter and in the style of his tribesmen. Hunters, horses (Appaloosas favored), and fawns are among his chosen subjects; the inevitable reddish cliffs appear in some of his paintings.

397

Fig. 7.71    Boyd Warner, Jr.
(Black Hair), Navajo. Navajo
Yei (Food Collector). *Courtesy,*
*Boyd Warner, Jr.*
—Neil Koppes

Colored papers are effectively used as background for Lee's well-handled bright colors.

There is a strong Tahoma feeling in some of Jerry Lee's paintings. For example, *Old Time Hunters,* a watercolor in the 1969 Scottsdale National show, reflects this influence in the vigorous animals, but reveals nothing of the finesse of the mature work of Tahoma. Horses frequently stand on a bit of an arched ground line; in the far distance is a trace of sunset where Lee displays the brightest of colors. Both men and horses are Navajo beyond doubt in the usual Jerry Lee painting (Fig. 7.72). He won a first place in student competition at the Scottsdale show in 1964. He continued to paint in the

following years, part of the time as an understudy to Beatien Yazz. In 1970 he was still producing a few pictures.

Born in 1946, in Keams Canyon, Arizona, Clifford Beck attended public schools in Winslow and Flagstaff. He then received a four-year art scholarship and went to the California College of Arts and Crafts in Oakland, graduating in 1968. He had some special training under Wolfgang Lederer, a design instructor who influenced Beck, particularly in composition.

Beck has favored charcoal and oils in his painting efforts; he has also done a good bit of photography. He has illustrated texts for the elementary schools, such as *Kinalda,* a ceremony, and *Navajo History,* both for the Rough Rock Demonstration School on the reservation. In early 1971 he was designer and photographer for the Indian Health Services, U.S. Public Health Service, Tucson, while attending the University of Arizona. He then returned to the Navajo Reservation where in 1971–72 he was teaching painting and commercial art at Navajo Community College.

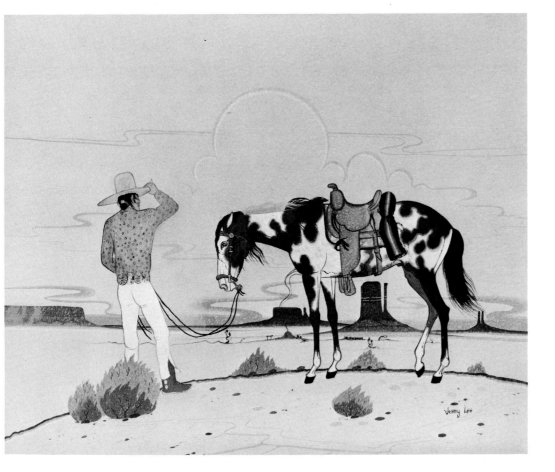

*Fig. 7.72    Jerry Lee, Navajo.* Watching. *Courtesy, the Avery Collection.*
—Ray Manley Photography

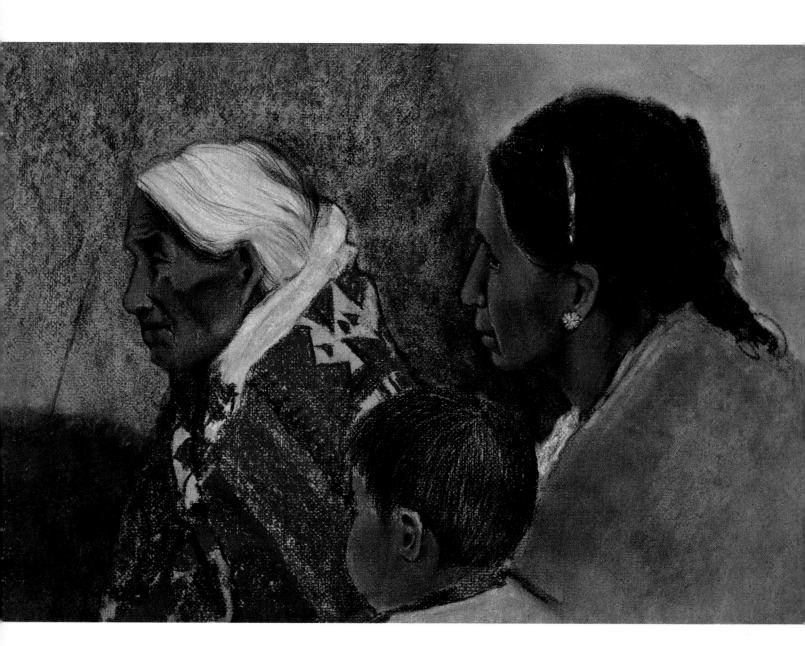

*Fig. 7.73   Clifford Beck, Navajo.*
*The Tallsalt Clan.*
*Courtesy, Dr. George C. Peck.*
*—Neil Koppes*

Because his father's clan is the Tallsalt, it is not surprising to find that in Beck's oil, *The Tallsalt Clan* (Fig. 7.73), one of the women in the group is the artist's late grandmother. The faces express the dignity of this tribe. This painting took a first award in the any-media class in the 1970 Heard Museum Guild Show. Beck's versatility is displayed in his *Spinning the Wool,* which took second place in drawing at the 1971 Scottsdale show.

Most of the subject matter treated by Beck has been of his own culture and people, but now and again he has represented

others, such as in *The Pima*. He has exhibited in San Francisco and Oakland, California, and in Phoenix and Scottsdale.

Another versatile Navajo artist, Guy B. Nez, Jr., has done sculpture, pottery, and jewelry in addition to painting. Born in White Cone, Arizona, in 1948, Nez attended the Holbrook, Arizona, public schools before going to Santa Fe Junior College on an art scholarship. He also studied fine and commercial art at Los Angeles Trade Technical College. In addition to water-based media, he has done some work in oil and in a variety of graphics. He won an honorable mention at Philbrook in 1970 for his casein, *Hunting Warriors*. In that same year he also entered the Heard Museum Guild Show, winning two honorable mentions in water-based paintings, and a first award in prints and drawings for his *Ye-Be-Chi* (Fig. 7.74). He exhibited in 1971 at Scottsdale, the Red Cloud show at Pine Ridge, and Gallup, taking an honorable mention at Pine Ridge in the oil and acrylic class, and winning a second-place award in three-dimensional paintings at Gallup. His versatility as a painter is displayed in a still life of a medicine man's paraphernalia (Fig. 7.75).

Richard Kee Yazzie (Hosh-Ke), also a Navajo, attended grade school in Crownpoint, New Mexico, where he was born May 5, 1944. He received his high school diploma from the Albuquerque Indian School, attended the San Francisco Academy of Art from 1964–65, and then enrolled at the Institute of American Indian Arts, Santa Fe, where he studied until he was drafted in January, 1968.

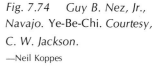
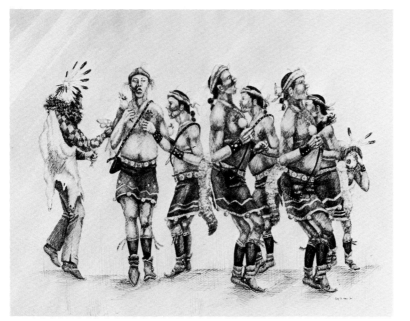

*Fig. 7.74    Guy B. Nez, Jr., Navajo.* Ye-Be-Chi. *Courtesy, C. W. Jackson.*
—Neil Koppes

*Fig. 7.75    Guy B. Nez, Jr.,*
*Navajo.* Medicine Man's
Dream. *Courtesy, Tom Bahti*
*Indian Arts.*
—Ray Manley Photography

He served in Vietnam with the 1st Air Cavalry, Infantry, and then took a course in drafting and design while stationed in Texas. Following his discharge in 1970, he went to Madison, Wisconsin, where he obtained employment as an artist and draftsman with the Wisconsin State Highway Department.

Yazzie's paintings have been exhibited in New Mexico at Santa Fe and Gallup, in Alaska, Wisconsin, San Francisco, Washington, D.C., at the Philbrook, and at Scottsdale, where he received the Governor's Trophy in the special student class in 1964 and a second-

place award in prints in 1968. His style of work is reflected in his fanciful creation, *Now you are husband and wife* (Fig. 7.76), an imaginative painting in which a variety of conventional birds, plant growth, rabbits and a skunk, plus a realistic donkey are portrayed in pleasing and original fashion. His drawing is clean and precise, and in several spots he has adapted native design—for example, to a bird.

Like a number of the other young Indian artists of the early 1970s, Yazzie has already had some commercial experience. He has designed record jackets for a recording studio in Albuquerque, and late in 1971 he reported that his work would appear on the cover of the 1972 Wisconsin highway map.

Alfred Clah was born at Ganado, Arizona, on the Navajo Reservation in 1945, but his home was Greasewood, in the northeast part of the same state. He attended schools in his home community, at Ft. Defiance, and at Flagstaff; later he spent five years at Intermountain, studying under Allan Houser, then was at the Institute of American Indian Arts from 1962–64. He has won awards at Scottsdale and Santa Fe.

Clah's painting is often in the current Navajo style—horses and men, full perspective with buttes in the background and rocks

*Fig. 7.76    Richard Kee Yazzie (Hosh-Ke), Navajo.* Now You Are Husband and Wife. *Courtesy, Mr. and Mrs. R. B. Applegate.*
—Laura Gilpin

403

and native growth in the foreground. Generally, horses are well done, but men are apt to be only fairly well depicted—in particular, their faces are poorly delineated. Clah is heavy on blues and grays in some of his paintings. These traits are to be noted in his *Horses Drinking at a Pool in the Desert* (Fig. 7.77).

He illustrated the 1967 publication, *Navaho Folk Tales,* written by Franc Johnson Newcomb. Quite appealing are his drawings of animal-headed, human-bodied creatures, all from a time "when animals and people spoke the same language." Delightful sketches portray the activities of First Man and First Woman, both dressed in early historic styles or the latter depicted in full, sweeping skirt, velveteen blouse, and wrapped leggings above moccasins. Simple though the sketches are, they portray action and amplify the story told in each chapter.

James Wayne Yazzie, born in 1943, painted in water media and oils. Frequently there are many figures in a single painting. Frequently, too, there are touches of humor, such as a Navajo girl pulling a man out to dance with her, or as in *Lazy Day* (Fig. 7.78), where a woman in the foreground is pouring a dipper of water over a sleeping tribesman. Yazzie was killed in a train accident in 1969.

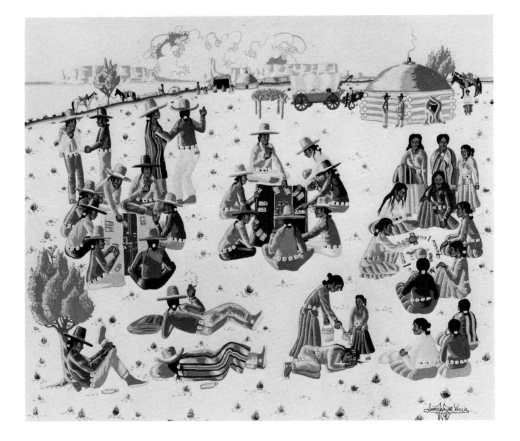

*Fig. 7.78    James Wayne Yazzie, Navajo. Lazy Day. Courtesy, James T. Bialac.*
—Neil Koppes

Keats Begay, a Navajo who lived in Chinle, Arizona, did a fair amount of painting in the late 1930s. He was represented in the "Contemporary American Indian Painting" exhibit of 1953 at the National Gallery of Art, Washington, D.C.

Much of his painting centered about sandpaintings and other Navajo symbols. If cliffs and buttes are portrayed, frequently they are schematic or unreal, as in *Navajo Sheep* (Fig. 7.79). In this painting, a mass of sheep in outline and silhouette is enclosed by the red cliffs;

*Fig. 7.79    Keats Begay, Navajo. Navajo Sheep. Courtesy, James T. Bialac.*
—Neil Koppes

405

in another painting, *Navajo Land*, there are comparable unreal formations with conventional symbols above and brown sheep silhouetted against the raspberry-red cliffs.

Frank Lee Joe, also a Navajo, has exhibited in the Southwest and is represented in several private collections. His *Going to Overnight Chant*, exhibited at the 1969 Arizona State Fair, depicted a man and a woman, both very typical Navajos, each riding a horse. The foreground was quite European, while in the background were conventional tiny buttes, and overhead quite conventional outlined clouds. He has painted in the traditional Navajo style (Fig. 7.80), except for occasional flairs in other directions.

Jimmie Abeita, a Navajo, was born around 1959 or 1960; Crownpoint, New Mexico, has been his home. He attended high school in Gallup. As a student in 1967, he took a first prize in the Gallup Ceremonials, Juvenile Class, for his casein, *Oops*, a refreshing and humorous work in which a rattlesnake startles a horse and his rider. This painting is in the style of contemporary realistic Navajo work, with buttes and pinnacles in the background and a blue sky, with white clouds, in the far distant background. In this and other paintings, frequently of horses, Jimmie Abeita shows considerable realism, action, and perspective, yet details are not too good. On

*Fig. 7.80    Frank Lee Joe, Navajo. Girl walking with sheep. Courtesy, Mr. and Mrs. H. S. Galbraith.*
—Neil Koppes

the other hand, he did *The Ancient One*, a portrait of a very wrinkled old man which is convincing down to the last wrinkle.

The names of three additional Navajos should be mentioned before closing this section: Larry Hoskie, Steve Jackson, and Fred Cleveland. Larry Hoskie has painted traditional and nontraditional subjects in many media; he was the staff artist at the Navajo Tribal Museum at Window Rock in 1970–71. Steve Jackson has painted in oils and acrylics primarily, and in three-dimensional style; portraits and traditional subjects are his strong forte. Fred Cleveland has also worked in the Tribal Museum. In 1971 he was instructional aide at Toyei Boarding School at Steamboat, Arizona; here he taught art to third- and fourth-grade children. Using oils primarily, Cleveland has reflected certain influences from Nailor although both his horses and his people tend to be more idealized or more exaggerated than those of the older artist. A cartoon he did for the July 8, 1971, *Navajo Times* dedicated to the Navajo Code Talkers Reunion reflects many comparable sketches with a bedraggled soldier. The figure is camouflaged and has a gun and walkie-talkie in hand. In the background are the usual South Pacific palm trees. Cleveland took a first award in graphics at the 1971 Gallup show.

The history of Navajo art is short but full of vigor. In the Southwest story, the Navajo have produced their share of outstanding artists, with men like Harrison Begay and Tahoma who have carried on in the Indian tradition and have added greatly to it. Navajo painting can be characterized by action, modeling, more or less bright colors, genre subjects with emphasis on horses and riders, ceremonial dancers, and dynamism.

## Apache

The Apache is a language brother of the Navajo. He has many culture traits that link him further to his linguistic relative. Not the least of these is his art, for it reflects the relationship in its subject matter, in treatment, in its virility. Like the Navajo, the Apache artist often pictures horses, or active ceremonial figures, or the everyday life of his people. Legend also comes in for its share of interest. Brighter tones appeal to the Apache—who is preeminently a watercolorist —as they do to the Navajo. Vivid action characterizes him in paint as it has in his history.

Steven Vicenti, or Ne-Ha-Kije, was a Jicarilla Apache. Born June 6, 1917, he died thirty-one years later, in Santa Fe. He has the distinction of being the first modern painter of the Apache tribe, exhibiting for the first time in 1934 in Santa Fe. After that he exhibited widely, in the Stanford Museum of Fine Arts; the Addison Gallery

of American Art, Andover, Massachusetts; and in the Art Gallery, Museum of New Mexico. He had a one-man show at the latter gallery in the mid-1930s.

For a while Ne-Ha-Kije came under the guidance of Dorothy Dunn of Santa Fe. But family cares took him back to herding sheep on the reservation, and it was there that he did most of his painting.

*Apache Runners*, by Ne-Ha-Kije, in the Dietrich Collection, illustrates many of the characteristics of this painter. Three stylized, light yellow tepees form a background for the runners. This was a common device employed by Vicenti—in other pictures it might be trees, or the edge of a structure, or campfires. Seven young runners moved to the right, but with their faces full front. Four chanters and drummers are to the far right. The faces of the runners are almost mask-like. Figures are tall, all too slender. This, too, is a characteristic of Vicenti. His compositions may be somber in color or bright and gay in flat painting. In one painting, the leaves of trees are large; in another the greenery is delicate. A feeling for vertical lines pervades his paintings in up-and-down striped blankets, in posts, in tall people, or in trees, as in *Horse* (Fig. 7.81). When horses are introduced they carry out the same effect in their long, slender legs. A fragile quality is typical of some of the work of Steven Vicenti.

In addition to men on horseback, Vicenti featured games and ceremonial dances. He also wrote and illustrated a story, "Jicarilla Apache Winter," which was published in *World Youth*. The paintings of Vicenti might be summarized in a few characteristics: a reliable

*Fig. 7.81     Steven Vicenti (Ne-ha-kije), Jicarilla Apache. Horse. Courtesy, The Columbus Gallery of Fine Arts.*

408

although limited record of his people; clean colors, often with touches of brilliant tones; originality; and delicate lines.

Allan Houser (Haozons), a descendant of the famous warrior and chieftain, Geronimo, was born at Fort Sill, Oklahoma, in 1915. He attended the Indian School in Santa Fe where he received the Arts and Crafts Award in 1936 for the best work produced by an artist in the school. He has exhibited widely throughout the United States, including an outstanding one-man show at the University of Oklahoma. Other exhibits have been at the Chicago Art Institute; the Museum of New Mexico; Tulsa, Oklahoma; and Geneva, Switzerland. In 1939 he had paintings at both the World's Fair in New York and the San Francisco Exposition. He was chosen as one of the six Indians to do the murals in the Department of the Interior Building, Washington, D.C.

A Guggenheim Fellowship in sculpture and painting was granted Houser in 1948. Just before this outstanding recognition of his abilities, he had completed a marble statue, *Comrades in Mourning*, as a memorial to Haskell Indian School students who lost their lives in World War Two.

The Devil Dancer or, more properly, the Gans Dancer (Mountain Spirit) is to the Apache artist what the masked kachina figure is to the Hopi; Houser has done many of these figures. One such painting, labeled *Devil Dancers*,[47] and done in 1936, is executed on black paper. The four dancers and the accompanying clown are all white-bodied, active figures. They wear delicate and effective headpieces and high-topped Western Apache moccasins with turned-up toes. Some modeling is suggested in added black lines on the white bodies.

Many of the scenes from everyday life, as painted by Houser, have a great appeal, perhaps because of the immense vitality of his figures. Warriors, duck hunters, *Leaving Camp, Burying the Baby*— these and many another subject have given Houser ample opportunity to express himself fully.

*Burying the Baby*[48] expresses much of the stoicism that still predominates in Indian character. A simple ground line is carried across the paper, dipping downwards to form the open grave. An Apache man and woman stand to the right, a small girl clings to her mother's skirts. To the far left and near the hole in the ground is the baby on the cradleboard, with a few other items scattered about on the ground. Back of the woman is the basket waterbottle still made by this tribe, the *tus*. The mother's face is constrained. The father's lips are parted in characteristic Houser fashion, this time perhaps to sing a last song to the baby. Colors are soft throughout. It was this same subject that won for Houser, in 1948, the grand prize for all

tribes at the Third Annual Exhibit of American Indians, Philbrook Art Center, Tulsa, Oklahoma.

In another scene, which is as amusing as the above is sad, Houser has painted all of his characters laughing hilariously. Sitting in the doorway of a green *wickiup* (these houses are constructed of native bear grass) is an Apache woman. Before the house a man is bending over a small fire. Under a nearby ramada (an open shade) a lad sleeps, and near the posts are several girls. A Devil or Gans Dancer is pointing meaningfully with his thumb at one of the girls as he awakens the youth. The significance of the laughter is found in the brief legend on the back of the painting: the girl has asked the Gans to get the man she wished to dance with. Again, the colors are soft; the detail is excellent in costume, in facial expressions, in house features; the touch of humor is appealing.

Like so many other Apaches, Houser had heard tale after tale from the older members of his family of the "good old days." Not the least among these were the stories of buffalo hunts, of warriors of bygone times. So accurately were these told to the young people and so indelibly were they impressed on their minds that many have successfully recorded fragments of these stories in paintings. One of Houser's paintings done in 1938 shows a hunter shooting a buffalo. The great animal on the right twists its body, either in agony from the arrow which pierces its back or to avoid a head-on collision with the horse and rider to the left. The man presents the epitome of tensed action necessary to draw the heavy bow: his mouth is open, baring his teeth, eyes are closed tightly, his drawing finger is still pulled back, his foot is slightly upturned in sustained action.

In many of Houser's paintings there is splendid action. Mouths are wide open in speech, arms participate in gestures, legs of the horses are lifted in high-stepping manner. Carefully drawn outlines often stress the vigor of figures; modeling lines make them more real. Coupled with his talent for drawing and the simplicity of line which tells so much is Houser's ability to handle color. In one painting of a girl's puberty rite, or "coming out" ceremony, subtle tones make the buckskin garments appear "soft to the touch."

Another painting by Houser is one simple in subject matter but beautiful in color and strong with human appeal, *Apache Mother* (Fig. 7.82). The mother strides along, her infant in a cradleboard on

*Fig. 7.82    Allan Houser (Haozons), Chiricahua Apache. Apache Mother. Courtesy, Mr. and Mrs. John P. Wilson, Jr.*

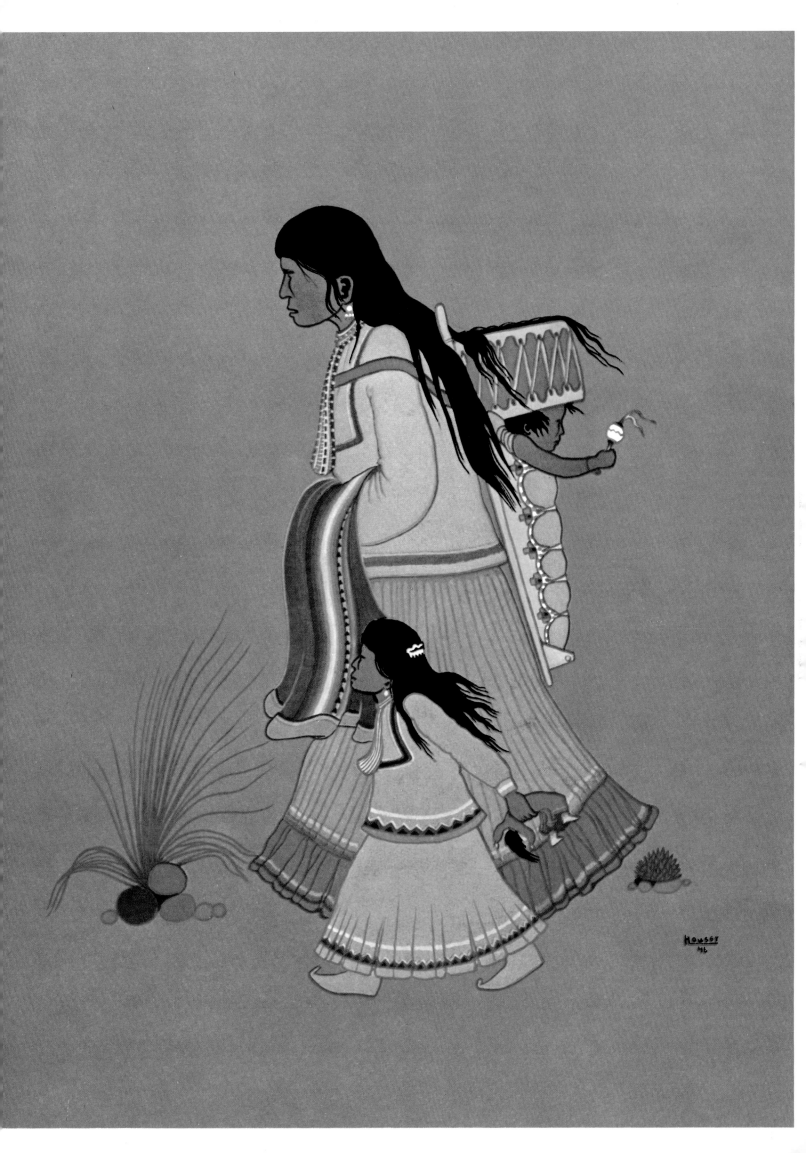

her back, her small daughter silhouetted against her voluminous skirt. A soft rose-colored paper was used against which the subtle tones of dresses and blanket stand out. Turquoise, blue, and lavender are pointed up with yellow, pink, and lavender bias tape on the loose blouse and full skirt worn by the mother. The child's pink costume, so carefully and effectively placed against the contrasting tones of the mother's skirt, is a miniature version of her parent's dress. And the same dress theme is repeated somewhat more sketchily in a doll grasped about the middle by the little girl.

In a few simple lines Houser catches the feeling of motion and vitality, the characteristic features of the Apache face, and full detail of costume. His work is decorative; it is reminiscent of design. It is dynamic, subtle, strong, full of color. Houser paints primarily in the typical Indian two-dimensional manner, with broad and flat brush strokes. His outlines, whether narrow or broad, are clean and definitive. Moving, vital, dynamic can be the single-line leaves of the yucca, or the full softness of a blanket carried over the arm of a person who is walking, or the bodies of humans and animals. Houser can say much with few lines and flat color.

In a group of paintings exhibited in 1962, Houser showed much development in certain traits. Subjects are somewhat the same: men, horses, waterhole, a shepherdess, warfare; there are also much the same vitality and life; there are modeling and perspective. However, there is more in the way of background, such as trees and clouds; there are more figures in some of the individual paintings; and there is more variety in subject presentation. Early and late, large-sized paintings are typical of Houser; for example, one is 21 × 27 inches.

At various points in his career, Houser has painted in fresco secco, egg tempera, casein, and oils. Although he likes the traditional style, he has also said, "I find it much more exciting to allow myself more freedom."

Among other honors in recognition of his painting, Houser received the Palmes de Academiques from the French government, and the Grand Award at the Philbrook in 1948, 1950, 1955, and 1961, and again in 1968. He has won many other awards at Philbrook and a few prizes at other exhibits, such as the Scottsdale show where he received the first award in 1962. He has done various murals, including the one in Washington, D.C., mentioned above.

During the 1960–70 decade, Houser produced some fine sculpture which surpassed his painting of the same years. Also, he was an instructor in sculpture and traditional painting at the Institute of American Indian Arts, Santa Fe, during these years. In 1971 he was head of the arts and crafts division of this institution.

At the Heard Museum in Phoenix in 1970, Houser had an outstanding one-man show which featured both his sculpture and painting. The latter tended to emphasize comparable subject matter, such as warfare, ceremonies, and hunt scenes, but changed in comparison to his earlier work in the addition of full and sometimes dynamic backgrounds. Good examples to illustrate these trends are *The Wild Horses* (Fig. 7.83), and *Dance of the Mountain Spirits* (Fig. 7.84). The former, a 1953 painting, shows less background—and that rather schematic—while the latter, done in 1970, shows wickiups; hills, plants—all conventionalized—and realistic sky back of the performers.

Wilson Dewey, or "Sundust" as he sometimes signs his paintings, shows the influence of contacts with both whites and Indians. Simple in composition though many of his paintings are, he tells a story on many occasions. Dewey's subject matter is somewhat limited; he features figures of bears (Fig. 7.85), Devil Dancers, horses, cacti, Apache women, and scenes of Apache camp life.

Sundust, a San Carlos Apache (Arizona) who was born in 1915, attended the Indian School at Santa Fe. He has exhibited in

*Fig. 7.83    Allan Houser (Haozons), Chiricahua Apache.* The Wild Horses. *Courtesy, The Heard Museum of Anthropology-Primitive Art, Phoenix.*
—Neil Koppes

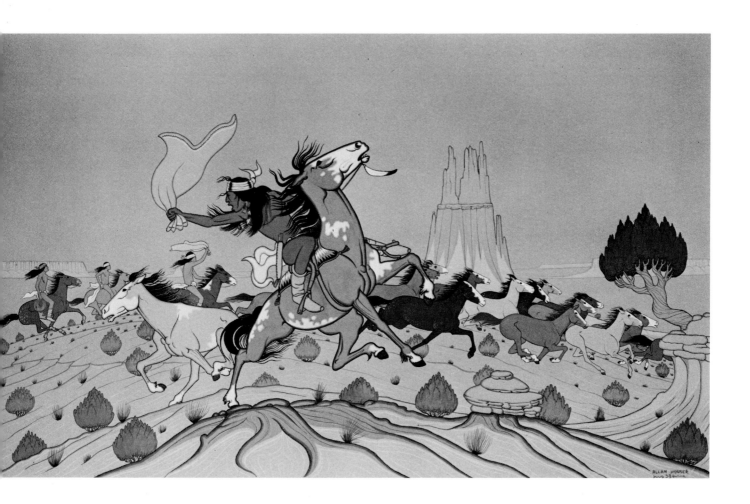

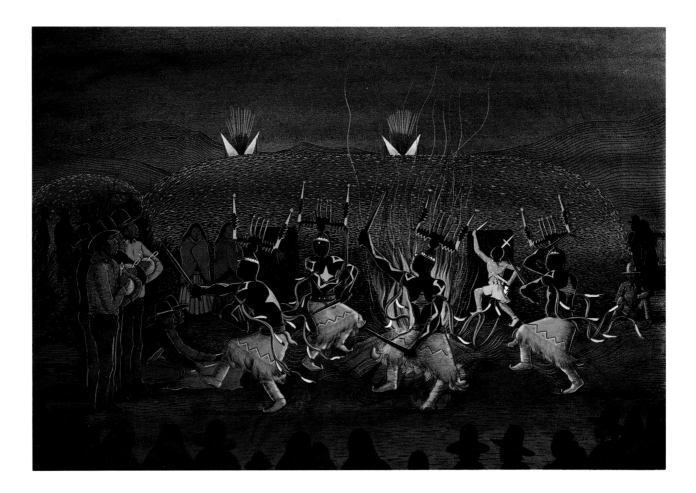

Fig. 7.84　Allan Houser
(Haozons), Chiricahua
Apache. Dance of the
Mountain Spirits. Courtesy,
Allan Houser.
　　　　　—Neil Koppes

Fig. 7.85　Wilson Dewey
(Sundust), San Carlos Apache.
The Beast and His Prey.
Courtesy, Museum of
New Mexico.
　　　　　—Laura Gilpin

various art galleries, perhaps the most important being in Puerto Rico where he received a prize for which he was given public acclaim in the leading magazine of that commonwealth. Dewey served for several years in the United States Army during World War II.

Although not an outstanding artist, Dewey has shown some talent. He has a delicacy of touch that appeared in some of his earliest work at the Santa Fe school. Three small paintings, each of which is but 4 × 6 inches, illustrate this point. Two of them are of Apache girls, each wearing the typical Apache cotton dress of full skirt and loose blouse. Details are exquisitely represented in the prints of the dresses, in the Western Apache moccasins with upturned toes, and in the delicate and conventional plants at the sides of each figure. The third picture shows an Apache Devil or Gans Dancer. Delicate treatment of detail is to be noted in the dancer's fringed buckskin skirt and soft boots.

Dewey reflects quite a sense of humor in many of his paintings, particularly when he portrays a bear. Several treatments of this animal show him sitting contentedly, with a full belly, in front of a most productive flat-leaf cactus, with fruit all over the plant and scattered about on the ground. Just the way the bear sits, his placid face, his obviously full stomach, evoke a smile from all viewers. Equally entertaining and much more active is his *Scared Horse*. An innocent and unperturbed little skunk sits on a rock; a great hulk of a horse jackknifes itself into an amazing position in fright at the small creature. Dewey's portrayal of hoofs and legs gives the animal the appearance of running in all directions at once. The mane and tail of this wild creature remind one of Beatien Yazz's work. The very wildness of the animal is mindful of Tahoma, as is a small conventional bird at the top of the picture.

Some of the later Devil Dancer figures painted by Dewey show the progress that he made in much of his work (Fig. 7.86). Rhythmic and flowing lines appear; excellent detail makes these paintings significant ethnologic studies; and some of them are dynamic in the treatment of action.

With other Indians from the Santa Fe school, Dewey participated in the group decoration of the Maisel Building, Albuquerque, but he did not follow up his talent in this line. He has not exhibited much for some years.

Another Apache who has shown ability similar to that of Dewey is Wesley Nash. He, too, attended the Indian School at Santa Fe, and he, too, painted his people, some everyday subject matter such as a mother and child, and some ceremonial subjects such as the ever-popular Gans Dancer (Fig. 7.87). Nash has shown keen ability in depicting detail, such as the painted design on the body of

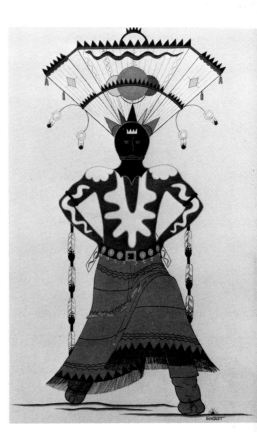

*Fig. 7.86   Wilson Dewey (Sundust), San Carlos Apache. Mountain Spirit Dancer. Courtesy, Inter-Tribal Indian Ceremonial Association, Gallup, N. M.*
—George Hight Studios

415

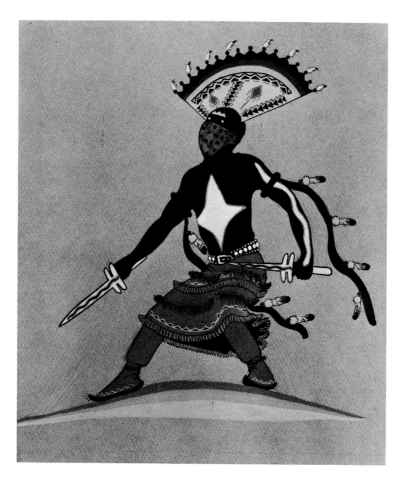

*Fig. 7.87    Wesley Nash,
Apache. Apache Gahn
Dancer. Courtesy,
Millicent A. Rogers
Memorial Museum, Inc.
—Dick Spas*

a dancer, the four layers of fringe on a buckskin skirt, the designs on the headpiece worn by the dancer. When he paints plant life, the same convention prevails in the treatment thereof that is found in the work of his tribesmen. Withal, the work of Nash is neat, carefully and accurately drawn.

Nash was represented at the Santa Fe Indian School 1944 Annual Exhibit in the Art Gallery, Museum of New Mexico, by a number of masked dance studies. He was commended for their beauty, particularly as reflected in exquisite detail. In 1948 his paintings in another show at the same gallery revealed him as a youth of outstanding ability.[49] Little or no work was done by Nash during the 1950s and 1960s.

Another of the Apache artists is Rudolph Treas. That he is a member of the Mescalero tribe of New Mexico and is not from the Western Apache group is interestingly reflected in some of his paintings. For example, in his Gans Dancer figures, Treas shows the greater simplicity and delicacy of the headpiece worn by the dancers of the more eastern Apache tribe, as well as the simpler designs on the bodies of the same performers.

In the 1962 Scottsdale show, Treas exhibited a painting that showed some development. It depicted an Apache mother and her children, and it had a great deal of background, such as conventional outline clouds and very small figures of a lad and girl on horses in the far distance. This, like most of Treas's work, was done in water-based paint. Another later painting by Treas, titled *San Carlos Mountain Gods,* shows two striding and graceful figures on dark-gray paper. Old-style buckskin skirts and boots and the heavier headpiece used by the Western Apaches are well painted, colors are pleasing, and the composition is good.

Treas attended the Indian School at Santa Fe for several years. Unquestionably he was influenced by other Indian artists there or by their works in the collections at the school and about Santa Fe. Later he attended the University of Arizona, Tucson, taking some work in art. Much of his work shows no ground at all, nor clumps of growth. Then, in a painting of *Plains Indians Moving,* he depicts a ground line in waves and stylized growth; and above the main figures are three blue birds with streaks after them which, in their stylization and suggested motion, are certainly Tahoma-like. Not unlike this is *Traveling* (Fig. 7.88), in ground-line growth and birds above.

Treas's work can be briefly characterized in a few traits. He uses flat colors predominantly, occasionally suggesting modeling in

*Fig. 7.88  Rudolph Treas, Mescalero Apache. Traveling. Courtesy, The Heard Museum of Anthropology-Primitive Art, Phoenix.*
—Neil Koppes

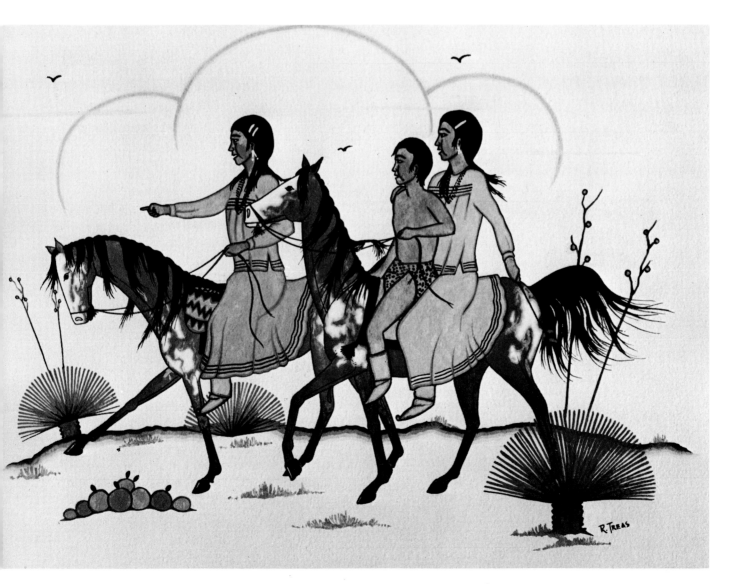

lines. Figures are more often flat portrayals against a blank ground; occasionally there may be a bit of ground suggested in a line or a patch of color. If portrayed, growth is conventional. His drawing has not yet been perfected, but it depicts in a simple style much of the detail of costume and paraphernalia of his people. Composition is bettered in later work, background becomes more elaborate in some instances, and figures and action are more realistic.

Carl Vicenti,[50] a Jicarilla Apache Indian, was born at Dulce, New Mexico, in 1930. He graduated from Albuquerque High School, attended Haskell Institute for one year, Brigham Young University and several other Utah colleges, and the National University of Mexico, Mexico City; he had art training at all of these schools. For a time he was art instructor at Intermountain School, and in 1968 he was illustrator for the U.S. Army School of Engineers.

Many prizes have been claimed by Carl Vicenti, including a first award in 1964 and others at Philbrook, several at the Scottsdale National and at the Gallup Ceremonials (a first and special awards in the abstract class in 1969), and many others. He won first place in the watercolor division at the Heard Museum Fair in 1968. He entered the 1970 Scottsdale show and the 1971 Gallup show where he took two third-place awards.

Vicenti has used all media and portrayed a wide variety of subject matter. His styles include the traditional Apache with little or no background, European with background, and abstract. Colors may be predominantly somber, as in some of his abstracts, or on the brighter side, as in *To the Race Track* (Fig. 7.89), in which a cluster of riders in varicolored bright dress on many-colored horses are painted on turquoise paper. Complete European perspective is not uncommon in Vicenti's painting—such is attempted in *Gathering of the Band,* wherein people and details of countryside are scattered from the bottom of the paper to a distant and narrow skyline.

One of Vicenti's realistic paintings, titled *Off to the Raid* (1967), shows the warrior ready to leave on horseback; high on a hillock and slightly off-center, is his wife in a prayerful position in the foreground. There are patches of ground with sage-like growth on them and slender young aspen trees in the distance. A conventional cloud, a typical touch, silhouettes the rider. This painting reflects certain Navajo qualities, yet it is not entirely in this tradition; perhaps the dress and the stance of the rider make the difference, for both are more Plains-like.

Vicenti's abstracts have a quality all their own; many reflect a feeling of circular motion, almost meteor-like in quality (Fig. 7.90). In some of his paintings, it is smoke swirling out of a slender fire, turning from red to gray as it spirals upward. Despite indistinct figures

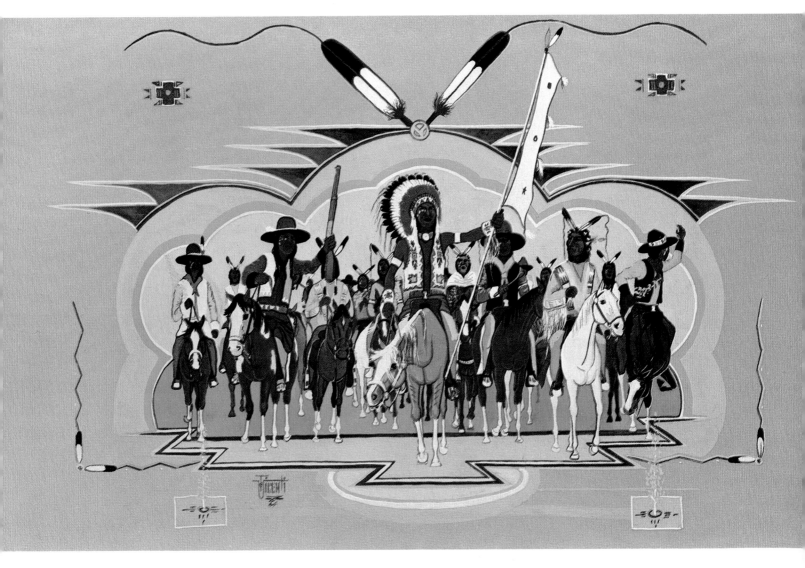

*Fig. 7.89    Carl A. Vicenti,
Jicarilla Apache.* To the Race
Track. *Courtesy, the Avery
Collection.*
—Howard's Studio

*Fig. 7.90   Carl A. Vicenti,
Jicarilla Apache.* Study #10—
Christmas Eve. *Courtesy, the
Avery Collection.*
—Howard's Studio

in one such painting, there is a jewel-like quality to its colors. His first-award picture in the 1969 Gallup show, *Jicarilla Apache Marriage,* has ethereal vapor-like bands arising from a fire and floating upward in front of the figures. Other bands, which are more irregular and angular, appear as background and repeat the feeling of smoke.

Like many other Indian artists of the 1960–70 decade, Vicenti produced a variety of Christmas cards. His penchant for design, for swirling and rayed lines, has aided the production of many effective cards.

Carey Vicenti, the son of Carl, was born in 1954. By early 1968 he was exhibiting in important shows, taking a first award in the student division at the Scottsdale National for his *Printemps.*

Carey has done both watercolors and graphics; a scratchboard of *Eskimo Masks* (Fig. 7.91) is imaginative, well composed, and very well executed for a young student.

Frank Vigil, a Jicarilla Apache who was born in 1922, married a Jémez woman and has since lived in that pueblo. He served in the U.S. Army during World War II. A self-taught painter, he has exhibited rather widely, particularly at the Gallup Ceremonials, at the Scottsdale National, and at Philbrook. Although he has painted traditional subjects such as Crown Dancers, often in a static manner, he has also painted rather mystical themes, such as *Spirit Horses* (Fig. 7.92). This portrays two large and active animals in white on a black ground, and with much fine linework that gives a feeling of the unreal. Vigil received an honorable mention for his *Mountain Spirit Dance* at the Scottsdale National in 1962.

Ignatius Palmer, a Mescalero Apache, was born about 1921. He was painting as early as 1939 (one example of this work depicts

Fig. 7.91    Carey Vicenti, *Jicarilla Apache.* Eskimo Masks. *Courtesy Woodard's Indian Arts Collection.*
—George Hight Studios

Fig. 7.92    Frank P. Vigil, *Jicarilla Apache.* Spirit Horses. *Courtesy, the Avery Collection.*
—Howard's Studio

Fig. 7.93    Ignatius Palmer,
Mescalero Apache. Apache
Gan Dancer. Courtesy, James
T. Bialac.
—Neil Koppes

teepees and a warrior with a shield), but he seems to have done most of his exhibiting between 1957 and 1962. At the Scottsdale show in the latter year he received a second award for his *Dance of the Mountain Gods,* a painting executed in tempera. Another such Gans dancer (Fig. 7.93) illustrates his general style. Palmer is represented in several major collections, including the Museum of the American Indian, New York, and the Museum of New Mexico.

David W. Sine, a Yavapai-Apache, was born in the Verde Valley, central Arizona, in 1921. He received his elementary education in the area of his birth, then went on to Phoenix Indian School, and later studied for two years at a business school in Tucson. He spent seven years in the U.S. Army, largely in the Pacific; this accounts for some of his exhibits in military shows in Japan, the Philippines, and Australia. He designed the "Bushmaster Regimental Insignia" for the 158th Infantry in 1942; it was still in use thirty years later. In 1971 Sine was working at Sells, Arizona, on the Papago Reservation where he had been employed by the Bureau of Indian Affairs for some years.

A self-taught artist, Sine has made both easel art—oil and watercolor—and murals his areas of expression. Interestingly, Sine has painted Christian religious subject matter a great deal, for example, the *Stations of the Cross* for the San Solano Mission at Topawa, and a mural of *The Last Supper* for Pisinimo Mission, both on the Papago Reservation. Otherwise his subject matter is broad, ranging

from environmental scenes—such as a light and delicate watercolor of Mission San Xavier del Bac that is very well done—to native subject matter, particularly Apache, as in *The Coming Out,* a depiction of the puberty rite of this tribe. He has employed European perspective in some of his work, in both easel art and murals; this style was in evidence in several of his 1970 paintings. Sine has not made painting a career.

Ernest Whitehead, a Mescalero Apache, was a student at the Institute of American Indian Arts in Santa Fe about 1964. He has had limited exhibits, including the showing of his paintings at the U.S. Department of the Interior, Washington, D.C. His *Apache War Dancer* (Fig. 7.94) shows strength in the face and likely dress and war equipment for the early years of this tribe.

A White Mountain Apache, Garrison Johnson (Gahn) was born in 1933. He taught himself to paint, except for what little he learned

*Fig. 7.94    Ernest Whitehead, Apache. Apache War Dancer. Courtesy, James T. Bialac.*
—Neil Koppes

423

Fig. 7.95   Garrison Johnson
(Gahn), White Mountain
Apache. Apache Crown Night
Dancers. Courtesy, Miss
Marlene Malin.
—Neil Koppes

in the Whiteriver elementary and high schools. His media have been watercolor, pastels, and ink. Garrison only began to exhibit at the end of the 1960s, with works in the 1970 Heard Museum Guild Show. He has favored native subject matter, in paintings such as *Apache Crown Night Dancers* (Fig. 7.95).

As the foregoing discussion indicates, Apache art, like that of the Navajo, is concerned with different subject matter and is a more dynamic, vital expression than pueblo painting. Nonetheless, both Apache and Navajo art fit into the Southwestern pattern. Both are basically two-dimensional painting. Both stress conservatism and perfection of line. Color runs rich and high in the paintings of these tribesmen. In both there is attention to detail; both stress design above all else.

424

No full chapter discussion need be given to the other natives of the Southwest, because of their very limited production. Thus, a few words should be said here about the Pimas, Papagos, Utes, Paiutes, and the Yuman tribes, along with this discussion of the other two non-pueblo groups, the Navajos and Apaches. Unquestionably a certain amount of painting was done by members of all of these other groups in their schools; unfortunately for the record, little or none went beyond the four walls of the classroom. Sheer accident brought to light some of the examples mentioned below; it is even more rare to find any adult painters from these tribes, although several will be mentioned. A few have become known in very recent years through attendance at advanced schools or through exhibits.

Some childish drawings and paintings in the Denver Art Museum collection, viewed in 1948, probably are earlier than this date by some years (they are not dated at all). They are unmistakably Yuman, as indicated in dress, facial painting, beads, and neckpieces. Dresses of some of the women show patterning, while some of the same figures may reveal no hands or feet. Men are presented with complete dress, even to bandanas about their heads and ties about their waists; another man, a warrior, wears but a breechcloth and feathers in his loose hair. Women are static, some of them hardly more than mere designs; men are more active, and the warrior definitely shows action.

These paintings, poor as they are, reveal a flair for color, variety, and a potential in drawing which seemingly has never been realized. No significant Yuman paintings appeared in any important exhibits until the late 1960s. A Hualapai, Erna Smith, had several prints in the 1969 Scottsdale show.

Another painting in the same Denver Art Museum collection is signed "Brigg George"; apparently this person was from Utah and could have been a Ute or Paiute. A horse's head is childishly depicted in blue and green colors, with touches of red within the ears. An unusual red framing line surrounds the head.

Nothing further is to be noted for Ute and Paiute tribes until the late 1940s and thereafter. Frederick McCook, a Ute, did a few simple but very pleasing landscapes when a sixteen-year-old, around 1947. One painting in pale yellows and blues, with touches of green, and with brown outlines, gives a view of closer and more mesa-like foreground with highly conventional plants growing about, and with three tall peaks in the background. Simple and angular clouds cut across the peaks while more rounded clouds are barely visible in the distance. Another Ute, Clifford Duncan, did a landscape in more intense colors in 1951 when he was about seventeen years of age. Two very tall pines dominate the picture, although they are very light

Other
Non-Pueblo
Tribes

425

in color. A snowcapped peak to the right is pencil outlined, but the lower part of the mountain below the snow is purplish-brown in color. The ground and a cliff are brown; green yucca-like plants grow profusely in a low foreground. Red and yellow and slim in outline, clouds form straight lines across the sky. Both of these paintings are watercolors.

In both 1968 and 1969, Carol Lee Frazier, a Paiute, exhibited at the Scottsdale show, taking a second award in the latter year for a polymer; she also entered the Heard Museum Guild Show in 1968. She has used oils as well as polymer. Titles of her paintings are suggestive of a more abstract style, for example, *Lightning! Lightning!* and *Earth Pigment One.* Some of Frazier's painting is in a rather poor European traditional style, while other examples are completely non-traditional, as mentioned above. Frazier has also done prints.

Another Paiute, Clayton Sampson, exhibited several paintings at the Heard Museum show in 1969, one of a single person, another picturing seven people.

Seemingly, there were no members of any of these non-pueblo tribes mentioned above in attendance at the Indian School in Santa Fe during the 1930s. To be sure, these natives were geographically more distant, and generally their children were not sent so far from home. And, as a matter of fact, they seem to have been on the fringe of art otherwise, for in their schools practically all of the art expressed was in the form of simple European-style landscapes. Interestingly, this is another case of the paintings of children reflecting the general style of their elders.

Such were the efforts of the Papago children for many years. All of a group of watercolors and crayons done in the 1940s by children of this tribe who were from seven to ten years of age, are executed in full European style and almost all of them in the same manner. Mountains are always dominant and in the background, and they tend to be blue or purple; separate ranges are indicated by heavy black outlines. Desert plants are abundant, with the sahuaro cactus most prominent. Deer are not uncommonly portrayed; a rabbit appears in one crayon and a most unlikely boat is silhouetted against a mountain, going "full steam ahead" with smoke flowing out of its stack! Perhaps the most appealing of this group is a story told by a nine-year-old, in a group of small pictures done in crayons and all in full perspective. A cowboy leads his horse to a saddle, saddles up, and rides away; he meets with a wild horse, lassoes it, and takes it back to the corral where it is saddled; another man attempts to ride the wild creature but is bucked off; and the last scene shows the first cowboy lassoing the riderless horse. Incidentally, there is no background in the last three sketches; perhaps the lad became too

interested in the subject of his pictures, or a bit weary, and did not bother to add such detail.

These Papago efforts reveal little beyond the usual products of other youngsters of comparable age except for fair handling of color and a bit more action. Seldom did these children express any artistry along native design lines, although occasionally a teacher would allow them to do this. The usual results were designs from pottery or basketry presented much as such patterns might appear on the crafts themselves. An adaptation of basketry patterns to a Papago chapel executed by Frank Mariano in the late 1960s resulted in rather stark decoration about the entrance.

One painting executed by an unknown nineteen-year-old Papago (his age is noted on a photograph of the painting) at an unknown time—probably in the 1930s or 1940s—is a Papago dance for rain. This is done in the more traditional pueblo manner. There are seven independent figures and four pairs of dancers, three of the latter carrying tablets that symbolize clouds and lightning and the fourth pair carrying effigies of birds that are supposed to bring rain. Of the seven male performers, six are naked save for a breechcloth; the dark bodies have white dots painted all over them. Apparently the bodies of four women in the procession are similarly painted, and they wear white skirts that reach from their waists to their ankles. All the figures are painted against a blank paper. All faces and bodies are in profile; facial features are but simply portrayed. This painting, done at the Phoenix Indian School, may well reflect an influence from other Indian artists. Nothing more of this type is known to have developed among the Papagos.

Louis Valdez, an adult Papago, was exhibiting paintings in 1946 and for several years thereafter. He had served in World War II, was wounded, and while in a hospital in England became interested in painting. At the 1946 Sells Fair, on the Papago Reservation, he exhibited several portraits executed in pastels. This seems to have been his forte, and he developed a fair ability in this subject field and in this medium. Some scenes of the desert and his homeland were painted in the European manner (Fig. 7.96). However, Valdez did not continue to paint for any length of time.

In the early 1950s, Domingo Franco, another Papago, was painting. His chief subjects were primarily the same as the children's work described above, desert scenes, often with a horseback rider or several of them. Many of these were in oils and surely had no particular artistic merit. On the other hand, a painting of the San Xavier Mission which he exhibited at the 1955 Arizona State Fair

427

*Fig. 7.96    Louis Valdez,*
*Papago.* Papago Harvest.
*Courtesy, James T. Bialac.*
—Neil Koppes

was much better. Occasionally he attempted historical subject matter, such as a buffalo hunt.

With the establishment of the Institute of·American Indian Arts in Santa Fe in 1962, and its far-reaching attraction to many tribes, several Papagos have been drawn to this school and have taken advantage of the opportunity for higher training in art. As a result, the first signs of latent talent in this tribe have begun to emerge. This is true of several Pima Indians as well. In the 1968 and 1969 Scottsdale National shows, paintings by Pimas and Papagos were entered, largely in student competition. One in particular was a simple but charming and well-executed drawing of a lone Papago house. Timothy M. Antone, a Papago student, took a first award at the above 1969 show for a watercolor of a native *Corn Harvest Dancer.* Antone also exhibited at the Heard Museum Guild Show in 1969.

Several additional young Papago Indian painters might be mentioned briefly. One, Muriel Segundo, born at San Xavier Mission on May 6, 1948, was a studio art major at the University of Arizona, Tucson. She has worked in several media, including watercolor and acrylics. She has attempted to express tribal feelings in her art work.

David Montana, a Papago from Sells, was born about 1944. He attended the Institute of American Indian Arts at Santa Fe. After

his third year at this school, in 1965, he entered an abstract painting in oil in the New York City Riverside Museum special exhibit for Indians. The painting, titled *Parrot Coming Out of the Darkness into the Light,* features a shield-like affair wherein designs like wings are prominent among other abstract motifs.

It would seem, then, from this very brief sampling, that there is some latent talent among these artistically less-well-known non-pueblo tribes of the Southwest. Although they have exhibited a major trend in the direction of the traditional European style of painting, several recent art students have also demonstrated that they are capable of using and excelling in the more modern idioms of painting. Experience and time will tell. Without question it can be stated that these tribes have developed no traditional nor distinctive style, no subject matter which is their own, nor have they specialized in any particular medium.

In summary, it may be said that Navajo art has changed in many respects through the years, yet in some ways it has remained the same. Among the earliest subjects were yei or other dance figures and, of course, horses; today these are still the most popular subjects, but to them have been added many others. Water-based media have been and still are most popular among Navajo artists, despite the fact that other materials have tempted them along the way. To be sure, some individuals have experimented in all available media. Acrylics have had a strong appeal, for they combine features of water-based paints with additional qualities. Although the Navajos have seldom painted subjects against a completely blank paper, many have increased the background from ground lines and bits of growth to full European perspective.

Harrison Begay exemplifies the career painter who has never veered from the traditional Navajo style, while at the other extreme is R. C. Gorman who, in some of his modern styles of painting, would not be thought of as Indian except for his subject matter. One aspect of the Navajo situation that should be stressed is the fact that today there are more young men from this tribe entering the field of painting than from any other native Southwestern group. To be sure, the Navajos number more than 120,000, and thus are the largest tribe in the United States.

The Apaches present quite a contrast to the Navajos. Numerically they are a small group; they also have produced few outstanding artists. There are many Apaches painting but few of them show real promise. Rare individuals in the Apache tribe have made a career of art, among them Allan Houser who is, of course, one of

429

the outstanding Southwest painters. A majority of Apaches have adhered to Navajo traditional standards, a basic simple style expressed in water-based media, treating primarily the subjects of dancers and horses with or without riders. Very few, such as Carl Vicenti, have experimented with new materials and techniques. Basso[51] reports that many paintings of highly realistic Crown Dancers and cowboys, plus pen-and-ink drawings of old chiefs (apparently from old photographs), were exhibited at the 1968 Western Apache Fair. Perhaps there is some future for these Apaches in such directions.

Little can be said about the remaining non-pueblo tribesmen, the Utes, Paiutes, Yumans, Pimas, and Papagos. In the late 1960s and early 1970s, several members of these tribes displayed potentials of becoming artists. ■

# Old roots–
# new directions

**H**owever European the materials and techniques may be, Southwestern Indian easel art is essentially native; it is unmistakably *Indian*. It is the end product of age-old technologies and of a philosophy developed through the centuries in response to an unpredictable environment. It is a transitional art, an art that is bridging the gap between craft decoration on the one hand and an independent art form on the other. The Indian has survived in spite of the white man's every effort to conquer him. Certainly these things testify to his innate vitality. But they reflect another side of the Indian as well, a creative force that emerges in terms of a sustaining philosophy; then that philosophy is converted into abstract and concrete forms of art.

There are binding characteristics in all modern Indian painting that have come from these deep roots. Modern painting, as we have seen, has been influenced by old technologies in prehistoric weaving, pottery designs, and ceremonial patterns. Most closely related are mural paintings where horizontal alignment of figures influenced the first watercolors.

In modern craft arts, as in the prehistoric, there is to be noted a high synchronization of styles with new materials and ideas, and with specializations, such as form and size of articles. It is not surprising to find that the puebloans were able to cope with the many problems introduced by the new materials and media—paper and water-

colors—and the problems of the flat and limited surface of the former, in their first efforts with easel art.

In modern painting, we see a reflection of the sex division of labor. Among the puebloans of the Rio Grande, the men executed the majority of the arts, while the women were restricted in this area of expression. It was natural, then, that the men would be the producers of watercolors. Even among the Hopis, where the women paint the pottery, designs are so highly stylized that these women have developed no great ability in free delineation. Among the Navajos the general situation is quite the same; for centuries, apparently, it has been the men who have painted skins and ritual objects. This native situation is changing today with the attendance of women in advanced art classes, such as the Institute of American Indian Arts. More paintings by Indian women are appearing in exhibits.

One of the most important influences on modern Indian art is the religious philosophy which, in turn, reflects the social and economic bases of life. It is difficult to comprehend the many centuries which went into the formulation of the ideas of the relation of man to his environment, expressed in the abstract myths, prayers, songs, chants, the dance, and limitless art forms of the Southwest Indians. "However intrinsically beautiful, its beauty to the Indian is in its meaning."[1] This is the philosophy back of Indian dances, of Indian art, a philosophy which is still a guiding principle. It is accountable for much in modern painting, as, for example, its objective nature. It probably explains conventional themes in painting; it explains the realistic-plus-abstract styles of the Rio Grande, and the emphasis on ceremonial subject matter in general as expressed by many Indians.

To interpret the deeper philosophy back of Indian ceremonialism is extremely difficult, for there is much about the beliefs of the native tribes which is still unknown. At best, one can but touch upon externalities; the deep intimacies of the religion of most of the Southwest peoples are still unfathomed. Puebloan Indian religion has been and still is rooted to the land; the cultivation of corn was and is basic. The kachina cult is the most fundamental aspect of the religion of the puebloans. Today it is a combination of a weather-control–fertility–death cult.

The Southwest Indian has quite a different attitude toward the animal world as compared with other folk. Since there was no real creation but an emergence instead, relationships are relative to the sequence in which different creatures appeared on earth. There are many spirits, each supreme in its own sphere but not beyond it, and most spirits possess anthropomorphic traits. Too, animal spirits appear in human form; all they have to do is remove their skins,

and there is a man. The puebloid concept of the interrelationship of all things makes it necessary for a pueblo man to beg the pardon of an animal before he kills it. It makes it possible for him to feel the nearness of the game animals at the time of the lovely Animal Dance so often pictured by their artists.

To the Indian, nature about him is alive, breathing; it is peopled with many beings, some strange, some like himself. The forces of nature are animistically portrayed, for that is how they are. The Rainbow Goddess of the Navajo has a head and hands, a prolonged body, and feet. Man can pray to these forces of nature, can dance for them, can picture them in all things, with dignity and majesty, for his relationship is with them an exalted one. The Indian has symbolized for his devotion and for his esthetic satisfaction the many forces in nature which have become benefactors to him. Art has thus come to assume a supernatural purpose, art is often an abstraction of religious beliefs and concepts. By the same token, one need not give deep and mystical symbolic meaning to every line drawn or painted by an Indian artist; much of such expression is a pleasurable beholding of familiar designs that are devoid of deep meaning when out of context.

Although these people do not have a graded pantheon, nonetheless they do think in terms of a grouping of spirits. The Sun is most important in many pantheons; Earth Mother (often symbolized in a corn-ear fetish) is outstanding in others; and Father Sky, Moon, Stars, the Twin War Gods, Lightning, Storm Clouds, Water Serpents, and others come in for their share of attention. Obviously, the elements which have to do with rain are extremely significant in all deific or spirit groupings, particularly with agricultural peoples. These are integrated with the religion, and the religion is reflected in endless symbols in art. These symbols have penetrated the non-religious artistic expressions on the level indicated above.

Religious rites control many activities in connection with planting, cultivating, harvesting, and their success; they are extended to hunting, and, in the past, to war. Tribal ceremonies also reflect the establishment of the social order, such as the Emergence and Migration of peoples. They reflect the Indian's beliefs in his relationship to his fellow men and to the world about him and its order, both the social order and the equilibrium between the forces of nature. Balanced harmony prevalent in Indian art may possibly reflect this belief in an ordered universe.

Not only do the ceremonies give the puebloan peace of mind, but they also reflect his unity of purpose, his one-mindedness, his cooperative effort for the common good. It is in the dramatized dance that he brings together beauty, synthesis, rhythm, color. It is here that

433

he expresses his mystical relation with an unseen world. It is here that he gives thanks for the bounty he has received. Like the Hopi, the Rio Grande puebloan often expresses the belief that what he does will bring the desired reciprocal action from the powers of the universe. And again, the ceremony must be perfectly performed for that reason. Proper ceremonies must occur at the proper moment and with regularity. All paraphernalia must be correctly and traditionally prepared. Art enters at many points in all of this: the legend and myth are basic, forming the framework of the drama; songs, chants, and instrumental music accompany most of these rites; painting, sculpture, weaving, and many other art forms are essential to the proper functioning of the whole. All art expressions must be perfectly and traditionally performed or produced in order to attain the purpose of the ritual. This may explain in part the high artistic quality of much of the first easel art, particularly that produced by mature men, like Awa Tsireh, who were close to the ritual life of their village.

Thus the liturgical arts are of great import in the social order of the pueblo world. As that complex whole which might be referred to as the religion of these folk evolved, art forms developed hand in hand with their beliefs. As religion prospered through the well-being of the village, so too did art flourish. Just as religion, the political order, and society were greatly integrated, so too was art. And above all was tradition, a compelling force in organization and art alike. Through countless centuries this religion, this art, these traditions served the people well. This may explain in part many of the qualities which have been retained in easel art, for these beliefs affected all, they came through these people to be expressed in decorating ceremonial paraphernalia and objects of daily use.

Then came the Spanish. By force they made the pueblo folk of the Rio Grande accept a new and strange religion. Churches were built, and the Indian worshipped in them. Any outward evidence of his native worship was quelled. A group of civil officers was forced upon the people. But how could one cast aside that which had been essential to the well-being of all for centuries, that which was at the very core of existence? The breadth and depth of the religious in pueblo life can be measured in its survival against these great odds.

Time moved apace. Traders and then others from the eastern United States came into the Rio Grande, and a new chapter opened for the natives. Not only did the newcomers make every possible effort to crowd out the Indian, but also they tried to take away what little land had been left to him by the Spaniards. They tried to draw him away from his culture, offering no real substitute. This was greatly destructive because of the highly integrated life of the native. Further, to the Indian the loss of lands meant the loss of fields to

plant with corn; this, in turn, struck at the heartbeat of the pueblo: why pray for rain if there were no planted fields thirsting for water? If there were no dances, there would be no need for costumes, for drums, for chants; the integrated pueblo would begin to collapse. Art declined or disappeared in some of the villages where the white men were successful.

However, some pueblos managed to survive these Spanish-Anglo incursions. Some even continued in the old ways, worshipping in the village church and performing the Corn Dance and the Animal Dance, thus retaining the religion-dominated life as of old. Often art in one form or another flourished under these conditions. It was in such a pueblo, San Ildefonso, that watercolor painting was born; it has been in such pueblos that it has flourished. Few of the pueblos that have lost this integration, or that do not have this native religious domination, have produced outstanding traditional artists.

The latest historical blow to be struck the puebloans is the mechanization of their lives and increasing emphasis on personal freedom. These influences have been strong and have occurred in significant measure. They are striking at the innermost consciousness of the pueblo people, for the fresh knowledge of the control of dams and power machines, and scientific information about planting, irrigation, and cultivation ultimately will tear the ritual basis of pueblo unity to shreds. No longer can the religious philosophy based on the intimacies of the dance-rain-food-life and man-universe relationships be a reality. This, too, will become a legend, a legend known to fewer and fewer as the years speed by. What then of art? That chapter cannot be written for some years to come.

It should be kept in mind that not all the puebloans, much less all Southwest tribes, will react to these and other late circumstances in the same ways and to the same degree. Some, like the Navajos, have accepted modern machinery and all that comes in its wake and have become stronger as a tribe. On the other hand, to the end of the 1960s one Hopi village leader was still fighting the piping of water into his pueblo, for he was wary of what water and the other modern conveniences that would follow would do to his people, and, most of all, to their religion.

Should the Indian change in his art expressions? It is sheer sentimentality to expect him not to change, for when he reaches a static point he is dead. This unique form of art, Southwest Indian painting, is the end product of hundreds of years of growth, of expressions intimately related to distinct social orders, with added influences from other cultures. Art is a reflection of a culture; extremely rapid change in the social order, which will make something new out of the Indian, is bound to make something different

435

of his art. Joe H. Herrera and Patrick Swazo Hinds have expressed new forms on a high plane in their abstracts. Can the new culture produce more Joe H. Herreras, more Swazos? Certainly the new cultural aspects will produce new artists. Not the least of these influences is formal training in art itself; the late 1960s and early 1970s saw the beginnings of this dynamic change, as a result not only of the Institute of American Indian Arts in Santa Fe but of other art schools as well.

Another point might be kept in mind, a point that will explain some of the differences between the Navajo-Apache on the one hand and the puebloan on the other. The impersonal outlook of the puebloan as a member of a group, as a part of the whole, is quite different from the personal outlook of the Navajo-Apache. Ceremonies of the pueblo folk are designed to maintain the harmony in the universe and thus within the group. Apache-Navajo rites cure the individual. This may explain the impersonal reserve and dignity of much pueblo art, the more emotional art of the Navajo-Apache, from subject matter to treatment.

Few puebloan artists who have been reared closely within the village and according to its precepts have deviated from the tradition-focused expression in easel art. Navajo and Apache artists seemingly have found it easier to successfully digress, to stray into new paths of art style, to seek and to achieve stylistic change. But even with these two tribes, there remain those qualities which make their art Indian—the sensitive design, the strong and confident lines, the rhythmic repetition, the disciplined brush, the strange combination of directness and subtlety of the primitive.

If anything is basic in Southwest Indian art it is a feeling for design, perhaps more pronounced in pueblo groups than among the Apache-Navajo. Order and repetition are related to the decoration of objects; so, too, is the formalism that characterizes much native art. Formalism is the end product of many centuries' application of similar designs to given situations. It is in the dance group formation, the rhythmic step, the drum beat. It is also a quality intimately related to any arts that are deeply rooted in textile origins, for technology dictates a certain amount of formality whether the artist wishes it or not. The Indian has an innate feeling for symmetry and balance. As Cassiday says, he does not have to study dynamic symmetry, he *has* it.[2] Naturally this quality has carried over into easel art.

Although all religious expressions carry a heavy burden of established symbolic meaning, it does not follow, necessarily, that the same designs applied to paper convey the same symbolism. It is more likely that designs that evolved naturally, as a result of technological determinism, came to have certain meaning only in

436

certain context. To the modern artist, symbols are much more a part of a design or composition scheme. That this is true can be illustrated in the established color and form for certain designs for ritual use, whereas the modern watercolorist may vary both color and form according to the whims of the moment or the dictates of the situation. Thus, originality appears in the handling of old forms in the new media and with the new vistas by the easel artists.

Colors are often harmonious, subtle, and beautiful. Houser's colors are striking and forceful; harmonious and pleasing shades, with a generous use of Chinese white, are typical of Harrison Begay and Charlie Lee; Tsihnahjinnie's colors run the gamut from delicate, blending tones to harsh reds and purples. Tahoma often employed varied colors high in tone; Ma-Pe-Wi featured subtle shades of red and gray-black on dull tan, with a sprinkling of bright color, usually in conventional motifs. Tonita Peña had a gift for handling color, seldom using more than a splash of a bright shade to relieve a possible monotony of rich but subdued tones. In some of Patrick Swazo Hinds' paintings, color is so delicately controlled as to create a feeling of the mystical. Many Navajos are also clever in handling color-value changes, particularly in juxtaposed situations. As a whole, the Indians express great virtuosity in handling flat areas of color. This, too, is another inherited trait, for shading is practically unknown in prehistoric and historic native art.

The Indian watercolorist visualizes the completed picture before he puts brush to paper, and only rarely is there overpainting. This contributes further to his already clean and clear color potentials and overall unity of design or composition.

The combination of realistic and conventional themes, which was not unknown in native ritual art, is common in modern painting; it may be used simply, with a single conventional sun symbol, or some may be more complex, integrating convention with the realistic throughout the painting, in a manner more like some of the known kiva decorations. Or the circle is completed in a return to pure design, on a more sophisticated plane, in some of the most modern abstracts; and why not, since Indian art is rooted in the nonrepresentational; the Indian is a natural abstractionist. In later examples of such painting, greater virtuosity is often expressed in expanded color range, in more facile drawing, and in more complex creations. These comments, surely, would support the use of the term "traditional" for much Southwest Indian art, embracing extreme abstracts, particularly the cubistic, as well as other styles.

Many have criticized this term, "traditional"; some have referred to it as a misnomer, others have labeled it "trumped up." But what could be more traditional than art styles that are heavily laden

with qualities that go back hundreds of years? Superficially, this appears untrue, but as Southwest Indian easel art is analyzed more deeply, it becomes ever more apparent that the ties with the past, even the distant past, are strong.

Interestingly, there were sufficient cultural differences among the various tribes to foster three distinct styles—the semi-realistic Navajo-Apache; the perspectiveless Western Pueblo style with a bit of figure modeling; and the two-dimensional and heavily conventionalized Rio Grande puebloan. Each was to become traditional for its respective group; each of these traditional styles (despite deviations by individuals) prevailed to the end of the 1960–70 decade. Thus easel art perpetuates another of the qualities of the craft and ceremonial arts of painting, its tribal nature.

As long as Indian groups maintain qualities that make of them integrated tribes, and as long as individuals are highly absorbed into these groups, traditional art styles will continue, at least in some measure. On the other hand, where education, travel, and other personal experiences remove the individual artist from his tribal background and culture, the chances are great that traditional art will change. Experiences such as those to which young Indians have been exposed at the Institute of American Indian Arts in Santa Fe—for example, contact with and an opportunity to express non-Indian styles of painting—surely will have their influence on native Southwest easel art. Thus in the late 1960s and early 1970s there was discernible the beginning of a significant shift from tribe-inspired traditional art to individual, nontraditional styles. Actually, no one Indian had evolved his own distinctive, individual, nontraditional style by 1971, but certainly some, like R. C. Gorman, were moving in new directions. This trend may well be the beginning of the end of traditional craft-oriented styles, it may well mark the beginning of the entrance of the Indian artist into the field of the fine arts. The question may then be asked: Will the resultant art style be *Indian?* The hand of the white man is heavy. Only in the future and in the paintings of the future will one find an answer to this question.

Restrained action is the rule in early pueblo painting, particularly in the Rio Grande. Hopis seldom went beyond a restrained motion. It took the Navajos and Apaches to introduce vivid action. Thus some styles of presenting motion are tribal, as the Hopi; some are reflective of individual dignity and conservatism, as with Tonita Peña; some represent a carryover from the traditional art of design that is composed and ordered. Tribal or individual, there have been changes through the years. More recently, individuals from puebloan groups have been able to throw off the shackles of restrained motion, while some Navajos have portrayed quiescent and ordered scenes.

The treatment of the human form is interesting among modern watercolorists. In Precolumbian art and in the historic styles preceding the recent movement, there was relatively little in the way of realistic portrayals of human beings. Then came the San Ildefonso artists, concentrating largely on the masked ceremonial dancer. There were no difficulties involved here, except in the body parts and proportions. Hands and feet were often too small, but in time many of the artists conquered this problem. A few brave souls depicted the face, almost always in profile; it was not particularly human, and certainly not generally Indian; in this matter, Tonita Peña was one of the first to approach achieving a resemblance to her tribesmen in her depictions of them. When the face was turned full front, the Indian artist usually had still more trouble; some of those depicted seem scarcely human; many of them look as immobile or even as geometric as the masks worn by dancers. Other than these generally difficult problems, anatomical correctness marked the work of many of the artists.

The position of the figure was another problem. The technique of presenting the head and lower body and legs in profile and the shoulders in full front was common for almost all the early painters. Some corrections were made here also, but the majority of artists still have difficulties in this matter. None of these problems deterred the Indian artist from painting endless human beings, masked and unmasked, costumed in hunting, or war, or everyday, dress. Children are seldom represented, perhaps because in part at least they were seldom participants in the dances and other ritual scenes, and perhaps too because in a majority of cases when attempted they turn out to look like wizened old men. Houser is one of a few Indian artists whose portrayal of a child looks like what it is meant to be.

Many of the Southwest artists, the Navajos and Apaches in particular, have become very proficient in painting various animals. Early in his painting career, Tahoma showed great skill in depicting a crouching lion, a frisky colt, or a proud horse. He improved his animal forms in later years, making them more realistic in spite of their unreal coloring. In a single painting, Ma-Pe-Wi could depict decidedly realistic horses as well as most conventional or highly stylized buffalos. To him, it seems, the horse was reality, the buffalo but a tradition. Truly magnificent animals were painted by Tahoma, Houser, and Nailor; long-legged, gentle creatures were portrayed by Lee and Begay; Tsihnahjinnie could paint horses as realistic as any, more ethereal, or large enough to accommodate a half dozen youngsters on one unnaturally long back, or as wild as the wildest. Northern Rio Grande painters, from the Taos artists to Julián Martínez, were inspired by Plains horses, but they usually portrayed them

439

as too short bodied. Pop Chalee's horses are utterly fantastic, with manes and tails greater by far than the animals themselves. Sometimes animals are painted in flat color; more often they are modeled, either in simple lines or in the full use of shading in color. In general, the treatment of life forms, when traditional subject matter is used, is more often conventional or stylistic in manner. However, if the subject is nontraditional, there is apt to be more realism in the portrayal. Natively, Indian art is two-dimensional, that is, with length and breadth but no depth. Much of the early presentation of dancers was in this tradition; many artists still paint in this manner. " . . . the bright little figures always stand out in space with nothing to show in what world they move."[3]

Some artists have developed a suggestion of depth in the individual figure, in simple lines, or more perspective in European modeling in color. Further, some artists, particularly the Navajo, have introduced a third dimension into the entire composition. This ranges from a simple ground line, which is barely suggestive of this feature, to full European landscape. In the latter, there is limited work of high caliber. In many pueblo and Navajo paintings the background is often distilled to the barest essentials. Individuals often started with a two-dimensional, flat concept in painting and gradually developed perspective in various ways—again, some attaining full European perspective. Interestingly, some individual pictures combine both two- and three-dimensional work. The most recent development along these lines is to cover the entire background with some form of abstraction; cubistic or impressionistic treatments are common. Sometimes a realistic subject, such as yeibechai or other dancers, is painted against a background of yei or pictographs that are subdued in color and definition of form as though the artist were telling a story with religious or historic connections.

Many times Southwest Indian painting has been likened to that of Oriental peoples, by both the layman and the trained critics. Any further remarks on the subject should be prefaced by the statement that there can be no connection except in terms of a similar stage in the cultural and art growth of the two distant peoples. The similarities now mentioned will be pointed in that direction. Comparisons are based solely on the fact that certain traits in Indian art are comparable to the same traits in Oriental art, as a common stage in their respective developments, even though it is possible that a few individual Indian artists may have seen private or other collections of Oriental painting.

Because of the greater knowledge of the art of the Eastern world, certain traits have come to be known as Oriental. Some of these traits include a flat decorative style, lack of European perspec-

tive, sensitivity to color, delicacy and simplicity of line, the absence of backgrounds and foregrounds, decorative stylization, an objective character, a lack of shadows, and sensitive drawing. Olive Rush wrote of this problem, "But while the Indian color recalls the Persian, his command of line links him with the Chinese painters."[4]

A number of more specific traits in Japanese art further illustrate this comparison. There is a flatness in composition and little modeling in figures; when done, modeling is often achieved through the use of lines. There is no interest in shadows; and a concentration upon single figures to the total or partial exclusion of surrounding detail. When background is used there is a difference between the presentation by the Japanese and the Southwest Indian. The former softens it; the latter gives it the same sharpness as the foreground. "But the Japanese passion for precise rightness and for decorative sharpness leads to amazing feats in delineation of those details that the artist deems important to his purpose. There is this quality of strict formalization and devotion to miniature truth, in countless works."[5] In these words, Cheney might well have been speaking of Southwest Indian art rather than Japanese. It may be predicted that these traits will linger in traditional styles of Indian art.

One additional point in relation to the significance of Indian art is its ethnologic interest. This has been mentioned time and again and for good reason. The integrity of the work of many of the artists is apparent. Some artists, too, dipped back into the past and recorded ceremonials or costumes now obsolete. To be sure, it is obvious that sometimes the ethnological aspects robbed the picture of its artistic flavor. Emery has summed up such situations very aptly in these words: "The depiction of domestic activities, games, etc., will sometimes be of greater interest to the ethnologist than to the artist, with what the painting tells taking precedence over form and design of its telling."[6] On the other hand, many paintings combine artistic and ethnologic values, many also reflect changes in native culture through the years. As young people move out of their native habitats, much ethnologic detail and accuracy is lost.

The white man has given encouragement to the Indian in the realm of easel art in several ways. He has created interest through exhibits; he has encouraged the Indian by offering prizes. Subject matter has been suggested to the Indian artist. Materials have been made available to him, including everything from crayons to tempera, Shiva, oils, fresco, casein, casein-tempera, gouache, and acrylics. In a few cases the Indian has returned to his own background and used earth colors. Many Indians were trained in the art departments of the Santa Fe, Albuquerque, and other Indian schools; many have had higher formal training. But those Indians who never

441

went to school and who were not exposed to this direction, painted little differently from their trained tribesmen within the scope of the traditional styles.

A closer look at a few pertinent points relative to these more influential aspects of Indian contacts and influences follows.

Traders, as noted before, have been and still are influential on the Indian and his art. For years the craft arts were in the limelight, but, beginning in the 1950s, and more importantly in the 1960s, ever-greater interest was expressed in painting by an ever-increasing number of traders. More personal contacts between trader and artist made for better understanding on an expanding scale. Not only did the traders aid the Indians in obtaining better materials and media and by guiding them along more desirable lines of artistic expression, but also they helped the young artists with their personal problems. Too often the Indian is sadly caught between two cultures, his and that of the white man. Too often the money from the sale of paintings has brought liquor to the Navajo hogan or pueblo room, carrying tragedy in its wake. Some traders have worked long and conscientiously to counter this situation; a few have succeeded, but all should be lauded for their efforts. The late M. L. Woodard made an especially worthy contribution in this direction.

An influence that has been felt by the Indian artist and the general public alike has been the written word. Informed writers of books, articles, and newspaper items have called more and more attention to the Indian painter and craftsman, and have aided the more intelligent selection of Indian art by the buying public. And certainly the notation in the *Wall Street Journal* that Indian art was the third best investment in the country did not interfere with the growing popularity of this commodity.

Another major influence on Southwest Indian painting has been that of the collector. Although both private and public collections existed prior to 1950, certainly the trend toward collecting took a new vigor during the late 1950s and was accelerated throughout the 1960–70 decade. Literally hundreds of paintings found their way into collections during these years. A feverish attendance at preview exhibits and equally feverish buying of paintings encouraged a healthy revival of painting and undoubtedly contributed to the making of full-time artists out of some young Indians who might otherwise have been forced to follow other endeavors.

The importance of museum collections of paintings is obvious; private collections are equally valuable in many instances. Both have become repositories for collections for posterity. Individuals are often aware of the need to keep their collections intact, and more frequently they are acquiring with a definite objective in mind, be it

the paintings of a single individual, a tribe, or the entire Southwest; some are keeping valuable records on each painting; and some are prepared to leave their collections to a museum or art gallery where they can be of permanent value to posterity.

A profound influence on Southwestern Indian artists has been exerted by exhibits of their works. Some museums and art galleries have done this for years, particularly in Santa Fe and Albuquerque, New Mexico, Flagstaff, Arizona, and at the Philbrook, Tulsa, Oklahoma. The Gallup Ceremonial competitive exhibits have been important for years also. During the 1960–70 decade each of these institutions continued in its significant role and others joined them. The Heard Museum, Phoenix, has featured general and one-man shows. One of the most influential of all the competitive exhibits has been the Scottsdale National Show, Scottsdale, Arizona. It began in 1962 with a modest number of paintings; in 1969, more than 1,000 paintings were entered in competition. For this show, the judges are chosen for their different perspectives and inclinations; consequently there is recognition of all styles of art, from the most traditional to the most "mod" of modern art. A successful effort has also been made to offer considerable prize money, which, in turn, attracts some of the best of the American Indian artists. Great appreciation is felt by all for Mr. Paul F. Huldermann, who was the instigator and original organizer of this outstanding show. His enthusiasm and continued interest have contributed to the ever-increasing importance of this show.

Other Indian art shows throughout the country reflect an effort on the part of their directors to recognize change in Indian painting during the 1960–70 decade. As early as 1959, Philbrook Art Center awarded its top prize to an abstract painting by a Plains Indian. Although admittedly dedicated to the traditional in Indian art, the Gallup Ceremonial show directors created in the late 1960s two new classes in painting that acknowledged the new and modern trends. These represent concrete recognition of a changing art.

The Indian painter has progressed far beyond his beginning years at the Santa Fe Indian School wherein he established many aspects of traditional styles, and where, under formal tutelage, many Indians made the transition from craft to easel art. Other schools exerted great influence on individuals or groups of artists through the 1940s, the early 1950s and into the 1960s, among them the Phoenix and Albuquerque Indian Schools and many elementary schools such as Jémez, New Mexico, and some day schools on other reservations. Usually it is the individual instructor who succeeds in developing an interest in art—and then starts the real artist on his way. Lloyd New (Kiva) had a great influence on his students at the Phoenix

443

Indian School; Al Momaday likewise has exerted considerable influence on his students at Jémez Day School.

The Institute of American Indian Arts at Santa Fe was the result of an interesting series of events. Teaching of art in Indian schools had been on the decline during the mid- and late 1950s, and few new artists were developing. On the other hand, production and quality in the craft arts was rising but there was no comparable economic return to the Indian. There was a profound need for the consumer public to be better informed and educated in relation to good Indian art. It was also sensed by a few that new directions were needed to allow the fulfillment of the potentials of the Indian artist.

A conference was set up at the University of Arizona, sponsored by the Rockefeller Foundation, to explore the above and other problems and to "exchange ideas on the present status and the possible future of American Indian art."[7] Involved in the meetings were Indians, teachers of art in elementary schools and universities, traders and dealers in Indian art, museum representatives, and others. The result of this conference was the establishment of the Indian Art Project, held at the University of Arizona for three summers, 1960, 1961, and 1962. Generously supported by the Rockefeller Foundation, the project exposed young Indians with artistic potentials to many new facets of their own art and to world art, and they were introduced to new and exciting media, techniques, and styles in the craft and painting fields. The students themselves were encouraged to experiment, to explore, and to seek new directions in art. As a result of attendance at this school, a number of the students have followed art as a life career. And, as a result of both the conference and the project, old departments of art in Indian schools were reactivated and some new ones were established. Among the latter was the Institute of American Indian Arts, Santa Fe—commonly referred to as IAIA.

Increasing quantities of student entries in competitive exhibits in the mid- and late 1960s testify to the revived art activity in the Indian schools. In the early 1970s the most vigorous, the most capable, and the most important school in relation to the future of Indian art was the Institute in Santa Fe. The impact of its credo, "Tradition serves as a vital springboard for new expression," was still being felt in these years despite individuals who turned in other directions.

In the early 1970s, the IAIA was serving as one of the most dynamic influences on the changing art of the native American. The aims of the Institute are to meet the social and academic needs of Indian students and to give them specific training in various artistic fields. Many Southwest Indians of high school and post-high school levels (sixteen to twenty–two years of age), have been attending this

school; as they return to their respective tribes or go into the white man's world, unquestionably they will influence their fellow artists. The IAIA offers broad training, including everything from the crafts to dramatics; in painting, the student has wide choices from traditional to the most progressive of modern art—abstract, expressionism, and the like—all made possible by a variety of faculty members, many of them artists in their own right.

Organized in 1962 under the Bureau of Indian Affairs, U.S. Department of the Interior, the Institute of American Indian Arts accepts students with one-fourth or more Indian blood from any of the fifty states. It has good representation from this large area, which is important in itself, for this fosters an exchange of ideas of students from vastly different cultural backgrounds. Some of these students have attended other art schools; again this offers further possibilities in exchange of ideas pertaining to art. All of these situations will contribute heavily to further fusions of art styles, exchange of subjects, and a general breaking away from the limitations of the three traditional ways of painting. The art coming out of this school often has a polished and professional quality, and frequently reflects the influence of individual instructors.

One other organization should be mentioned, namely, American Indian Artists. This nonprofit group was organized in February, 1966, to assist young artists and to make the public more aware of American Indian art. Its members held their first National Exhibit in Oakland, California, the year of organizing.

All of these new influences the Indian artists have shared, along with their common roots that have given them common nourishment and traits basically alike. What of the future of this art? What will happen when the Indian artist is cut off from his basic roots, and the "new" influences take over? This is occurring.

World War II and service in the armed forces since then have taken Indians to far places and have introduced them to new facets of life. This has been, probably, one of the most dynamic influences on Indian art, and the war may well account for much of the degeneracy that followed in the later forties. Some of the young artists returned from war in a confused state. Some, like Beatien Yazz, were able to reestablish themselves. Many others did not sufficiently adjust to new conditions to enable them to return to painting. During these years the young men were made aware of the importance of education, not only for themselves but also for younger members of their respective groups; further, they made their families aware of it. Education is apt to destroy the basic pueblo unity, for it will put emphasis upon things that are not of the pueblo tradition. Service during the war and thereafter increased the Indians' interest in the outside

445

world; it equipped them for new jobs. Appreciating fresh approaches to life, other than the old and formalized traditional ways, some of these young men—and women, too—have been drawn away from their homes. They have sought employment and a new way of life away from their homelands; they have acquired scientific knowledge that is far removed from the traditional. Some Indians have been able to continue painting in spite of separation from their culture, while others have not been able to make this adjustment. This is particularly true of some of the youth of the Rio Grande pueblos.

Indian culture is an on-going affair. New experiences are like a breath of fresh air, invigorating and life-giving. Changes occurred at the turn of the century to give birth to easel art; further cultural changes will but speed this art on its way, will give it new directions.

Nevertheless, the roots are strong—strong enough to have survived changes in the past. In a sense, the Indian has been impregnable. In the new changes, with the freedom offered by new media, it is inevitable that new forms would develop, still influenced in part by tradition.

Indian art was not on the wane in the early 1970s. Indicative of this are the facts that, first, there were more and more upcoming and promising youthful artists, and second, practicing young artists were receiving top prizes along with their older and established tribesmen. Examples of this situation would be Helen Hardin and her mother, Pablita Velarde; Tony Da who has shown even more promise than his father, Popovi Da, or his grandfather, Julián Martinez; R. C. Gorman who was rapidly gathering more honors than his father, Carl Gorman—to mention but a few. Tony Begay was another outstanding young artist. As always, the younger stand on the shoulders of their elders; they stand taller, they have broader vistas, they build on firmer and more tried foundations, they are nourished by deeper roots.

"In his bag the god carries a ray of the sun with which to light his pipe."[8] May this "ray" be the colors of the palette; may the lighting of the pipe be the ever-new and fresh forms of art; may the "bag" in which the ray is carried be the deep roots of Indian culture, to enfold and warm the inevitable change that makes art an always creative gesture and force to enrich men's lives.  ■

# Supplementary Information

# Notes to the Text

### CHAPTER ONE

1. Quoted in Ewing, 1969, p. 33.
2. Ewing, 1969, p. 39.
3. This fact was brought to the attention of the author by Bernard Fontana in 1969.

### CHAPTER TWO

1. Harrington, 1933, pp. 109–13.
2. Gladwin, Haury, Sayles and Gladwin, 1937, pp. 199–202.
3. Haury, 1936, Figs. 1, 3, and 4.
4. Vaillant, 1939, p. 5.
5. Morris and Burgh, 1941, Figs. 12–19, 23–32, 35–39.
6. Holmes, 1886, p. 453.
7. Kidder, 1924, Plate 31.
8. Judd, 1954, Plate 67.
9. Martin and Willis, 1940, Plate 106.
10. Amsden, 1936, p. 44.
11. *Ibid.,* p. 52.
12. *Ibid.,* p. 44.
13. Haury, 1936, Fig. 1.
14. H. S. and C. B. Cosgrove, 1932, Plates 108–21.
15. *Ibid.,* Plates 192–233.
16. Kabotie, 1949, preface.
17. Kidder, 1924, p. 103.
18. Chapman, 1938, p. 147.
19. *Ibid.,* p. 143.
20. *Ibid.,* Plate 11.
21. *Ibid.,* p. 147 and Fig. 8.
22. Haury, 1945, p. 64.
23. *Ibid.,* pp. 65–70; also Figs. 15, 16.
24. Kidder and Guernsey, 1919, p. 192–98.
25. *Ibid.,* p. 197.
26. Cummings, 1940, Plate XXXIV.
27. Smith, 1952.
28. Hewett, 1938, pp. 26, 115, 148; Tanner, notes from original paintings and copies of the same, 1948, Santa Fe, New Mexico.
29. Hibben, 1960.
30. Prudden, 1914, pp. 48, 49.
31. Smith, 1952, p. 57.
32. Martin, 1936.
33. *Ibid.,* Plates LVIII, LIX, LXII.
34. *Ibid.,* Plate LX.
35. *Ibid.,* Plates LXII and LXIV.
36. Hewett, 1938, p. 92.
37. Villagrá (1610), 1933, p. 140.
38. *Ibid.*
39. Vivian, 1935, pp. 113–19; Sinclair, 1951, pp. 206–15.
40. Tanner notes—all comments on Kuaua from notes taken in 1948, Museum of New Mexico, Santa Fe, from original murals and reproductions unless otherwise indicated.
41. Smith, 1952, p. 77.
42. *Ibid.,* p. 107 ff.
43. *Ibid.,* p. 22.
44. *Ibid.,* p. 30.
45. *Ibid.,* p. 31.
46. *Ibid.,* p. 113.
47. Martin, 1936, Plate LX.
48. Smith, 1952, pp. 107–12.
49. *Ibid.,* p. 107.
50. *Ibid.,* p. 110.
51. *Ibid.,* p. 111.
52. *Ibid.*
53. *Ibid.,* p. 112.
54. *Ibid.,* p. 113.
55. *Ibid.,* p. 148.
56. *Ibid.,* pp. 115, 116.
57. *Ibid.,* pp. 120–48; also pp. 172–250.
58. Hibben, 1960.
59. Smith 1952, Figs. 27, 28.

### CHAPTER THREE

1. Chapman, 1936, p. xi.
2. Sloan and LaFarge, 1931, p. 27.
3. Fewkes, 1919, pp. 217, 218.
4. Marriott, 1948, pp. 217, 218.
5. Chapman, 1936, pp. xi–xiv, 3–39.
6. New Mexico Department of Vocational Education, 1943.

7. Bunzel, 1929, pp. 38–42; M. R. Colton, 1938, pp. 6–11.
8. M. R. Colton, 1931, p. 6; Bartlett, 1938, p. 22; M. R. Colton, 1938, Figs. 9, 11–14.
9. Amsden, 1934, pp. 32 ff.
10. Vaillant, 1939, p. 36.
11. Sloan and La Farge, 1931, p. 19.
12. Mera [1947], Plate 29.
13. M. R. Colton, 1938, Figs. 5, 6; *ibid.*, June, 1931, pp. 4–6.
14. Parsons, 1929, p. 200.
15. Earle and Kennard, 1938, Plate XXII.
16. *Ibid.*, Plate XXI.
17. Haile, 1947, plate facing p. 46.
18. *Ibid.*, plate facing p. 60.
19. *Ibid.*, plate facing p. 40.
20. *Ibid.*, p. xiv.
21. H. S. Colton, 1949, Fig. 15.
22. *Ibid.*, Fig. 5.
23. Earle and Kennard, 1939, Plate XXII.
24. Simpson, 1850, Plates 7–11.
25. *Ibid.*, Plate 7.
26. Ellis, 1952, p. 150.
27. *Ibid.*, pp. 149, 150.
28. Simpson, 1850, Plate 8.
29. *Ibid.*, Plate 11.
30. *Ibid.*, Plate 9.
31. Bloom, 1938, p. 228.
32. Smith, 1952, pp. 212–16.
33. White, 1932, p. 113.
34. *Ibid.*, Plate 11.
35. Stevenson, 1904, Plate CVIII.
36. *Ibid.*, p. 453.
37. *Ibid.*, Plate CX.
38. *Ibid.*, Plate XXXVI.
39. *Ibid.*, p. 179.
40. Smith, 1952, Fig. 36a.
41. *Ibid.*, Fig. 36c.
42. Bourke, 1884, p. 120.
43. *Ibid.*, Plate XXIII.
44. *Ibid.*, p. 132.
45. *Ibid.*, Plate XXIV.
46. Smith, 1952, p. 124, Figs. 27a, 90c.
47. All Pueblo shields herein described were observed at Clay Lockett's, Tucson, Arizona, in 1952.
48. Tanner, 1948, pp. 26, 27.
49. *Ibid.*, p. 27.
50. Comments following on pictographs and petroglyphs based on Schaafsma, 1963.
51. Stevenson, 1904, Plate CII.
52. In Arizona State Museum, Tucson.
53. Vaillant, 1939, p. 3.
54. Sloan and La Farge, 1931, p. 5.

## CHAPTER FOUR

1. Vaillant, 1939, p. 34.
2. Woodward, correspondence, 1949.
3. Van Valkenburgh, conferences, 1948.

4. Woodward, correspondence, 1949.
5. Shufeldt, 1889, pp. 241, 242.
6. *Ibid.*, p. 242.
7. *Ibid.*, pp. 243–44.
8. *Ibid.*, pp. 243, 244.
9. Fewkes, 1903.
10. Indian Arts Fund Collection, Santa Fe. (See Tanner and Forbes, 1948, for details of this collection as it was then.)
11. Denver Art Museum Collection.
12. On back of painting, apparently in hand of artist, Denver Art Museum Collection.
13. "Historic Indian Paintings," *El Palacio*, November 1941, p. 259.
14. Dutton, 1942, p. 143.
15. Dietrich, 1936, p. 20.
16. Henderson, 1931, p. 11.
17. Dunn, 1968, p. 205.
18. Marriott, 1948, pp. 165, 166.
19. Dietrich, 1936, p. 21.
20. Dunn, 1951, p. 344.
21. Dietrich, 1936, p. 21.
22. Dunn, 1951, pp. 344, 345.
23. Dunn, 1968.
24. Dunn, 1935, p. 426.
25. *Ibid.*, p. 428.
26. *Ibid.*, pp. 426, 427.
27. *Ibid.*
28. *Ibid.*, p. 435.
29. Coze, 1936, pp. 13–16.
30. The late Frank Patania, Sr., conferences, 1949.

## CHAPTER FIVE

1. Bandelier and Hewett, 1937, p. 59.
2. "Annual Exhibition of the Indian School," *El Palacio*, May 1945, p. 82.
3. [Dutton], 1942, pp. 128, 129.
4. Dietrich, 1936, p. 21.
5. [Dutton], 1942, pp. 128, 129.
6. Chapman, 1938, p. 141.
7. Dietrich, 1936, p. 20.
8. Dunn, 1951, p. 340.
9. *Ibid.*
10. Hewett, 1938, p. 126.
11. *Ibid.*
12. Hewett, 1922, p. 108.
13. "Indians and Indian Life, Exhibit of Indian Paintings," *El Palacio*, May–June 1920, p. 125.
14. "It Is Written," *El Palacio*, April 1, 1922, p. 91.
15. Cahill, 1922, p. 131.
16. *Ibid.*, p. 128.
17. *Ibid.*, and illus. p. 126.
18. Bandelier and Hewett, 1937, p. 60.
19. Simpson, 1850, Plates 7–11.
20. *Ibid.*, Plate 11.
21. Kenneth M. Chapman, personal conferences, 1952.
22. "Indian Artist Honored," *El Palacio*, July 1920, p. 183.
23. "The Southwest Indian Fair," *El Palacio*, October 16, 1922, p. 96.
24. "New Mexico Painters," *El Palacio*, November 15, 1925, p. 218.
25. Marriott, 1948, p. 113; also see pp. 39–52.
26. *Ibid.*, pp. 276, 277.
27. Dunn, 1968, p. 211.
28. Popovi Da, personal conference, August 8, 1968.

29. "Annual Exhibition at the Indian School," *El Palacio*, May 1945, p. 82.
30. Dunn, 1968, p. 324.
31. Data for this development compiled from Herrera show, Art Gallery, Museum of New Mexico, Santa Fe, 1952; also Dunn, 1952, pp. 376–83.
32. Smith, 1952, p. 31.
33. *Ibid.*, p. 113.
34. "April at the Art Museum," *El Palacio*, April 1944, pp. 77, 78.
35. Jones, October 1948, p. 326.
36. Forbes, 1950, p. 246.
37. "Death of Artist Ben Quintana," *El Palacio*, January 1945, p. 9.
38. C. S., *El Palacio*, May 1939, p. 114.
39. Hewett, 1922, p. 107.
40. Pach, 1920, p. 343.
41. Hewett, 1922, p. 108.
42. "Museum Notes," *El Palacio*, February 3, 1932, p. 68.
43. Dietrich, 1936, p. 22.
44. "Kiva Murals Shown," *El Palacio*, July 6–August 3, 1938, p. 19.
45. Alexander, 1932.
46. Dunn, November 1952, p. 338.
47. "Exhibit of Indian Paintings," *El Palacio*, June 20–27, 1934, p. 200.
48. Dunn, November 1952, p. 341.
49. Velarde, 1960.
50. Jones, 1947, p. 143.
51. Snodgrass, 1968, p. 205.
52. "Painters and Sculptors," *El Palacio*, June 1, 1925, p. 239.
53. Forbes, 1950, p. 240.
54. Morang, 1940, p. 118.
55. Snodgrass, 1968, p. 51.
56. Forbes, 1950, p. 243.
57. Represented in the Laboratory of Anthropology Collection, Santa Fe.
58. Cassiday, 1938, p. 22.
59. Forbes, 1950, p. 241.
60. "Indian Art Exhibit," *El Palacio*, October 1941, p. 235.
61. Wolf Robe Hunt, personal communication, August 14, 1968.
62. *Ibid.*
63. Bucklew, 1966, p. 22C.
64. *Ibid.*
65. *Ibid.*
66. Hunt, personal communication, August 14, 1968.

### CHAPTER SIX

1. Lockett, 1933, p. 21.
2. Thompson and Joseph, 1944, pp. 36–44.
3. *Ibid.*, p. 44.
4. Fewkes, 1903, p. 14.
5. *Ibid.*
6. *Ibid.*, Plate L and p. 114.
7. *Ibid.*, Plate XXXVI.
8. *Ibid.*, p. 15.
9. *Ibid.*, Plate XXII.
10. *Ibid.*, Plate XLIX.
11. *Ibid.*, Plate XXXVIII.
12. *Ibid.*, Plate XX.
13. *Ibid.*, Plate XLIII.
14. *Ibid.*, Plate LIII.
15. *Ibid.*, Plate XLVII.
16. *Ibid.*, Plate LIII.
17. *Ibid.*, Plate XLIII.
18. *Ibid.*, Plate XXIV.
19. *Ibid.*, Plate LIII.
20. "Further Note on Indian Painting," *El Palacio*, March 1949, p. 76.
21. De Huff, 1924, pp. v, vi.
22. Tanner, 1951. Material on Kabotie taken from this article.
23. Bywaters, 1947.
24. "Kabotie Awarded Guggenheim Fellowship," *El Palacio*, June 1945, p. 119.
25. Kabotie, 1949, preface.
26. Smith, 1952.
27. Pach, 1920, p. 345.
28. Fred Kabotie, personal interview, April 18, 1969.
29. Alfred Whiting, personal conferences, 1948.
30. The late Frank Patania, Sr., personal conferences, 1949, for many details.
31. Jacobson and D'Ucel, 1950, p. 7.
32. Lemos, 1935, p. 417.
33. Nelson, 1937, Plates VII and misc. to XXXII.
34. *Ibid.*, Plates XXXV, XXXVI, XXXVIII, XL, XLI, and XLII.
35. The late Frank Patania, Sr., personal conferences, 1949.
36. Lemos, 1935, p. 417.
37. Alfred Whiting, personal conferences, 1948.
38. Smith, 1952, Figs. 27, 28.
39. Jones, 1949, p. 185.
40. Alfred Whiting, personal conferences, 1948.
41. *Ibid.* (Whiting contacted Timeche, December 8, 1947.)
42. Barton Wright, personal interview, August 14, 1969.
43. "Kooyama—Hopi Indian Boy Painter," *Progressive Arizona*, August 1927, p. 28.
44. Barton Wright, personal interview, August 14, 1969.
45. Alfred Whiting, personal conferences, 1948.
46. Loloma, personal conferences, 1953.
47. Jones, 1947, p. 145.
48. Alfred Whiting, personal conferences, 1948.
49. Loan Collection, Denver Art Museum.
50. Some of the paintings in this collection are dated in the early 1900s.
51. Alfred Whiting, personal conferences, 1948.
52. Jones, 1948, p. 185.
53. Michael Kabotie, personal interview, November 8, 1968.
54. Naha, personal interview, November 18, 1967.
55. The late M. L. Woodard, personal interview, April 14, 1969.
56. Talaswaima, personal interview, April 8, 1967.
57. Lomakema, personal communication, November 14, 1968.
58. Harvey, 1968.
59. Indian Arts Fund Collection, Santa Fe.
60. *Ibid.*
61. *Ibid.*
62. *Ibid.*
63. Snodgrass, 1968, p. 212.

451

## CHAPTER SEVEN

1. Details of his life are taken from personal conference, March 11, 1948, and from informal visits, 1948–1950, and 1969, with Begay.
2. Dietrich Collection, now part of the Dunn Collection.
3. Wyman, 1967.
4. All personal data on this artist from personal conferences, 1948–1953.
5. C. S., *El Palacio,* May 1939, p. 113.
6. Jones, 1952, p. 294.
7. *Ibid.,* p. 295.
8. Dunn, 1968, pp. 320–21.
9. All facts pertaining to the life of Charlie Lee from personal conference, March 11, 1948, and informal visits, 1948.
10. *Ibid.*
11. Watson, personal conferences, 1948.
12. Jones, 1947, pp. 143, 144.
13. Richard Van Valkenburgh, personal conferences, 1948, and brief autobiography written in hand of Shirley in possession of Van Valkenburgh.
14. Clay Lockett, personal conferences, 1946.
15. Van Valkenburgh, 1948, pp. 4, 5.
16. Mural was in the Arizona Title and Trust Co., Tucson, Arizona. The building has since been razed.
17. Hannum, 1944, p. 58, places his birth in 1930 or 1931.
18. *Ibid.*
19. *Ibid.*
20. *Ibid.,* p. 57.
21. *Ibid.*
22. Laboratory of Anthropology Collection, Santa Fe.
23. "Annual Indian School Exhibit," *El Palacio,* May 1944, p. 83.
24. The Amerind Foundation, Inc., Collection, Dragoon, Arizona.
25. On one of his paintings, Dietrich Collection, "age 19, 1937."
26. Date of birth written on one of his paintings.
27. Schaefer, 1940, p. 8.
28. Most of the facts in this paragraph from Schaefer, 1940.
29. *Ibid.,* p. 35.
30. Clark, the four titles in the *Little Herder* series, 1940.
31. Clark, *Little Herder in Autumn,* 1940, p. 91.
32. *Ibid.*
33. *Ibid.,* p. 50.
34. From age on a dated picture, Dietrich Collection.
35. "Birney Book Illustrated by Indian Artist," *El Palacio,* January 1, 8, 15, 1936, p. 9.
36. *Ibid.,* p. 8.
37. Snodgrass, 1968, p. 54.
38. Rush, 1937, p. 106.
39. Carl Gorman, personal communication, March 2, 1969.
40. Chee, personal communication, March 2, 1969.
41. Draper, personal interview, August 14, 1969.
42. R. C. Gorman, personal communications, 1967–1969.
43. Bittner, 1962.
44. Tanner, 1968, [p. 39].
45. Cohoe, discussion based on personal communications, December 1968, and October 6, 1969.
46. Roger and Ernest Lewis, personal communication and interviews, August 8, 1968.
47. Dietrich Collection.
48. *Ibid.*
49. Jones, 1948, p. 185.
50. Carl Vicenti, personal communication and correspondence, 1968–1969.
51. Keith Basso, interview, September 10, 1968.

## CHAPTER EIGHT

1. Henderson, 1931, p. 3.
2. Cassiday, 1938, p. 32.
3. Underhill, 1945, p. 130.
4. Rush, 1937, p. 106.
5. Cheney, 1937, p. 482.
6. Emery, 1950, p. 188.
7. *Directions in Indian Art.*
8. Tozzer, 1909, p. 325.

# Bibliography

Alexander, Hartley Burr. *Pueblo Indian Painting*. Nice, France: C. Szwedzicki, 1932.

Amsden, Charles Avery. *Navaho Weaving*. Santa Ana, Calif.: Fine Arts Press, 1934.

————. *An Analysis of Hohokam Pottery Design*. Medallion Papers, No. 23. Globe, Ariz.: Gila Pueblo, 1936.

"Annual Exhibition of the Indian School," *El Palacio*, Vol. 52, No. 5, pp. 81–82, Santa Fe, N.M., May 1945.

"Annual Indian School Exhibit," *El Palacio*, Vol. 51, No. 5, pp. 83–84. Santa Fe, N. M., May 1944.

"April at the Art Museum," *El Palacio*, Vol. 51, No. 4, pp. 77–78. Santa Fe, N. M., April 1944.

Bandelier, Adolph F. and Edgar L. Hewett. *Indians of the Rio Grande Valley*. Albuquerque: University of New Mexico Press, 1937.

Bartlett, Katherine. "Notes on the Indian Crafts of Northern Arizona," *Museum Notes*, Vol. 10, No. 7, pp. 21–25. Museum of Northern Arizona, Flagstaff, January 1938.

"Birney Book Illustrated by Indian Artist," *El Palacio*, Vol. 40, Nos. 1–3, pp. 8–9. Santa Fe, N. M., January 1, 8, 15, 1936.

Birney, Hoffman. *Ay-Chee, Son of the Desert*. Philadelphia: Pennsylvania Publishing Co., 1935.

Bittner, Herbert. *Kaethe Kollwitz*. New York: Thomas Yoseloff, 1962.

Bloom, Lansing B. (ed.). "Bourke on the Southwest, XIII," *New Mexico Historical Review*, Vol. 13, No. 2, pp. 192–239. Albuquerque, N. M., April 1938.

Bourke, John G. *The Snake-Dance of the Moquis of Arizona*. New York: Charles Scribner's Sons, 1884.

Bucklew, Joan. *Arizona Republic*. May 8, 1966.

Bunzel, Ruth L. *The Pueblo Potter*. New York: Columbia University Press, 1929.

Bywaters, Jerry. "Southwestern Art Today—New Direction for Old Forms," in *Six Southwestern States*, an exhibition by Dallas Museum of Fine Arts, June 15–September 14, 1947.

Cahill, E. H. "America Has Its Primitives," *El Palacio,* Vol. 12, No. 10, pp. 125–31. Santa Fe, N. M., May 15, 1922.

Cassiday, Ina Sizer. "Art and Artists of New Mexico," *New Mexico,* Vol. 16, No. 11, pp. 22, 32, 33. Albuquerque, November 1938.

Chapman, Kenneth M. *The Pottery of Santo Domingo Pueblo.* Memoirs of the Laboratory, Vol. 1. Santa Fe, N. M., 1936.

———. "Pajaritan Pictography: The Cave Pictographs of the Rito de los Frijoles," Appendix I of *Pajarito Plateau and Its Ancient People,* by Edgar L. Hewett. Albuquerque: University of New Mexico Press, 1938.

Cheney, Sheldon. *A World History of Art.* New York: Viking Press, 1937.

Clark, Ann. *Little Herder in Autumn.* Phoenix: U. S. Office of Indian Affairs, Education Division, Phoenix Indian School, 1940.

———. *Little Herder in Spring.* Phoenix: U. S. Office of Indian Affairs, Education Division, Phoenix Indian School, 1940.

———. *Little Herder in Summer.* Phoenix: U. S. Office of Indian Affairs, Education Division, Phoenix Indian School, 1940.

———. *Little Herder in Winter.* Phoenix: U. S. Office of Indian Affairs, Education Division, Phoenix Indian School, 1940.

———. *Who Wants To Be a Prairie Dog?* Phoenix: U. S. Office of Indian Affairs, Education Division, Phoenix Indian School. 1940.

———. *Young Hunter of Picuris.* Chilocco, Okla.: U. S. Office of Indian Affairs, Education Division, Chilocco Agricultural School, 1943.

———. *Little Boy with Three Names.* Chilocco, Okla.: U. S. Office of Indian Affairs, Branch of Education, Chilocco Agricultural School, 1950.

Colton, Harold S. *Hopi Kachina Dolls.* Albuquerque: University of New Mexico Press, 1949.

———. *Hopi Kachina Dolls.* Revised edition. Albuquerque: University of New Mexico Press, 1959.

Colton, Mary-Russell F. "Technique of the Major Hopi Crafts," *Museum Notes,* Vol. 3, No. 13, p. 26. Museum of Northern Arizona, Flagstaff, June 1931.

———. "The Arts and Crafts of the Hopi Indians," *Museum Notes,* Vol. 11, No. 1, pp. 26–28. Museum of Northern Arizona, Flagstaff, July 1938.

Cosgrove, H. S. and C. B. *The Swarts Ruin.* Papers, Peabody Museum of American Archaeology and Ethnology, Harvard University, Vol. XV, No. 1. Cambridge, Mass., 1932.

Coze, Paul. "Les Indiens Peints Par Eux-Memes," *L'Illustration,* Tome CXCIV, pp. 13–16. Paris, France, May 1936.

Cummings, Byron. *Kinishba, A Prehistoric Pueblo of the Great Pueblo Period.* Tucson: Hohokam Museums Association and the University of Arizona, 1940.

*Dancing Kachinas: A Hopi Artist's Documentary.* Phoenix: The Heard Museum, 1971.

"Death of Artist Ben Quintana," *El Palacio,* Vol. 52, No. 1, p. 9. Santa Fe, N. M., January 1945.

De Huff, Elizabeth Willis. *Taytay's Tales.* New York: Harcourt, Brace, 1922.

———. *Taytay's Memories.* New York: Harcourt, Brace, 1924.

———. *Swift Eagle of the Rio Grande.* Chicago: Rand, McNally, 1928.

———. *Five Little Kachinas.* Boston, Mass.: Houghton Mifflin, 1930.

Dietrich, Margretta S. "Their Culture Survives," *Indians at Work,* Vol. III, No. 17, pp. 18–24. Office of Indian Affairs, Washington, D. C., April 1936.

*Directions in Indian Art.* The report of a conference held at the University of Arizona, March 20–21, 1959. Tucson: University of Arizona Press, 1959.

Douglas, Frederick H. and Rene D'Harnoncourt. *Indian Art of the United States.* New York: Museum of Modern Art, 1941.

Dunn, Dorothy. "Indian Children Carry Forward Old Traditions," *School Arts Magazine,* Vol. 34, No. 7, pp. 426–36. Worcester, Mass., March 1935.

―――. "The Development of Modern American Indian Painting in the Southwest and Plains Areas," *El Palacio,* Vol. 58, No. 11, pp. 331–53. Santa Fe, N. M., November 1951.

―――. "Pablita Velarde, Painter of Pueblo Life," *El Palacio,* Vol. 59, No. 11, pp. 335–41. Santa Fe, N. M., November 1952.

―――. "The Art of Joe Herrera," *El Palacio,* Vol. 59, No. 12, pp. 367–73. Santa Fe, N. M., December 1952.

―――. *American Indian Painting of the Southwest and Plains Areas.* Albuquerque: University of New Mexico Press, 1968.

D., B. P. [Dutton, Bertha P. ] "Indian Artists Visit Museum," *El Palacio,* Vol. 49, No. 6, pp. 128–30. Santa Fe, N. M., June 1942.

Dutton, Bertha P. "Alfredo Montoya—Pioneer Artist," *El Palacio,* Vol. 49, No. 7, pp. 143–44. Santa Fe, N. M., July 1942.

Earle, Edwin and Edward A. Kennard. *Hopi Kachinas.* New York: J. J. Augustin, 1938.

Ellis, Florence Hawley. "Jémez Magic and Its Relation to Features of Prehistoric Kivas," *Southwestern Journal of Anthropology,* Vol. 8, No. 2, pp. 147–64. Albuquerque, N. M., 1952.

Emery, Irene. "Annual Indian School Arts and Crafts Exhibition," *El Palacio,* Vol. 57, No. 6, pp. 187–88. Santa Fe, N. M., June 1950.

Ewing, Robert. "The New Indian Art," *El Palacio,* Vol. 76, No. 1, p. 39. Santa Fe, N. M., Spring 1969.

"Exhibit of Indian Paintings," *El Palacio,* Vol. 36, Nos. 25–26, pp. 198–201. Santa Fe, N. M., June 20–27, 1934.

Fewkes, Jesse W. "Hopi Katcinas," Bureau of American Ethnology, *Annual Report,* No. 21. Washington, D. C., 1903.

―――. "Designs on Prehistoric Hopi Pottery," Bureau of American Ethnology, *Annual Report,* No. 33. Washington, D. C., 1919.

Forbes, Anne. "A Survey of Current Pueblo Indian Paintings," *El Palacio,* Vol. 57, No. 8, pp. 235–52. Santa Fe, N. M., August 1950.

"Further Note on Indian Painting," *El Palacio,* Vol. 56, No. 3, p. 76. Santa Fe, N. M., March 1949.

Gladwin, Harold S., Emil W. Haury, E. B. Sayles, and Nora Gladwin. *Excavations at Snaketown: Material Culture.* Medallion Papers, No. 25. Globe, Ariz.: Gila Pueblo, 1937.

Haile, Berard. *Head and Face Masks in Navaho Ceremonialism.* St. Michaels, Ariz.: The St. Michaels Press, 1947.

Hannum, Alberta Pierson. "Little No-Shirt," *Collier's Magazine,* pp. 56, 57. March 4, 1944.

―――. *Spin a Silver Dollar.* New York: The Viking Press, 1946.

Harrington, Mark Raymond. *Gypsum Cave, Nevada.* Southwest Museum Papers, No. 8. Los Angeles, April 1933.

Harvey, Joy. *Antelope Boy, A Navajo Indian Play for Children.* Phoenix: Arequipa Press, 1968.

Haury, Emil W. *Some Southwestern Pottery Types.* Medallion Papers, No. 19. Globe, Ariz.: Gila Pueblo, 1936.

―――. *Painted Cave, Northeastern Arizona.* Amerind Foundation, Inc., No. 3. Dragoon, Ariz., 1945.

Henderson, Alice Corbin. "Modern Indian Painting," *Introduction to American Indian Art,* Part II, pp. 3–11. New York: The Exposition of Indian Tribal Arts, Inc., 1931.

Hewett, Edgar L. "Native American Artists," *Art and Archaeology,* Vol. 13, No. 3, pp. 103–13. Washington, D. C., March 1922.

————. *Pajarito Plateau and Its Ancient People.* Albuquerque: University of New Mexico Press, 1938.

Hibben, Frank C. "Prehispanic Paintings at Pottery Mound," *Archaeology,* Vol. 13, No. 4, Winter 1960.

"Historic Indian Paintings," *El Palacio,* Vol. 48, No. 11, p. 259. Santa Fe, N. M., November 1941.

Holmes, William H. "Origin and Development of Form and Ornament in Ceramic Art," Bureau of American Ethnology *Annual Report* No. 4. Washington, D. C., 1886.

"Indian Art Exhibit," *El Palacio,* Vol. 48, No. 10, pp. 235, 236. Santa Fe, N. M., October 1941.

"Indian Artist Honored," *El Palacio,* Vol. 8, Nos. 7–8, pp. 182–83. Santa Fe, N. M., July 1920.

"Indians and Indian Life, Exhibit of Indian Paintings," *El Palacio,* Vol. 8, Nos. 5–6, pp. 125–27. Santa Fe, N. M., May and June 1920.

"It Is Written," *El Palacio,* Vol. 12, No. 7, pp. 91–92. Santa Fe, N. M., April 1, 1922.

Jacobson, O. B. and Jeanne D'Ucel. *American Indian Painters.* Editions D'Art. Nice, France: C. Szwedzicki, 1950.

Jones, Hester. "At the Art Gallery," *El Palacio,* Vol. 54, No. 6, pp. 143–46. Santa Fe, N. M., June 1947.

————. "At the Art Gallery," *El Palacio,* Vol. 55, No. 6, pp. 184–87. Santa Fe, N. M., June 1948.

————. "At the Art Gallery," *El Palacio,* Vol. 55, No. 10, pp. 326–27. Santa Fe, N. M., October 1948.

————. "At the Art Gallery, *El Palacio,* Vol. 56, No. 6, pp. 185–86. Santa Fe, N. M., June 1949.

————. "Gerald Nailor, Famous Navajo Artist, 1917–1952," *El Palacio,* Vol. 59, No. 9, pp. 294–95. Santa Fe, N. M., September 1952.

Judd, Neil M. *The Material Culture of Pueblo Bonito.* Smithsonian Miscellaneous Collections, Vol. 124. Washington, D. C.: Smithsonian Institution, 1954.

"Kabotie Awarded Guggenheim Fellowship," *El Palacio,* Vol. 52, No. 6, p. 119. Santa Fe, N. M., June 1945.

Kabotie, Fred. *Designs from the Ancient Mimbreños with a Hopi Interpretation.* San Francisco: The Grabhorn Press, 1949.

Kidder, Alfred Vincent. *An Introduction to the Study of Southwestern Archaeology.* New Haven, Conn.: Yale University Press for the Department of Archaeology, Phillips Academy, 1924.

———— and Samuel J. Guernsey. *Archaeological Explorations in Northeastern Arizona.* Bureau of American Ethnology, Bulletin 65. Washington, D. C., 1919.

"Kiva Murals Shown," *El Palacio,* Vol. 45, Nos. 1–5, p. 19. Santa Fe, N. M., July 6 and August 3, 1938.

"Kooyama—Hopi Indian Boy Painter," *Progressive Arizona,* Vol. 5, No. 2, pp. 13–28. Tucson, August 1927.

Lemos, Pedro J. "Mootzka, the Hopi Artist, Painter of Indian Tribal Ceremonies," *School Arts Magazine,* Vol. 34, No. 7, p. 417. Worcester, Mass., March 1935.

Lockett, Hattie Green. *The Unwritten Literature of the Hopi.* University of Arizona Social Science Bulletin No. 2. Tucson, May 1933.

Marriott, Alice. *María: The Potter of San Ildefonso.* Norman: University of Oklahoma Press, 1948.

Martin, Paul S. "Lowry Ruin in Southwestern Colorado," *Field Museum of Natural History Anthropological Series,* Vol. 23, No. 1. Chicago, 1936.

———— and Elizabeth S. Willis. "Anasazi Painted Pottery in Field Museum of Natural History," *Field Museum, Anthropology Memoirs,* Vol. 5. Chicago, December 1940.

Mera, H. P. *Navajo Textile Arts.* Santa Fe, N. M.: Laboratory of Anthropology, [1947].

Mindeleff, Cosmos. "The Cliff Ruins of Canyon de Chelly, Arizona," Bureau of American Ethnology, *Annual Report* No. 16. Washington, D. C., 1897.

Morang, Alfred. "Annual Indian Art Exhibit," *El Palacio,* Vol. 47, No. 5, pp. 117–118. Santa Fe, N. M., May 1940.

Morris, Earl H. and Robert F. Burgh. *Anasazi Basketry, Basket Maker II Through Pueblo III.* Publication 533, Carnegie Institution. Washington, D. C., 1941.

"Museum Notes," *El Palacio,* Vol. 32, No. 5, pp. 68–69. Santa Fe, N. M., February 3, 1932.

Nelson, John Louw. *Rhythm for Rain.* Boston, Mass.: Houghton Mifflin, 1937.

New Mexico Department of Vocational Education. (Carmen Espinosa, foreword.) *New Mexico Colonial Embroidery.* Santa Fe, N. M., 1943.

"New Mexico Painters," *El Palacio,* Vol. 19, No. 10, pp. 216–18. Santa Fe, N. M., November 15, 1925.

Pach, Walter. "Notes on the Indian Water-Colours," *The Dial,* Vol. 68, pp. 343–45. New York, March 1920.

"Painters and Sculptors," *El Palacio,* Vol. 18, Nos. 10–11, pp. 237–40. Santa Fe, N. M., June 1, 1925.

Parsons, Elsie Clews. *The Social Organization of the Tewa of New Mexico.* American Anthropological Association Memoirs, No. 36. Menasha, Wisc., 1929.

Pepper, George H. *Pueblo Bonito.* Anthropological Papers of the American Museum of Natural History, Vol. 27. New York, 1920.

Prudden, T. Mitchell. "The Circular Kivas of Small Ruins in the San Juan Watershed," *American Anthropologist,* n.s., Vol. 16, No. 1, pp. 33–58. Menasha, Wisc., January–March 1914.

Roberts, Frank H. H. *The Village of the Great Kivas on the Zuñi Reservation, New Mexico.* Bureau of American Ethnology, Bulletin 111. Washington, D. C., 1932.

Rush, Olive. "Annual Indian Art Show," *El Palacio,* Vol. 42, Nos. 19–21, pp. 105–108. Santa Fe, N. M., May 12, 19, 26, 1937.

S., C. "Annual Indian School Exhibit," *El Palacio,* Vol. 46, No. 5, pp. 112–15. Santa Fe, N. M., May 1939.

Schaafsma, Polly. *Rock Art in the Navajo Reservoir District.* Museum of New Mexico, Papers in Anthropology No. 7. Santa Fe, 1963.

Schaefer, Mathilde. "Winter in Navajoland," *Arizona Highways,* Vol. 16, No. 12, pp. 8–11. Phoenix, December 1940.

Shufeldt, R. W. "A Navajo Artist and His Notions of Mechanical Drawing," Smithsonian Institution, *Annual Report* for 1886, Part 1, pp. 240–44. Washington, D. C., 1889.

Simpson, Lt. J. H. "Report of an Expedition into the Navajo Country," *Executive Documents* of the Senate of the United States, 31st Cong., 1st Sess., pp. 55–168 and 250 ff. Washington, D. C. 1850.

Sinclair, John L. "The Pueblo of Kuaua," *El Palacio,* Vol. 58, No. 7, pp. 206–15. Santa Fe, N. M., July 1951.

Sloan, John and Oliver LaFarge. *Introduction to American Indian Art,* Part I. New York: The Exposition of Indian Tribal Arts, Inc., 1931.

Smith, Watson. *Kiva Mural Decorations at Awatovi and Kawaika-a.* Papers, Peabody Museum of American Archaeology and Ethnology, Harvard University, Vol. 37. Reports of the Awatovi Expedition, No. 5. Cambridge, Mass., 1952.

Snodgrass, Jeanne O. (comp.). *American Indian Painters, A Biographical Directory.* New York: Museum of the American Indian, Heye Foundation, 1968.

"The Southwest Indian Fair," *El Palacio,* Vol. 13, No. 8, pp. 93–97. Santa Fe, N. M., October 1922.

Stevenson, Matilda Cox. "The Zuñi Indians: Their Mythology, Esoteric Societies, and Ceremonies," Bureau of American Ethnology, *Annual Report* No. 23. Washington, D. C., 1904.

Tanner, Clara Lee. "Sandpaintings of the Indians of the Southwest," *The Kiva,* Vol. 13, Nos. 3–4, pp. 26–36. Arizona Archaeological and Historical Society, Tucson, March–May 1948.

————. "Contemporary Indian Art," *Arizona Highways,* Vol. 26, No. 2, pp. 12–29. Phoenix, February 1950.

————. "Fred Kabotie, Hopi Indian Artist," *Arizona Highways,* Vol. 27, No. 7, pp. 16–29. Phoenix, July 1951.

————. *The James T. Bialac Collection of Southwest Indian Paintings.* Tucson: Arizona State Museum, The University of Arizona, 1968.

Thompson, Laura and Alice Joseph. *The Hopi Way.* Indian Education Research Series, No. 1. Lawrence, Kan.: U. S. Indian Service, Haskell Institute, 1944.

Tozzer, Alfred Marston. "Notes on Religious Ceremonials of the Navaho," in *Putnam Anniversary Volume, Anthropological Essays,* pp. 299–344. New York: G. E. Stechert and Co., 1909.

Underhill, Ruth. *Singing for Power.* Berkeley: University of California Press, 1938.

————. *The Papago Indians of Arizona and Their Relatives the Pima.* Lawrence, Kan.: Education Division, U. S. Indian Service, Haskell Institute, 1940.

————. *Pueblo Crafts.* Phoenix: Education Division, U. S. Indian Service, Phoenix Indian School, 1945.

————. *Workaday Life of the Pueblos.* Phoenix: Education Division, U. S. Indian Service, Phoenix Indian School, 1946.

————. *People of the Crimson Evening.* Riverside, Cal.: Branch of Education, U. S. Indian Service, Sherman Institute, 1951.

Vaillant, George C. *Indian Arts in North America.* New York: Harper and Bros., 1939.

Van Valkenburgh, Richard. "Wolf Men of the Navaho," *The Desert Magazine,* Vol. 11, No. 3, pp. 4–8. Palm Desert, Cal., January 1948.

Velarde, Pablita. *Old Father the Story Teller.* Globe, Ariz.: Dale Stuart King, 1960.

Villagrá, Gaspar Pérez de. (Alcalá, 1610), translated by Gilberto Espinosa, *History of New Mexico.* The Quivira Society Publications, Vol. 4. Los Angeles, 1933.

Vivian, Gordon. "The Murals at Kuaua," *El Palacio,* Vol. 38, Nos. 21–23, pp. 113–19. Santa Fe, N. M., May–June 1935.

Wyman, Leland C. *The Sacred Mountains of the Navajo.* Flagstaff: Museum of Northern Arizona, 1967.

White, Leslie A. "The Acoma Indians," Bureau of American Ethnology, *Annual Report,* No. 47, pp. 17–193. Washington, D. C., 1932. ∎

# Index

474